Jean-Honoré
FRAGONARD

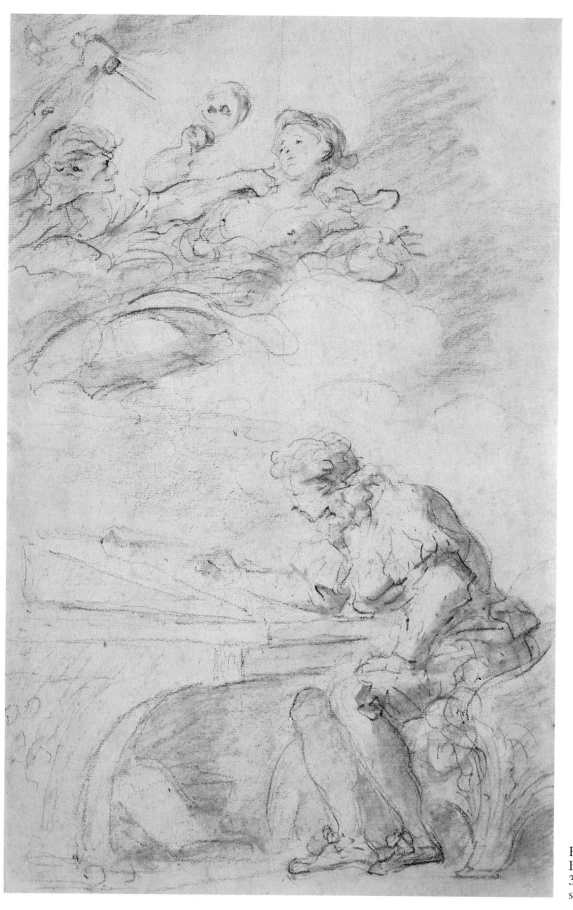

Frontispiece *Young Man Writing.*
Black chalk and gray wash,
36.6 × 23.5 cm. Cabinet des Dessins, The Louvre, Paris

Jean-Pierre Cuzin

Jean-Honoré
FRAGONARD
Life and Work

Complete Catalogue of the Oil Paintings

Harry N. Abrams, Inc., Publishers, New York

Translated from the French by: Anthony Zielonka (text) and
Kim-Mai Mooney (catalogue)

Originally published in French under the title:
Fragonard: Vie et Œuvre

Library of Congress Cataloging-in-Publication Data

Cuzin, Jean Pierre.
 [Fragonard. English]
 Fragonard/by Jean-Pierre Cuzin.
 p. cm.
 ISBN 0-8109-0949-9
 1. Fragonard, Jean Honoré, 1732–1806—Criticism and
interpretation. 2. Painting, French. 3.Painting,
Modern—17th–18th centuries—France. I. Title.
ND553.F7C8813 1988
759.4—dc19 87–31906
 CIP

A Times Mirror Company

Printed and bound in Switzerland

Contents

Introduction
Rediscovering Fragonard

Fragonard's life and œuvre are surrounded by so much confusion, so many groundless legends, and so many misunderstandings of various kinds that our appreciation of this artist has, to a large extent, been distorted. The image that has come down to us of one of the most popular French painters is oversimplified and vague and is obscured by the glorious reputation of a few paintings that have become stereotypes of eighteenth-century France.

When studying Fragonard we should beware of generally accepted ideas and make allowance for the legends that have arisen. People have tended to see Fragonard as the lover of actresses and dancers and as the wooer of his young sister-in-law. Critics have systematically labeled his family scenes and portraits as images of his children, Rosalie and Alexandre-Evariste, as well as of his sister-in-law. Lack of information about the artist's life has led commentators to read his pictures as a chronicle of his own life. This is a risky undertaking, and moving from his life to his works and from his works to his life only has the effect of muddling our perception of both. Ideas that are as attractive as they are unfounded become firmly entrenched and give a storybook view of the man and of his life.

An attempt needs to be made to get to know Fragonard's work as well as possible in order to understand its full range and diversity, and in order to follow its development. That is not an easy task with the artist in question. In the first place, many of his paintings have been lost; to demonstrate this it is enough to recall those that appeared in public sales when Fragonard was still alive and which were often precisely described in the catalogues.[1] Some have reappeared, others will, hopefully, see the light of day again. But the contempt that was generally felt for Fragonard's art began when he was still alive and was not dispelled until about 1840. This attitude could not fail to have

repercussions. Some works have disappeared forever, especially those associated with decors, a genre which is threatened whenever fashions change; and, of course, some subjects were suddenly judged to be too risqué, notably the nudes, which were considered indecent and were censured once and for all.

Fragonard's œuvre has thus come down to us in a fragmentary, amputated form. But, as a consequence first of early neglect and then of a restored reputation, it has been considerably enriched by external elements. The image of the artist has been strangely distorted because of this, for not only has his œuvre been supplemented by a large number of copies, imitations or pastiches, as is the fate of all great painters, but through idle short-sightedness or greedy calculation, the majority of paintings from the second half of the eighteenth century which are painted in a spirited and fluent style and whose authorship is problematical have tended to be attributed to Fragonard. Such a situation can hardly be rectified when connoisseurs defend it. Nevertheless, an effort should be made to identify the inaccuracies that have built up. The difficulties of such a task are compounded, however, by the fact that Fragonard had clever imitators as well as admirers who were able to be totally receptive to his style. Even a great painter can have a bad day and there were occasions when Fragonard was lazy. It should also be said that the greater a painter is, the more surprises he can have in store for us.

There is thus a need for caution; only those works that have been documented on good authority may be regarded as definitely by Fragonard. Decisions also have to be made concerning the manner in which these works may be associated with other works, where a similarity of style justifies the comparison. In view of all the estimates and judgments that have to be made, it is very easy to make a

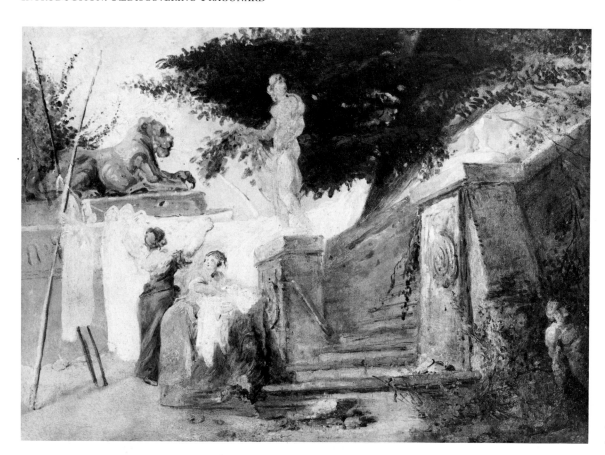

2 Hubert Robert (1733–1808). *The Washerwomen.* c. 1760. Oil on canvas, 47 × 65 cm. Musée de Picardie, Amiens

mistake. The most reliable method of revising Fragonard's catalogue and of drawing up a more accurate one consists in finding out whether doubtful pieces are not really the work of other artists who were contemporaries of Fragonard, such as Hubert Robert or Louis Durameau (b. 1733), Jean-Baptiste Le Prince (b. 1734), as well as the slightly older Jean-Hugues Taraval (b. 1729). It can also involve slightly younger artists, such as Jean-Jacques Lagrenée (b. 1739), and especially Jean-Simon Berthélemy (b. 1743) or François-André Vincent (b. 1746). All of them unquestionably knew Fragonard's works well; but to refer to them as imitators would be to make a cursory judgment.

This method has recently produced interesting results and will certainly continue to do so. A few examples will suffice to make the point. In the case of Hubert Robert, the most striking one is that of *The Washerwomen*, in the Museum in Amiens, which is still admired as a typical Fragonard; the works of these two friends have often been confused.[2] The case of Durameau is more complicated; a work like *Young Mandolin Player*, in a collection in Strasbourg in 1960, may not be by Fragonard, since it is more descriptive in its more complicated and dispersed luminosity and in its concern for the picturesque, which recall paintings that are definitely by Durameau.[3] A similar

question mark may be placed over the startling *Portrait of an Artist Painting a Miniature* in the Fine Arts Museum of San Francisco, which is universally known as a Fragonard and is considered to be a self-portrait of the artist painting a miniature.[4] Yet, the red and green colors are very different from those used by Fragonard, which are generally warmer; the touch is too uneven and casual, the light effect is too harsh. These characteristics might well point to Durameau, and in that event the painting would be an exceptional masterpiece.

The freedom of technique of some of Le Prince's paintings is the reason why critics have been able to attribute them to Fragonard. Mention should also be made of a sketch (private collection, Paris) of the *Rendezvous in a Park*, in the Alte Pinakothek, Munich.[5] Similarly, certain landscapes in the Dutch manner and some ardently executed drawings, in ink or paint, may have to be attributed to Le Prince instead of to Fragonard; such is the case of the renowned *Pasha*, in the Cabinet des Dessins, in the Louvre.[6] Taraval is completely neglected today, in spite of the study that Marc Sandoz has devoted to him; he seems to be the author of several paintings that were negligently attributed to Fragonard. Taraval definitely painted a *Lying Nude*, which is very Fragonardesque. It is a sketch for a painting that is signed and dated 1779, which is in the Musée des

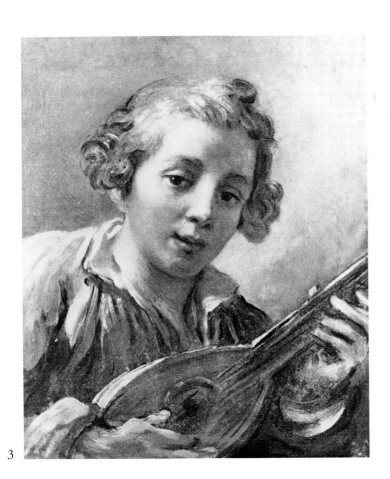

3

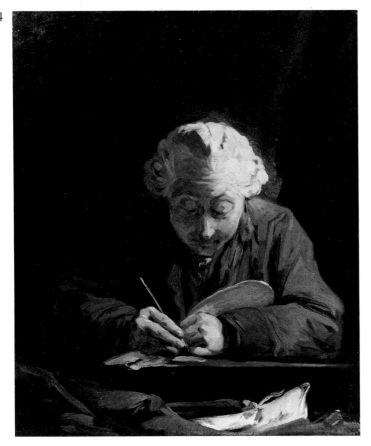

4

3 Attributed to Louis Durameau (1733–1796). *Young Mandolin Player.* c. 1770–75(?). Paper mounted on canvas, 29 × 23 cm. Private Collection

4 Unknown painter (Louis Durameau?). *Portrait of an Artist Painting a Miniature.* c. 1770–75(?). 45.6 × 37.5 cm. The Fine Arts Museum of San Francisco. Gift of Mr. and Mrs. Louis Benoist

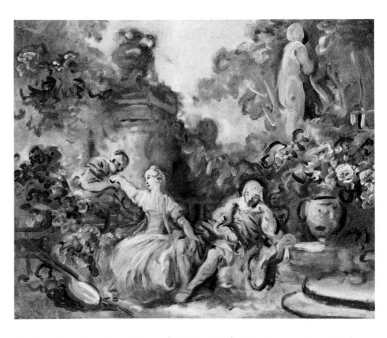

5 Jean-Baptiste Le Prince (1734–1781). *Rendezvous in a Park*, or *The Useless Precaution.* 1774. Oil on canvas, 37 × 45.6 cm. Private Collection, Paris

6 Attributed to Jean-Baptiste Le Prince (1734–1781). *The Pasha.* c. 1775(?). Brush and brown ink, 24.7 × 32.9 cm. Cabinet des Dessins, The Louvre, Paris

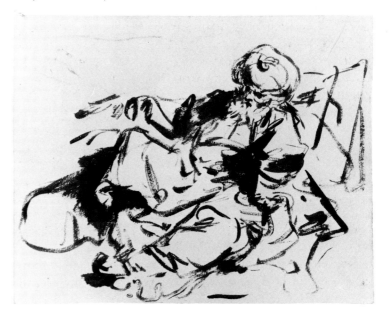

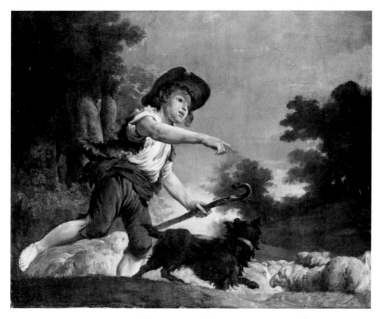

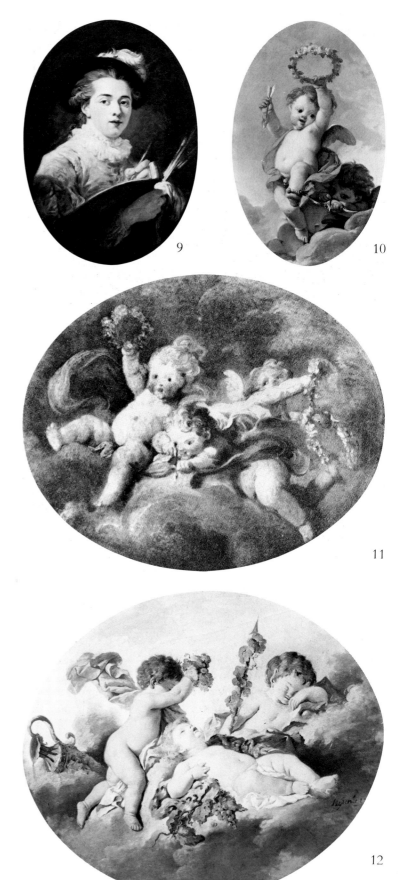

7 Jean-Hugues Taraval (1729–1785). *Woman Lying on a Bed.* 1779. Oil on canvas, 24 × 31.5 cm. Private Collection

8 Jean-Hugues Taraval (1729–1785). *Young Shepherd with a Dog.* Probably in the Salon of 1775. Oil on canvas, 93.5 × 120.4 cm. Private Collection

9 François-André Vincent (1746–1816). *Self-Portrait in Spanish Costume.* c. 1770. Oil on canvas, 71 × 54 cm. Musée Fragonard, Grasse

10 Attributed to Jean-Hugues Taraval (1729–1785). *Two Cupids in the Clouds,* or *Love Triumphant.* c. 1775(?). Oil on canvas, 62 × 41 cm. Private Collection, Paris

11 Attributed to Jean-Hugues Taraval (1729–1785). *Cupids in the Clouds.* c. 1780(?). Oil on canvas, 18 × 22 cm. Private Collection

12 Jean-Jacques Lagrenée (1739–1821). *Bacchanalia with Cupids.* 1765. Oil on canvas, 123 × 152.5 cm. Private Collection

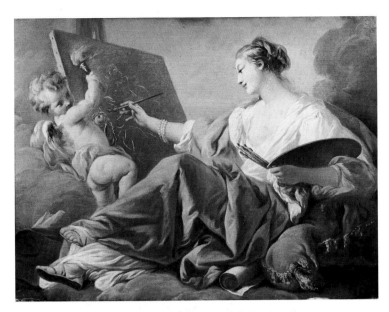

13 Jean-Jacques Lagrenée (1739–1821). *Allegory of Painting*. c. 1770
Oil on canvas, 101 × 138 cm. Private Collection, Paris

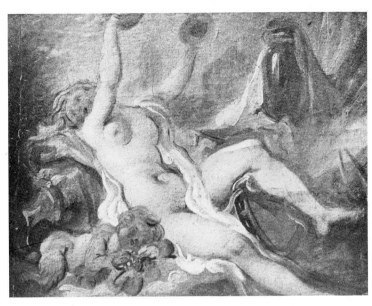

14 Jean-Simon Berthélemy (1743–1811). *Reclining Bacchante Playing Cymbals*. 1778. Oil on canvas. Private Collection

Beaux-Arts in Tours.[7] In the present writer's opinion Taraval is also the author of the *Young Shepherd with a Dog*, which was formerly in the David-Weill Collection where it was considered to be a Fragonard; it was probably exhibited by the true artist at the Salon of 1775.[8] The same is probably the case of *Two Cupids in the Clouds*.[9] Jean-Jacques Lagrenée may have been responsible for several of these pictures too.[10] But it was Berthélemy and Vincent, the youngest of these painters, who were unwittingly responsible for the most serious confusions. Natalie Volle has revealed that several of Berthélemy's paintings and drawings were falsely attributed to Fragonard, notably some painted sketches for ceilings, executed in a fluent style, which are elegant and occasionally rather weak.[11] One could add the amusing sketch of a *Bacchante* (1778), which was formerly in the Doistau Collection and is now in a private collection.[12] Vincent has suffered to an even greater extent as approximately ten of his paintings and many of his drawings have become much-admired "Frago-

nards": they include the *Self-Portrait in Spanish Costume* in the Musée Fragonard in Grasse, *Madame Griois*, in a private collection, the *Woman Wearing a Turban* in the Bührle Collection in Zurich, and the *View of Tivoli* in the Musée Borély, in Marseilles.[13]

Mention should also be made of landscape painters like Francesco-Giuseppe Casanova, Philip James de Loutherbourg or, once again, Le Prince, some of whose landscapes in the Dutch manner have been considered to be by Fragonard.[14] And even if Fragonard were still smiling at the fact that works by Claude Vignon[15] or François Verdier[16] could have been regarded as being by him, he would probably have been quite pleased that paintings by Alexis Grimou (1678–1733), a painter whom he admired immensely, were also attributed to him.[17]

We shall see that Fragonard was a painter of many guises, but care must be taken not to allow those of other painters to become superimposed on his own identity with its specific characteristics.

Chapter I
1732–52 Grasse and Paris
Childhood and Apprenticeship

Childhood

Jean-Honoré Fragonard was born in Grasse on April 5, 1732. His parents, François Fragonard and Françoise Petit, had been married on May 25 of the previous year and each of them came from a family of shopkeepers: the certificate of baptism states that the boy's father as well as both his grandfathers were shopkeepers. Other contemporary documents in Grasse refer to François Fragonard as a glover, while several other members of the family, which seems to have been comparatively well off, were perfume-sellers. The Fragonards had lived in Grasse for a long time and the family can be traced back to an ancestor who had settled in the town at the end of the sixteenth century and who was said to have been born in Tracan, a suburb of Milan; the patronymic does indeed appear to be of Italian origin. The child was christened after his paternal grandfather, Jean-Honoré. A second boy, Joseph, was born in the following year but he died at the age of ten months: young Jean-Honoré was to remain an only child.[1]

The painter's early childhood was spent in the town of his birth, a town of alleyways, flights of stairs, and terraces commanding diverse and picturesque views. Grasse was already the realm of perfumers, where magnificent vegetation grew in abundance and where there were many gardens full of roses and other flowers. The Goncourt brothers and, less successfully, Fragonard's subsequent biographers, have enthusiastically commented on the way the child's earliest impressions must have shaped his character as a painter. There is probably a connection, a kind of resonance or echo, between Fragonard's work and the region in which he was born. The sunlit scenes, masses of plant forms, clusters of flowers, and thick trees depicted on the painter's canvases are reminiscent of his native town.

But it might be more accurate to say that it is the observer who sees Grasse when looking at Fragonard's work. Although the artist was born in Provence, it should not be forgotten that he probably left Grasse at the age of six.

In 1734 the artist's grandfather divided his fortune between his sons, Honoré and François. The latter invested his share in the fire engine company of François-Nicolas du Périer, chief of the royal fire brigade, who had a scheme to install fire hydrants in the streets of Paris. When the venture failed in 1738, François Fragonard went to Paris in an attempt to reclaim his money. That was presumably when he decided to settle there with his family and to become a mercer's assistant.[2]

Apprenticeship: The Studios of Chardin and Boucher

According to the same family account, which the Goncourt brothers received from the painter's grandson,[3] Jean-Honoré, about whose education little is known, was put into a notary's office when he was about thirteen years old. The notary, seeing that his young clerk did nothing but draw, may have advised his parents to encourage their son's vocation for they took him to François Boucher, who was then at the height of his career. Realizing that the child was only a beginner, the painter recommended that Fragonard learn the rudiments of the painter's craft before coming to his studio. Another prominent artist, Chardin, agreed to take charge of the burgeoning artist and gave him practical chores to do as well as making copies of engravings. It is difficult, today, to imagine

Fragonard as an adolescent in Chardin's studio and especially difficult to imagine what he could have retained of that training. Are there two painters more dissimilar? But perhaps it was from this great painter that the apprentice Fragonard unwittingly acquired a confident way of arranging shapes in a particular light and a sense for appealing browns and whites that would later be found in his own paintings; his admiration for the Dutch Golden Age may also have come from his first master.

Be that as it may, Chardin did not think highly of Fragonard. Family accounts also tell us that Fragonard did not work hard and that the master discouraged his parents from letting him persevere in that direction. Yet Fragonard assiduously visited the churches in Paris and eagerly studied the paintings found there, which he would later sketch from memory. Having been dismissed by Chardin, he went back to show Boucher the fruits of his first efforts. Boucher now seemed to be convinced of the young man's talent and took him into his studio in about 1749 or 1750.

During his training, which lasted for two or three years, Fragonard must have worked on the large paintings on mythological subjects destined to be used as cartoons for the Gobelin tapestries.[4] Female nudes, putti, garlands of flowers, and an entire charming decorative vocabulary in bright and contrasting colors were a more radical change after Chardin's studio than could be imagined.

Thus, Fragonard began his career as a painter under the illustrious but contradictory patronage of the two greatest figures in Parisian painting of the middle of the eighteenth century. This start gave the young painter the opportunity to acquire early on a taste for studies painted from life and for decorative painting that he was never to lose.

Cat. L62 It is likely that during those formative years Fragonard painted copies. For example, *Hercules and Omphale* was a copy of an early Boucher, which was then in the Randon de Boisset Collection, and is now in the Hermitage, Leningrad, and became part of the Varanchan Collection, but it is not known when Fragonard painted it. Nor are the dates Cat. L19, certain of *Girl with a Broom* and of *Danaë*, both after L20 Rembrandts in the Crozat Collection, Paris, at the time (the first of which is now in the National Gallery of Art, Washington, D.C., and the other in the Hermitage, Leningrad). These copies, which belonged to Boucher's son-in-law Jean-Baptiste Deshays, whom Fragonard would have known, were later sold in 1765. Whatever became of them after that is unknown.

205; Another copy made at that time, which has survived to Cat. 58 this day, became part of Boucher's own collection. Once again the young Fragonard turned for inspiration to a Rembrandt masterpiece, *The Holy Family*, which, like the others, was in the Crozat Collection and is presently in the Hermitage; yet this work is also difficult to date. Its skillful execution and faithful rendering of the original make it hard to believe that it is an early work, prior to 1752.

Just as intriguing is a series of four pictures, each painted with a free and virtually identical technique. One of this series now hangs in the M.H. de Young Memorial Cat. Museum, San Francisco; the others are in private collections. They all show a detail from the *Holy Family* of the cradle with the Infant and the Virgin, which was not copied but interpreted since the mother is bending over to a much greater degree than in Rembrandt's original. It is hard to imagine Fragonard painting an almost identical picture four times except as an exercise; and as these paintings have not been historically documented it is possible that this was a subject assigned, perhaps by Boucher, to several pupils and that one of the four paintings really is by Fragonard. The picture in San Francisco, which is of fine quality, may well be his work,[5] yet this attribution can only be made with reservation for it cannot be proved that these copies were made during his training with Boucher.

What did Fragonard produce during those years? No evidence enables us to reconstruct his drawings based on the engravings of Chardin or his sketches inspired by the paintings in Parisian churches. Nor can the part he played in Boucher's decorative canvases be determined, even if it were ever discernible. Fragonard scholars have always dated from those years with Boucher quite a large number of paintings on pastoral or mythological subjects, mostly having a decorative purpose, whose style, type of figures, and colors are so close to Boucher's that they have led to a certain amount of confusion, some of which has persisted.[6] It seemed quite logical to date such works from the years Fragonard spent in the master's studio. Yet the facility of brushwork that they reveal and their decorative vigor are astonishing for a novice. The painting with which Fragonard was to compete for the Prix de Rome, *Jeroboam Sacrificing to the Idols*, which certainly dates from 15; 1752, reveals a much more constrained style, a hesitating Cat. and light touch. It looks almost amateurish by comparison with the paintings "à la Boucher" that have been preserved, and the breadth of the decorative programs they presuppose implies that the artist who painted them was well known. Is it possible to attribute them to an unknown artist aged eighteen or nineteen? Yet, we shall see that the style of many of those paintings perfectly matches that of the ones Fragonard painted between 1752 and 1756, after winning the Prix de Rome, and that these works bear the mark of a fully controlled art, which is, in fact, quite complex and noticeably different from one work to another. Although Boucher's influence had an enriching effect on a whole section of Fragonard's work, it was not immediately expressed or directly evident.

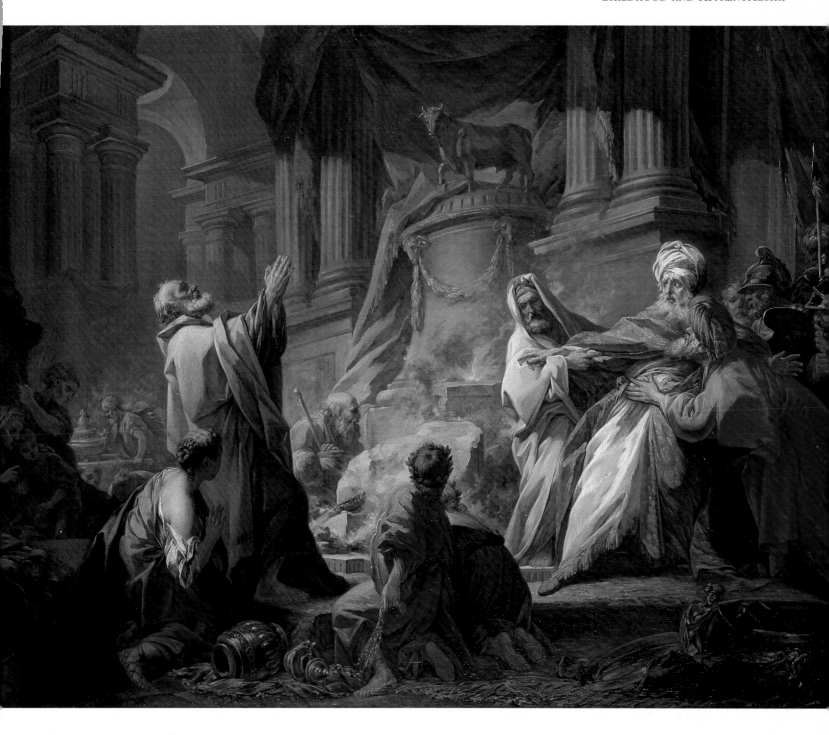

It was Boucher, the Goncourts also tell us,[7] who made Fragonard compete for the Prix de Rome, in spite of the fact that the young painter was not a pupil of the Académie Royale. The regulations dating from January 1751 stipulated that only those pupils of the institution who had been "duly enrolled as such" could compete for the main prize. In addition, they must already have been awarded one of the "small term prizes" and have presented certificates from their teachers stating their standard in

15 *Jeroboam Sacrificing to the Idols.* 1752. Oil on canvas, 115 × 145 cm. Ecole Nationale Supérieure des Beaux-Arts, Paris (cat.no. 1)

perspective and anatomy. Boucher's cavalier disregard of these regulations gives the impression that he enjoyed special favors and had well-placed friends at the Académie. It

is said that Boucher's response to Fragonard's objections was simply: "It doesn't matter, you are my pupil." Thus Fragonard entered the competition and won the prize.

The Grand Prix of 1752

The painting, now preserved in the collections of the Ecole des Beaux-Arts, Paris, with other prize winners of this famed competition, is puzzling. Everything about it suggests that it was painted by a good pupil of the Académie, and few of its features reflect the art of Boucher. It has to be said that the young Fragonard's training remains mysterious. Can it be categorically denied that he attended courses at the Académie? One may wonder whether the account given by his grandson a century later was totally accurate.

One thing is certain: Fragonard was among the competitors for the Prix de Rome in 1752. In keeping with tradition, the different stages of the competition were held in the spring and summer. First, contestants were required to make a sketch of a set subject for a preliminary selection; then under supervision they painted the picture in a prescribed format. The subject given to the candidates that year was *Jeroboam Sacrificing to the Idols*. The scene was to be set in Bethel, in the temple founded by the schismatic King Jeroboam. Jeroboam, the first king of Israel to oppose Roboam, the son of Solomon, had instituted a cult to the Golden Calf there. Let us go back to the biblical text to understand fully the scene Fragonard has depicted with a genuine concern for expressive detail, a quality that was certainly decisive in the eyes of the academicians who awarded him the prize:[8]

> As Jeroboam stood by the altar to burn the sacrifice, a man of God from Judah, moved by the word of the Lord, appeared at Bethel. He inveighed against the altar in the Lord's name, crying out: "O altar, altar! This is the word of the Lord: 'Listen! A child shall be born to the house of David, named Josiah. He will sacrifice upon you the priests of the hill-shrines who make offerings upon you, and he will burn human bones upon you.'" He gave a sign the same day: "This is the sign which the Lord has ordained: This altar will be rent in pieces and the ashes upon it will be spilt." When King Jeroboam heard the sentence which the man of God pronounced against the altar at Bethel, he pointed to him from the altar and said: "Seize that man!" Immediately the hand which he had pointed at him became paralyzed, so that he could not draw it back. The altar too was rent in pieces and the ashes were spilt, in fulfilment of the sign that the man of God had given at the Lord's command. The King appealed to the man of God to pacify the Lord his God and pray for him that his hand might be restored. The man of God did as he asked: his hand was restored and became as it had been before. (I Kings 13,1-6)

Fragonard chose the moment of highest emotion: the idolatrous king, on the right, looking terrified, with his arm and hand outstretched and stiff, is supported by two priests who are watching that hand; on the left, the "man of God," in prayer, his hands raised toward heaven, implores the Lord to break the evil spell. In the center, between the two men and surmounted by the statue of the Golden Calf, is the just-shattered altar surrounded by smoking ashes that have been scattered on the ground.

Fragonard won the prize with a learned composition based on the diagonals of the canvas with figures placed on two levels, an approach he would long favor: in the foreground, and at the foot of a platform, three assistants, a young girl and two thurifiers, in semi-contre-jour, serve as *repoussoirs*. The "man of God," in profile, is mounting the platform and is opposing the restless group of King Jeroboam and his retinue with calm and determination. It is a vital picture for it enables us to study the art of the very young Fragonard; and it is a touching picture because of the artist's wish to do things properly for the sake of art and not merely to satisfy imposed requirements. Without being labored, the painting is a résumé of the most spectacular and most expressive ideas that had been put forward by the history painters in the middle of the eighteenth century, and as such it is somewhat reminiscent of the cartoons of the *Story of Esther* by Jean-François de Troy (who died in a kind of disgrace that same year in Rome). Its spacious palatial decor, turbaned figures on the right, and the excessively pompous bustle have a sense of narrative that is more descriptive than moving. But the analogies are even stronger with painters who were then at the height of their fame and influence: the grand style, the vigorous postures, verging on the excessive, recall Carle Van Loo.[9] Jean Restout could also be cited here, with his rather systematic way of arranging characters and groups in triangular patterns.[10]

One might also cite the names of several painters from the middle of the century, but not that of Boucher. The composition, consisting of triangular groups based firmly on the diagonals of the canvas, reflects a totally different approach from that adopted by Boucher, who composed by means of curves and counter-curves, rounding off shapes that seem to rebound off one another. Among the

figures in the picture, only one or two, a soldier on the right, a woman kneeling on the left, faintly evoke the art of Fragonard's teacher. And the figures in the background, with their blended brushstrokes and their pastel colors, are not in the style of Boucher at all but, rather, that of Restout. The painting should not be criticized for being scholarly for by its very purpose it is a milestone in a process of schooling, and Fragonard was still a novice when he painted it. In spite of all the painting's merits, it is, nevertheless, heterogeneous: some parts, like the hands, are appliquéd; his touch is sometimes rather dry, sometimes blurred and fuzzy; the group of Jeroboam and his two assistants borders on the melodramatic and can make one smile. But, already, the light is correctly distributed, with the middle distance luminous and vibrant toward the center, contrasting with the lateral parts and the foreground, which have been left in a half-light, an effect that would recur in the painter's mature work. And the range of colors, the whites, pale grays, beiges, soft fawns contrasting with the reds, the blues, the turquoises, prefigures many a later painting. The seeds of a whole aspect of Fragonard's art are contained within this picture dating from his twenties. The profile of the head of the "man of God" itself prefigures the heads of old men he would later paint.

The fact remains that one finds Fragonardesque qualities in the *Jeroboam* because that is what one is looking for in the picture. It is a painting by a good pupil that marks the beginning of the œuvre of an artist who was so frequently to demonstrate his independence.[11]

Chapter II
1752–56 Paris
L'Ecole Royale des Elèves Protégés

Paintings Presented at Versailles from 1754 to 1755

The Grand Prix did not immediately open the doors of the Académie de France in Rome. Fragonard remained in Paris until the end of 1756 and was enrolled as a student at the Ecole Royale des Elèves Protégés like the other winners of the prize and as was required by the regulations. He had to wait several months for a place to become vacant and, when Gabriel Briard left for Rome, Fragonard joined the Ecole Royale on May 20, 1753.

Founded in 1748, this school, which was situated near the Louvre, provided the young prize-winners with both an artistic and an intellectual education. Carle Van Loo, its principal, seems to have been a great teacher who kept a close watch on his students' progress. His wife, Christine, who was liked and respected, had the difficult task of running the school's household affairs on a low budget.[1]

It must have been a real pleasure to study at the Ecole because the young artists did not appear to be in too much of a hurry to set off for Rome. When in 1754 a boarder's place became vacant at the Académie de France, Abel-François Marigny, who succeeded Lenormant de Tournehem as General Director of the Painters to the King for royal buildings *(Directeur Général des Bâtiments du Roi)* in 1751, asked François-Bernard Lépicié, a professor at the Ecole, which pupil wanted to take it, Lépicié replied: "It can only be given to one of the three remaining student painters: Monsieur Fragonard, who has been at the Ecole for a year, Monsieur [Charles] Monnet, who has been here for nine months, and Monsieur [N.] Brenet, who has been here for four months. However, Sir, these three students feel so strongly that they still need to follow Van Loo's

classes and example in color and composition that they beg you most respectfully to allow them to complete their course with so good a teacher."[2]

In accordance with the wish that Tournehem had expressed in 1749, the sponsored students *(élèves protégés)* had to paint a composition piece every year, to be presented to the king at Versailles at the beginning of the year. This practice would quite soon be brought to an end and the last exhibition of such works was held in 1755. The academicians themselves, who did not enjoy such a privilege made every effort to have it withdrawn.[3] By a stroke of luck, the two paintings by Fragonard that were exhibited in 1754 and 1755, *Psyche Showing Her Sisters Cupid's Presents* (National Gallery, London), and *The Washing of the Disciples' Feet* (Cathedral, Grasse), form the only sound basis for the study of Fragonard's art during these four years preceding his departure for Rome.

The *Psyche Showing Her Sisters Cupid's Presents*, probably painted in the second half of 1753 during the first stage of Fragonard's training at the Ecole Royale des Elèves Protégés, and long considered to have been lost, has been identified by David Carritt.[4] This major work gives us a valuable chronological reference point as it is the second canvas by Fragonard, after the *Jeroboam*, the date of which is certain; furthermore, it is a true masterpiece, providing the first evidence of the fact that Fragonard was already beginning to acquire the characteristic features of his style. Many of the elements present in the *Jeroboam* are found here once again, expressed with a fresh facility: the architectural setting with its columns, the steps in the foreground with the richly fringed carpet, the items of gold plate, the contre-jour position of the kneeling or bending figures; one of them, on the left, is a direct reminiscence of the young girl kneeling by the side of Jeroboam.

17;
Cat. 2

19;
Cat. 22

17;
Cat. 2

16 *Sculpture*. c. 1753. Oil on canvas, 82 × 102 cm. Private Collection, U.S.A. (cat. no. 4)

And the luminous white of Psyche's drapery, next to the red drapery of her companion, bowing down before her, recalls the effect of the colors of the turbaned priests on the right of the earlier painting. It is as though Fragonard, now free to choose a subject or at least treating a subject he likes, were painting his prize-winning picture over again at his convenience, in a light-hearted manner, using female figures. Here and there, a few "regrets" are apparent, indicating a good student who corrects an anatomical detail, reinforces a shoulder, trims down a leg, or changes the position of one of the cupids on the upper right. There is, perhaps, too much accumulation of elements in the picture, caused by his wish to captivate the onlooker, which suggests a display of trinkets in a gynaeceum, but which is quite appropriate to the subject. The abundance of shimmering fabrics, golden fringes, gold plate, garlands of flowers, and pearls recalls the Gobelin tapestries of the *Story of Psyche*, woven in the 1740s from Boucher's cartoons. But, apart from any superficial analogies, the female

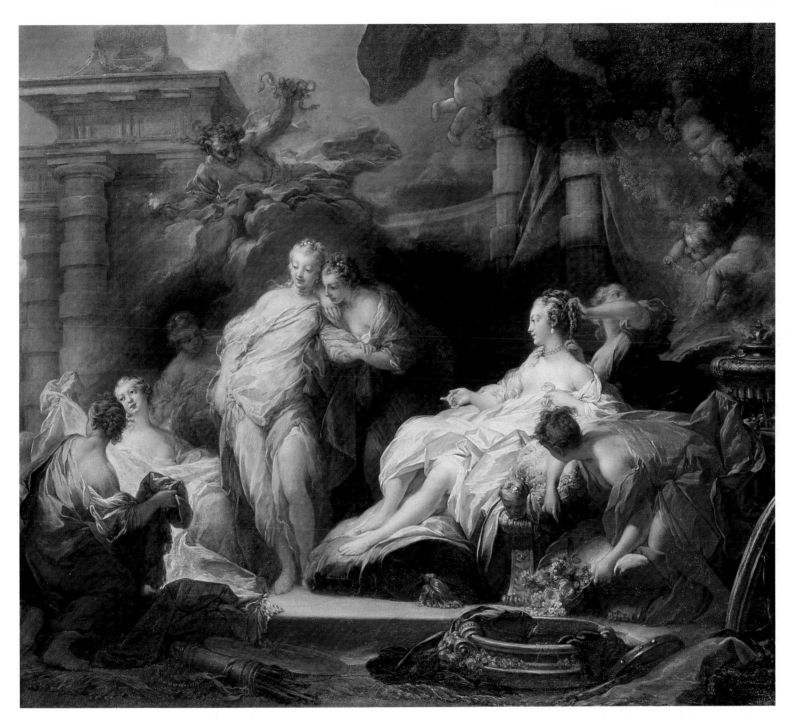

figures here are quite different, more mobile, delicate, and almost fragile. The bright billowing draperies evoke not so much the draperies of Boucher as those of Carle Van Loo in contemporary works such as the *Spanish Conversation* in the Hermitage.[5]

In order to judge such a painting one must bear in mind that it has been cut and that, on the extreme left, one or two figures, who were turning to the right, balancing the composition, are no longer there. Also missing, on the

17 *Psyche Showing Her Sisters Cupid's Presents.* 1753–54. Oil on canvas, 167 × 192 cm. The National Gallery, London (cat.no. 2)

upper right side, is a part of the curtain that gave the area a dark quality that was necessary for the balance of the forms. Nevertheless, the coherence and brilliance of the bright and scintillating pictorial fabric in *Psyche and Her*

21

Sisters is admirable. It is painted with a technique that is light, with hardly any thickening, with blended brushwork, and in colors that are dominated by whites, pinks, and yellows. Here and there, one finds subtle *canggianti* and, elsewhere, stronger blues and reds, ensuring the intensity of the effect. Certain parts reflect a fully-assumed mastery, such as the astonishing figure of Envy, treated with a free technique, and associated with a tangle of clouds fringed with pink and turquoise.

In 1755, the exhibition, at Versailles, of the works of the students of the Ecole Royale des Elèves Protégés was held in April.[6] Amongst the paintings that the Marquess of Marigny presented to Louis XV was a large canvas by Fragonard, *The Washing of the Disciples' Feet*, which measures twelve square meters and, with *Coresus and Callirhoe*, is the largest of the painter's works. It had been commissioned on May 18 of the previous year by the Brotherhood of the Blessed Sacrament in Grasse, Fragonard's home town, for its chapel in the cathedral. (The painting, which cost seven hundred livres, now hangs in the Cathedral of Grasse.) This impressive painting, one of the artist's best-known works, and one of the great achievements of religious painting in the eighteenth century, is puzzling, coming, as it does, after *Psyche and Her Sisters*. The latter is a work that is full of decorative coquetries, with its ringed columns, garlands, and gold plate. Here, by contrast, is a work that is almost austere, a fact that is emphasized by the imperious vertical lines of the columns, despite the contrasts of its colors: red, bluish-green, beige, and white. The architecture daringly takes up most of the painting and the figures are placed in the middle ground, on a kind of platform. There is no movement, only the expression of the apostles' emotional reaction to Christ's gesture of humility. Individual parts are masterly, particularly the old men's faces, which are powerful, fine, and moving. The still life in the right foreground is unique, in his œuvre, by its size and is admirable because of its simplicity and authority, with its extensive display, on the steps, of an arrangement of draperies, a metal vase, a staff, and a basket of wickerwork. The broad rhythms of the still life join those of the architecture and of the figures by means of the ropes tied around one of the columns, and draw the viewer's gaze further into the picture, to the basin in the middle ground. On the right, one sees only the red-sleeved arm of one of the apostles, leaning against the column; a touch which is a true stroke of genius. This painting demonstrates the diligence and seriousness with which Fragonard worked at the Ecole Royale des Elèves Protégés, as well as his ability to assimilate renowned models. One thinks, surprisingly in Fragonard's case, of the example of Poussin: the vast vertical format, the prominence of the architecture with its columns and its

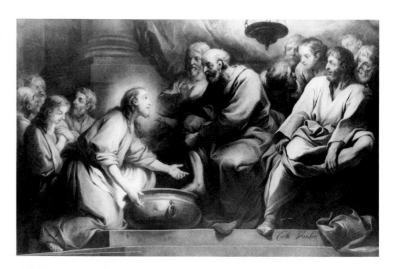

18 Carle Van Loo (1705–1765). *The Washing of the Disciples' Feet.* 1742. Oil on Canvas, 158 × 248 cm. Musée de Tessé, Le Mans

entablatures, the candlelight as well as the attention paid to the reactions of the apostles justify a comparison with the *Institution of the Eucharist*, which was painted by Poussin for Saint-Germain-en-Laye. And certain effects of the figures, who are half-visible behind the columns, recall the *Marriage* from the series of the Chanteloup *Sacraments*. In his handling of this religious subject, Fragonard becomes the unexpected heir to a tradition that can be traced back to the tapestries of the *Acts of the Apostles* by Raphael. The draped apostles in Fragonard's painting also evoke the example of Jean-Baptiste Jouvenet, as transmitted by Jean Restout.

But it is especially interesting to compare the large painting in Grasse not with the religious paintings of Boucher but, rather, with those of Carle Van Loo, with *The Washing of the Disciples' Feet*, which was painted in 1742 for the choir of the now destroyed church of Saint-Pierre-des Arcis, in Paris.[7] It may be presumed that Fragonard knew the painting, which is presently in the Musée de Tessé in Le Mans, and the group of Christ and St. Peter are very similar in both paintings. From 1754 to 1755, moreover, Van Loo was completing his series of vast canvases on the *Life of St. Augustine*, for the choir of the church of the Petits-Pères, the present Notre-Dame des Victoires.[8] The last paintings in the series, the *Baptism of St. Augustine* and the *Preaching Before Valerius*, dated 1755, may be compared with *The Washing of the Disciples' Feet* in Grasse; one

18

19 *The Washing of the Disciples' Feet.* 1754–55. Oil on canvas, c. 400 × 300 cm. Cathedral, Grasse (cat. no. 22)

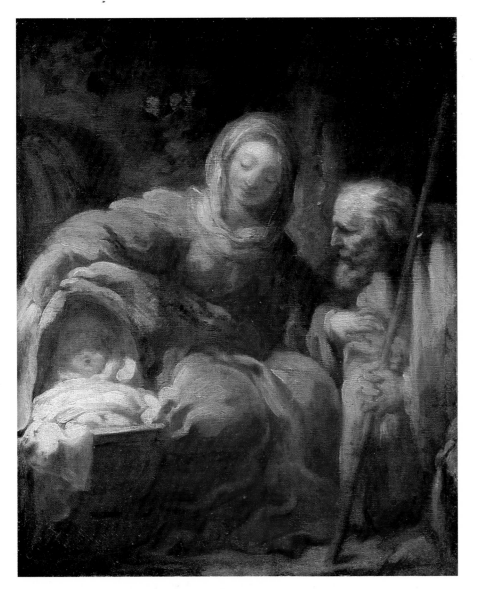

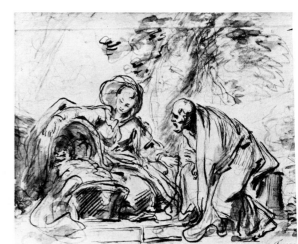

20 *The Rest on the Flight into Egypt.* c. 1755. Oil on canvas. 52 × 42 cm. National-museum, Stockholm (cat. no. 30)

21 *The Rest on the Flight into Egypt.* c. 1754–55. Pen and brown wash over black chalk underdrawing, 21.5 × 27 cm. Nationalmuseum, Stockholm

22 *The Rest on the Flight into Egypt.* c. 1755. Oil on canvas, 57 × 74 cm. Private Collection, (cat. no. 29)

23 *Bust of the Virgin.* c. 1755. Oil on canvas, 40 × 32 cm. The Gösta Serlachius' Fine Arts Foundation, Mänttä (Finland) (cat. no. 31)

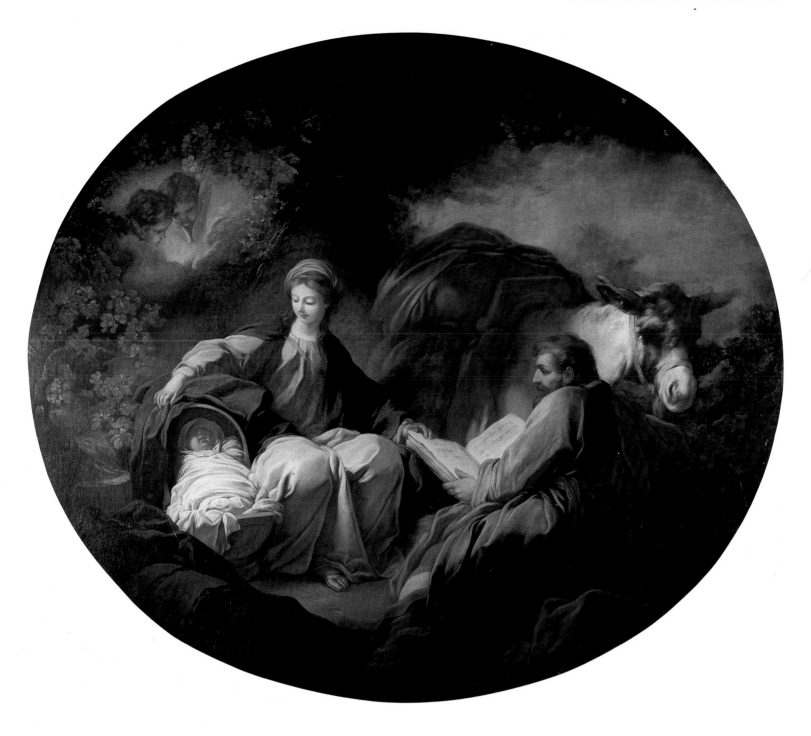

24 *The Rest on the Flight into Egypt*. c. 1755. Oil on canvas, 190 × 221 cm. The Chrysler Museum, Norfolk, Virginia. On loan from the Collection Walter P. Chrysler, Jr. (cat. no. 28)

notices, in both works, the simplicity of the luminous effect, the nobility of the postures of the figures, with their drapery falling straightforwardly, and the role played by the vertical lines in a bare architectural setting. It is likely that Fragonard studied Van Loo's grand set pieces as they were being completed. *The Washing of the Disciples' Feet*, in Grasse, provides direct evidence of the influence of Van Loo's teaching on Fragonard whenever he tackled a grand subject.

The Rest on the Flight into Egypt

Another religious composition to which sufficient attention has not hitherto been paid could be dated from 1754 or 1755, a date close to that of *The Washing of the Disciples' Feet*. This painting is *The Rest on the Flight into Egypt* in the N.P. Chrysler Collection in Norfolk, Virginia, the various stages of the elaboration of which can be followed because of a stroke of luck that is almost unique in Fragonard's work. Several preparatory studies have, in fact, been preserved: a general drawing and three painted sketches, two of the whole composition and one study of a detail.

The drawing in the Nationalmuseum, Stockholm, is thus the earliest known drawing by Fragonard. The group of the Virgin and Joseph is a free arrangement of apparently disordered, sinuous lines that cross each other, with some hatching, in rapid and flowing zigzags. It is an extraordinary drawing which is so unlike anything one expects of Fragonard, like the wash drawings on which his fame rests, that it has been queried.[9] The discontinuous and slightly vague delineation of elastic and capricious forms, the almost exclusive use of twirling brushwork, in the oriental manner, situate it a long way from Boucher. The model for the bony face of Joseph comes more likely from Fragonard's elders, Van Loo or Restout.

A first painted sketch, also in Stockholm, which is unfortunately fragmentary, takes up the basic composition of the drawing. Joseph has come even closer to see the child and is leaning on a stick. We can see here a creamy technique and overlapping effects of brushwork, forms that lack structure but are dynamic and generous, in blue, bright pink, and soft yellow colors. Every one of these features should be carefully noted as part of Fragonard's debut as a painter of sketches.

In a second painted sketch, formerly in the Salavin Collection in Paris, the technique has become lighter, more diffuse, in a paler range of pinks, soft blues, and straw tones. The Virgin and the Infant, in his cradle, reappear, hardly altered at all, but Joseph, seen from the back, adopts quite a different posture (half-sitting, half-lying down, in a diagonal movement corresponding to that of the body of the Virgin), and is shown reading a large book. In the smoothness and mellowness of their technique, the two small canvases by the young Fragonard are very different from Boucher's sketches, which are more sharply delineated and contrasted. Seeing these blended strokes and soft colors, one thinks, rather, of François Le Moyne or of Restout. It is, in fact, Restout's rendering of this subject of the Holy Family in Egypt that makes an interesting comparison with Fragonard's two sketches, because of the way they treat forms and because of their technique and use of color. Restout exhibited his canvas, whose excessively sketchy technique was deplored by the critics, at the Salon of 1753.[10]

The large *Rest on the Flight into Egypt*, in the Chrysler Collection, basically takes up the grouping of the figures in the Salavin sketch. But the composition has matured and has gained a wider scope and a more satisfying spatial arrangement. The Virgin's hand is placed on Joseph's book in a more natural and explicit movement and her face is now turned to the left, making it more apparent that she is looking at the child. The painting's rhythms are completely altered because of this and are organized with great ease within an oval format. In addition, Fragonard introduces a gray donkey on the right; it is, possibly, the first and one of the finest animal figures by an artist who was to paint so many of them, and it dominates the sacred group. The color-range remains cool, in fine shades, dominated by whites, grays, lavender tones, and a resonant blue, with occasional touches of yellow and red. The light is distributed with a consummate skill that already recalls Sébastien Bourdon; the foreground remains

25 Jean-Baptiste Deshays (1729–1765). *The Rest on the Flight into Egypt*. c. 1755(?). Oil on paper, 33.4 × 30.7 cm. Cabinet des Dessins, The Louvre, Paris

immersed in shadow; the light gradually reaches Joseph's drapery and is concentrated on the Virgin, the cradle, and the book; the background disappears, in turn, in the shade of a large tree, the donkey's head emerging alone into the light, and the whole group stands out softly against an unclear sky.

There is nothing casual about such a painting, whose solemn restraint is as striking as its ambitious content: the Virgin lifts the drapery covering the cradle with one hand, thereby showing Jesus to the faithful; she places her other hand on the book of scriptures held by Joseph, clearly indicating by this dual gesture that the little child is the Messiah whose coming was announced in the Bible. There is, in the entire work, a concern for detached elegance that is almost cold, revealing no trace of the sanguine temperament generally credited to Fragonard. Such a picture again recalls Carle Van Loo and the two cherubs' heads that appear above the cradle evoke those painted by Van Loo as much as those of Boucher.[11] By his wisdom and facility, Fragonard leaves the other painters of his generation far behind him; his canvas is one of the earliest pieces of evidence of the fact that, as early as the 1750s, the most demanding painters were turning toward a more sober and reserved art, more delicate than Boucher's or more capable of adapting artistic means to suit the subject being treated.

Fragonard and Boucher

The young "sponsored student" was thus a good pupil who paid heed to Van Loo's lessons and benefited from them. His paintings also show a great capacity for treating very diverse subjects with equal success. In fact, this ability to change style as well as subject and to adapt one to suit the other is one of the first lessons of academic training. Fragonard was to draw the natural conclusion from this, and whenever he had to tackle mythological or pastoral subjects for decorations, he would adopt a different style or, strictly speaking, several different styles, though he would look increasingly toward Boucher as the undisputed master of those subjects and whose preeminence as a decorative painter nobody could question. This quality was not opportunistic but, rather, mimetic, because of the natural facility Fragonard had for assimilating an artist's technique or style and perhaps also because of the taste he had already acquired for moving from one kind of painting to another. Fragonard liked to contradict himself and was not content to develop in a straight line. Boucher, on the other hand, had a style and he kept to it. The originality of the older artist, and also at times his limitation, is the astonishing coherence of his painting: it is an artificial but convincing world where everything is resolved in curves, curls, and wreaths, in which volume is rounded off and where the human figure is of no greater significance than a bush or an accessory. Hence, we have shepherdesses and prepubertal adolescents with undifferentiated and indifferent faces and conventional smiles. The varying of fixed formulas and the indulgence in pretty effects were not mere clumsiness with Boucher, but served a particular purpose. There is, in Boucher's painting, a need for a certain banality, for an absence of characterization, in order for only shapes and colors, curves and counter-curves to remain and to define a world of happiness in which the human figure is brought into harmony with the whole of creation, and this Fragonard understood.

The majority of the paintings that are generally dated between 1750 and 1752 were executed between the Prix de Rome and Fragonard's departure for Italy in 1756. As has already been suggested, it is difficult to see these paintings as the work of an apprentice owing to their virtuosity and the large number of commissions they prompted. The similarities in style with the documented works in London (*Psyche and Her Sisters*) and Grasse (*The Washing of the Disciples' Feet*) seem to be a decisive factor. There is, in addition, a link between these Fragonards "in the style of Boucher" and the decorative paintings of Boucher himself.[12] Did Fragonard occasionally work in Boucher's studio again during these years? It was precisely from 1752 that Boucher had the use of an apartment and studio in the old part of the Louvre. The courses given at the Ecole Royale des Elèves Protégés must have allowed the young artists some leisure time, and the connections between certain works by Fragonard from those years and the works of Boucher are sometimes so close that it is most probable that the young artist had frequent contact with his former teacher. Their friendship and mutual admiration seem to have lasted until Boucher's death in 1770, and during the four years that preceded Fragonard's departure for Rome, Boucher continued to advise his gifted protégé and even, seeing his brilliance as an artist asserting itself, procured decorative commissions for him. Financial need may have prompted Fragonard to undertake this type of painting. His success was, in any case, considerable, to judge by the number of works that have survived, which might have been one of the reasons why, in 1754, Fragonard was not in too great a hurry to leave for Rome.

A significant portion of Fragonard's output would not have come into being were it not for Boucher. And while it is necessary to stress the significance of this influence, it would be too simplistic to believe the Goncourt brothers' facile statement that Fragonard's painting had come entirely "from the pink bowels of Boucher's painting."[13]

The extent of influence between master and pupil is not at all like that often applied to Raphael or Van Dyke, who, apparently, only gradually asserted individual artistic personalities, having originally been obscured by Perugino's and Rubens' entirely studied approaches to painting. Fragonard was well aware of imitating Boucher and even distanced himself from his teacher in certain respects.

Decorative Paintings on Pastoral Themes

The subjects of Gardeners and Gardening Girls, borrowed from Boucher, are two of the favorite themes of Fragonard's decorative painting during these years. Four decorative panels, now in the Detroit Institute of Arts, and reputed to have come from the Hôtel de Mortemort Rochechouart, in the Rue de l'Université in Paris, portray, under the general and traditional title of *Scenes of Country Life*, four figures called *The Harvester, The Woman Gathering Grapes, The Gardener*, and *The Shepherdess*, and make up the most impressive decorative series painted by the young Fragonard before his departure for Rome which has been preserved. Its date remains uncertain; it may be slightly later than that of *Psyche and Her Sisters*, possibly 1754 or 1755. The works may have been linked in pairs, as pendants. Judging by the movement of the figures and the colors, *The Gardener* may be considered a pendant to *The Shepherdess, The Harvester* a pendant to *The Woman Gathering Grapes*. The colors are clear and especially bright and are always based on the harmony, favored by Fragonard during these years, of greenish-blue, yellows, and pinks tempered by whites and silvery grays, with a few brilliant touches, the cherry red of the gardener's clothes and the bright blue of the harvester's. This idea of linking paintings in pairs or in larger groupings, which is traditional in decorative painting, would frequently recur in the painter's œuvre. It implies exchanges of gestures, looks, and counterpoints of poses. The figures in the Detroit painting are lively and graceful; they stand out authoritatively and conform to very simple principles of interpretation, very fine effects of contrasting outlines against the sky and with characters either in light contre-jour or brightly lit. Tree-trunks, bushes, little branches, and leaves twirl around the central figure in firm and graceful movements. One should, of course, imagine panelling, probably carved with flowers and foliage, extending and enhancing this effect.

Two other paintings, comparable in format and theme to those in Detroit and preserved in a private collection, reveal an even freer and more successful art, which is perfectly in control of the means that it employs. *The Woman Gathering Grapes* and *The Shepherdess* are two young mothers playing in a garden. Chubby and playful children

[margin notes: 26; 11–14]

[margin notes: 27; 45–46]

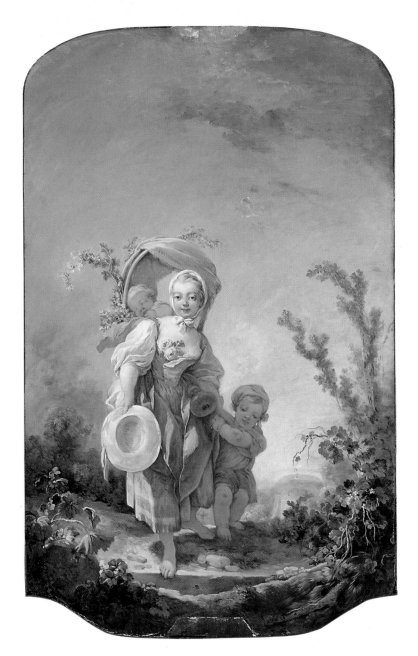

26 *The Shepherdess*. c. 1754(?). Oil on canvas, 143.5 × 90.1 cm. Detroit Institute of Arts (cat. no. 14)

27 *The Woman Gathering Grapes*. c. 1755. Oil on canvas, 188 × 94 cm. Private Collection, U.S.A. (cat. no. 46)

move about; busy and indulgent young women distribute grapes to their offspring and entertain the youngest one, pushing him around in a wheelbarrow, in a decor of potted shrubs, creeping branches, bushes of flowers, and blossoming boughs. The colors range from orange to pink and

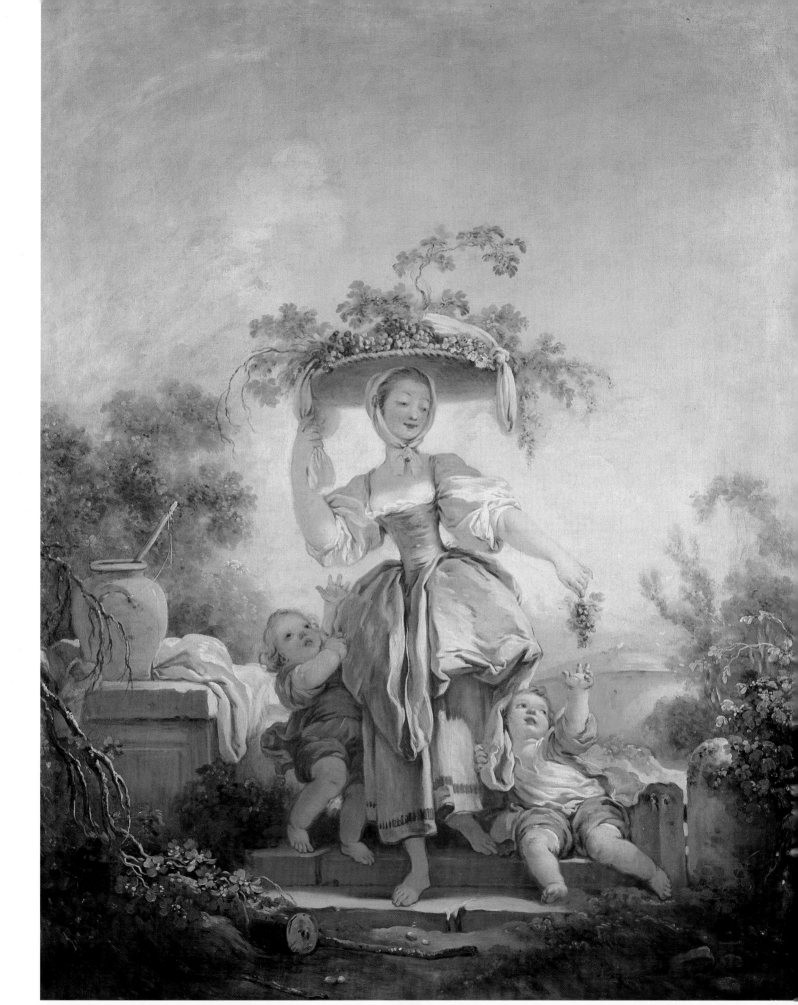

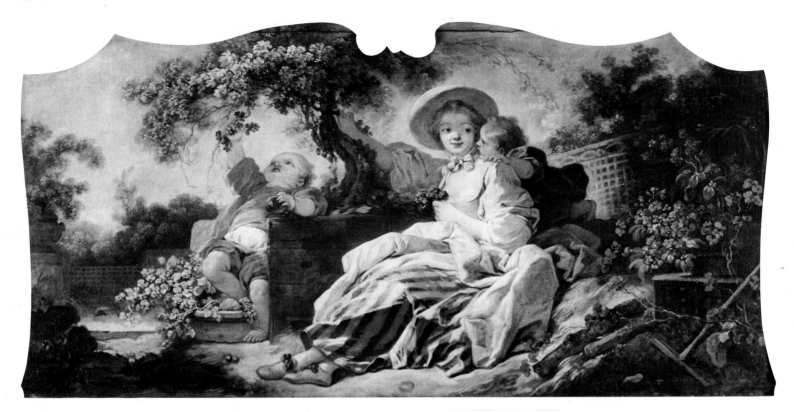

28 *Spring*. c. 1755–56. Oil on canvas, 80 × 164 cm. Hôtel
Matignon, Paris (cat. no. 50)

raspberry, from straw-yellow to lime-green, from moss-
green to bluish-green; the shadows, in shades of mother-
of-pearl, are tinged with gray and turquoise; there are no
sharp contrasts: everything is bathed in a pleasant bright
light and the varied treatment moves from rich and blend-
ed brushwork to a flowing and rapid touch. Everything
would appear unclear, even weak, if it were not for the
joyful vibrations of a thousand strokes painted with the tip
of a fine, rapidly-moving brush, indicating thin fallen
branches, underlining the contours of the figures, and
occasionally accentuating their clothes or hair with sharp
touches. We see here a virtuoso and twirling technique of
drawing that is halfway between dabs and lines: a drawing
turning into a painting and a painting turning back into a
drawing. One can already see that talent that only Frago-
nard had for placing, before a luminous sky, the arabesque
or the streak of a branch, the puff of fused elements that
makes the air vibrate and tremble and which characterizes
his works more effectively than a signature. There is no
vulgarity here, because the exhilaration of the rhythms is
so appropriate. It should be remembered that these are
decorative panels and that this pyrotechnist's art is meant
to delight the onlooker in a moment of surprise and then

to disappear into a decor and to blend in with the silks, the
panelling, and the gilded bronzes. Here, for the first time
in the work of the future painter of *The Pursuit of Love* and
of *The Fête at Saint-Cloud* we see figures that are in har-
mony with the joy of nature rearranged by man.[14]

It was probably later, shortly before Fragonard's depar-
ture for Italy, that the overdoors for the Hôtel Matignon,
depicting similar themes, were painted. *Spring*, *Summer*,
and *Autumn* have remained in place in the central room of
the house; it would appear that the fourth season, *Winter*,
is a painting that is now in the Los Angeles County Mu-
seum of Art. It must, for some obscure reason, have been
separated from the rest of the set. Because of the exuber-
ance of the rhythms of the figures, of the plants arranged
in sharp contrasts of light, the brightness of the fruity
colors, and the humor of the playful little children, the
Matignon *Seasons* may be considered among the most suc-
cessful of Fragonard's decorative works, which makes it
regrettable that the four are not together.

The themes of the Pastoral Scenes, which are directly
related to those of the Gardeners for the costumes and the

28–. Cat.

Cat.

29 *Summer*. c. 1755–56. Oil on canvas, 80 × 164 cm. Hôtel
Matignon, Paris (cat. no. 51)

30 *Autumn*. c. 1755–56. Oil on canvas, 80 × 164 cm. Hôtel
Matignon, Paris (cat. no. 52)

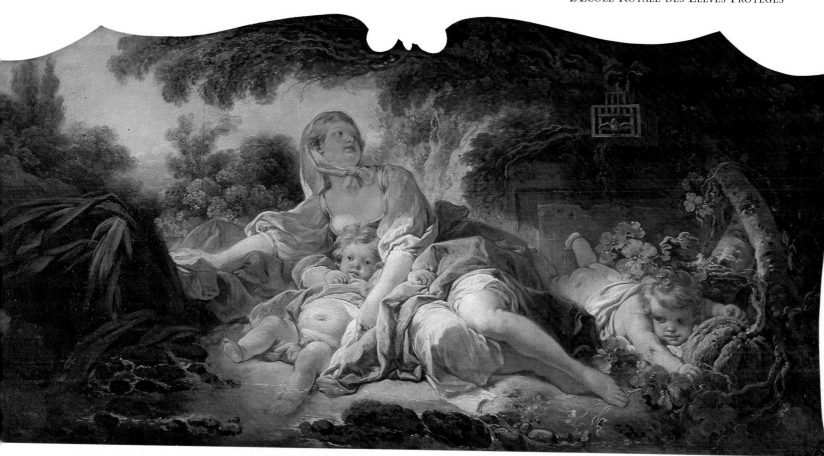

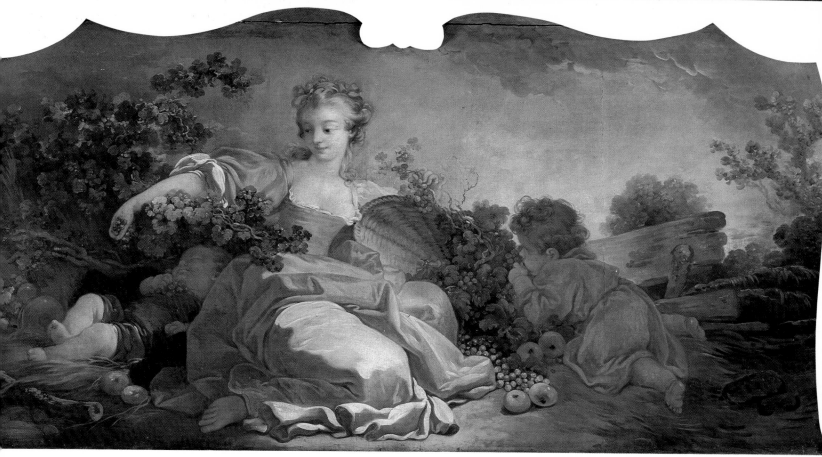

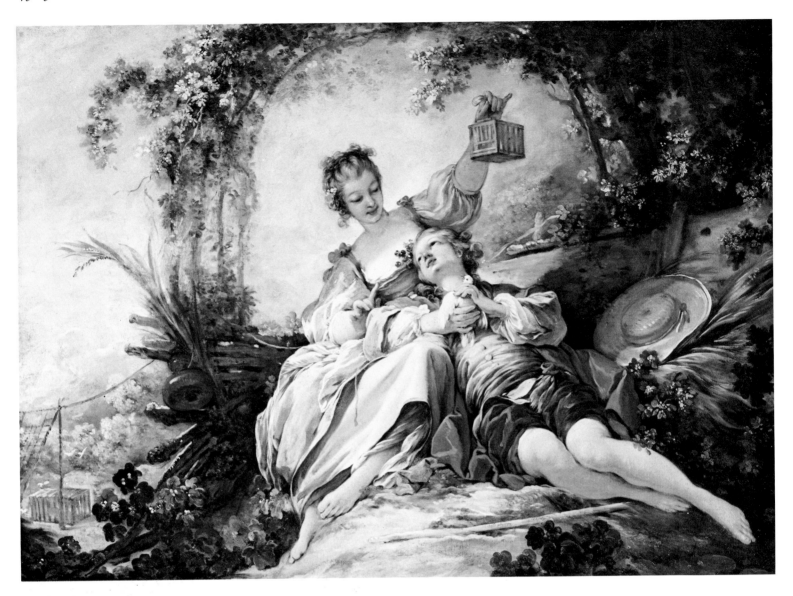

31 *The Cage*, or *The Happy Lovers*. c. 1754–55. Oil on canvas, 90 × 119 cm. The Norton Simon Foundation, Pasadena (cat. no. 40)

32 François Boucher (1703–1770). *The Musette*. 1753. Oil on canvas, 88 × 115 cm. The Louvre, Paris

rustic settings are the same, are also derived from Boucher. They were in fashion at the time and decorative painters specialized in them until the 1780s. They introduced amorous themes, even though the combination of masculine and feminine pendants and the gift of a bird offered by the gardener in the Detroit panels had already had amorous connotations. *The Cage*, also known as *The Happy Lovers*, at the Norton Simon Foundation in Pasadena, one of the most convincing and successful of these Pastoral Scenes was definitely an overdoor, whose curved for-

mat, formerly set within the sculpted panelling of a Parisian house, has been placed within a rectangular frame. The style is quite close to that of the vertical panels of the *Gardener* or the *Woman Gathering Grapes*, with a comparably joyful exuberance in the type of figures and flowing vegetation. The forms are longer and more supple; they are portrayed as being penetrated by the light and are almost translucid. The colors are quite different from those of Fragonard's teacher; they include every pale shade, from fruity pink to the golden yellow of ripe corn, and turn gray, silvery, turquoise-green in the half-tones, with fine bright colors in the young man's clothes. In those years, Boucher's drawings were becoming more schematic and sometimes had harshly outlined contours; whereas Fragonard played with ductile forms whose soft

and hazy relief is more evocative of Le Moyne, Boucher's teacher, than of Boucher himself. *The Shepherdess*, in the Charles Allis Art Museum, Milwaukee, portrays a seated girl making a crown of flowers for her shepherd, whom we see some way off running toward her. The elegant, curved movements of the branches, arms, and drapery create lively, bouncing, and flowing rhythms that have, once again, been carefully worked out to match a given decor.

Such paintings are often looked down upon and are seen as pre-Fragonard Fragonards, as simple reflections of

33;
Cat. 41

33 *The Shepherdess.* c. 1755. Oil on canvas, 119 × 162.5 cm. Milwaukee, Charles Allis Art Museum. Leon and Marion Kaumheimer Bequest (cat. no. 41)

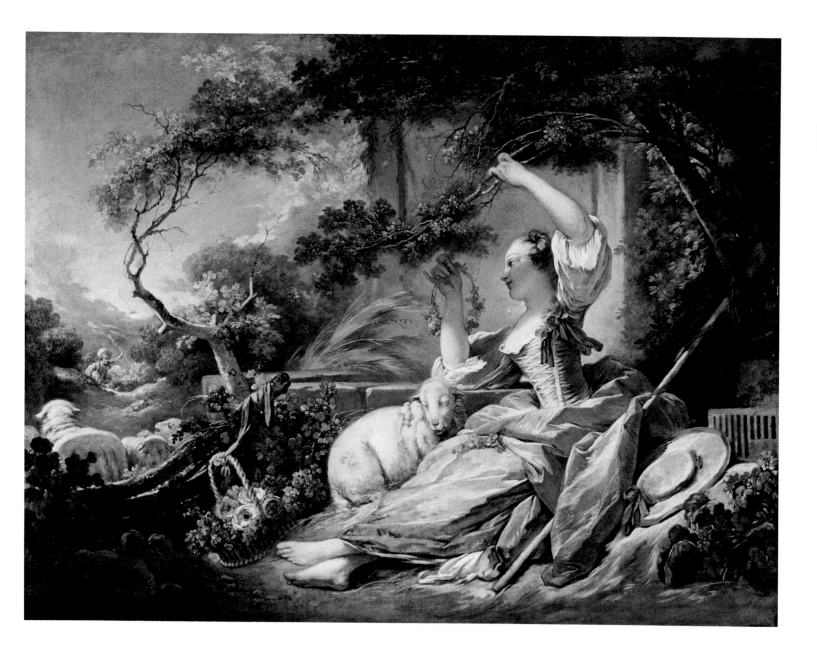

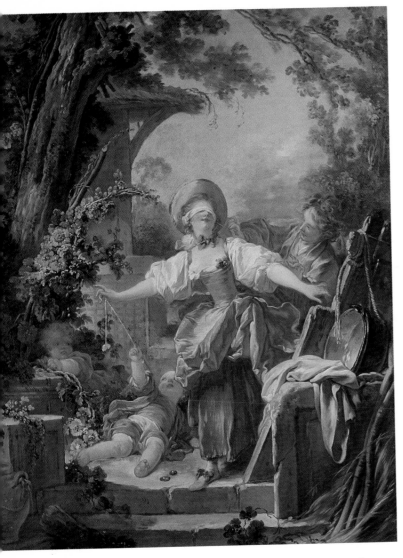

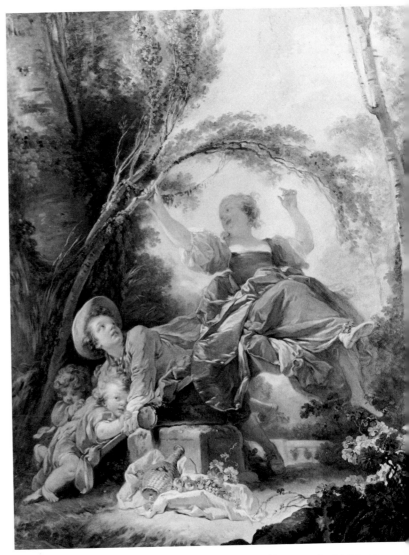

35 *The See Saw.* c. 1755. Oil on canvas, 120 × 94.5 cm. Thyssen-Bornemisza Collection, Lugano (cat.no. 43)

34 *Blindman's Buff.* c. 1755. Oil on canvas (fragment), 116.8 × 91.4 cm. The Toledo Museum of Art, Ohio. Gift of Edward Drummond Libbey (cat.no. 44)

Boucher's art. But they must be given their due, even though the amorous paradise of the mid-eighteenth century, which they depict, is no longer shared by us today, and makes them foreign to us. If Fragonard borrowed Boucher's physical types, the round faces of his young girls with curly hair that is worn up, and the cherub-like faces of his youths, it was to gain a certain distance, a kind of anonymity, through these characters whose soft bodies will never age, which enabled him to paint more freely. Fragonard's way of painting at the level of the canvas softens the dimensions of space to a much greater extent than does the style of Boucher, for example, who made naked bodies contrast with dark areas or bright colors. Fragonard

uses lighter tones; the forms are elongated and lose part of their volume; everywhere the brush moves playfully in long strokes that are wide or thin, blended or separated and that create materials or areas of ground in fragmented, lively, or flat dabs that turn into leaves or flowers. It is the cursive or jerky touch that becomes the essential feature of the work.

One should also place into the category of decorative panels two pictures that are among the most popular of Fragonard's works and that remain the most successful and convincing of his paintings in "the manner of Boucher," the *Blindman's Buff* in the Toledo Museum of Art, Ohio, and *The See Saw* in the Thyssen-Bornemisza Col-

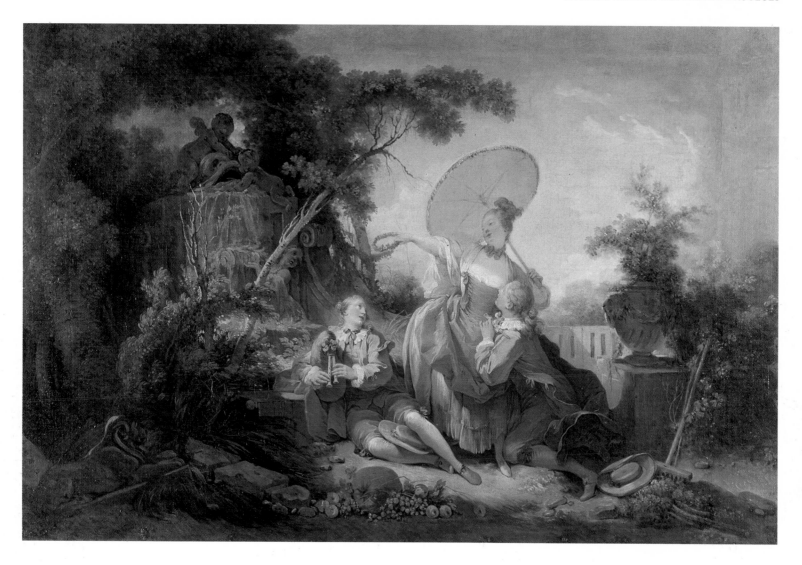

36 *Conversation Galante in a Park*, or *The Lover Crowned*. c. 1754–55. Oil on canvas, 72 × 109 cm. Wallace Collection, London (cat. no. 38)

lection, Lugano. The paintings have come down to us in a mutilated state, their upper parts, in which the foliage of the trees spread out fully across the sky, having been cut away. Yet they are still admirable paintings containing something more than a lively and fussy prettiness, for Fragonard has fully mastered here what was to be one of the great strengths of his art, namely, movement. Whatever there was that was slightly too sedate about the vertical panels showing single figures, such as those in Detroit, making them resemble porcelain figures, has disappeared. Everything is carried away with the exhilaration of a game, even if the compositions are kept firmly within the framework of a pattern of diagonals. The *See Saw* appears as a battle of intersecting oblique lines against which curves and counter-curves of fresh flesh tones, of scintillating materials, of shimmering branches lean and bounce off. The brushstrokes run as rapidly as the line thrown by the fisherman, the touches jostle each other like arpeggios. We have here the first painting by Fragonard in

which a violent and fleeting movement carries away the figures, in an œuvre where jumping, dancing, and racing were to play such an important role. The little girl's movement is like the twirling leap of a dancer who is cavorting about. Such brilliance and panache make even more perceptible the very delicate passages of light in contre-jour behind the figure, who has become as translucent as a shell against the pale background of the sky. Her plump flesh receives the light fondly and the touches of color are blended in tones of petals and flowers. The chubby faces and greedy lips of the youth and of the children who are pushing the see saw are sketched in sanguine red. Rubens seems already to be fully understood here. Fragonard prob-

37 *Jupiter and Callisto.* c. 1755. Oil on canvas, 78 × 178 cm. Musée des Beaux-Arts, Angers (cat. no. 24)

38 *Jupiter and Callisto.* c. 1755. Oil on canvas, 46 × 55 cm. Private Collection (cat. no. 26)

ably meditated on Rubens' cycle of the *Life of Marie de Medici*, in the Palais du Luxembourg, on the Left Bank of the Seine, as early as this. The other work, *Blindman's Buff* in Toledo, is based on a diamond shape, on subtle, oscillating movements of the woman's body, and on the balancing action of her arms. An analogy can obviously be made with the panels of the two *Young Mothers*, with the same light and cursory treatment of the hands, whose outlines are indicated by a single stroke, and the reappearance of the seated child, who is leaning back and who, in the Toledo painting, brandishes his fishing rod instead of seizing some grapes. Both paintings, in their light and fleeting charm, are free of any seriousness and are remarkable because of their even light and the fineness of their blond or silvery tones. Almost the whole of Fragonard's art is already present here. The influence of Boucher is still clearly perceptible too, but of a Boucher who has been revitalized by the study of Rubens. Fragonard still lacks energy and poetry but we already have the seeds of that thrown-back movement of the head that was to appear in the *Figures de Fantaisie (Imaginary Figures)* and the large trees of *The Fête at Saint-Cloud*. We also see here a style that is still not able to condense various elements and that is slightly dispersed, but which is already fluent and vivacious, a style that carries the onlooker away and delights him.[15]

Decorative Paintings on Mythological Subjects

39 *Cephalus and Procris.* c. 1755. Oil on canvas, 78 × 178 cm. Musée des Beaux-Arts, Angers (cat. no. 25)

Other subjects are directly linked to mythology, as in the two overdoors in the Musée des Beaux-Arts, Angers, painted in a very elongated format: *Jupiter and Callisto* and *Cephalus and Procris.* The influence of Boucher is all too obvious in the first, with its pale colors suggesting a semi-nocturnal light, as seen in overdoors painted by Boucher on themes from Tasso's *Aminta* for the Hôtel de Toulouse (the present Banque de France where these overdoors, *Sylvia Curing Phyllis of a Beesting*, are still in place). The second work in Angers, *Cephalus and Procris*, is one of the masterpieces of Fragonard's youth, a great sorrowful poem in flowing, almost gasping rhythms. Its colors, like those of the companion piece, are dominated by cold tones: blues, grays, greens, with pink and yellow in the clothes of the distraught and despairing Cephalus, which recall the harmony of colors in the Thyssen *See Saw.* The side-lighting, in slight contre-jour, is especially effective, with a soft and mysterious semi-darkness in the center, which gives an almost moon-like effect. One thinks, here, of another of Boucher's works in the Hôtel de Toulouse cycle, *Aminta Returning to Life in the Arms of Sylvia*, now in the Musée des Beaux-Arts in Tours, where the organiza-

40 *The Birth of Venus.* c. 1753. Oil on canvas, 54 × 83 cm. Musée Grobet-Labadié, Marseilles (cat. no. 7)

39;
25

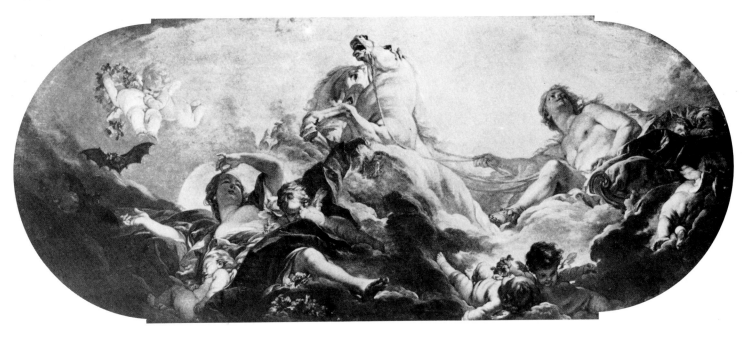

43 *Diana and Endymion*, or *Night*. c. 1755–56. Oil on canvas, 95 × 137 cm. National Gallery of Art, Washington, D.C., Collection W.R. Timken (cat.no. 56)

tion and range of colors are similar. The link between the paintings of Fragonard and those of Boucher is not without significance since Boucher's paintings are dated 1755 and 1756. If Fragonard did see them, as seems plausible, his paintings could date from the same years, just prior to his departure for Rome.[16]

There must have been other overdoors by Fragonard on mythological subjects: the Musée Grobet-Labadié in Marseilles has a small pink and blue *Birth of Venus*, painted with a complex and frothy technique that is not without a certain weakness, which may be directly compared with the sketches that have already been discussed and which were supposed to prepare for a larger painting that has since been lost. A few other works have fortunately been preserved: *Dawn* also entitled *Venus Awakening*, in a private collection, arranges the figures in a somewhat scholarly way according to the diagonals of the canvas in large puffs of contrasting clouds, with some fine elements directly

inspired by Boucher; a *Diana and Endymion*, or *Night* in the National Gallery of Art in Washington, D.C. is so close to the art of that painter that it is only recently that it has, quite rightly, been attributed to Fragonard.[17] It may even be a pendant to the previous painting; the format is the same, the composition symmetrical, the themes comparable and the colors similar. The figures of Aurora and Diana, stretched out on the clouds, are both very close to the *Poetry* in the series of the *Four Arts*, a fact that definitely convinces one of their common authorship. The color-range of *Dawn* and of *Diana and Endymion* are very specific and are clearly different from those in the paintings of gardeners and shepherds. The Washington painting is particularly striking because of its range of pinks, pale blues and grays, with a clear contrast, which avoids any dullness, of two bright tones, the blue of Diana's drapery and the red of Endymion's.[18]

A Self-Portrait?

One wonders whether Fragonard painted any portraits at this time. A painting like the *Portrait of a Woman* dressed as a priestess of Venus (traditionally considered to be a

41 *Venus Awakening*, or *Dawn*. 1755–56. Oil on canvas, 95.2 × 131.5 cm. Private Collection (cat.no. 55)

42 François Boucher (1703–1770). *The Chariot of Apollo*. 1753. Oil on canvas, 130 × 250 cm. Château de Fontainebleau

43; Cat. 56

Cat. 5

Cat. 36

40; 7

41; 55

44 Fragonard(?), *Portrait of a Young Man* (Self-Portrait?) c. 1755. Oil on canvas, 65.3 × 54.4 cm. National Gallery of Art, Washington, D.C., Collection Samuel H. Kress (cat. no. 49)

portrait of Madame Bergeret but which looks like a youthful work) might date from this period at the Ecole Royale des Elèves Protégés. Its round, understated, and slightly schematic forms and the quest for an intensely picturesque quality in its crumpled drapery are very reminscent of Boucher. As for the striking *Portrait of a Young Man* in the National Gallery of Art in Washington, D.C., sometimes considered to be a portrait of Hubert Robert, its attribution to Fragonard remains problematical. But it should not be rejected without further inspection. The confident and virtuoso technique, with its blended effects, the clear colors, bringing together grays, greens, and pinks, evoke the works of Fragonard's youth, and if one considers the slightly awkward movement of the arms, it might even be a self-portrait. It shows a confident, rather portly young man, with a turned-up nose, perfectly round cheeks and

44;
Cat. 49

chin, candid and lively eyes, and a greedy mouth. Could this be a portrait of Fragonard at the age of twenty-three or twenty-four, before his departure for Rome? The scarcity of self-portraits, all of which are late works, does not help one to find an answer.[19]

These Parisian years were still years of training; but it is already obvious, through his ability to assimilate the art of his elders, to move from a sober to a florid manner, to adopt a particular style and a brighter and more brilliant technique for the pictures that have a decorative purpose, to what extent Fragonard reveals himself to be a changing, elusive artist who refused to restrict himself to a single style and who was expert at moving from one style to another. As a young man that was the kind of artist he was, and that was exactly how he would remain until the end of his career.

Chapter III
1756–61 Rome
L'Académie de France

Fragonard as a Student in Rome

At the end of 1756, Fragonard finally set off for Rome to begin the stay there that had been made possible by his winning of the Prix de Rome. Very little is known about the five years he spent in Italy. What did he paint while he was there? We have only very sketchy and fragmentary information about a few of the works that he painted during this very important period, though many of the chronological details are known. Luckily, the drawings, which are more often documented than the paintings, provide information that the paintings do not give; yet it would be imprudent to try to retrace, on the basis of these drawings, the precise details of the development of Fragonard's art in Rome.

A valuable source is the correspondence that was quite regularly exchanged between Paris and Rome by the Director of the Académie de France at Rome, Charles Natoire, and the Director of the Painters to the King, Abel-François Marigny.[1] These letters, which are often concerned with the activities of the student artists, provide the only evidence that there is of the works painted by Fragonard at the Académie. They even include a few assessments of his talent and character.

We learn from this correspondence that Fragonard and his colleagues, the new students with whom he had traveled, arrived in Rome in December 1756, as Natoire informed Marigny of this on December 22.[2] They traveled by land, accompanying Christine Van Loo as far as Turin, where she was to visit her family. The Director wrote on January 25, 1757 that the latest arrivals had started to work,[3] and on April 6 that they "are now drawing copies of the Carraccis in the Farnese Gallery...,"[4] an exercise that the students were traditionally asked to do.

It seems that the young painters, including Fragonard, struggled with the academy figures that they were then required to send to the Académie Royale in Paris. On November 2, 1757, Natoire wrote to Marigny: "I cannot send you their studies before the beginning of the New Year; I made them start afresh what they had already done to fulfill this duty, having considered their efforts too weak. I hope that they will do better."[5] On March 15, 1758 the results could hardly have been considered to be any more brilliant, to the consternation of Natoire, the great specialist of drawn academy figures, who wrote to Marigny at the time, referring to these works: "I am annoyed that after such a long delay and the trouble I have gone to I still do not know when they will be ready. The weakness of their talents is the cause of it all; they do not know how to make a decision and whatever I do to get them to make up their minds, I constantly see changes that prove that my impression is correct."[6] He appreciated their good will but, as he noted again on April 12: "They need to acquire some knowledge."[7] The studies left Rome on May 3: "This is all that I was able to obtain form their talents, and even that was difficult to do...," Natoire wrote at the time.[8] Neither Fragonard's academy figure nor his colleagues' have been preserved; however, it is possible to get some idea of it from the comments that the academicians made on it in Paris and which are mentioned by Marigny, who copied them out in a letter he sent to Rome on July 31: "The academic male figure painted by Monsieur Fragonard appeared less satisfactory than if one had not known what brilliant arrangements he displayed in Paris; not that there is any sign of carelessness, but one fears that the imitation of some Masters might be harmful to him and might make him use mannered color tones, as can be seen in this figure, in which there are several half-

Cat. L1

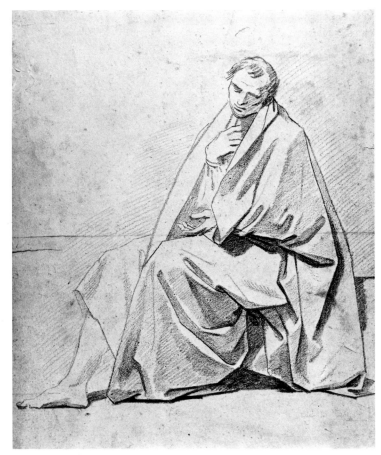

46 *Study of a Seated Draped Male Figure.* c. 1759–60. Red chalk, 46.9 × 37.8 cm. Private Collection, Paris

◁

45 *Study of a Deacon Carrying a Book.* c. 1758(?). Red chalk, 54 × 43 cm. Musée des Beaux-Arts, Orléans

tones that are too blue and golden yellows that are not natural. He may well have imitated those of Monsieur Barocci, who is, in many respects, an admirable painter, but whose use of color may be dangerous to imitate. Encourage him therefore to observe in the great Masters only those features that are characteristic of a true imitation of nature."[9] One can only imagine the effects of blended and delicate relief, of pale shadows tending toward bluish-gray, of pearly lights, the appearance of bright pinks, which justified the assessment of the Parisian judges, fine connoisseurs of Italian painting, and the comparison they made with the works of Frederico Barocci. Was Fragonard impressed by the latter's paintings, which he could have seen on what were probably frequent visits to the churches in Rome, to the Minerva and the Chiesa Nuova, for example, to the point of revealing something of this influence in his own paintings? It would be unwise even to suggest that that was the case. But it should be

noted that the other work by Fragonard that was among the paintings sent on May 3, a *Head of a Priestess*, which has also been lost, must have been painted in a similar way because the academicians found that it was "painted in rather too smooth a manner." By contrast, the drawings included in the consignment were the subject of compliments: "but we were more satisfied with his drawings, which we consider to have been done with subtlety and confidence." Were the style and colors of the academy figures and of the *Head of a Priestess* close to those of the works painted in Paris before his departure for Rome? It may be assumed that they were and the criticisms of the Parisian professors could also be applied to a work like the *Diana and Endymion*, at the National Gallery of Art, Washington, D.C.

On August 30, 1758, Natoire answered Marigny with the following lines, in which he admitted, rather naïvely, that he was having difficulties in "restraining" the young

47 *Study of a Leaning Draped Male Figure.* c. 1759–60. Red chalk, 50.5 × 31 cm. Musée Atger, Montpellier

48 *Study of a Standing Draped Male Figure.* c. 1759–60. Red chalk, 53 × 34 cm. Musée Atger, Montpellier

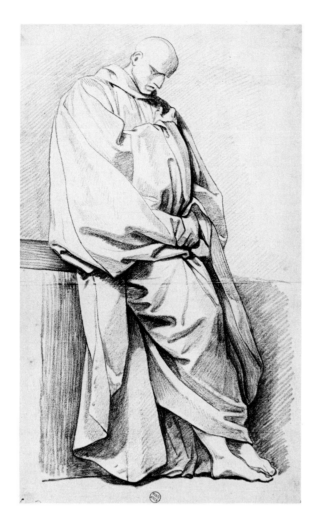

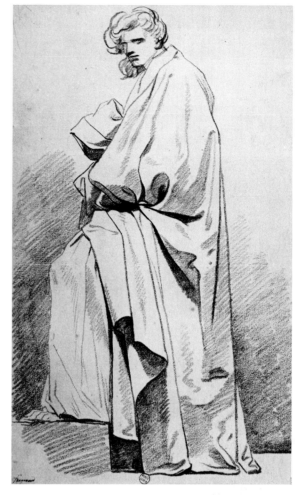

49 *Study of a Reclining Draped Male Figure.* c. 1759–60. Red chalk, 32.5 × 52 cm. Musée Atger, Montpellier

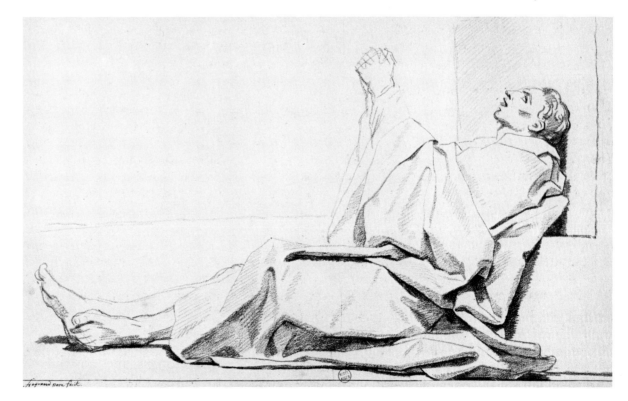

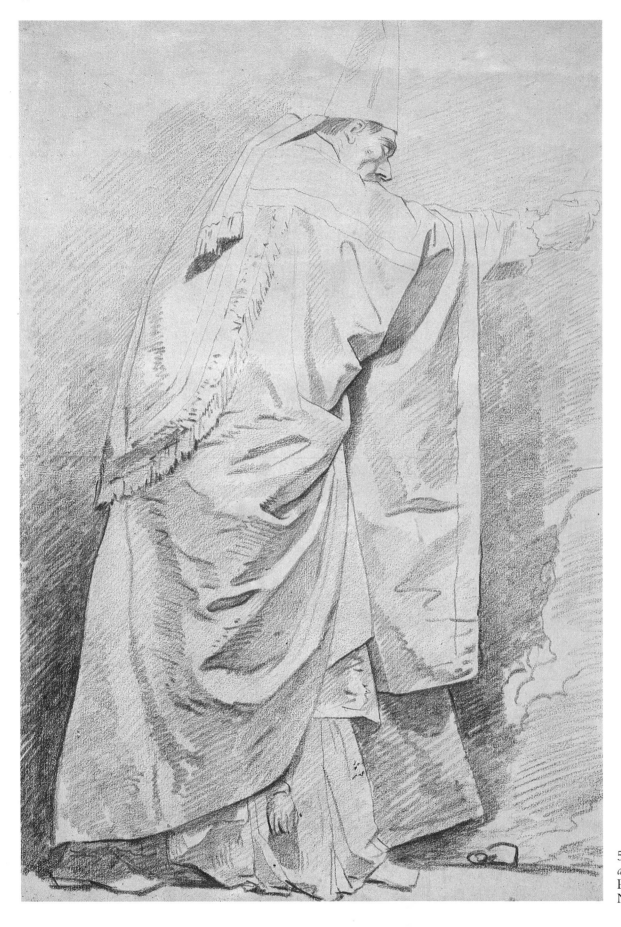

50 *Study of a Model Dressed as a Bishop.* c. 1760–61. Red chalk, 57.2 × 39.2 cm. Nationalmuseum, Stockholm

painters: "Fragonard finds it astonishingly easy to change his mind from one moment to the next in his arrangements, a fact which makes his work uneven. These young minds are not easily led. I will always try to get the most out of them without restraining them too much, because genius has to be allowed a certain degree of freedom."[10] Fragonard's debut at the Mancini Palace does, nevertheless, seem to have been difficult and he may have experienced a crisis of discouragement.[11]

The main work done by Fragonard in 1758 was probably the copy that he had to paint, in the church of the Capuchins, of a painting by Pietro da Cortona representing *St. Paul Looked After by Anania as He Recovers His Sight*. Natoire had informed Marigny on November 2 of the previous year, of his intention to give the young painters three paintings to copy, two in the church of the Capuchins (*St. Paul* by Pietro da Cortona and Guido Reni's *St. Michael*), and one in the Chiesa Nuova, the *Laying in the Tomb* by Caravaggio, adding that he would assign the paintings to be copied "in such a way that their three different styles may make each painter study the aspects he needs to study."[12] But on December 13 he had still not received the approval of the Director for this choice of paintings to be copied so that work on them did not begin until the spring of the following year, as is revealed in a letter from Marigny of January 7. On October 18, 1758, Natoire noted in one of his letters that "M. Fragonard is getting on with the copy he is making of the Pietro da Cortona in the church of the Capuchins. This young artist has some difficulty painting flesh and rendering the true character of views of heads. I implore him not to tire of retouching his work again and again, for he imagines that he has already done all that is necessary and all that he has been able to do."[13] One imagines, in spite of what the Director said, which seems to prove that he painted with enthusiasm, how interested Fragonard must have been in the work and how much his art benefited from it. Had Natoire sensed that the sensual and generous painting of the great Baroque painter (of which this was an especially noble and well-balanced example) might suit Fragonard's temperament? It is not known what became of Fragonard's copy and it is therefore impossible to judge it.

Academy Figures

What has been preserved are several of the large red chalk drawings Fragonard did of the draped model. Some of them are very sober, with an intensely descriptive technique, like the *Study of a Deacon Carrying a Book*, in the Musée des Beaux-Arts of Orléans.[14] A set of four sheets in

the Musée Atger in Montpellier shows men either fully draped in long coats or in monk's habits.[15] The drawing has gained energy and fluency by comparison with the Orléans drawing; the lines are more authoritative, the forms simplified, their volume asserted by the sharp diagonal hatching that forms the shadows. Another, *Study of a Model Dressed as a Bishop*, in the Nationalmuseum, Stockholm, is striking because of the freedom and of the pleasing variety of its red pencil work.[16] These drawings should, of course, be linked to the practice Natoire had just instituted of making the painters draw draped models, often dressed in religious costumes, of which he writes in the same letter of October 18: "I have revived a scholarly custom that was practiced in my time at the Académie, during the vacations, when we used to draw, from models, figures draped in all kinds of styles and in different clothes, especially clerical robes, which produced very fine folds. The session only lasts an hour because the model cannot rest; that is why the time is used as fully as possible and the sessions we are now having give me confidence in the positive results of this type of study."[17] Can it therefore be assumed that the more sober scholarly drawings of draped figures by Fragonard (like those in Orléans) date from the fall of 1758 and that the more energetic ones, like those in Montpellier, date from the following year, the ones in Stockholm being of an even later date?

Another drawing can be associated with Fragonard's scholarly activities in Rome; it is particularly important

51 *Tancred Baptizing Clorinda.* 1757. Pen, brown wash, and white highlights, 38 × 45.8 cm. Private Collection

52 Children's games, called *Evening*, or *Peace*. c. 1758–60. Oil on canvas, 38 × 46 cm. Private Collection, Paris (cat.no. 65)

because it bears a date that is quite plausible, 1757, which means that it dates from the first year of the artist's stay in Rome. *Tancredi Baptizing Clonida*, which is of a very large size and is drawn in ink and brown wash on tinted paper with white highlighting, is one of the most ambitious essays of the young Fragonard in the domain of historical composition.[18] It has not been authenticated by Fragonard specialists because its technique and style appear so surprising. Yet the sheet, with its curvilinear, flowing, knotted lines, drawn with an impatient or calligraphic pen, fits perfectly between the Stockholm drawing for the Chrysler

63 *Rest on the Flight into Egypt* and the drawing for the *Storm*, in Chicago, dating from 1759, which will be discussed later. It is an exceptional drawing that reveals a zealous Fragonard who is still close to Carle Van Loo and who has studied the *Belvedere Torso*, which he takes for the figure of Tancredi.

17 The young painters continued to produce painted academy figures. Two of these, by Fragonard and by Monnet,

53 Children's games, called *Morning*, or *War*. c. 1758–60. Oil on canvas, 38 × 46 cm. Private Collection, Paris (cat. no. 64)

were sent to Paris on August 22, 1759.[19] It seems that Fragonard had worked particularly carefully on this painting, possibly in response to Natoire's advice. He may even

have painted it too carefully. Marigny wrote on October 22, to inform the director of the academicians' verdict, by simply copying out the report of the Académie. The text concerning Fragonard deserves to be cited here:

We are satisfied with the careful treatment and with the attentiveness we notice in the academic male figure painted by Monsieur Fragonard; however one fears that an excess of care may completely extinguish the fire that once burned within this artist. Exertion is apparent in it yet one does not find in it that pleasing casualness or that facility of brushwork that he may previously have carried to excess, but which should not be entirely lost when corrected. His colors do not present those fresh tones that may be used with great success by an artist who has studied his talent and who consciously abandons himself to the impulses of his genius. Everything is blended and finished. It is time for Monsieur Fragonard to have confidence in his talents and, by working more boldly, to rediscover that early fire and that pleasing facility he once had and that excessive studiousness appears to have curtailed or even destroyed. One is truly satisfied with his drawings; they are pure, scholarly and accurate; but are they not drawn with too little rounding off and effect? They would be worthy of infinite praise if they were the work of somebody who was going to be a sculptor; but should a painter forget color and effect, even when he is drawing?[20]

A Fragonard lacking in boldness–this is a surprising view that does not correspond to the idea we have of the artist. But, as has already been said, it seems that during his first years in Rome the painter experienced moments of doubt and remained undecided about the course he was to follow. Nevertheless, in the fall of 1759 the young artist's enthusiasm seemed to be intact. Natoire wrote to Marigny on October 24 concerning his copy of Pietro da Cortona's *St. Paul*: "Fragonard has immense talent but excessive fire and a lack of patience cause him to work on his copies with insufficient precision; that is what you will see in the copy he has made after Pietro da Cortona."[21] On November 7, in order to reassure Marigny following the criticisms the latter made in a letter of October 11, Natoire affirms that "One should not fear that Monsieur Fragonard will cool the enthusiasm he naturally has for his talent. It is true that, wishing to surpass himself, he can sometimes find himself faced with a task that exceeds his capacities, but I believe that this painter will find it easy to pick up again what nature has given him and I occasionally see

Cat. L18

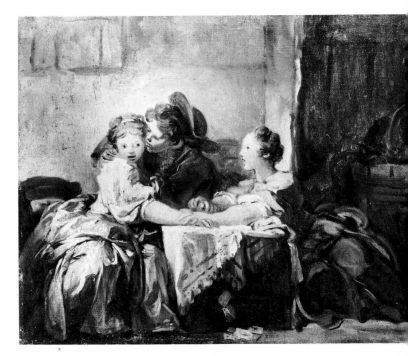

54 *The Lost Forfeit*, or *The Captured Kiss*. c. 1759–60. Oil on canvas, 47 × 60 cm. The Hermitage, Leningrad (cat.no. 77)

55 *The Preparations for a Meal*, or *The Poor Family*. c. 1759–60. Oil on canvas, 47 × 61 cm. Pushkin Museum, Moscow (cat.no. 78)

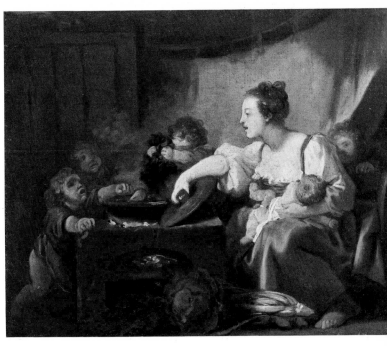

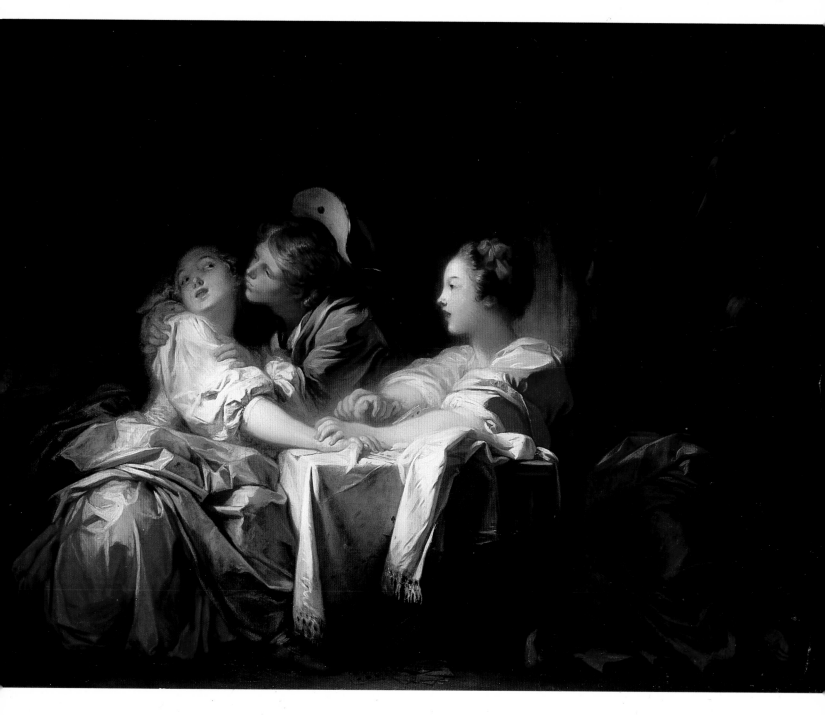

things that he has done which give me good reason for hope."[22]

Although any idea of Fragonard's scholarly works of this period is limited to what can be imagined of them—aside from his admirable drawings—two paintings that were, in fact part of Natoire's own collection may be associated with this activity. (Fragonard may have given Natoire these works,[23] and they may have been among those that gave the Director "good reason for hope" in the young painter's future.) These two works based on

56 *The Lost Forfeit*, or *The Captured Kiss*. c. 1759–60. Oil on canvas, 48 × 62 cm. The Metropolitan Museum of Art, New York, Gift of Jessie Woolworth Donahue, 1956 (cat.no. 76)

grand subjects, *Evening* or *Peace* and *Morning* or *War*, which are now in a Parisian collection, were almost certainly painted in Rome and form pendants. They are small history paintings that should be compared to the *Children's*

52, 53; Cat. 64.

Bacchanalia by Poussin rather than to all the cupids produced by Boucher as overdoors. They are unique among the works of Fragonard, and show naked little children in the clouds, a theme he would often treat in the course of his career. The very sharp contrasts of shadow and light, with the use of contre-jour, dramatizes the effect, especially, of course, in *War*, and prevents them from being considered simply as little decorative pictures. The color-range is particularly subtle, practically in monochrome and restricted to pinkish-browns, highlighted here and there with straw-colored tones, pinkish-gray, or faded turquoise. Here, within a quite specific type of subject, one finds further evidence of the primacy of chiaroscuro; with their restricted planes and their very clear outlines, these works are highly evocative of sculpted *modelletti*.

Interior Scenes

There are, however, a large number of interior scenes, street scenes, and pastoral landscapes that are deliberately personal works. Some of these paintings must have found their admirers early, in Rome itself. One of these works, a painting that is truly exceptional, provides evidence of this since it belonged to an eminent person, which proves that Fragonard's talents were already beginning to be recognized at this time.

This painting, one of the most astonishing of the works Fragonard produced during his stay in Rome, is in the Metropolitan Museum of Art in New York. It is astonishing because this interior scene, which is known as *The Lost Forfeit* or *The Captured Kiss* and which is meticulously finished, stands out from the other Roman paintings, marked by their vigorous brushwork. What has happened here? The painting was very probably a commission and the person for whom it was painted may well have wanted a finished painting, or Fragonard may have thought his client would be pleased with a work painted in this way. The person for whom it was painted was Jacques-Laure de Breteuil, who was then ambassador of the Order of Malta to the Holy See and who would subsequently be ambassador in Paris.[24]

This painting is, already, a masterpiece. It contains many reminiscences of Boucher, in the physical type of the almost childish young girls with their round faces and their turned-up noses, as well as in the picturesque and crumpled draperies. One rediscovers here the character types of the pastoral scenes Fragonard had painted between about 1755 and 1756 before leaving Paris.

The source of the painting's captivating originality is the curious contrast between, on the one hand, the exu-

56;
Cat. 76

berance of the subject, the vivacity of the poses of the sturdy characters and, on the other, the delicate fineness of the treatment and the colors, which are restricted to pale or faded pinks, greenish-yellows, mauve-grays, and pearly whites. Standing out against a very dark background and lit up by a moon-like light, the group of figures acquires a radiant, almost magical luminosity.

The subject deserves to be commented upon: some very young people, shepherds, judging by the crooks decorated with ribbons that can be seen in the background, have been playing cards around a low table. A young girl has lost and, according to the rules of the game, she should accept a kiss from the man who has won. But she refuses, struggles, and her companion has to immobilize her by seizing her by the wrists so that the young man, whose hat is almost falling off because of his excitement, can obtain his due. This may seem to be a weak subject. But the excitement really is carrying the characters away and the adolescents are acting out a true little drama; what we have here is no longer the rather conventional, aimiable, and sweet gallantry of the bright Parisian pastoral scenes. This is clearly an amorous subject. Was Fragonard known as a painter of such works at the time? The first easel painting bought from him by an admirer, that we know of, was an amorous scene, and that is probably no coincidence.

There is a second, very similar version of *The Lost Forfeit* in the Hermitage in Leningrad. Its dimensions are almost

54
C

57 *The Washerwomen*. c. 1759–60. Oil on canvas, 61.5 × 73.1 cm. St. Louis Art Museum (cat. no. 72)

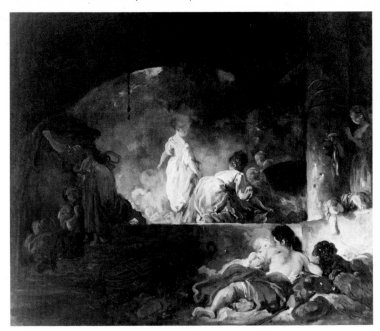

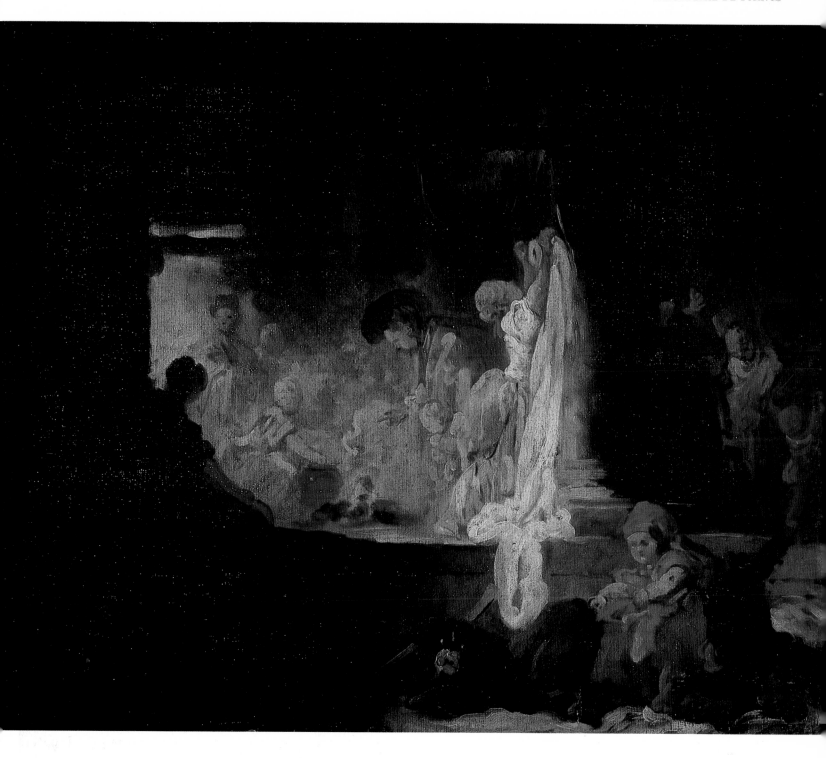

identical, it is painted with a sketchy technique, the colors in it are warmer, and there is a more even luminous effect. Not only the type of figures but also the treatment recall Boucher, with an added alertness and a lighter touch than one finds in the Parisian master.[25] Thus Fragonard apparently enjoyed being able to treat the same subject with diverse techniques.

58 *The Laundresses.* c. 1759–60. Oil on canvas, 54 × 69 cm. Musée des Beaux-Arts, Rouen (cat.no. 71)

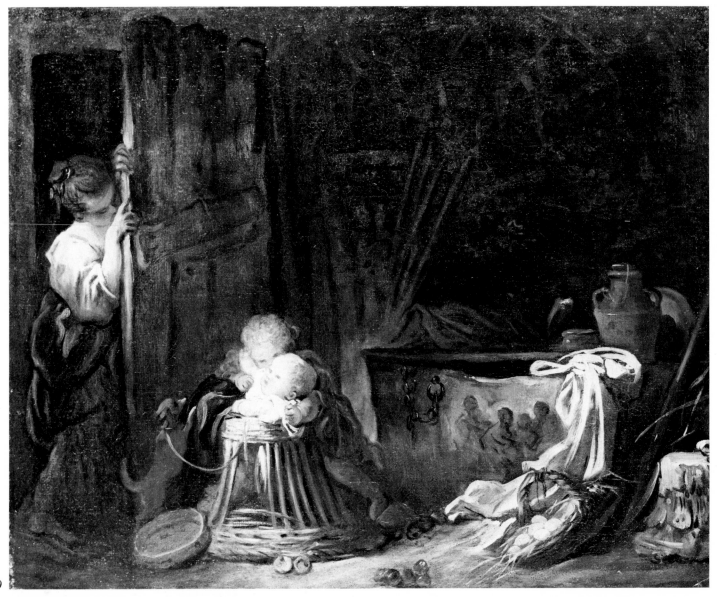

59

60

61

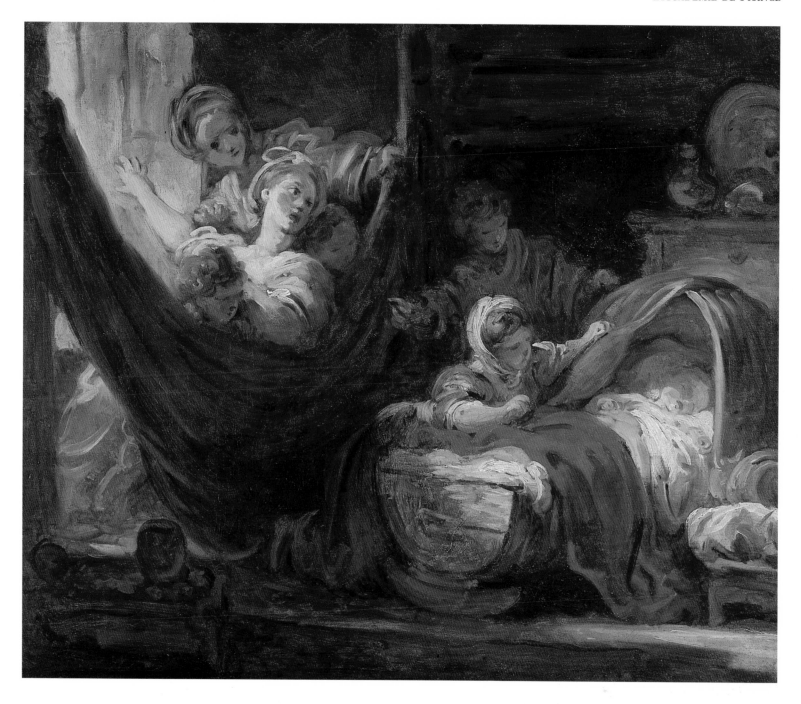

59 *Two Children Playing in a Room*, or *Hide-and-Seek*. c. 1758–60. Oil on canvas, 49 × 62 cm. Private Collection (cat. no. 63)

60 *The Italian Family*, also called *The Happy Mother*, or *Village Interior*. c. 1759–60. Oil on canvas, 48.9 × 59.4 cm. The Metropolitan Museum of Art, New York. Harris Brisbane Dick Fund, 1946 (cat. no. 74)

61 The farmyard, called *The Stable*. c. 1759–1760. Pen and brown wash, 27.5 × 39 cm. Musée Ile de France, Saint-Jean-Cap-Ferrat. Ephrussi de Rothschild Fondation.

62 *The Cradle*. c. 1760(?). Oil on canvas, 46 × 55 cm. Musée de Picardie, Amiens (cat. no. 84)

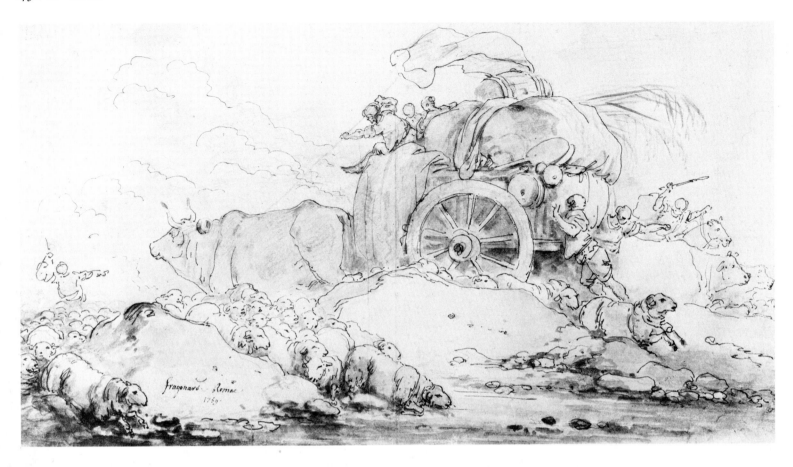

Roman Street and Country Scenes

We also have, from Fragonard's stay in Rome, quite a co-
herent series of rustic or popular scenes. It could be said
that he takes up the subjects and even the tone of the
scenes of revelry of which French artists had produced
some magnificent examples in Rome in the seventeenth
century. Did he study the paintings of Van Laer and
Dujardin while he was there? It is ironic to think that it
was by meditating on Dutch artists that Fragonard
approached Italy and Italian nature. Such paintings are
striking because of their contrasts of light and shade; they
are dominated by warm browns and by a frank and clear
touch that is almost jerky. They look, at first, like exercises
in situating forms in terms of space and light, and are
authoritatively sketched with a rapid brush. Many ele-
ments are still linked to Boucher, especially in the figures
of *At the Fountain* or *Turkey-Cocks* as it is sometimes called.
The Fountain in Rome, a companion piece to *Two Children
Playing in a Room*, or *Hide-and-Seek*, in private collections,
is particularly striking because of the energy and clarity of
the outlines, with its contrasting areas of reddish-brown
shade and of sunlit white sheets. All the narrative or anec-
dotal elements, the dog, the milestone, the wine flask, and

Cat. 69

Cat. 62

59;

Cat. 63

63 *The Storm*, or *The Cart Stuck in the Mud*. 1759. Pen, brown and
gray wash over light tracing in red chalk, 21.5 × 39.5 cm. The Art
Institute of Chicago. Gift of the Print and Drawing Club

64 *The Storm*, or *The Cart Stuck in the Mud*. 1759(?). Pen and brown
wash over red chalk counterproof, 34.7 × 48 cm. Museum of Fine
Arts, Budapest

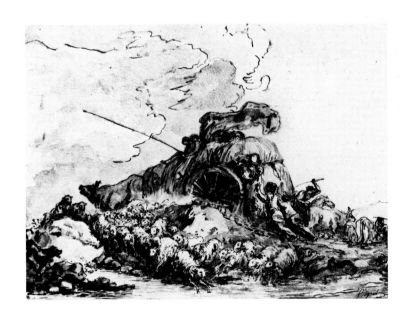

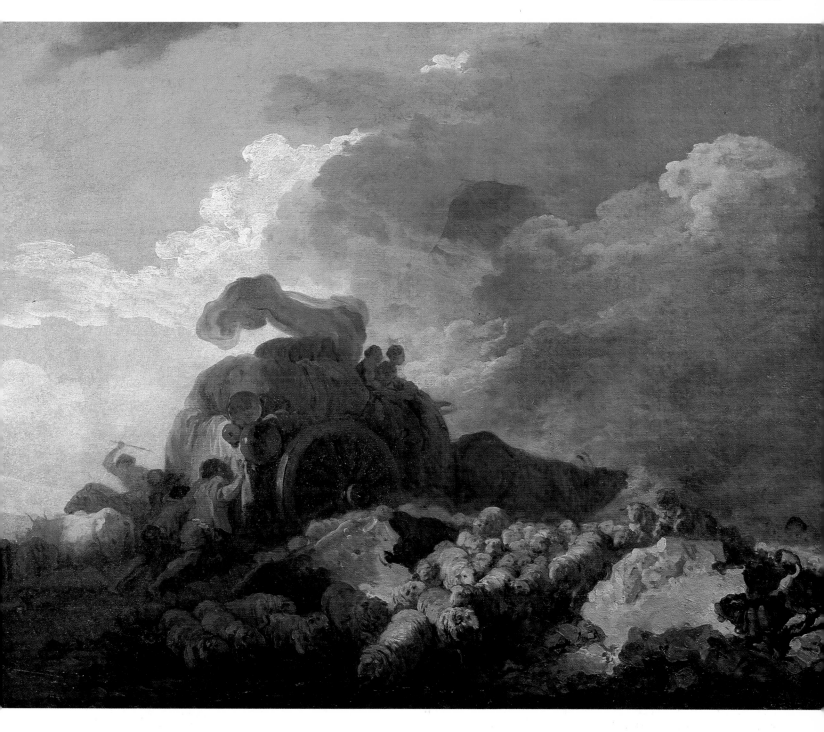

65 *The Storm*, or *The Cart Stuck in the Mud*. 1759(?). Oil on canvas, 73 × 97 cm. The Louvre, Paris (cat. no. 66)

the barrel in the foreground, the busy washerwoman on the left, the strange fountain, the inquisitive young onlooker in the background give the painting a rare charm and humor; but everything is subordinated to the luminous effect that summarizes and simplifies the whole picture.

Fragonard painted many pictures of this kind during this period. The subjects of *Washerwomen* or of *Laundresses*, particularly appealed to him since they allowed him to make female figures stand out from a semi-darkness,

shown preoccupied with their work, in clouds of luminous vapor. These two paintings—the first in the St. Louis Art Museum and the second in the Musée des Beaux-Arts, Rouen—are masterpieces of poetry and exhilaration, both

conceived along similar lines, with the principal scene showing laundresses boiling linen or stretching it out while standing on a kind of raised platform. Half of the foreground is left in the shade and, in the lower part, in front of the platform, accessory figures are individuated: a donkey, a little boy, and a dog, in Rouen; a young man, a child, and another dog, in St. Louis. In the painting in Rouen, the darkness is enlivened by a few sharp accents of light, marking the contre-jour outline of a young woman leaning against a column, or the white flash of a sheet that is being stretched out. The exquisite reds come to life as in the work of Sébastien Bourdon, against a range of bluish-grays and dark browns. Neither these scenic effects, which are so successful, nor such lighting, which is unexpected but correctly calculated, were to be forgotten by Fragonard. Such quick sketches in color, even if they could hardly have been painted from life, organized as they are like history paintings, provide evidence of strong impressions of nature that the spectacle of the alleys and avenues of Rome made on Fragonard. But his working method remains a mystery to us. Did he make sketches of arrangements in preparation for such paintings? Were the painted figures based upon drawings from life? That does indeed appear to have been the case, yet none of these drawings has been preserved. In contrast to the working method adopted by Robert, hundreds of whose sketches have been preserved, and who re-used his sketches in his paintings, Fragonard painted his quick sketches off the cuff.

Throughout his career, Fragonard admired the Genoese painter, Benedetto Castiglione to such an extent that his contemporaries sometimes described his work as "in the style of Benedetto." Castiglione's subjects, flocks of sheep, shepherds, and caravans, like his superbly elegant and energetic style, which was attentive to reality but frenzied, had all the qualities Fragonard would have admired, and several of Fragonard's Roman paintings reveal this influence. Two small paintings in a private collection, *The Train of Cattle* and *The Watering Place*, were painted as pendants, in an unusual format with an extended width and in a thick and sinuous paste. The works are daringly framed for the strips of ground in the foreground partially cut the figures. *The Storm*, in the Louvre, is a famous painting that is important for more than one reason. It is the most animated and most Baroque of the paintings from Fragonard's stay in Italy. It is a little drama, set in the Roman countryside, and shows the meeting, at the top of a pebbly path, of a heavily-laden wagon that is being pulled by an ox, of a flock of sheep, which is arriving from the opposite direction, and of a herd of cattle, which is crossing the spot a little further back. The work is a struggle of opposing forces: the exertion of the men straining as they push the wagon toward the top of the mound, and the

surge of the terror-stricken sheep tumbling down from the right, as they are chased by the shepherd and terrified of the huge dog in the foreground on the right. The flock of sheep is divided by a rock, and they come together again at the front; in the background, on the left, the herd of cattle is moving away more calmly. The rising wind chases away the clouds, which rush along like the sheep, and lifts up a canvas sheet that flaps about on top of the wagon like a scarf. Here again, what counts most of all is the opposition between shadow and light. The light is especially appropriate because it suggests the light of a stormy landscape: the wagon and ox are silhouetted clearly against the sky. Fragonard's technique is violent and he carves out, or almost hammers out, the forms in large areas of light and shade, in a generous and heavy paste, leaving them as they appear at the first attempt, without any retouches. Is this the first landscape Fragonard painted? In spite of the important role played by the landscape, the animal figures take up most of the painting and can be reduced to a network of signs or forces in motion. No face is visible here; all that one sees are the two ball-like and barely visible heads of the drivers of the wagon, shown in contre-jour against the sky. Moreover, the essential feature of this painting, the effects of contrast and the quasi-seismic conception, was to reappear consistently in Fragonard's landscape paintings.

The Storm can be dated with comparative certainty thanks to a drawing from 1759 in the Art Institute of Chicago.[26] Fragonard was already master of a style that is authoritatively affirmed and he seems to have overcome the doubts and hesitations of his initial years in Rome. It appears that at the end of 1758 or at the beginning of 1759, Fragonard's work took a new direction, prompted by his studies from life and by his association with Hubert Robert. By combining and complementing each other, these two elements were able to infuse Fragonard's art with new blood, giving it plasticity and exuberance.

Fragonard and Hubert Robert

Fragonard and Hubert Robert did indeed collaborate during this period and there was probably mutual emulation and friendly complicity between them. Robert, who was only very slightly younger than Fragonard, had not won the Prix de Rome and had not been a student at the Ecole Royale des Elèves Protégés. Yet, under the patronage of the Count of Stainville, later the Duke de Choiseul, he obtained a place at the Académie in the Mancini Palace in the fall of 1754, on condition that he would pay for his meals and follow the program of instruction. He very

66 Hubert Robert (1733–1808). *The Hermit's Courtyard in the Colosseum.* 1758(?). Red chalk, 39.2 × 27.5 cm. Musée des Beaux-Arts et d'Archéologie, Besançon

67 *The Hermit's Courtyard in the Colosseum.* 1758. Red chalk, 36.8 × 26.7 cm. Collection A. and J. H. Steiner, New York

quickly specialized in landscapes with ancient ruins, painted or drawn in the style of Gian Paolo Pannini, the famous Roman artist who had also specialized in such paintings and who was, in fact, professor of perspective at the Académie de France. Natoire appreciated Robert's zeal: "He is a good student and works with infinite enthusiasm...," he wrote to Marigny on February 28, 1759.[27] The latter wrote many flattering assessments of the young painter. He even wrote to Natoire on Novem-

ber 20, 1760: "Redouble all the cares you are taking in the cultivation of so fine a plant that will be an honor both to you, as Director, and to the arts in France."[28]

It is from 1758, when, on Natoire's advice, the two artists began to draw from life, that there is clear evidence of Robert's and Fragonard's collaboration. Two red chalk drawings, which are very similar and remarkably faithful to reality, have been preserved. They represent a simple motif, a picturesque corner of the Colosseum known as

68 *View of a Farm in an Ancient Monument.* c. 1760. Red chalk, 33 × 47.3 cm. Statens Museum for Kunst, Copenhagen

The Hermit's Courtyard in the Colosseum.[29] One is by Fragonard, the other by Hubert Robert; they worked side by side or immediately followed each other at the same site. What is striking about Robert's drawing, in the Musée des Beaux-Arts of Besançon, is the almost brutal energy of its delineation. Fragonard's drawing, in a private collection in the U.S.A., is more elegant and supple in the way it is built up, more skillful in the way it orders areas in terms of light effects, and more finely shaded and varied in the way the red chalk evokes the materials: stone, brick, wood, or foliage. These qualities, as well as some reminiscences of Boucher's style of drawing, show that this drawing, which bears the date 1758, is probably one of Fragonard's earliest successful attempts at drawing in the open air. For Robert, the experience was quite new; an old inscription on the drawing's mount, probably put there by the architect Pierre-Adrien Pâris, who later owned it and who bequeathed it with his collections to the city of Besançon, even states: *Robert's first drawing from life*, which must reflect an accurate account. Robert thus allowed himself to be led out into the open air by Fragonard, and the latter, a prize-winner at the Académie and an artist who was gifted at drawing from models, may well have advised his friend. This may have been the start of a long period that was to last until 1761, the year of Fragonard's departure, in which

both artists produced many landscape drawings of Roman parks. They were certainly drawn in an atmosphere of emulation, sometimes with such similar results that it explains, but does not justify, a great deal of the confusion that has arisen around them, especially as the artists occasionally seem to have copied each other's drawings or to have worked on counterproofs of each other's works. The most amusing example seems to be that of *The Storm*, by Fragonard, both the painting (in the Louvre), which has already been discussed, and the drawing, dated 1759 (in Chicago). There is another version of the drawing in the Fine Arts Museum in Budapest; it is executed with flamboyant strokes, in pen and ink and wash, on a light counterproof in red chalk.[30] In spite of an authoritative-looking signature, *Fragonard*, the drawing in Budapest is quite clearly the work of Hubert Robert. Another example, that of the *Washerwomen*, in Amiens, which has already been mentioned, shows that paintings too, including some of the most famous ones, have been taken away from Fragonard and attributed to Robert. There is no better proof of how close the two painters' preoccupations were about 1758–60.[31] One might even say that a competitive spirit developed between Fragonard, who was the product of an academic training, and Robert, who always remained rather an independent artist. The art of both

69 *A Shepherd and Shepherdess in a Stable.* c. 1760. Oil on canvas, 48 × 58.5 cm. Private Collection (cat. no. 80)

men unquestionably benefited enormously from this relationship. It seems that, through his association with Robert, Fragonard developed his sense of the narrative and of the incongruous, which was often tinged with humor. But the skill of constructing a space correctly and of calculating the effects of lighting for this purpose was to remain the special gift of Fragonard, who achieved, through his obser-

vation of ordinary life in Rome, a joyful but robust art. Robert would always remain more casual and more whimsical. One likes to imagine them working together,

with the atmosphere of emulation, the jokes they made in the studio, as they worked in a climate that must have been very cheerful.

The Patronage of Abbé de Saint-Non

At the end of 1759, on November 21, according to Natoire, the Abbé de Saint-Non arrived in Rome. Claude-Richard, abbé de Saint-Non (1727–1791), was an engaging personage and one of Fragonard's great admirers and patrons. His name has remained linked to that of the painter and we shall come across it again later. He was a descendent of the Boulogne family and was himself a dedicated amateur artist, a draftsman, painter, and engraver.[32] Having arrived in Rome, he would visit the house of the Magistrate de Breteuil, the art-collector, where he probably saw Fragonard's *The Lost Forfeit*. Saint-Non wandered around Rome and "almost worked himself to death drawing, engraving and painting."

Saint-Non appears to have got on well with Hubert Robert, who had been brought up on Classical literature like himself and was a good Latinist, and who, having already been in Rome for five years, must also have been an excellent guide. He wanted to take the painter as his companion on a trip to Naples and Herculanum. Robert obtained permission to undertake the trip, even though he had only been a regular student at the Académie since August 1759, and they both set off in April 1760. They returned at the end of the following month with a harvest of drawings of monuments and of ancient paintings done at Campania.

In the summer of the same year, 1760, the Abbé de Saint-Non took Fragonard with him on a trip to Tivoli and put him up at the Villa d'Este, in the palace belonging to the duke of Modena, who had put it at the priest's disposal for the summer. It is not clear whether Hubert Robert accompanied them. In his letters, Natoire only writes of Fragonard, who was busy drawing in the famous gardens: "Abbé de Saint-Non has been at Tivoli for six weeks with the student painter Fragonard. The artlover is enjoying himself tremendously and is very busy. Our young artist is drawing some very fine studies, which can only be useful to him and do him great honor. He has a very keen appetite for this type of landscape, into which he introduces pastoral subjects that are very successfully drawn. Monsieur Robert is doing just as well...," one reads in a letter to Marigny dated August 27.[33]

Fragonard was apparently happy to be sketching all the time; it was at this time that he produced the large views in red chalk of the Villa's gardens, which are considered some of his most powerful, most radiant works, and which reveal his love for Italy most intensely. Ten of the more spectacular ones remained in Saint-Non's collection and then went into the collection of Pierre-Adrien Pâris, who bequeathed them to the library in Besançon; they are still in the Musée des Beaux-Arts of that city.[34]

They are grandiose and unsurpassable achievements that were soon admired, and that have never stopped being admired. Pierre-Jean Mariette, a collector of engravings respected for his critical judgment, remarked when he saw them at Saint-Non's home, that he had scarcely seen a better hand. Five years later, at the first Salon at which Fragonard exhibited a picture—he showed *Coresus and Callirhoe*—there were also two of his red chalk sketches, *The Great Cypresses of the Villa d'Este* and the *Entrance to the Fontanone*. Naturally, he soon realized that they were both successful and popular. He sketched another version of *The Great Cypresses* in brown wash, which is now in the Albertina in Vienna, and a third, in ink and wash on a counterproof in red chalk, now in a private collection.[35]

The drawings are all in the same large format (approximately 48 × 36 cm), used vertically or horizontally. Each of these admirable works contains a powerful force, as though it were heavy with a sap that cannot be contained. They are dominated by vigor, brilliance, and a tumultuous quality, but there is no disorder in them. The various planes assume their rightful place, the pieces of ground are organized, the architecture is clearly delineated. A generosity, a superabundance even, of lines dominates the work and the artist's hand moves with great speed. The whole sheet is simply a shimmer of red chalk, giving either intense or light hatching effects that are often febrile and always highly rhythmical, making the white paper vibrate and revealing a thousand unexpected forms. The line runs along, is rounded off, curls up, becomes jagged, plays around in little zigzags, twirls itself into fine curls and then leaps up, rushes along, and bounces into an infinite number of variations. There is not a single weak or indifferent stroke, and in spite of the soft and crumbly medium, everything remains acute, precise, and nervous. There is nothing gratuitous here for every line is the result of a fervent observation of the marvelous Italian scenery. Everything is taut and ordered in the deep breathing of the elements of nature, in the movement of the wind, in the glare of the sun and in the restfulness of the shade. These are among the most truly lyrical drawings that a landscape has ever inspired, and they are achieved, paradoxically,

70 *The Great Cypresses of the Villa d'Este*. 1760. Red chalk, 47.8 × 35.4 cm. Musée des Beaux-Arts et d'Archéologie, Besançon

71 *The Great Staircase at the Villa d'Este.* 1760. Red chalk, 35 × 48.7 cm. Musée des Beaux-Arts et d'Archéologie, Besançon

72 *The Great Staircase at the Villa d'Este.* c. 1760. Oil on canvas, 81.5 × 105 cm. Private collection (cat. no. 82)

73 *The Waterfalls at Tivoli*, also called *The Great Waterfall at Tivoli.* 1760. Red chalk, 48.8 × 36.1 cm. Musée des Beaux-Arts et d'Archéologie, Besançon

▷

74 *The Waterfalls at Tivoli.* c. 1760–62. Oil on canvas, 72.5 × 60.5 cm. The Louvre, Paris (cat. no. 83)

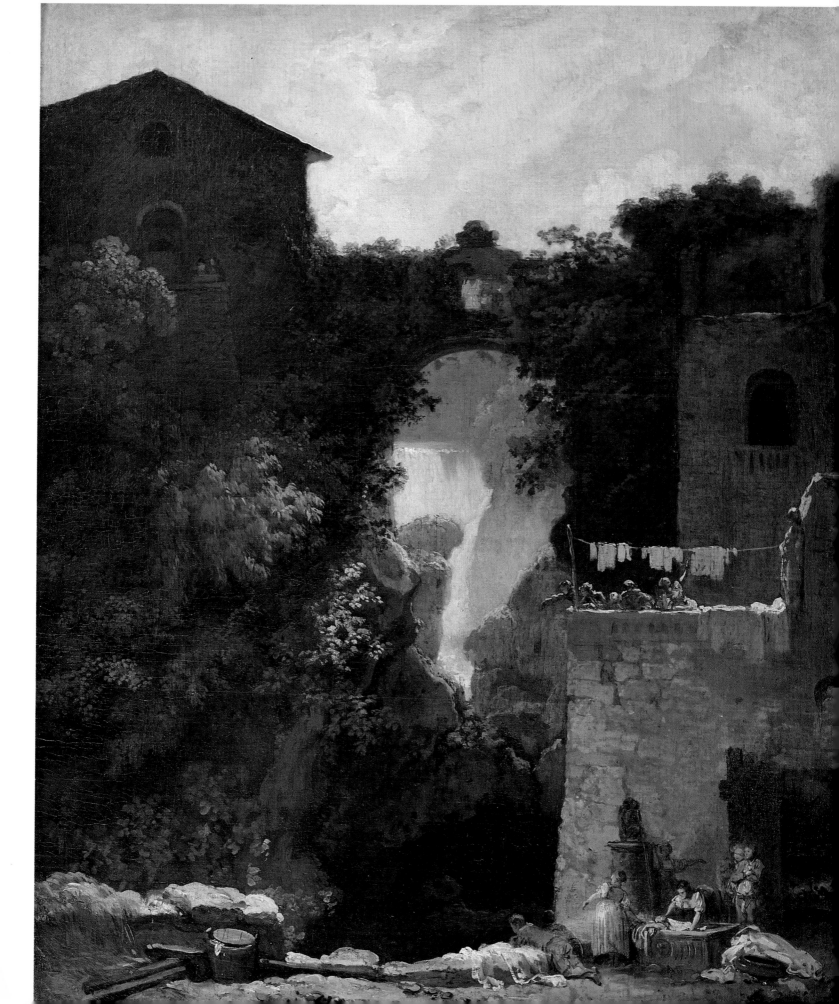

without the use of any color other than the ferruginous tones of red chalk.

Each of these drawings is intended to be a complete and finished work, and should not be considered as having been made in preparation for a painting. Nevertheless, two paintings do correspond to two of the sheets in Besançon, and this once again leads one to raise the question of the links between the drawings and the paintings in which Fragonard treated the same motif. It is all the more revealing since each of the paintings that have been preserved, *The Great Staircase at the Villa d'Este* (private collection) and the *Waterfalls at Tivoli* (the Louvre), is painted in quite a distinct style.

72; Cat. 82

The first painting, *The Great Staircase at the Villa d'Este*, formerly in the Gould collection, is quite a large canvas that was executed rapidly in somewhat pale tones, with a brisk, almost schematic technique. Fragonard may have taken up the drawing again when painting it, because the light effect is very similar in both works. But one cannot totally rule out the possibility that the painting was the earlier of the two works.

The sketchy and vigorous technique, which may be compared with that of the other canvases from Fragonard's stay in Italy, suggests that the work was painted in Rome. The fact that it was part of Natoire's collection, like the small paintings of *Peace* and *War* confirms this; it may have been a present given by Fragonard to the director of the Académie or a purchase made by the latter. The second landscape related to one of the red chalk drawings in Besançon, the famous *Waterfalls at Tivoli*, which came to the Louvre with the La Caze Collection, was for a long time attributed to Hubert Robert until Charles Sterling discovered who really painted it. This view of the waterfalls at Tivoli, seen through the arch of a small bridge, dominating the Anio, is one of the most authentic of Fragonard's painted landscapes and evokes all the freshness of an impression that one gets in the open air. What is especially striking here is the frankness and accuracy of the luminous effect, with the sun hidden, the shapes outlined in contre-jour, and the light that is filtered, playing over the foliage, and illuminating the white linen that is hanging out to dry. Light and shade alternate in a series of screens and the painting has a special depth in the center because of the glare coming from the waterfall under the arch of the bridge. The whole picture is made up of solid masses; no concession is made to decoration and the work is painted with a clear and varied but also very precise technique. It is probably Fragonard's finest achievement in landscape painting during his stay in Italy. This innovative painting prefigures the investigations that French artists would be making at the end of the century and at the start of the next century. The delightful diversity of technique,

74; Cat. 83

the skill and humor of the small figures indicate a work that was painted at the very end of his sojourn in Italy. Can it be totally excluded that it might have been painted after Fragonard's return to Paris, in 1761 or 1762? One cannot imagine the painting having been produced before the drawing, whose framing and luminous effect it echoes.

An intriguing painting, *The Game of Battledore*, in the Musée des Beaux-Arts in Chambéry should also be linked to one of these red chalk drawings from the end of Fragonard's stay in Rome. It shows, in the shade of a park adorned with balustrades and statues, a group of young people playing battledore, a game that was similar to the more popular game of hot cockles. The costumes and the galant subject recall works from before Fragonard's stay in Rome, such as the *Blindman's Buff* or the *Swing*. The group thus re-appears, on a smaller scale, enlivening a *Scene in a Park* in the Städelsches Kunstinstitut in Frankfurt-am-Main,[36] a drawing that seems to have been done in Rome, but which is drawn in a finer, more discontinuous manner than the red chalk drawings in Besançon; this would therefore enable it to be given a slightly later date. The painting in Chambéry appears to be earlier and might date from about 1759 or 1760, from approximately the same time as *The Lost Forfeit* in the Hermitage, and the *Preparations for a Meal* in the Pushkin Museum, Moscow, which are painted in a similar technique. The blue-red-yellow tones and the physical types of the figures indicate a style that is close to Boucher's, with contrasting luminous effects and a cursive touch that are truly typical of Fragonard. The painting in Chambéry appears to be a fragment of a larger work, the full appearance of which is revealed by copies drawn of it. The painting may also have had a pendant and might therefore be a picture that has come down to us in an incomplete state, the sole surviving example of a large decorative work dating from Fragonard's stay in Rome. It treats vigorously, and with the strong light effects he had elaborated in Rome, a galant pastoral scene that is similar to the ones he had painted in Paris and which is set within the decor of an Italian park.

Saint-Non suggested that Fragonard accompany him on his return journey to France and thereby provided the ever eager artist an oppurtunity to study closely the masterpieces throughout Italy. Natoire informs us in a letter of March 18, 1761, that the Abbé, who was "always ready to be of help to this student, since he is taking him with him, has just sent him [Fragonard] to Naples, to see the fine things that are contained within that city before they begin their journey home."[37] They thus set off; Natoire wrote on April 15, of Fragonard, who had just left: "This young artist, who has made progress in Rome, will be glad to profit from this advantage and will continue to do studies wherever they stop."[38]

75; Cat. 8

76

75 *The Game of Battledore.* c. 1759–60. Oil on canvas, 67.5 × 114.7 cm. Musée des Beaux-Arts, Chambéry (cat. no. 81)

76 *Scene in a Park.* c. 1760–61. Red chalk, 34.9 × 46.8 cm. Städelsches Kunstinstitut, Frankfurt-am-Main

77–84 Eight female figures after the antique. c. 1758–60. Red chalk, approximately 36 × 20 cm. Bibliothèque Municipale, Besançon (album 453, nos. 303–10)

The Return Trip to Paris

The diary kept by Saint-Non throughout his two-year-long journey to Italy has just been published as a fine book.[39] The priest's return journey from Rome to Paris lasted five and a half months. Fragonard accompanied him, but at no time does the artist's name appear in his patron's journal. Fortunately, most of the large number of black chalk drawings done by Fragonard for Saint-Non (sketches of sites and especially sketches of works of art the priest admired in galleries and churches) have been preserved and enable us to follow their journey step by step and to see it through the painter's own eyes.

The travelers left Rome on the morning of April 14 and, after fifty kilometers, Fragonard was already drawing the medieval town of Ronciglione (British Museum).[40] Shortly afterwards, in Caprarola, the artist naturally sketched the *Farnese Palace* (private collection).[41] Next came Siena and Florence, where the travelers stayed for a few days. On April 25, Fragonard produced a *View of the Courtyard of the Pitti Palace* (British Museum),[42] and numerous sketches in the Palatine Gallery, after Raphael, Rubens, Andrea del Sarto, and after the frescos of Pietro da Cortona in the vaults; he worked in the sacristy of San Lorenzo after the tombs of the Medici by Michelangelo, at the Uffizi Gallery after the Grand Duke's Old Masters, after the paintings at the Corsini Palace, at the Medici-Riccardi Palace, and after the paintings of Luca Giordano in the vault of the gallery. After a brief detour through Pisa, where Fragonard drew the *Piazza dei Miracoli* (May 1, 1761; British Museum),[43] Leghorn and Lucca, they went back to Florence, leaving once again on May 6 and going on to Bologna, Ferrara, and Venice, where the travelers arrived on May 8. Their stay there lasted for six weeks and was undoubtedly an overwhelming experience for the painter. Saint-Non complained about the state of preservation of the paintings, and greatly admired Tintoretto: "nothing equals the genius of this great man and the passion he had for painting." He appreciated Tiepolo and, to an even greater extent, Sebastiano Ricci. Fragonard made many sketches after Titian and Veronese, and even more after Tintoretto and others; among the most moving of these are sketches after Ricci and Tiepolo. On June 23, having left Venice, they saw the Villa Pisani in Stra: "Tiepolo is presently painting a gallery there...," wrote Saint-Non,[44] but this gallery was still unfinished and they were not able to see it. Fragonard and Tiepolo may at the time have stood a few yards away from each other without meeting. They then went on to Padua, Vicenza, where the

85 *View of the Courtyard of the Pitti Palace in Florence.* April 25, 1761. Black chalk, 20.7 × 29.4 cm. British Museum, London

86

88

87

89

90 *The Staircase of the Balbi Palace at Genoa.* August or September 1761. Black chalk, 20.2 × 29.1 cm. British Museum, London

91 *The Maison Carrée at Nîmes.* September 17 or 18, 1761. Black chalk, 19 × 28.5 cm. Staatliche Kunsthalle, Karlsruhe

artist drew Palladio's *Villa Rotonda* (Norton Simon Foundation, Pasadena),[45] Verona, Mantua on July 5, where Fragonard made a sketch after Giulio Romano at the Palazzo Te, then to Modena and then, once again, to Bologna, where they stayed until the end of July. Fragonard made many drawings there after the great Bolognaise artists of the sixteenth century, in the churches and palaces. They then left for Parma, Piacenza, and stayed in Genoa until August 21, where they had a pleasant and productive stop lasting twenty days, during which time Fragonard constantly drew views of the city: the *Palazzo Durazzo Pallavicini*, the *Palazzo Balbi* (two drawings in the British Museum), the *Palazzo Doria* (the Louvre), two *Entrances to*

Genoa (British Museum and private collection),[46] as well as sketches of paintings in galleries and churches, notably by Castiglione and Rubens. They also visited the surroundings of Genoa, and Fragonard drew the *Gardens of the Villa Centurione Doria*, in Pegli (private collection, U.S.A.), and the *Villa Lomellini Rostan*, in Multedo.[47] On September 10, the travelers set sail for Antibes and returned to Paris via Toulon, Marseilles, Aix, Saint-Rémy, where Fragonard made two fine drawings of the *Antiquities* (British Museum), and Nîmes, where he drew the *Maison Carrée* (Karlsruhe).[48] On September 26, 1761 Saint-Non and Fragonard were back in Paris again.

It is impossible to exaggerate the importance, for the painter's art, of these hundreds of sketches "after the masters"; they are marvels of intelligence and wit, and they grasp the essence of the originals with a sureness of eye and an almost infallible hand, in one acute and lively line of black chalk. The forms never become heavy or mere outlines and there is, in these drawings, a free and lively use of hatching, of various intensities, the areas of which are superimposed or juxtaposed. One cannot help noticing the growing mastery of these drawings; whereas certain sheets from Rome or Florence, from the Farnesina or the Pitti Palace, show a style that is still weak and almost timid, the ones from his stay in Genoa radiate authority and power. Occasionally, at moments for which he can easily be forgiven, when he is unable to see a detail in a dark church, Fragonard omits or adds a figure, or introduces the type of young women or children with impish faces of which he was so fond. He often modified the

86 *The Holy Family with Cat* (after the painting, now destroyed, by Federico Barocci at the Pitti Palace in Florence). April or May 1761. Black chalk, 27.2 × 20.4 cm. Museum Boymans van Beuningen, Rotterdam

87 *Train of Animals* and *God Appearing to Jacob* (after two drawings by Giovanni Benedetto Castiglione then in the collection of the Consul Smith in Venice). May or June 1761. Black chalk, 28.6 × 20.9 cm. The Norton Simon Foundation, Pasadena

88 *The Education of the Virgin* (after the painting by Giovanni Battista Tiepolo in the church of Santa Maria della Fava in Venice). May or June 1761. Black chalk. The Norton Simon Foundation, Pasadena

89 *Abraham and Melchizedek* (after a painting by Francesco Castiglione then in the Balbi Palace). August or September 1761. Black chalk, 20 × 27 cm. British Museum, London

contrasts of various elements to suit his own taste. We see him hiding the lower part of the *Sala de S. Zaccaria*, by Veronese, behind plumes of smoke, perhaps because he realized that his sheet of paper was not large enough to accommodate the whole of the composition.[49] And we even see him making deliberate corrections. For example, he eliminates the angel that Tintoretto had painted in the upper part of his *Vision of St. Peter*, in the Madonna dell'Orto, and replaced it with two cherubs.[50] Of course, the artist drew whatever Saint-Non had chosen. Nevertheless, his own initiative is evident in the large number of studies after the supple and flowing figures of Pietro da Cortona in the Pitti Palace, after the dancing figures of Luca Giordano in the Medici-Riccardi Palace, in Florence, or after those of Tiepolo, in the Dolfin Palace in Venice, which are sturdy and overwhelming. Of particular interest are the sketches he made after the drawings of Benedetto Castiglione, which were in the possession of Consul Smith, in Venice, at the time, and which are now in the British Royal Collections; Fragonard's interpretations (several of which are in the Norton Simon Foundation)[51] show that he discovered a more nervous style, more elongated and supple forms, and a vibrant and jerky line, which would have a tremendous impact on him. And he would not forget certain kinds of faces by Castiglione, with their protruding chins, sensual mouths, and turned-up noses.

This journey proved to be the most fertile of schools for Fragonard. In a yearning to see and to learn, which is well evoked by the raging and jubilant energy of his drawings, the painter had acquired an incomparable visual vocabulary. His lively sketches indirectly formed a mine of energy on which he could draw for his subsequent paintings.

87

Chapter IV
1761–67 Paris
The Birth of a Reputation

Fragonard's Landscapes: Italy and Holland

Fragonard had left Paris as a good student; he returned as a great painter. Yet little is known about the years immediately following his return from Italy. The preparation of the large painting that would allow him to follow in the footsteps of every history painter returning to Paris from Rome and to be recognized by the Académie Royale took a long time as this painting was not presented until the spring of 1765. He was not solely occupied with the preparation of that painting. It cannot be completely ruled out, for example, that he once again painted decors in the style of Boucher, like those of the Hôtel Matignon.[1]

It may be assumed that his Italian experience was directly reflected in the works he painted immediately after his return to France. With the help of his drawings, Fragonard may then have painted some of the Italian landscapes that are usually dated from the period he spent south of the Alps. This possibility has already been suggested concerning the *Waterfalls at Tivoli*, in the Louvre. It should be considered again with regard to one of the most famous landscapes of Tivoli, the small and exquisite picture, *The Gardens of the Villa d'Este*, in the Wallace Collection, Lon-

92 Study of heads: different human and animal types. 1765, according to Morel d'Arleux's manuscript inventory of the Cabinet des Dessins. Black chalk, 19.7 × 28.1 cm. Cabinet des Dessins, The Louvre, Paris

93 Study of heads: figures confronted by a lion. 1765, according to Morel d'Arleux's manuscript inventory of the Cabinet des Dessins. Black chalk, 20 × 28.6 cm. Cabinet des Dessins, The Louvre, Paris

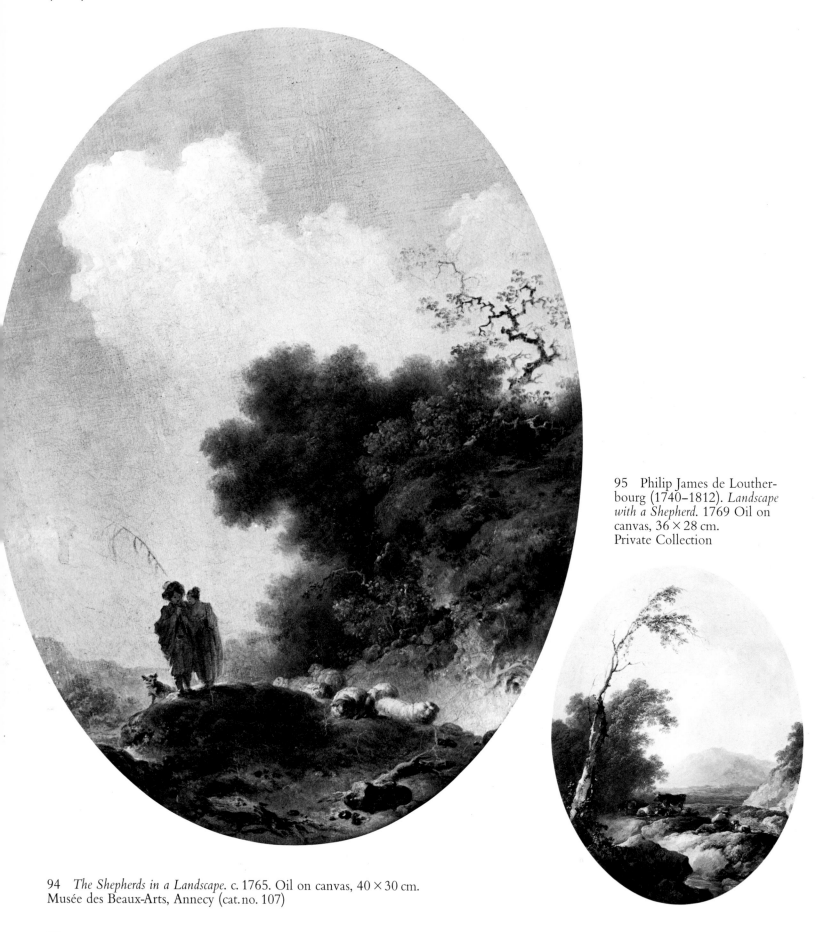

95 Philip James de Louther-
bourg (1740–1812). *Landscape
with a Shepherd*. 1769 Oil on
canvas, 36 × 28 cm.
Private Collection

94 *The Shepherds in a Landscape*. c. 1765. Oil on canvas, 40 × 30 cm.
Musée des Beaux-Arts, Annecy (cat. no. 107)

don, often referred to as *The Little Park*, which is truly enchanting because of the intelligent portrayal of space that is presented with faultless authority and grace because of the way Fragonard has treated the light. It is, quite simply, an arrangement of successive terraces. The subtlety of the picture lies in the centrality of the elements that rise up symmetrically before us, seen from just below. One has

96 *The Gardens of the Villa d'Este*, also called *The Little Park*. c. 1762–63. Oil on canvas, 38 × 46 cm. Wallace Collection, London (cat. no. 88)

the impression of going up a flight of stairs, and gradually entering a humming and magical universe whose perspectives open out giving a truly cinematographic effect of

88

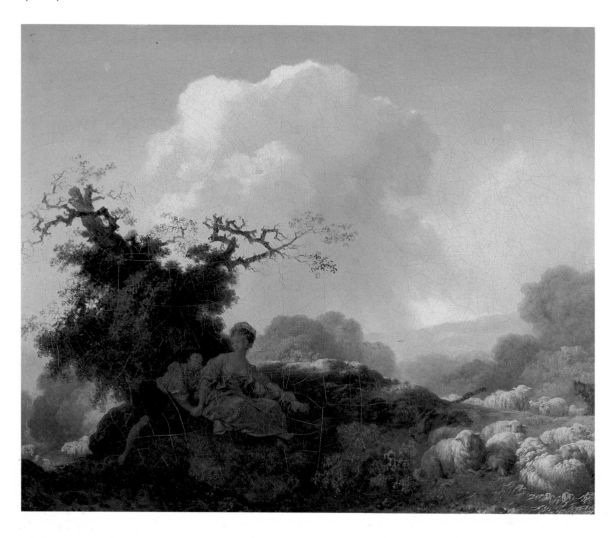

97 *Annette and Lubin*, or *Annette at the Age of Twenty*. c. 1764–66. Oil on canvas, 36 × 46 cm. Galleria Nazionale d'Arte Antica, Rome (cat. no. 106)

mobility: first a dark foreground with a few steps, figures, stone lions, and balustrades, which are silhouetted against an illuminated space, then a retaining wall that rises toward the shade, then yet another balustrade and statues standing out against a brightly lit background, and finally shady groves of trees whose foliage is gradually being lit up. This refinement in the study of transitions in a carefully balanced light, a very fine technique, and bright and varied colors, suggests that this was a work that was painted for an artlover in Paris rather than a work that was painted in Rome.[2]

It is really difficult to study Fragonard as a landscape painter during any period of his career. Some quick studies in gouache or oils on paper, like the *Landscape with Shepherds* in the Musée des Arts Décoratifs in Lyons, or the *Family of Shepherds and their Flocks* in a collection in Paris,[3] which resemble a painting like *The Storm* by their tone and style, were probably painted after Fragonard's return from Italy. One finds in them a predilection for blocks of ground that are sharply opposed by contrasts of light, for *da sotto* views which make unusual effects possible, and for

the kind of dead tree-trunks, silhouetted in zigzag patterns, which would often recur in his works. A finished painting like *The Shepherds in a Landscape*, which was conceived on similar lines, must also date from about this time. A valuable point of chronology is established by the sending, to the Salon of 1765, of a *Landscape* that is mentioned in the catalogue as belonging to the collector Bergeret de Grancourt, whom we shall meet again later. This picture appears to be *The Shepherds in a Landscape*, a small painting in a vertical oval format, of which at least two versions exist; one has been lost, the other is in the Musée des Beaux-Arts in Annecy. The description given of it by Diderot, in his *Salon de 1765,* seems to correspond perfectly to this picture.[4] The dancing rhythms of the forms within the oval format, the fine vivacity of the branches, the figurines, and the bright colors all give the painting decorative charm.

Two pendants engraved in 1772 by François Godefroy, *Annette at the Age of Fifteen*, which has been lost, and *Annette and Lubin*, Galleria Nazionale in Rome, whose subjects are taken from a novel by Jean-François Marmon-

98 *Landscape with Flock Fleeing from a Storm.* c. 1763–65. Oil on canvas, 52 × 73 cm. Private Collection, Paris

tel dating from 1762, may perhaps be dated from about 1764–66. The small painting in Rome, which was carefully finished, is significant, principally, because of the effect of contre-jour that leaves the hillock, the tree, and the couple in the dark, and makes the background iridescent with light. Such paintings, which are meant to delight the onlooker, must have been avidly sought after by artlovers.

Do some of Fragonard's most convincing landscapes, such as *Landscape with Flock Fleeing From a Storm, The Watering Place,* and *The Rock*—all in private collections—also date from about this time or a little earlier? In these paintings, Fragonard takes up the motifs of herds of cattle and flocks of sheep led by their shepherds which he had fav-

ored in Rome, inspired as he had been by Castiglione. He integrates them into vast landscapes of rough terrain, traversed by fine effects of light that is altered by the clouds, which are similar to the effects that Ruisdael had favored. Fragonard must have had the opportunity of seeing paintings by Ruisdael in the exhibition rooms in Paris. *Landscape with Flock Fleeing from a Storm,* with its rumbling and surging rhythms, realizes this skillful synthesis of Castiglione and Ruisdael, in the splendid contrasts of shady

98;
Cat. 10

99 *The Rock*. c. 1763–65. Oil on canvas, 53 × 62 cm. Private Collection, Paris (cat. no. 111)

100 *The Watering Place.* c. 1763–65. Oil on canvas, 51.5 × 63 cm.
Private Collection, Paris (cat. no. 110)

101 *Landscape with a Lame Man.* c. 1766. Oil on canvas, 24 × 32.5 cm. Private Collection, Paris (cat. no. 131)

102 Jean-Baptiste Le Prince (1734–1781). *Landscape with Fisherman.* 1775. Oil on canvas, 47 × 62 cm. Pushkin Museum, Moscow

and sunlit planes. *The Watering Place* and *The Rock* are more directly related to the Dutch painter; they are more tranquil, with delicately balanced light effects, in a constant dialogue between the forms of terrain and trees and those of the clouds, which are extended in diagonal rhythms or are reflected as echoes, in pictorial effects of a sumptuous richness that take up and expand those suggested by Ruisdael; the brush trembles in flowing, thickening movements and with a graphic fineness.

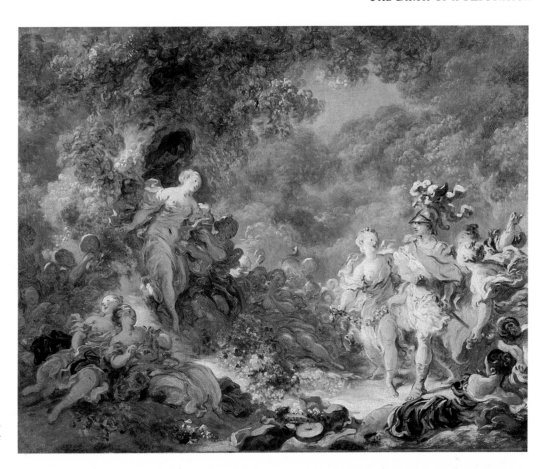

103 *Rinaldo in the Gardens of Armida.*
c. 1763. Oil on canvas, 72 × 91 cm. Private
Collection, Paris (cat.no. 95)

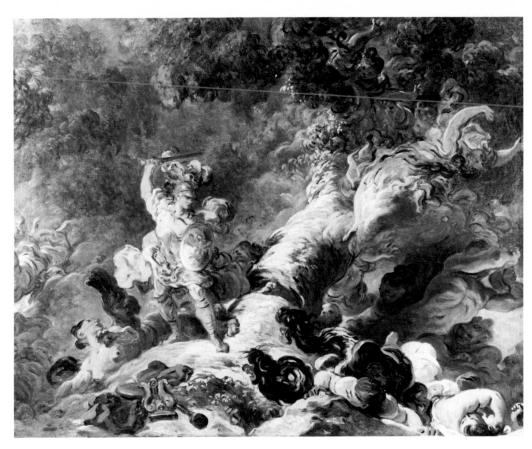

104 *Rinaldo in the Enchanted Forest.*
c. 1763. Oil on canvas, 72 × 91 cm. Private
Collection, Paris (cat.no. 96)

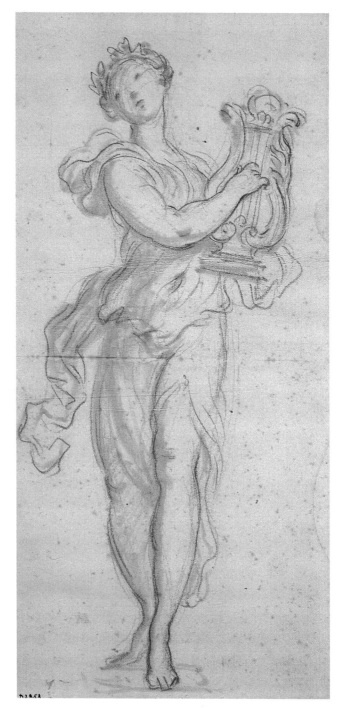

105 *Young Woman with a Lyre* (the muse Erato?). c. 1763–65(?). Red chalk, 41.6 × 19.7 cm. Musée des Beaux-Arts et d'Archéologie, Besançon

106 Study for a composition with several figures. c. 1762–65(?). Pen, 16 × 24 cm. Fogg Art Museum, Cambridge Mass. Purchased through the Louise Haskell Daly Fund

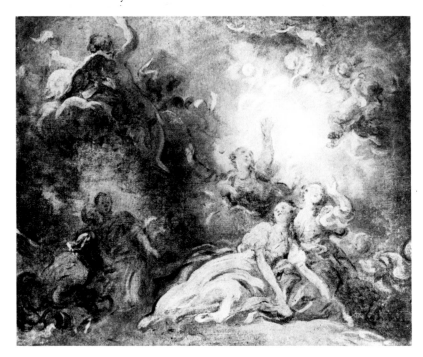

107 Mythological scene, called *Cupid and Psyche*. c. 1763. Oil on canvas, 37 × 45 cm. Private Collection (cat. no. 98)

Fragonard was to draw inspiration from Ruisdael until he was well into his career, in paintings that may be simple pastiches and that sometimes seem to have been commissioned by artlovers—who would hang them in their homes as pendants to "real" Ruisdaels—and to have been painted freely with a vigorous technique. It has to be admitted that it is very difficult to date them, even approximately. One may thus measure the admiration that Fragonard and the artlovers had for Dutch landscapes as well as for pastiche. This was a time when artists like Ruisdael or Jan Wijnants, whose animated and sandy landscapes and dead trees were surely appreciated by Fragonard, were at

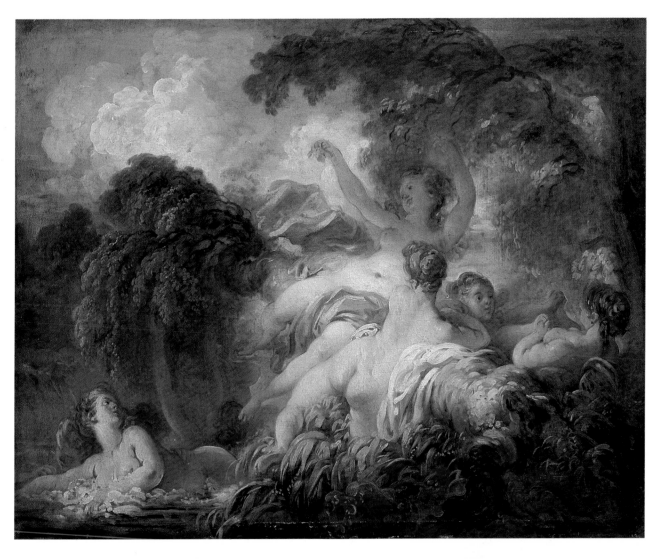

108 *Women Bathing*. c. 1763–64. Oil on canvas, 64 × 80 cm. The Louvre, Paris (cat. no. 101)

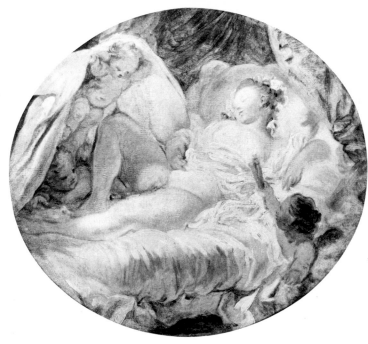

109 *All in a Blaze*. c. 1763–64. Oil on canvas, 37 × 45 cm. The Louvre, Paris (cat.no. 100)

the height of their reputation. And such paintings were not new in Europe; one need only think of the landscapes painted twenty years earlier, between 1745 and 1747, by Thomas Gainsborough, or those of Ebenezer Tull, "the English Ruisdael," which also date from the middle of the century. And, in France, one should not forget the landscapes in the Dutch manner by Loutherbourg or Le Prince, which have been confused with Fragonard's.[5]

Painting in the Style of Sketches

Two celebrated masterpieces in a Parisian collection, *Rinaldo in the Gardens of Armida* and *Rinaldo in the Enchanted Forest* take their subjects from the *Gerusalemme Liberata* by Tasso, and it is possible that a production in Paris in 1761 and 1764 of the opera *Armide*, with a libretto by Philippe Quinault (1686), which was Jean-Baptiste Lully's masterpiece, may have given Fragonard the idea for these paintings. This brilliant world of artifice certainly evokes the world of opera and, to an even greater extent, that of ballet. When contemplating *Rinaldo in the Enchanted Forest*, one thinks of the theatrical machinery of the period, and Armida's companions, in the other painting, evoke ballerinas. Rinaldo and his neighbor even seem to be dancing a pas-de-deux. Both paintings should be viewed as pendants; Fragonard quite consciously opposes a joyful painting with a violent one. The trunks and the foliage of the two large trees, with their accompanying sites, order the two compositions in opposing movements, describing two large open curves on the distant bluish backgrounds, in front of which the two plumed silhouettes of Rinaldo correspond to each other in the two paintings, and even seem to link the two parts of a single action: in one he has stopped suddenly and is ready to draw his sword; in the second, he is shown in action, brandishing his sword. In one there is a tree, at the foot of which appears Armida who gives the suggestion of a pretty dancer's bow at the end of an act and who appears to be a kind of emanation of that tree, a quivering, light tree that looks like a plume of smoke penetrated by an amber light; in the other, a trunk, which is twisted and contorted as though it were alive, rolls over defiantly, taking everything with it as it falls. The paintings subtly balance each other; in the *Gardens of Armida*, the forms turn gently in concentric rhythms, the figures move toward an empty center, where the ground is slightly hollow; in contrast to this, in the *Enchanted Forest*, everything is projected toward the corners of the picture in an explosion of centrifugal forces and, in the center, the ground is raised like a dome by an irrepressible thrust. Each painting is thus a kind of negative of the

other and it is, above all, the astounding conception of space in these works, which is reversed, turned head over heels, as though gravity no longer existed, in an apparent confusion that does nevertheless have a certain order, which makes them so original. The technique also adds to the general dizziness, in the flow of forms, some of which are dissolved in the iridescence of light, and which run, roll, and gush forth in great bursts; the strokes are dispersed in murmuring waves, the figures become weightless and float like scintillating scarves. This is the domain of the sketch for the sketch's own sake, as it would be impossible to imagine finished works related to these paintings, so self-sufficient is this world of flying sparks. And the colors themselves flare up in shades of ripe corn and of golden bread or turn crimson in shades of purplish-red. Such freedom and such force are new; they stem not only from the ease of brushwork or from the refinement of the palette, as in the decorative works from before Fragonard's stay in Rome, or from the synthetic power of the rendering of a light effect, as in the works painted in Rome. The entire painting has become a living organism in which, for the first time in Fragonard's work, the energy and the vitality of the hand do full justice to the daring of the idea. At the end of his stay in Rome, the red chalk drawings of the Villa d'Este and then the sketches after the Masters had suddenly revealed a draftsman who was in perfect control of all the means at his disposal. These two paintings assert, in a kind of sudden explosion, the painter's mastery over his means. The ardor of the execution and the daring of the spatial construction reveal that Fragonard was almost certainly familiar with the sketches of the Italian Masters. In Naples or Venice, in particular, Fragonard was able to see many works by such painters as Luca Giordano, Sebastiano Ricci, or Gian Antonio Pellegrini, whose vitality of execution and colorful splendor must have filled him with wonder, the echo of which may perhaps be found here.[6]

This unchecked rush of figures who seem to have broken free of gravity as well as this masterful distribution of light effects which makes use of transparent and golden half-lights reappears in another extremely popular painting, the *Women Bathing* in the Louvre, which may be slightly later (c. 1763–64) than the two *Rinaldos*. But here, the firm contours of the bodies, with their plump limbs, are still very evocative of the works of Boucher: the bathing woman seen from the back in the foreground even appears to be directly inspired by the central figure in a *Pan and Syrinx* painted by Boucher in 1761, which was part of the Varanchan Collection.[7] Fragonard does not feel the need to have a mythological pretext: the two girls are enjoying themselves; they are fighting; in fact, these mischievous girls are stealing apples or other fruit, making use of a

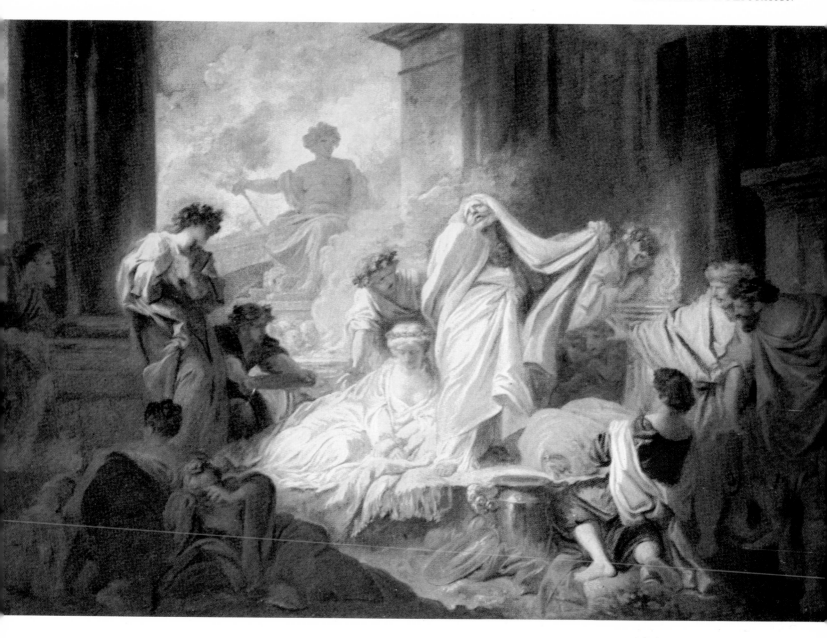

110 *Coresus and Callirhoe*. c. 1763–64. Oil on canvas, 129 × 186 cm. Musée des Beaux-Arts, Angers (cat. no. 118)

treetrunk that has fallen across the stream. It is a dazzling display of forces that burst out in every direction, a surge of clusters of foliage and of light bodies that are leaping about. As in the paintings of *Rinaldo*, the space opens out, sways irresistibly, and the bodies and natural elements are harmonized in a single breath; roots of trees, tufts of leaves, fabrics blowing in the wind, female bodies—everything rushes about and is tossed together in a light the color of golden tortoiseshell. The light and vibrant pictorial texture is punctuated by accents that give it an energy, a density, and a luminosity: sparkling drops of water, flashes on the grass, the foliage, or the bodies, or little dark touches; highlights in the plants or the hair, black eyes, navels, and dimples. It is, at first, difficult to understand

the subject: a half uprooted tree crosses the composition diagonally above the water; the bathers hold on to it and one of them, falling backwards and apparently freed from the force of gravity, seems to be letting herself fall into the water after having picked the fruit of the tree on the right; further away, a bather, in the water, stretches out her arms to seize the fruit of the uprooted tree. This large, twisted, vine-like trunk, which is hardly perceptible at first glance, lends its structure to the whole composition, like the one in the *Rinaldo and Armida*.[8]

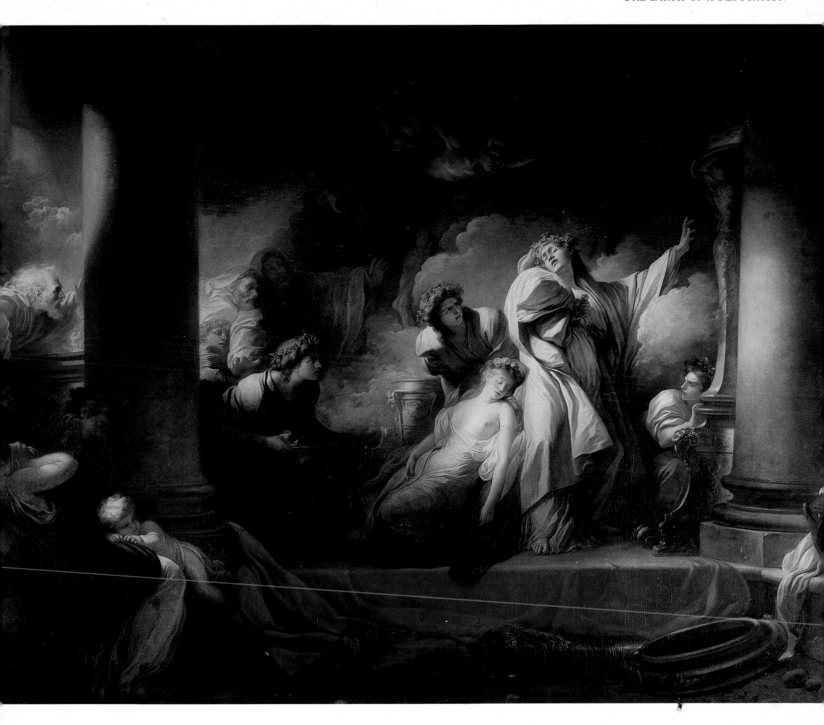

111 *Coresus and Callirhoe*. (Detail of Pl. 112)

112 *Coresus and Callirhoe*. Salon of 1765. Oil on canvas, 309 × 400 cm. The Louvre, Paris (cat. no. 117)

The Salon of 1765: Coresus and Callirhoe

On March 30, 1765, Fragonard presented a large painting, *Coresus and Callirhoe*, to the Académie Royale in order to obtain his official status as a member of the Académie. The painter was officially recognized and the painting,

which was greatly admired, went on display at the Salon the following August. The undertaking of the *Coresus* was prepared with great care; the large sketch in the Musée des Beaux-Arts of Angers was elaborated very carefully and appears so different from the definitive work, in its composition and color range, that one cannot rule out the

113 Carle Van Loo (1705–1765). *The Sacrifice of Iphigenia*. Pen, brown wash, white highlights in watercolor over black chalk underdrawing, 75.2 × 93.4 cm. The Metropolitan Museum of Art, New York. Rogers Fund, 1953

114 *Coresus and Callirhoe*. 1765(?). Brown wash over black chalk underdrawing, 34.7 × 46.5 cm. The Pierpoint Morgan Library, New York

possibility that an intermediate sketch, which has since been lost, may once have existed. The Angers painting already contains the main decisions concerning the huge canvas, with the figures distributed on two levels, the arrangement of the architecture, and the central triangular group, but Fragonard later eliminated essential elements, like the group of three men in the right foreground and the figure of the man standing on the left in front of the column; he left out the luminous sky and the statue in the background. In the painting in Angers, the scene is set in the open air, in front of a temple, in stark sunlight. The light is carefully distributed, with a sharp contrast between the central section, which is brightly lit, and the foreground and architecture, which are kept in the shade. Fragonard introduces subtle effects of contre-jour which may be compared with those that he was fond of in his decorative paintings prior to his stay in Rome, for the statue standing out against the sky and for the young man who stands on the left, whose neck is brightly lit and whose face disappears into the shade. The colors delight the onlooker with their warm shades of honey, of scarlet, and of pink, which harmonize with the jade-greens and silvery-whites, with the addition of the fine dissonant note of the bright blue tunic of a kneeling assistant, seen from the back in the foreground.

The unusual subject is taken from Pausanias' *Descriptions of Greece*. The great poet Coresus is in love with Callirhoe who is indifferent to him. Coresus looks to Bacchus, patron of the city, to avenge this slight, and the latter complies with this request by driving the inhabitants to insanity. Then the god demands the life of Callirhoe as the price for restoring order. Fragonard depicts the final scene: Coresus, on the verge of stabbing Callirhoe, stabs himself instead.

Here, in fact, is the result of the years of work in Rome; here, integrated into a vast composition, are the draped figures he studied for such a long time in the models at the Mancini Palace, and one can even see, in the pose and face of Coresus, a reminiscence of the *Laocoön* in the Vatican. The drama is expressed forcefully and clearly; a great movement overcomes the figures; the light effect is simple and effective, the composition well constructed; the touch is firm and well-articulated. Here and there, one still finds a few children's faces, just visible in the half-light, reflecting Fragonard's training with Boucher. But of all of Fragonard's paintings, *Coresus and Callirhoe* in Angers is, decidedly, the most Italian one. Pietro da Cortona and Gaulli, whom he studied in Rome, may be discerned in the vibrant animation of the figures who lend their support to a single, unified movement and in the joyful opposition of the colors; the influence of Francesco Solimena, seen in Naples, and of his cursive and winding rhythms, and his intense half-lights, is discernible here, as well as that of

Giovanni-Battista Tiepolo, whom he had admired in Venice and whose sense of spectacle and lyricism appears here. After such a sketch, could one not expect to see a violent painting with vivid, contrasting colors, with sudden movements comparable to those of Jean-Baptiste Deshays or Gabriel-François Doyen?[9]

In fact, the large canvas from the Salon of 1765, which is now in the Louvre, is quite different from what the sketch leads one to expect. The composition has been lightened by the removal of several figures; the architectural setting has acquired greater importance; but, above all, the luminous part of the picture has become almost nocturnal and the range of colors has become almost monochrome, transforming the effect completely; it is as though the range of white – beige – gray of the central part of the sketch had taken over the whole painting, as though the bluish-gray smoke rising from the altars had invaded the entire canvas. Whatever remained slightly disparate in the sketch, with a rather naïve exaggeration of the melodramatic content, has disappeared and the whole composition has acquired unity and nobility. In his large painting, Fragonard clears the foreground, bringing in two steps, which raise the central group onto the stage of a theater, the two columns of which seem to be there to reduce the width of the stage. This effect echoes the large compositions painted before his departure for Rome, such as the *Washing of the Disciples' Feet*, in Grasse and, above all, the outcome of all the investigations into spatial and luminous structure that he had carried out in Italy, as seen in the *Washerwomen* and *The Launderesses*.

The painting has been seen as an imposed work, the effort of a painter going against his true nature in order to conform to academic requirements and, at the same time, as the proof of the vanity of that effort, which made him decide to abandon "grand subjects." But such an interpretation would imply starting with a preconceived idea of the painter's true personality, to misjudge his ambitions, and to miss seeing in the *Coresus* one of the finest and most innovative paintings of the eighteenth century. After *Jeroboam* and *Washing of the Disciples' Feet*, here is a third ambitious historical composition, on which Fragonard meditated more carefully and for much longer. It is, undoubtedly, a reflection of his long years of training. It is once again to his teacher, Carle Van Loo, that Fragonard appears to have looked,[10] and his painting, in many ways, reflects the whole tradition of French academic teaching based on the admiration of Raphael's large compositions; his contemporaries could surely not have failed to recognize, in the figure of Despair, or of Vengeance, which hovers over the central group, one of the avenging angels of *Heliodorus Expelled from the Temple*. But knowing this cannot account for the captivating charm of such a work, which is unique in French painting. Everything is structured by means of a masterful use of crossed oblique lines following the diagonals of the picture, but the figures appear to evolve freely; they are bent and twisted as though they are being pushed by the breeze, in a dreamy languidness. The drama is now treated without any real violence, in a sort of slowness or, rather, slow motion. In the middle stands the tragic couple, the two protagonists are opposed, back to back but turned toward each other in a final twisting movement; they are unconscious and both their heads are tilted back. Coresus, in a kind of hypnotic state, appears to be stuggling whilst experiencing a nightmare, and frees himself from his ample drapery. Diderot was the first of many commentators to criticize this figure for his asexual and rather feminine appearance; one should, on the contrary, admire the startling conception of these four young people crowned with leaves, who are, admittedly, almost androgynous and who dance around the girl being sacrificed, who is crowned with flowers, in this strange ballet of love and death. The light effect is controlled with exceptional skill, giving a changing and mobile light effect in the middle of the plumes of smoke that envelop the architecture. Pale gray moonlight, which enters from the left, almost from the back, lingers on the foreheads and cheeks of the terrified faces, strikes a column, illuminating the occasional piece of drapery and many a figure in vibrant half-light, while, in the center, the soft light of Callirhoe's spared chest is radiant; she is motionless but alive. Everything expresses the true subject of the painting with a miraculous vigor, fineness, and elegance, as though in the last act of an opera: the revelation and demonstration of love. All in all, the painting is a pathetic and despairing declaration of love: everybody hears, everybody shouts out, and the beloved remains alone in the middle, inaccessible and unconscious. We are now very far from Boucher or even from Van Loo, and at the opposite pole from Deshays and Doyen. Fragonard, the great lyrical poet, achieves, in this picutre—with its sculptural forms, but without effects of brushwork and with hardly any color, the light effect counting above all else—a frisson of terror which is, already, Neoclassical. The *Coresus* achieves a balance between the contribution of Italian painting and the new aspirations to express feeling and drama, which were being expressed by innovative artists at the time. Fragonard reveals in this painting that he is one of the great French poetic artists; it is remarkable that he was able, within what was probably a short period of time, to conceive such a painting and to paint effervescent works like *Rinaldo and Armida* and the *Women Bathing*. Already a great painter, he was able to master the means at his disposal totally, with a view to obtaining a desired result.

115 An ancient sacrifice, called *The Sacrifice to the Minotaur*. c. 1765–66. Oil on canvas, 71 × 90 cm. Private Collection (cat. no. 120)

116 An ancient sacrifice, called *The Sacrifice to the Minotaur*. c. 1765–66. Oil on canvas, 72 × 91 cm. Private Collection (cat. no. 121)

As has already been said, the painting was received with great approbation; Fragonard also painted two smaller versions of it, one in oils (in the Academia San Fernando, in Madrid), the other in brown wash (in the Pierpoint Morgan Library, in New York).[11] The absence of variants, when these works are compared with the large painting, shows that neither the painting, which has a thick texture but is rather constrainted and tautly painted, nor the drawing can be considered to be preparatory pieces, even though their quality as original works cannot be questioned. This makes them less interesting as far as the genesis of the large painting is concerned, but they remain fascinating for the study of Fragonard's working method, because they furnish indisputable proof that he took up his own paintings again in one technique or another, probably prompted by the wishes of customers and the desire to acquire commissions.

A few days after Fragonard's triumph, Charles-Nicolas Cochin asked Marigny to have the painting purchased for the king, and to commission the painter to produce a companion piece—which was what Fragonard had hoped for; both pictures could then be woven as tapestries at the Gobelins.

It seems that this pendant to the *Coresus* was at least planned by Fragonard because two painted sketches have been preserved of *An Ancient Sacrifice* (private collection), generally referred to as *The Sacrifice to the Minotaur*, the proportions of these paintings, their scale, the number of figures, and the subject make them perfectly plausible pendants to the *Coresus*. Both show a young girl surrounded by companions and by her family; she seems to be drawing a note out of an urn, in front of a tall priest and a smoking tripod. One of the pictures is barely outlined with a few twirling and bubbling strokes. The other, showing a different composition, is more detailed; as in the painting at the Salon of 1765, the figures are arranged on two levels, with a low step and a higher, raised step. The *repoussoir* figures in the foreground, are similar, as is the spotlight directed on the central figure who, with her swooning pose and her outstretched arms, would balance the figure of Coresus well. The clouds surrounding the groups, the mythological figure hovering at the top, have their equivalents in the painting in the Louvre. And yet, this shimmering and pathetic work that seems to bring together the qualities, the vivacity, and the picturesque touch of the *Rinaldo and Armida* and those of the *Coresus* (notably in the force of the luminous effect, and in the successful simplification of the structure, with some astonishing parts like that of the weeping mother lying in the foreground, with her tragic strength that anticipates Romantic painting) did not give rise to the great painting that was expected of Fragonard.

Genre Painting Influenced by Greuze

In addition to the *Landscape*, which has already been mentioned, another painting by Fragonard, now in the Hermitage in Leningrad, appeared at the Salon of 1765. Fragonard may not have decided to include it until the last possible moment because it only appears in the supplement to the catalogue under the somewhat strange title: *Children Who Want to Make a Dog Eat Fruit*. It is generally called *The Parents' Absence Turned to Account* and was engraved in 1770 by Jacques Beauvarlet under a different title, *The Farmer's Family*. It is a small genre scene, comparable in format and finish to *The Lost Forfeit*, painted in Rome for Breteuil. In a rustic interior, three young children seem to be enjoying themselves pretending to be having a meal and almost torturing two fine dogs, which seem to be used to the children's pranks; in the background, in the half-light, an older boy wants to put his arms around a young girl who vigorously pushes him away. Such a painting, which has on the whole attracted few comments, appears to be essential for it has been carefully finished with a fine light effect: a ray of sunlight strikes the figures in the middle and on the right, and is reflected on the young boy on the left, leaving the decor of the background barely visible.

But the meticulously realistic description of the various elements, the evocation of the very material these objects are made of—the game bag, the drum, the straw, the barrel, the casserole—the dogs whose forms and coats are firmly and minutely evoked, the sturdy children's faces with their clearly defined blond hair are all new to Fragonard's work and reflect quite different preoccupations from those of *Coresus and Callirhoe*. The influence of the works of Jean-Baptiste Greuze may almost certainly be seen here. The painter from Tournus, who was seven years older than Fragonard, had, of course, met the latter in Rome and his paintings, which often portray small family episodes in which children and animals frequently play a part in rustic interiors full of everyday objects that are described with the utmost care, were enjoying their greatest success during these years.[12]

A certain number of drawings that probably date from this period and show family scenes, belong to the same Greuzian context; compositions like *Visiting Grandfather* or *The Return* accumulate figures who are huddled together in true clusters. There are children everywhere and a pleasant rustic and picturesque quality predominates; loose floorboards, farming equipment, plants, and, above all, numerous animals, depicted with verve and humor, including dogs, poultry, or cats. Such drawings evoke works on similar subjects which Fragonard had produced

89

117 *The Parents' Absence Turned to Account*, or *The Farmer's Family*. Salon of 1765. Oil on canvas, 51 × 61 cm. The Hermitage, Leningrad (cat.no. 115)

61 in Italy, like *The Stable* engraved by Saint-Non in 1762; but the drawing on that sheet, which is more discursive and still closer to Boucher in the style of the figures, is quite different. Fragonard's style, perhaps through his contact with the older artist, has become more structured and coherent, articulating planes well, constructing strong and well-proportioned characters with clearly-defined facial types.[13] The way the figures are grouped tightly together within a semicircle (a feature also found in *The Parents' Absence* in the Hermitage) seems to be inspired by Greuze, who uses the technique in the *The Village Arbitrator*.

A painting that is generally considered to be much later, *A Visit to the Foster Mother* in the National Gallery of Art, Washington, D.C., may be linked to this group of works and may be dated from about 1765–66. This fine painting, which is insufficiently known, reveals exceptional daring in its artistic coherence and distinct three-dimensional

118 Family scene, called *A Visit to the Foster Mother*.
c. 1765–66(?). Oil on canvas, 73 × 92 cm. National
Gallery of Art, Washington D.C. Collection Samuel
H. Kress (cat. no. 123)

119 Family scene, called *A Visit to the Foster Mother*.
c. 1765–66(?). Pen and brown wash, 26 × 29 cm. Private
Collection

forms. The composition is established with geometric precision in a clear network of horizontals and verticals and, once again the figures are arranged in the arc of a circle, in harmony with several circular forms, straw hats, and the arch of the cradle. The strong light coming from the left falls on the figures in the middle with their light-colored clothes, and is stopped by the vertical plane of the door. The shades are almost those of a monochrome: whites, luminously golden, straw-colored, and creamy tones, and grays, with yellows and the faded red of the woman's dress as the only colors.

There are many analogies that can be drawn with the *Coresus,* in the organization of the picture, the light effect, the color range, and the *Visit to the Foster Mother* almost appears to be its equivalent in the domain of genre painting. The face of the father is, in fact, similar to those of the two assistants of Coresus, on each side of the central group, and the treatment of the lamp and drapery on the window ledge, in the Washington painting, evoke those of the vase and drapery in the *Coresus* in Madrid.

Like *Coresus and Callirhoe,* this work also reveals the care Fragonard took to refer to glorious examples in the academic tradition. The Washington painting, with its characters arranged in a pyramid within a shallow space, is arranged like a *Holy Family* by Poussin, with the presence of a nurse-Elizabeth, and of children-cherubs.[14] Without losing any of his qualities of charm and humor, which are transparent in the evocation of the baby, the nurse, the young children, and the cat under the cradle, Fragonard reveals here a wholly intellectual concern for legibility by laying out a well-organized canvas. This extremely stable, square picture, with its horizontals and its verticals, and the use of triangles within which the figures are inscribed, is in direct contrast to paintings on a similar subject, like *The Cradle* in Amiens, which was probably painted several years earlier. That picture is baroque in spirit, full of violence and brilliance. The *Visit to the Foster Mother* contains another innovation: the protagonists are a man and a woman, young adults, and no longer the plump young people in late adolescence who had appeared in his earlier works. They no longer belong to the pastoral world of Boucher or to the rustic Italian scenes but to contemporary urban life: they are city dwellers who have come to the home of the nurse or foster mother, in the country, to admire their offspring.[15]

The Salon of 1767

Critics have often wondered why Fragonard turned away from the obvious course that seemed to be open to him, to

become an academician by presenting a second piece to gain admittance, and to obtain official commissions and exhibit regularly at the Salon. On May 3, 1766, the academicians met to decide which works were to be assigned to Fragonard and Durameau; each was given one of the ceilings of the Galerie d'Apollon, at the Louvre, to decorate. They were to complete the decor portraying the four *Seasons,* which had been left unfinished by Charles Le Brun. Louis Durameau would not present his work, *Summer* or *Ceres and Her Companions Imploring the Sun,* until 1774, and Fragonard seems to have given up, early on, any idea of painting the work he had been entrusted with, the subject of which is not known. Jean-Hugues Taraval had, for his part, painted his acceptance piece more quickly, as he became an academician as early as 1769 with *Autumn* or *The Triumph of Bacchus and Ariadne.* Fragonard may have been given either the subject of *Winter*–which Jean-Jacques Lagreńee was subsequently asked to paint *(Eola Unleashing the Winds)* in 1775 – or of *Spring*–for which Antoine-François Callet was received into the academy in 1780 with *Zephyr and Flora Crowning Cybela with Flowers.* There is nothing to suggest that Fragonard ever began working on the project; one can only mention a sketch for a ceiling on the theme of Dawn, now in a collection in Buenos Aires, which may date from these years and whose ambitious and sumptuous character, in the grand manner, may give some idea of the artist's project.[16]

Another project that was never realized was the plan to give Fragonard two overdoors to paint for the gaming room of the Château de Bellevue, which belonged to *Mesdames,* the daughters of Louis XV. In July 1766, Cochin had suggested that Marigny should entrust Fragonard with this project. It seems that the projected pictures, on the theme of Day and Night, were never painted.

In the summer of 1767, Fragonard exhibited for the last time at the Salon of the Académie, but he only exhibited two paintings and a few drawings. Nothing is known about these drawings. According to the catalogue of the Salon, the painting represented "*Groups of Children in the Sky,* an oval painting which comes from M. Bergeret's exhibition room"; it almost certainly came to the Louvre with the Péreire bequest, and is known as *The Swarm of Cherubs.* It may have been a project for a ceiling, as Diderot assumed in his commentary on the Salon.[17] In the painting in the Louvre, small, naked children, who are comically tangled up, form clusters or garlands, almost complet-

120 Group of children in the sky, called *The Swarm of Cherubs.* 1767 or slightly earlier. Oil on canvas, 65 × 56 cm. The Louvre, Paris (cat.no. 144)

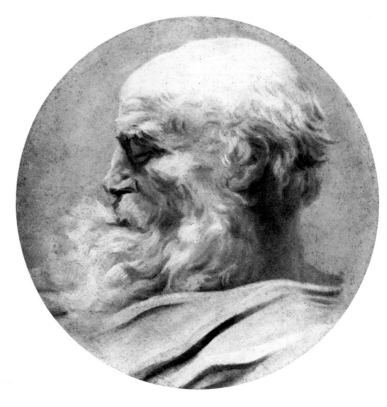

121 *Head of an Old Man in Profile*. Salon of 1767(?). Oil on canvas, diam. 21 cm. Ball State University Art Gallery, Muncie, Indiana. On permanent loan from the Collection E. Arthur Ball, Ball Brothers Foundation, 1951 (cat.no. 145)

122 *Head of an Old Man in Profile*. Salon of 1767(?). Oil on canvas, diam. 37 cm. Private Collection, Paris (cat.no. 146)

ely filling a cloudy sky, in which they are finding it rather difficult to fly away. A picturesque and contrasting light leaves whole groups in the shade as though other clouds were moving in front of the sun and intervening, creating a vivid and animated effect of spring light. Apart from the Boucher-like cupids, this exquisite work is an extremely humorous commentary on the *Virgin of the Holy Innocents*, by Rubens (Louvre), which was then in the royal collection; but Diderot was not pleased with Fragonard's picture, if the painting that is now in the Louvre really was the work exhibited at the Salon. The writer's comments are well-known, witty, and inadequate: "a fine, large omelette of children; there are hundreds of them, with their heads, thighs, legs, bodies, and arms interlinked in a particularly skillful way. But there is no strength, no color, no depth, no difference of level... it is flat, yellowish, with unvarying, monotonous colors, and is painted hazily... Monsieur Fragonard, it is awfully dull. A fine, really soft omelette, quite yellow and not burnt." Further on he includes the following phrase of total disdain: "an apeing of Boucher."

Diderot comments more concisely but just as disdainfully on the other painting exhibited by Fragonard in

1767, a "Head of an Old Man, a round picture," according to the catalogue of the Salon, which he considers "weak and yellow." This picture may well be the *Head of an Old Man in Profile* that is at the Ball State University Art Gallery in Muncie, Indiana. But a very similar, larger work, in a private collection in Paris, might just as easily have been the work exhibited in 1767.

These are, possibly, the earliest studies of heads by Fragonard, painted from life, that have been preserved. The fact that he painted two works that are as close as this shows how greatly he enjoyed painting them. Seeing these simple studies of volumes in light, firmly structured and almost severe, one is reminded of Van Loo and, more especially, of Restout. Paintings such as these, which are still within the academic tradition, provide us with important data on the artist's chronology since they date, in all probability, from 1766 or 1767 and they prove that even at the time when he was producing his most effervescent sketches, Fragonard was able to concentrate on a careful study of a model. Nevertheless, one cannot totally exclude the possibility that these works may date from a few years before this time and that Fragonard exhibited at the Salon an old study which he considered to be success-

ful. One can understand why the critics were disappointed: "the public was expecting to see a more significant painting from the author of Callirhoe," noted a critic of the *Mercure de France*, and Louis Bachaumont asked in his *Mémoires Secrets*: "Why has Monsieur Fragonard, on whom such high hopes were based at the last Salon, suddenly stopped still...?" Diderot had still not calmed down: "Monsieur Fragonard, when one has made a name for oneself, one should have a little more self-respect."[18]

In point of fact, we do not know what had happened. According to the critic of the *Mercure de France*, Fragonard had had two large paintings removed from the Salon before it was opened—"out of consideration for other people." Georges Wildenstein supposes that they had amorous subjects.[19] Fragonard's independence of mind may have played a major part in this decision to give up an academic career, but financial necessity must have been a factor too. The administration was very late in paying for his *Coresus* and did not fully settle the payment until 1773.

The success he had already enjoyed amongst artlovers must have been more influential than a hypothetical and sudden distaste for "grand subjects." And it would probably be wrong to assume that there could have been a sudden change in the subjects chosen by Fragonard or in the manner in which he was painting at the time. But it has to be recognized that he tackled, in these five or six years following his stay in Italy, a whole range of subjects and of styles which is almost disconcerting; it also means that it is very difficult to establish a reliable chronology. There are hardly any stylistic links between the large sketch for the *Coresus*, in Angers, the paintings of *Rinaldo*, and the landscapes in the Dutch style. The painter displayed an unusual passion for experimenting, yet he may also have been expressing doubt and hesitancy by this tremendous variety, truly unsure of which style he should develop. Whatever the case may be, he was, without reserve, willing to try his hand at the entire range of what is possible in the realm of painting.[20]

Chapter V
1767–73 Paris
The Successful Easel Painter

The Swing and Other Light Subjects

Fragonard did not exhibit any more works at the Salon. One painting has remained a symbol of the new and sudden direction that he had taken by deciding to devote himself to the painting of small works on erotic subjects, destined for a wealthy clientele. That painting is *The Swing* or *The Happy Hazards of the Swing*, in the Wallace Collection, London, which has become one of the brand images of eighteenth-century French painting. Charles Collé writes in his *Mémoires* of how Doyen, who had just exhibited his enormous *Miracle des Ardents*, painted for the church of Saint-Roch, at the Salon of 1767, was asked by the Baron de Saint-Julien, a minister in the French clergy, to paint a saucy picture. The artlover said to Doyen, pointing to his mistress: "I would like you to paint Madame on a swing, being pushed by a bishop. You will position me in such a way that I will be able to see the legs of this beautiful child, and even more of her if your wish to enliven your picture..."[1] Doyen refused drily and suggested that Fragonard be approached with a commission of this kind.

The Swing does in fact have a slightly different subject from that described by Collé, as the old man pushing the swing appears to be the father or possibly the aged husband of the young woman, and the youth hidden in the bushes could not have been a portrait of Saint-Julien. Several painters, including Watteau and Nicolas Lancret, had treated this theme before Fragonard, though in a less explicitly erotic manner. It would be pointless to contest the glorious reputation of the small painting in the Wallace Collection, which is rather overloaded with intentions: the cupid calling for silence, the lady's gesture of complicity—her shoe, which has, perhaps intentionally, been abandoned to provide an excuse for making a search

in the bushes, where she can meet her admirer—as well as the yelping dog. It is difficult not to see in it a kind of vignette, with its wealth of illustrative elements: fashionable costumes, decorative statues, gardening tools, and that neat and, for once, uniform and slightly dry execution, which perhaps contradicts the panache of the movement of the composition. But there is also the almost irritating crackling, the bee-like buzzing of all those tiny leaves, and the astonishing appearance, in a bluish light, of this excessively pretty porcelain doll who is thrown back, as though on a bed, with her hitched-up frills and flounces flying like pink butterflies. Around her, all the elements of the picture turn as though in an oval garland, and the lively movement of her legs is taken up in an echo by the zigzagging branches toward the top and on the left of the picture. It is a bizarre and complex picture, a small allegory of provocation, which is not at all in keeping with tastes in the late twentieth century and which has been trivialized by countless copies and appalling adaptations, but its strained and almost crystalized appearance, this momentary immobilization, which could not be more fleeting, in the torment of desire, is itself the purpose of this fussy but unforgettable painting.

The fact that this picture can be precisely dated from 1767 is especially important, even if its detailed technique puts it into rather a special category. But one should give up the generally held idea that Fragonard abandoned his career as a history painter overnight to concentrate on the naughty scenes that he painted for a select clientele. Such amorous or erotic subjects were by no means exclusive to Fragonard and he seems to have treated them quite early on in his career.

The possibility that several of Fragonard's paintings on deliberately erotic subjects date from before *The Swing*

123 *The Kiss.* c. 1766–68. Oil on canvas, 52 × 65 cm. Private Collection, Paris (cat. no. 128)

124 *The Bed with Cupids.* c. 1765–70(?). Pen, brown wash, and watercolor over black chalk underdrawing, 45.7 × 30.4 cm. Musée des Beaux-Arts et d'Archéologie, Besançon

should definitely not be ruled out. The flowing and loose style and the soft blending of the colors in works like *The Kiss* (private collection) or *The Longed-for Moment* might suggest a date somewhere around 1763–65. In the two versions of *The Longed-for Moment* (private collections), the way the female forms are composed, delicately articulating round and plump volumes, clearly evokes Boucher's figures, and the pink and turquoise shades of the color-range recall paintings produced by Fragonard before 1756. A small picture like the famous *All in a Blaze*, which came to the Louvre with the Beistegui bequest, may be contemporary with the two *Rinaldo and Armidas*. Here again the sturdy and rather short proportions recall Boucher and the transparent golden browns, painted in scumbles, are juxtaposed with blue-green shadows, giving an almost excessively fiery contrast.[2] Such paintings are very different from the affected concern for minutiae of *The Swing*, and express a real sensuality; there is a feverish sensuality and an insistant sauciness in *All in a Blaze*, which overshadows the innocent gaiety of the rapid brushstrokes; it is an ardent sensuality that is still overflowing with childish joy in *The Kiss*, where the light and curving forms coil up lovingly in an oval format. Fragonard's world is immodest but because of the youthfulness of the lovers it represents, it is not indecent. In *The Longed-for Moment*, an image of the joy of love, Fragonard achieves a pure lyricism. The painter speaks to each of us here in a moving, intense, and elegant way. It is a marvel of spontaneity and fervor, a poem containing nothing that is vulgar, and there is a grace in the whirling and in the giddiness of this couple. But in spite of the spontaneity of the painter's brush caressing the canvas, everything is organized as in a history painting and the large, sinuous rhythms respond to each other and are arranged in accordance with the directions of the diagonals of the picture. The fact that there are two versions of the painting, which are almost identical and of a similar format, proves that such a success must have been applauded, that Fragonard enjoyed painting it, and that it could only have been painted in a sketchy style.

125 *The Happy Hazards of the Swing*, also called *The Swing*. 1767. Oil on canvas, 83 × 65 cm. Wallace Collection, London (cat. no. 147)

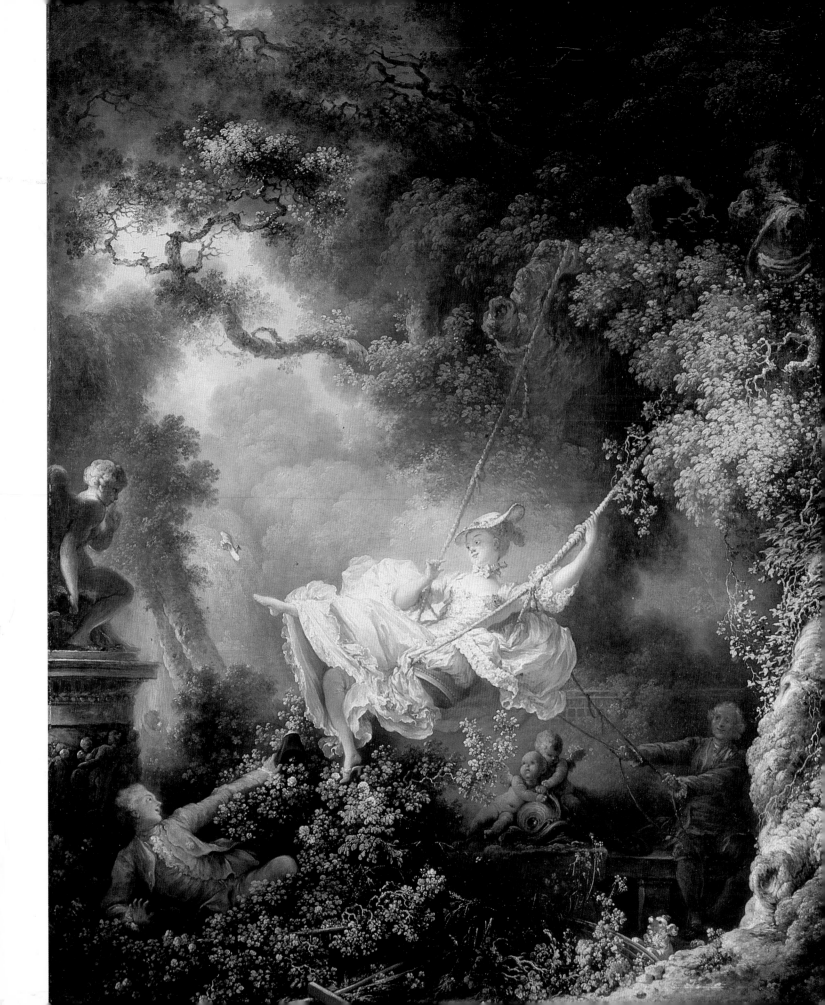

126 *The Little Swing.*
c. 1768–70. Oil on canvas,
50 × 68.5 cm. Private
Collection, Paris (cat. no. 192)

Fragonard had become a sought-after painter; he had pupils[3] and was well off; he settled down and, in 1769, he was married. His bride, Marie-Anne Gérard, who was fourteen years younger than he, was the daughter of a perfume-seller in Grasse and it is certain that the two families knew each other well. The wedding took place in the country, in the church of Saint-Lambert de Vaugirard, on June 17, 1769.[4] Not long afterwards, on December 9, their daughter Henriette-Rosalie was born.[5] The family's financial position must have been good because the painter was collecting art; in February 1771, at the posthumous sale of the works of his teacher Boucher, who had died in May of the previous year, Fragonard bought several works.[6]

The Landscapes

During these years, Fragonard probably pursued his activities as a landscape painter in the style of Ruisdael. But, at the same time, he was developing quite a different style, derived from *Views of Italian Parks*, views of gardens with workshops, statues, and arbors, enlivened with walkers or lovers. In 1767 the landscape of *The Swing* gave a glimpse

of this more unrealistic and capricious style, and drawings like the *View of a Park* in the Allen Memorial Art Museum of Oberlin College, Ohio,[7] which seems to date from the end of the 1760s, or the *Draftsman* in the Metropolitan Museum of Art, New York,[8] which is slightly later and possibly a study for a decorative panel, look forward to *The Pursuit of Love* at Louveciennes, whose exuberant and proliferating landscapes are an inheritance from Boucher rather than from the Dutch artists. As will be seen, the landscapes in Louveciennes, particularly the *The Lover Crowned*, make admirable use of effects of contre-jour and of border-lighting, bringing about a brilliant lace-effect at the fleecy tops of the tall trees. But such effects of shade and of iridescence were used repeatedly by Fragonard throughout the 1760s and already appear in the *Armida* paintings. The justly admired *The Fête at Rambouillet* whose title is only traditional and which is in the Fundação Calouste Gulbenkian in Lisbon, is generally considered to be a late work, painted between 1775 and 1782. In fact, this very full, multiple, and complex composition, with its vegetation in unfurling clusters, its sparkling, detailed, and varied technique, and its emerald and golden colors, with the vibrant addition of pink and purple shades, tends to suggest, instead, that the picture was painted about 1768–70; one should add that there is nothing in the cos-

127 Fête in a park, called *The Fête at Rambouillet*. c. 1768–70. Oil on canvas, 72 × 91 cm. Fundação Calouste Gulbenkian, Lisbon (cat. no. 193)

tumes, some of which are perceptibly Spanish in style, to justify a dating from about 1780. Such a painting should be placed between the *Waterfalls at Tivoli* and the panels of Louveciennes. The dead tree, whose jagged lines run nervously across the picture removing any weakness from the masses of plants that move like seaweed on the oceanbed, was apparently inspired by Chinese art. It is found, with many different variations, in the paintings of the 1760s; compared with it, the trees in *The Fête at Saint-Cloud* appear lifeless. This festive atmosphere is not very different from the *Figures de Fantaisie*, with this dim light of a stormy summer evening and the feeling of something that is temporary; elation suddenly gives way to anguish, the torrent becomes frightening, the tree's claw-like form threatening, and the statues, at the back of the park, become dangerous, making *The Fête at Rambouillet* one of the most richly poetic paintings of the century.[9]

128 Rembrandt (1606–1669). *Portrait of Saskia*, also called *In a Fanciful Costume*, 1638(?). Oil on panel, 98 × 70 cm. Private Collection, Switzerland

129 Jean-Baptiste Santerre (1658–1717). *Portrait of a Young Woman*. Engraving by Chateau, 1708

Figures de Fantaisie: Models and Subjects

The *Figures de Fantaisie* are among the most popular of Fragonard's works. Dazzling, powerful, and, one might even say, full of humor, they have the added attraction of the mystery which surrounds them. Fourteen pictures, which are dispersed among various museums and different private collections (eight of these works being in the Louvre), but with the same dimensions, all show a man or a woman in half-length portraits and dressed in what were known as Spanish costumes. Their expressions are generally lively, their eyes turned away; they look as if they have been frozen in the middle of an action, their bodies twisted and animated by a violent movement.

30-44;
169-82

It may be useful to draw up a list of them. The Louvre has the portraits presumed to be of the Abbé de Saint-Non, sometimes called simply *Imaginary Figure*; and of his brother, La Bretèche, known as *Music*; of the *Man Writing*, generally titled *Inspiration*; a young woman in Spanish costume, called either *Study* or *The Song*; a man in Spanish costume, called *Portrait of a Young Artist*; and the portraits of Diderot, Mademoiselle Guimard, and the Duke de Beuvron. The portrait of the Duke d'Harcourt as well as two more figures in Spanish costumes called *The Comedian* and *The Singer* are in private collections. Three other portraits that belong to this group are found in the United States. The Metropolitan Museum of Art has *Portrait of a*

Woman in Spanish Costume Holding a Dog; *The Warrior*, a portrait of a man in Spanish costume, is at the Sterling and Francine Clark Art Institute in Williamstown, Mass; and finally *The Reader*, also dressed in Spanish costume, is at the National Gallery of Art in Washington, D.C. The portrait of a man in Spanish costume, often considered to be a portrait of the astronomer Joseph-Jérôme Lalande, in the Petit Palais in Paris, may be regarded as a fifteenth *Figure de Fantaisie*, but its different format and style set it apart from the others.

22
Ca

The more interesting question, since it concerns the artist's creativity, is whether he wanted these various paintings to be associated and, if so, in what way. It would be just as interesting to determine what significance was attributed to them by him and by the people who commissioned them. In order to answer that question the identity of the models portrayed in them needs to be considered. One may also ask whether all these pictures were painted at the same time or whether they were spread out over several months or several years. First of all, it appears obvious that they really are portraits. In spite of the extreme speed with which they were painted, which

130 *Portrait of Mademoiselle Guimard*. c. 1768–69. Oil on canvas, 81.5 × 65 cm. The Louvre, Paris (cat.no. 171)

131 Portrait of a man in Spanish costume, called *Portrait of a Young Artist* (the author J.-A. Naigeon?). c. 1770. Oil on canvas, 81.5 × 65 cm. The Louvre, Paris (cat. no. 178)

132 *Portrait of Diderot.* c. 1769. Oil on canvas, 81.5 × 65 cm. The Louvre, Paris (cat. no. 174)

might suggest that they were fantasies born of the imagination, all the signs are that these works were painted *del vivo*, after models, or that is at least how most of them appear to have been painted. However, in the case of the female portraits, the hands may have been done from memory. Who were these models, and what were the connections, if any, between them?

It may well be that the three lady musicians or readers, in a private collection, in the Louvre, and in Washington, D.C., must remain three ravishing strangers, and that the *Portrait of a Woman Holding a Dog*, in New York, will retain the mystery of her round eyes, her full cheeks, and her cherry-red mouth. But the fifth lady, in the Louvre, is almost certainly Mademoiselle Guimard, the famous dan-

cer who was the talk of the town at the time; "La Guimard" was known for the disordered aspects of her private life as much as for the graceful character of her dancing. But the objects placed in front of her are perplexing as is her gesture, which seems to require that the picture be linked to another one, placed to the left of it, featuring another character who would make the overall idea explicit. What is "La Guimard" doing? She seems, with one hand, to be catching hold of a small piece of paper (a letter, a miniature, or a playing card), that is being slipped to her and, with the other, to be crumpling some sheets of paper. On the shelf, too sketchy to be identified, lie two medallions or a single medallion and its cover, in which Charles Sterling believes he can see "two shells containing

Cat. 171

133 *Portrait of the Duke d'Harcourt*. c. 1770. Oil on canvas, 80 × 65 cm. Private Collection, Switzerland (cat.no. 176)

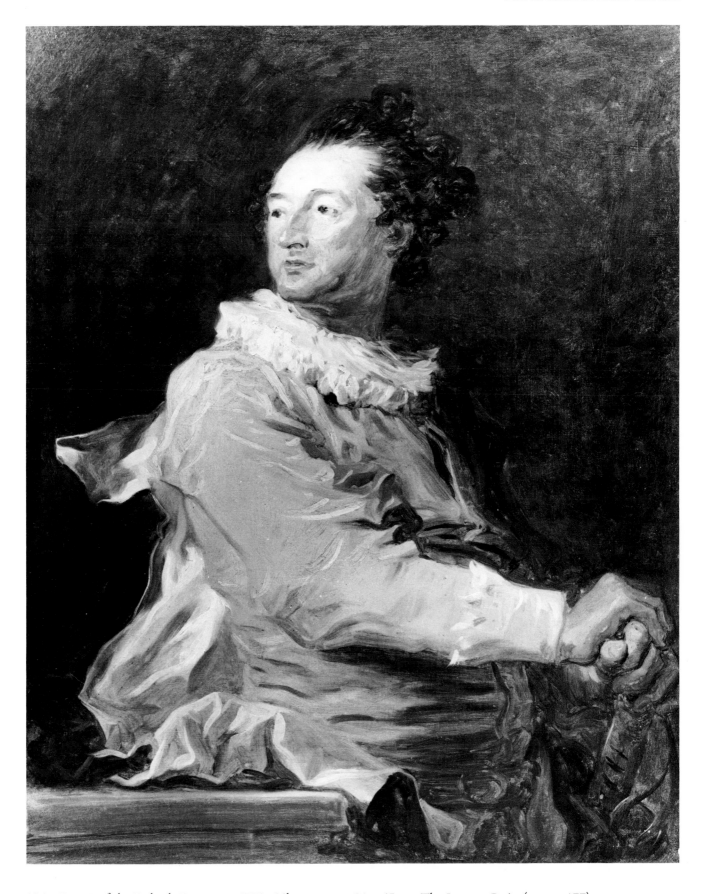

134 *Portrait of the Duke de Beuvron.* c. 1770. Oil on canvas, 81 × 65 cm. The Louvre, Paris, (cat.no. 177)

135 Portrait of a young woman in Spanish costume, called *The Singer*. c. 1770–72. Oil on canvas, 81 × 65 cm. Private Collection (cat.no. 181)

136 Portrait of a man in Spanish costume, called *The Comedian*. c. 1770–72. Oil on canvas, 80 × 65 cm. Private Collection (cat. no. 180)

the kinds of pigments used by miniaturists,"[10] which leads him to conclude that "La Guimard" is being portrayed as a painter, and to identify the picture as a possible allegory of painting. This all seems quite conjectural and "La Guimard" may have requested a very specific portrayal related to a given event in her life that only she and a few intimate acquaintances were in a position to understand and about which we know nothing.

Some of the male models retain their anonymity. It would take the luck of finding another perfectly faithful and positively identified portrait before names could be given to the persons portrayed in *The Comedian, The Warrior*, or *Inspiration*. It has sometimes been thought that the last of these might represent Saint-Non, an idea invalidated by a comparison with the identified portrait that there is of him; the face is larger, and the color of the hair different. The model of another picture, *Artist*, which came to the Louvre with the Beistegui Collection, is quite

hypothetical. It cannot have been the painter from Dijon, Jean Naigeon (1754–1832), as was long supposed to be the case, because he did not come to Paris until 1780 and would only have been about fifteen years old at the assumed, and probable, date at which the picture was painted. The suggestion that the model be identified as Jacques-André Naigeon (1738–1810), a writer and philosopher friend of Diderot's, is more plausible; the Naigeon family who owned the painting, being ashamed of having as one of its members a freethinker who openly professed atheism, would thus have preferred to forget the portrait's true identity. If this is the case, then the object the young man is holding, generally thought to be a portfolio of drawings, may be an ordinary portfolio; it must also be said that there is no paintbrush or pencil-box in the picture that would identify the man as a painter. Another male model can be identified with certainty. The portrait that has been in the Louvre since 1972 is now universally

131;
Cat. 178

137 *Man Writing*, also called *Inspiration*. c. 1767–68. Oil on canvas, 80.5 × 64.5 cm. The Louvre, Paris (cat. no. 169)

recognized as being that of Diderot. It is slightly surprising to find the eminent philosopher among this company of grand gentlemen who are enjoying themselves and of ladies who may be women of easy virtue. Diderot had commented critically on Fragonard's contributions to the Salons of 1765 and 1767, yet had welcomed the artist's drawings for the illustrations of the *Encyclopédie*.[11] His portrait is not the finest of the *Figures de Fantaisie*. His fingers appear strangely contorted and parts of the painting appear a trifle weak. And why is his hand raised? Is it placed on the collar or is it getting ready to receive an object (possibly a letter) that is being held out to him? The face is splendidly vivid, even though, in his haste, Frago-

nard has given Diderot blue eyes when they should have been brown. We know that the philosopher knew Mademoiselle Guimard. In his correspondence with Sophie Volland, Diderot made several allusions to the dancer in November 1768 when writing about a mysterious dinner and he even seems to have known her quite well. He makes the following comments about her which are free of any illusion or antipathy toward her: "How do I come to know La Guimard? Well, there have always been a hundred ways and, at my age, there are a hundred reasons for knowing La Guimard. One finds that such girls have so many essential resources that one cannot hope to find in a respectable woman, not counting the fact that one can

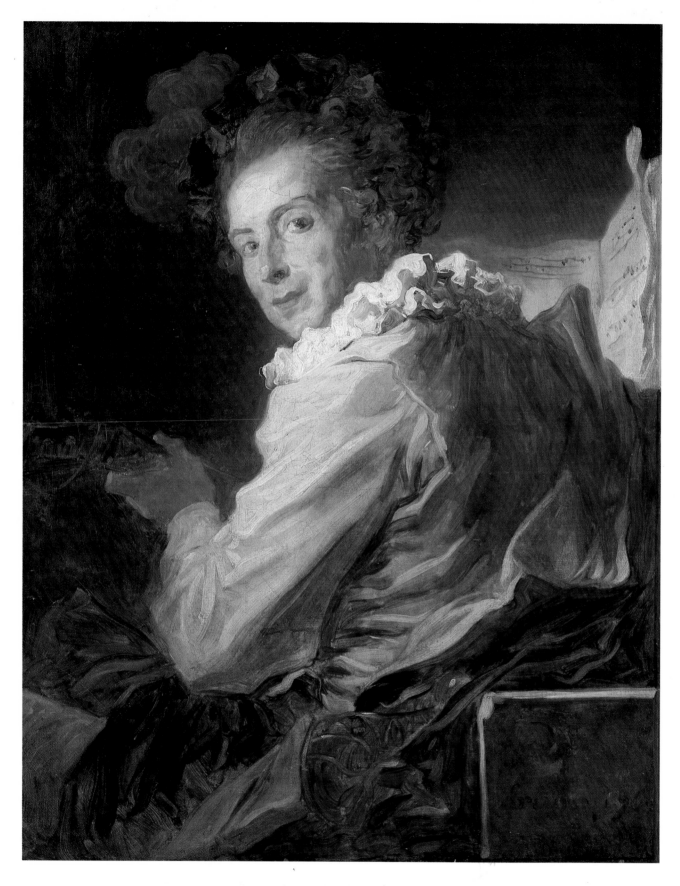

138 Presumed portrait of La Bretèche, called *Music*. 1769. Oil on canvas, 80 × 65 cm. The Louvre, Paris (cat. no. 172)

139 Presumed portrait of the Abbé de Saint-Non, sometimes called *Imaginary Figure*, 1769(?). Oil on canvas, 80 × 65 cm.
The Louvre, Paris (cat.no. 173)

140 Portrait of a young woman in Spanish costume, called *Study* or *The Song*. c. 1769. Oil on canvas, 81.5 × 65.5 cm. The Louvre, Paris (cat.no. 170)

141 Alexis Grimou
(1678–1733).
Young Girl Reading,
also called *The
Studious Young Girl.*
c. 1720–30. Oil on
canvas, 84 × 70 cm.
Private Collection

behave exactly as one likes when one is with them; one can be good without feeling vanity or bad without feeling shame."[12] Be that as it may, the two "fantasy portraits" of the philosopher and of the dancer do not seem to be directly related because they are not looking at each other.

In a few cases identifications are as certain as the links between pictures. The two portraits of the *Duke d'Harcourt* and of the *Duke de Beuvron* provide fascinating information as the pair has only recently been separated and the pictures are undoubtedly portraits of the two aristocrats, François-Henri, Duke d'Harcourt (1726–1802), Governor of Normandy, and his younger brother, Anne-François d'Harcourt, the Duke de Beuvron (1727–1797). Both are portrayed in flattering poses, probably not without a degree of irony, in their bright costumes; the elder of the brothers has one hand by his side while the other one plays with a gold chain; his brother is leaning with both hands on the handle of his sword. Some attention should be paid to these swords, which also appear in other pictures in this group; they are enormous rapiers with open hilts which seem to date from the sixteenth century and must have provoked a few smiles at the time when Fragonard painted them. According to a family account, Fragonard had painted six portraits during a feast held at the Château d'Harcourt in the Calvados. But apart from these two family portraits, the other pictures remain unknown, if indeed, they have survived. There is, in the d'Harcourt park, a pavillion called the "Fantasy Pavillion," which evokes the name traditionally given to these portraits, the *Figures de Fantaisie*;[13] but it will become clear further on that there are other explanations for this name. Were these portraits, then, mementos of feasts that had a whiff of scandal about them? At any rate, the soberly framed

Harcourt portraits were not hung in the same gallery of the château in which the family portraits were displayed.

The models of two other paintings in the Louvre can be identified with virtual certainty from old labels that they had on the back; they portray the Abbé de Saint-Non, a friend of Fragonard's whom we have already encountered on his walks around Rome with the painter in 1760–61, and his brother, La Bretèche. They appear, originally, to have been pendants but it is not known whether they were part of a larger series. One cannot tell whether the Harcourts could also have been part of the same series. La Bretèche, seen from the back, is playing the guitar and is turning toward us with a smile. Saint-Non, with one hand bare and relaxed, is looking over to one side. A third pair may be formed with reasonable certainty, namely, two paintings that have remained in private hands, the portraits of unknown persons traditionally called *A Comedian* and *A Singer*. The latter seems to have appeared by itself at the Roettiers sale in 1778, but it re-appeared with its present pendant a little later, in 1794, at the Godefroy sale. These two paintings may have formed part of a larger series and they may not have been meant to be juxtaposed. One cannot tell what may link the other pictures. Does the young man who is writing, known as *Inspiration* and *The Song*, also known as *Study*, both of which came to the Louvre with the La Caze Collection at the same time as the *Saint-Non* and the *La Bretèche*, form part of the same group as the other pictures? It is not even clear whether La Caze bought them together. The fortunes of the other pictures appear to have been completely separate. The *Woman Holding a Dog*, in the Metropolitan Museum of Art, was by itself when it appeared in a sale in 1779, if that really was this picture, just as *The Reader* was a single picture at the Count du Barry's sale in 1776. All the others appeared in the middle of the nineteenth century or much later. A reconstitution of the groups can only be based on a comparison of the bodies, of the direction of the figure's gaze, and on the relations between the colors. Georges Wildenstein's suggested (cited by Charles Sterling who considers this plausible but remains cautious) considering *The Warrior* and *La Bretèche*, on the one hand, and *Saint-Non* and *A Comedian*, on the other, as four overdoors, commissioned by Saint-Non in 1769.[14] Such reconstitutions are as appealing as they are debatable.

The assembled company thus consists of aristocrats, a famous writer, an artlover, a demi-mondaine, unidentified persons of various ages, a few ravishing young women, a chubby lady, and her little dog.

The grouping together of the *Figures de Fantaisie* in pairs or in series remains largely hypothetical. Were there two main series, as Sterling suggests, one painted for the Harcourt brothers, the other for Saint-Non? Some of the pic-

143 Portrait of a young woman in Spanish costume, called *The Reader*. c. 1770–72. Oil on canvas, 82 × 65 cm. National Gallery of Art, Washington, D.C., Gift of Mrs. Mellon Bruce in memory of her father Andrew W. Mellon (cat. no. 179)

◁ 142 Portrait of a man in Spanish costume, called *The Warrior*. c. 1769–70. Oil on canvas, 81.5 × 64.5 cm. Sterling and Francine Clark Art Institute, Williamstown, Mass. (cat. no. 175)

tures might simply form pendants, or may even be independent works. The difficulty in grouping the pictures necessitates caution with regard to any iconographic interpretation. Was there an overall intention or several different intentions to make each of these pictures say something specific, to make it the representation of an art, an occupation, or a craft? Sterling groups the female figures together, seeing the young girl in the Louvre who is generally referred to as *Study*, as a representation of *Poetry*, *Mademoiselle Guimard* as *Painting*, and *The Singer* naturally, as *Music*.[15] But the first of these, with her harpsichord in the background, would seem, instead, to be a singer or a musician, holding a score and, perhaps, beating time; and we have seen that the objects placed before "La Guimard" have been the subject of debate. If these really are allegories of the Arts, one would have to say that they are not very obvious ones. Among the male figures, *La Bretèche*, in the Louvre, might represent *Music, Man Writing*, known as *Inspiration* could be *Poetry*, and the *Young Artist* from the Beistegui Collection could be *Painting*; and one could, again according to Sterling, juxtapose *The Warrior* in Williamstown and the *Diderot* in the Louvre as representations of Active Life and Contemplative Life.

But would that not be going too far? It is more likely that the *Figures de Fantaisie* are occasional works, entertaining works of a private nature, destined for small groups of people who were able to appreciate their wit; some of them may be works that allude to minor intrigues. The key, if there is one, lies rather in the association of male and female figures and the theme, if there is one, must quite simply be, once again, the theme of love. The *Inspiration* may just as easily be *The Love Letter*, and the musical subjects that appear in three of the pictures are the conventional equivalent of the amorous dialogue. They might, therefore, be couples who are neither legitimate nor, possibly, very long-lasting.

The Spanish costumes in which the models are dressed stem from the same idea and are commonly associated with amorous subjects. With regard to the *Spanish Conversation* exhibited by Carle Van Loo at the Salon of 1755, it is believed to have been Madame Geoffrin (who commissioned the picture and its pendant, the *Spanish Reading* from the Salon of 1761), rather than Madame de Pompadour, as has been proposed, who suggested to Van Loo that he use seventeenth-century Spanish costumes; these costumes assured both works of a great success because of their curiosity value.[16] His nephew and contemporary

144 *Portrait of a Woman in Spanish Costume Holding a Dog.* c. 1770–72. Oil on canvas, 81.3 × 65.4 cm. The Metropolitan Museum of Art, New York. Fletcher Fund, 1937 (cat.no. 182)

Louis-Michel Van Loo in turn painted several pictures on similar subjects, a *Spanish Concert* in 1768 (the Hermitage, Leningrad) and *A German Lady Playing the Harp* in 1769 (private collection), both of which show clearly identifiable models in Spanish costumes, evoked with great richness of detail, at precisely the time when Fragonard was painting *La Bretèche*.[17]

It was pointed out long ago that the only thing that is Spanish about such costumes is their name and that they were really inspired by French costumes from the age of Henry IV and Louis XIII; the Gallery of Marie de Medici, by Rubens, in the Palais du Luxembourg, appears to have been one of the main sources of inspiration for these costumes. It seems that Madame Geoffrin, if she really was the person responsible, only revived a fashion by suggesting the use of "Spanish" costumes to Van Loo; many examples of it can be found early in the century, in the works of Alexis Grimou.[18]

How can the hypothesis that amorous exchanges were intended be maintained? *The Comedian* and *The Singer* would thus continue their dialogue, but is it really the *Man Writing*, in the Louvre, who turns toward the indifferent *Reader*, in Washington? Or should it not rather be the *Young Artist*, in the Louvre, a picture that is painted in a more appropriate, freer, and lighter technique, who is eyeing her? And at whom is *The Warrior* aiming his gaze? Is it at the *Woman Holding a Dog* in New York? Should one see in these two pictures images of the old fogey and the duenna, as in the theater? It cannot be ruled out that such amusing confrontations were intended, perhaps mocking the models without their knowledge. It seems obvious that we are in a world of entertainment where the exaltation of the liberal arts is not the painter's main concern. The hypothesis of a libertine context does, at least, correspond to the tradition associated with the portraits of the Harcourt brothers, to what Diderot's correspondence suggests about him, and, of course, to "La Guimard's" reputation for free-and-easy morals. It would also account for the presence of the very young and pretty girls in *Study* and *A Singer*, or especially in *The Reader* who, seen from this angle, would seem to fit especially well beside the other *Figures de Fantaisie*, as its dimensions, its framing, and the Spanish costume would suggest. The fact that the character is, for once, shown in profile, absorbed by her reading of a little novel, and that her arm is resting on a rail, with, on the right, the corner of a wall that is needed to support the cushion, is not sufficient to doubt the assimilation. Other paintings in the series also include elements that suggest a space behind the figure, the music book in *La Bretèche*, or the harpsichord in *Study*. This indifferent girl is a coquette who knows that she is being watched and one expects to see, facing her, a pendant portraying an admirer.

143, Cat. 17*

These paintings might thus recall fancy-dress parties or pleasure parties. It is difficult to tell and such hypotheses may themselves be too fanciful. Nevertheless, even if it cannot be ruled out that there were series of more than two paintings, it is difficult to imagine the *Figures de Fantaisie* being painted to form overdoors, as has been suggested, because of the *da sotto* view of the models; it would be difficult to account for the rectangular format and one could hardly explain why Fragonard has represented the narrow table on which several of the characters are leaning as seen from above and not in the correct perspective; nor would one understand why the light always comes from the left if these pictures were to be hung on different walls of a single room.

Moreover, this table, shown in the foreground, is by no means the rule, and it only appears when it is required by the model's pose, for example, if he or she is leaning on it or if objects (a music book or a piece of drapery) are resting on it. In other cases, a stone block can appear in the foreground, in a corner of the canvas, to support the composition and bear the artist's signature. In *Inspiration*, in the Louvre, the narrow table is replaced by a real table, with an inkstand on it, and by the armrest of an armchair, on which one of the model's hands has been placed. *Diderot* also has his books on the table like the *Young Artist*; the *Woman Holding a Dog*, in New York, lifts the animal with both hands and has no need for a table; the *Reader* is leaning on a horizontal bar that evokes a windowsill. In fact, the parapet in the *Saint-Non*, in the Louvre, originally only covered half of the width of the canvas, in order to support his hat; it appears in the lower left portion of the work and, in the excitement of painting, was extended so that the hand could be placed on it, a fact which seems totally to exclude any preconceived idea of a similar presentation for the whole series of paintings, or even for most of them. The artistic necessity of firmly anchoring the composition of such frenzied and diverse paintings can explain the frequent, if not obligatory, presence of the parapet, a procedure that had been standard among portrait painters since the fifteenth century and which continued to be common in later centuries.

Another argument leads to dividing up the paintings into several groups or pairs, and even to spacing them out in time; it is the similarity in the manner of presentation of several of the male characters, shown with their heads thrown back and looking over their shoulders. If the portraits were exhibited as an ensemble, these effects, which are included in several of them, would have appeared repetitive. One can more easily imagine Fragonard using them at different times for different clients wanting portraits that were similar to those they already admired.

The fact remains that the almost total similarity of the formats of these paintings is astonishing and can scarcely be accounted for. The painter may have wished to keep to a format that had been popular and to a frame size that had already become standardized in the art trade.[19]

The *Figures de Fantaisie* in the History of Art

The *Figures de Fantaisie* are truly dazzling and defy analysis. They have perhaps been misjudged because of this. The labels that two of the most famous ones, *Saint-Non* and *La Bretèche*, used to bear, assert that they were painted "in an hour's time." This may be true but it made such a deep impression on the commentators that they saw the paintings simply as *tours de force*, as exercises in pictorial acrobatics, and they were led to view the artist who painted them as simply a virtuoso of speed. The Goncourt brothers conclude with some well-known and irresistible phrases, speaking of "furious sweeping" and of the "jumble by a man who is possessed and inspired."[20] But Fragonard's impulsiveness was only apparent and his fury was carefully calculated: dabs that are thrown down and deliberately quite visible are an artistic means that is clearly used to convey excitement and panache, but especially to construct shapes and forms, and to make them turn in space in a particular way.

One should look again at the portrait of *La Bretèche*, who appears massive and scintillating in his great swirling movement, in that twisting motion that would whisk him away if the figure were not firmly anchored by the illuminated horizontal and vertical edges of the stone cube on the lower right side. The picture is made up entirely of corners and thrusts and is painted with a brush that has a kind of electric yet caressing touch. The folds of clothing are unfurled in drawn out or emphatic touches that leap up or are tied in bundles, the thickening-out of the fluffy collarets is achieved in little white waves. But the firm and square volumes are established between the vibrant half-light and the glare of the full light by means of a quite extraordinary knowledge of chiaroscuro, ricochets of reflections, and mobile half-tones of infinite complexity and richness that are controlled because of the power of the perfectly appropriate light that strikes the shoulder, the collaret, and the face, standing out, on the left, against the dark background, breaking up like a wave and sweeping across the rest of the canvas. The full and massive volumes seem to be partly hollow, between the edges of

light that are represented by means of longitudinal brush-strokes which are broken or cursive. These hard volumes, defined by soft lines, seem to be about to lose their shape, to be dented; they almost seem to defy all logic and the character seems to be almost a caricature, so powerful and acute is the analysis. Drawing and painting are unified, the brushwork says it all; the whole canvas comes alive with this drawing that is turning into a painting. There is not a single square inch that is not vivid, where the strokes do not run, sizzle, bounce, or rest and introduce a muted vibrato. Is this a sign of facility or of an off-the-cuff manner of painting? In fact, it reveals a perfectly mastered knowledge of painting, and shows a perfect body, seized in the apparent excitement of a single moment.

Saint-Non is at once similar yet also very different. It is more affectionate and possibly less subtle in its construction, which appears to have been torn apart. It is, at any rate, an unforgettable portrait of Fragonard's friend, seen as though facing the wind, like a navigator in the prow of his ship. Here the *da sotto* view is a pretext for a magnificent and almost incredible distortion of the face; the angle of the jaw is exaggerated, making the cheekbone jut out further back, making the forehead look bumpy, and raising the locks of his hair. The touch, even more rapid than that of *La Bretèche*, becomes resonant, in brighter shades of blue, yellow, and red; and yet it produces a vibration in the whole picture, because of the brown scumbles at the back, the shadows, and the hair, which allow the clear base of the preparation to stand out unevenly, giving the entire picture transparency and lightness. The folds of clothing, of the coat, roll diagonally in a kind of torrent toward the right, as if they are being carried away by a violent wind; but the hair is moving in the opposite direction, and the white feathers of the hat, on the narrow table, are lying still. The movement is only apparent and the result of this gust of wind is a tremendous sense of balance; with this massive neck that is as solid as a column, and these forms that are treated in terms of large planes, the figure appears like a sculpture that is made up of enormous streaks of light and shade. We see here a kind of final outcome, or perhaps a caricature, of the whole tradition of European portraiture since the Renaissance, with the large and extremely stable triangle of the bust, the shoulders seen in perspective, the hands joined and leaning on the table, one arm bringing forward a sleeve that is carefully evoked, and the face turning toward the onlooker.

The light, fragmented, and vibrant touch of *La Bretèche*, where the almost transparent paint sometimes barely covers the surface of the canvas, re-appears in the *Young Woman* in the Louvre, often called *Study*, with a comparably soft and luminous range of yellows, dark browns, and greenish-grays, highlighted with red accents. But the round face is shaped firmly, in the style of Rubens, in blended shades. The sudden movements of the male characters have been replaced by this complex pose, marked by a twisting movement, which nevertheless has an exquisite and supple grace, like that of a light and trembling dancer who is bowing with her arms outstretched. The virtuosity of the technique used in this picture, with effects of repetition imprinted in the fresh paint with the handle of the brush, as seen in the jewels, is found again in the *Portrait of Mademoiselle Guimard*, with a creamier touch that is occasionally smoother and more emphatic, for example, in the face; it is marvelously free and transparent in the dress where, in a feast of pure painting, a mahogany tone is blended with the reds and the greens in a technique that appears to come directly from Rembrandt. The movement, which once again makes the character pivot around herself, is more tense and angular than in the previous picture, but it is lively and full of elegance: what we are seeing, this time, is a professional dancer.

It is again Rembrandt who may be evoked in the case of the *Diderot*, in the Louvre. The presence of a certain heaviness or weakness is disturbing in a picture that is not one of the best of the *Figures de Fantaisie*. But a certain casualness predominates here and it does not really matter if the forearm that is drawn up in front of the chest appears rather long or if the fingers of the hand are strangely limp and contorted. What is most important here is that the fine harmony of red, black, and yellow should resonate, that the white of the collar should respond to that of the open book, and that the pages of that book should quiver in harmony with the crumpled fabrics. The mark of Rembrandt appears here even more intensely than in the other paintings of the series; the black coat, against which a gold chain stands out, evokes several *Self-Portraits* by the master from Amsterdam; the large, open book with the light playing on its pages, which are exaggeratedly enlarged at the edges, recalls the *St. Matthew* in the Louvre, as do the picture's dramatic power and luminous effect, and the quality of the vibrant gray in the background. *The Warrior*, in Williamstown, is more like *Saint-Non*, with rounder and more supple forms that practically shimmer, a less broken style, and a kind of dappled treatment of certain parts, particularly the background and the face. Its realistic and anxious expression, which is by no means a caricature, introduces quite a different feeling. One would have to analyze each painting indefinitely, and examine each of these dynamic constructions, each of these sparkling and subtle color ranges where the yellows turn green or take on the mottled effects of ripe plums, where the reds shine out in the light or well up in the shadows, where the precious blues assume a luster of satin, and one sees so many flaming or faded colors, without a single

dissonance that has not been calculated, without a single element of vulgarity.

Only one of the *Figures de Fantaisie* bears a date: *La Bretèche*, in the Louvre, where one can read, on the stone block that serves as a support for the character's back: *frago 1769*. This date is usually given to the whole series of paintings, and the hypothesis remains logical considering the close links in style that exist between them. One can see, in the context of such a problem, how important it is to decide whether or not the paintings constitute a single series or several different series, or whether they should be grouped in pairs, or considered separately. A second minor piece of information, which may facilitate the dating of these works, is the fact that, in the fall of 1768, Diderot undoubtedly knew Mademoiselle Guimard. In his letters to Sophie Volland, he alludes several times to a meeting in Pantin, at the home of the dancer. But one cannot, of course, state conclusively from this evidence that the portraits of the dancer and of the writer were part of the same series or that they date from 1768.

137; Cat. 169

It is not inconceivable that the paintings were painted over a period of several years, between 1767 and 1772. One of the *Figures de Fantaisie* appears to be earlier than the others, the Louvre's *Inspiration*, whose mood and technique are noticeably different. A technique of building up forms in full paste defines clearly legible volumes; the character appears massive in his crouched position, as if he were ready to leap up (with his sanguine face, his cheeks and nose blazing), and is carefully constructed and shaped; his expression is almost brutal, with that powerful neck that shoots up from the open collaret, and those strong, solid hands. Warm colors predominate in the whole picture: yellow, orange, and red contrasting with a harsh white and jet black. In the other *Figures de Fantaisie*, everything seems to be lighter, more nervous, and fleeting; the canvas is covered to a lesser extent, the brush is less heavily loaded and more alert. Here, the power of the luminous contrast, the fullness of the volumes, as well as the fine contrast of red-black and white-brown, evoke a work like the *Young Girl Holding a Letter* (private collection), which

Cat. 91

appears to date from the years following Fragonard's return from Italy. *Inspiration*, which was possibly painted about 1767, may be the first of the *Figures de Fantaisie* to have been preserved.

Other paintings might date from a few years after *La Bretèche*. This may be true of *The Singer*, who is a little cold and sophisticated, and of *The Comedian*, painted with that marvelous jagged technique, with those mobile and flowing touches that blend the rarest tonalities like reflections on water. It may also be true of *The Reader*, where the technique appears more economical, especially in the background, and whose overall effect looks more simpli-

35, 136; Cat. 180, 181

143; Cat. 179

145 Attributed to Alexis Grimou (1678–1733). *Portrait of a Woman*. 1720–30 Oil on canvas, 38 × 32 cm. The Hermitage, Leningrad

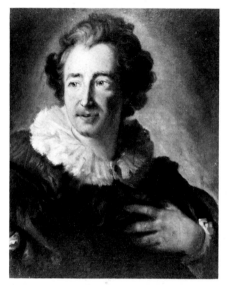

146 Attributed to Alexis Grimou (1678–1733). *Portrait of a Man*. 1720–30. Oil on canvas. Musée des Beaux-Arts, Angers

147 Alexis Grimou (1678–1733). *The Spaniard*. Engraving by Flipart

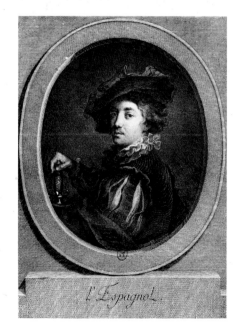

148 *Portrait of a Young ▷ Woman in Spanish Costume*. c. 1770(?). Oil on canvas, 62.9 × 52.7 cm. Dulwich Picture Gallery, London (cat. no. 184 a)

fied than that of the other works in the series. In the present writer's opinion, a much later date should be given to the *Portrait of a Man*, in the Petit Palais, where quite a different technique is used and which seems to have been painted after Fragonard's second journey to Italy, a fact that would prove the lasting success of the formula. But Fragonard's versatility and his appetite for every kind of experience must, naturally, be taken into account; the *Figures de Fantaisie* appear to have been used by him as an experimental ground on which he could try out all the effects that the *fa presto* would allow. He probably modified his technique depending on the model, on the time available, on the mood he was in at the time, and it would be imprudent to attempt to classify the paintings in time.

One almost hesitates, when faced with such appealing works, expressing such good humor, and which appear to have been painted so spontaneously, to look for their antecedents. And yet, one must try to understand and to realize that behind this brilliance there lay a great deal of culture. There are, first of all, many analogies here with the presentation of half-length portraits in the Italian Renaissance, especially those of the Venetians, where the parapet often recurs in the foreground, occasionally jutting right out; an example of this would be the *Portrait of a Man*, known as *Ariosto*, by Titian, in the National Gallery in London. Sebastiano del Piombo often gives his figures violent oblique movements and has a liking for changes of axis and twisting movements; *The Man in Armor* (Wadsworth Atheneum, Hartford, Conn.) or the *Francesco Arsilli* (private collection, Senigallia), are extremely interesting to compare with the *La Bretèche*.[21] The formula and the mood—sometimes also the treatment—of Fragonard's paintings evoke certain figures painted in Rome in the 1620s, by French artists like Simon Vouet or Claude Vignon. Portraits by these earlier artists are hardly any more serious, and they sometimes use costumes that are just as fanciful and vague, and poses that are just as animated and casual, painted with a similar *furia*, with a splendid disregard for the finished effect. As with Fragonard, attempts have been made to see various types of character in such works (*The Assassin, The Musician, The Singer*), when they are quite obviously portraits of friends or of fellow artists, and they still radiate the sympathy that the painter had for them.[22]

But it was Dutch painting of the seventeenth century, and especially the art of Rembrandt, that had the greatest influence on the *Figures de Fantaisie* and their "Venetian" quality may also be derived from the Dutch Master; one may note the arrangement of the *Self-Portrait* of 1640, in the National Gallery in London, which is so close to some of Fragonard's works, with the arm leaning on the parapet. The luminosity of the paintings, the way that volumes are constructed in the light, frequently recalls Rembrandt, who has already been mentioned with regard to the *Diderot* and the "La Guimard." One can only concur with Charles Sterling in the parallels he establishes between Fragonard's technique and that of the painters who were active in Venice, like Domenico Fetti, but, although Sterling is right when he says that the all too frequently cited analogy with Franz Hals is merely superficial, the link with Rembrandt is fundamental and the latter's influence is almost a paternal one. Some of Rembrandt's paintings, such as *Self-Portrait With a Plumed Hat*, in Berlin-Dahlem (c. 1633),[23] whose contours are so freely drawn, in rapid and thickened strokes, with its greenish shades, contrasting with the luminous reddish-browns, the transparency in its shadows, and the imprints made in the fresh paint with the handle of the brush, seem to have had a deeper influence on Fragonard than the Italian artists he once imitated. Fragonard may well have seen some of Rembrandt's portraits dating from 1636–38, with their extravagant costumes, such as the *Standard-Bearer* (private collection, Paris), the *Man in Polish Costume* (National Gallery of Art, Washington D.C.), or the *Portrait of Saskia*, known, precisely as *In a Fanciful Costume* (private collection, Switzerland).[24]

It may seem bizarre to stress the link between such obviously carefree paintings that were painted in an hour, and Rembrandt's meditative art. But it was the early Rembrandt who impressed Fragonard, the happy and cheerful Rembrandt of the 1630s. One cannot deny the existence of the link between the *Figures de Fantaisie* and the Baroque art of Rome, Venice, and Genoa. But the antecedents of such paintings appear to come from Northern Europe rather than Italy, and the dialogues between one painting and another recall, above all, certain masterpieces of the Dutch painters who liked to paint a husband and wife as if they were conversing from one picture to another; we can see this in Hals's *Stephanus Geraerdts*, offering a rose to *Isabella Coymans*, or in Rembrandt's *Unidentified Couple* of 1633, in the Kunsthistorisches Museum in Vienna.[25]

Fragonard certainly had the opportunity to study the paintings of Rembrandt in Parisian collections. But, between 1765–70, he seems to have paid particular attention to the French painter Alexis Grimou (1678–1733), who is, unfortunately, not very highly regarded today. Grimou's entire œuvre owes such a considerable debt to Rembrandt that he has often been called "the French Rembrandt." He specialized in "character figures," studies of character types from life, portrayed with a subtle sense of chiaroscuro, often of young women or of young men, dressed in fanciful costumes and emerging from a dark background. The debt Fragonard owed to Grimou appears to have been very

221; Cat. 279

great, especially as far as the *Figures de Fantaisie* are concern-
ed, even if Grimou's relief is softer and more blended,
and his colors more often restricted to a range of browns.
One must inevitably cite works like the *Bust of a Man*
holding a sword, engraved by Charles-François Flipart
under the title *The Spaniard* or the *Young Girl Reading*
(private collection), her forearm leaning on a narrow table,
which was engraved by Gerard René Levillain in 1768
under the title *The Studious Girl*; this last picture has a
truly pre-Fragonardesque charm and anticipates his *Study*
and his *Reader*.[26] The *Portrait of a Man* in Angers, with his
collaret, his hand held across his chest, and his ruffled hair,
already seems to be a *Figure de Fantaisie*. Is it surprising that
several *Studies of Heads* which really seem to be the work
of Grimou (for example, a *Head of a Laughing Man* in the
H. Frick Museum, Pittsburgh, curiously known as *Portrait
of a Woman Called Fragonard's Cook*, and a *Head of a Woman*
in the Hermitage), have been attributed to Fragonard. On
the other hand, it was possible for a striking painting, the
Portrait of a Young Woman in Spanish Costume in the Dulwich
Picture Gallery, near London, to be attributed to Fragon-
ard, by Pierre Rosenberg, in spite of the fact that it bears
Grimou's signature. It is a fascinating document, demon-
strating Fragonard's admiration for Grimou and also, sure-
ly, the latter's influence on the elaboration of Fragonard's
figures in the Spanish style. It is a homage to the painter,
but also a wink to the artlovers of the time, because the
signature could not be considered to reflect a wish to
deceive. Fragonard painted it in a technique that was more
blended and softer than usual, doing a pastiche of Grimou
but deliberately giving the game away by giving full rein
to the ardor of his brushwork. He must have enjoyed
painting this funny little woman, giving her the propor-
tions of a young girl, signing his name and then covering
up his signature and replacing it with that of Grimou.

What are the *Figures de Fantaisie*? They may be seen as
images of entertainment, filled with panache, as images of
the easy life, or as snaphots of happiness. They may also be
seen as tragic or derisory masks, rather like those of
Daumier or James Ensor, of actors in the social comedy,
jesters of illusion, the human wrecks of pleasure, whose
heads would soon roll, as a final feast before the Revolu-
tion. And how can one ignore the fact that the "Spanish
costume," with its plumed hat, ruff, slashed coat, and large
sword, was precisely the costume given to the aristocrats in
popular prints of 1789 showing the three "estates" of
French society?[27] But such paintings are, first and fore-
most, a feast of painting and a lively summary of Western
painting, in the insolent mass of dabs of color that frame a
space, and are not simply superficial strokes. They are
revolutionary paintings because of their paradoxical na-
ture; these so-called "fantasy" portraits mark the return to

149 Portrait of a man, called *Don Quixote*. c. 1770. Oil on canvas,
80.5 × 64.7 cm. The Art Institute of Chicago. Gift of Mr. and
Mrs. Leigh B. Block (cat. no. 184)

French painting, after a period that fluctuated between
coldness and insipidness, of an enthusiastic and direct
study of reality, which is hardly refined at all, in the radiant
waves of a bright light. A kind of seismic disturbance, an
extremely salutory eruption of nobility of spirit, has occur-
red here. And these figures from a masquerade appear less
dressed-up than so many contemporary portraits: there are
no more wigs; there is no more powder; the complexions
are suntanned; the necks are full; wrists become tense;
color rises to their cheeks with a flush of life.

Other Portraits: Between Reality
and Fantasy

The *Figures de Fantaisie* really should be seen as portraits.
They were obviously painted from real life and owe their

151 Rembrandt (1606–1669). Seated figure, called *An Actor*. Pen and brown wash, 18.3 × 15.2 cm. Rijksmuseum, Amsterdam

against a bright background, with a sinuous outline and a more lateral direction of light, which comes almost from the back, strikes the face, and harshly shows up its bony contours. Once again, how can one avoid evoking the art of sculpture? And the scumbles of the bright background are further enlivened by all the articulations, the outlines that order the silhouette like a ground swell. This is almost a caricature and the slightly aggressive severity of the result is almost disturbing. Is this really a Don Quixote? Rather than a commissioned portrait, this may be a character study after a studio model, which could be compared to the studies of old men of the kind that are in Nice, Amiens, and in the Musée Jacquemart-André, in Paris. The hat worn by the man in Chicago is very much like that seen in the Musée Jacquemart-André's picture, and one wonders what could possibly be Spanish about his costume. The painting in Chicago is much more evocative of Italian examples, and Charles Sterling rightly compares it to the *Portrait of an Actor* by Domenico Fetti, which is now in the Hermitage, and which Fragonard could have seen in the Crozat Collection in Paris.

One should also mention, in connection with the *Figures de Fantaisie*, a painting in a larger format which is in the Museo de Arte Moderno in Barcelona; it shows a full-length portrait of a man who is seated and is holding the halter of his horse, which is seen drinking behind him; with his other hand, the man is leaning on a large saber. It is generally called *The Abbé de Saint-Non in Spanish Costume*. The movement of the upper part of the body, of the arms, of the head that is thrown back, the *da sotto* angle of vision, and the Spanish costume all clearly evoke the *Figures de Fantaisie*. But the background of the sky and the picturesque setting introduce some totally new elements. The exaggerated characterization of the figure, which is present in the *Figures de Fantaisie*, is taken further here, as is shown by the extravagant hat, its red rosette, and its tall feather, the huge cutlass, and the nag in the background.[28]

Are we to imagine that the painting was conceived in relation to a pendant, and that there was once a blue rider or even an elegant young lady, who was shown in an indignant pose? The picture is clearly the first draft of a painting; it was painted on impulse and some corrections or changes of mind can be distinguished in it. The catalogue of the Varanchan sale of 1777 calls it a "freely painted sketch." It is a marvel of vivid construction, within a large diamond-shaped frame, with that balancing movement of the arm and of the large saber, in a glare of reds and with the resonant black of the hat and cape. One could compare it with the most coruscating Italians, Fetti, Castiglione, and Tiepolo. But there is also the influence of Rembrandt in this work—an echo of the plumed hat and of the derisory tone of the *Standard-Bearer*.

immediacy and startling intensity to this direct confrontation with the model. Certain paintings are so close to the *Figures de Fantaisie* that they have often been included among their number; the half-length portrait of a man, called *Don Quixote*, in the Art Institute of Chicago, was painted on a canvas of the same dimensions as these works, in a heroic, slightly mocking vein, with a similarly intense, sweeping technique. But the framing is very different and puts the accent on the face alone and not on the movement of the upper part of the body and of the arms; and the motionless model is looking out at us, which changes everything. The luminous part of the picture is quite different; we see a dark silhouette standing out

◁ 150 A gallant in Spanish costume, called *The Abbé de Saint-Non in Spanish Costume*. c. 1769. Oil on canvas, 94 × 74 cm. Museo de Arte Moderno, Barcelona (cat.no. 183)

◁ 152 Portrait of a young man holding a gun, called *Portrait of Honoré-Léopold-Germain Maubert.* c. 1768–70. Oil on canvas, 65 × 56 cm. Private Collection (cat. no. 188)

Setting aside the famous series of the *Figures de Fantaisie,* what can be said about Fragonard's activities as a portrait-ist in this period? Such an undertaking is difficult because this appealing and casual painter naturally wished to avoid the fixed patterns of portraiture as it was practiced in his own time. A portrait of a young man holding a gun (private collection), which has not attracted sufficient attention, has been considered one of Fragonard's last works. Painted in 1790, during the painter's stay in Grasse at the home of his cousin, Alexandre Maubert, it shows the latter's son, Honoré-Léopold-Germain, at the age of fifteen. In spite of the weight of tradition and the paint-ing's provenance (from the painter's family), it seems impossible to give this painting such a late date and it should, instead, be situated about 1768–70, at a time close to the *Figures de Fantaisie.* The presentation of the parapet on which the character is leaning in the foreground, the treatment of the forms by means of simplified and clearly-articulated planes, and the handling of the brush in long, sustained dabs support this view. The luminous effect, the colors, combining soft greens and reddish-brown and gol-den shades, evoke certain *Figures de Fantaisie,* such as "La Guimard." The contours of the face, which are both soft and smooth, with luminous thickened areas which make the prominent parts of the face shine and which make the bridge of the nose sparkle, are particularly close.[29]

Several female portraits may also be dated from the same period (1767–73), during which Fragonard was enjoying his greatest success among an aristocratic clien-tele. Some verge on naughtiness, like *The Dark Girl* in the Fogg Art Museum in Cambridge, Mass.; as in the *Figures de Fantaisie,* the strong diagonal movement suggests an arrested movement that was set down immediately in round and bouncing rhythms. It is a picture that is impu-dent but not at all vulgar, in the force of the contrast be-tween the white of the shirt, the black of the scarf, of the hair, of the eyebrows, of the pupils of the eyes, with its pearly and cold tonalities in the light, and more golden

153 *Bust of a Young Girl,* also called *The Dark Girl.* c. 1770–72. Oil on canvas, 47 × 39.4 cm. Fogg Art Museum, Cambridge, Mass. (cat. no. 219)

154 *Bust of a Young Girl,* also called *Adeline Colombe.* c. 1770–72. Oil on canvas, 60 × 50 cm. Private Collection (cat. no. 218)

155

156

155 *The Two Sisters.* 1770 (? or c. 1772?). Oil on canvas, 71.3 × 55.9 cm. The Metropolitan Museum of Art, New York. Gift of Julia A. Berwind, 1953 (cat. no. 195)

156 *The Girl with the Ring Biscuits.* c. 1772. Oil on canvas, 37 × 45 cm. Private Collection, Paris (cat. no. 252)

157 *Bust of a Smiling Woman,* c. 1770–72. Oil on canvas, 40 × 31 cm. Private Collection (cat. no. 211)

▷

158 *Portrait of a Lady as a Vestal Virgin,* also called *The Présidente Aubry.* c. 1770–72. Oil on canvas, 80 × 63 cm. Private Collection, U.S.A. (cat. no. 210)

159 *Old Man Reading*, also called *St. Jerome*, or *The Philosopher Reading*. c. 1766–68. Oil on canvas, 59 × 72 cm. Kunsthalle, Hamburg (cat.no. 163)

and warmer ones in the shade, brightened up by the red accents of the lips and of the ribbon, that "pink and black" gem. Another oval portrait of a young girl, in a private collection, presents similar characteristics of life, freshness, and dynamism, in the simplicity of a dress in the antique style. This portrait reflects a new taste that is quite different from that of Nattier's actors, who were dressed up as mythological characters.

154; Cat. 218

Yet another female portrait, which should be directly linked to the *Figures de Fantaisie*, is the best example of the fashion for Antiquity that flourished during these years; it can be compared by its theme to the oval *Portrait of a Lady as a Vestal Virgin*, exhibited by Louis-Michel Van Loo at the Salon of 1769 (Musée Calvet, Avignon). Little is known about this painting of *The Présidente Aubry* (private collection), shown as a Vestal Virgin, burning incense on an altar. The almost monochrome appearance of the painting, with its magnificent opposition of reddish-browns and amber tones in the half-light and the white with pearly nuances in the full light, allow one to appreciate, perhaps more fully than ever before, the energy and the variety of Fragonard's brushwork, of the translucent

15 Ca

scumbles with waves of long dabs that run, bend, rebel, and break up with the ease of calligraphy and the power of a storm.

Other portraits, which may have been commissions of a different sort, are totally different from the *Figures de Fantaisie*, in their framing and in their technique, but might be dated from about 1770–73. *The Two Sisters*, in the Metropolitan Museum of Art, was unfortunately cut quite some time ago, and was thus distorted. Fortunately, a copy of it by the Abbé de Saint-Non, which is also at the Met, reconstitutes the whole picture and also provides a date, 1770, which is almost certainly that of the original. The two girls are definitely not representations of Marguerite Gérard, who did not arrive in Paris until 1775, and Rosalie, Fragonard's daughter, who was born in December 1769. The picture shows two girls, one of whom is only three or four years older than the other, caught up in the game they are playing; the older one is pushing the wooden horse on which her little sister is sitting. It is a striking painting because of the brilliance of its shades of bright yellow and pink, and because of the power of a light that makes the busts and dresses of the two young girls stand out, leaving the rest of the picture in a flickering half-light of bluish-green and orangey shades. The brisk but careful technique seems to indicate that the work was a commission; but who are these two young girls who have such fine toys, a horse decorated with ribbons and a large Punchinello, who are wearing Polish-style dresses and are wearing their hair pinned up in the latest fashion, and who are portrayed within this luxurious decor of columns and pillars? In this picture, Fragonard is, to a certain extent, reviving the genre of portraits of children with toys, which had been common in the work of such artists as François-Hubert Drouais, by involving the figures in an activity that gives them life and spontaneity. It is an attempt which is, admittedly, only partly successful, in spite of the charming faces, especially the gentle and mischievous face of the younger sister, which is very close to that of one of the girls shown fleeing in *The Pursuit* in the Louveciennes series.

The picture of another little girl might be a portrait. In *The Girl With the Ring Biscuits* (private collection, Paris), whose style is also close to that of the Louveciennes panels (the flowers on the left are treated in a very similar way), the figure is clothed in a simple little white dress with a white ribbon holding up her powdered hair, probably indicating the new fashions in the Greek manner; the chairs, however, are quite rocaille in style. The picture is treated in a colder light, which is gently silvery, with a magnificent opposition of black and white, and with a daring degree of refinement, considering the childish subject, appearing next to the pinks, turquoises, and yellows

that Fragonard was so fond of. The gesture, directed toward the right, the attentive and amused expression of the girl's face might lead one to assume that the work once had a pendant, perhaps the picture of a little boy, of which all trace has been lost.[30]

The Old Men: Between North and South

It seems that studies of old men, shown in large or small busts, and sometimes only as heads, were favorite subjects of Fragonard at the time when he was painting the *Figures de Fantaisie* and possibly over a longer period of time. We have already encountered, in the Salon of 1767, a circular *Head of an Old Man*, shown in profile. There is no doubt that his work as a history painter, during the painting of the *Coresus* and in the years that followed, gave him the idea of isolating "noble old men," of the same type as the high priests or certain other characters featured in his vast painting. A work like the oval *Old Man Reading*, in the Kunsthalle in Hamburg, is of course very close, in its clearly articulated lines and effervescent touch, to the most rapid of the *Figures de Fantaisie*, and should be dated, like

160 *Head of a Bearded Man.* c. 1768(?). Oil on canvas, 47 × 37 cm. Private Collection, U.S.A. (cat.no. 168)

161

them, from about 1768–70; but the choice of lighting, striking the character from the back, and of colors, restricted to pale and almost dull shades, clearly recall those of the frightened old men who loom up on the extreme left of the *Coresus*. The tone here is that of history painting, and the subject could be a philosopher or a St. Jerome.

160;
Cat. 168

Another *Old Man* (private collection), his head thrown back, which was painted with an even more energetic and sweeping technique, might also be the face of a philosopher. The movement of the head, the arrangement, and the light bear such a striking resemblance to the *Figures de*

161 *Bust of an Old Man Wearing a Cap.* c. 1769. Oil on canvas, 53 × 42 cm. Musée Jacquemart-André, Paris (cat. no. 166)

162 Rembrandt (1606–1669). *Bust of an Old Man.* 1632. Oil on canvas, 66.5 × 51 cm. Fogg Art Museum, Cambridge, Mass.

163 Giovanni Battista Tiepolo (1696–1770). *Bust of an Oriental Man.* c. 1755. Oil on canvas, 38 × 30 cm. Fine Arts Gallery, San Diego

▷

164 *Bust of an Old Man.* c. 1769. Oil on canvas, 61 × 49 cm. Musée des Beaux-Arts (Jules Chéret), Nice (cat. no. 167)

Fantaisie that one wonders whether it is not the fragment of a picture showing the bust of a character, busy reading or writing at a table covered with books. The mass of dabs, each of which defines a plane and situates it precisely in terms of light, does indeed appear to be interrupted here by the present edges of the canvas, and would be more fully developed in a larger format. As in the picture that has just been discussed, it is the reference to Italian prototypes, especially from Bologna, which appears striking in the *Head of an Old Man*, in the Musée des Beaux-Arts in Amiens; this picture is often described as *St. Peter*, and the reference it contains to the *Heads of the Apostles* by Guido Reni appears blatant, in its fluent use of rapid dabs and full paste, moulding the volumes by means of a light that comes, once again, from the back.

Cat. 165

The most theatrical of these portraits is *Bust of an Old Man Wearing a Cap*, found in Paris, at the Musée Jacquemart-André; the strange apparel of the hat and large collar trimmed with gold braid and a jewel in the collar evokes the Venetian Masters and one thinks of the paintings representing busts of old oriental men painted by Giovanni Battista Tiepolo in the 1750s, examples of which Fragonard could have seen during his stay in Venice in 1761.[31] The intensity of the expression, with the jaws clenched, the defiant mouth, and anxious backward glance, situate him within a world that is not unrelated to the *Figures de Fantaisie*, but which is more dramatic and tense. This old man's expression is that of an actor, in oriental drama, and is hardly a study of facial expression any more; it belongs to a register that is quite different from that of the heads in Hamburg and Amiens.

161;
Cat. 166

163

But, with Fragonard's Old Men, one senses that Rembrandt is never far away. A profound understanding of Rembrandt's art is revealed in a large study of a *Head of an Old Man* (private collection, U.S.A.), which is freely and tastefully sketched in oils on paper. It would seem that this picture, rather than being a quick sketch painted after a painting by Rembrandt or by one of his pupils, which has since been lost, is a truly phenomenal pastiche that achieves the right balance of light and half-tones, which Fragonard was proud to sign.[32]

164

One of the most moving of these works, *Bust of An Old Man* in the Musée des Beaux-Arts in Nice, shows a man who is completely still and remarkably serious-looking; but it contains a true frenzy of comma-like dabs, which twirl jerkily and whose chaos of oranges, pale yellows, and scarlets, contrasting with turquoises and harsh whites, form an amazing colored fabric. The brightness of the side-light is the only thing that gives consistance and firmness to the volumes, which are shaken about as if they were being stirred by small, irresistable wavelets. As can be seen in Chaïm Soutine's work, the magnificence of the medium with the splendors of the paste and of color establishes a strange contrast with the subject; the old man, at death's door, is immobilized in the quivering of a blaze of flowers. Is this pure painting? Is the model merely a pretext? Fragonard paints with such exuberance that the man's age only appears more distressing beside it.

There were many such pictures. There were at least nine other Old Men or Philosophers by Fragonard, which were mentioned in sales during his life-time, some of which were "in the style" or "in the manner" of Rembrandt. They were certainly not merely exercises in virtuosity but were genuinely representative of the taste for Dutch painting that was then coming into fashion. Chardin's pastel of an *Old Man* of 1777 (private collection, Florida), or the one painted by Wille (1777, Musée des Beaux-Arts, Angers), not to mention the works of provincial artists like Jean-Jacques de Boissieu or Jacques Gamelin, are other examples of this genre that flourished in the late eighteenth century.

There is, in Fragonard's Old Men, a kind of meeting of two currents, that of the "noble old men" in the style of Guercino or Guido Reni, of which Natoire and Vien had produced significant derivations, and that of Rembrandt, which tended to have a greater influence on Fragonard's art. In fact, these casual, rapid sketches constitute a dazzling synthesis of the whole of the visual culture of the painters of the period. In their timeless dress, these characters, who are on the very edge of life, attain a paradise in painting where Bologna, Venice, and Amsterdam are joyfully reconciled.

Chapter VI
1767–73 Paris
The Successful Decor Painter

Commissions from du Barry, Demarteau, and Guimard

It is not easy to assess how many decorative works Fragonard produced during this period and no series painted by him is still in place; many works must have been destroyed and one must often be satisfied with dispersed sets or sketches. However, the number of decorative works painted by Fragonard appears to have been considerable and it was as a decorator that he was celebrated and that he received prestigious commissions. Although it is difficult, today, to judge whether it was the painter's capriciousness

and the excessive demands he made, or his patrons' lack of good will or dissatisfaction that were to blame, many works were never painted or were refused by their clients. One may recall the examples of the ceilings commissioned in 1766 for the Galerie d'Apollon and the overdoors for Bellevue. In December 1770, Fragonard was commissioned to paint two overdoors for the king's dining room at Versailles, a commission he shared with Huet, who was to paint the other two panels; Fragonard seems never to have painted these works.[1] Cat. L24 25

Other overdoors, which were formerly at the Château de Louveciennes, have, however, been preserved. They are 165, 167–69; *The Three Graces*, in the Musée Fragonard in Grasse, *Cupid Setting the Universe Ablaze*, in the Musée d'Art et d'Histoire in Toulon, *Venus and Cupid* or *Day* in the National Gallery of Ireland in Dublin, and *Night Spreads Her Veils* or *Twilight* in a private collection. It is known that the Château, offered by Louis XV to the Countess du Barry in 1769, was subsequently altered. The memoirs of François-Hubert Drouais, painter by appointment to the king's favorite, indicate that four paintings by Fragonard were bought from him in June 1770. Three of the paintings were backed and enlarged before being hung. They seem to have been representations of the *Hours of the Day: The Three Graces* symbolizing Dawn, *Cupid Setting the Universe Ablaze* symbolizing Dusk, *Venus and Cupid, Day* and an allegorical figure, *Night*. But one is surprised by the changes in format and even more by the disparities in style. *The Three Graces*, with their round forms, in the style of Boucher, their smiling and rather conventional faces, seem to antedate the other paintings; *Cupid Setting the Universe Ablaze* and *Venus and Cupid* show children who are very close to the *Garlands of Cupids*, in the Louvre, and Cat. might date from 1766–67. The style of the *Night* appears 155–58 Cat. 148–51

165 *The Three Graces*. Before 1770 (c. 1766–68?). Oil on canvas, 89 × 134 cm. Musée Fragonard, Grasse (cat. no. 148)

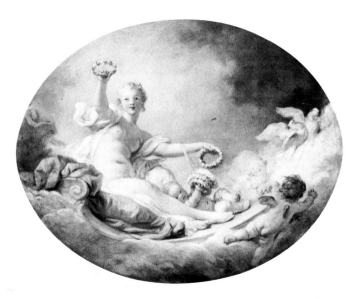

166 *Venus and Cupid*, or *Day*. Before 1770 (c. 1768?). Oil on canvas, 32 × 40 cm. Private Collection (cat. no. 152)

167 *Venus and Cupid*, or *Day*. Before 1770 (c. 1768?). Oil on canvas, 114 × 133 cm. National Gallery of Ireland, Dublin (cat. no. 150)

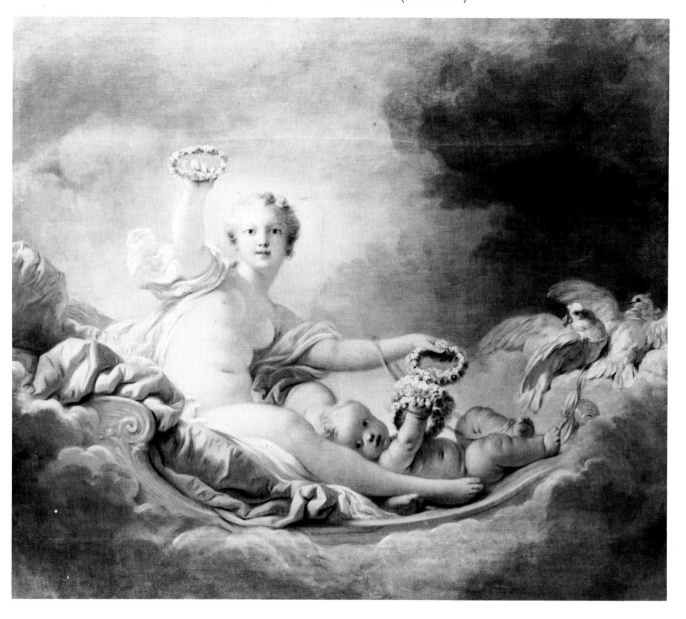

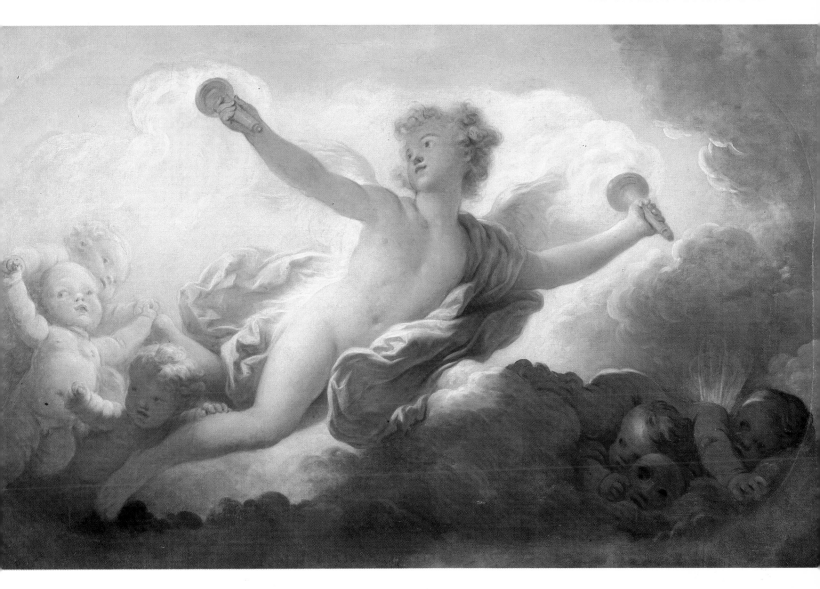

168 *Cupid Setting the Universe Ablaze.* Before 1770 (c. 1768?). Oil on canvas, 116 × 145 cm. Musée d'Art et d'Histoire, Toulon (cat. no. 149)

freer and more fluent, and closer to that of a series of four paintings featuring cupids (private collection). *Night*, whose format does not seem to have been modified, may have been painted by Fragonard in 1770, to complete a series of unused paintings of various dates and to give them iconographic coherence. To assume this may be to attach little importance to the prestige of the lady of the house, but haste may have dictated such a solution.[2] The problem is not made any simpler by the existence of another overdoor featuring *The Three Graces*, discovered and published by Jacques Wilhelm in 1956, which is similar in composition to the painting in Grasse, but whose more nervous and spirited style (as well as the direction of light in a variety of contre-jour effects) point to a later date, possibly between 1768–70, which is close to that of the three other paintings at Louveciennes. Here, at least, is clear proof that, at an interval of a few years, Fragonard did

not hesitate to take up his own compositions again and to introduce variations into them.

A series that has been preserved almost intact is that of a small salon in the house of the engraver, Gilles Demarteau, in the Rue de la Pelleterie in the Ile de la Cité, in Paris, which was decorated under Boucher's direction in the last years of the painter's life and reassembled in the Musée Carnavalet. The decor, consisting of landscapes featuring animals, goes round the room; the doors themselves are decorated too. Whilst the large landscapes of the walls and overdoors appear to have been painted by Jean-

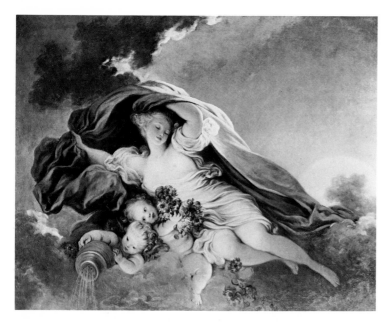

169 *Night Spreads Her Veils*, or *Twilight* 1770(?). Oil on canvas, 115 × 146 cm. Private Collection (cat.no. 151)

Cat. 194

Baptiste Huet and one or two of Boucher's collaborators, the master himself is the author of the decor of three of the four doors; painted statues of cupids eating grapes or holding bowls of water stand out against the background of flowery bowers. The fourth door was decorated by Fragonard, whose golden and light technique is quite distinctive: it shows a sculpted cupid holding up, in his outstretched arms, an arrow and a crown of flowers. Jacques Wilhelm, who has published the whole of the decoration,[3] suggests that Fragonard participated in the flowers that appear in the foreground of several of the panels. Indeed, the magnificent quality, the firm and soft brushstrokes, the fine representation of light in certain parts, an overturned pot of flowers here, roses near a bird's nest there, evoke similar elements in the Louveciennes panels so intensely that they may be attributed to the same painter. One may wonder why Fragonard, a respected painter who was no longer a novice, participated as a mere collaborator in the painting of a decorative work that was, admittedly, of minor importance; perhaps it was simply to help his former teacher, who was determined to go on working in spite of his age. The style of Boucher's paintings is both rather harsh and relaxed, and it does indeed lead one to place them late in his career, about 1768–69. One may even wonder whether Fragonard completed a series that Boucher may have left unfinished at his death in 1770.

We have already seen that Mademoiselle Guimard was a great admirer of Fragonard's talent, but there is no evidence to support the idea that she was his mistress, as has been suggested. In fact, they became involved in a serious dispute. The renowned dancer had had a house built for her by Claude-Nicolas Ledoux in the Chaussée d'Antin. She asked Fragonard to paint four panels on mythological subjects to decorate the salon. According to Fréderic-Melchior Grimm, a quarrel arose; the dancer dismissed the artist, and the latter, in order to avenge himself, secretly altered the face of the Terpsichore in one of the paintings in which the Muse of dancing bore the smiling features of "La Guimard," transforming them into those of the frenzied Tisiphone, one of the three Furies. According to a family account given by the painter's grandson and reported by the Goncourt brothers, it was, on the contrary, Fragonard who, irritated by the haughty pride of the impatient Mademoiselle Guimard, who kept asking him, "Monsieur Fragonard, will it never be finished?" took the initiative for the break and slammed the door saying: "It *is* finished!"[4] The conflict seems, in fact, primarily to have had a financial motive. A letter from Jean-Baptiste Pierre, the First Painter, to Ledoux, dated November 15, 1773, reveals that Fragonard, after having asked for 6,000 livres in payment for his work, had subsequently asked for 20,000—"after the preliminary sketch"—asserting, in addition, that it would take him four years to complete the work. A "frightened" Mademoiselle Guimard therefore gave up the project and Fragonard left the decor unfinished. The dancer, who must have been embarrassed, gave the decor to Jacques-Louis David, then aged twenty-five, who, at the time, was trying to win the Prix de Rome year after year, but without success. In his letter to Ledoux, Pierre wishes to exonerate David and to defend him from the accusations the architect seemed to be making against him, to the effect that he, David, had not informed Fragonard of his wish to succeed him:

Monsieur Fragonard had left and had made it so clear that he did not want to finish this project that Monsieur David did not write him, because of the assurances he had received from several persons of M. Fragonard's loss of interest. His first mistake was to have asked for only 6,000 livres for a project that was worth 20,000 or more, even if it were carried out by a beginner, and that is what led to the general harrassment and complaints on both sides. What can you do, Sir, if Mademoiselle Guimard no longer requires M. Fragonard, and if M. Fragonard has tacitly given up the project? Surely, Mademoiselle Guimard should be allowed to make her own choices, and David does not appear to behave like a

man who has anything to reproach himself for. On the contrary, he believes that he is doing M. Fragonard a favor by relieving him of a job, the excessively lively nature of which puts him off and drives him away.[5]

At the time, Fragonard had indeed gone away; he had left Paris six weeks earlier, accompanying the financier Bergeret on his trip to Italy, and he was to be away from Paris for a whole year. This episode tells us something about Fragonard's quick-tempered nature and perhaps about his insincerity, his versatility, and his desire for financial gain. One can imagine that he was delighted at the opportunity offered by Bergeret, of having a "change of air" and getting away from dancers, their demands, and their fantasies. Perhaps he had even got himself into a tight spot by not honoring his obligations; the slim dancer had a great deal of influence.

David's biographer, Chaussard, states that he worked on the decor of the Guimard house for two years, until the fall of 1775.[6] It is by no means the least interesting aspect of this story that we have glimpsed here what may have been the first meeting of two great geniuses of French painting, one aged about forty, the other twenty-five. All the evidence suggests that although their careers were very different, relations between them subsequently remained cordial and the episode of the Hôtel Guimard may have marked the start of their friendship.

What did the decoration of the Hôtel Guimard look like? It would be interesting to know what Fragonard painted there as well as what was painted by David. The latter may simply have completed the decor that the older artist had sketched out, in a style that may have been that of his *Death of Seneca*, in the Petit Palais, which was presented for the Prix de Rome competition in that same year of 1773. Its style is bouncing and almost playful and not at all incompatible with Fragonard's. David does, at any rate, mention the "Salon of Mlle Guimard" in the catalogue he drew up of his own works. He may only have painted the ceiling, which he specifically mentions as his own work. The house was destroyed in the nineteenth century, and four very large subjects drawn from mythology, of similar dimensions, appeared in a public sale in Paris in 1846, with an attribution to Fragonard; they could well be the remnants of the Guimard Salon, but no further mention has since been made of them.

Only the text by Grimm, who writes of a Terpsichore, can help specify the theme of the series, in which music and dancing were to be prominent.[7] It seems that no drawing or sketch by Fragonard can be linked to this project, which appears to have been extremely ambitious, considering the of time the painter required for its completion.

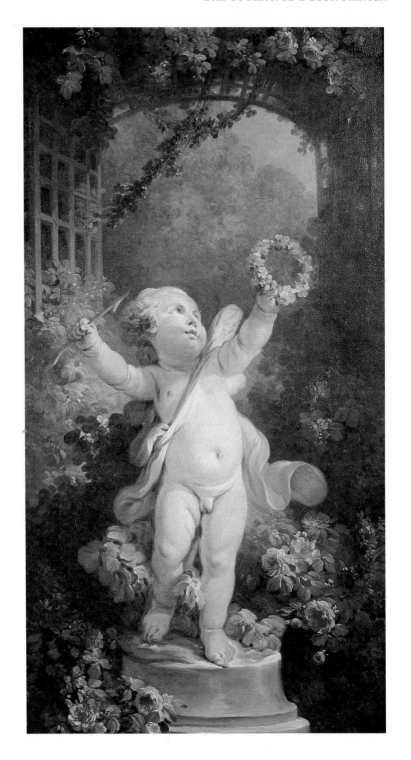

170 *Love Triumphant.* Part of the decoration for the Demarteau Salon. c. 1769–70(?). Oil on canvas, 137 × 72 cm. Musée Carnavalet, Paris (cat.no. 194)

171 Two decorative subjects: *Architecture* and *Poetry?*. c. 1770(?). Pen, brown wash over sketch in black chalk, 5 × 12.1 cm. Musée des Beaux-Arts et d'Archéologie, Besançon

172 Three decorative subjects: Cupid on a pedestal and two female figures. c. 1770(?). Pen, brown wash over black chalk sketch, 15.7 × 5.5 cm (on several pages joined together). Musée des Beaux-Arts et d'Archéologie, Besançon

Decor Sketches

However, some sketches must have existed, just as there are sketches for the Louveciennes decors, and for other paintings that were to have a decorative purpose and that seem to date from the same years, from shortly before Fragonard's second trip to Italy. A painting like the *Two Cupids*, or *Spring*, which was clearly originally an overdoor (the very rapidly painted sketch of which is in a private collection), may give some idea of the style of the decors of the house in the Chaussée d'Antin. The same is true of the tiny and delightful little sketches brought together by Pâris; they show, in a style that is very close to the *Two Cupids*, cherubs with garlands of flowers, children holding crowns, all of which appear to be decorative projects.[8] Does the very fine sketch of a ceiling painted on a circular

173 *The Triumph of Venus*, or *The Toilet of Venus*. c. 1770–72. Oil on panel, diam. 75 cm. Musée des Beaux-Arts et d'Archéologie, Besançon (cat.no. 234)

174 Sketch for a ceiling. c. 1770. Oil on canvas, 29.5 × 42 cm. Private Collection (cat.no. 233)

175;
Cat. 237

Cat. 238

71, 172

173;
Cat. 234

panel (which was also part of the Pâris Collection that came to the Musée des Beaux Arts of Besançon) also date from the time of the decors for the Hôtel Guimard? It does appear to be a true project for a ceiling or for a surbased cupula, and not a casually sketched work, so skillfully worked out are the areas of light and shade, the use of contrasting outlines, the linking of plumes of clouds and of clusters of figures, in a carefully calculated opposition of cold and warm tones: a sky of pale blue, clouds set ablaze by the evening sun or quivering with fawn shadows. Another sketch, in a very different style, which is very rapid and graphic, shows an oval opening in small dimensions, encircled by a balustrade on which vases have been placed and from which three hovering cupids look down at us, throwing flowers and one of them proudly shaking a fool's bauble. This ceiling decor was probably done when Fragonard painted other overdoors, formerly in the Kraemer Collection, which show, in two vertical ovals, two chubby cupids, one of whom is shooting an arrow from a bow, the other shown asleep, and which are presumably representations of Day with its activity and Night with its calm.

A sketch that has since been lost, and about which nothing is known after its appearance in a sale in 1776, probably also dated from the same period; it was described in the catalogue of that sale as a "ceiling, architectural ornaments with children holding garlands of flowers." In connection with this, one should mention two large overdoors of a less fine and florid style, representing Day and Night, which are now in a private collection in Rome. The bold contours of the forms, arranged in intense contrasts of light and shade, the types of some faces, enable them to be linked to the Louveciennes compositions and to be given a similar date, about 1771–72.

The four or five years that preceded his second journey to Italy really do seem to have marked Fragonard's heyday as a decorator; he had achieved mastery of a specific style and was very much in demand in this field. How unfortunate it is that so many series of works have disappeared, preventing one from ever making a full assessment of one of the greatest French decorative painters of the eighteenth century. One thinks of Tiepolo: those of his decors that were painted on canvas have been taken apart, but his more numerous decors, painted on the walls themselves, remain. How lucky fresco painters are! Among the works that have disappeared one in particular should be mentioned: a ceiling for the Chancellerie d'Orléans, which has since become the Hôtel d'Argenson, and definitely painted between April 1767 and June 1769, as is revealed by the letters written by the architect Charles de Wailly to his illustrious client, the Marquess d'Argenson, and as Monique Mosser has kindly pointed out to the present

175 Two cupids, called *Spring*. c. 1772. Oil on canvas, 76 × 87 cm. Private Collection (cat. no. 237)

writer. The architect wrote to his client on April 4: "the cornice and the garlands in the dining room which still had to be gilded have now been completed, the stylistic ornaments of the background of the ceiling have been tried out in every possible way, and we have recognized that they should be left as they were by darkening the areas surrounding Monsieur Fragonard's painting, in order to highlight it. Monsieur Fragonard begins painting next Monday." This was an important painting whose subject, presumably a sky with a ceiling of figures, has still not been identified, and which seems to have been judged more severely than the one executed at the same time by Durameau for another ceiling in the house. De Wailly himself wrote to Argenson on June 5, 1769: "You might not be as pleased with Fragonard's ceiling as with Durameau's, which everybody here is praising."

Several overdoors in grisaille may also date from this period; they show false sculptures, of the kind that Fragonard must often have painted. Three *Seasons* (in a private collection) show sturdy cupids, small pyramid-shaped groups standing out forcefully in high relief inside a niche, and already reveal the evolution of interior decoration toward the use of monochromes. The analogy betwen such works and the groups of cupids sculpted by Augustin Pajou for certain overdoors in the Hôtel d'Argenson is striking; they were part of the same decorative project,

141

176 Two cupids with doves, called *Spring*. c. 1772. Oil on canvas, 79 × 120 cm. Private Collection, Paris (cat. no. 250)

177 Two cupids sleeping on flowers, called *Summer*. c. 1772. Oil on canvas, 79 × 120 cm. Private Collection, Paris (cat. no. 249)

directed by de Wailly, as Fragonard's ceiling, which has disappeared.[9]

It is fascinating to compare such paintings, whose function is solely decorative, with works painted by Fragonard before his stay in Rome as a student painter; his style has evolved in the course of ten or fifteen years. The influence of Boucher's art is still discernible, but the firm relief, organized in solid planes, differs completely from the round and systematic relief of the late Boucher and the faces of the putti, still close to those of Boucher in the sketch for the *Coresus*, are now of a quite characteristic type, with high, domed foreheads and hair in powdered puffs above their ears. The bright colors include yellow reflections and raspberry tones unique to Fragonard. One can even imagine that the clientele that had addressed itself to Boucher, who had grown old and died in 1770, was now turning to Fragonard.

The Louveciennes Panels: The Subject

Apart from all these decors by Fragonard that have been destroyed, dispersed, or that cannot be assessed, one glorious masterpiece has, luckily, been preserved; the series of *The Loves of Shepherds*, also called *The Pursuit of Love*, the whole of which is now in the Frick Collection in New York, is the artist's most ambitious series to have been preserved without undergoing any mutilation. The paintings did, however, have to endure many tribulations: commissioned by the Countess du Barry as decorations for a salon in her house *(pavillon)* in Louveciennes, the four paintings were rejected by her and were taken back by Fragonard, who, at the time of the Revolution, transported them to the south of France and installed them, with other paintings, in the house of his cousins, the Mauberts, in Grasse. A prestigious commission by a royal mistress, this series of paintings remains, of all the artist's works, the one that is the subject of the largest number of anecdotes and the one that is commented upon at greatest length, giving rise to diverse and contradictory interpretations. It represents a kind of résumé of Fragonard's work, as it includes a decorative purpose, a gallant theme, and a landscape and figures in Spanish costumes.

The four works were painted to decorate a salon, known as the *Salon en cul-de-four*, in the house at Louveciennes that was built between December 1770 and January 1772 by the genial Ledoux for the king's favorite; once again, as in the case of the Hôtel Guimard, the names of two great artists are linked. The precise date of the commission is not known, but Fragonard seems to have set to work during 1771. Two payments of 1,200 livres, made to the artist, appear in Countess du Barry's accounts in June and September, and were paid to the artist in July and November of the same year.

The pictures appear in an inventory of the château of May 1, 1772. They had, therefore, been installed by then; but had they been completed? Bachaumont mentions the paintings in his *Secret Memoirs*, on July 20, specifying that they had "not yet been finished," which might indicate that the panels were not completed until they had been

installed. It should be borne in mind that two of the paintings, which were more than thirty centimeters wider than the other two, were hung in the part of the salon forming the *cul-de-four*, and had to be hung in curved frames. It

must therefore have been easier to work on them once the frames had been hung and Fragonard may also have wished to see the overall effect of the decor before adding the final touches to it. It is therefore quite probable that

178 *The Pursuit.* c. 1771(?). Oil on canvas, 67 × 38 cm. Private Collection (cat. no. 243)

179 *Storming the Citadel.* c. 1771. Oil on canvas, 67 × 38 cm. Private Collection (cat. no. 244)

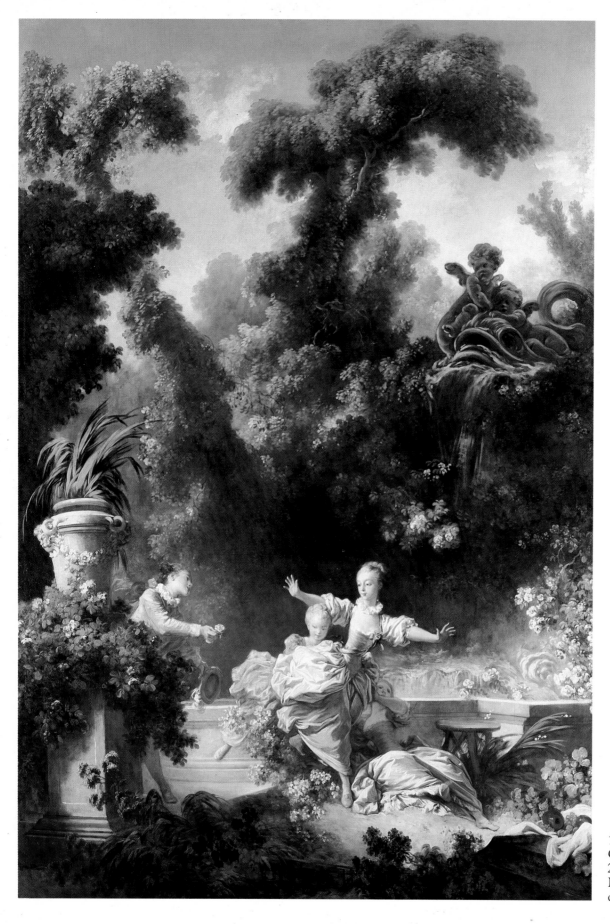

180-81 *The Pursuit*. 1771–72.
Oil on canvas, 317.8 ×
215.5 cm. Frick Collection,
New York (cat.no. 239) and
detail

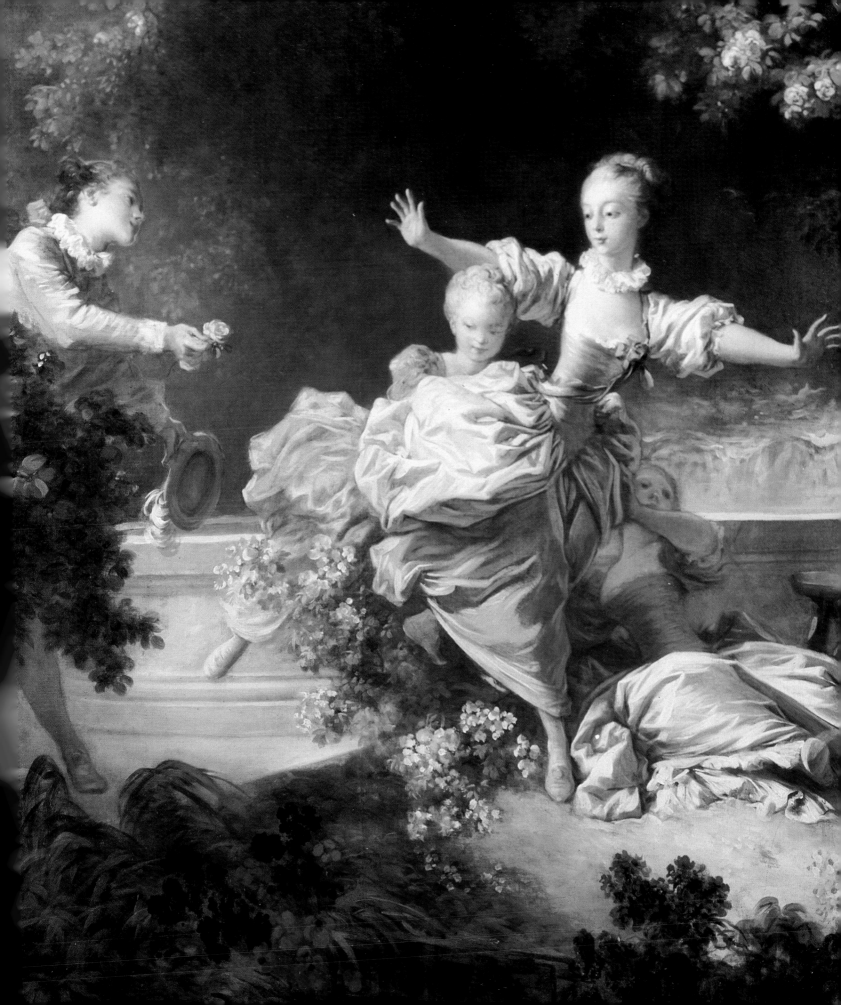

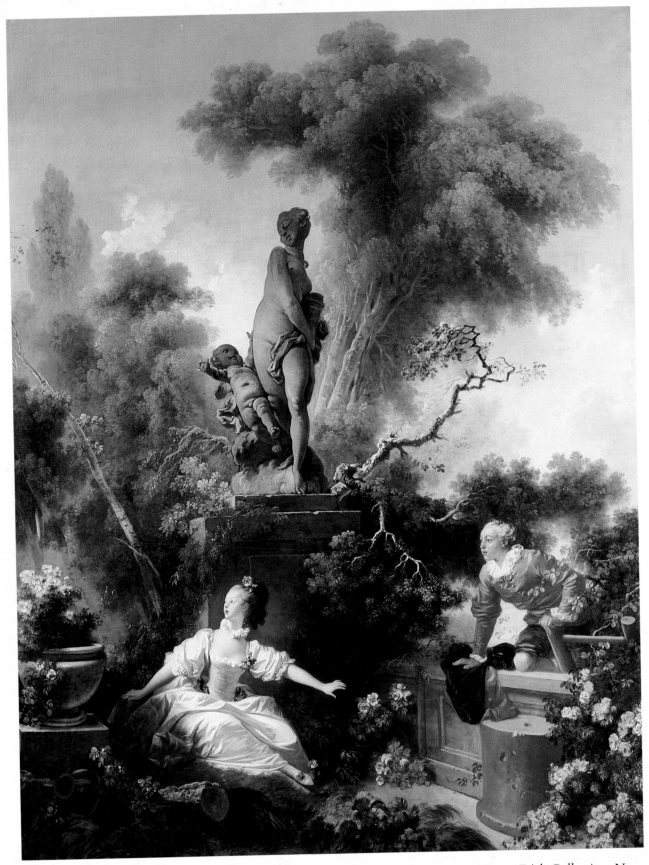

182-83 *The Rendezvous,* or *Storming the Citadel.* 1771–72. Oil on canvas, 317.5 × 243.8 cm. Frick Collection, New York (cat. no. 240) and detail

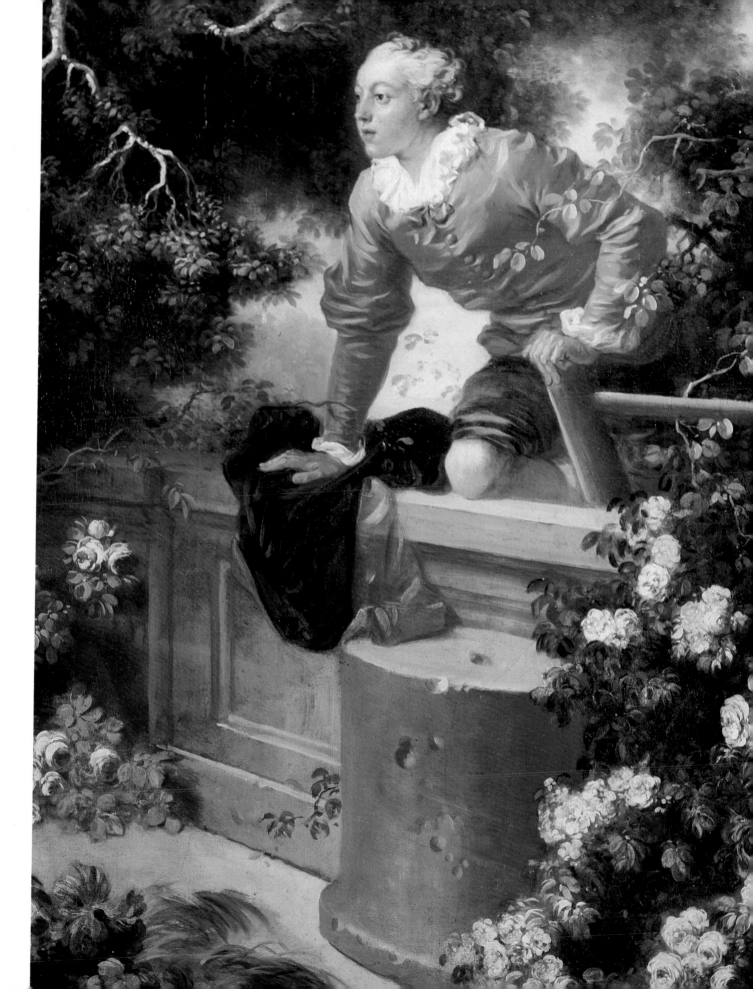

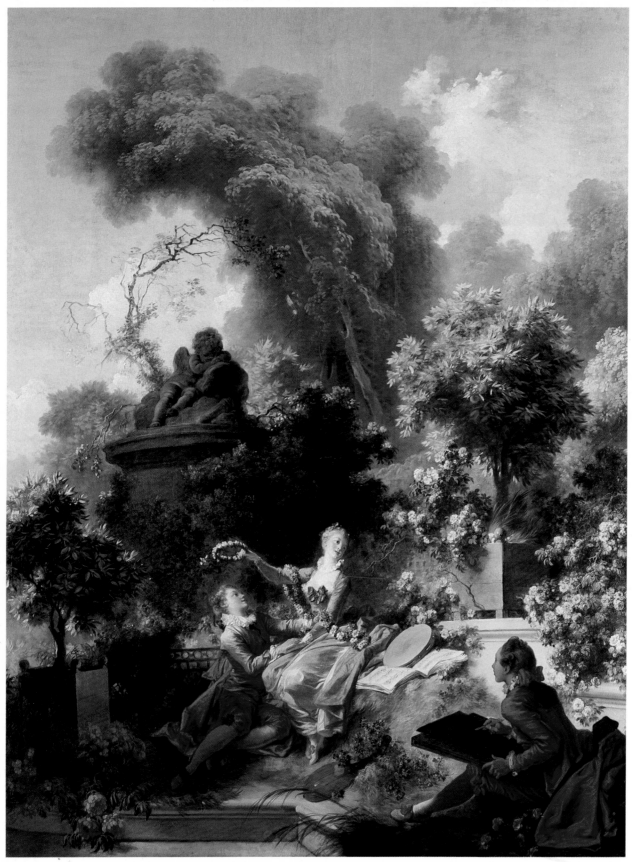

184-85 *The Lover Crowned*. 1771–72. Oil on canvas, 317.8 × 243.2 cm. Frick Collection, New York (cat.no. 241) and detail

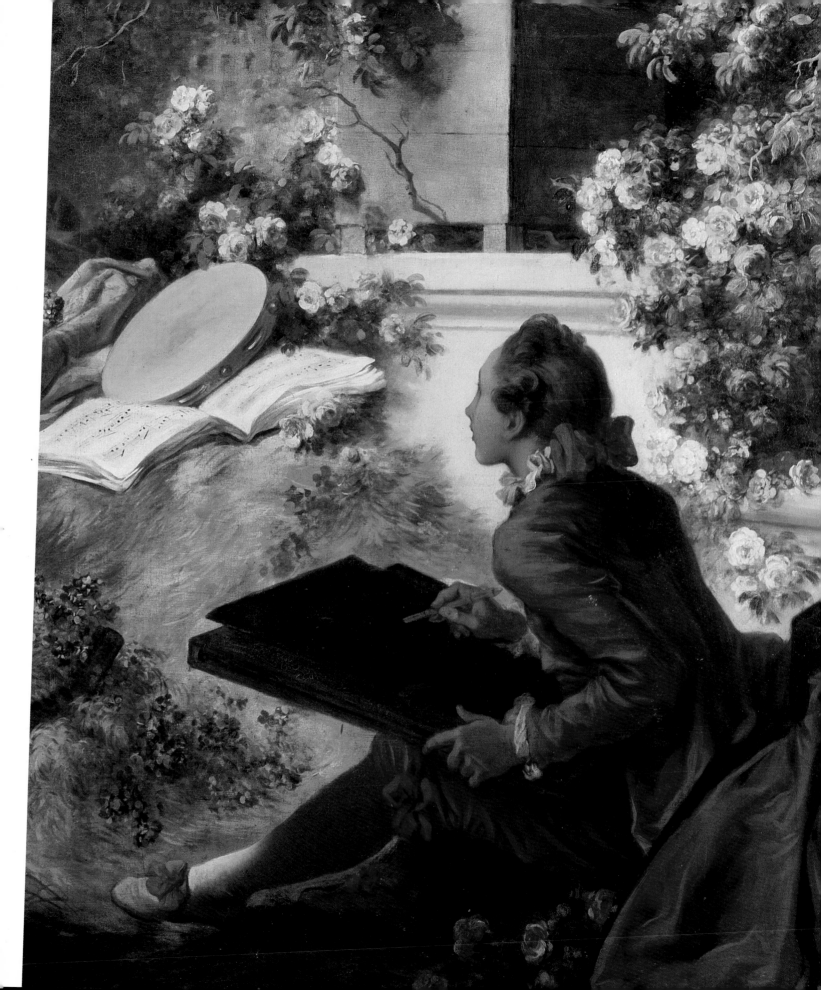

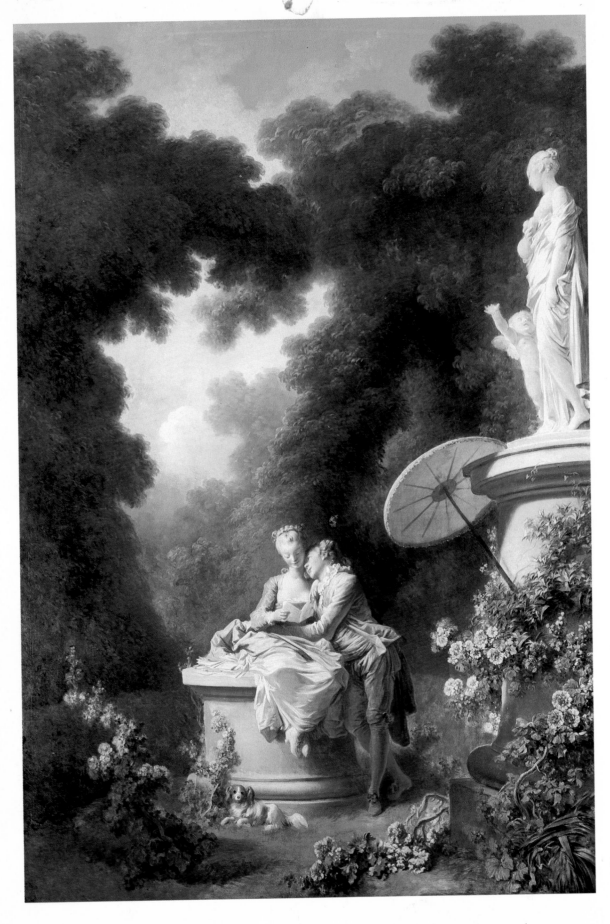

186-87 *The Love Letters.*
1771–72. Oil on canvas,
317.1 × 216.8 cm. Frick
Collection, New York
(cat. no. 242) and detail

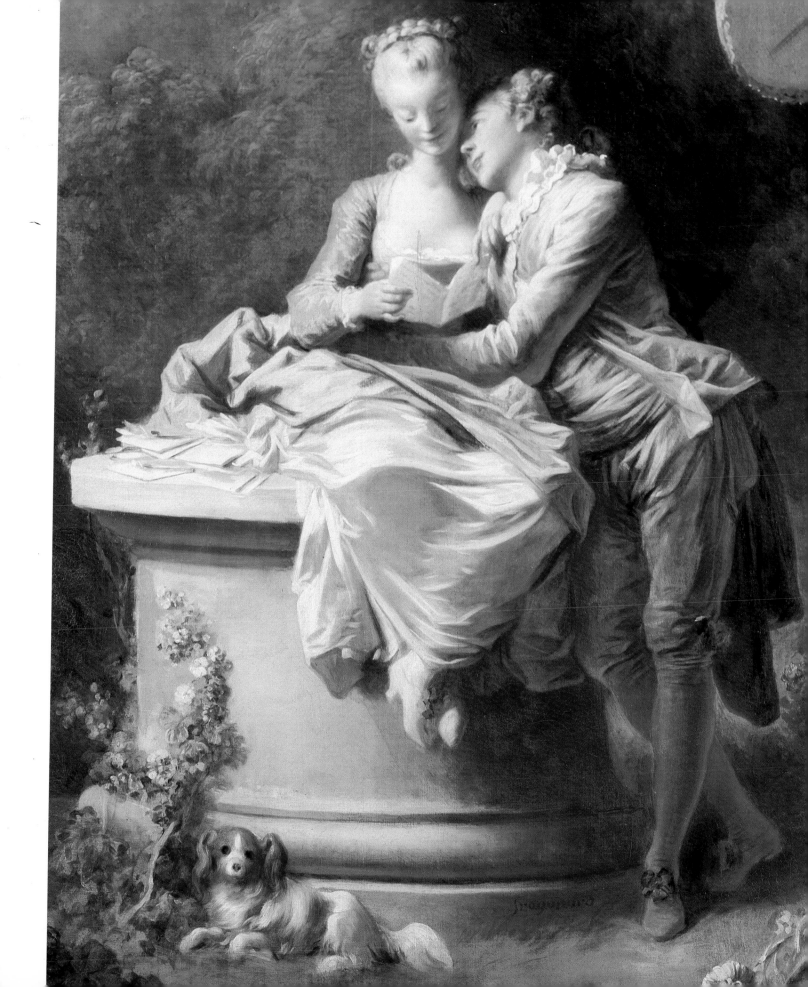

the paintings were completed in the summer, or even the spring, of 1772.[10]

This series was complemented by a ceiling by Jean-Bernard Restout, completed in May 1772. It simply showed, in a skillful counterpoint to the luxuriant vegetation in Fragonard's panels, an expanse of sky with clouds. Also in the same salon, were four circular overdoors by Drouais, representing child musicians or children holding fruit or flowers, which were delivered in August 1772 and now appear to be lost; but a painting by Drouais, signed and dated 1772, which appeared on the London market in 1970, may well be one of these pictures. In this picture, titled *A Small Boy Playing a Basque Drum*, the trees and roses in the background, the little boy's suit, the range of bright colors, and the lively and elegant tone appear to have been intended to harmonize with Fragonard's large panels.[11]

The subjects of Fragonard's paintings, the order in which one was supposed to view them, and their position in the room have been the subject of many commentaries and controversies. It may be noted that it is not the same couple that reappears in the various panels; there are differences in the faces, colors, and hair; one should not therefore attempt to read the series as if it were a cartoon with logical links between episodes. Marianne Roland Michel has even proposed a distribution of the paintings that deliberately breaks with any "logical" linking of episodes.[12] However, it would be difficult not to take into account the designation in the inventory of 1772, "the four ages of love," which implies an order in which the works are to be read. One can make this title correspond to the decorative program by placing, to the left of the French windows leading to the garden, *The Pursuit*, whose movements are directed toward the right, and, on the right, *The Rendezvous*, placed within the *cul-de-four*, with its figures turned toward the left, but whose plumed tree balances the one in *The Lover Crowned*, which is placed symmetrically in the *cul-de-four*; *The Love Letters* with its centered composition, supported on the right by the statue of Venus, completes the series, opposite *The Pursuit*.

Seen in this way, the pictures form two groups of two; two paintings, on one side, show a very young heroine, who is still almost a little girl, dressed in white; with her companion, she runs away from her admirer and then, half-consenting, has a meeting with him right at the back of the garden. The other two show two young women, one crowning the lover who has won her heart, the other reading a love letter with him. The four paintings present a true transposition of the amorous quest, with all its enthusiasm, waiting, ardor, and reverie. *The Pursuit* resembles a game, with little girls running away and falling, and the boy smiling and holding his hat in his hand; he holds

out some flowers to them, which they refuse to accept. This slightly confused race represents the pursuit of the beloved; the fruit are intact, on a plinth on the far right, and the water really does appear ready to quench one's thirst. The second picture, generally known as *Storming the Citadel* or *The Rendezvous*, might more properly be called *The Assault*; the surprised young girl is reticent and does not yet give in to her suitor; Venus, whose statue dominates the composition, refuses to give Cupid the quiver he seems to be demanding by stamping his feet. It is a moment of anxiety, of intense excitement; the young girl appears to be losing her head and is spinning round like a top. *The Lover Crowned* is the most passionate of the paintings in this series; it portrays a love that has been declared, a shared ecstasy, a union that is publicly recognized. It is a truly nuptial picture, which even includes orange trees in boxes; there is something of the "wedding photograph" about the way in which the young couple pose before the artist. The fourth and last painting, *The Love Letters*, also called *The Declaration of Love*, which used to be placed before *The Lover Crowned*, shows the couple, united by their love, rereading their love letters; everything seems to have calmed down. Venus, chastely draped, seems to want to hold on to the heart that Cupid is asking her for, in order that he may play with it. The park, at the back, gives one a glimpse of what will be an everyday scene and the little dog, symbolizing faithfulness, is seen alone, intently watching the first onlooker to gaze upon this scene. The "four ages of love," seen, of course, by the lady who had commissioned the paintings, are thus, apparently, the rejection, the accepted meeting, the happy giving-in to love, and happiness in fidelity and affection. These pictures are exquisitely transposed into a world of fiction and have a timeless youthfulness.

What subsequently happened is well-known: when the paintings were hung Countess du Barry was displeased with them and rejected them. This is one of the most famous cases, in the history of painting, of the repudiation by an uninspired client of paintings that were subsequently recognized as great masterpieces; other examples would be the *St. Matthew and the Angel* and the *Death of the Virgin* by Caravaggio, or David's *Madame Récamier*.

Several reasons have been put forward for this rejection. Louis XV is said to have recognized his own features in those of the young man in *The Rendezvous* and is supposed to have been afraid of a scandal; Bachaumont writes that these "Loves of shepherds seem to be allegories of the affairs of the mistress of the house." The truth seems to have been simpler: the countess, and perhaps Ledoux her architect, probably found that the paintings were out of place in the house once its decors had been completed. The panels, with their masses of flowers bursting with

188 François-Hubert Drouais (1727–1775). *Young Boy Playing the Tambourin*. 1772. diam. 42 cm. Private Collection

movement and color, were certainly shocking in the context of Ledoux's Neoclassical setting; this would be especially true of the pieces of decorative sculpture that Fragonard had included, notably the Venus in *The Rendezvous*, aggressively twisted in its volumes and full of Rococo spirit, which must have seemed in really "bad taste." Countess du Barry was proud of being at the forefront of fashion and her role in supporting the origins of the Greek style in furniture and decoration is well-known. She may have found Fragonard's decor old-fashioned and may have been afraid of being mocked. The paintings were indeed made fun of; an anonymous booklet published at the time of the Salon of 1773 comments with biting irony: "At Lussiennes [Louveciennes] you have seen the *nec plus ultra* of *all that clashes, is rolled together, well-whipped, and excessively colorful*... I am speaking of the divine Frag[onard], the most remarkable of artists, in the opinion of our leading painters... He has made a reputation for himself among financiers and, for a painter, that is as good as any other kind... All their offices are decorated with his works. I am not surprised that he has such customers and Midas, good old Midas, can make him his favorite painter..."[13] This was not exactly being kind to the Countess who considered herself a patron of the arts and who liked to initiate new fashions. But the paintings had already been rejected several months earlier and Joseph-Marie Vien had already been commissioned to paint four works to take their place. It was precisely at the Salon of 1773, which was opened at the end of August, that Vien exhibited two paintings, *Two Young Greek Girls Swear That They Will Never Fall in Love* and *Two Young Greek Girls Meet the Sleeping Cupid*. They were commented on in the catalogue in the following way: "these two paintings belong to Countess du Barry and are destined for Luciennes [Louveciennes]. The last one will

not be able to be exhibited until after the Salon has opened." The other two subjects, *A Lover Crowning His Mistress* and *Two Lovers Are United at the Altar of Matrimony*, were not painted until afterwards; an inventory of the house dated June 30, 1774, reveals that the fourth picture, unfinished, had still not been hung.[14]

It is not at all surprising that Countess du Barry had recourse to Vien, who was the initiator of the Neoclassical style in painting and whose *Seller of Cupids* had been exhibited ten years earlier at the Salon. Nor is it surprising that the countess should have asked Vien to treat the same subjects that Fragonard had treated and to paint them in the same order, giving them an antique appearance and toning them down. Here, once again, were *The Rejection of Love, The First Meeting with Love, Satisfied Love,* and *The Promise of Faithfulness.* It is the fact that the commission originally went to Fragonard that is really surprising, because the king's mistress should have known what to expect when she turned to Fragonard. She may have been captivated by the four overdoors that Drouais had just procured for her, which had, admittedly, much more subdued effects and much more discreet colors. But it is quite possible that it was the client or the architect who wished the painted panels to have an exuberance of vegetation and flowers, in order that the salon that they were to decorate should appear a little like a loggia, giving a foretaste of the splendors of the garden onto which the French windows, in the center of the room, opened out. When studying dispersed fragments of decors that Fragonard probably painted at the same time, one realizes that he was perfectly capable of adopting a more sober style that was closer to the antique manner.

The Louveciennes Panels: The Painting

We have, to a certain extent, lost the taste for happiness in painting that these panels illustrate; but the Fragonards at Louveciennes are a delight of pure painting; they are a little garrulous, as stunning as a Bengal light, the very epitome of eighteenth-century France. Here, once again, we see the same park as in *The Swing*; the lovers are still plump, the foliage fluttering; we see the flowers and sculpted cupids; but whatever was still over-ornate and strained in the small picture, has now disappeared and we see a quite different rhythm, a new mastery. It seems that Fragonard has again meditated on the example of Boucher who, in his decorative works, had found the right harmony of figures and of a natural setting. The repertoire of picturesque and contrasting vegetation, of statues and vases and flowers, evokes the tapestries of the *Italian Fêtes* or of the *Noble Pastoral,* woven at Beauvais. Certain panels, painted in the late 1750s and 1760s, appear closer still. The influence is clear and Fragonard wanted to be recognized as Boucher's successor; the Countess du Barry probably realized this herself, finding the series quite "Pompadour" in style.

But whereas in the art of the late Boucher, all the elements become hardened and constrained in an excess of bouncing but dead forms, Fragonard gives new life to the formula. His *Loves of Shepherds,* which are not about shepherds at all (as one looks in vain for a crook or a sheep), add a new impulse and a new élan. The forms are spread out like bouquets in space; they burst forth, turn, explode gently in plumes of foliage or in zigzags of twigs. Of course, we are shown nature within a park, a public garden, a glasshouse; but had the power and the elegance of plants, which are organized and ordered by architectural and sculpted elements, ever been as well understood and portrayed? Let us take another look at the extravagant statue of Venus in *The Rendezvous* that rises like a spiral of shadow and light on a firm axis, around which the trees and bushes shoot out in all directions like living forces. The agile but energetic and stocky figures seem to be those of children on vacation and blend delightfully into this idyllic natural setting. Notice also in *The Rendezvous,* the young man, who is enveloped and encircled with branches and leaves that accompany the rhythms of his hair, of his collaret, and of his clothes; we see how, in *The Pursuit,* the folds of the little girls' skirts harmonize with the clusters of flowers and bushes. The plants seem to imitate the figures, taking up their movements in a kind of echo, and living in a playful and dramatic bustle of the whole of creation, in a vast rhythm of waves and of undulations.

Since the pictures were restored in 1985, they can be studied to better effect. It is their luminosity that first strikes one, the contrast between light and shade, in the mysterious incandescence of the colors, with yellows that are used as reflections in the dark areas and the tasteful contrasts of yellowish-greens next to lilac or grayish-turquoise tones that one finds almost everywhere. The range is modified from one painting to another. In *The Pursuit,* there is a dominance of immaculate whites that assume nuances of mother-of-pearl, with a blue ribbon here, a pink ribbon there; a few patches of scarlet, apple- or poppy-red shine out from the foreground, giving their full value to the greens, which are finely modulated from nuances of grayish-green to those of moss and green gold. *The Rendezvous* takes up a similar harmony, with the white of the dress, where reflections are enlivened with bright yellow; but on the right, with the sudden arrival of the lovers, the cherry-red of the tunic and the black and the

corn-like gold of the cape, are introduced in a superb dissonance. In *The Lover Crowned*, the colors flare up, the flowers that open out, are tinged with blood-red, the lover and the draftsman are dressed in scarlet, bright pink, and orange; the girl in golden yellow, in the fading light of a summer's evening. In contrast, *The Love Letters* marks a return to a softer palette, close to that of *The Pursuit*; whites and grays predominate, accompanied by pinks and a touch of sky-blue, in a faded color-range nearing a monochrome.

Fragonard utilizes all the means at his disposal in these works. They are his largest arrangement since the *Coresus* and the most ambitious of his projects to have been preserved. When all is considered, is this not the most complete and most representative as well as the most convincing decor series in the whole of eighteenth-century French painting? It may be the only one, apart from Le Moyne's *Hercules* ceiling, from the beginning of the century, that can compete, in its inspiration and lyricism, with the great Italian decors. Fragonard would be still more poetic, but he would never be more powerful and stirring, asserting himself here by his theme, by the joyful sensuality of his colors and of his technique, as the final heir of Rubens' *Gardens of Love*. These are impressive masterpieces that were too rapidly assessed (following their rejection and replacement by Vien's paintings) as merely the last outburst, in decorative painting, of a late Rococo style, before the triumph of Neoclassicism. It is difficult to say, today, whether it is a sign of courage or of conformity to admit to seeing vacuousness and dullness in Vien's compositions and whether it is simply a taste for paradox that leads one to judge them as being already outmoded and rather anaemic echoes of the paintings of Carle Van Loo from the early 1760s, appearing ten years after the Salon of 1763, at which the *Seller of Cupids* was exhibited.[15] But it was the study of the paintings of Caravaggio and of the antique sculptors, not of Vien, that was to give rise to the first masterpieces by David, the *Saint-Roch* and the *Bélisaire*, a few years later. As far as painting is concerned, it was Fragonard rather than Vien who, at Louveciennes, embodied the true tradition and who represented true modernity. Perhaps this should not be confused with the evolution of taste, which often means the evolution of fashion; that was obviously what the Countess du Barry was interested in and it was, precisely, a fashion that Vien's *Athenian Women* started. Major movements, which are always unexpected yet which profoundly alter the course of painting, are often determined by a reaction to fashion.

Chapter VII
1773–74 Italy
The Journey with Bergeret

Bergeret and His Journal

Pierre-Jacques-Onésyme Bergeret de Grancourt, born in 1715, was the son of one of the wealthiest Farmers-General (tax collector in France in the seventeenth and eighteenth centuries). He owned a fine house in Paris, in the Place des Victoires, and had acquired the Château de Nointel, and the Château de Nègrepelisse in the Quercy. In 1751, with his father's help, Bergeret had obtained the post of general inspector of taxes for the Montauban region, and, after his father's death, he became General Treasurer in 1764, which meant that he was automatically ennobled and received the sash of the Ordre de Saint-Louis. Presiding over an enormous fortune and receiving a large income from the position he held, he led the life of a great aristocrat. A lover of the arts, a collector, and himself an amateur artist, he had been an *amateur honoraire*[1], that is, a free member of the Académie Royale de Peinture et de Sculpture since August 1754.[1]

Bergeret seems to have been very keen to undertake a study trip to Italy, like the one the future Marquess de Marigny had been on in 1749, accompanied by Germain Soufflot, Charles-Nicolas Cochin, and the Abbé Le Blanc, and like the one the Abbé de Saint-Non had undertaken in 1760 accompanied by Hubert Robert. Bergeret, who had already visited the Low Countries and England in 1772, would have to be accompanied by an artist on his trip to Italy. How did Bergeret meet Fragonard? The collector undoubtedly had links with Boucher, several of whose paintings he owned, and thus he could have gotten to know Fragonard quite early on, perhaps before his first stay in Italy as a student painter. He was, at any rate, one of his faithful and avowed admirers and we have seen that the *Landscapes* at the Salon of 1765 and the *Swarms of Cherubs* of 1767 are mentioned as belonging to him in the catalogues of the Salons. It was not surprising that he wished to enjoy the company, the commentaries, the advice, as well as the drawings of an artist whom he admired.

The journey to Italy that Bergeret and Fragonard undertook in 1773–74 is well-documented since the financier kept a journal, destined for his nieces, a copy of which has been preserved and is now the property of the Société des Antiquaires de l'Ouest, in Poitiers.[2] Of course, Bergeret does not speak of Fragonard as often as one would wish. But with the help of this document we can follow the

189 *Portrait of Bergeret.* 1773–74. Red chalk, 44 × 33 cm. Musée Atger, Montpellier

190 Two coaches drawn up under the trees, called *Bergeret's Lunch on the Road to Italy*. 1773(?). Red chalk, 28.5 × 32.7 cm. Museum Boymans-van Beuningen, Rotterdam

artist day by day and almost step by step, as he traveled with the financier. We can know with almost total certainty which buildings he visited, whom he met, which works of art he saw, and there is no doubt that he took advantage of this role of Cicerone to see again sites, series of frescos, altarpieces, and collections of paintings. It also seems, although one should be more cautious here, that the reflections of Bergeret, whose artistic judgment was not always very sound, sometimes echo the commentaries of Fragonard. A large number of drawings, which are precisely dated and sometimes annotated, have fortunately been preserved and illustrate this travel journal.

It is Fragonard that we shall attempt to follow when reading Bergeret's letters, without paying too much atten-

191 *The Château de Nègrepelisse.* October 1773. Red chalk, 36.2 × 49.4 cm. Museum Boymans-van Beuningen, Rotterdam

tion to the problems they encountered on their journey, to the concerns with society life, to the terrors of the lack of comfort and, above all, of not finding good and copious meals at the various stops, which make up a large part of the correspondence of the General Treasurer, who, in spite of this, was not a person who lacked wit or who did not appreciate the funny side of life. In addition to the financier himself, Bergeret's carriage was occupied by his mistress—called *gouvernante* (housekeeper)—Jeanne Vignier, a former chambermaid of his first wife who had died (Miss Vignier would give him a daughter in 1775, and they were married two years later), and "Monsieur and Madame Fragonard, an excellent, highly talented painter whom I need, especially in Italy, but who is also very even-tempered and easy to get along with on the journey. Madame is just like her husband and as he is very useful to me,

I wanted to repay him, in gratitude, by taking his wife along too; she has talent and a capacity for enjoying such a journey that few women have." Bergeret adds: "My son is following us in a cabriolet with a cook; my two tall coachmen sit on the seat and my valet, Loss, runs along with my son's manservant." The group thus consisted of ten people and Bergeret notes that in the carriage's heavy load "there is no lack of books and portfolios with a variety of selected drawings."[3] On October 9, in Uzerches, Fragonard was drawing: "as we arrived early in the worst possible spot, on a hill surrounded by mountains and leading

down to a river flanked by embankments and mills that produce waterfalls and cascades, we have, as artlovers, admired in ecstasy what nobody admires and our learned Monsieur Fragonard, who is always active and works hard, planned and worked on a drawing of this site until it was time for our dinner..."[4] The drawing has been lost but Bergeret interestingly reveals that Fragonard was constantly producing drawings. A red chalk drawing in the Boymans Museum of Rotterdam, dating perhaps from those days, shows the two carriages standing under the trees, and its occupants resting. On October 12, the travelers arrived in Nègrepelisse, of which Bergeret was the lord, and they remained there for two weeks. The Boymans Museum in Rotterdam also has a fine red chalk drawing of *The Château de Nègrepelisse*, which has been demolished. There is also a very lively wash drawing, annotated by Fragonard, of the *Common Oven of Nègrepelisse* in a private collection in New York.[6] They traveled through Aix, where they visited several picture galleries, through Marseilles, Toulon, where Fragonard did a wash drawing of a *Market Under the Trees* (private collection, New York),[7] then Antibes, where bad weather obliged them to wait before setting sail; but "we have good shelter and have portfolios, drawings, and books and are coping well with the boredom of waiting."[8] They traveled by felucca as far as San Remo, where, on November 11, Fragonard drew a kitchen at an inn, which he calls *Kitchen in San Remo* (private collection).[9] They then went on to Genoa, on mules, as is shown by a drawing dated November 17, which bears the inscription:

Passage on the road from Savona to Genoa (private collection).[10] In addition, a wash drawing in the Musée des Beaux-Arts in Besançon shows a *View of the Coast near Genoa*.[11] They stayed in Genoa for five days and visited the city's palaces. A little farther on, at Sesti, Fragonard drew the *San Stefano Bridge* (Besançon).[12] They were in Pisa on November 29, Florence on the 31st, then in Siena on December 2, and finally in Rome on December 5: "Here I am at last!" writes Bergeret.[13] The travelers were to remain in the city for four months, until the middle of April 1774.

Rome and Naples

Bergeret speaks frequently of his visits to the Académie de France, of its director, Natoire, and of the student painters – "very honest young men, all of them are fond of working"—especially Pierre-Adrien Pâris—"an architect, the best guide; he knows everything, including historical anecdotes"—François-Guillaume Ménageot and Jean-Simon Berthélemy—"some of whose drawings I liked so much that they gave them to me and I have kept them in my portfolio..."[14] he writes, and he often dined with them. Bergeret wrote on February 24: "I see something new here every day... Sometimes it is a nice drawing, an amorous scene that some of the students at the Académie draw for me... sometimes it is a new drawing by my traveling companion, M. Fragonard."[15] He held a discussion group on Sundays, which attracted a lot of people and whose success delighted him: "It is occasionally a little noisy, being made up of a lot of young artists, most of whom are very talented... We display there, in my study, what my traveling companion, M. Fragonard, has done during the week, as well as the work done by M. Vincent, a student on a royal scholarship at the Académie; he has a special talent and provides us with items with which to furnish our little salon."[16] Bergeret appears to have especially admired François-André Vincent, a student painter. The twenty-eight year old painter gave Bergeret a picture of his grayhound, Diane, and then began painting Bergeret's portrait; this was the comical picture the artist exhibited at the Salon of 1777, and which is now in the Musée des Beaux-Arts in Besançon, in which the General Treasurer poses majestically in casual, domestic dress and without a wig, surrounded by antiques and by portfolios; the work provides overwhelming proof of both the painter's and the model's humor.[17] During these four months, Fragonard reveled in walks around Rome and was pleased to see again the sites he had admired about fifteen years earlier. He naturally took part in Bergeret's discussion group and

192 *View of the Coast near Genoa.* November 1773. Pen and brown wash over black chalk underdrawing, 35.3 × 46.2 cm. Musée des Beaux-Arts et d'Archéologie, Besançon

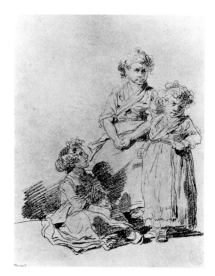

193 François-André Vincent (1746–1816). *Three Young Italian Women*. 1774. Red chalk, 37 × 28 cm. Bibliothèque Municipale, Besançon

194 *Two Young Italian Women*. 1774. Red chalk, 44.5 × 28.6 cm. Musée des Beaux-Arts et d'Archéologie, Besançon

195 *Little Boy Seated*, also called *Child with a Cat*. 1774(?). Red chalk, 35.6 × 49.4 cm. Cabinet des Dessins. The Louvre, Paris

196 *A Man and a Woman in an Interior*. 1774(?). Red chalk, 38.2 × 48.6 cm. The Fine Arts Museums of San Francisco. Achenbach Foundation for Graphic Arts Purchase, Collection René Fribourg

197 *The Dwarf Baiocco and a Young Woman*. 1774. Brown wash, 36.5 × 28.5 cm. Städelsches Kunstinstitut, Frankfurt-am-Main

198 *Seated Man*. 1774. Brown wash, 36.3 × 28.6 cm. Cabinet des Dessins, The Louvre, Paris

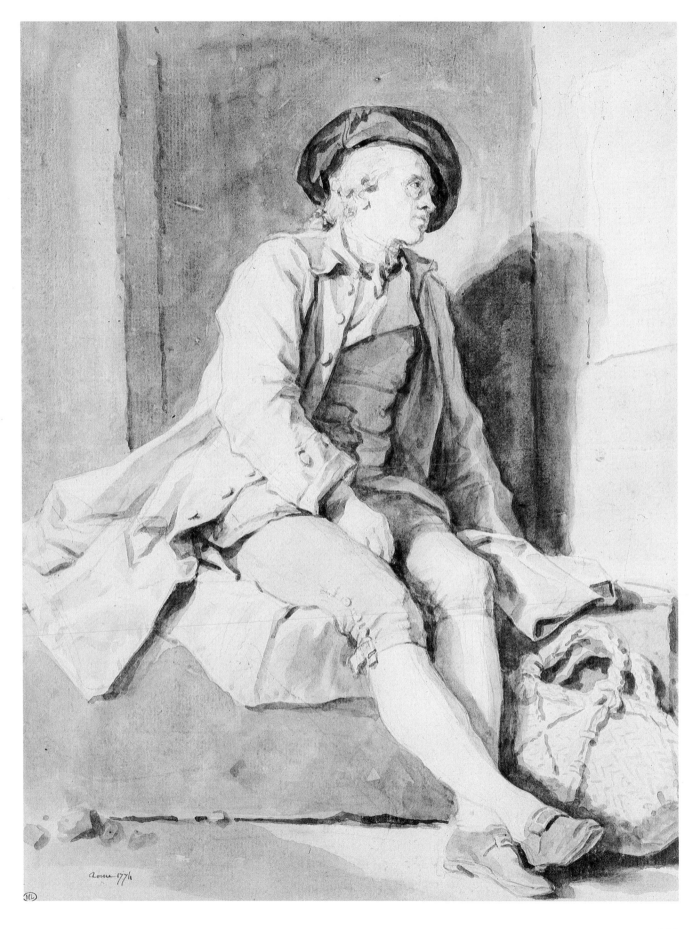

was able to have long meetings with the young student painters, whom he may already have known in Paris.

Fragonard and Vincent seem to have admired each other's work and their friendship was able to grow at this time. Mention should be made of four drawings that formed part of the collection of Pâris, who bequeathed them to the library of Besançon and all of which the architect believed to be by Fragonard, through a lack of attention, a poor memory, or as a result of a successful hoax perpetrated by the artist. Two of them were, in fact, by Vincent, who drew the same little street girls at the same sitting as the older artist.[18] In the same way, Fragonard was seen drawing in the Colosseum, sixteen years earlier, beside Hubert Robert. Vincent reveals himself to be an attentively realistic draftsman who uses light and well-articulated strokes. Fragonard used red chalk in a richer and more sensuous way and both of his drawings, which are masterly in their distribution of light and in the quivering effect of the hatching, achieve an exceptional degree of accuracy and emotion, in a sound and original characterization of individuals. It is not necessary to stress the fascination that Vincent must have felt for Fragonard's art. His drawings clearly reflect it and Vincent's *Self-Portrait* painted in about 1770 (Musée Fragonard, Grasse) already shows the clear influence of the *Figures de Fantaisie*. It is more interesting to attempt to determine, conversely, the influence that Vincent could have had on Fragonard. It seems that the nervous and tense drawing style of the younger painter, his strokes, which were sharp and spirited but free of fantasy, and his painstaking characterization of the model, appealed to Fragonard, whose drawings from life of Roman characters seem to gain a new strength and intensity. This is true of studies in red chalk like the *Little Boy Seated* in the Cabinet des Dessins du Louvre,[19] and of the large sheets of wash drawings like the two studies of *Seated Men*, whose treatment is monumental and sober, not at all witty but almost severe.[20] Other drawings to mention are the famous red chalk drawing in the Musée Atger in Montpellier, the *Portrait of Bergeret*, or the *Postilion*, whose energy is stunning.[21] One may also evoke a red chalk drawing preserved in the Fine Arts Museum of San Francisco and often considered to be a self-portrait of Fragonard in his studio; in fact, this drawing, probably made in Rome or, at any rate, at some point on the journey with Bergeret, seems to be a faithfully transcribed "slice of life." But the character's pose and the *da sotto* view do not suggest a self-portrait; the hand placed on the table is not, in any case, the work of a chalk. It seems, quite simply, to be a drawing of an artlover or of an artist looking at drawings lying on the floor before him and commenting on them as he turns toward his young wife. But who is the model? The man appears to be a little too young to be Bergeret.[22]

199 *Roman Interior*, also called *The Charlatan's Kitchen*. 1774(?). Oil on canvas, 25 × 32 cm. Private Collection, U.S.A. (cat. no. 272)

Fragonard drew several large views of Roman parks, in the technique of extended washing that he was especially fond of; these include the two *Gardens*, now in Besançon, which belonged to Pâris, and *The Umbrella Pines of the Villa Pamphili* in the Rijksmuseum of Amsterdam.[23] He also made copies of paintings using the same technique, like the *Martyrdom of St. Andrew* after the fresco by Mattia Preti in Sant'Andrea della Valle (private collection).[24]

Did he simply draw at this time? It is hard to imagine that he did not pick up a brush once during this trip. Mention may simply be made of a little picture in a private collection, strangely entitled *The Charlatan's Kitchen*; there are one or two monkeys in it as well as a lot of children. It is a scene from the life of the ordinary people of Rome which one is tempted to compare with similar subjects dating from his first stay in Rome. The painting is boldly divided by the pattern of horizontals and verticals of the architecture and by the semi-circle of the arch of the doorway in the background. The result is a geometric game that is entirely modern in effect, with simple forms that fit together like mechanical parts and disappear, here and there, in vaporous effects, with dark silhouettes against a dark background. Such a composition evokes the *Rustic Interior*, painted after 1774, which could

200 *The Umbrella Pines at the Villa Pamphili*. 1773–74. Brown wash, 44.7 × 33.7 cm. Rijksmuseum, Amsterdam

201 *Visit to a House at Pompei.* May 1774. Brown wash over black chalk underdrawing, 28.7 × 36.9 cm. Musée des Arts Décoratifs, Lyons

202 *Portrait of a Woman of Santa Lucia.* 1774. Brown wash, 36.7 × 28.1 cm. Collection Mr. and Mrs. Eugene Victor Thaw, New York

suggest that this painting dates from the time of Fragonard's second stay in Rome.

On April 15 the travelers arrived in Naples, where they were to spend two months. On May 6 they were in Pompeï; there, Fragonard produced the amazing drawing, now in the Musée des Arts Décoratifs in Lyons,[25] which appears to be the direct illustration of Bergeret's account: "In one house... a heap of ashes on which lies the body of a woman, in the position of somebody who, after having tried to escape from the molten ash that flowed in everywhere, had finally fallen on her back and died. The whole pose indicates precisely such a movement and one remains in awe of the space of 1700 years."[26] It was also in Naples that Fragonard made two drawings in a very impressive technique of washing of a *Seated Woman of Santa Lucia.* In the first of these, a drawing in the Städelsches Kunstinstitut in Frankfurt-am-Main, she is seated, and in the second one, in the Thaw Collection in New York, she is shown in a bust.[27] The second drawing is a true portrait of the young woman; her head is seen from the front, and its effective realism probably again owes something to Vincent, who went on this trip too and who also drew and painted the same model in the same costume.

After returning to Rome on June 14 Bergeret's little group spent two or three more weeks touring the city before setting off again, spending a few days in Florence, where they particularly admired the ceilings of Pietro da Cortona, at the Pitti Palace. They then went on to Bologna and passed through Padua, arriving in Venice on July 18, where they stayed for two weeks, long enough to look round the city and to visit its palaces and churches. Fragonard seems disappointed at the state of preservation of the paintings in the churches he was seeing again. "I found myself," writes Bergeret, "with people who had seen them fourteen years ago [in reality, fifteen years]. They found them worn and dirtier and darker than before." But in Santa Maria della Fava, they admired Tiepolo's *Education of the Virgin,* "whose composition is most felicitous and whose colors are most beautiful."[28]

The Return Trip and the Quarrel

Instead of visiting other Italian cities, Bergeret decided to go and see the art galleries of Vienna, Mannheim, and Dusseldorf. "I am looking forward," he wrote, "to returning

▷

203 *Seated Woman of Santa Lucia.* 1774. Brown wash, 36.2 × 28.1 cm. Städelsches Kunstinstitut, Frankfurt-am-Main

from all those places with a number of exceptional drawings."[29] In Vienna, where they stayed for one week, Bergeret visited the Liechtenstein Palace: "I am bringing back drawings made there by M. Fragonard."[30] After passing through Prague, the travelers arrived in Dresden on August 20. "We are doing a lot of drawing and are running through our portfolios," wrote Bergeret the next day, which was a Sunday, a day on which the gallery was closed. And on August 2 he wrote: "I have returned to the galleries where M. and Mme. Fragonard have been since this morning, to harvest the crop of drawings."[31] They then went on to Frankfurt and Mannheim, but gave up the idea of going to Dusseldorf and seemed to be delighted to return to Paris about September 10 or 12, 1774, after a journey that had lasted for almost a year.

The whole trip ended with a quarrel, as is well-known. Fragonard intended to keep the drawings he had made during the journey whilst Bergeret, who had paid all the expenses, considered that they belonged to him. Which of the two men was acting in bad faith? Once again, here was Fragonard breaking off relations with a "client" in a quite striking way. Bergeret was, in any case, furious and deliberately crossed out of his journal the flattering comments noted here concerning the Fragonard couple. He replaced them with the following disenchanted sentences: "I will not name these traveling companions because they do not deserve it and have been of no help to me...," and, concerning the "always even-tempered" he had written about Fragonard, he now wrote: "always even-tempered!— because he had feigned this evenness and all the flexibility he appears to have comes from cowardliness, of being afraid of everyone and of not daring to give a frankly negative opinion, always saying what he does not think. He has admitted it himself. As for Madame, it is not worth speaking of her, it might spoil my paper." And later on, he writes, of the painter: "one can prove the limits of his talent, which even I had been too enthusiastic about. His knowledge, which may also be limited, is of little use to an artlover as it is submerged beneath a lot of fantasies. I thus believe that all his talent and knowledge are only of value to him and to the few enthusiasts of whom I used to be one." He concludes: "I was with deceitful people."[32] There was a court case. The Goncourt brothers assert, citing Frédéric Villot, that Bergeret was ordered to give back the drawings or to pay Fragonard 30,000 livres, which is finally what he did.[33]

Even though this journey was shorter than his stay in Italy as a student painter, roughly fifteen years earlier, it assumed an importance for Fragonard's art that was almost as great. This year spent looking, observing, and drawing, made him turn toward a close study of the Masters, which was necessary for his large copies in wash; at the same time, Fragonard seems to have rediscovered drawing from life, landscapes or human characters, in an attentive, patient, and sometimes slow approach that is the contrary of what is generally said about his character. It was a new training, because of the drawings, the contact with the young Frenchmen in the Mancini Palace, and the emulation of Vincent, which may have been influential in this renewal of interest in working from life. It was, perhaps, a moment for Fragonard to reflect on the means he used in his painting, corresponding to a broadening of his vision. This journey seems to have had a cleansing effect, so to speak, bringing about a diversification, a maturing of his art in the years to come. There would subsequently be fewer rough drafts, a less florid and charming style, yet a pictorial sense that would be even more open and varied in the years to come.

Chapter VIII
1774–c. 80 Paris
The Painter's Independence

The Trip to Holland

Shortly after his journey to Italy Fragonard probably traveled to Holland. This journey is not documented and it is the subject of controversy as historians have situated it at different points in Fragonard's career.[1] No drawing or painting of a landscape produced by the artist in the Low Countries has been preserved. Did he make copies there? The paintings that have already been discussed and which he painted after Rembrandt's *Holy Family* were, of course, painted in France before the sale of the Crozat Collection to Catherine II in 1772. The picture that was painted in about 1765–68 after a *Mercury and Argus* by Carel Fabritius (now in the Louvre) is of hardly any help because that painting was in France too. Another painting in France was the *Forest Landscape with a Ford* by Ruisdael, of which, as Seymour Slive has demonstrated, Fragonard made a partial but faithful copy, which is now in the Kimbell Art Museum in Fort Worth. Fragonard's painting was part of the Lempereur Collection, sold in 1773, and then joined the collection of the painter J. A. Gros, the father of the great painter of battle scenes. It appeared in the sale of that collection in 1778 beside a series of large drawings by Fragonard, many of which have unfortunately been lost. The drawings appear to have been made in Amsterdam and the Hague after paintings by Rembrandt, Van der Helst, and Jordaens. This *terminus ante quem* of the spring of 1778 may perhaps be brought forward because there is, in a collection in Paris, a quite complete wash drawing after the *Blessed Hermann Joseph Before the Virgin*, by Van Dyck in the Kunsthistorisches Museum, Vienna, which did not leave Antwerp until 1776 and could not therefore have been made in August 1774, when Fragonard and Bergeret were in Vienna.[2] If one examines the brilliant but precise execution of such a wash drawing and of the *Victory of Frederick-Henry of Nassau* a drawing in the Gros sale (which is now in the Louvre and was almost certainly made in the Hague after Jordaens,[3] in a style comparable to that of similar drawings made during the trip to Italy of 1773–74), and if one bears in mind that in about 1770–73 Fragonard was fully occupied with various decorative projects, one is tempted to place the journey to Holland (which could only have lasted for a few weeks and which took him to Antwerp, Amsterdam, and the Hague) in 1775 or, possibly, 1776. The precise and intense style of a small drawing in Besançon, after the Frans Banningh Cocq in Rembrandt's *Night Watch*, does not contradict such a date.[4] It would be pointless to expatiate on the consequences of such a journey, because Fragonard had long been familiar with Dutch painting, but it could have reinforced his commitment to a more realistic form of painting, executed more slowly and possibly expressing greater emotion.[5]

Religious Subjects

The large *Education of the Virgin* by Fragonard, which is in San Francisco, must have been one of his most impressive paintings before somebody foolishly reduced its dimensions, removing more than half of the surface area of the canvas on the right, at the top, and especially at the bottom, leaving only a horizontal painting, whereas, in the work's original state, a large and sumptuous area had fanned out from the feet of St. Anne and the Virgin. This mutilation could not be repaired and the cat on the extreme right looks surprised at having escaped the mas-

204 *Mercury and Argus* (after Carel Fabritius). c. 1763–65(?). Oil on canvas, 59 × 73 cm. The Louvre, Paris (cat.no. 105)

205 *The Holy Family*, or *The Infant Jesus Asleep* (after Rembrandt). Before 1756?. Oil on canvas, 91 × 75 cm. Private Collection (cat.no. 58)

▷

206 *The Blessed Hermann Joseph Before the Virgin* (after Van Dyke). 1775 or 1776(?). Brown wash over black chalk underdrawing, 24.6 × 21.5 cm. Private Collection, Paris

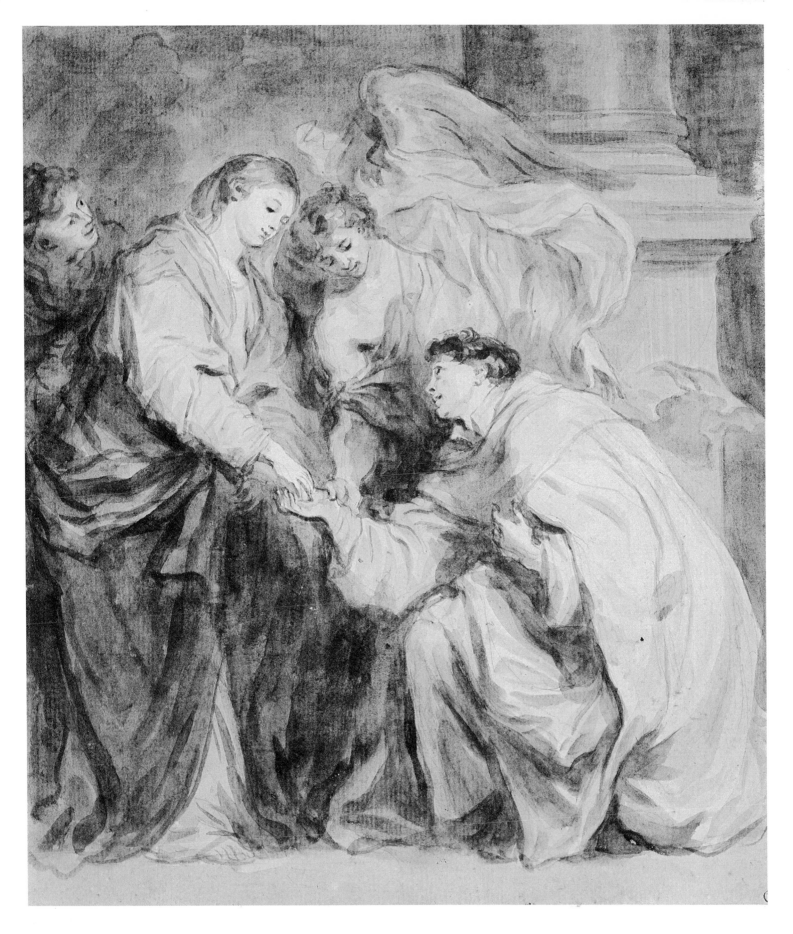

207 *The Victory of Frederick-Henry of Nassau* (after Jordaens). 1775 or 1776(?). Brown wash over black chalk underdrawing, 33.5 × 43.5 cm. Cabinet des Dessins, The Louvre, Paris

sacre almost unscathed. But other versions, painted or drawn in a small format, enable one to imagine how the painting must have looked in its original state. The authoritative delineation and the way the forms are built up of large, flowing planes recall the *Figures de Fantaisie*. Dating the work remains uncertain but it may have been painted about 1772–73, shortly before Fragonard's depar-

ture for Italy. Yet, one is tempted to date it from about 1775, after his return from Italy; the composition seems to bear the mark of a meditation on the great paintings in Italian churches, and the links between this work and Tiepolo's painting on the same subject in the church of Santa Maria della Fava in Venice, seen for the second time with Bergeret in 1774, have frequently been commented upon. There is, in Fragonard's painting, a new, more serious tone, a well-considered use of visual effects, with a new role given to the empty spaces that temper the effect, notably in the case of the large empty space in the upper part of the painting. There is no longer anything seething or restless here; the only mischievous note is provided by

208　*The Education of the Virgin.* c. 1775(?). Oil on canvas, 84 × 115 cm (fragment). The Fine Arts Museums of San Francisco, Gift of Archer M. Huntington in memory of Collis P. Huntington (cat. no. 273)

209　*The Education of the Virgin.* c. 1775(?). Oil on panel. 30.3 × 24.4 cm. The Armand Hammer Foundation, Los Angeles (cat. no. 275)

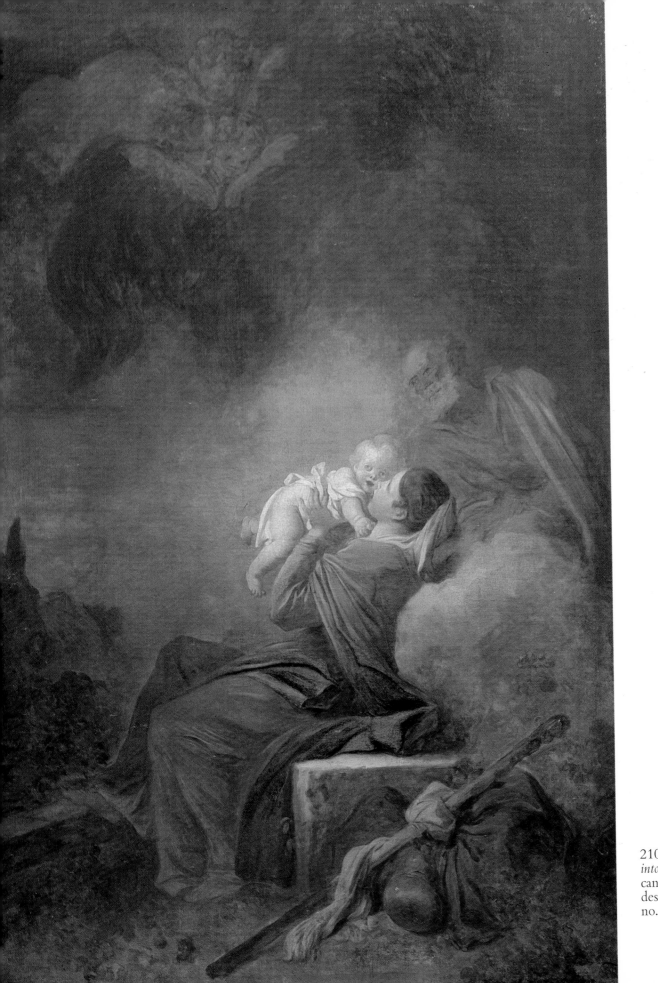

210 *The Rest on the Flight into Egypt*. c. 1776–78. Oil on canvas, 188 × 124 cm. Musée des Beaux-Arts, Troyes (cat. no. 315)

211 *The Rest on the Flight into Egypt.* c. 1778. Oil on canvas, 55 × 45 cm. Yale University Art Gallery, New Haven. On loan from the Barker Welfare Foundation (cat. no. 317)

212 *The Rest on the Flight into Egypt.* c. 1778. Black chalk, pen, brown wash, and watercolor, 42.2 × 34 cm. Cabinet des Dessins, The Louvre, Paris. Gift of O. Kaufmann and F. Schlageter

the cat and a cherub's head. One notices the slightly formal character of the two long, solid figures, and the slightly cold, almost Parmigianesque elegance of the young Virgin. It is a picture that was painted rapidly but to which a lot of thought had undoubtedly been given, and which was the result of an attempt to achieve the simplicity of the antique style. The light that strikes the books and slips into the background is the true subject of the work. The clashing and flaming colors of the *Figures de Fantaisie* turn into a monochrome of ochre beiges, of grays and whites, with the delicate pale blue of Mary's waistband and a simple flash of scarlet provided by her mother's cloak. For such a "grand subject," Fragonard thus goes back to a palette similar to that used in the *Coresus*. But here, the pic-

torial sense is quite different and the background, the half-light, is enlivened with transparent scumbles in earthy tones that contrast with the creamy touch of the drapery. It would be wrong to speak of Neoclassicism here but accurate to speak of discipline, of the mastery of effects, of a new ambition.

There are two other versions of this composition, both in a similar format, and it is difficult to say whether they are sketches for the painting in San Francisco or whether they are later versions. Their dimensions are different, but the same variants in relation to the large picture are found in both, notably the Virgin's face, which is turned up toward her mother's. The larger picture, in a private collection, is considered to be unfinished but may well

Cat. 27

213 *The Adoration of the Shepherds.* c. 1775. Brown wash over black chalk underdrawing, 36 × 46 cm. Cabinet des Dessins, The Louvre, Paris

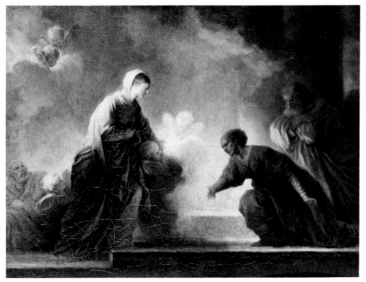

214 *The Visitation.* c. 1773. Oil on canvas, 24.3 × 32,4 cm. Private Collection (cat. no. 269)

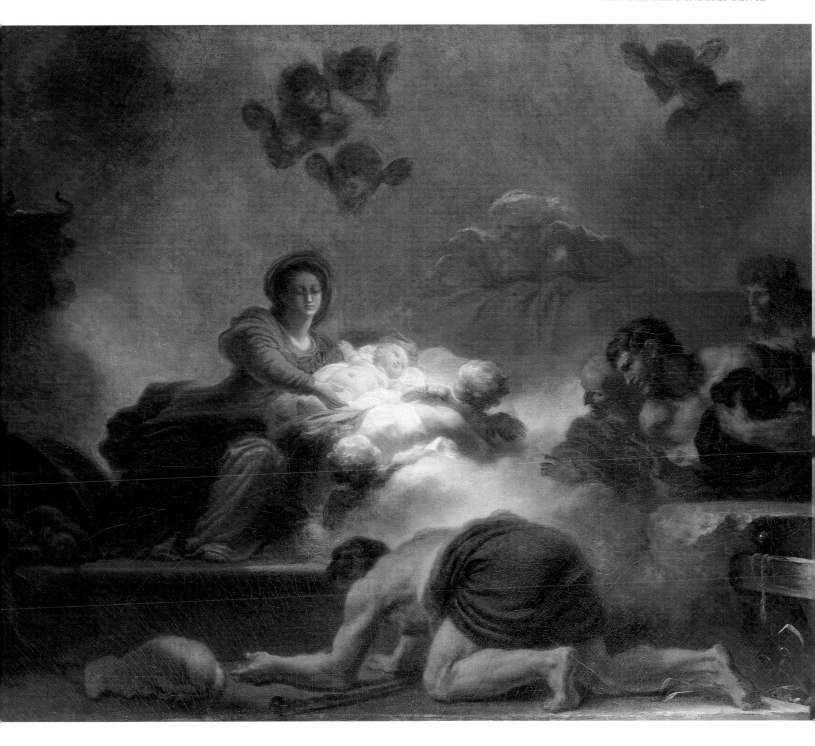

215 *The Adoration of the Shepherds.* c. 1775. Oil on canvas, 73 × 93 cm. Private Collection, New York (cat. no. 300)

have been left in this state deliberately. The painting is filled with light and is almost ghostly in the indecisiveness of the slightly vague volumes, which almost seem to be lit from the inside. The second picture, which is really small in size and which was painted on a wooden panel, is now in the Hammer Foundation in Los Angeles; it is a pure monochrome in all the tones of golden bread that a Rembrandt might have; it is sumptuous in the alert liveli-

ness of the way the paint is thickened out. The pictures are not fantasies in the style of Rembrandt, but are, rather, almost experimental pictures, transpositions into the

75

language of oil painting of Fragonard's brown wash drawings, which were getting more and more complex and elaborate at that time.

Several drawings are associated with this composition. One of them, in black chalk (also in the Hammer Foundation),[6] might have been a preparatory study for the painting in San Francisco, since the same elements are present in it: the Virgin looking at the book and the cat near St. Anne. But wash drawings in a lively and joyful style, closer in composition to the two sketched canvases, are not necessarily earlier and, like those works, may have been produced a little later.[7] As this example shows so well, it is hardly possible, in the case of Fragonard, to discern a logical development from preparatory drawings to a painted sketch and from that to the definitive work. This is because he did not need preparatory drawings or sketches and because it is the definitive work that is painted with the "sketchiest" of techniques. It is thus almost impossible to determine in which order the different versions were painted. But were they separated by a few days, a few months, or several years? The demand of collectors or of dealers certainly prompted him to paint many a picture and to make many a drawing with the same composition as another work that these clients admired. It must be admitted that it is now impossible to date these works precisely. With what facility, what verve, Fragonard must have moved from one format to another, from a finished picture to a sketched one, from a grisaille to a colored work, from an oil painting to a wash drawing, to a gouache, to a pastel!

210;
Cat. 315

Another large religious painting, *The Rest on the Flight into Egypt* in the Musée des Beaux-Arts in Troyes, seems to date from a few years later, and is also accompanied by related works, though perhaps in a different way. It is once again a vertical composition on the theme of motherhood, and the painter takes up (c. 1776–78?) a theme that he had treated as a young man. The painting comes from the church of Saint-Nizier in Troyes, but its origin is unclear and its date remains conjectural. One is struck by the more animated appearance Fragonard has chosen here, compared with *The Education of the Virgin*, by the natural and spontaneously graceful pose of the Virgin as she lifts the child up to her face, and by the more flexible and vibrant outlines. Most of the painting was painted in browns and grays, with a light brush, in a sketchy technique that suggests rather than describes elements in the picture. A vibrant but dense pictorial texture brings the whole painting to life; the ground, the cloud on which the Virgin is leaning, the sky and the leaves of the palm tree, the cherubs, the donkey, and St. Joseph himself, practically dissolve away into a vibrating and warm mist. And in the middle, as though protected, the young Madonna and Child, radi-

ant with happiness, stand out in the full light as solid shapes that turn clearly in bright colors of blue, red, white, and golden yellow. The whole composition really does come to life around this motif of pure love, which appears sinuous and fluid and is well-supported by the block of stone that the Virgin is seated upon, which appears like a luminous brace.

By making his subject slightly more concentrated within an oval format and by reducing the format to that of an easel painting, Fragonard produced two small versions of the *Rest on the Flight into Egypt* which are in the Yale University Art Gallery in New Haven, and in the Museum of Art in Baltimore. The lit-up edges of the stone block are even more necessary as a base for the composition, which is carried away by an irresistible drive. The clouds appear to be gradually taking over, and Joseph, who seems to be imitating a *Figure de Fantaisie*, appears to be getting worried. The painting at Yale, which is smaller and more of a sketch, flares up in bright colors, brilliant red, blue turning into emerald green, and corn-yellow; the one in Baltimore, which is more complete and possibly colder, concentrates all the interest on the luminous effect, in the Dutch manner, making the sacred group emerge from the dark background. A delightful blackish-brown wash drawing with highlights of red and bluish watercolor, donated to the Louvre with the Schlageter-Kaufmann Collection, takes up the composition again, introducing hardly a single variant.[8] It was probably the work exhibited at the Salon de la Correspondance, in 1781. It is not easy to suggest a date for these works; it is not clear whether they were exact contemporaries or whether the picture in Troyes was painted first, as would seem to be the case. Moreover, the works exhibited at the Salon de la Correspondance could have dated from well before the date of this exhibition; the watercolor might nevertheless date from just before 1781. In this whole group of works, the importance of the light effect, the role of brushwork in the half-tones and shadows, the blended effect of the touch, as well as its briskness, and a quality of humanity—which it is difficult to imagine appearing earlier—suggest that these pictures were painted quite a long time after Fragonard's return from Italy, in about 1778 or 1780.

Paintings such as those in San Francisco or in Troyes may have served as altar paintings and the intensity of their luminous contrasts and the decisiveness of their delineation may have facilitated legibility. By contrast, *The Adoration of the Shepherds* was destined for an exhibition room and was almost certainly commissioned by an artlover, the Marquess Louis Gabriel de Véri (1722–1785), to whom it belonged. The Marquess de Véri was an interesting character, and one of the first collectors to open an exhibition room, which contained mainly works by living

French painters, notably works by Vernet, Pierre, Robert, Lagrenée, several Greuzes, including *The Ungrateful Son* and *The Punished Son* which are now in the Louvre, and eight other Fragonards, including *The Two Sisters*, which is in the Metropolitan Museum of Art in New York. It seems that the collection was put together within a few years, between about 1775 and 1779. In 1785, the connoisseur Alexandre-Joseph Paillet noted how pleased the collector was "to receive our best artists at his home daily, to converse with them, to see them thinking up and painting new projects for him which became more entertaining and more interesting every day."[9] This *Adoration of the Shepherds* (private collection, New York) is without doubt one of Fragonard's greatest masterpieces and one of the few eighteenth-century French religious paintings to convey real emotion. Fragonard has opted in this picture for the same type of arrangement as in the *Visitations* that he had painted earlier; the figures are raised onto a platform and there is a golden and luminous half-light in which one can see cherubs and which partly obscures the figures, who are silhouetted in contre-jour or lit from the side. In 1816, Alexandre Lenoir said that the picture had been painted "in the style of Rembrandt,"[10] which explains this light effect and the burnt tones that appear in it. But Fragonard is really referring here to great Italian painting of the Renaissance: the muscular young athletes evoke Michelangelo; a bony face appears to be a direct reference to Leonardo da Vinci, and the misty and blurred effects remind us of Corregio as much as of Rembrandt—names rarely associated with that of the painter from Grasse. And for the face of the Virgin herself, which is oval in shape, with a straight nose and an impassive expression, Fragonard did not choose one of the impish types of which he was so fond. Here again the recent impressions of the Italian journey are evident as well as the influence of Poussin's *Adoration of the Shepherds* (which he obviously admired), where one of the shepherds leans forward toward the Virgin in a pose that is very close to that of Fragonard's prostrated figure. The subject could easily be adapted to the rustic fashions in the Dutch manner of which he was so fond. But the artist chose a deliberately heroic and even antique tone. Is this proof of his ambition, after having produced too many failures, to be recognized as capable of producing a history painting that could recall the *Coresus*?

At any rate, his knowledgeable arrangement of frontal planes, the blended and vibrant technique, and the fervent tone are admirable. And one is even given cause to smile at several details: the ox, which pushes its head in on the left is reminiscent of many of the artist's bulls; the Infant Jesus wants to play with one of the cherubs, whose wing he has caught hold of; and it must be admitted that the obvious

reference to the St. Joseph in Raphael's *The Holy Family of Francis I* also adds a touch of humor. A painting in which references to Italy resonate with such an intensity may have been painted in about 1775, shortly after Fragonard's return from Italy.[11]

The Bolt

Among the Fragonards owned by Louis-Gabriel de Véri, one picture, *The Bolt*, of the same size as *The Adoration of the Shepherds*, is described in the catalogue of the Marquess' posthumous sale in 1785 as a pendant to it. It is one of Fragonard's most renowned paintings and was popularized by the large number of prints that were made of it and were frequently copied. The work was for a long time considered to have disappeared but was fortunately bought by the Louvre in 1974 when it reappeared on the art market. The way the painting was elaborated is the subject of some debate. Fragonard seems to have reused the composition of a wash drawing of which there are at least two versions that appear to date from a few years earlier and must have been produced before the Italian journey of 1773–74.[12] It is very unlikely that such florid drawings could be "preparatory" drawings. Here the room's furnishings are heavier; they include paintings on the wall and some heavy armchairs which, judging from their subdued rocaille style, date from about 1765–68. The whole picture remains rather anecdotal and is like an illustration, with its rather short figures and its dispersed picturesque elements. It was about 1778, perhaps at Véri's suggestion, that Fragonard took up his composition again with the idea of painting a work in which he could give more power and efficacy to the composition, reduce and simplify the accessories, refine the figures by making the groups sway slightly, and, above all, introduce the tremendous effect of harsh light that outlines them against the wall, which is bare and free of any ornament. Fortunately, the sketch that must have immediately preceded the definitive work has been preserved (private collection); it was painted with a quivering brush and the arrangement of the finished composition was already determined in this preliminary work. The luminous part, which is so unusual and which is the true subject of the picture, is already clearly indicated, with the light shining on the hand that is raised toward the bolt, on the far right, forming a kind of large halo and projecting the man's shadow onto the white door.[13]

The range of soft yellows and harsh whites of *The Bolt* is taken up from the sketch. But it has been modified considerably; Fragonard sharpens the contrasts of light

216 *The Bolt.* c. 1778. Oil on canvas, 73 × 92 cm. The Louvre, Paris (cat. no. 336)

217 *The Bolt.* c. 1778. Oil on panel, 26.3 × 39.5 cm. Private Collection (cat. no. 337)

218 *The Useless Resistance.* c. 1775. Oil on canvas, 45 × 60 cm. Nationalmuseum, Stockholm (cat. no. 284)

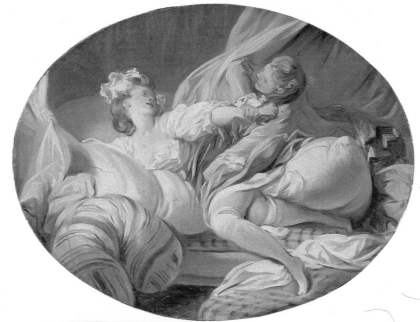

219 *The New Model.* c. 1778. Oil on canvas, 52 × 62 cm. Musée Jacquemart-André Paris (cat. no. 333)

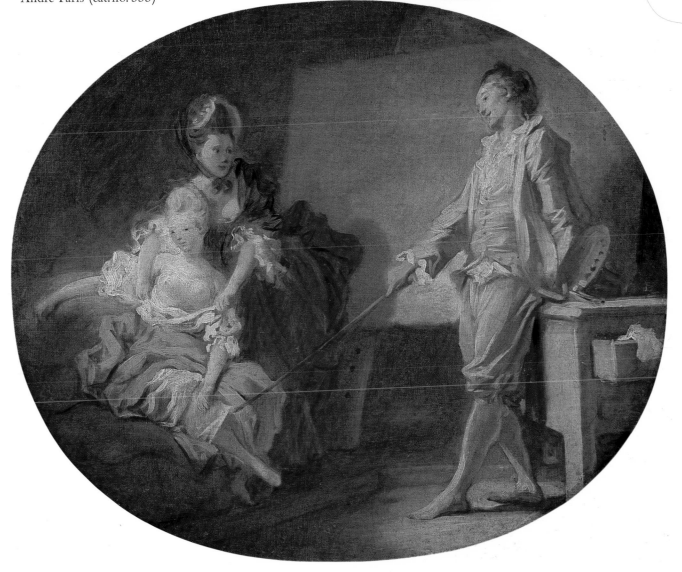

and shade, refining the execution with a fine but lively brush, forming new shadows; he also introduces black passages that make the golden tones reverberate: the lover's hair (which was a delicate but dull blond in the sketch), the cushion of the folding chair, and the shawl that has been thrown onto the floor; he disturbs the harmony of the picture by using a sumptuous madder red that is new to his palette. By reinforcing the shadows he also makes the luminous part brighter; the light shines past the table, on the extreme left, is caught on the satiny white quilt, and then breaks up on the yellow skirt, bursting and whirling in the turbulent knot of brilliant folds that extend, across the white shirt, as far as the man's arm, his hand, and the bolt. In this way, Fragonard establishes the tumultuous and bouncing rhythm of the diagonal of light that crosses the entire painting.

A comparison of the two pictures tends to confirm that *The Bolt* was indeed intended to be a pendant to *The Adoration*: the composition of the religious picture, which is complex but essentially based on a diagonal line rising from the right to the left, is mirrored in the amorous picture, which is masterfully based upon the opposite diagonal. The effects of light and shade, the golden, red, and brown colors, the scale of the characters are all comparable. The robust physique of the lover responds to that of the shepherds; the frontal view of the oval, almost expressionless faces of both women, their eyes lowered, one with brown, the other with blond hair, are similar. Just as striking, if one sets aside the difference in subjects, are the features that separate the two paintings: the diffuse light, the transparencies in the warm shades, the vibrant subtlety of the transitions, with the effects of *sfumato* that characterize the *Adoration* but are not found in *The Bolt*. In the painting in the Louvre, an unexpected view of Fragonard is given by the vigorously projected light, the strong, black shadows, the glare of the large crimson band of the curtain, the polished and clear shapes that emerge, shining, from the half-light, the finer brush, and colder effects of color. It really does seem as though a few years separate the execution of the two paintings.

Are we to see an allusion to Original Sin in the apple that is placed prominently on the left of the table, as has been suggested, and, in this way, justify *The Bolt* and the *Adoration of the Shepherds* as pendants, as representations of sin and redemption?[14] Such an interpretation would be hard to justify for several reasons. The apple may simply be an amorous symbol, like the upturned vase on the far left, like the bouquet of flowers on the floor on the right; one may recall the large red apple that appears prominently in the foreground of *The Pursuit* in the Louveciennes series. Apart from that, if the apple is what gives the picture its full significance, how can we explain the fact that it

does not appear in the sketch? The apple may just as easily have been placed there for artistic effect, because of its completely spherical shape, which almost makes it into the representation of the idea of an apple rather than the depiction of an actual fruit.

The debate is not pointless because it has to do with the painter's ambition; one is tempted to see, in the Marquess de Véri's two paintings, proof that after the difficulties Fragonard had had with capricious patrons, after the critics had mocked him, the artist wanted to show that it would be wrong to restrict himself to a single genre and style and that he was also capable of painting serious subjects, as well as to elevate a picture "from the lower genre" to the level of history painting. But is the choice of subjects simply a sign of Fragonard's desire to oblige the critics, who were blinded by a concern for nothing but "genres," to open their eyes? Or, does he not reflect the collector's wish to be free to associate as pendants paintings on very different subjects? These may have been the first signs of the breaking down of the sacrosanct "hierarchy of the genres" that some artists and innovative collectors were calling for. In spite of that apple, then, the two pictures should not necessarily be taken as a deliberate opposition between sacred and profane love.

The Bolt does, at any rate, mark a turning-point in Fragonard's œuvre, and perhaps also in French painting as a whole about 1778–79; it marks the discovery of the potential of a more contrasted chiaroscuro and of satiny fabrics in the Dutch style. Paillet, the expert at the Véri sale in 1785, affirms that the painting gives "a good idea of the progress of our School." Pierre Rosenberg was able to affirm, in 1974, that "one would have to wait until the Salon of 1785 and the *Oath of the Horatii*, to find a more innovative picture in French painting."[15] It is undoubtedly a vital picture, because of its simplification (it could easily be contrasted with *The Swing*), and because of the extraordinary daring of the decentered light, like the halo of a spotlight pointing to the far right, to the bolt, to the young man whose white clothes glare out at us, outlining him sharply in dark shadow on the door, and this movement toward the right only heralds the couple's imminent movement to the left, toward the bed (the spotlight fades, we feel that we should leave them alone). The lovers' dance-like movement, on the tips of their toes, thus comes to life and appears like a kind of pendulum. The importance given to empty space, the dramatic contrasts of light

220 *Young Girl Playing with a Dog on Her Bed*, often called *The Ring Biscuit*. c. 1775. Oil on canvas, 89 × 70 cm. Alte Pinakothek, Bayerische Staatsgemäldesammlungen, Munich (cat.no. 282)

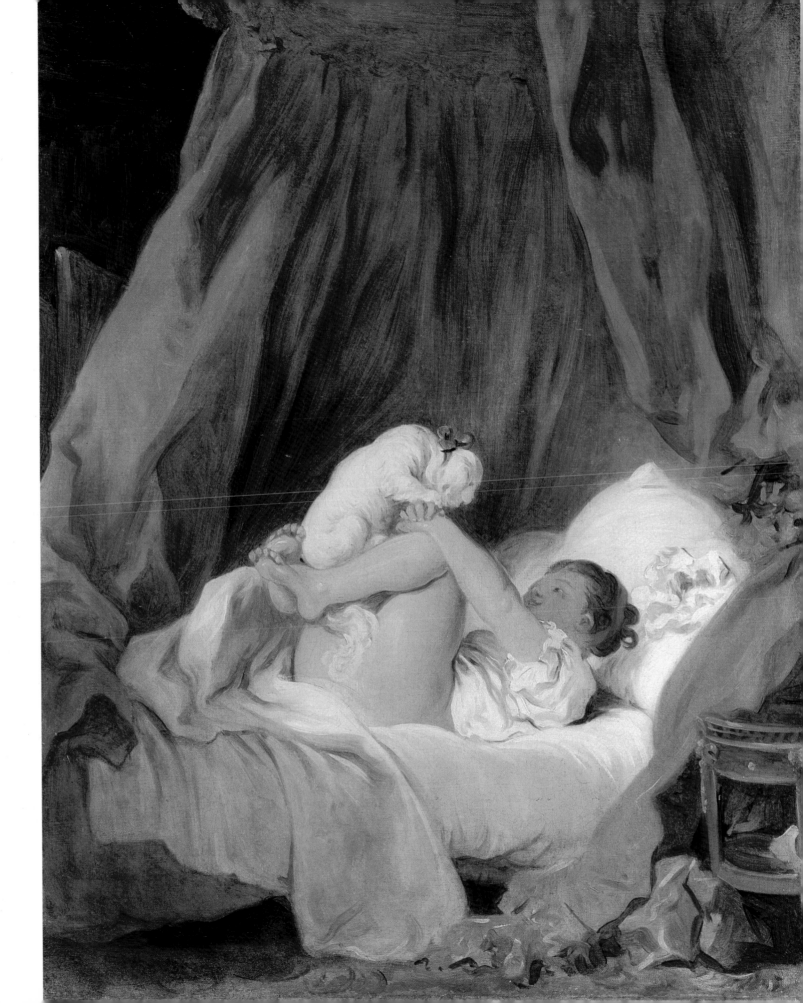

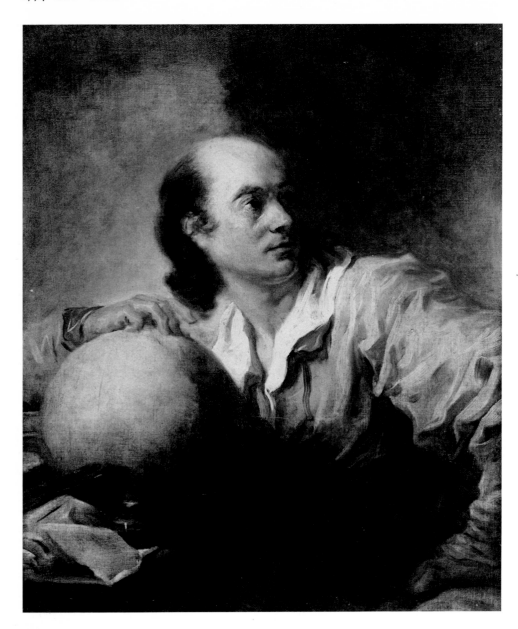

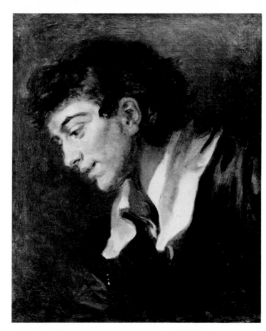

222 *Bust of a Young Man.* c. 1775–78(?). Oil on canvas, 46 × 38 cm. Musée des Beaux-Arts André-Malraux, Le Havre (cat.no. 318)

221 Portrait of a man in Spanish costume, called *The Astronomer Lalande.* c. 1775. Oil on canvas, 70 × 58 cm. Musée du Petit Palais, Paris (cat.no. 279)

and shade, the small part that is played by facial expressions, are precisely the features that characterized the works of the young artists who were most interested in innovation at this time. Examples would include: Suvée's *Birth of the Virgin* of 1779, Peyron's *Bélisaire* of 1779, and Vincent's *Chancelier La Galaizière in Nancy* of 1778. Fragonard was thus recognized with this ambiguous masterpiece as a painter of the avant-garde (that is, if it is not just today that he is recognized as such), and the snubs he had received at Louveciennes had, perhaps, at last been forgotten.

Gallant Subjects and Portraits

The famous *Ring Biscuit* from about 1775 in the Alte Pinakothek in Munich, a golden picture that is briskly executed and reveals some final echoes of Boucher, and the *Bolt* (c. 1778–80) represent two extremes in the style of Fragonard's gallant subjects, which reveal how swift and yet how complex the painter's development really was. There appear to have been many such themes in these years. One should mention *The Useless Resistance* in the

Nationalmuseum of Stockholm, where a complex and skillful game of compressed and opposing forces is played out in an oval format, forces which are twisted in space, in a clash of bouncing forms, involving shins, arms, and bolsters, in a wild flurry of curtains, skirts, and sheets. Like a kaleidoscope its forms are whirling in a spiral range of colors, turning from golden yellow to purplish-red, with magnificent nuances of white and a few tones of pink or pale turquoise.

Does *The New Model*, one of Fragonard's most famous pictures and the glory of the Musée Jacquemart-André, in Paris, also painted in an oval format, date from this period? It fully supports the legend that the painter was a rogue; a woman, probably the young girl's mother, uncovers the future model's bosom before a painter who lifts up her skirts with his maulstick. It is an exquisite picture, though really only a secondary work, almost an illustration, which was painted with the tip of an elegant and nervous brush. The light and golden texture of the pink, yellow, white, and straw colors, and the lady's hair that is worn straight up point to a date about 1775–78.

The *Young Girl Stretched out on Her Bed*, in a Parisian collection, is another of those works with a mischievous eroticism that is both charming and amusing, which are quite modern, and no longer have any of Boucher's excessive simplicity, and which are painted with an almost electrified agility of touch that seems to anticipate Boldini. This work is very different from the round and bouncing forms, from the pink and fiery colors of similarly entertaining pieces like *All in a Blaze*; the forms are refined, in curly or tangled lines, in a fine and hazy light; the work may date from approximately the same time as *The Fête at Saint-Cloud* about 1778–80.[16]

It could be said that, in the domain of portraits, as in his other subjects, Fragonard's investigations and experiments were made using more golden colors and a more restricted pictorial content and less prominent shadows than in the works preceding his trip to Italy. One of the most revealing pictures illustrating this new approach is the famous portrait known as *Lalande* at the Musée du Petit Palais in Paris, and has often been included in the *Figures de Fantaisie*. In fact, even if the half-length portrayal and the pose justify the comparison, the work's much smaller size and, especially, its treatment, exclude the possibility of it dating from the same period. The pictorial content is restricted

223 *Portrait of a Young Girl.* c. 1778. Oil on canvas. 45 × 37 cm. Private Collection, Paris (cat. no. 329)

224 *The Little Coquette.* c. 1778. Oil on panel, 32 × 24 cm. Private Collection, Paris (cat. no. 324)

225 *Young Couple at the Window.* c. 1775–78. Oil on panel, 17 × 13 cm. Musée des Beaux-Arts et d'Archéologie, Besançon (cat. no. 303)

226 *Young Mother and Her Child.* c. 1775–78. Oil on panel, 17 × 11 cm. Musée des Beaux-Arts et d'Archéologie, Besançon (cat. no. 304)

227 Young girl with two doves, called *Portrait of Marie-Catherine Colombe* c. 1775–78. Oil on canvas, diam. 70 cm. Private Collection (cat. no. 302)

by light scumbles that hardly cover a canvas, the grain of which trembles. The brush treatment is generally softer with effects of blending, especially in the face, and little bright accents, added with the tip of a fast brush to the freshly-painted surface, create the light effect. The background, daringly divided into pearl gray and vibrant brown, suggests a complex space and allows the round and prominent form of the head to stand out gently, finding an echo in the ideally geometrical shape of the globe; it recalls *Saint-Non* and *La Bretèche*, treated in adjacent planes with a furious technique. And the face itself, serious, worried rather than triumphant, is quite different from those of the renowned series. It is less a mask than the face of a man. Who was that man, apparently aged about forty? The identification that is most often made, with the astronomer Joseph-Jérôme Lalande (1732–1807), cannot be considered as certain for the resemblance with known portraits of the scientist is not entirely convincing. Moreover, even if it did account for the presence of the globe and the books on which his arm is resting, it would be more difficult to explain the presence of the paintbrushes, the roll of paper, and the bottle (possibly of spirit or of varnish) in the left foreground. One should also note that this is one of the rare pieces in Fragonard's œuvre that could be called a still life, a very distant and very elusive homage to his first teacher, Chardin. Nevertheless, it is difficult to imagine such a work, which was painted rapidly but is precisely delineated and soberly realistic, being

228 Young girl holding a dog and a cat which are playing together, called *Portrait of Adeline Colombe.* c. 1775–78. Oil on canvas, diam. 70 cm. Private Collection (cat. no. 301)

229 *The Billet-Doux,* or *The Love Letter.* c. 1778. Oil on canvas, 83 × 67 cm. The Metropolitan Museum of Art, New York. Collection Julius Bache, 1949 (cat. no. 335)

painted at the time of the *Figures de Fantaisie*.[17] The portraitist seems therefore to have discovered quite different directions and soon, probably as a consequence of the heads he painted from life in brown wash, acquired a taste for more careful studies, in which the brush is controlled or at least no longer plays for its own sake.

We thus have several pictures, studies of heads rather than portraits, which testify to the variety of his experiments in the years after 1774. All of them tend toward a closer study of the models, toward calmer colors and a more restrained luminosity.

222; at. 318

In the Musée des Beaux-Arts André-Malraux in Le Havre, a *Bust of a Young man*, which appears to be a transposition into the technique of oil painting of a sepia wash drawing, is treated in a cursive and rapid way, but the paint becomes lighter, is enlivened by the transparency of the background that employs wide scumbles; and these touches portray the man's brown hair with an almost tactile verisimilitude, and outline the face firmly yet delicately. The palette is restricted to browns and grays, with a few warmer tones in flesh tints; it is a fine life-study, in the Flemish style, which Fragonard was to use again in one of his genre scenes. Similarly, the famous *Bust of a Little Girl*

at. 309

with an Open Book, in the Wallace Collection, also appears, in the firmness of outline that may owe something to an admiration of Greuze, as one of those life-studies, painted with great integrity, in which Fragonard renewed his inspiration as well as his working method.

223; at. 329

The delightful *Portrait of a Young Girl* in a Parisian collection, which has been thought to portray "La Guimard," is a vibrant study in chiaroscuro that contains the energy of Rubens and the seriousness of Rembrandt; it also testifies to what might be called a deepening or a clarifying of Fragonard's art. The sideways movement of the head, a last reminder of the *Figures de Fantaisie*, characterizes a very simple and natural pose that is full of restraint. One sees how, in the lace collar, in the hair, the sparkling touches break up, divide, and intersect, disappearing into the pictorial fabric; the face and neck appear to have the fullness and the flavor of a fruit, but the outlines acquire a moving complexity in the round volumes, which emerge hazily from the half-light.

', 228; Cat. 4, 302

The two famous round portraits of young girls, which are in private collections (one figure is holding a cat and a dog which are fighting; the other is shown with two doves) are traditionally assumed to be portraits of two actresses who were famous at the time, the sisters Marie-Catherine and Adeline Riggieri, known as the Demoiselles Colombe; however, their real identity is not at all certain.[18] The portraits are carefully and smoothly executed and the volumes have a density and a delicacy that make some other female figures, painted for decors about

1770, appear a little schematic or even weak. The round format, less elegant than the oval one, strengthens the feeling of fullness and solidity conveyed by the pictures, both of which date from about 1775–78; the doves, the birds of Venus, are very similar to those in *Nature's Awakening* a painting dating from 1780, which has been lost but had been engraved.

Cat.

Other pictures are even more different from what is traditionally understood by the art of portraiture. Such is the case of the famous *Billet-Doux*, or *The Love Letter*, at the Metropolitan Museum of Art in New York, in which critics have seen Boucher's daughter, Marie-Emilie, who married for the second time in 1773. Her husband's name, Charles-Etienne-Gabriel Cuvillier, may be read on the note. A sparkling style highlights and underlines the forms with fine lines, dabs, or accents indicating shadows, a style that makes the light come alive through the use of hatching and commas. The technique is particularly revealing of Fragonard's work at this time and is close to that of *The Fête at Saint-Cloud*. The canvas is entirely covered, almost in monochrome, in translucent browns and golden tones; the color of the dress, a jade green, indicates the only parts that are in the full light where the green responds to the golden background and reflects the yellow of the curtains; a few pink touches in the flowers, in the cheeks, on the hat ribbon, add a pleasing dissonance. The whole painting, which is drawn as well as painted, becomes a joyful orgy of dabs made with the tip of the brush; the dabs are thinner and more tense than in 1770, the forms are longer, and the overall effect is more transient.

229; Cat.

Another exquisite picture may date from about the same time as *The Billet-Doux* (c. 1778?). *The Little Mischief*, in a private collection, Paris, is characterized by the limpidity of its bright pink and pale green colors, and is also marked by a fine, nimble, and varied touch. It is almost a caricature of a rich little girl, dressed up and with her hair done like a little marquise, with her sumptuous toys and furniture, and yet, the picture is as enchanting as a game and the little girl, playing with her fine Chinese automaton, seems almost as happy as her poor little friends, who are portrayed, in other paintings by Fragonard about the same time, playing with donkeys, cats, and dogs.

Cat

Happy Household Scenes

In fact, the renewed contact with Italy seems to have inspired Fragonard to treat rustic scenes again in the way in which he had painted them about 1760. *Happy Fertility*, also called *The Happy Family* after the title of some prints,

23 Ca

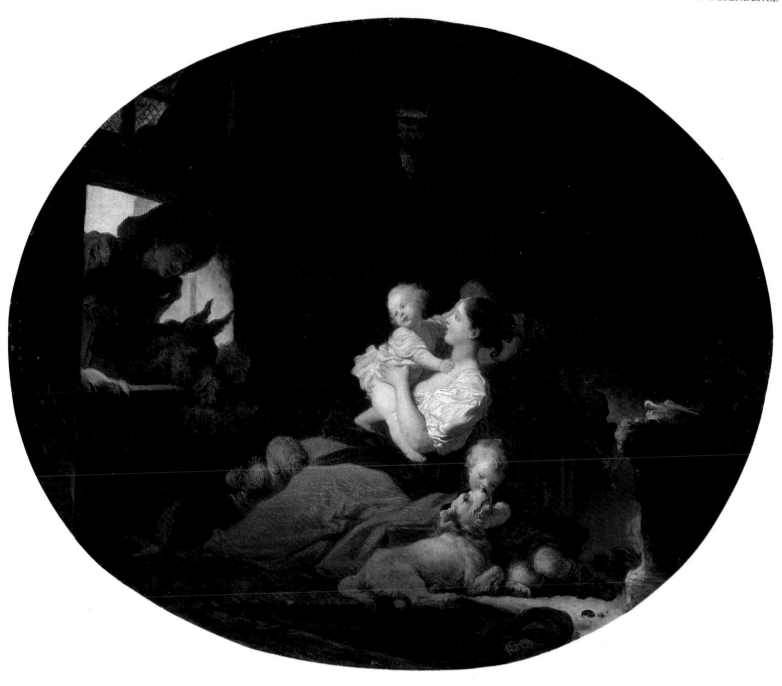

230 *Happy Fertility*, also called *The Happy Family* c. 1776–77. Oil on canvas, 53.9 × 65.1 cm. National Gallery of Art, Washington, D.C., Mrs. W.R. Timken Bequest (cat.no. 311)

presents a particularly elaborate oval composition, painted with great care, which must have been popular because there are several versions of it, one in a private collection, another in the National Gallery of Art in Washington, D.C. The complex setting, showing a peasant interior provisionally installed in some ancient ruins, with a sculpted altar on the right, recalls the quickly-painted sketches from his first stay in Rome, and the arrangement of the planes of this decor, in successive screens, illuminated through a skillful use of light, also recalls such paintings. The forms, which really do turn in space, constitute a masterly con-

structed pyramid, and the group of the mother and the blond-haired child in the middle, which is strongly lit, is outlined against the dark background with the same contrasting power that makes the father and the donkey stand out, conversely, in dark silhouettes against the light space

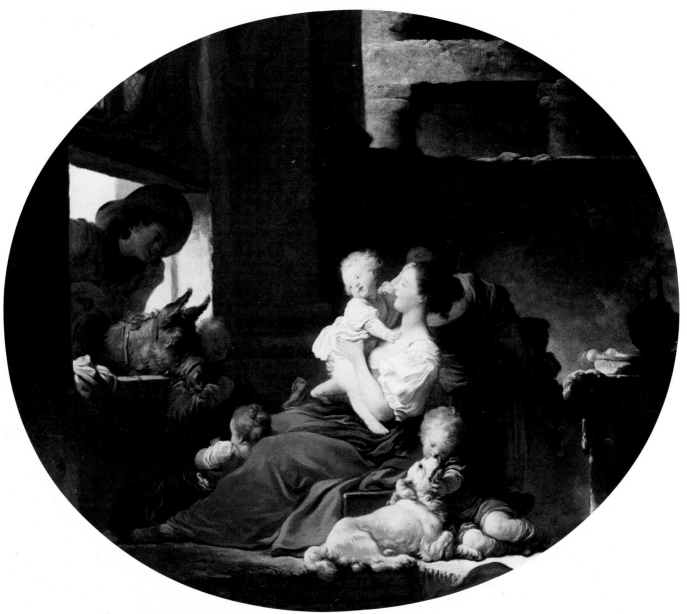

231 *Happy Fertility*, also called *The Happy Family*. c. 1776–77.
Oil on canvas, 54 × 64.8 cm. Private Collection (cat.no. 312)

232 *Maternal Love*. c. 1776–77. Oil on paper, mounted on
canvas, 19 × 22 cm. Private Collection, U.S.A. (cat.no. 313)

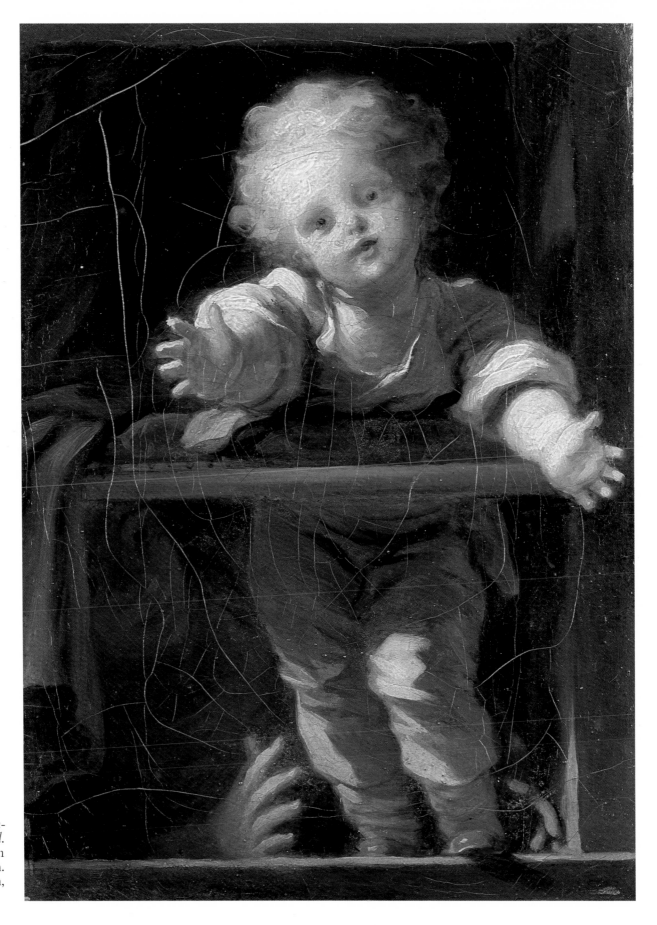

233 *Young Child Standing on the Windowsill.* c. 1775(?). Oil on canvas, 15 × 12 cm. Private Collection, U.S.A. (cat. no. 276)

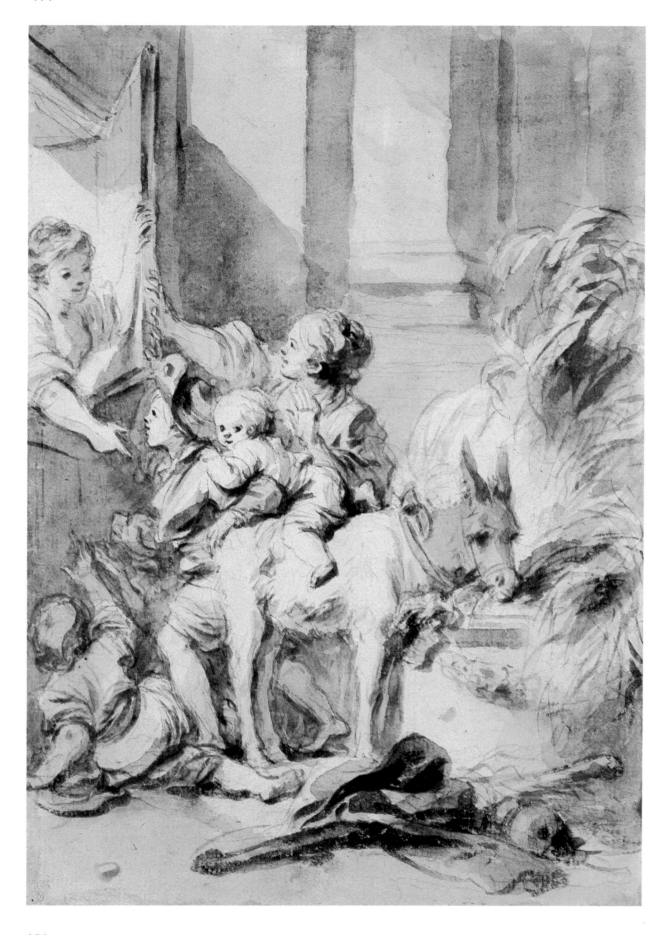

234 *The Donkey's Stable.*
c. 1775(?). Brown wash over
black chalk underdrawing,
23.2 × 16.7 cm. Graphische
Sammlung Albertina, Vienna

235 *Children Playing with a
Donkey,* or *The Donkey's Break-
fast.* c. 1775–78. Brown wash
over black chalk underdraw-
ing, 34 × 49 cm. Fogg Art
Museum, Cambridge, Mass.
Gift of Mrs. Herbart N.
Straus, 1978

of the window. This idea of contrasts and the type of
figures liken the work to the small versions of the *Rest in
Egypt.* In the version of *Happy Fertility,* which is in a private
collection, a balance is achieved between the cold colors,
gray and slate tones, the greenish-blue of some parts of the
drapery and the warm colors, the browns of the depths of
the blond hair and of certain light effects, and the sump-
tuous scarlets of the skirt. The version that is in Wash-
ington, in which the colors are more subdued and warmer
with glowing red half-lights, recalling Rembrandt, pro-
duces quite a different effect.[19]

27 In a famous painting, *The Donkey's Stable* in a private
collection, two children surround a little donkey with
their attentions as he is eating docilely on an ancient
plinth, and seem to be being called by their mother, whose
figure appears through the open door. The picture is made
up of yellows and browns, its pictorial content is limited
and the work may be slightly later than the previous one.
A wash drawing in the Albertina takes up the theme in a
similar composition, but in a vertical format and with
additional characters.[20] The happy family motif is por-
trayed in *The Donkey's Breakfast* in the Fogg Art Museum
in Cambridge, Mass., and in other drawings, all of which

are florid and bushy compositions full of radiant faces.[21] It
is interesting to compare with this group of rustic scenes a
lost drawing, the *Wardrobe,* which we know about because
of the engraving Fragonard himself made of it.[22] This
plate, dated 1778, gives us one of the few chronological
markers that one can be sure of during this period. This
time the picture tells a story that is intended for adults: the
angry parents find their daughter's lover in the family war-
drobe.

The theme of childhood seems to have been invading
Fragonard's painting at the time and two famous pendants,
The Little Preacher in a Parisian collection and *Education
Does All* in the Museu de Arte, São Paulo, can be dated
about 1780. These two delightful little theatrical met-
aphors are detailed paintings, concerned with the repre-
sentation of different materials; we see round faces, full
forms, painted with a light brush but always with a limpid
and vibrant technique, in the bright lemon or golden yel-
low or orange tones of the elements that are lit up, as in
the mahogany-colored shadows.[23]

There are three painted versions of a composition
known as *The Return Home* or *The Reconciliation,* two
paintings that are finely finished (one large one in a Swiss

237;
Cat. 35
236;
Cat. 35

239;
Cat. 31

193

236 *Education Does All.* c. 1780. Oil on canvas, 54 × 65 cm. Museu de Arte, São Paulo (cat.no. 352)

237 *The Little Preacher.* c. 1780. Brown wash over black chalk underdrawing, 34.9 × 46.7 cm. The Armand Hammer Foundation, Los Angeles (cat.no. 351)

238 *The Schoolmistress,* or *Say "Please."* c. 1780. Oil on canvas, 28 × 37 cm. Wallace Collection, London (cat. no. 348)

239 Young couple contemplating a sleeping child, called *The Return Home, The Reconciliation,* or *The Happy Family.* c. 1776–78(?). Oil on canvas, 72 × 92 cm. Private Collection, Switzerland (cat. no. 320)

240 Landscape with a horseman, called *The Glade*, or *The Shepherds*. c. 1766–68 (or c. 1775?). Oil on canvas, 38 × 45 cm. Detroit Institute of Arts (cat. no. 141)

241 *Landscape with a Herd*. c. 1775(?). Brown wash over black chalk underdrawing, 16 × 22.3 cm. Museum of Fine Arts, Budapest

collection and a smaller one in a collection in New York), and quite a large, freely sketched painting that is in a collection in Paris. A third title that is often given to the paintings, *The Happy Family*, seems more appropriate, even though there is a risk of them being confused with other works by Fragonard.[24] One can only analyze the subject of the picture: a young woman is kneeling on a kind of prie-dieu in front of her child, who is asleep in its cradle, and turns toward a young man, who seems to be arriving at the house, taking his hand and apparently inviting him to look at the child. Two little boys are following the man, one takes his hand affectionately; in the background, the grandmother or a servant can be made out. The clothes shown here attract attention; they are by no means contemporary costumes, as in the *Visit to the Foster Mother*, in Washington, D.C., nor are they the cast offs of Italian peasants, but, rather, seventeenth-century clothes. And, rather than being "Spanish costumes," it seems that they are clothes inspired by the Golden Age of Dutch and Flemish painting; the woman's are inspired by Rubens, the man's by Van Ostade or Wouvermans. The sketch in Paris, if it really is a sketch, is different in a few details but especially in the luminous sections, which makes the figures emerge from a dark background in golden brown tones, in the style of Rembrandt; Fragonard uses a rapid and limpid touch here. The option taken in the two "finished" paintings is all the more striking: the delicate, almost cold execution carefully subdues the colors and polishes the

volumes. The room is immersed in shadow, over to the left, and gradually lights up toward the right. On the left, the lit-up cradle emerges from the dark; on the right, the young man is outlined like a dark silhouette, and the old woman behind him is lit up harshly. The effect of the light coming in from outside is thus successfully conveyed. In the New York version, rays of light falling diagonally even make the luminous part brighter. There is elegance and power here, and a new and unexpected contrast. Alexandre-Evariste Fragonard, the painter's son, who will be mentioned again later, was to draw inspiration from such innovations for his own paintings. What should be stressed is that Fragonard gave his "genre scenes" a certain timeless quality because of the neutrality of the costumes; his scene is transposed into a rustic realm or into another country. Even the lovers in *The Bolt* acquire a generalized quality from the simplification of their clothes and of their setting.

The Fête at Saint-Cloud and Other Landscapes

It is certain that, during these years, Fragonard continued to paint landscapes in the style of Ruisdael; a painting in a private collection, *The Herd*, bears the date *1775*. With its c

242 *The Sunny Hillside*. c. 1775. Brown wash, 34.4 × 46.7 cm. The Pierpont Morgan Library, New York

pendant, *The Two Windmills*, it provides evidence of the same evolution toward a more attentively realistic art than is seen in the portraits or genre scenes. Even the dead trees inscribe very real silhouettes onto the sky and no longer capriciously decorative ones. Landscapes like *The Glade* in the Detroit Institute of Arts, or *The Three Trees*, in a private collection, have similar characteristics. In the same way, the admirable *Sunny Hillside*, a wash drawing in the Pierpoint Morgan Library in New York, is finely descriptive, both spacious and generous, and could not have been executed anywhere except in the open air.[25]

Fragonard had probably already painted large and animated landscapes that were to have a decorative purpose. It has already been suggested that that was probably true of *The Game of Battledore*, and of *The Swing*, of which only a fragment remains, in the Musée des Beaux-Arts, Chambéry. It seems that the fashion for these rectangular decor-

197

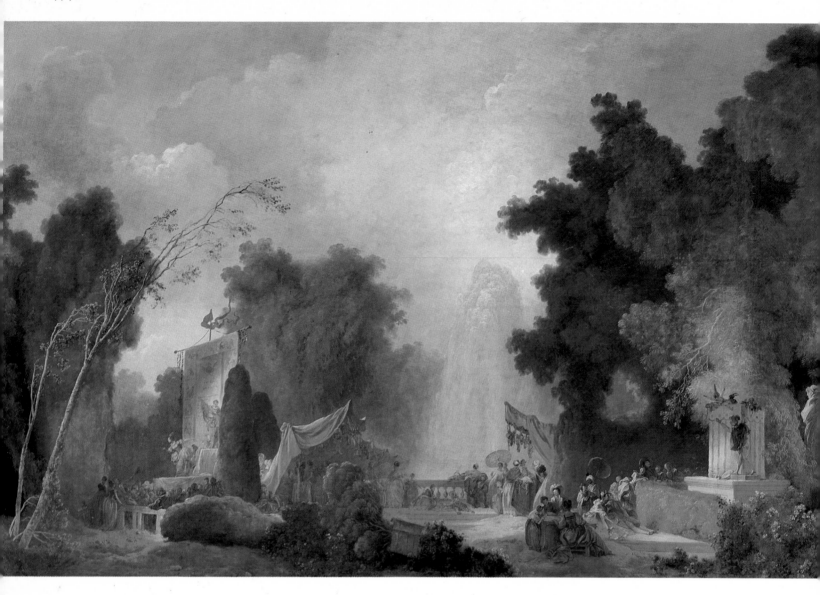

243–44 View of a park with popular amusements, called *The Fête at Saint-Cloud*. c. 1778-80. Oil on canvas, 216 × 335 cm. Banque de France, Paris (cat.no. 342) and detail

243–44;
Cat. 342

ative panels representing lively landscapes and small figures had spread. Does this reveal the influence of his friend, Hubert Robert, who was a prolific specialist of such works?

If the term did not have a certain pejorative connotation, *The Fête at Saint-Cloud* (Banque de France, Paris) would have to be described as a "decorative panel." It may well be Fragonard's most complete and most admirable painting, one of the richest in poetry, a kind of résumé of all his painting and of all that was most original in eighteenth-century painting. Its history remains obscure and it is not certain that, as is generally maintained, it was commissioned by the Duke de Penthièvre for the Hôtel de Toulouse, whose buildings form part of the present Banque de France, and where the painting has been hanging since at least the beginning of the nineteenth century. Similarly, the title by which the picture is universally known is purely traditional.[26]

A tremendous distance separates such a painting from the panels of *The Pursuit of Love* in the Frick Collection; there is something softer in it, a more extensive and peaceful touch, a more delicate feeling for nature as well as a lyrical effusion that few French landscape paintings of the eighteenth century can match. One would have to go back

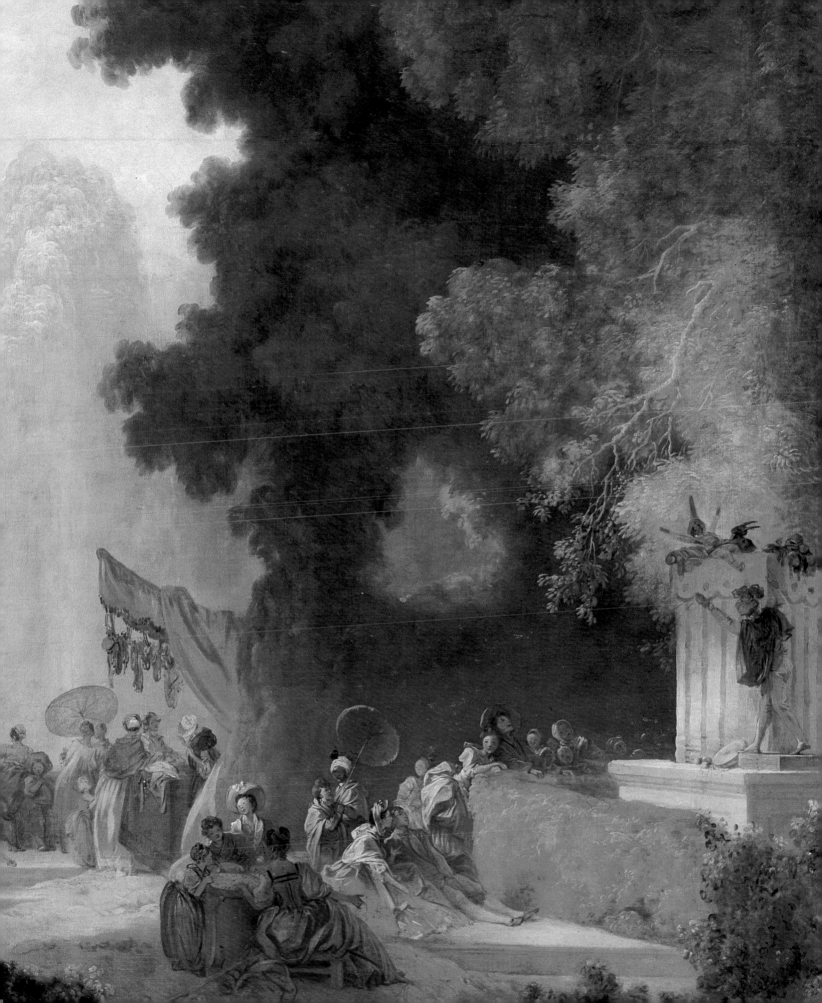

245 *The Marionettes.* c. 1778–80. Oil on canvas, 67 × 86 cm. Private Collection, Paris (cat. no. 343)

to the *Pilgrimage to Cythera* by Watteau, which is quite precisely evoked here by the lace-effect of the autumnal foliage and by the sculpted fountain on the right, as well as by the note of fine melancholy. Fragonard's park appears almost deserted, in a late afternoon light at the end of summer. The two performances, that of the buffoons and that of the puppeteers, and the puppets offered for sale, situate the scene, in the world of the theater, of illusion, in which the actors are more real than the audience, in which the puppets imitate the destinies of men, in which the world of adults and that of children are mingled. It is a marvelous horizontal display with different centers of interest stretching the picture and giving it the panoramic aspect that is necessary in a decor. The center of the picture appears to have been evacuated, between the orange tree in its box, which has been knocked over, and the foaming fountain; the space comes to life and is twisted in a grand about-turn by the simultaneous and successive sight of two performances, one seen from the front, the other from the back, in the two wings of the large canvas.

246 *The Charlatans.* c. 1778–80. Oil on canvas, 49 × 38.7 cm. Private Collection, (cat. no. 344 a)

247 *The Toy Seller.* c. 1778–80. Oil on canvas, 40.6 × 34 cm. Private Collection, U.S.A. (cat. no. 344 b)

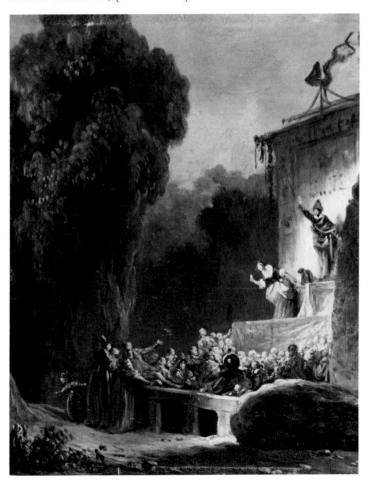

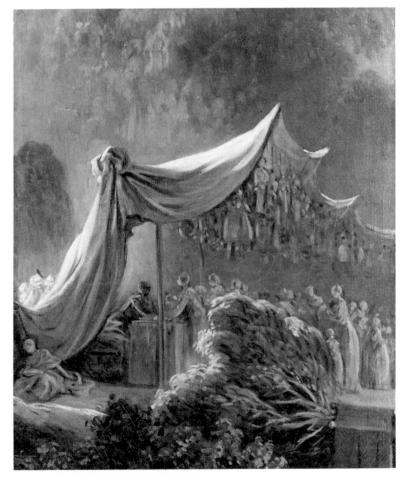

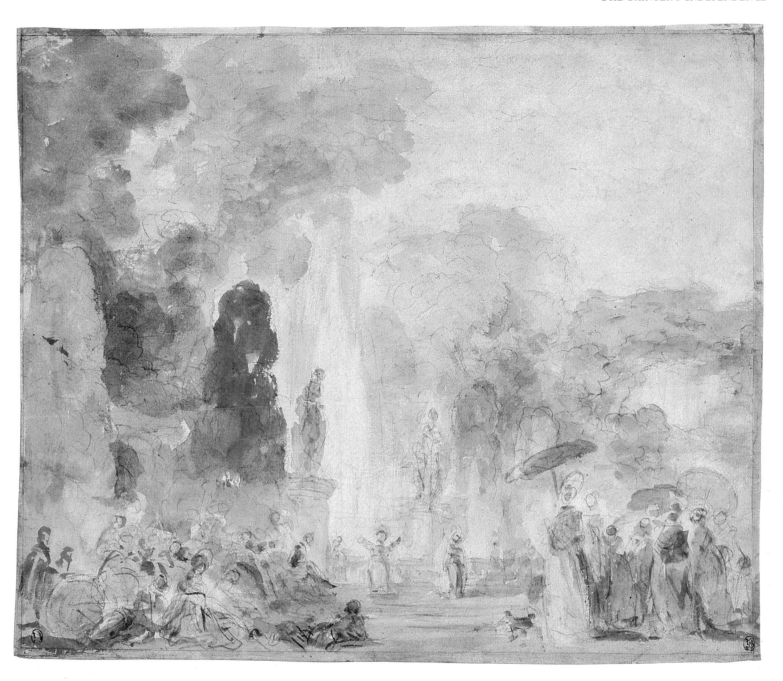

248 View of a park animated with figures, called *The Fête at Saint-Cloud*. c. 1778–80. Black chalk, brown wash, and watercolor, 34.3 × 42.5 cm. The Metropolitan Museum of Art, New York. Collection Robert Lehman, 1975

The foliage of the bushes and the tall trees, the clouds, and the fountain belong to a single universe that is gentle and mobile, and a golden haze reigns in every part of the picture. A few touches are blended into it and the lines of the folds of a skirt or of a scarf are thrown in with the confidence of an oriental calligrapher; the lines of a bush, the black eyes of a child, the outline of leaves that tremble in the rays of the setting sun are all here. The colors assume truly musical qualities in the harmony of the most diverse greens, from olive to emerald and gold; they resonate in the turquoise tones of the sky and in some of the clothing in the pinks and oranges, and especially the few fine reds that are thrown in here and there, and in the black boy's parasol or the buffoons' banner.

The Fête at Saint-Cloud, which is masterfully constructed in alternating areas of shade, full light, and half-tones, has all the charm of an improvisation. It seems, however, that

201

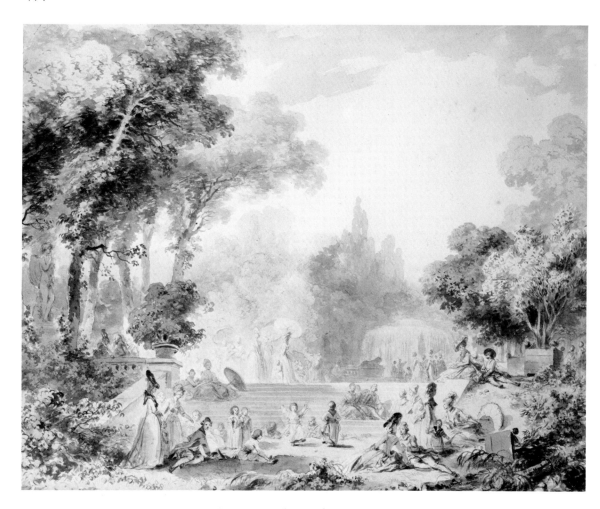

249 View of a park animated with figures. c. 1778–80. Black chalk and brown wash, 34.8 × 43.1 cm. Rijksmuseum, Amsterdam

245;
Cat. 343

Fragonard made use of three slightly earlier pictures in its elaboration. The finest one, called *The Marionettes*, is in a Parisian collection. In it one finds, in a horizontal format, an arrangement that is very close to that of the right section of the painting in the Banque de France. The larger number of characters, the more complex nature of the whole arrangement, which is enriched by a thousand whimsical strokes of the brush and by refinements of light, and especially the different proportions cause one to hesitate before concluding that such a painting could have been intended as a sketch. Is it not, rather, an independent work? In fact, this painting might have led to the idea of the large canvas, with its simplified and more comprehensible effects. In contrast, the two works which were in the Bührle Collection for many years, could be sketches for the two principal elements of the left section, painted once Fragonard had decided on the elaboration of the large work. They are sketches that delineate vigorously, almost harshly, the part played by light and shade; they were taken up with only minor variations in the definitive painting. Certain elements in *The Toy Seller*, such as the

246, 247;
Cat. 344

tree in the box that has been knocked over, or, on the left, the lit-up audience and the seated woman with her basket, which are also found in the large painting, can only be explained if this is indeed a sketch. One may also wonder whether these pictures were not meant as two parts of a single canvas, as the composition of *The Toy Seller* is so unusual. It would not have been illogical if the painter had made a sketch corresponding to the left side of the projected painting. Several drawings can also be linked to the painting in the Banque de France, including a watercolor, in the Metropolitan Museum of Art in New York, and a wash drawing in the Rijksmuseum in Amsterdam, whose figures reveal a very similar style.[27]

Two large paintings, which are really a single painting, as Pierre de Nolhac realized years ago, hang in the National Gallery of Art, in Washington, D.C., under the titles *Blindman's Buff* and *The Swing*. They could both be called *Entertainments in an Italian Park*. They show a large and lively decorative landscape, which has been split and whose motifs correspond exactly from one work to the other. The painting is of the same height as *The Fête at*

Saint-Cloud but is longer by about fifty centimeters. One may wonder whether both paintings did not form part of a single set, commissioned to have the precise dimensions of the panels of a salon. The very different states of preservation do not help in coming to any conclusion. The painting in Paris has a yellowish appearance, because of the layers of old varnish; the one in Washington, apart from its unfortunate mutilation, is worn and has been extensively cleaned, giving it bright, slightly acid, and not very pleasant colors. The composition of one work, with two masses framing a central void, would seem to correspond well to that of the other, with a central mass framed by two vistas; the subjects would be clearly opposed: on the one hand a French, or rather English-style park, with popular entertainments; on the other, an Italian park with amusements for the aristocracy. The composition in Washington, once its unity is restored, takes up the elements of Fragonard's Italian landscapes, with tall cypresses and statues, in a violent and torrential movement that is more Baroque than the style of the *Fête*; the pieces of land shown are organized theatrically in a complex arrangement, with a central mound; in the foreground, in front of the slope, the table that has been used for the meal is being cleared and, on the right, a couple is amusing itself by tossing an unfortunate little white dog into the water. This admirable picture, which has been somewhat overlooked, remains impossible to judge properly until it is put together as a single painting again; it allows one to appreciate the rumbling and tumultuous movement of the ground and of the masses of greenery, which rise with the force of a gradual explosion; the clouds themselves, whether lit up or dark, acquire plumes in the same exhilaration, echoing this irresistible rhythm. Parts of the painting are dominated by an anecdotal aspect, but above the frivolous movement of the groups of people, right at the top, on the terrace, a statue of Minerva, protecting or threatening the scene, seems to add an element of permanence.

Two other paintings—which also came to the National Gallery of Art, but after following a different itinerary that is not documented beyond the Romantic period—appear very close to the large panel of the *Entertainments in an Italian Park* by their themes, arrangement, technique, and colors. Did this *Game of Horse and Rider*, and this *Game of Hot Cockles*, whose figures are of the same scale, spirit, and texture as those of the large canvas, form part of the same decorative series? There seems to be a possible link between them. Once again, it appears that these are pictures that have been mutilated; the upper part of the trees has been cut in a quite surprising way and there is nothing to prevent one from supposing that the two works are simply the lower parts of panels in an extended vertical

format, in which elaborate and fantastic foliage used to rise up much higher. Hubert Robert painted many decorative works of such proportions. It would be imprudent to make conclusive judgments, but it might even be imagined that *Horse and Rider* and *Hot Cockles*, fragments of true vertical panels, may have formed part of the same series as the *Entertainments in an Italian Park* and therefore, perhaps, as *The Fête at Saint-Cloud*, which would then bring together three popular entertainments (*Marionettes, Acrobats,* and *Horse and Rider*), and three aristocratic entertainments (*Blindman's Buff,* the *Swing,* and *Hot Cockles*). On the other hand the paintings may have formed part of different decorative series, parts of which have since been lost. There is one mention of Fragonard's series of paintings on canvas, which featured in the Marchal de Saincy's sale, in the spring of 1789, but no details were provided which would enable a link to be established with the paintings in Washington or in Paris. The author of the catalogue only cites "five large pictures, composed and executed to form the decor of a salon; they represent various landscape subjects in varied and charming sites and are adorned with interesting figures." Fragonard probably painted more than one decor of this type. With their figures in contemporary costumes, such paintings must have gone out of fashion more rapidly than Hubert Robert's fantasies in the antique style, and many must have been destroyed. Such pictures must be considered in the context of the decorative role for which they were conceived; they form coherent sets, a fact that enables them to be seen not as simple jests or even as merely exquisite and poetic examples of painting, but as one of the most ambitious undertakings of eighteenth-century French painting. The onlooker was thrust into a realm of painting that encompassed an entire decor in an even more complete way than at Louveciennes, rather like the fresco decorations in villas by Tiepolo. In spite of the date that is usually given to *The Fête at Saint-Cloud*, 1775 (although what evidence this date is based upon is by no means clear), this set of paintings may be given a later date, 1778 or even 1780, as the study of the costumes seems to prove.[28]

Cat. L141-4.

Next double page

250 View of a park, called *Game of Blindman's Buff.* c. 1778–80. Oil on canvas, 216.2 × 197.8 cm. National Gallery of Art, Washington, D.C. Collection Samuel H. Kress (cat. no. 339a)

251 View of a park, called *The Swing.* c. 1778–80. Oil on canvas, 215.9 × 185.5 cm. National Gallery of Art, Washington, D.C. Collection Samuel H. Kress (cat. no. 339b)

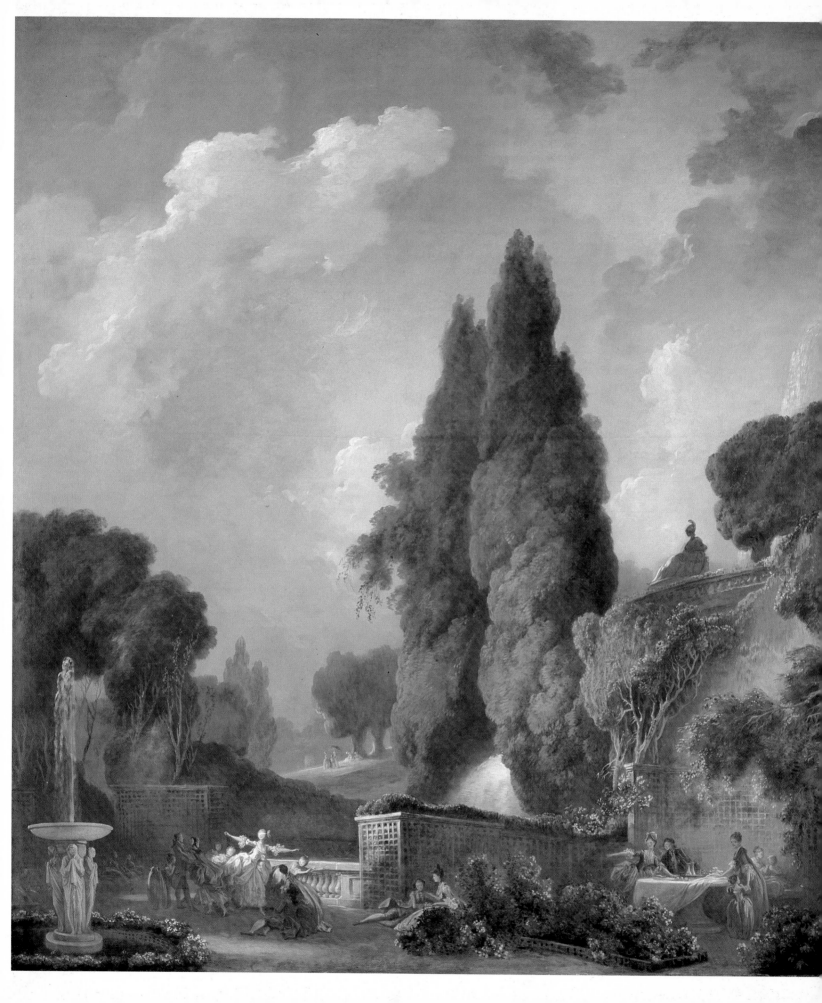

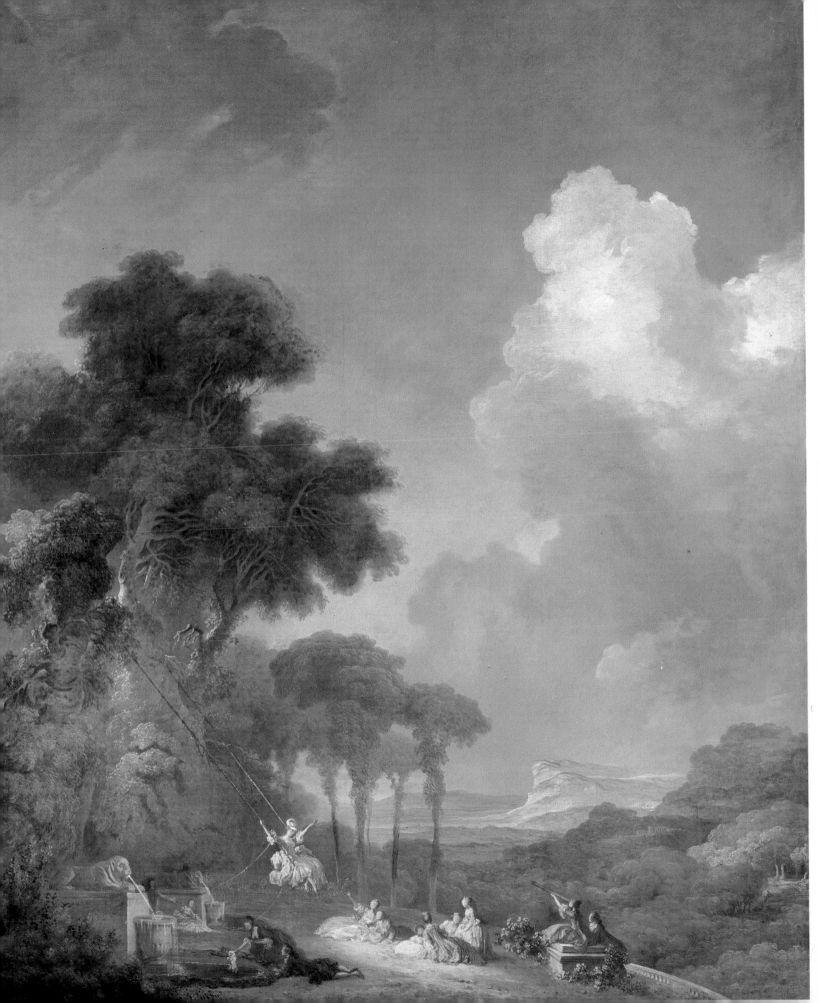

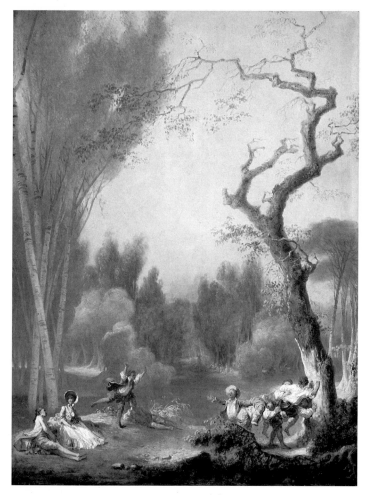

252 View of a park, called *A Game of Horse and Rider*. c. 1778–80. Oil on canvas, 115 × 87.5 cm. National Gallery of Art, Washington, D.C. Collection Samuel H. Kress (cat.no. 340)

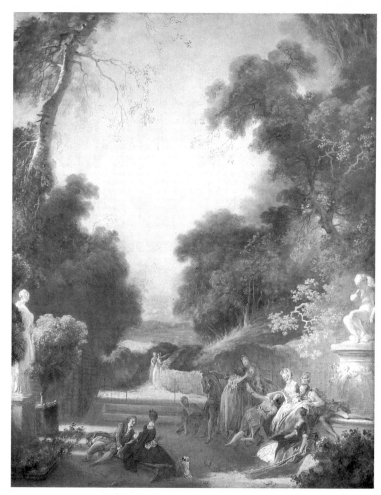

253 View of a park, called *A Game of Hot Cockles*. c. 1778–80. Oil on canvas, 115.5 × 91.5 cm. National Gallery of Art, Washington, D.C. Collection Samuel H. Kress (cat.no. 341)

These phenomenal years, in which Fragonard made use of all means, from Rembrandt-like monochrome to the most colorful and sumptuous effects, were years of experimentation and of deepening knowledge. It is difficult to establish a logical order as the dates of the paintings remain annoyingly imprecise, yet it is obvious that several styles were intertwined in these years. One style is distinguished by clarity and sparkle, in which finer and finer touches are made on frequently transparent grounds, with bright colors dominated by pinks and greens and, especially, yellows; this is the style of the erotic subjects, of *The Billet-Doux*, and of the large decorative landscapes. The second style is marked by chiaroscuro, and a more blended technique. The first manner corresponds to the most charming paintings, light subjects or decorations in which swiftness of movement adds to their vitality and the proportions of the figures are elongated to the point of extravagance, and acquire fashionable elegance. The second manner is associated with investigations into light and shade, sometimes verging on monochrome in the translucent or thickened areas. It was this second direction that Fragonard would increasingly favor .

Chapter IX
c. 1780–89 Paris
Crisis or Renewal?

Fragonard and Neoclassicism

1780 did not only mark the start of a new decade, it was also an important date in the history of French painting because of the warning shot that was fired by Jacques-Louis David; the works he exhibited at the Salon, *Saint-Roch* and *Bélisaire*, relegated the large history paintings by Joseph Suvée, Nicolas-Guy Brenet, François-André Vincent, and others to the attic, in terms of art history.

Too little is known about the chronology of Fragonard's painting to be able to retrace his development year by year. *The Bolt* may have been painted shortly before 1780; it is also a revolutionary painting, in its own right, as has already been pointed out. Fragonard's works dating from this period have often been misunderstood. It would be a serious error to see the painter as an isolated figure, a painter overtaken by the implacable advance of the Neoclassical movement, and who "adapted to suit the taste of the day." However, what was actually taking place was a dual and fundamental movement, which, from about 1750, underpinned the development of French painting: the popularity of grand subjects, which had in fact begun earlier and had only just been maintained by successive Directors of the Painters to the King, the Neoclassical style, initiated by Vien, and, on the other hand (as a reaction against the light and bright colors inherited from Boucher), the need for a powerful and expressive style of painting whose forms stand out clearly and which is painted from life. The two movements came together in David, who was the first painter "to match the subject to the means employed to represent it...," as Antoine Schnapper puts it, quite succinctly.[1] *Bélisaire*, or *The Oath of the Horatii*, was not simply an antique subject, a frieze-like composition; it also brought about the effective representation of

light, a subdued and rich color-range, a feeling for the pictorial aspects of life, with a vibrant touch. By comparison with him, all the other "innovative" painters would look weak, cold, and garish.

But Fragonard, in a different register and through his art, of which the *Coresus* was an early manifestation, was also an artist who completely changed the language of painting, utilizing empty spaces, avoiding the prestige of a technique, penetrating spaces less and less deeply, and arranging groups progressively, parallel to the picture, making delicate forms stand out from the background.

Fragonard had already painted amorous allegories; *The Dream of Love*, or *The Warrior's Dream*, in the Louvre, may Cat. 253 even date from before the Italian journey of 1773–74. It seems that after *The Bolt* Fragonard painted many small allegorical pictures, often on amorous themes, often in an antique style and as night scenes. One of these paintings appears, unfortunately, to have been destroyed during the Second World War. It was not on an amorous subject or a night scene, but its allegorical vocabulary allows it to be studied in such a context. This work *The Elements Pay* Cat. 354 *Homage to Nature,* also known as *Nature's Awakening,* bore the date 1780. The composition, which is very elaborate and possibly the result of a commission, considering the ingenious and complex subject, showed, on the edge of a grove with rustling foliage (recalling that of *The Swing*), a statue of Nature, draped and with her eyes covered by a veil and holding a cup. A cassolette is burning in front of her. Cupids are flying around her; they seem to be praying and are kissing her feet. Other cupids, in the foreground, are emerging from the water and are offering her shells and coral; two slightly pathetic lions are lying prostrate, brought under control by a cupid who also bows before the statue; higher up, an eagle is holding a thunderbolt in

254

255

256

254 *Sultana on an Ottoman.* c. 1776–78(?). Oil on canvas, 33 × 22 cm. Ball State University Art Gallery, Muncie, Indiana. On permanent loan from the Collection E. Arthur Ball, Ball Brothers Foundation, 1951 (cat. no. 325)

255 *Portrait of a Young Woman as a Sultana.* c. 1772. Oil on canvas, 97 × 81 cm. Private Collection (cat. no. 266)

256 Carle Van Loo (1705–1765). *The Sultana.* 1754. Oil on canvas, 121 × 95 cm. Private Collection



its claws; above it, doves are flying about. The work contains all the elements of an illustration that is treated with charm and finesse, that is full of inventiveness and humor but without any true lyricism. What we see here is a cheerful and almost farcical Antiquity, portrayed in a bouncing rhythm of wavelets, of plumes of smoke, of rose bushes, and of rustling wings.

The Vow of Love is one of Fragonard's most renowned works; it was made widely known by several editions of prints, countless numbers of which were printed and sold. Its success was all the greater because it was on a very respectable subject, showing fully dressed characters, and Mathieu's engraving was used as a pendant to Launay's engraving of the *Good Mother*.[2] In the middle of a park, on a clear night and in front of a statue of Love, a very young couple is embracing and making a vow on a marble plaque held by little cupids and bearing the words, "Vow to love for the rest of one's life." The engraved picture seems to have been the one that was in the Rothschild Collections in Frankfurt-am-Main and then in London; it is fully executed and quivers in the pale ray of moonlight that shines down on the couple. It is an exquisite image of youth, of purity and of lyricism, which pleases simple souls, and simple souls are right to like it. Another version of the composition, which is rectangular, lightly sketched in greenish and brown tones with added yellow, and which is in a poor state, is in the Musée Fragonard, in Grasse, having been deposited there by the Louvre, to which it had been bequeathed by a great-grandniece of Fragonard's. Neglected until now, it may well antedate the Rothschild version. The drawings associated with *The Vow of Love* are also rectangular,[3] especially a marvelous wash drawing in which the proliferating and discontinuous forms are dissolved in a whirling bouquet, a mad scramble of touches of wash and of cursive lines; this is luminous Tachisme, a metaphor of ecstasy. As in *The Bolt*, the couple embrace in a movement that has the impeccable elegance of a dance step. But here, it is less violent and evokes the rhythm of the waltz, which pulls the whole composition into a whirl of light rapture; and the oval format that was finally chosen successfully extends this idea. *The Vow of Love* is situated halfway between allegory and the amorous scene in a park. But the new element, from an artistic and emotional point of view, is that this is a night scene; it places the picture in a new register, which was to be that of Romanticism.

With *The Invocation to Love* one changes register and enters fully into the repertoire of Antiquity. The park is reduced to a dark background, in front of which is seen the young girl and the base of the statue, standing out, struck by a ray of light, making them almost phosphorescent; the upper part of the statue is mysterious and remains in a

257 *The Vow of Love.* c. 1780(?). Oil on canvas, 62 × 51 cm. Musée Fragonard, Grasse (cat. no. 364)

half-light, as though to signify the indifference of the god Cupid to the prayers of the beautiful girl who is in love. The faces do not count; it is as though they were wiped out by the luminous effect; the only things that matter are the solid arabesque of light and the tension of the diagonal movement that crosses the picture. As in *The Bolt*, the organization of the picture is determined by this diagonal, which pushes the whole of the upper left half of the picture into an empty darkness. But the round and solid forms affirm their weight and stand out well in space, and the weeping girl, the statue, and its plinth seem to form a single sculpted group. It is reminiscent of the painted sculptures of a painter like Piat Sauvage, arranged in a frieze in front of a background that may be of black stone. Here, then, is a "Neoclassical" masterpiece that bears no influence either of Joseph-Marie Vien or Louis Lagrenée. The hard volumes remain full of life and generously spread out in space; the brightly-lit forms stand out against a dark background and are then outlined in contre-jour

258 *The Invocation to Love*, or *The Votive Offering to Love*. c. 1785. Oil on canvas, 52 × 63 cm. Private Collection, New York (cat.no. 377)

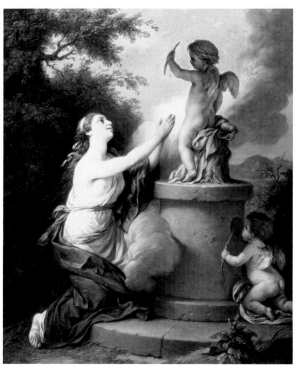

259 Carle Van Loo (1705–1765). *Homage to Love*. 1760. Lost painting. Engraving by J.-B. de Lorraine, 1772

260 Jean-Louis Lagrenée (1725–1805). *The Prayer to Love*. c. 1780–90(?). Oil on panel, 44.5 × 36 cm. Private Collection, Paris

261 *The Invocation to Love*, or *The Votive Offering to Love*. c. 1785. Oil on panel, 24 × 32.5 cm. The Louvre, Paris (cat. no. 378)

262 *The Invocation to Love*, or *The Votive Offering to Love*. c. 1785. Brown wash, 33.5 × 41.6 cm. The Cleveland Museum of Art. Grace Rainey Rogers Fund

263 *The Fountain of Love.* c. 1785. Oil on canvas, 47 × 37.5 cm. Private Collection, U.S.A. (cat.no. 374)

264 *The Fountain of Love.* c. 1785. Oil on canvas, 64 × 56 cm. Wallace Collection, London (cat.no. 373)

against the background, which becomes brighter, in a way that is baroque in spirit and enlivens the effect. The composition unfolds *almost* like a frieze, an important qualification; in fact, the movement starting from the young woman's foot goes some way into the picture, without being really parallel to the plane of the picture. This tiny distance and the luminous part give the work a dynamism and a restrained energy. Painting sculptural, moonlike effects in an antique vein, Fragonard remains ardent and tense; he creates his own Neoclassicism.[4]

The sketch of *The Invocation to Love*, in the Louvre, has always been much admired as a little gem, painted on a panel, with a texture that is a poem of pure emotion, in which everything moves and glistens—the fur-like tones, the blond hair, and the wine color of a piece of drapery. This barely sketched-out work is actually more touching than the definitive painting.

A clear development seems to be revealed in *The Fountain of Love*, one of the treasures of the Wallace Collection and one of the summits of Fragonard's œuvre. The empti-

265 *The Sacrifice of the Rose.* c. 1788–90. Oil on canvas, 65 × 54 cm. Private Collection, California (cat. no. 385)

ness of night has taken over the upper part of the canvas; the leaning stance of the girl in *The Invocation to Love* and her almost squat appearance, square with the ground, have given way to light figures who seem to be caught in mid-flight, and whose parallel movement evokes that of Michelangelo's famous *Runners*; the forms are more fluent, rather slender, of a Hellenistic or Bellifontaine fineness, the flowing drapery is swept away and the bodies appear practically naked. Little cupids move about, ready to offer the thirsty lovers the cup that will quench their thirst. Yet there is none of the slightly gratuitous bustle, fever, or flurry of emotion that almost makes *The Elements Pay Homage to Nature* into an anecdote. What a fine understanding of Antiquity Fragonard reveals here; the two pro-

files, in the middle, are as bright as antique medals, the man's repeating the woman's like an echo; and her body stands out with the elegance of a cameo against the background, where one can just see some dark foliage.

A marvelous sketch of *The Fountain of Love* in tones of mother-of-pearl (private collection), shows how carefully the painting was elaborated; all the elements are present but the unerring arabesque of light in the gray and greenish monochrome of the picture in the Wallace Collection, which is very close to Leonardo, has still not been captured.

The Sacrifice of the Rose, of which Fragonard painted several versions (in private collections), is quite different because of its fuller composition, its sinuous rhythms,

266 *The Sacrifice of the Rose.* c. 1785(?). Brown and gray wash, watercolor over black chalk underdrawing. The Minneapolis Institute of Arts. Gift of Mr. and Mrs. Clinton Morrison, 1983

arranged in space in a complicated way, the rounder and heavier appearance of its figures, and the insistent character of the erotic metaphor. The elements in this picture anticipate the painting of Pierre-Paul Prud'hon, who is supposed to have copied it.[5] And in the paintings of Jean-Baptiste Regnault, who liked to set lovingly moulded nudes against a nocturnal background, there is the extension or the consequence of a whole section of Fragonard's work in the 1780s. With these works, in which the influence of the shining figures, standing out against a nocturnal background and seeming to be lit from inside, of Adriaan Van der Werff (who was much admired at the time) may have played a role, Fragonard may, in fact, stand at the origin of a whole current of non-Davidian

Neoclassical painting; it was this current that was to be marked, in François Gérard, Anne-Louis Girodet, or Pierre Guérin, by a taste for unrealistic effects, nocturnal atmospheres and faded tones. One senses to what an extent labels such as Neoclassicism or Romanticism only partly define such a current.[6]

Marguerite Gérard: Pupil and Collaborator

These were important years for the Fragonard family; a son, christened Alexandre-Evariste, was born in Grasse on October 26, 1780. Fragonard had remained in Paris, but

267 *Sappho Inspired by Cupid.* c. 1780. Oil on canvas, 63 × 53.3 cm. Private Collection, Switzerland (cat. no. 355)

268 *Sappho,* or *The Muse and Cupid.* c. 1780–85. Oil on canvas, 30.8 × 22.2 cm. Private Collection (cat. no. 358)

perhaps while she was pregnant, Marie-Anne wanted to be with her family again and to have her baby in her native city.[7] On March 4, 1781, the painter's father, François Fragonard, died in Grasse at the age of eighty-one.[8] And a few years later, an event occurred that was a cruel blow to Fragonard, the death of his daughter, at the age of eighteen; Rosalie died of an unidentified illness on October 8, 1788. Her father had drawn her many times before she died. She had been staying, probably in order to rest, in the Isle Adam, near Paris, at the Château de Cassan, the country home of Bergeret, the son of the great artlover, who had died in 1785.[9] The quarrels that had followed their Italian journey had been forgotten and Fragonard appears to have found true friends in the Bergerets, father and son.

No mention has so far been made here of Marguerite Gérard, Marie-Anne Fragonard's young sister. She had come to Paris from Grasse when she was about fourteen, about 1775, and had gone to live in the Fragonards' home.[10] She very soon took drawing lessons from her brother-in-law, who was twenty-nine years her senior. From 1778 she worked on several engravings, based on his drawings and with his help.[11] Marguerite, who was a meek and gifted student, seems to have assimilated the master's style and to have helped him. The part she may have played in the execution of his works in the 1780s and 90s is still the subject of debate and this problem has largely contributed to the vague idea that we now have of Fragonard's late work. It is therefore important to know what was painted by whom. And in order to find that out one has to rely on the evidence that has come down to us, signed works, engraved works bearing one of their names, or both, works exhibited or sold in Fragonard's lifetime under one or other, or both, their names. From about 1780, Marguerite Gérard's collaboration with Fragonard on his paintings was, in all probability, frequent, extensive, and assumed many different forms.

The most famous and least contentious case is that of the two pendants now in the Fogg Art Museum, in Cam-

269 *Seated Young Girl* (probably Rosalie Fragonard). 1785. Red chalk, 22.5 × 17.2 cm. Courtauld Institute Galleries, London. Collection Count Antoine Seilern

270 Fragonard and Marguerite Gérard. *The First Step of Infancy.* c. 1785. Oil on canvas, 44 × 55 cm. Fogg Art Museum, Cambridge, Mass. Gift of Charles E. Dunlap (cat. no. 409)

270;
Cat. 409
bridge, Mass., *The First Step of Infancy* and *The Beloved Child* engraved in 1786 by Gérard Vidal and Nicolas Regnault and bearing the inscription: "painted by M. Fragonard and Mlle. Gérard." The paintings, which were probably painted about 1785, appear to have been largely the work of Fragonard rather than that of his student. In *The First Step*, only the young mother, sitting on the right, with the rather cold purple passage of the satin dress, seems to be

271;
Cat. 410

271 Fragonard and Marguerite Gérard. *The Beloved Child*, or *The Walk*. c. 1785. Oil on canvas, 44 × 55 cm. Fogg Art Museum, Cambridge, Mass. Gift of Charles E. Dunlap (cat. no. 410)

272 Fragonard and Marguerite Gérard. Young woman playing the guitar near a cradle, called *Sleep My Child*. c. 1788. Oil on canvas, 55 × 45 cm. Staatliche Kunsthalle, Karlsruhe (cat. no. 411)

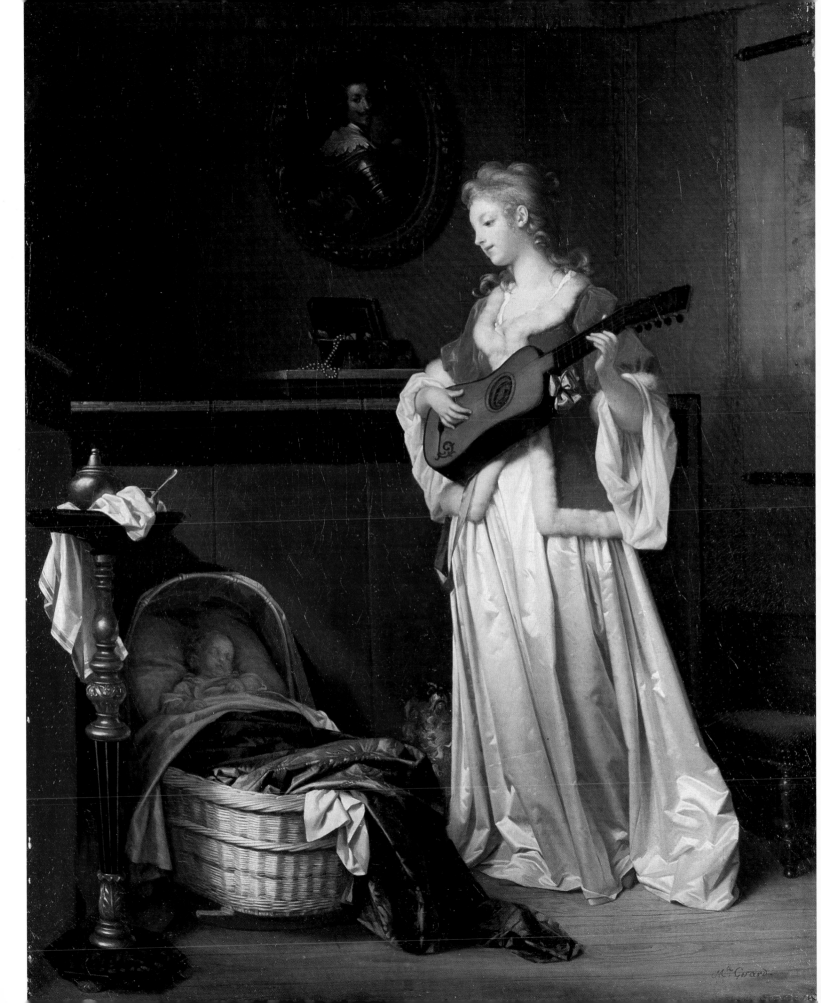

M.^{me} Gerard

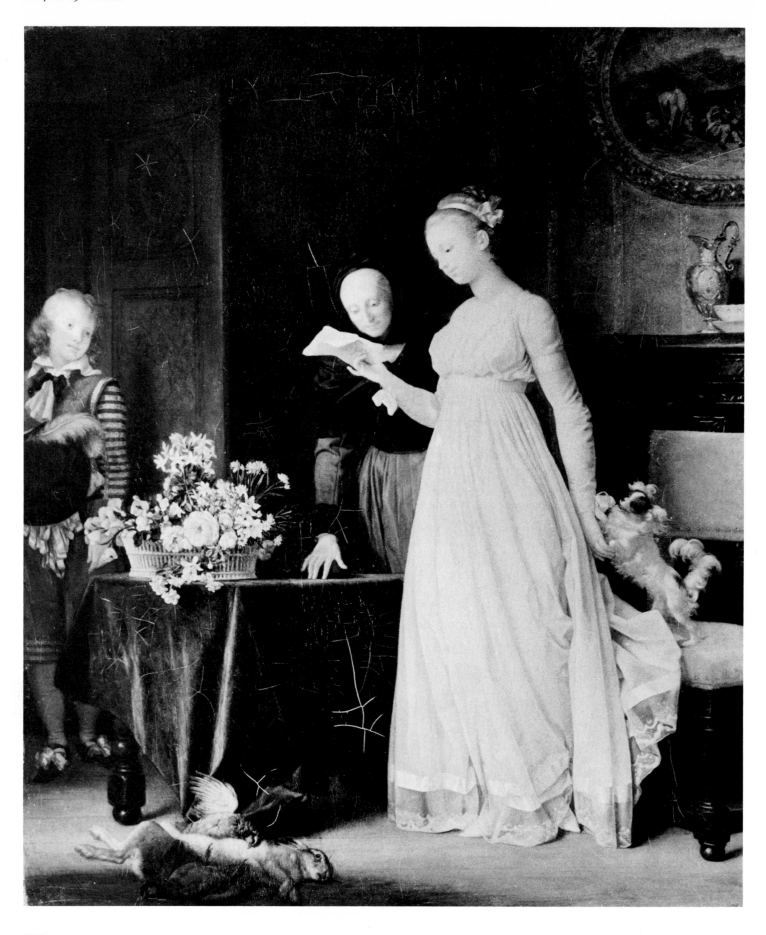

A similar painting, *Sleep My Child*, also called *The Sleeping Child*, in the Kunsthalle in Karlsruhe, bears only the signature of Marguerite Gérard, who was clearly responsible for the faultless finish of the accessories, of the furniture, and of the drapery; but, can the exquisite face and the blond hair really be the work of any hand except that of her teacher? The painting was auctioned under the name of both artists in the Villers sale in 1795. Similarly, it was under Marguerite's name alone that, in 1798, Vidal engraved two pictures, *The Present* and *I Was Looking After You*, which, in the catalogue of the same Villers sale, are attributed to both artists, with the following commentary: "These two graceful compositions are executed with the usual care and spirit of these artists' works." The first of these pictures, which is in the Hermitage, bears the name of Marguerite Gérard but is, in fact, obviously a collaborative work: her minute and slightly cold style may be discerned in the basket of flowers, the poultry, and furniture; whereas the shapely contours of the young woman who is bathed in light and the servant's face can only be the work of Fragonard. On the other hand, a picture whose style is very similar, the *Sleeping Child*, which appeared on the London art market in 1962, seems to bear the stamp of Marguerite Gérard in the furniture, accessories, and fabrics, whilst the faces, painted with a warmer and more vibrant technique, are clearly by Fragonard; the painting is signed by Fragonard alone. In the same way, *The News of the Return*, a painting that has been lost, was engraved by Louis-Charles Ruotte under the name of Fragonard,

272;
Cat. 411

273;
Cat. 413

274;
Cat. 412

Cat. L14

274 Fragonard and Marguerite Gérard. *The Sleeping Child*. c. 1788. Oil on canvas, 45.5 × 37 cm. Private Collection (cat. no. 412)

by Marguerite; in the rest of the work, the treatment of light and the technique are typical of Fragonard at his best, in the careful style of *The Invocation to Love*. The execution of *The Beloved Child* may have involved a more complex form of collaboration; the young artist may have worked on the fabrics, but most of the painting, with its fine range of white, red, and pink, especially the faces and the Dutch-style landscape, is undoubtedly by Fragonard. Eunice Williams has recently demonstrated the preponderant role played by Fragonard, by publishing one of his drawings, in which the composition of *The First Step of Infancy* is arranged.[12]

◁ 273 Fragonard and Marguerite Gérard. Young woman reading a letter brought to her by a page boy, called *The Present*. c. 1786–87(?). Oil on canvas, 55 × 45 cm. The Hermitage, Leningrad (cat. no. 413)

275 Young woman playing the lute in the company of an officer, called *The Music Lesson*, c. 1784–85(?). Brown wash over black chalk under-drawing, 39 × 26 cm. Private Collection

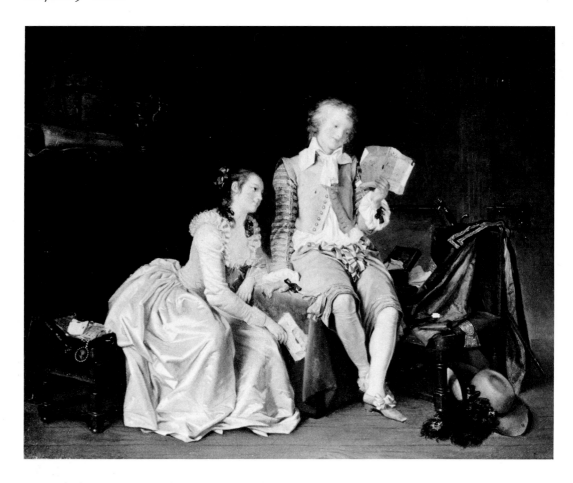

276 Fragonard and Marguerite
Gérard. Young couple reading letters,
called *I Reread Them with Pleasure*.
c. 1785. Oil on canvas, 30 × 39 cm.
Private Collection (cat.no. 415)

Cat. 414

276;
Cat. 418,
19, 415

278;
Cat.
76, L13

although it bears characteristics that could be attributed to
Marguerite. *The Reading*, in the Fitzwilliam Museum, in
Cambridge, appeared in a sale in 1787 under the name of
"Mademoiselle Gérard, M. Fragonard's student." Even if it
is obvious that Marguerite painted most of the picture,
who, apart from her teacher, could have painted the bust
and face of the young girl who stands there, witty and
radiant? In the same way, paintings that are always attrib-
uted to Marguerite alone, such as *The Caresses of Innocence*,
The Childhood of Paul and Virginia or *I Reread Them with
Pleasure* may well have been, at least partly, the work of
Fragonard, to judge by the type of figures that appear in
them.[13]

The *Contract* belongs to the same marital or family
themes; the picture was engraved by Maurice Blot in
1792, to form a pendant to the print he had produced of
The Bolt, which could have been painted between 1785
and 1788. Two versions of the picture appear to exist, or to
have existed. Did Marguerite Gérard play a part in the
painting of this work? It would be rash to draw any con-
clusion, since the picture engraved by Blot bears only
Fragonard's name.

The fact that Marguerite Gérard worked on parts of
these pictures in the Dutch manner should not prevent

one from seeing them as Fragonard's creations. For Frago-
nard and his contemporaries, the realm of great painting
meant, more than ever, Dutch painting of the Golden Age;
with the help of Marguerite Gérard he reconstituted this
Golden Age with a respectful attentiveness, with a con-
cern for costumes, and the inclusion of a large number of
minutely rendered accessories. It seems that it was his
student who tried her patience by executing highly pol-
ished furniture, ewers, and wickerwork baskets, as it is
these elements and this technique that one invariably dis-
covers in her subsequent work. And Fragonard, delighted
with his student's progress, and probably pleased with the
success such works were having, "launched" Marguerite
Gérard, helping her in every way that he could, including,
apparently, allowing her to sign pictures that he had help-
ed to paint. Such works should not be underestimated,
for by their precious execution in the Dutch manner, they
were one of the sources of "troubadour" painting. Frago-
nard's son Alexandre-Evariste, who had just been born,
would be one of the main representatives of this genre.
Their influence on an artist such as Louis Boilly, who was
then just beginning to paint, should not be overlooked
either. Fragonard, a painter of light, of what is pictorially
appealing, felt comfortable with Dutch painting. The

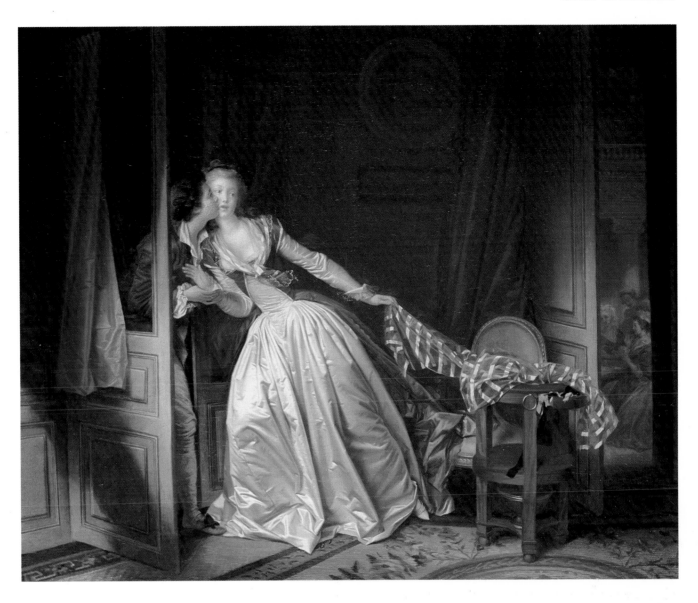

278 Fragonard and (or?) Marguerite Gérard. *The Contract.* c. 1785–88(?). Oil on canvas, 45 × 55 cm. Location unknown (cat. no. 376)

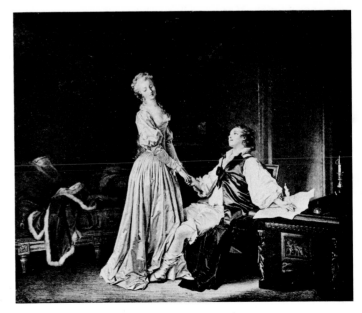

277 *The Stolen Kiss.* c. 1786–88. Oil on canvas, 45.1 × 54.8 cm. The Hermitage, Leningrad (cat. no. 383)

223

knowledge of and fondness for the Dutch Golden Age were then such that it was greatly admired for its coherence and its complexity. For Fragonard, passing from a technique of painting in the style of Rembrandt, to the delicate touch of a Gabriel Metsu, may have been a way of dominating the whole of the pictorial realm. Fragonard, author of the *Women Bathing*, is difficult to recognize as the author of *The Stolen Kiss*, because it is thought that this work goes against his "temperament." But Fragonard and his contemporaries liked Metsu and Gérard Dou more than we do today and discovered magic and a form of escapism in their works. We are perhaps the victims of our reluctance to admire their finely finished works and we only see a pastiche in a picture that was itself inspired by a work that had been carefully elaborated. Who would think of reproaching Fragonard for having worked within the spirit of the sketches of Rubens or Luca Giordano?

The Stolen Kiss

277;
Cat. 383

The Stolen Kiss, in the Hermitage, is one of Fragonard's most famous works; but it is not one that is very popular today. *The Swing* has maintained some of its saucy attractiveness because of its very lack of realism, and its presentation, which recalls on operetta or a florid carrousel. The audacities of *The Stolen Kiss* are now quite conventional; they no longer titillate young people or shock their parents. The picture has simply become quaint. Rather, it is easy to imagine the critical comments it would attract: coldness, coquetry, and sentimentality. The painter has lost his fire and to please the dealers he has forced himself to produce small interior scenes painted in an affected way, with obligatory skirts of white satin, in the style of Metsu and Pieter de Hooch.

One should try to take a fresh look at *The Stolen Kiss* because, during the 1780s, when he painted this picture, Fragonard was at the height of his fame. The picture is one of his great creations but it has been the subject of many misunderstandings. At first sight, it shows a white satin skirt, with flowing and crumpled folds that can almost be heard rustling, and is a kind of manifesto of the imitation of the Dutch style. In fact, through the study of the painters of Dutch interiors, Fragonard was looking for a different apprehension of light. He may, at times, have felt weary of the sharply contrasting effects of contre-jour and of side, or border, lighting and he may well have wanted to experiment. What is so fascinating and revealing is what separates such a picture from *The Bolt*, which was probably not painted much earlier. The organization of the forms is close to that of *The Bolt*, with a similar, clearly defined

diagonal. But *The Bolt*, in its tension, presents only nervous oblique and curved lines; whereas *The Stolen Kiss* distributes the verticals with an emphasis on an almost geometrically arranged composition, with the long oblique lines of the arm extended by the scarf and the many geometric divisions of the panels and wainscoting, the circles of a frame or of the back of a medallion chair. The space is thus calmly organized and well-constructed in terms of linear perspective.

But the true subject of a picture such as this is, once again, light itself; it is so appropriate, so fine that one forgets about it. The light comes slightly from the left, almost from the front, slips across the doors, without the cut-out effect with which we have become familiar. There is no longer a light effect; it is the entire canvas that shines with a gentle pearly brightness, and the reflections of the white satin skirt, the transparency of the striped scarf, the other fabrics, the gold or bronze color of the furniture, the florid carpet are only there to receive the light gently. We see here the development and the outcome of an entire and very fine current of Fragonard's art. One is surprised by the almost fragile aspect of these thin figures. Instead of seeing Marguerite Gérard's influence or hand in it, it is more useful to establish a parallel with *The Fountain of Love* and its very delicate protagonist and to see, in *The Stolen Kiss*, a similar kind of investigation. Nicolas Regnault engraved the picture in 1788, giving it Fragonard's name alone. If the painter allowed or wanted works produced jointly to be signed by Marguerite alone or engraved with her name, with the aim of making his student and protégée better known, it would be hard to understand why he had one of Marguerite's works engraved using his name, when such a confusion would not necessarily have flattered the young woman. Whether the girl did or did not paint a few folds of the satin skirt is of little interest. The picture really is by Fragonard, but we shall never know whether it was painted to dazzle Marguerite Gérard even if she never recovered from its inscription.

It would be inappropriate to explain away such a picture and others like it as an aberration in the artist's œuvre. Nor would it be productive to accuse Fragonard of having created this vogue of an artist on the look-out for success by calmly adapting his art to suit the tastes of his clientele. It is preferable to think that Fragonard himself decided the way he wanted his painting to develop. Works that do not correspond to our taste, in the late twentieth century, are not necessarily works that Fragonard painted reluctantly. *The Stolen Kiss* is an admirable picture precisely because it is the opposite of what one expects of Fragonard. It displays a fascination with ivory color, with delicate effects, as well as the discovery of an invisible touch. The master of broad effects of thickened paint has clearly developed a

new style and, taking up the light again on the white satin, he lets himself be carried away by a fascination with trompe-l'oeil.

Drawings for Ariosto

There was something to compensate for so much fineness and so many delicate and polished curves in Fragonard's work. His remarkable drawings illustrating Ariosto's *Orlando Furioso* probably date from the 1780s and, together with a few pictures sketched in the 1760s, they are some of his most unrestrained, spirited, and prematurely Tachiste works. These 137 drawings, in a large, vertical format (approximately 40 × 25 cm), seem to have remained in the artist's family until they were bought by the collector Hippolyte Walferdin, but have since been dispersed. They could be part of a vast enterprise, worked on in several stages and left unfinished, as the drawings only illustrate twenty-five cantos of the epic poem that contains forty-six cantos.[14] They cannot, in any case, be drawings that were destined specifically to be engraved because they are often very informally executed. The lines of black

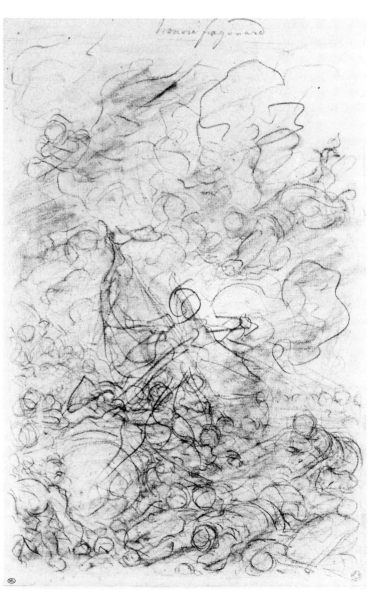

279 *Battle Scene with a Warrior Holding a Flag.* c. 1780–85. Black chalk 41.8 × 27 cm. Cabinet des Dessins, The Louvre, Paris

280 *Bradamante Fighting with the Hippogriff.* c. 1780–85. Black chalk and brown wash, 38.4 × 24.5 cm. National Gallery of Art, Washington, D.C. Gift of Edith G. Rosenwald

281 *Charlemagne in Prayer.*
c. 1780–85. Black chalk and brown
wash. Private Collection, London

282 *Figures Dancing in a Palace.* c. 1780–85. Black chalk and brown wash, 40.5 × 25.3 cm. Musée des Beaux-Arts, Narbonne

283 *St. Michael Finding Vices in the Church.* c. 1780–85. Black chalk, pen, brown wash, 38.1 × 24.2 cm. National Gallery of Canada, Ottawa

chalk quiver and proliferate, defining shapes by a network of flowing strokes against which the circular heads bounce off like balls, and the patches of brown wash, quite clear or diffuse, resonant and light, form an airy structure. Many drawings achieve a grandiose strangeness, by means of the daring effects they employ and by their convincing technique of narration. Their daring "modernism" can only be compared to certain wash drawings by Greuze, whose technique and style are very different. Works by Fragonard from the same period, like the sketch in the Musée Municipal des Beaux-Arts in Quimper, a *Scene from the Illiad*, with its lively technique, reflect investigations that are similar to those of the *Orlando Furioso* drawings. The drawings for Ariosto, which have phenomenal energy and a breathless rhythm, are among Fragonard's most lyrical; they reveal a growing quest for light and for dynamic life which makes them comparable to paintings like *The Vow of Love* and *The Fountain of Love*.

284 *View of an Italian Park.* 1786. Brown wash over black chalk underdrawing, 23.8 × 38 cm. Crocker Art Museum, Sacramento

285 *He Has Won the Prize!* c. 1780–85. Black chalk, brown and gray wash, 42.9 × 34.2 cm. The Pierpont Morgan Library, New York

The Portraits

Fragonard's activity as a portraitist did not experience a decline; but it is evident that, during these year, he turned almost exclusively to portraits of children, which were often small in size and occasionally made use of Spanish costumes. There must have been a clientele that was truly captivated by such pictures, the sweet little faces of which were probably not exclusively portraits of the young Alexandre-Evariste, who was born in 1780. They are also not to be confused with works by Marguerite Gérard who, at the end of the 1780s and at the start of the following decade, seems to have been inspired by such portraits, giving her own a slightly heavier touch and a more emotional, almost sentimental, tone.[15]

On the other hand, though, some of these small pictures by Fragonard may be perfect portraits of little Alexandre-Evariste, whom everybody called Fanfan. This would give them approximate dates: he is two or three in the exquisite oval picture that is as limpid as a watercolor (the Henry E. Huntington Library and Art Gallery, San Marino, Calif.); he is about four years old in a vertical picture (private collection), in which he is shown with short hair; he might be six in another small picture, in which he is wearing a feathered beret and a little collaret (private collection); he may be eight or nine in the portrait in the Museum of Art in Cleveland, Ohio, where he is given a serious expression. But the perceptible differences in the types of faces and in the hair color suggest caution, though it is likely that the picture in Cleveland really is of his son. However, it is more difficult to recognize the child in the completely blond boy in *The Child Dressed as Pierrot*, one of the most famous pictures in the Wallace Collection, a pendant to the *Girl with a Pearl Necklace* (private collection), which has been thought to portray his sister, Rosalie. With its graceful costumes and serene expressions, its blending of soft colors, and its excessively sparkling eyes, *Pierrot* verges on prettiness and sentimentality. The glorious reputation of such a picture is quite suspect. But Fragonard may have wanted, in this inconsequential work, gently to pastiche Watteau's *Gilles* by showing the face from the front. Such a work and other portraits in the same style should, of course, be compared with the many miniatures that were painted in the style of Fragonard, of

286 *Portrait of a Child with a Collar* (Alexandre-Evariste Fragonard?). c. 1783–85(?). Oil on canvas, 21.5 × 19 cm. The Henry E. Huntington Library and Art Gallery, San Marino, California (cat. no. 370)

287

288

289 *The Child Dressed as Pierrot.* c.1785–88. Oil on canvas, 61 × 51 cm. Wallace Collection, London (cat.no. 379)

busts of children, often shown in Spanish costumes. It is often difficult to define the part played by Fragonard in a largely mediocre series of works, which may have been painted by his wife Marie-Anne or by other imitators. Their limpid technique, which makes good use of blending of the ivory tones, clearly makes them counterparts of the *Pierrot*, in the domain of oil painting.[16]

Fragonard may have produced a large number of portraits in pastels. The Musée des Beaux-Arts in Besançon owns a fine portrait of an elderly woman in this fragile

287 *Portrait of a Young Boy* (Alexandre-Evariste Fragonard?). c.1786–88(?). Oil on panel, 21.2 × 17.2 cm. The Cleveland Museum of Art. Gift of Grace Rainey Rogers in memory of her father William J. Rainey (cat.no. 384)

288 Portrait of a young fair-haired little boy, called *Fanfan.* c.1780–85. Oil on canvas, 19 × 13.5 cm. Private Collection (cat.no. 369)

290 *Portrait of a Child Dressed as an Angel.* c. 1785(?). Pastel, 45 × 55 cm. Private Collection, Geneva

291 Portrait of an elderly woman, called *Portrait of Sophie.* c. 1785(?). Pastel, 59 × 50 cm. Musée des Beaux-Arts et d'Archéologie, Besançon

medium, which is traditionally titled *Portrait of Sophie*, the Fragonards' maid.[17] The frontal portrayal of the bust is the same as in the oil paintings and in the contemporary miniatures. The relief is handled firmly by means of planes, and a balance is achieved between the stump effects and the bright, sharp, and nervous accents, testifying to a controlled virtuosity. Without giving up any candor of gesture or of expression nor abandoning the effect of chiaroscuro which, once again, reveals his debt to Rembrandt's *Old Men*, Fragonard imbues this portrait with a feeling of warmth that is quite genuine. At the opposite end of the age-range, a pastel which might also date from the 1780s, a *Portrait of a Child* as a cherub (private collection, Geneva), has a delightful gaiety because of the twirling lines, which

suggest forms in a light that evokes miniatures that gleum like pearls.[18]

This period in Fragonard's career has perhaps been neglected until now, because of the equivocal nature of Marguerite Gérard's participation in his work; in point of fact, Fragonard surpassed himself in these years, in which the development of painting was moving faster and faster. If the painter's style was transformed, it was not by some opportunistic updating; it was within the context of a logical and internal evolution: *The Vow to Love* is already contained within the *Coresus*, and the *Stolen Kiss* in the *Farmer's Family*. Fragonard accomplished his own pictorial revolution at this time and its significance and influence have tended to be underestimated.[19]

231

Chapter X
1790–1806 Grasse and Paris
The Eclipse

The Sojourn in Grasse

Why did Fragonard leave Paris with his wife and sister-in-law to go and live in Grasse, the city of his birth, for over a year? They appear to have arrived on January 12, 1790, and were to remain there until March 10, 1791, staying with their cousin, Alexandre Maubert, to whom they paid rent.[1] Was it because there were fewer clients in Paris? But it is not at all clear whether there were more of them in Grasse. Was it because of the events of the French Revolution? Yet only a few months before their departure, on September 7, 1789, Marie-Anne Fragonard and her sister Marguerite had been members of the delegation of twenty artists' wives, led by the wife of the sculptor Alexandre Moitte, who had offered their jewelery to the Nation to help pay off the national debt.[2] The Fragonards seem to have espoused progressive ideas. The main reason for their move to Grasse may have been simply that they wanted to see the region again and to find a home for the four paintings of *The Pursuit of Love* which had been rejected seventeen years earlier.

Be that as it may, Fragonard arrived there with the pictures. Whether Maubert had made an arrangement with Fragonard, prior to the trip, or whether he allowed himself to be convinced on seeing the works, the fact remains that the painter hung the paintings in his cousin's salon and completed the decor by painting several extra panels on the spot.[3]

The large picture Fragonard painted to complete the decor of the Mauberts' salon is known as *The Young Girl Forsaken* and is now in New York with the other paintings. A young girl, sitting at the foot of a column, appears to be waiting for the lover who does not come or who will not come any more; at the top of the column, Cupid is sitting on a globe and pointing to the passing hours. Everything is conceived in such a way that the picture should correspond to the other four, with the trees outlined against the sky, the bushes standing out and in contre-jour in the foreground, and the statue of Cupid. But the treatment is strikingly different: the trees, which burst forth like plumes of foam, appear more calmly realistic; everything is less overwhelming, smooth, and radiant with contrasting colors, and the whole picture is rendered like a large golden sketch, in the same spirit as a wash drawing in which graphic accents predominate and in which there are only a few touches of color.

As is often the case with Fragonard, one may wonder whether the fine drawing showing the whole composition that is in the Fogg Art Museum in Cambridge, Mass., is preparatory to or later than the painting.[4] The allusive and quivering style of this moving fabric, where spots of wash are superimposed onto rolling graffiti and light hatching, recalls that of the drawings for the Ariosto, but produces a more complex effect, giving the false impression of a rough sketch, in which the touches of wash are finer and overlap.

Four very narrow panels representing flowers, which are usually described as *The Hollyhocks*, were painted at the same time to complete the decor of the Maubert salon; Fragonard abandons himself here to the pure joy of painting and the effects of blending, the contrast between areas that are hardly covered in paint and thickened-out areas, the exuberance of the technique, as well as so much good-natured effusion in the face of a jubilant nature, justify a comparison with Renoir or with Monet.

294-95; Cat. 39

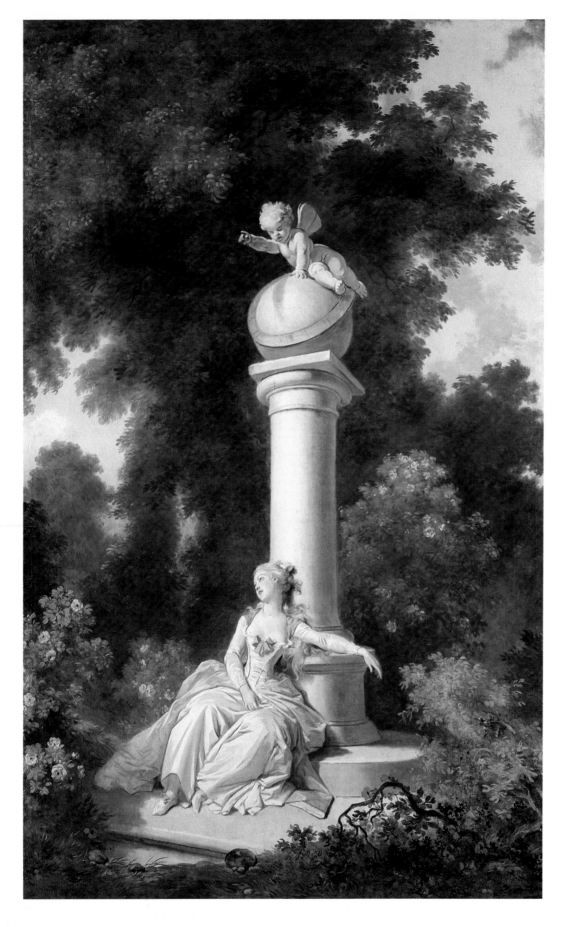

293 *The Young Girl Forsaken.* 1790(?). Black chalk and brown wash, 33.8 × 25 cm. Fogg Art Museum, Cambridge, Mass. Gift of Charles E. Dunlap

292 *The Young Girl Forsaken.* 1790. Oil on canvas, 317 × 197 cm. Frick Collection, New York (cat. no. 390)

294–95 *The Hollyhocks* (Details). 1790. Oil on canvas, 318 × 63 cm and 318 × 140 cm. Frick Collection, New York (cat. nos. 396–99)

Difficult Years: Fragonard, Curator of the Louvre

Things were starting to move faster and faster in the Revolution and Fragonard's position was clearly not good.[5] His friend Saint-Non died in November 1791. Fragonard managed to get Alexandre-Evariste, then aged twelve and already a pupil of David's, admitted to the Académie Royale in September 1792, shortly before it was abolished.[6] Whether it was through conviction or opportunism, Fragonard got through this period without encountering any difficulties, unlike his friend, Hubert Robert, who was imprisoned at Sainte-Pélagie and then at Saint-Lazare during the Terror. Fragonard applied for and obtained a certificate of non-emigration (March 18, 1794), a certificate of residence in Paris (April 18), and a certificate of public-spiritedness (May 14).[7]

The fact that so few paintings by Fragonard dating from these years have been preserved may be due to the fact that his name was associated with a period of frivolous manners and of painting that was being repressed and that some people considered his art to be old-fashioned. It may also be because the painter was doing other things at the time. From 1793 to 1800, Fragonard was very active and held several positions in the administration of the arts, and was especially concerned with the assembling of the national collections.[8] Fragonard, who had already been chosen as a mentor by Bergeret, at the time of the latter's trip to Italy, was recognized as a connoisseur of painting; in March 1793, he was a member of the provisional committee in charge of the selection, from various consignments of works from what had been the royal collections, from churches, and from the collections of the émigrés, of those works that deserved to be included in the museum, which was soon to be opened.[9] On July 4, the painter became a member of the Commune des Arts (Arts' Council), established by a decree of the National Assembly which, soon afterwards, on August 8, abolished the Académie Royale de peinture et de sculpture.[10] On November 4, the Société Républicaine des Arts (Republican Association of the Arts) was founded to replace the Commune des Arts; Fragonard and his brother-in-law, the engraver Henri Gérard, were made members of this new society,[11] and, on November 15, Fragonard was elected a member of the jury that was given the responsiblity of awarding the prizes.

On December 17, David proposed that the museum committee be abolished and that it be replaced by a conservatory. In his famous report, he censures its members, notably Vincent, "whose patriotism is colorless...," criticizing, among other things, the restoration of certain paint-ings which he considers to have been carried out clumsily, and he proposes that it be replaced by "artists who are as enlightened as they are patriotic." Among the most prominent painters whom the Comité d'Instruction publique (Department of Education) chose to make up this new conservatory of the museum, David cites Fragonard, who "has numerous works in his favor; warmth and originality are what characterize them; he is both a connoisseur and a great artist and will devote his later years to looking after the masterpieces whose number he helped to increase in his youth."[12] This is a marvelous document that assures us of Fragonard's "patriotism," of the esteem in which his qualities as a "connoisseur" were held, of the admiration David had for his art, and of their friendship.

The Conservatoire des Arts was created on January 16, 1794. Fragonard was a member of it and received an annual salary of 3,000 livres; he also kept his apartment in the Louvre.[13] He was to participate regularly in the activities of the Conservatoire and had to deal with all of the administrative and academic problems of the museum. On March 9, Fragonard and three other members of the Conservatoire were asked to "select the finest drawings," which were to be exhibited "in the new rooms that will be available to the Conservatoire."[14] With the other members, he had to deal with many problems, often of a purely practical kind: the inspection of the paintings, transportation, the state of the works, security, problems of copyists, and of attendants. These tasks were enough to keep the artist fully occupied.

In April 1795, the Conservatoire was reorganized: the government nominated five curators, Fragonard, Hubert Robert, Pajou, Picault, and de Wailly. Replacing Vincent, who had originally been chosen, Fragonard became its president.[15] Many questions had to be resolved, concerning works arriving from abroad, the security of the museum, the printing of the catalogue, the work of fitting out the museum and, of course, the supervising of the attendants. An effort was made, on November 12, to find a studio for "Citizen Fragonard Junior," and one can imagine Fragonard intervening on his son's behalf.[16] Fragonard and Picault frequently had to deal with the problem of getting supplies of canvas for the restoration workshops.[17] In February 1796, Fragonard was still president and there was great alarm about a threatened theft at the museum, which finally never occurred.[18] The meetings of the Conservatoire continued to be held until March 1797. In the summer of 1797, Fragonard was given the title of "Inspector of the transportation of the works of art" and was made responsible for the supervision of the transportation of works of art between Paris and Versailles, for the setting-up of a special museum of the French School at the Château de Versailles. These duties kept him busy in 1797

L'AMOUR DE LA LIBERTE.

and 1798 and for part of the following year; it was not until June 1800 that they were completed and that Fragonard stopped being remunerated for the position.[19]

The Last Work: The End of a Career

Even though he was considered a specialist of the "graceful and erotic genre," it is difficult to believe that Fragonard could have refrained from treating patriotic subjects altogether. But it is well known that many works of this kind were destroyed. It would not be unreasonable to suppose that he may have put forward a proposal for the competition announced in August 1793, when the Comité de Salut public (Committee of Public Safety) invited all artists, without distinction, to present a sketch on a subject of their choice evoking "the most glorious episodes of the French Revolution."[20] He seems to have withdrawn his sketch yet his name is found again among the members of the jury elected by the artists themselves by secret ballot, in November 1794–after the Terror–to judge the works. Of all the painters, Fragonard won the largest number of votes, ending up ahead of Vien and Hubert Robert.[21] This is valuable evidence of the man's popularitiy and his colleagues' appreciation of him as a good judge, which indicates that he had not become unfashionable at the time. A strange document proves this: an anonymous aquatint entitled *The Love of Liberty* takes up in a round format Fragonard's *Cupid Holding an Arrow*, painted ten years earlier, but shows a lictor in Cupid's arms, crowned with a Phrygian cap;[22] the pleasures of the Ancien Régime and the new aspirations were thus symbolically reconciled.

296
297;
Cat. 225

One of Fragonard's great undertakings as an illustrator–for the *Tales* of La Fontaine–did not take shape until the time of the Revolution. He had made a series of rapid black chalk sketches, which have since been scattered, probably as early as the late 1760s; they were followed by another series, made up of counterproofs of the first ones, touched up in pen and wash and which have remained intact (fifty-seven drawings in the Petit Palais, Paris). Fragonard seems to have taken up the idea again in about 1780, making new drawings in black chalk and wash, retaining his compositions and adding variations. In 1789,

296 Anonymous. *The Love of Liberty*. c. 1792(?). Engraving. Musée Carnavalet, Paris

297 *Cupid Holding an Arrow*, also called *Marie-Catherine Colombe as Cupid*. c. 1770 (or c. 1775). Oil on canvas, 55 × 44 cm. Private Collection, U.S.A. (cat. no. 225)

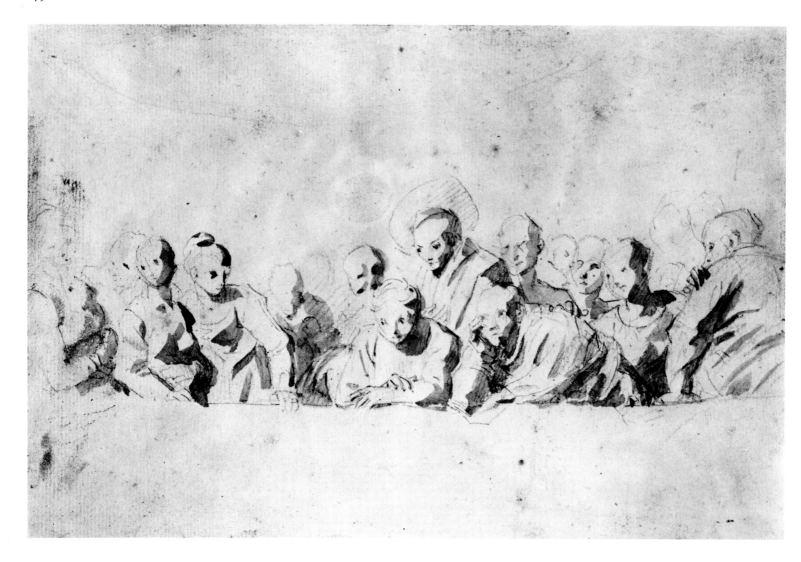

298 *Assembly of Figures.* c. 1790(?). Black chalk, pen, and brown ink on blue paper, 16.8 × 25.5 cm. Museum Boymans-van Beuningen, Rotterdam

299 *Woman with a Dog.* c. 1790(?). Black chalk on blue paper, 21.5 × 17 cm. Museum Boymans-van Beuningen, Rotterdam

300 Mother and her daughter in a park, called *"Mother, the Lovely Nest!"* c. 1790. Oil on canvas, 56 × 45.8 cm. Private Collection, Paris (cat. no. 400)

301 *Head of a Man.* c. 1790–95(?). Oil on canvas, 41 × 33 cm. Private Collection (cat. no. 405)

303 Fragonard(?). *Head of a Man.* c. 1800. Oil on canvas, 80 × 63.5 cm. Location unknown (cat. no. 408)

the publisher Didot produced a prospectus announcing an edition of the *Tales* in four volumes, and then commissioned Fragonard to do some additional drawings. The book did not appear until 1795, in two volumes, including only twenty plates, sixteen of which were based on Fragonard's drawings.[23] The edition does, at least, show that during these years Fragonard's style had not gone completely out of fashion and that a certain sector of the public remained loyal to him; in addition, in 1791 and 1792, engravings by Nicolas de Launay, Nicolas Regnault, Antoine Romanet, and Maurice Blot appeared based on Fragonard's compositions.[24]

◁
302 *Bust of a Little Boy.* c. 1790(?). Oil on canvas, 39.4 × 29.2 cm. Private Collection (cat. no. 403)

Did Fragonard stop painting when he returned from Grasse, and did he allow himself to become totally absorbed in his work as a curator? It is difficult to believe that he remained completely inactive in the last fifteen years of his life. He may have continued to paint genre scenes in the Dutch style in the 1790s, with or without Marguerite Gérard's collaboration. A family scene in a very different style shows a young mother sitting in a garden; her daughter is seen running up to her, carrying a bird's nest. The picture, which probably dates from about 1790, is entitled *Mother, the Lovely Nest!* and is freely painted, in grisaille, in a style recalling that of the *Forsaken* with slightly blurred brushwork and an elegant, dreamy tone typical of English painting. The style and tone evoke the proposals for illustrations for *Veillées au château* by Madame de Genlis, which may be dated from the 1780s and it would seem to be yet another theme related to the bringing-up of children.[25] It is difficult to say whether he continued to work on portraits, particularly of children, or to give dates for the paintings that have been preserved. A bust entitled *Head of a Man*, which was sold in Lucerne in 1967 with an attribution to Fragonard that seems correct—in spite of the unusual nature of the work—might date from the 1790s. It is very different from the *Figures de Fantaisie* and the softened relief evokes Greuze as well as English portraitists like Sir Thomas Lawrence, whilst the hand placed across the chest recalls Van Dyck; Fragonard, who was always experimenting, and who seems to have wanted to compete with David or Prud'hon, was being soberly realistic in this work.

A *Portrait of a Family* in a landscape, in the Musée Fragonard in Grasse, which is attributed to Marguerite Gérard, appears, in fact, to be the work of Fragonard; it may even be the last of his paintings to have been preserved. It is a strange, slightly composite work whose colors appear grayish and almost cold; but a few red details give it a silvery quality. The central character, who is rather stiff, scarcely bears the mark of Fragonard but the thin and bony-faced man, the two young girls sitting on the left, and the lightly painted landscape, which contains a subtly varied succession of planes in the Dutch manner, reveal the artist's hand. The costumes point to a date about 1795–98; the dresses in the antique style, with high waistbands, are those worn under the Directory, just as the man's clothes, with the tight-fitting trousers, the high cravatte, and the hat with its rosette, recall *Monsieur Sérizat*, which was painted by David in 1795. Such a painting takes its place in an international movement that was especially active in the 1790s; it included painters like Louis Gauffier, Louis Boilly, or Jacques Sablet, who liked to paint full-length portraits in a landscape in a small format. This unexpected work by Fragonard, which appears a

304 *Portrait of Marie-Anne Fragonard.* c. 1785–90. Black chalk, diam. 12.6 cm. Cabinet des Dessins, The Louvre, Paris

305 *Portrait of Alexandre-Evariste Fragonard.* c. 1788–90. Black chalk, diam. 12.6 cm. Cabinet des Dessins, The Louvre, Paris

little anaemic, may be disappointing and one cannot rule out the possibility that Marguerite or even the young Alexandre-Evariste played a part in it. Regardless of its flaws the painting shows how far Fragonard had come since his initial treatment of mythological subjects that were confused with the works of Boucher.

Fragonard was, by this time, an old man and he may have stopped working all together. His son had become a famous painter in his own right and Jean-Honoré was now only "Fragonard senior." In April 1805, by decree of the emperor, the artists living in the Louvre were asked to leave the palace, because of the alterations being made to install the museum. They all signed a petition, but they still had to move.[26] Such a predicament for a man at the age of seventy-three was not easy; Fragonard had lived in the Louvre for exactly forty years. He was awarded an annual pension of a thousand francs and, that summer, he moved to the Palais Royal, into the house that was also occupied by the famous restorer Véri. It was there that he died, a year later, in 1806, of an unknown illness.[27] The *Nouvelles des Arts* stated in a very short obituary: "Fragonard senior died on August 22 after quite a short illness. He was seventy-four and a half years old and was extremely fat...," and it called the artist a "justly esteemed painter...," citing three paintings: *"Callirhoe, The Fountain of Love,* and *The Sacrifice of the Rose,"* which sum up the way artlovers of the time looked upon an œuvre that had already been partly forgotten and which, in a matter of a few decades, would fall into total disrepute, in spite of having once been a source of delight.[28]

Conclusion
Fragonard, or the Restlessness of the Artist

The Image and the Character

He occasionally signed his works *Frago*, but I have refrained from using this diminutive that places yet another screen in front of the œuvre and in front of the man. Little is known about him. Even his face remains vague and the few undoubted portraits that there are of him, all of which show him in later life,[1] reveal coarse features, a face lacking in consistency, and almost elusive. That is, unless, as has been suggested here, *The Young Man* in the National Gallery of Art in Washington, D.C., should be regarded as a self-portrait; it shows Fragonard's sensual features and sparkling eyes at about the age of twenty-three.[2] The brief portrait provided by the certificate of residence given by the Commune de Paris on April 13, 1794 gives these details "Citizen Jean-Honoré Fragonard, painter, aged sixty-two, height: four feet and eleven inches, hair and eyebrows: gray, high forehead, medium-sized nose, gray eyes, average mouth, round chin, marked by smallpox."[3] Fragonard was less than five feet tall; but that does not tell us very much about him. Portalis relates the rather too picturesque view of Fragonard in the last years of his life which echoes family accounts: "Round, fat, dashing, always alert, always cheerful, he had fine red cheeks, sparkling eyes, gray and very tousled hair, and he could always be seen in the galleries dressed in a loose-fitting greatcoat or *roquelaure*, of gray tweed, which did not have any hooks, straps or buttons, and which the guy used to tie back at the waist when working, with anything that came to hand, a piece of string, or a rag. Everybody loved him."[4]

Who exactly was this man? A resourceful character who had decided to succeed by whatever means? "Get things done as best you can" might have been the young Frago-

306 *Self-Portrait*. 1789. Black chalk, diam. 17.5 cm. Fondation Custodia, Institut Néerlandais, Paris

nard's motto.[5] Natoire described him as someone who was easily satisfied and who worked with "too much ardor and too little patience...," and, in a comment that is quite accurate and tells the whole story of the man and the painter, adds that Fragonard had "an extraordinary ability to change his mind from one moment to the next."[6] We

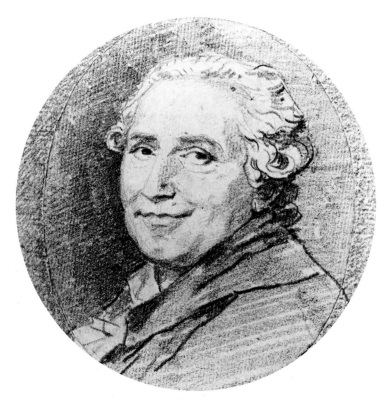

307 *Self-Portrait*. c. 1780(?). Black chalk, diam. 12.6 cm. Cabinet des Dessins, The Louvre, Paris

308 *Self-Portrait*. c. 1790(?). Black chalk with highlights in red chalk, diam. 12.6 cm. Cabinet des Dessins, The Louvre, Paris

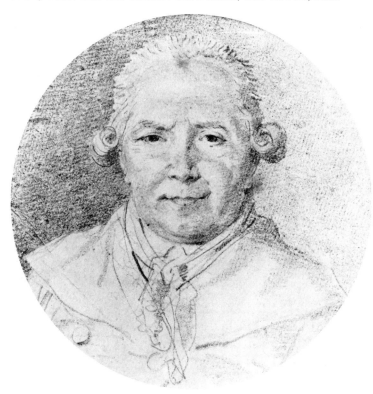

have already cited Bergeret's comments on the painter at about the age of forty: "always saying what he does not think. He has admitted it himself."[7] Fragonard thus boasted if not of hypocrisy at least of his inner contradictions. He obviously found it even easier to be contradictory in his painting. A bad-tempered and slightly false-hearted man, he quarrelled with everybody about financial matters, and perhaps a little too insistently to have always been in the right. Was Fragonard self-interested and a spendthrift? Did he have financial problems? One should recall here the letters addressed by Marguerite Gérard, in about 1800, to her impecunious brother-in-law, in which she recommends thrift. But in spite of that Marguerite draws an affectionate portrait of her *bon petit papa* (dear little father): "If I wanted to paint the joy, cheerfulness, capriciousness, the caresses, the happiness of a child, I would take him [Fragonard] as my model." She adds, more caustically: "I see nothing except your kind spirit; a child who is easily upset and who is easily calmed down, a true child of fancy."[8] Jean-Honoré Fragonard was capricious, inconstant, and a joker; he was also very frank, casual, and not always true to his word; but he was crazy about painting and was heard to declare, with the volubility of a man from the Midi who takes pleasure in shocking people: "I would even paint with my ass."[9] Apart from this last remark and although he seems to have been a gourmand, this rather crafty man could not have been totally agreeable. But does that really matter? Fragonard put generosity and tenderness into his painting and it would be a shame to dwell on the man's human failings.

The Creative Painter

There are few painters who are more complicated than Fragonard and the good-natured exuberance with which his works overflow is deceptive. His amorous subjects are probably responsible for this ambiguity; these paintings are considered free, risqué, and daring, to use ambivalent terms that refer to the rapid technique, visual effects, and erotic themes. But is pictorial freedom not simply there to make the freedom of the subject more explicit? Or does the unstable, shy Fragonard hide behind these subjects in order to paint freely? One is almost reminded of Fra Angelico, the religious fervor of whose works caused them to be widely distributed in the form of prints, but which may have overshadowed what was most daring and innovative about them.

The painter of alcoves, the decorator of the salons of pretty kept ladies, was not a Jules Chéret (who decorated prefectures), or a Jean-Gabriel Domergue. Behind the titil-

lating charm of the paintings, which is so typically Parisian, one must look for the painter. Fragonard must be recognized for what he was: the most cultured and most innovative painter of his age. If everything in the works of this wily but charming painter seems easy, luminous, and apparently executed while he was whistling, this is simply because Fragonard has achieved his purpose. It would be wrong and possibly unfair to imagine that he worked effortlessly and that the happiness that radiates from his works was also the happiness of their creator.

Surveying the œuvre, one is struck, first of all, by the incredible variety of subjects and of styles. Fragonard was a decorator who depicted mythological and pastoral scenes; he was a painter of religious subjects, of interior scenes of every kind, of portraits that made use of every technique, of landscapes in every style, of animals of every kind; he was an illustrator of literary works; and he was all these things throughout his career. At every stage, he was able to move from a rapidly painted canvas to another that was finished slowly. The coherence of his œuvre may reside in the very variety with which he seems to want to amaze us. It is true that there is something elusive about his work; Fragonard seems to have played with his œuvre himself, taking up one technique or another, one style after another, at various times, in a kind of game, and perhaps doing so to a greater extent than any other artist.

The painter and the draftsman cannot be separated and they enrich and complement one another; the generous technique of bister wash is also found in the wide glazes of the oil paintings, and the stippling, hatching and accents of red or black chalk are echoed in the nimble movements of the brush. The painter's *fa presto* is often an echo of the art of the draftsman. But the way the draftsman develops is just as unpredictable as that of the painter and does not always run parallel to it. In the painted works, as in the drawings, it appears that what he acquired and assimilated could resurface many years later. There is a casual quality, the insolence of a genius claiming the right to cite himself, to develop not in a linear fashion, but freely and in every possible direction within his œuvre. Fragonard's evolution is at once a rapid development and a tour or a stroll.

However, even though Fragonard must be allowed this freedom and even though the chronological details of his career cannot be known fully, one must ask what exactly his itinerary was and whether, beyond the image of the Provençal who knew how to enjoy life and the sketchy technique of his paintings, there is a coherence to his œuvre.

This sketchy technique, which has done so much for Fragonard's reputation, to the extent of causing ambiguity, makes it necessary to consider his drawings once again. Just as a drawing, whether it be in black chalk, red chalk,

309 Charles Le Carpentier. *Portrait of Fragonard*. 1808. Etching. The Louvre, Paris. Collection Rothschild

or wash, is always a résumé of a framework or of an articulation, and expresses the structure of forms in terms of the relationship between light and shade, a well-delineated touch expresses the same concern for constructing forms. It is one of the aspects of structure, of organization in a painting that is expressed by means of color, light, the use of different planes, and the flow of rhythms, all of which are parts of Fragonard's creativity. It is fascinating to study the evolution of this touch: it is a rather gratuitous

245

310 Signed receipt from Fragonard, given to his cousin Maubert in Grasse in 1790. Frick Collection, New York

display of fireworks in the decorations of his youth, then powerful and almost coarse in Rome, in a violent chiaroscuro, and then ardent and evocative of rough sparks; it is sturdy, dazzling, and authoritative in about 1770, and able to express every nuance and every thunderous din; later, it seems to become more fluent and mobile. It is deeply moving to see him giving up this artistic technique in his last works, in a desire to go beyond it. From as early as 1775–80, the dabs of paint, in his sketches, become finer and more fragmented, they jostle each other, are dissolved and a thrown or hurled touch turns into a sober, pointed, and rubbed touch, which has become a simple vibration and which was to remain as a light and fleecy effect in the finished works, as in *The Inovacation to Love*.[10]

In Fragonard's works, the touch cannot be separated from the very construction of the picture, from the definition of space, from the color, or from the light. Fragonard had a very special way of constructing space; it has the effect of projecting us into the painting. This has been commented upon in connection with the *Figures de Fantaisie*, which are shown simultaneously from above and below, as though seen by somebody who is moving around in front of the pictures. Their perspective is generally variable, fluctuating, bouncing, and this is, of course, helped by the explosion of touches and of dabs in a wide-open space. The mastery of decorative painting in the experience Fragonard acquired early on with his work on overdoors, must have played an important role in this predilection for ambiguous spaces. *The Swing* is a good example of Fragonard's art because it is, first and foremost, a giddy tour de force. It seems that, progressively, complex compositions were lightened, spatial structures were more fully worked out, and the sense of empty space increased. The picture was built up solely of contrasts of light; a few areas of light and shade are almost enough to form the moving pictorial substance. This daring way of ordering spaces is the mark of a great innovator; Bonnard, another poetic painter of the female body who worked with light, can be compared to Fragonard for he, too, was truly revolutionary beneath a pleasant and reassuring façade, and was ostensibly on the fringe of avant-garde currents.

The Artistic Commentator

One may, or one should, consider the way in which eighteenth-century French painting is related to the painting of earlier centuries. Fragonard, whom we have so frequently seen drawing or painting after the masters, is the most dynamic witness of those links. This activity may, at times, have been scholarly or, more often, lucrative; but one cannot deny that it reveals a true liking and even a passion. Before Delacroix, Fragonard was the commentator of the history of French painting, going beyond the vogue for pastiche that thrived at the end of the eighteenth century, and his entire œuvre is illuminated by this.

A history of art based not upon influences but upon visual images would make people aware both of the irreducible specificity of every great creator and of the fraternal

311 *The Dream of Plutarch.* c. 1780. Oil on panel, 22 × 31 cm. Musée des Beaux-Arts, Rouen (cat. no. 361)

bond that unites them. Standing between Rubens and Picasso, two other commentators of genius, Fragonard looks at everything, grasps everything, and draws on his experience to create his own original art. Artists used to have a feeling of the sharing or of the community of their research: to borrow was not the same as to plagiarize but was an expression of one's admiration. Fragonard's references to earlier painting are acute and witty; he was pleased with the diversity of the world and of painting, and this should be contrasted with today's painters whose

quotations from the past are so often arid and despairing. Fragonard, who was so greedy, so easily influenced, borrowed from everyone and yet he cannot be imitated. He happily squandered his fortune and he was right to do so because it was inexhaustible. At the risk of making the

247

wrong choices, let us cite three artists who were closest to his heart: Sébastien Bourdon, the versatile pasticheur, a charmer like Fragonard himself, who also tackled every genre, from a feast of chiaroscuro to the large, bright and resonant decor; Benedetto Castiglione, who draws when he paints and paints when he draws, the Italian who was so fond of the Dutch School; and, finally, Rembrandt, who is ever present, and who is the true, the only master. It is paradoxical to link the painter of *The Jewish Bride* with the painter of *The Swing*; but the little Provençal always looked fervently at the work of the Dutch painter. Fragonard, who is considered an impulsive artist, was always fond of Rembrandt's art which he knew so well, and it was by his own deliberate choice that he was influenced by it. Fragonard's œuvre thus emerges as a marvelous and proliferating kaleidoscope of the realm of painting at the end of the eighteenth century.

One must stress how much exuberance there is in these paintings in this almost pantheistic acceptance of the whole of creation, in the love of nature, the profound understanding of human beings, and in the instinctive, intense, and joyful feeling for life. It is, naturally, expressed in a love for women, whose beauty Fragonard renders better than anyone else, in works that are spicy, free of affectation, and radiant with genuine sensuality; it is also revealed in his affection for children, who rush across his canvases by the hundreds: putti or cherubs, children from towns or from the country, all smart and joking, and so appropriately gentle and comical that they look forward to those of the young Bonnard. So many painters fell into a repetitive inaneness; Fragonard, on the contrary, retained his freshness and that is a tremendous power.

Is this œuvre itself not without ambition, with all its charm, its profusion of elements, its use of echoes of the art of the past, and with the way it cites itself? Or, is Fragonard simply singing of the joys of life, the jocular commentator of serious art, a mere Offenbach of painting, who is caught in the trap of his own greed and skillfulness? Did he not, wisely, steer clear of the creative forces of his age?

Fragonard in His Time

Fragonard should, in fact, no longer be seen as an isolated figure; his painting takes its place splendidly within the innovative currents of the second half of the eighteenth century. From the 1760s, he was the first artist to introduce a concern for the organization of a painting in terms of light and color, in the arrangement of planes, and to diversify types just as clearly, qualities that had been forgotten since the time of Poussin, Bourdon, and Le Brun. An

entire quest for pathos is evident in French painting of the 1780s; Fragonard's dual orientation at the time, toward realism and expressivity, was shared by his contemporaries. It would be difficult to say whether he adapted his art to suit a movement or whether it was he who was its leader. All that one can say is that he took part in it. The development of painting at the time should not be reduced to that of the incomparably great figure of David. In its own way, *The Bolt*, with its light effect, is hardly any less original than the *Bélisaire*, which is roughly contemporary to it. The paintings of other innovators, such as Vincent or Jean-François Peyron, with their fine, silhouetted figures, their use of empty spaces and of chiaroscuro, reveal tendencies similar to those found in Fragonard's painting. A whole section of the painting of the Neoclassical artists, Regnault, Prud'hon, Gérard, and Girodet, drew its inspiration from the art of Fragonard.[11]

Throughout his career Fragonard was searching for light. From the faces of the shepherdesses in the style of Boucher, shown in contre-jour, to the Rembrandtesque chiaroscuro and fineness in the manner of Gerard Ter Borch, he sought out all possible effects—from the most sparkling ones to those that were most original and unusual. But he did even more than that; Fragonard is one of the few painters whose entire pictures turn into light, radiating a silvery brightness or a golden glow of ripe corn, like an incandescent hearth or glowing embers. And if there is a coherence and a growing depth in his painting, then it is to be found in this purification of light, which itself increasingly becomes the subject of his painting. In the late works, like *The Vow of Love* or *The Fountain of Love*, the touch disintegrates, the bright colors gradually dissolve, as they are too delectable and sensual, and all that remains is a shimmering, almost abstract drama, evoked by the light alone.

Our conclusion takes the form of a paradox. Fragonard, that most unrestrained of artists, with the brilliance of his colors and of his brushwork, in whom one can already see Renoir and Soutine, is the heir of a tradition, rather like Delacroix, who would be yet another "modern" in spite of himself. But the innovative artist lies in the more elusive side of Fragonard: the painter who is less accessible today and who produced those works that were conceived over a long period of time and painted slowly, where he made a tremendous effort and achieved the lyricism of works ranging from the *Coresus* to *The Fountain of Love*. The restlessness that characterizes this artist who feverishly explored every aspect of the realm of painting, and who was divided, like no other artist, between tradition, which restricts, and innovation, which frees, has still not been fully accounted for but is the source of Fragonard's greatness as an artist.

Notes

For the full bibliographic details of works mentioned in abbreviated form, consult the Bibliography, pp. 359–63. "Wildenstein" or "W" refer to the 1960 monograph by Georges Wildenstein; "Ananoff" followed by a roman numeral refers to the four volumes of the catalogue of drawings (1961–70) by that author.

Introduction

1 See pp. 341.

2 On the painting in Amiens (W. 102) and other examples, see Cuzin, 1986, I, pp. 60–61 and nn. 11–19; see also the *Garden of the Villa Aldobrandini*, a red chalk drawing, recently sold in New York (Sotheby's, April 30, 1982) under the name of Hubert Robert, a counterproof of which is in the museum in Orléans, and which has been correctly catalogued by Ananoff (IV, no. 2161).

3 W. 375; for some interesting stylistic comparisons, see *The Drinker* and *The Violin Player* in the museum in Besançon, which came from the Collection Pâris, and some of the figures of adolescents in the background of *St. Louis Washing the Feet of the Poor*, from the Salon of 1773 (Chapel of the Ecole Militaire, Paris).

4 W. 486; the picture is attributed to Vincent by P. Rosenberg in his "Catalogue of French Paintings in the California Palace of the Legion of Honor, San Francisco" (forthcoming).

5 The painting bears the date 1774; there is a pendant to the grisaille sketch, *Musical Gathering*. See also, in a very similar style, *The Walk in the Park* in a Parisian collection, which has been attributed to Fragonard but should, in fact, be attributed to Le Prince (exhibition, Galerie Charpentier, Paris, 1929, no. 116).

6 Inv. 26,600 (Ananoff, II, no. 757); see Cuzin, 1986, II, p. 180. The very free technique of the drawing in the Louvre may be compared with sheets like *The Supplicant Woman* by Le Prince (1768), which was sold in Paris in 1919 (Wyzewa sale, February 21–22, lot 163). A very similar *Holy Family*, casual in treatment and accepted by Ananoff (III, no. 1775), might actually be by Le Prince.

7 Sales at Sotheby's, London, June 19, 1957 (Fragonard), and Sotheby's, Monaco, December 8, 1984, lot 382 (Taraval); see Sandoz, 1972–73, p. 234, no. 100.

8 *A Young Shepherd with His Dog* to round up his flock, exhibited as a pendant to *A Reaper*, whose wife has sent her son with a frugal meal for him, signed and dated 1775, both bearing the no. 80 (see Sandoz, 1972–73, p. 228, nos. 83–84 and fig. 16); the *Young Shepherd* appeared under Fragonard's name in the Walferdin sale (April 12–16, 1880, lot 41), and subsequently in the catalogue of the Collection David-Weill (Henriot, 1926, I, pp. 111–13). For a preparatory red chalk drawing (20 × 28 cm), see the drawing sold in Paris on February 17, 1984 (room 2, lot 30, "French School, 18th century," not reproduced).

9 Like the *Two Cupids* known as *Love Triumphant*, a vertical oval panel (62 × 41 cm) in a Parisian collection (Wildenstein, 1921, no. 2; sales: M. P. [aulme], November 22, 1923, lot 41; Sotheby's, London, November 30, 1966, lot 74; Galliéra, March 14, 1972, lot 160), or the sketch of the *Triumphant Cupids* (private coll.), might the *Cupids Sleeping* and the *Cupids at Play* in the Wallace Collection (W. 64–65) also be the work of Taraval?

10 One may cite a *Bacchanalia with Cupids* signed and dated 1765 (sale, June 18, 1982, lot 8) and a very Fragonardesque allegory of *Cupid Encouraging Painting* (private coll., Paris; 100 × 138 cm). Might the *Diana and Cupids* in the Musée Ile-de-France in Saint-Jean-Cap-Ferrat (W. 82) also be the work of J.-J. Lagrenée?

11 Volle, 1979, p. 76, no. 25; p. 87, nos. 63–67, all formerly attributed to Fragonard.

12 Dayot-Vaillat, 1907, fig. 91; for the definitive picture, see Volle, 1979, p. 82, no. 47, fig. 33.

13 See Cuzin, 1981–83, passim.

14 One can mention the *Landscape* in the Musée des Arts Décoratifs in Lyons (Cuzin, 1986, I, pp. 64–65, n. 25, fig. 9), now attributed to Fragonard, and which was formerly attributed to Casanova; on Loutherbourg, see Chapter IV, n. 5; more attention should be paid here to Le Prince: one may cite the *Peasants Drinking and Merrymaking in a Landscape* (Panel; 53.3 × 73.6 cm), in a Parisian collection (sales, Christie's, London: July 7, 1972, lot 33; subsequently April 13, 1973, lot 78, as Fragonard), which appear to be by the artist from Metz, Le Prince.

15 *The Young Singer* in the Louvre, which is so freely painted, was formerly attributed to Fragonard. One may also cite works by J. Restout (*Head of the Virgin*, in the museum in Rouen; see Cuzin, 1986, I, p. 66, n. 27), by J.-F. de Troy (*Philosopher*, sale at the Galerie Charpentier, May 2, 1951, lot 23), or by J.-B. Re-

gnault (*Sacrifice to Priapus* in the Musée Rodin, Paris), which were attributed to Fragonard because of their elliptic or casual technique or because of their spicy subject.

16 A series of drawings that appeared in a sale in New York (Kende Galleries, April 10, 1952), and which were considered to be early works by Fragonard.

17 See Chapter V, pp. 122–23.

Chapter I

1 See Portalis, 1889, p. 11, n. 2 and Wildenstein, 1960, p. 5, n. 3; p. 43.

2 Goncourt, 1882 ed., pp. 247–48.

3 Ibid., pp. 248–49.

4 Ibid.

5 W. 8–11; see also (cat. no. 57) the copy of a *Man Drinking at His Window* by Adrien Van Ostade, in the collection of the count of Vence, which was dispersed in 1761, and which is known because of a 1756 engraving by Pierre Chenu: there is nothing to suggest that Fragonard's copy dates from his very early years.

6 See cat. nos. 42, 53 a, 56; the *Meeting on the Road* by Boucher, in the Museum of Fine Arts in Springfield, Mass., was attributed to Fragonard (W. 113) for a long time.

7 Goncourt, 1882 ed., p. 249.

8 The subject is therefore much more specific than that of *Jeroboam Sacrificing to the Idols*, and one might entitle the picture and the Biblical chapter the *Condemnation of the Altar of Bethel*.

9 For example, the *Victory of Theseus over the Bull at Marathon* at the Salon of 1745 (Musée des Beaux-Arts [Jules Chéret], Nice).

10 For example, *Alexander Cutting the Gordian Knot* from the Salon of 1746 (Nationalmuseum, Stockholm), or the *Exaltation of the Cross* from the Salon of 1748 (Musée des Beaux-Arts, Lyons).

11 Among the unsuccessful candidates for the prize that year was Gabriel de Saint-Aubin, whose painting has since been lost, unlike his *Nebuchadnezzar and Sedecias* in the Louvre, with which he won the Second Prize in the following year.

Chapter II

1 The students and the principal lived at the king's expense in a house in the Place du Vieux-Louvre, very close to the palace in which the Académie Royale was housed; the studios were in the Galerie d'Apollon, which was divided up into individual rooms. In the mornings the professor of history taught ancient and modern history; he was the engraver François-Bernard Lépicié, the father of the painter and the author of the *Lives of the First Painters to the King* and of a meticulous catalogue of the royal collections; after his death, at the start of 1775, this position was held by Michel-François Dandré-Bardon, who came from Aix and was a great painter (now underrated). Later in the day, the students would draw from ancient models in the rooms of the academy. The end of the afternoon was devoted to drawing from live models; then, after supper, the young artists read Homer, Virgil, or Ovid, in order to become familiar with what was referred to as "Fables" (Courajod, 1874, pp. 18–23, 27–28, 33–34, 56–58, 61–68, 80–82).

2 Ibid., pp. 66–67 and *Correspondance des directeurs*, Vol. XI, p. 27.

3 Ibid., p. 370.

4 David Carritt (1978, no. 20) has established that the painting was part of the collection belonging to Count Papillon de La Ferté (1727–97), Master of the Revels from 1762 until the Revolution, who was very fond of Boucher; it featured in his sale after he was guillotined; Carritt rightly suggests that Fragonard borrowed the theme from La Fontaine's tale, *The Loves of Psyche and Cupid*, rather than from *The Golden Ass* by Apuleus, which was a more common source of inspiration for artists. The four allegories of the Arts, in a private collection (cat. nos. 3–6), which are very similar in style to the painting in London (in the type of figures they show and in their bright and mottled colors) must date from about the same period.

5 Salon of 1755; Sahut, 1977, no. 147, p. 75.

6 Courajod, 1874, pp. 36–37.

7 Sahut, 1977, no. 86, p. 56.

8 Ibid., nos. 120–52, pp. 63–64.

9 Bjurström, 1982, no. 950; see Rosenberg, 1984, p. 66 ("doubtful attribution"). In the present writer's opinion, this is the only certain drawing by Fragonard dating from before his departure for Italy that has been preserved.

10 Pushkin Museum, Moscow; Rosenberg-Schnapper, 1970, no. 78, p. 203. The Gösta Serlachius' Fine Arts Foundation, in Mänttä, Finland, also owns a sketched bust of the Virgin, undoubtedly by Fragonard (cat. no. 31), in which he prepared a detail of the painting in Norfolk. There is a clear link between the composition of the Chrysler picture and a work in oils on paper on the same subject by Deshays (Cabinet des Dessins, Louvre, inv. 26,199); see R. Bacou, *Il Settecento Francese* (I Disegni dei Maestri series), Milan, 1971, p. 84 and pl. XX.

11 See, for example, the *Adoration of the Angels* in the Musée des Beaux-Arts in Brest, painted in 1751 for the wedding chapel at Saint-Sulpice (Sahut, 1977, no. 121, p. 69). Van Loo's influence on the development of Fragonard's art cannot be overstressed. The *Notice des tableaux du Musée Spécial de l'Ecole Française*, from the year X (1802), says only "by a student of Van Loo," when cataloguing *Coresus* (cat. no. 99), at a time (1802) when, it is true, that Boucher's patronage was hardly ever evoked.

12 For example, the young woman who is waking up in the *Dawn* (cat. no. 55) irresistibly recalls Night who is being awakened by *Apollo's Chariot*, painted by Boucher on the ceiling of the Council Chamber in the Château of Fontainebleau between May and November 1753. On the dating of works by Fragonard from the period 1752–56, painted in the style of Boucher, see Cuzin, 1986, I, pp. 58–59; p. 65, no. 5.

13 Goncourt, 1882 ed., p. 263. Little attention has been paid to C. P. Landon's article about *Coresus and Callirhoe* (in: *Annales du Musée*, 2nd ed., Vol. I: *Ecole française moderne*, 1832), who points out (p. 92) that "Fragonard Senior" had been "a pupil of Chardin, of Van Loo, and, later, of Boucher." Is this really an error? It has to be said that Fragonard's training prior to 1756 remains rather mysterious.

14 *The Joys of Motherhood* in Indianapolis (cat. no. 34), which is so similar to the *Shepherdess*, but is painted with a heavier technique and with too insistent a decorative effect, might be slightly earlier.

15 From a drawing he reproduces under the name of Saint-Aubin, Ananoff (1976, II, pp. 9–10) draws conclusions that appear to be neither clear nor prudent, concerning the link between the two compositions and two other pictures and the collaboration between Fragonard and Boucher.

16 A sketch of *Jupiter and Callisto*, in a private collection (cat. no. 26), the upper part of which is more highly developed, suggests that the paintings in Angers (the contours of which may once have been more lively) may have been cut; its smoother technique recalls that of the sketches of *The Rest in Egypt* in Norfolk.

17 Alan P. Wintermute, in the cat. *The First Painters of the King* by Colin Bailey. (New York, Stair Sainty Matthiesen; New Orleans Museum of Art; Columbus Museum of Art), 1985–86, p. 137; see also Cuzin, 1986, I, pp. 65–66, no. 6. Fragonard's drawing *Apollo and the Muses* in the library at Besançon (c. 1763–65?; Ananoff, IV, no. 2417) and a grisaille in oils of identical composition, attributed to Boucher (private coll. Paris; Ananoff, 1976, II, no. 353, p. 56), could also be mentioned among the Fragonard-Boucher problems. Fragonard's drawing seems to be a spontaneous first attempt; however, this may hide what is actually owed to his master's imagination.

18 It is quite possible that both pictures formed part of a set of three or four pictures portraying the *Hours of the Day*; Diana may have represented Evening (see the pictures by N. Hallé at the Salon of 1753, nos. 50–52).

19 See the Conclusion of the present work, p. 243, and no. 1.

Chapter III

1 Edited by A. de Montaiglon and J. Guiffrey; references are to Vol. XI (1901).

2 *Correspondance des directeurs*, Vol. XI, p. 168.

3 Ibid., p. 172.

4 Ibid., p. 178.

5 Ibid., p. 200.

6 Ibid., p. 207.

7 Ibid., p. 209.

8 Ibid., p. 210.

9 Ibid., p. 216.

10 Ibid., p. 232.

11 The Goncourt brothers (1882 ed., pp. 249–50) concur with the account given by Théophile Fragonard, the painter's grandson, according to which Natoire, who was worried by the weakness of Fragonard's studies from life, suspected that he had not really painted the picture with which he had won the prize. The principal of the Académie wanted to write to Paris about this, but Fragonard is said to have won a reprieve of three months, during which time he worked "night and day, from models and from anatomical models *[écorché]*. Natoire soon saw that he had been mistaken and bestowed his friendship upon him." And Alexandre Lenoir (1816, p. 479) attributes the following remarks to Fragonard, who was ill at ease, at first, when confronted with the painters of the Renaissance, "The energy of Michelangelo scared me; I experienced a feeling that I cannot express; seeing the beauties of Raphael I was moved to tears, and the pencil slipped out of my hand; in the end, I remained, for a few months, in a state of indolence that I was no longer able to overcome; that was before I began to study the painters who gave me cause to hope to be their equal one day and that is how I became interested in Barocci, Pietro da Cortona, Solimena, and Tiepolo."

12 *Correspondance des directeurs*, Vol. XI, p. 199.

13 Ibid., p. 239.

14 Ananoff, II, no. 770. Another *Deacon*, depicted in profile (sale, Christie's, London, April 3, 1984, lot 85), which seems to be correctly attributed to Fragonard, may be close in date, like the *Bishop*, properly catalogued by Ananoff (1976, II, no. 771) but put up for sale recently with an attribution to Edmé Bouchardon (April 19, 1986, lot 202).

15 Ananoff, I, nos. 241–44.

16 Bjurström, 1982, no. 951; Rosenberg, 1984, p. 66 ("doubtful attribution").

17 *Correspondance des directeurs*, Vol. XI, pp. 239–40.

18 Sale at Sotheby's, London, October 21, 1963, lot 139 (38 × 45.8 cm); annotated at bottom left, "Fragonard. Roma 1757"; it bears an inscription on the mount, "Tiré du Cabinet de Mr. Deschamps contemporain de l'auteur."

19 *Correspondance des directeurs*, Vol. XI, pp. 294–95.

20 Ibid., p. 313.

21 Ibid., p. 317.

22 Ibid., p. 318.

23 They featured in Natoire's posthumous sale, on December 14, 1778, lot 55. The eight female figures after the Antique in the library at Besançon (album 453, nos. 303–10) can be linked to the student-artist's period of study. Alain Pasquier has pointed out to us that two of them (plates 84, 86) should be considered identical with *Hygeia* and *Isis* in the Musei Capitolini, Rome (Vol. 3, pl. 29, no. 1177, pl. 555; pl. 7 no. 2575, pl. 992 in the selection by Clarac). Perhaps the eight drawings were done after engravings and are later.

24 On Jacques-Laure de Breteuil, see Guimbaud, 1928, pp. 65–67; Breteuil was in Rome from June 23, 1758 (information kindly supplied by Sylvie Yavchitz), which allows the painting in New York to be dated with slightly greater precision.

25 The work in the Hermitage may be a sketch for the one in New York, but this is not certain; it used to be linked, in the Collection Youssoupov, to *The Preparations for a Meal* or *A Poor Family*, which is now in the Pushkin Museum in Moscow (cat. no. 78).

26 Ananoff, II, no. 825; Williams, 1978–79, no. 3.

27 *Correspondance des directeurs*, Vol. XI, p. 262.

28 Ibid., p. 365.

29 On Robert's drawing, see Cornillot, 1957, no. 131; on Fragonard's drawing, see Ananoff, I, no. 385 and Williams, 1978–79, no. 2.

30 Ananoff, II, no. 827; Williams, 1978–79, no. 3; Cuzin, 1986, I, pp. 62–63, no. 18.

31 See the Introduction, p. 7 and n. 2.

32 On the character of Saint-Non, see Guimbaud, 1928, passim; Wildenstein, 1959, pp. 225–37, and especially Rosenberg, 1986, pp. 8–33.

33 *Correspondance des directeurs*, Vol. XI, p. 354.

34 Ananoff, II, nos. 867, 879, 891, 908, 919; III, nos. 1423, 1435, 1532, 1534; Cornillot, 1957, nos. 32–41.

35 Ananoff, II, no. 894; III, no. 1434, fig. 392; sale, November 29, 1985, lot 61; for the three drawings, see Roland Michel, 1987 (chapter "Techniques et médias").

36 Ananoff, II, no. 820; see also Cuzin, 1986, I, p. 59, n. 8; p. 66. The painting in Chambéry appears to be very similar in style to the *Two Shepherds in a Stable* in a private collection (cat. no. 80), which is undoubtedly of about the same date.

37 *Correspondance des directeurs*, Vol. XI, p. 378.

38 Ibid., p. 381.

39 Rosenberg, 1986.

40 Ananoff, IV, no. 2126; Rosenberg, 1986, p. 163, no. 123; p. 365.

41 Ananoff, II, no. 926; Rosenberg, 1986, p. 163, no. 121; p. 364, no. 122; p. 365.

42 Ananoff, IV, no. 2292; Rosenberg, 1986, pp. 169–75, no. 126; p. 366.

43 Ananoff, III, no. 1495; Rosenberg, 1986, p. 186, no. 166; p. 374.

44 Rosenberg, 1986, p. 215.

45 Ananoff, IV, no. 2296; Rosenberg, 1986, pp. 221–22, no. 239; p. 392.

46 Ananoff, II, nos. 928, 930, 927; idem, I, nos. 327, 380; idem, II, no. 930; Rosenberg, 1986, pp. 238–45, no. 319; p. 319, no. 320; p. 413, no. 330; p. 416, nos. 342–43; p. 419.

47 Ananoff, II, no. 937; IV, no. 2156; Williams, 1978–79, no. 13; Rosenberg, 1986, pp. 249–50, no. 356; p. 422. See also: Ananoff, III, no. 1489; Rosenberg, 1986, p. 250, no. 357.

48 Ananoff, II, nos. 864, 885, 877; Rosenberg, 1986, p. 254, nos. 358–60.

49 Ananoff, III, no. 1802; Rosenberg, 1986, p. 381, no. 192.

50 Ananoff, III, no. 1861; Rosenberg, 1986, p. 55, no. 171; p. 376.

51 Rosenberg, 1986, pp. 388–90, nos. 222–29. Saint-Non made aquatints himself from many of the drawings he brought back from Italy, making collections he called *Fragments*, or *Scribbles*; see Cayeux, 1986, pp. 326–33.

Chapter IV

1 The fashion for such decors seems to have lasted for a long time, to judge by the Pastoral Scenes that an artist like Jean-Baptiste Huet painted until the 1780s (see, a *Shepherd* dating from 1773; sale, Christie's, London, July 7, 1972, lot 10, and *The Basket of Roses* and *The Nest of Doves*, dating from 1785, Kraemer sale, April 28–29, 1913, lots 31–32). Fragonard's drawing in the Louvre, *Venus at Her Toilet* (Ananoff, I, no. 402), which is dated "1785," must also be mentioned; it should probably be accepted as authentic, although the variety of shapes employed still derives from Boucher: Fragonard probably knew how to adapt himself to the tastes of his patrons.

2 Fragonard himself made a fine etching of the motif in 1764 (Wildenstein, 1956, no. II, p. 8), and drew it three times (Ananoff [I, nos. 351–52] catalogues two red chalk drawings and a wash drawing on a counterproof in red chalk [IV, no. 2148]). Moreover, a pretty gouache of the composition also exists on vellum (Ananoff, III, no. 1575; sale, Sotheby's, January 14, 1987, lot 181).

3 See Cuzin, 1986, I, pp. 64–65, p. 66, no. 25, for the first; Ananoff, I, no. 298 for the other.

4 Seznec-Adhémar, 1960, pp. 196, 200; see also the horizontal drawing *The Shepherd*, with a very similar style and theme (private coll.; Ananoff, I, no. 847). Wildenstein (1961, p. 49) believes that the *Landscape*, like *The Farmer's Family* from the same Salon (cat. no. 115), were part of the collection of Nicolas-Joseph Bergeret de Grancourt (d. 1777), the uncle of Jacques-Onézyme Bergeret (1715–85), who owned the *Swarms of Cherubs* from the Salon of 1767 (cat. no. 144).

5 On Ebenezer Tull, see: John Hayes, "Ebenezer Tull, 'The British Ruysdale': An Identification and an Attribution," in: *The Burlington Magazine* (April, 1978): 230–33. The *Herdsman Resting* (W. 154, fig. 85b), which may formerly have been considered as a pendant to a version of Fragonard's *The Shepherds* (W. 154, fig. 85a), appears to be a work by Loutherbourg; a very similar

version (36 × 28 cm, private coll., Paris) bears a monogram and is dated "L 1769," on the lower left (its attribution to Loutherbourg has been suggested by P. Rosenberg). It may be noted that Loutherbourg first exhibited at the Salon of 1763, where his painting was praised by Diderot; the painter was made an academician in 1767 and settled in London in 1771. Fragonard, who was quick to seize whatever was "in the air," must have been fond of his confident style in the Dutch manner, recalling the style of Nicolaes Berchem (see, for example, the two *Landscapes with a Flock* in Dulwich Picture Gallery near London). On Le Prince, see, for example, the *Landscape with Fishermen*, in the Pushkin Museum in Moscow (N 996), which is very much in the Dutch style. A *Stormy Landscape*, in a similar style, whose attribution is problematical (private coll., Great Britain; exhibited in "France in the Eighteenth Century," Royal Academy, London, 1968, no. 235) is rightly denied an attribution to Fragonard by P. Rosenberg (1969, p. 99).

6 On two drawings (private coll.) that may be later than the paintings, see Ananoff, II, nos. 1702–3.

7 The painting, to which there was a pendant (both at the Salon of 1761), has been lost; on the sketch that formed part of the Varanchan Collection (and which Fragonard may have seen at the home of this artlover?), see Ananoff, 1976, II, p. 549, no. 8; fig. 1507, p. 213.

8 Another painting of *Women Bathing* (private coll., cat. no. 102), of the same dimensions, is considered by Wildenstein as the pendant to the picture in the Louvre; it does, at least, appear to be a contemporary work.

9 With regard to Deshays, one thinks especially of very animated works such as the *Flagellation of St. Andrew* from the Salon of 1761 (Musée des Beaux-Arts, Rouen), or *The Marriage of the Virgin* from the Salon of 1763 (church of Saint-Pierre, Douai).

10 The analogy has often been remarked upon between this composition and a large drawing by Van Loo, *Sacrifice of Iphigenia* (Metropolitan Museum of Art, New York; Sahut, 1977, no. 363, p. 123), made in preparation for a picture that appeared at the Salon of 1757, which is now in Potsdam-Sanssouci; similarly, the monochrome color range evokes that of the large paintings in Notre-Dame des Victoires (Sahut, 1977, nos. 120–53, pp. 63–64).

11 Ananoff, III, no. 1714; Williams, 1978–79, no. 18.

12 One could cite works like *Silence!* (1759, H.M. The Queen, British Royal Collections), *The Village Arbitrator* (1761, Louvre), or *The Paralytic and His Children* (1763, The Hermitage); they show a similar concern with realism and narrative, as well as similar types of children and of animals.

13 *Visiting Grandfather* and *The Return* are in private collections (Ananoff, I, nos. 42–43; *The Stable*, which is a farmyard (Ananoff, I, no. 2), is in the Musée Ile-de-France, Saint-Jean-Cap-Ferrat.

14 One thinks of the *Holy Family on the Staircase*, which was, until recently, in a Parisian collection, or of the *Holy Family* in the Fogg Art Museum in Cambridge, Mass.

15 An ink and wash drawing (private coll., Ananoff, II, no. 634), in the same technique and style as *Visiting Grandfather* and *The Return*, would seem to confirm the accuracy of our date.

16 The "Sketch of a composition executed on a ceiling in the Louvre" is mentioned at a date so late (sale, Saint, May 4, 1846, lot 155) that it can only be taken into account with the greatest hesitation.

17 Seznec-Adhémar, 1963, p. 280 ("the whole work resembles a project for a ceiling or cupola").

18 Ibid.

19 Wildenstein, 1960, p. (16).

20 Mariette, who was both impressed and reticent when faced with Fragonard's works, says of *Coresus* that it "seems to have been painted with difficulty," and comments on it very subtly. "I see in it, generally, a technique that aims for Bourdon's style"; he continues, "Shyness, which dominates this artist's character, holds back his hand and, never satisfied with what he has achieved, he goes over it again and revises what he has done, which is a method that is harmful to one's talent and might adversely affect this young painter" (Montaiglon, 1851–60, Vol. II, p. 263). The recent xrays of *Coresus* confirm Mariette's statement: in particular, Fragonard considerably changed the figure of the assistant at the far right, who was originally depicted standing.

Chapter V

1 Collé, 1767 (1868 ed.), Vol. III, pp. 165–66.

2 *The Stolen Shift* in the Louvre, which (unless it was a different version) seems to have figured in the Gros sale as early as 1778 as a pendant to *All in a Blaze*, might be of a slightly later date, as it is more unified and delicate.

3 Jean-François Martin from Cahors and Louis-André Dalbeau, who were admitted in June 1767 and May 1768 to follow courses at the Académie (Wildenstein, 1960, p. 47).

4 See Portalis, 1889, pp. 110–11, 257–58; Wildenstein, 1960, p. (18), n. 1 and p. 47; the marriage certificate was published by the Goncourt brothers (1882 ed., pp. 286–87, no. 2).

5 Wildenstein, 1960, pp. (18), 48.

6 Alastair Laing has generously specified for us (written communication, March 1987) that Fragonard purchased a small portrait attributed to Van Dyck (lot 11), a drawing by Leonant Bramer (lot 253), as well as four paintings and a drawing by Charles De La Fossé (lots 58, 61, 65, 343; see, for Fragonard's admiration of La Fossé, n. 10 to our Conclusion). Wildenstein (1960, p. 48) states that the painter bought fourteen lots from the catalogue, but the basis for his assertion is not clear to us.

7 Ananoff, II, no. 948; Williams, 1978–79, no. 20.

8 Ananoff, II, no. 650; idem IV, p. 374; Williams, 1978–79, no. 21.

9 The replica of the gouache of *The Fête at Rambouillet* (Straus Collection, New York; Ananoff, I, no. 246; Williams, 1978–79, no. 51) might date from a few years after the painting.

10 Sterling, 1964 (unpaginated, fig. 10 and n. 12); the other Fragonards considered to be portraits of "La Guimard," which bear no resemblance to the painting in the Louvre and which were painted at different times, cannot, in fact, be portraits of her (cat. nos. 212, 231, 329).

11 Two *Academic Figures* and a *Drapery Thrown over the Model*, engraved by A.S. Defehrt after drawings by Fragonard (it is difficult to establish whether they date from the time of his training at the Ecole Royale des Elèves Protégés or at the Académie de France in Rome), appear in the chapter on "Drawing" in the *Encyclopédie* (Vol. III, 1763, pls. XVII, XVIII, XXVII). A copy in red chalk of the first of these drawings, is in a private collection in Paris (see Madeleine Pinault, "Diderot et les illustrateurs de l'Encyclopédie," in: *Revue de l'Art*, no. 66 [1984]: 36, n. 61, fig. 35).

12 Letter to Sophie Volland of November 22, 1768 (*Correspondance*, pp. 228–29).

13 Vilain, 1980–81, no. 38, pp. 87–88.

14 Wildenstein, 1960, p. (16); Sterling, 1964, (unpaginated).

15 Sterling, 1964, unpaginated, nos. 10–12.

16 Sahut, 1977, no. 147, p. 75; no. 174, p. 84; Sahut, 1984–85, no. 110, pp. 370–72.

17 Similarly, Michel-Barthélémy Ollivier exhibited several *Spanish Conversations* and *A Spaniard Holding a Guitar and Listening to a Woman Who is Speaking to Him*, which appears to have been lost; Casanova exhibited a *Spaniard Dressed in the Old-Fashioned Way* at the Salon of 1767; Valade exhibited the *Portrait of a Young Child in a Spanish Costume*, a pastel, at the Salon of 1769, and Le Prince dated to 1768 a *Young Musician* in Spanish costume (sale, Charpentier, Paris, May 17, 1956, lot 19). This fashion appears to have lasted: Brenet exhibited a *Young Girl Dressed in Spanish Costume Taking Flowers out of a Vase* at the Salon of 1781; Greuze painted a young girl wearing a dress with slashed sleeves and a Medici collaret, known as *The Spanish Girl*, or *The Ingénue* (Wallace Collection, London), probably in the 1790s, and portraits with Spanish costumes still appeared at the Salon of 1793. Were "Spanish" costumes worn on stage? This seems highly probable; the female acrobat in *The Fête at Saint-Cloud* is wearing a ruff and a plumed hat (in the painting), and a Medici collaret (in the sketch). Her companion is also wearing a collaret (cat. nos. 342, 344). One also notices that *Mlle. Guimard*'s costume is very similar to that worn by the young woman on the left in Watteau's *Little Actors* in the National Gallery of Ireland, Dublin.

18 Mention may also be made of a lost painting by Doyen, from the Salon of 1761, *A Young Girl Busy Reading a Booklet with Her Dog on Her Lap*, which points directly to the *Figures de Fantaisie*; an idea of what it looked like is given by Saint-Aubin's sketch of it in the catalogue of the Lalive de Sully sale (1770).

19 The format of about 80 × 65 cm. was used by Fragonard: see cat. nos. 101–2, 191, 220–21; the format 92 × 72 cm. was also frequently employed: see cat. nos. 94–96, 186, 193, 274, 300, 320, 336, 362.

20 Goncourt, 1882 ed., p. 282.

21 Carlo Volpe and Mauro Lucco, *L'Opera completa di Sebastiano del Piombo*, Milan, 1980, no. 63, p. 114.

22 In Vouet's œuvre, one thinks of *The Assassin* in Brunswick, or of the *Girl Playing the Guitar* in the Patrizi Collection in Rome or, in Vignon's œuvre, of the *Young Singer* in the Louvre.

23 Jacques Foucart and Paolo Lecaldano, *Tout l'œuvre peint de Rembrandt*, Paris, 1971, no. 156, p. 103.

24 Ibid., no. 188, p. 104; nos. 205, 208, p. 106.

25 One of the two paintings by Hals is in the museum in Antwerp; the other in a private collection. On Rembrandt's couple, see Foucart and Lecaldano, 1971, nos. 123–24, p. 101.

26 The picture and its pendant, a girl sewing, engraved by Levillain under the title *The Hard-Working Girl*, appeared on the London art market in 1979. Another comparison may be made with the figures of another, even earlier artist, Jean-Baptiste Santerre (1658–1717), who specialized in half-length female figures, especially in *Young Spanish Girls*, whose similarity to those by Fragonard is striking. A revealing text, which appeared after Santerre's death, in the *Mercure de France* (September 1718), which Claude Lesné has brought to the present writer's attention, explains that the painter, disappointed by the reactions there had been to some of his portraits, "no longer wished to commit himself to painting perfectly faithful portraits. He painted imaginary heads, in which he incorporated the most admira-

ble features of the people for whom he painted them… It was at this time that he thought of painting only a half-figure in each picture, representing an art, a science, or simple actions…" One notices the use of the expression "imaginary head," which was widely used in the eighteenth century to characterize such works. Some of Santerre's figures are very similar in their layout to some of Fragonard's *Figures de Fantaisie*, such as *Mademoiselle Guimard* or *Study*.

27 See, for example, two prints, *Let's Hope That the Game Will Be Over Soon* and *I Knew We Would Get Our Turn*, reproduced in Michel Vovelle, *La Révolution française: Image et Récit. 1789–1799*, Vol. I: *De la prérévolution à octobre 1789*, Paris, 1986, p. 212.

28 It is not absolutely certain that the painting is of Saint-Non, as it appeared in the Varanchan sale (1777) as "Horseman dressed in the Spanish style." But it does bear a strong resemblance to the portrait in the La Caze Collection, in the Louvre.

29 A *Portrait of a Man*, traditionally considered to be that of Chardin (cat. no. 215), which Wildenstein (no. 525) believes to have been painted "in about 1789," might be contemporary or slightly later.

30 One should add to the portraits painted during this period the portrait of an unknown woman, called *The Sultana*, which has recently reappeared (cat. no. 226), and which may be dated about 1770–72; Fragonard painted versions of it in various smaller formats, in which the face is no longer individualized (cat. nos. 267–68, 325): three have been preserved; one, in Muncie, Indiana, appears to date from after the artist's second journey to Italy and proves how successful such works were. Turkish subjects were very popular at this time and mention may be made of paintings by Amand at the Salon of 1767, by Favray at the Salon of 1771, by Amédée Van Loo at the one in 1773, and by Taraval at the Salon of 1779. Special mention should be made of a "half-length figure of a Sultana," by Amand, (no. 170 at the Salon of 1765), which has been lost, and of a *Sultana Playing a Stringed Instrument* by Carle Van Loo (unknown private coll.), painted for Madame de Pompadour's Turkish Room, which is similar in layout to the paintings by Fragonard (Sahut, 1977, no. 150). Once again, the mark of Van Loo on his former student is quite evident here.

31 One should mention the paintings in the Museo Correr in Venice, in the Narodni Gallery in Prague, and in the Fine Arts Gallery in San Diego, all of which may be dated from about 1755 (Guido Piovene and Anna Pallucchini, *L'Opera completa di Giambattista Tiepolo*, Milan, 1968, nos. 223–24, 227, p. 121).

32 An anonymous copy in red chalk in the Musée Fabre in Montpellier (inv. 870-I-132), proves that such pictures were much admired; the drawing by Fragonard in the library in Rouen (Pierre Rosenberg and Antoine Schnapper, exh. cat. *Choix de Dessins anciens*, 1970, no. 16), appears to have no direct link with the painting and to be a much later work.

Chapter VI

1 Furcy-Raynaud, 1904, pp. 220–21; Wildenstein, 1960, p. 48.

2 Marie-Anne Dupuy and Pierre Rosenberg (*La peinture en Provence dans les collections du musée de Toulon du XVIIᵉ siècle au début du XXᵉ siècle*, Toulon, 1985, no. 12, pp. 87–89) date the works from the painter's youth, "very probably" from before 1755, which would seem to be too early. The drawing in the

R. McGowen Collection, *Venus in a Chariot*, appears to form part of the investigations that preceded the *Day*, in Dublin (Ananoff, I, no. 401; Williams, 1978–79, no. 1, who gives it too early a date). The iconography of the latter painting is not unique; one could mention an overdoor exhibited by Hallé at the Salon of 1753 (no. 50), showing "Noon, under the Emblem of Venus and Cupid."

3 Wilhelm, 1975, p. 16; Fragonard seems to have collaborated on the foreground of two of the large decorative panels, those showing a dog and some rabbits (Wilhelm, 1975, figs. 4 and 7) and waterfowl (ibid., figs. 15–16).

4 Goncourt, 1882 ed., p. 283, no. 1.

5 Published by Régis Michel, in the exh. cat. *David e Roma*, Rome, Villa Medici, 1981–82, p. 238.

6 Chaussard, 1806, p. 147.

7 In the catalogue of his own works that he drew up in about 1822, David includes: "no. 2, the ceiling of Mlle. Guimard's salon" (Wildenstein, 1973, document no. 1938, p. 226).

8 Ananoff, IV, no. 2457; Cornillot, 1957, no. 65.

9 See J. Mayor, "L'Hôtel de la Chancellerie d'Orléans à Paris," in *Gazette des Beaux-Arts* (1914–16): fig. on p. 359.

10 The two sketches that have been preserved (cat. nos. 243–44) might suggest that these panels were originally intended to have a narrower format.

11 Canvas, diam. 42 cm.; Greffuhle Collection, later MacDonald Collection; see the catalogue, Leggat Brothers, London, 1970, no. 5, fig. on p. 17.

12 Roland Michel, 1980; for a historical account of the commission and an interpretation of the subjects, see Cailleux, 1935; Biebel, 1960; cat. Frick Collection, 1968, Sauländer, 1968; Munhall, 1971; Posner, 1972; for a deliberately erotic interpretation, see also Kirby, 1982.

13 Anonymous [attributed to Renou], *Dialogues sur la peinture, A Paris, imprimés chez Tartouillis aux dépens de l'Académie*, Paris, 1773.

14 The paintings by Vien have unfortunately been dispersed; two are in the Louvre and two in the prefecture in Chambéry. On the commission that was given to Vien and on the iconography of the series, see Gaehtgens and Lugand, 1987, pp. 122–27.

15 See paintings by Van Loo such as the *Homage to Love* (1760), which has been lost but was engraved (Sahut, 1977, no. 247), or *The Offering to Love* from the Salon of 1761 (ibid., no. 246), which reappeared recently (exhibited: Heim Gallery, London, summer 1977, no. 12).

Chapter VII

1 On Bergeret, see Tornézy, 1895, pp. 1–65; Wilhelm, 1948, pp. 7–17; Wildenstein, 1961, pp. 40–49.

2 Published in full by Tornézy, 1895. Extracts from it, with photographs of Fragonard's drawings, were published by Wilhelm, 1948.

3 Tornézy, 1895, pp. 67–69; Wilhelm, 1948, pp. 19–20.

4 Tornézy, 1895, p. 73; Wilhelm, 1948, p. 21.

5 Ananoff, I, no. 334.

6 Ibid., nos. 381, 268.

7 Ibid., no. 255.

8 Tornézy, 1895, p. 88; Wilhelm, 1948, p. 26.

9 Ananoff, I, no. 267.

10 Ibid., no. 273.

11 Ananoff, III, no. 1614; Cornillot, 1957, no. 44.

12 Ananoff, III, no. 1590; Cornillot, 1957, no. 45.

13 Tornézy, 1895, p. 135; Wilhelm, 1948, p. 51.

14 December 27: Tornézy, 1895, pp. 171–72; Wilhelm, 1948, p. 70.

15 Tornézy, 1895, p. 240; Wilhelm, 1948, p. 88. See also the following remarks, noted on March 1, "We have been busier inside than out for several days, with drawings and minor works that we are following and that we shall see in our collection in Paris… The weather has just turned rainy… we will have recourse to our supplies of curios and to our learned friends" (Tornézy, 1895, p. 243).

16 On March 6: Tornézy, 1895, p. 245; Wilhelm, 1948, p. 90.

17 See Réau, 1956, p. 25 and fig. 11; Cuzin, 1981–83, p. 107, fig. 6; the Musée des Beaux-Arts in Besançon owns an interesting wash drawing that may be a copy made by Bergeret of his own portrait by Vincent (48 × 34.3 cm, Gigoux fund, D 2886, annotated: "9b 1783 par B… d'après Vincent"). Bergeret himself produced drawings, as is repeatedly made clear in his account of the journey.

18 Ananoff, III, nos. 1174–75 (Fragonard), nos. 1173, 1176 (Vincent); Cuzin, 1981–83, p. 113, figs. 17–20; it would appear that the two artists could not have collaborated on the *Drawing Lesson* (private coll., New York), and this picture, dated March 1774, is by Vincent alone (Cuzin, 1981–83, p. 107, fig. 7, nn. 18–22).

19 Ananoff, I, no. 10 (*Child with a Cat*); F.J. Gould Collection; this picture was acquired by the Louvre in 1984 (RF 40959).

20 Previously attributed to Aubry; Ananoff, I, nos. 215–16.

21 Ibid., nos. 217, 214.

22 Ananoff, III, no. 1313; Williams, 1978–79, no. 29.

23 Ananoff, IV, nos. 2389, 2252; Cornillot, 1957, nos. 46–47; Ananoff, IV, no. 2388.

24 Ananoff, IV, nos. 2576–77; the painted sketch that has been given the latter number may be by Berthélemy.

25 Ananoff, II, no. 670; exh. cat. *Dessins du XVIe au XIXe siècle de la collection du Musée des Arts décoratifs de Lyon*, Lyons, Musée des Tissus, 1984–85, no. 84.

26 Tornézy, 1895, p. 315; Wilhelm, 1948, pp. 110–11.

27 Ananoff, I, no. 119; Williams, 1978–79, no. 33.

28 July 20: Tornézy, 1895, p. 383; and July 25: Ibid., p. 389.

29 July 30: ibid., p. 394.

30 August 10; ibid., p. 400; Wilhelm, 1948, p. 141. See especially the copy of the *Funeral of Decius Mus* by Rubens (private coll., U.S.A.; Ananoff, II, no. 1098; Williams, 1978–79, no. 34).

31 Tornézy, 1895, p. 409; Wilhelm, 1948, p. 144.

32 Tornézy, 1895, p. 67, nn. 1–3, and p. 68, nn. 1–3; Wilhelm, 1948, p. 150.

33 Frédéric Villot, *Catalogue des peintures du Louvre: Ecole Française*, 1855, p. 127; Goncourt, 1882 ed., p. 292, no. 1; Wildenstein, 1960, pp. 24–25 and no. 1.

Chapter VIII

1 For the different hypotheses and for Fragonard's literal demarkations of Dutch paintings, see Réau, 1932; Wilhelm, 1948; Ananoff, 1959, and Slive, 1982.

2 Ananoff, I, no. 458; this work was part of the collection of Vassal de Saint-Hubert (sale, March 29, 1779, lot 186).

3 Ibid., no. 480.

4 Ananoff, III, no. 1879; Cornillot, 1957, no. 61.

5 For certain copies after the Dutch masters by Fragonard, or for those that are attributed to him, see also Chapter I, p. 14.

6 Ananoff, III, no. 1771.

7 Ibid., nos. 1769–70 (St. Louis Art Museum and private coll.).

8 Ibid., no. 1773; id., IV, p. 434; Rosenberg, 1984, no. 3.

9 On the Collection Véri, see Colin Bailey, "Le Marquis de Véri collectionneur," in: *Bulletin de la Société de l'Histoire de l'Art français, Année 1983*, 1985, pp. 67–83.

10 Lenoir, 1816, p. 420.

11 A fine wash drawing in the Cabinet des Dessins of the Louvre (Ananoff, I, no. 460) appears to be a preparatory piece, executed with zest, compared with which the painting, with its very well-organized light effect, seems tame and more simplified.

12 Ananoff, IV, nos. 2004–5; see Compin and Rosenberg, 1974, II, p. 272, figs. 12–13, pp. 268–69. The drawings are similar in style to a work like the *Bedtime* in the National Gallery of Art in Washington, D.C. (Ananoff, I, no. 87; Williams, 1978–79, no. 25), which may be dated to the 1760s.

13 Isabelle Compin and Pierre Rosenberg (1974, II, p. 276), conversely, stress the differences that separate the sketch from the painting, and consider that the former "must be much earlier…" than the latter.

14 Thuillier, 1974, p. 1; Compin and Rosenberg, 1974, II, pp. 277–78.

15 In the exh. cat. *David à Delacroix*, at the Grand Palais, Paris, 1974–75, no. 59.

16 A painting in a very different style, which makes extensive use of chiaroscuro, may date from about the same time: *The Useless Resistance* (cat. no. 305) in the De Young Memorial Museum, San Francisco.

17 The color range (yellows, browns, whites, and pure reds) is close to that of *The Little Preacher* in a Parisian collection (cat. no. 351).

18 According to Wildenstein (1960, nos. 410–11), the paintings came from the Château de Saint-Brice, the property of Marie-Catherine Colombe.

19 *The Happy Family* (cat. no. 314, private coll.), in which the motifs of the man and of the donkey's head reappear, seems to be of a similar date. Contemporary drawings treat rustic family subjects in the same robust style that is radiant with gaiety but free of any sentimentality; they include *The Chest* (private coll., Paris; Ananoff, I, no. 39).

20 Ibid., no. 6.

21 Ibid., no. 3; Williams, 1978–79, no. 45.

22 Wildenstein, 1956, no. XXIII.

23 The very popular work, *Say "Please"* in the Wallace Collection (cat. no. 348), appears to date from the same period; one should refrain from seeing images of the young Alexandre-Evariste in each of these works, which would mean that they would have to be dated from the start of the 1780s.

24 It is often thought that the subject of these three pictures was derived from the short novel by the Marquess de Saint-Lambert, *Miss Sara* (published in 1765) as was that of the three variants of *The Visit to the Foster Mother* (cat. nos. 123–25) and that of *The Cradle* in Amiens (cat. no. 84). But these identifications are uncertain (cat. no. 123).

25 Ananoff, III, no. 1380; Williams, 1978–79, no. 49.

26 It seems to have been first used by Portalis in 1889 (p. 83).

27 Ananoff, II, no. 790 and Williams, 1978–79, no. 39; Ananoff, 1976, II, no. 817.

28 See several hats in the English style that were fashionable in

1778 (M. Leloir, *Dictionnaire du costume*, Paris, 1951, figs. 15–16, p. 88), and some dresses in the Turkish style from 1780 (for example, *Galerie des Modes*, 1780, pl. 176).

Chapter IX

1 Schnapper, 1980, p. 64 (with regard to *Bélisaire*).
2 See cat. no. 261.
3 Private coll.; Ananoff, IV, no. 2428.
4 The fine wash drawing in the Cleveland Museum of Art (ibid., no. 2422) is considered, by Eunice Williams, to be an autograph reduced version of the finished picture; she puts forward good arguments for this view (1978–79, no. 50).
5 According to Gabriele Mandel (1972, no. 526).
6 See especially a work like *Hymen and Cupid Drinking from the Cup of Friendship* (the Louvre), by Regnault, or the later work *Daphnis and Chloe* by Gérard, of 1825 (the Louvre).
7 Wildenstein, 1960, p. 50. Fragonard's signature does not appear on the child's birth certificate, and it has been thought that he had remained in Paris. Sally Wells-Robertson (1977–79, pp. 179–80) suggests, on the contrary, that the couple had traveled to Grasse because they were anxious about the health of Fragonard's father, had decided to stay there until their child was born, and had allowed the child's grandfather to sign by himself "as a sign of respect...," and that they had then remained in the town for four months to look after the old man during his last days.
8 Wells-Robertson, 1977–79, p. 180.
9 the Goncourt brothers assert (1882 ed., p. 293) that Fragonard "was so violently affected that he caught a serious bout of cholera-morbus, which was then a rare disease, and it was after this illness that, on his doctors' advice, he went to spend a year in his native region." Fragonard seems to have drawn his daughter many times in the last years of her life (see Williams, 1978–79, nos. 54–55). The Goncourt brothers (1882 ed., p. 341) mention a large number of drawings ("about a hundred and fifty"), executed after everyday scenes of life in Bergeret's home, which appear to include *The Competition* and *He Has Won the Prize*, two compositions of which there are sketched versions (Städelsches Kunstinstitut, Frankfurt-am-Main, and Pierpoint Morgan Library, New York) as well as finished versions (private coll., Paris); see Goncourt, 1882 ed., no. 1, p. 341; Williams, 1978–79, no. 58.
10 According to the Goncourt brothers (1882 ed., p. 288), it was when Rosalie was born that Fragonard invited Marguerite to come to help the young mother.
11 *The Child and the Cat* bearing the inscription: "first plate by M. Gérard aged 16 years. 1778;" the allegory, *To Franklin's Genius* of 1778; *The First Riding Lesson*, signed and bearing the inscription: "Second plate dedicated to the ladies and gentlemen," followed by all the letters of the alphabet (dated "c. 1780" by Wildenstein); *Monsieur Fanfan*, signed with the names of Fragonard and his student; another of their plates bears the inscription: "Mr. Fanfan Playing with Mr. Polichinelle and Company" (dated 1782 by Wildenstein [1956, nos. XXVI-XXX]). While her teacher obviously played the more important role, the different states of the engravings bear the name of Fragonard, or of M. Gérard, or of both, as if in a kind of game. In the present writer's opinion, this casual and affectionate type of col-

laboration continued in many of the paintings of subsequent years.
12 Private coll., France; Eunice Williams, "Drawings for Collaboration," paper (forthcoming), presented at the Woodner Symposium, March 1985.
13 By contrast, paintings like *The First Step of Infancy* (the Hermitage, Leningrad), engraved in 1788 by Henri Gérard under the title *The Spirit of Nature*, or *The Piano Lesson*, (New York art market, 1983), dated 1785 or 1786, do not reveal anything of Fragonard's style, whether in the physical types that are portrayed or in the execution itself.
14 See Mongan, Hofer, and Seznec, 1945; Williams, 1978–79, pp. 152–53 and nos. 62–68; recently, Roschach, 1985, pp. 9–15, 25–29.
15 *The Blond Child* in the Musée Fragonard in Grasse, the *Portrait of a Child* in the Collection David-Weill in 1926 (Henriot, 1926, I, pp. 157–59), or the *Portrait of a Little Girl* formerly in the Haviland Collection (sale, Paris, December 14–15, 1922, lot 50) appear to be by Marguerite Gérard, as is, possibly, the *Head of a Young Child* (W. 512; private coll., New York) and the *Portrait of a Child* (W. 517; private coll.). The *Portrait of a Painter* (W. 524; private coll.), a full-length portrait in a seated pose, is typical of Marguerite.
16 Mention should be made, in view of the similar theme, of a *Child Dressed as Pierrot* by Monnet, a picture from the Salon of 1771 (no. 173) that has disappeared, and of the *Portrait of Hérault de Séchelles as a Child Dressed as Pierrot* by Drouais (Collection F. Doistau sale, June 9–11, 1909, lot 25; then Dutasta sale, June 3–4, 1926, lot 62). Fragonard's *Pierrot* seems, however, to be derived from portraits of children by Drouais: so often portrayed in full face with soft relief in the light tones.
17 Ananoff, IV, no. 2041; Cuzin, 1986, I, p. 65, n. 26, and p. 66.
18 Oval, 55 × 45 cm; the former collections of Groult and Paul Derval. Fragonard's miniatures deserve to be the subject of a separate study; it would be difficult to carry out such a project as most of the miniatures that are attributed to him (busts of children and girls, often dressed in "Spanish costumes") are boringly repetitive and undoubtedly the work of an imitator—perhaps not only Marie-Anne Fragonard. She may, at any rate, have continued producing such works for many years; her death certificate (1824) refers to her as an "artist" (Wells-Robertson, 1977–79, p. 182). Among the miniatures whose quality enables them to be attributed to the master, one should cite at least the delightful and joyful *Head of a Child*, formerly in the F. Panhard Collection (Galliéra sale, December 5, 1975, lot 120), a *Small Boy* in contemporary costume, painted in quite a realistic manner (sale, Sotheby's, London, March 17, 1986, lot 65), and, in the Cabinet des Dessins of the Louvre, *The Young Girl* with her head bowed (RF 4995) and the *Little Boy Dressed as a Fencer* (RF 30708). The fact that there is another version of the last work that is of the same quality, the pendant of a small *Pierrot* (sale, Sotheby's, Geneva, May 7, 1982; see Williams, 1982, pp. 210–12), shows the complexity of the problems that are encountered here.
19 Fragonard probably did not stop painting landscapes (perhaps still in the Dutch manner) at this time. A view of an *Italian Park*, in black chalk and wash (Crocker Art Gallery, Sacramento), bears the date "1786," which proves that, at the time, he still felt inspired to paint Italian views with antique sculptures and figures in a very specific technique of washing, using small triangular or zigzagging touches to create many facets, and with a great deal of stippling (Ananoff, II, no. 947).

Chapter X

1 Wildenstein, 1960, p. 51.

2 Ibid.

3 When he left Grasse, Fragonard left his cousin a receipt for the sum of 3,600 livres, the price of the works painted during his stay (document preserved at the Frick Collection, New York).

4 Ananoff, II, no. 723; Williams, 1978–79, no. 61.

5 Goncourt, 1882 ed., p. 307, n. on p. 293. Several of the letters that Marguerite Gérard sent to Fragonard have been preserved; they were probably all written quite late because one of them bears the date 1802. Attempts have been made to base an amorous story upon them, but they point to nothing more than a sincere and fraternal friendship. One thing, at least, is clear; it appears from one of the letters that Fragonard had gotten into some financial difficulty and asked his young sister-in-law, who was presumably quite wealthy, for some money, and she refused to give him any. On this correspondence, see Portalis, 1889, pp. 226–233; Thuillier, 1967, pp. 41–42; Wells-Robertson, 1977–79, p. 179.

6 Wildenstein, 1960, p. 52.

7 Portalis, 1889, pp. 236–38, 261–62.

8 Wildenstein, 1960, pp. 52–58; Cantarel-Besson, 1981, II, passim.

9 Wildenstein, 1960, p. 52.

10 Ibid.

11 Ibid.

12 Cantarel-Besson, 1981, II, pp. 212–13.

13 Portalis, 1889, p. 239; Wildenstein, 1960, p. 52.

14 Wildenstein, 1960, p. 52; Cantarel-Besson, 1981, I, p. 24.

15 Cantarel-Besson, 1981, I, p. 156.

16 Ibid., p. 273.

17 Ibid., pp. 272, 275–76, 300.

18 Ibid., II, pp. 22–23, 25, 27, 29, 36, 39.

19 Wildenstein, 1960, p. 58.

20 Renouvier, 1863, pp. 21–22; see also the exh. cat. *De David à Delacroix,* Paris, Grand Palais, 1974–75, no. 127.

21 Udo Van de Sandt, who is preparing a study on this competition of the year II (French Revolutionary calendar 1794), points out the following important reference on 10 Prairial (May 29, 1794), concerning no. 1359, "Citizen Fragonard, the Painter, has submitted a painting representing the genius of Liberty, with its registration number as a distinctive feature"; the entry has been crossed out and the word "withdrawn" has been written in beside it. It does not appear that there could be any confusion with Alexandre-Evariste, who submitted two sketches (drawings) for which he was awarded prizes.

22 See Michel Vovelle, *La Révolution Française: Images et Récit, 1789–1799,* Vol. IV, June 1793–May 1795; plate on p. 212 (print in the Musée Carnavalet, Paris).

23 See Roland Michel, 1970; Williams, 1978–79, no. 53.

24 Wildenstein, 1960, pp. 51–52.

25 Ananoff, I, no. 67; id., II, p. 296; eight drawings featured in the Groult sale on March 21, 1952, lot 39 (one was reproduced); see Portalis, 1889, p. 314, plate facing p. 214, fig. on p. 216.

26 Wildenstein, 1960, p. 59.

27 Goncourt, 1882 ed., p. 308, n. 2. The newspaper reports speak of a "short illness" and thus seem to contradict the Goncourts' account; they write: "returning on foot from a walk in the Champ de Mars, feeling thirsty and hot, he went into a café to have an ice cream; he subsequently suffered a stroke that caused his death," but this was probably an account that had been handed down within the family and therefore carries some weight.

28 This opinion must be qualified however, for a circle of admirers remained attached to Fragonard's work; their only regret was that the artist had created his œuvre during a decadent era. Thus Le Carpentier (1821, pp. 279–83) speaks warmly of the painter, saying that he would be numbered among the greatest artists "if fashion and the bad taste of the century had not distracted him from his serious studies," and he subtly stresses Rembrandt's role, emphasizing the quality of Fragonard's landscapes and family scenes.

Conclusion

1 The most fascinating picture, which is, nevertheless, of an almost ghostlike vagueness, is that of Fragonard in a seated pose, which he drew himself in 1789 and annotated as follows, "se ipsum delineabat Frago apud de Bergeret anno 1789" (Institut Néerlandais, Paris; Ananoff, III, no. 1515). Three black chalk portraits, formerly in the Hinzelin Collection and now in the Cabinet des Dessins in the Louvre, are considered to be self-portraits, based on the evidence of family accounts; this is plausible in the case of two of them (Ananoff, I, no. 121, c. 1790?, and no. 123, c. 1795?), but very doubtful in the case of the third (idem, I, no. 122). A bust-portrait of Fragonard, which is in the Musée Fragonard in Grasse, where it was deposited by the Louvre, and whose attribution is problematical (it may, possibly, be by Alexandre-Evariste), might be even later (c. 1800). Le Carpentier's moving engraving showing a frontal view of Fragonard in a bust format, is clearly dated "1803"; it is one of the few unquestionably authentic portraits of Fragonard. A picture showing a frontal view of a seated Fragonard, which is apparently directly related to the engraving, formed part of the Huot-Fragonard Collection, and was attributed to Fragonard (Dayot-Vaillat, 1905, no. 75; Sale, Christie's, London, December 12, 1982, lot 14).

2 See Chapter II, p. 40 and cat. no. 49.

3 Published by Portalis, 1889, p. 237.

4 Ibid., p. 242.

5 The Goncourts (1882 ed., p. 247) repeat a family account, according to which Fragonard replied in this way to those people who asked him about his early work and about his training.

6 See Chapter III, pp. 42–45 and n. 10; see also the portrait by Mariette, who speaks of "shyness" (Chapter IV, no. 20).

7 See Chapter VII, p. 168.

8 Cited by Portalis, 1889, p. 231.

9 Renouvier, 1863, p. 167.

10 Nitot-Dufresne records the following valuable piece of evidence concerning Fragonard's working method, by which he gave prominence to effects of light and shadow: "Mr. Fragonard Senior, who had a feeling for color that was like Rembrandt's, showed me a sketch for a ceiling by La Fosse, one of our best colorists; what he admired most was the feeling possessed by the painter, who seems to have handled color in terms of large masses, as one handles groups, in such a way that every group of clouds, of figures, or of areas of ground had a general tone; the painting's overall effect was determined first of all, and every plane was diversified by the light, shade, and variety of the harmonious

colors (all brilliant to a greater or lesser degree) with which he enriched it." (Ratouis de Limay, 1949, p. 76).

11 David, who seems to have felt genuine affection for Fragonard, in a letter to his student Alexandre-Evariste speaks of his student's father in the following terms, "May he derive full pleasure from the freedom he has allowed you in the arts; for, wise man that he is, he has realized that a goal may be reached by more than one route…" The sentence is full of meaning; it suggests how "tolerant" Fragonard was when confronted with the art of David's school, but one is also tempted to apply it to the profuse and apparently contradictory diversity of Fragonard's own painting (quoted by Goncourt, 1882 ed., p. 306, n. 1).

Catalogue of Oil Paintings

Catalogue numbers preceded by an asterisk signify that we are not absolutely sure of the attribution to Fragonard: either it is advisable to keep an open mind, although the work is usually attributed to him; or the work is generally not attributed to him (or only rarely), and we are suggesting, with caution, an attribution to Fragonard. The commentary at the end of the entry gives more details.

The bibliographic references in the catalogue have been reduced to the minimum; for full titles, consult the Bibliography, pp. 359–62. The particulars taken into account for the entries in the catalogue of lost works are all contemporary with the artist. Sales were held in Paris if a city is not mentioned.

The paintings in the catalogue are arranged chronologically; the lost works (the letter L has been placed in front of these catalogue numbers) are arranged by the date when the first mention of them was recorded, except for those lost works from which engravings were made (grouped at the beginning as L 1–L 14).

The present catalogue is based on the French edition of this work, which was published in September 1987. A few correction that came subsequently to light have been made to this edition: Cat. nos. 201, 209, 232, and L 2. Two further entries have also been added: Cat. nos. 72a and 143a.

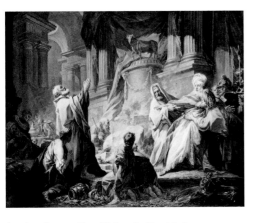

1 Jeroboam Sacrificing to the Idols
1752. Paris, Ecole Nationale Supérieure des Beaux-Arts. Canvas, 115 × 145 cm

Provenance: Competition for the Prix de Rome at the Académie in 1752: First Prize; Collection Académie Royale de Peinture
Bibl.: Goncourt, 1882, p. 249; Portalis, 1889, p. 14; Nolhac, 1906, p. 11; Wildenstein, 1921, no. 9; Réau, 1956, p. 141; Wildenstein, 1960, no. 88; Wilhelm, 1960, p. 3; Thuillier, 1967, pp. 21, 46, 59; Mandel, 1972, no. 96; Sutton, 1980, no. 22

See pp. 14–17; Pl. 15

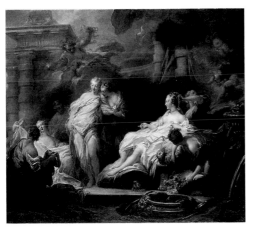

2 Psyche Showing Her Sisters Cupid's Presents
1753–54. London, The National Gallery. Canvas, 167 × 192 cm

Provenance: Presented to Louis XV in 1754 at Versailles; Collection Papillon de la Ferté, his sale, February 20, 1797, lot 100 [195 × 226 cm]; perhaps Collection Baron Mayer Amschel de Rothschild, Mentmore Towers, Buckinghamshire before 1874 (according to Carritt); Collection Hannah de Rothschild; Collection 5th Count of Rosebery, Mentmore Towers, until 1929; Collection 6th Count of Rosebery, until 1974; Collection 7th Count of Rosebery; Mentmore sale, Sotheby's, May 25, 1977, lot 2,422 (Carl Van Loo, *The Toilet of Venus*); D. Carritt; purchased by the museum in 1978
Bibl.: Portalis, 1889, pp. 18, 286; Nolhac, 1906, pp. 14–15; Réau, 1956, p. 146; Wildenstein, 1960, no. 89 (lost); Thuillier, 1967, p. 47 (idem);

Mandel, 1972, no. 97 (idem); Carritt, 1978, no. 20; Sutton, 1980, no. 23

See pp. 19–22; Pl. 17

The painting has been cut down. At the 1797 sale it measured 28 cm more in height and 34 cm more in width; sixteen figures are referred to in the description, whereas now there are only fourteen.

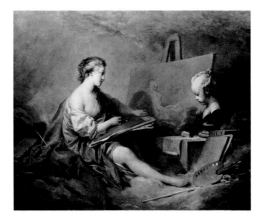

3 Painting
c. 1753. U.S.A., Private Collection. Canvas, 82 × 102 cm

Provenance: Painted with the three other *Arts* (cat. nos. 4–6) as part of the decoration for the Hôtel de Bergeret, Rue du Temple (?); perhaps Bergeret sale, April 24, 1786, lot 105 ("Four paintings representing the Arts as allegorical figures with their attributes," [62 × 130 cm]): purchased by the Abbé de Saint-Non, together with its pendants; Collection Baron James de Rothschild, Château de Fontaines; Wildenstein, New York
Bibl.: Portalis, 1889, p. 271; Nolhac, 1906, p. 160; Wildenstein, 1960, no. 57; Wildenstein, 1961, p. 74; Mandel, 1972, no. 65; Sutton, 1980, no. 11

In order to accept the identification of this painting and the following ones with the Bergeret *Arts*, one must assume that they have been considerably extended in height (which a study of the photographs would seem to confirm) and reduced in width. The edges appear to have originally been quite curvilinear.

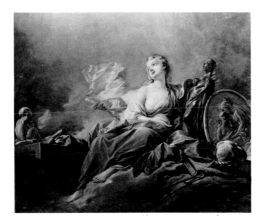

4 Sculpture

c. 1753. U.S.A., Private Collection. Canvas, 82 × 102 cm

Provenance: see cat. no. 3

Bibl.: Portalis, 1889, p. 271; Nolhac, 1906, p. 160; Wildenstein, 1960, no. 58; Wildenstein, 1961; Mandel, 1972, no. 66; Sutton, 1980, no. 12

See Pl. 16 on p. 20

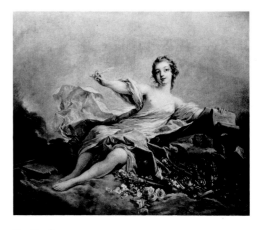

5 Poetry
c. 1753. U.S.A., Private Collection. Canvas, 82 × 102 cm

Provenance: see cat. no. 3

Bibl.: Portalis, 1889, p. 271; Nolhac, 1906, p. 160; Wildenstein, 1960, no. 59; Wildenstein, 1961; Mandel, 1972, no. 68; Sutton, 1980, no. 13

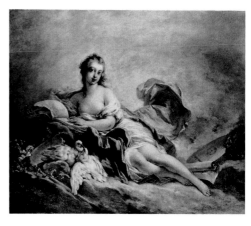

6 Music
c. 1753. U.S.A., Private Collection. Canvas, 82 × 102 cm

Provenance: see cat. no. 3
Bibl.: Portalis, 1889, p. 271; Nolhac, 1906, p. 160; Wildenstein, 1960, no. 60; Mandel, 1972, no. 67; Sutton, 1980, no. 14

7 The Birth of Venus
c. 1753. Marseilles, Musée Grobet-Labadié. Canvas, 54 × 83 cm

Provenance: Collection Grobet-Labadié; bequeathed in 1919

Bibl.: Réau, 1956, p. 147; Vergnet-Ruiz-Laclotte, 1962, p. 236; Cuzin, 1986, I, p. 58, nn. 2–4

See p. 39; Pl. 40

***8 The Birth of Amphitrite** (or **The Birth of Venus?**)
c. 1753. Location unknown. Canvas, 65 × 80 cm

Provenance: Duchange sale, Galerie Fiévez, Brussels, June 25–26, 1923, lot 63 (Fragonard)
Bibl.: Cuzin, 1986, I, p. 65, n. 6

The poor quality of the photograph in the 1923 catalogue prevents an accurate assessment. The analogy with certain parts of the Marseilles painting (cat. no. 7) can be noted; it could be the work of a fellow student of the École Royale des Élèves Protégés.

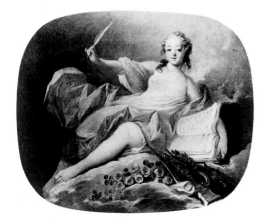

***9 Lyric Poetry**
c. 1753. Private Collection. Canvas, 72 × 83 cm (rounded corners)

Provenance: Cailleux, Paris; Private Collection
Bibl.: Algoud, 1941, n. p., plate 39

The quality appears to be only average, but it could be one of the decorative works executed by the artist soon after the Prix de Rome.

10 Allegorical Figure (History?)
c. 1753 (?), Lisbon, Fundação Calouste Gulbenkian. Canvas, 70 × 121 cm

Provenance: Mme. Charras, April 2–3, 1917, lot 8; Richard Owen; Collection C. Gulbenkian
Bibl.: Exh. cat. "Twentieth Anniversary of the Gulbenkian Foundation," Lisbon, Fundação Calouste Gulbenkian, 1976, no. 254

This may be one of Fragonard's first works at the Ecole Royale des Elèves Protégés (Royal School for Sponsored Students), when his style was not yet clearly defined.

11 The Harvester
c. 1753 (?). Detroit Institute of Arts. Canvas, 143.5 × 82.5 cm

Provenance: Collection R. Portalis; Kraemer sale, May 5–6, 1913, lot 35; Wildenstein, New York; Collection Judge Elbert H. Gary (according to Wildenstein); Collection Duveen, New York (idem); Collection Mrs. Anna Thomson Dodge, Rose Terrace, Grosse Pointe Farms, Michigan; Mrs. A. Thomson Dodge sale, Christie's, London, June 25, 1971, lot 8
Bibl.: Portalis, 1902, pp. 13–14, 19–24; Exh., Chardin-Fragonard, 1907, nos. 134–37; Réau, 1956, p. 172; Wildenstein, 1960, no. 36; Mandel, 1972, no. 36

See pp. 28–30

According to Wildenstein, reiterated by Mandel and by the editor of the Christie's sale catalogue in 1971, this picture and the following three were painted in 1753 for the Duke de Rochechouart. The source of this information is unknown. Portalis (1902, p. 14) indicates, without specifying the date, that the paintings came from the Hôtel de Mortemart-Rochechouart, Rue de l'Université. For other paintings originating from this group, see cat. nos. 16–19.

12 The Woman Gathering Grapes
c. 1753 (?). Detroit Institute of Arts. Canvas, 143.5 × 82.5 cm

Provenance: See cat. no. 11, Collection R. Portalis; Kraemer sale, May 5–6, 1913, lot 34; Mrs. A. Thomson Dodge sale, Christie's, London, June 25, 1971, lot 7
Bibl.: Portalis, 1902, pp. 13–14, 19–24; Réau, 1956, p. 172; Wildenstein, 1960, no. 37; Mandel, 1972, no. 34

13 The Gardener
1753 (?). Detroit Institute of Arts. Canvas, 143.5 × 90.1 cm

Provenance: See cat. no. 11; Kraemer sale, May

5–6, 1913, no. 33; Mrs. A. Thomson Dodge sale, Christie's, London, June 25, 1971, lot 9
Bibl.: Portalis, 1902, pp. 13–14, 19–24; Réau, 1956, p. 172; Wildenstein, 1960, no. 38; Mandel, 1972, no. 37

by Marie-Anne Dupuy. It is an important addition to the catalogue of the young Fragonard's œuvre. The sketchy treatment is reminiscent of the painting in the Musée Grobet-Labadié in Marseilles (cat. no. 7).

Bibl.: Wildenstein, 1960, under nos. 36–39 (not by Fragonard)

See cat. nos. 11–14

14 The Shepherdess

1753 (?). Detroit Institute of Arts. Canvas, 143.5 × 90.1 cm

Provenance: See cat. no. 11; Kraemer sale, May 5–6, 1913, no. 32; Mrs. A. Thomson Dodge sale, Christie's, London, June 25, 1971, lot 6
Bibl.: Portalis, 1902, pp. 13–14, 19–24; Réau, 1956, p. 172; Wildenstein, 1960, no. 39; Mandel, 1972, no. 35

See Pl. 26 on p. 28

16 The Little Musician

1753 (?). Private Collection. Oval canvas, 98 × 86 cm

Provenance: Perhaps part of the decoration for the Hôtel de Mortemart-Rochechouart; Kraemer sale, May 5–6, 1913, lot 22; anonymous sale, March 11, 1975, lot 23 (together with its pendant); Cailleux, Paris
Bibl.: Wildenstein, 1960, under nos. 36–39 (not by Fragonard)

See cat. nos. 11–14

18 The Little Pilgrim

1753 (?) Private Collection. Oval canvas, 82 × 76 cm

Provenance: Perhaps part of the decoration for the Hôtel de Mortemart-Rochechouart; Kraemer sale, April 28–29, 1913, lot 13 ("French School 18th century," 97 × 77 cm); Cailleux, Paris
Bibl.: Wildenstein, 1960, under nos. 36–39 (not by Fragonard)

See cat. nos. 11–14

15 The Shepherdess

c. 1753 (?) Burlington, The University of Vermont, Robert Hull Fleming Museum. Canvas, 50.2 × 37.5 cm

Provenance: Collection J. Simpson; presented to the museum in 1961

See cat. nos. 14 and 21

This painting was kindly brought to our attention

17 The Little Gardener

1753 (?) Private Collection. Oval Canvas, 98 × 85 cm

Provenance: Perhaps part of the decoration for the Hôtel de Mortemart-Rochechouart; Kraemer sale, May 5–6, 1913, lot 23; anonymous sale, March 11, 1975, lot 23 (together with its pendant); Cailleux, Paris

*19 The Clever Dog

c. 1753 (?) Cholet, Musée Municipal. Oval canvas, 83 × 75 cm

Provenance: Perhaps part of the decoration for the Hôtel de Mortemart-Rochechouart; Private Collection; Kraemer sale, June 2–5, 1913, lot 79 ("French School 18th century"); found in Germany in 1945; allocated by the Office des Biens Privés to the Musées Nationaux, MNR 68; deposited in the Musée de Mayenne, transferred to the Musée de Cholet in 1984 ("Boucher"?)

See cat. nos. 11–14

This painting may have been part of the same group as cat. nos. 16–18. The attribution to the young Fragonard is not absolutely certain, and the possibility that the hand of another of Boucher's students may be seen here should not to be excluded.

20 Young Woman with a Watering Can and Two Children, or **The Gardener,** wrongly called **The Flower Seller**
c. 1753–55 (?). Paris, Private Collection. Canvas, 60 × 38 cm

Provenance: M. sale, December 28, 1785, lot 79; Collection Mrs. Corbin (according to Wildenstein); Collection Vincent (idem); Wildenstein (idem); Collection Maurice de Rothschild; Collection Edmond de Rothschild, Pregny
Bibl.: Nolhac, 1906, p. 149; Wildenstein, 1960, no. 34; Mandel, 1972, no. 32

Wildenstein appears to have inverted, for this painting and its pendant, cat. no. 21, the titles given in the 1785 sale.

21 Young Woman with Two Children, or **The Flower Seller,** wrongly called **The Gardener**
c. 1753–55 (?). Paris, Private Collection. Canvas, 60 × 38 cm

Provenance: See cat. no. 20
Bibl.: Nolhac, 1906, p. 149; Wildenstein, 1960, no. 35; Mandel, 1972, no. 33

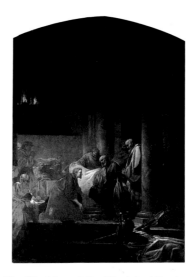

22 The Washing of the Disciples' Feet
1754–55. Grasse, Cathedral. Canvas, c. 400 × 300 cm

Provenance: Commissioned on May 18, 1754 by the Brothers of the Blessed Sacrament of Grasse from the "sieur Fragonard, from this town, living in Paris." Presented to the king at Versailles in April 1755
Bibl.: Goncourt, 1882, p. 323; Portalis, 1889, pp. 18, 280; Nolhac, 1906, pp. 15–16; Réau, 1956, p. 142; Wildenstein, 1960, no. 91; Wilhelm, 1960, p. 4; Thuillier, 1967, pp. 45, 47, 62; Mandel, 1972, no. 99

See p. 22; Pl. 19

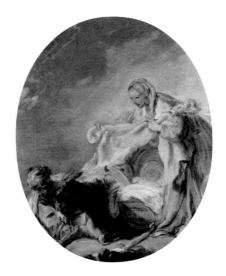

23 The Rest on the Flight into Egypt
c. 1754–55. Private Collection. Canvas, 53 × 43.5 cm

Provenance: H. Rouart sale, December 9–11, 1912, lot 37; Collection E. Rouart, Paris
Bibl.: Wildenstein, 1921, no. 12; Daulte, 1954, no. 4; Réau, 1956, p. 142; Wildenstein, 1960, no. 24; Mandel, 1972, no. 25

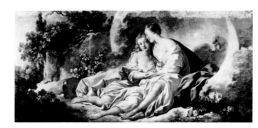

24 Jupiter and Callisto
c. 1755. Angers, Musée des Beaux-Arts. Canvas, 78 × 178 cm

Provenance: Mme. Gentil de Chavagnac sale, June 20, 1854, lot 50 (under the name of Boucher); Collection J. E. Duboys; bequeathed to the museum in 1882
Bibl.: Wildenstein, 1923, pp. 120–22; Réau, 1956, p. 147 (with incorrect measurements); Wildenstein, 1960, no. 50; Wilhelm, 1960, p. 49; Mandel, 1972, no. 55

See p. 37; Pl. 37

Restored, as was its pendant (cat. no. 25), to Fragonard by G. Wildenstein (1923).

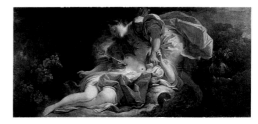

25 Cephalus and Procris
c. 1755. Angers, Musée des Beaux-Arts. Canvas, 78 × 178 cm

Provenance: Mme. Gentil de Chavagnac sale, June 20, 1854, lot 51 (under the name of Boucher); Collection J. E. Duboys; bequeathed to the museum in 1882
Bibl.: Wildenstein, 1923, pp. 120–22; Réau, 1956, p. 147 (with incorrect measurements); Wildenstein, 1960, no. 51; Wilhelm, 1960, p. 50; Mandel, 1972, no. 57

See p. 37 and cat. no. 24; Pl. 39

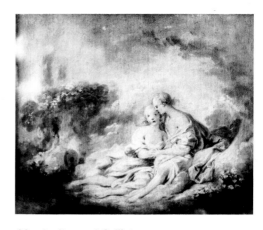

26 Jupiter and Callisto
c. 1755. Private Collection. Canvas, 46 × 55 cm

Provenance: Anonymous sale, December 15, 1873, lot 9; Collection F. Halphen, Paris (in 1923)
Bibl.: Wildenstein, 1923, pp. 120–22; Wildenstein, 1960, no. 49; Wilhelm, 1960, p. 49; Mandel, 1972, no., 56

See cat. no. 24; Pl. 38

The dimensions seem to differ from those of the sketch of the same subject which was sold at the Dulac (1778) and Pasquier (1781) sales: see cat. no. L 68.

27 St. John the Baptist
c. 1755. Private Collection. Canvas, 32 × 24 cm

Provenance: Collection Maubert, Grasse (according to Wildenstein); Collection Malvilan, Grasse (idem); Collection de Blic, Grasse (idem); Collection Mercedes Saavedra Zelaya, Buenos Aires
Bibl.: Wildenstein, 1960, no. 87; Mandel, 1972, no. 95; Sutton, 1980, no. 21

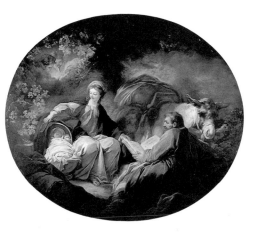

28 The Rest on the Flight into Egypt
c. 1755. Norfolk, Virginia, The Chrysler Museum, on loan from Walter P. Chrysler, Jr. Oval canvas, 190 × 221 cm

Provenance: Collection Baron Franchetti, Venice; Collection Jamarin, Paris; acquired by Walter P. Chrysler in April 1954
Bibl.: Suida Manning, 1956, no. 67; Zafran, 1976, unpaginated

See pp. 26–27; Pl. 24 and, for the preliminary sketches, cat. nos. 29–30

The top left-hand side with the two angels' heads, concealed by an overpainting, was restored in 1955. B. Suida Manning (1956) indicates that the painting was "painted for the church in Grasse, according to information obtained from Viscount Jacques de Canson, Paris."

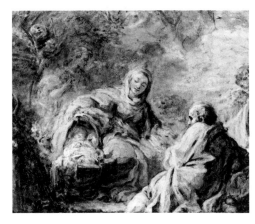

29 The Rest on the Flight into Egypt
c. 1755. Private collection. Canvas, 57 × 74 cm

Provenance: Perhaps Vien sale, May 17, 1809, lot 30 (without measurements; "sketch with the subject of the crib"); perhaps Ménageot sale, December 17, 1816, lot 15 ("subject of the crib, sketch"); perhaps A. sale, April 2, 1859, lot 15 (without measurements, *The Rest of the Holy Family*); Collection J. Strauss; Salavin sale, December 5, 1973, lot 34
Bibl.: Wildenstein, 1921, no. 78; Réau, 1956, p. 142; Wildenstein, 1960, no. 12; Wilhelm, 1960, p. 11; Mandel, 1972, no. 12

See p. 26; Pl. 22

Possibly of oval shape originally, as with the final version (cat. no. 28); perhaps to be related to lot 125 in the Le Prince sale, November 28, 1781, "of recumbant oval shape," [89 × 92 cm].

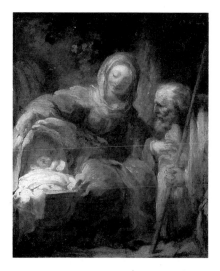

30 The Rest on the Flight into Egypt

c. 1755. Stockholm, Nationalmuseum. Canvas, 52 × 42 cm

Provenance: For the early provenance see cat. no. 29; Collection C. Nilsson, Countess of Casa Miranda; bequeathed to the museum in 1930
Bibl.: Réau, 1956, p. 142; Wildenstein, 1960, no. 13; Wilhelm, 1960, p. 10; Mandel, 1972, no. 13

See p. 26; Pl. 20 and cat. no. 28

Fragment; the painting in the 1781 Le Prince sale? (See cat. no. 29)

31 Bust of the Virgin
c. 1755. Mänttä (Finland), The Gösta Serlachius' Fine Arts Foundation. Canvas, 40 × 32 cm

Provenance: unknown
Bibl.: Museum cat., 1978, no. 159

See Pl. 23 and cat. no. 28

This would appear to be a study of a detail for the Norfolk painting (cat. no. 28).

32 The Cart of Roses
c. 1753–54 (?). Los Angeles, Collection Deane F. Johnson. Canvas, 95 × 126 cm

Provenance: Perhaps Collection J. Duclos; anonymous sale, March 8, 1920, lot 29, (as J.-B. Huet); Wildenstein, New York

Bibl.: Portalis, 1889, p. 280; Wildenstein, 1960, no. 28; Mandel, 1972, no. 29; Sutton, 1980, no. 6

33 The Cart of Roses
c. 1753–54 (?). Private Collection. Canvas, 50 × 60 cm

Provenance: Collection C. Davies (according to Wildenstein); Wildenstein, New York; Collection Mrs. Devoto, Buenos Aires, 1939 (according to Wildenstein)
Bibl.: Wildenstein, 1960, no. 29; Mandel, 1972, no. 30

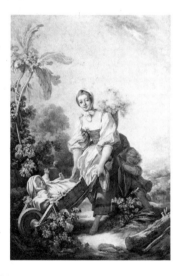

34 Young woman with a wheelbarrow and two children, called **The Joys of Motherhood**
c. 1753. Indianapolis, Museum of Art. Canvas, 145 × 98 cm

Provenance: Collection Count de Malleray, Versailles (according to Wildenstein); Collection J. Bache, New York (idem); Collection Baron de Rothschild, Paris; Wildenstein, New York; Collection J.K. Lilly, Indianapolis; Collection Herman C. Krannert; presented to the museum in 1973
Bibl.: Wildenstein, 1960, no. 30; Mandel, 1972, no. 31; Zafran, 1983, no. 49

35 Young girl with a basket of flowers, called **The Gardener**
c. 1754–55. Private Collection. Canvas, 89 × 101 cm

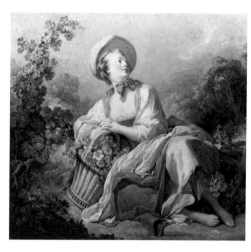

Provenance: Perhaps Etard sale, December 26, 1840, lot 7 (without measurements); Wildenstein, New York; Collection Lady Dunn, and offered by her to the Beaverbrook Art Gallery, Fredericton, New Brunswick; Lady Beaverbrook sale, Sotheby's, New York, November 27, 1963, lot 48
Bibl.: Wildenstein, 1960, no. 27; Mandel, 1972, no. 28

This could be the fragment of an overdoor.

36 Portrait of a Woman, also called **Mme. Bergeret de Grancourt**
c. 1754–55. Private Collection. Canvas, 42 × 35 cm

Provenance: Collection Bergeret (according to Wildenstein); Collection Bergeret de Fronville; Collection Wildenstein, New York; Private Collection, Lausanne
Bibl.: Réau, 1956, p. 177; Wildenstein, 1960, no. 403; Wildenstein, 1961, p. 66; Mandel, 1972, no. 428

See p. 40

The identity of the sitter remains uncertain.

***37 The Coquette Fascinated**
c. 1754. Location unknown. Canvas, 55 × 45 cm

Provenance: Collection J. Porgès, Château de

Rochefort (according to Wildenstein); Mme. L. Surmont sale, March 15, 1935, lot 3
Bibl.: Goncourt, 1882, p. 331; Portalis, 1889, p. 274; Wildenstein, 1960, no. 41; Mandel, 1972, no. 42

Engraved by J. Couché (engraving finished by J. Dambrun and dedicated to the Marquess de Boisandré) under the title *The Coquette Fascinated.* The painting is catalogued by Wildenstein (1960) as probably a copy; despite its apparently mediocre quality, one cannot exclude it as being an original. The Goncourt brothers record (1882, p. 331) "a lightly colored grisaille of this composition" at the Walferdin sale, in which it does not figure.

38 Conversation Galante in a Park, or **The Lover Crowned**
c. 1754–55. London, Wallace Collection. Canvas, 72 × 109 cm (original measurements 62 × 74 cm)

Provenance: Blondel de Gagny sale, 1776 (according to the catalogue of the Wallace Collection); Count de Merle sale, March 1, 1784 (idem); anonymous sale, March 2, 1839 or George sale, April 2, 1839 (according to Soullié lot 1151); Viscount d'Harcourt sale, January 31, 1842, lot 21; d'Harcourt sale, 1873 (according to Mireur; does not figure in the catalogue); Collection Lord Hertford; Collection Sir Richard Wallace; Lady Wallace Bequest, 1897
Bibl.: Watson, 1961, p. 39; Wallace Collection Catalogue, 1968 (sixteenth edition), p. 120; Mandel, 1972, no. 584 (rejected)

See Pl. 36 on p. 35

The painting, previously catalogued as Boucher, once carried on the bottom left the barely legible letters "F.B." Its attribution to Fragonard seems indisputable.

39 The Music Lesson
c. 1755. Paris, The Louvre. Canvas, 109 × 121 cm

Provenance: Collection H. Walferdin; donated to the museum in 1849
Bibl.: Goncourt, 1882, p. 335; Portalis, 1889, p. 282; Réau, 1956, no. 168; Wildenstein, 1960, no. 248; Wilhelm, 1960, p. 106; Mandel, 1972, no. 265; Compin-Rosenberg, 1974, no. 17

The painting is generally dated much later, but the characteristics of its style can only be accounted for as an early and incomplete work.

Bibl.: Wildenstein, 1960, no. 31; Mandel, 1972, no. 40

See pp. 32–33; Pl. 31

quired in 1974 with funds from the Leon and Marion Kaumheimer Bequest
Bibl.: Réau, 1956, p. 172 (*L'agneau retrouvé*)

See p. 33; Pl. 33

40 The Cage, also called The Happy Lovers
c. 1754–55. Pasadena, The Norton Simon Foundation. Canvas, 90 × 119 cm

Provenance: Collection Portevin; Gimpel and Wildenstein; Collection Judge E. H. Gary, New York; Collection Mrs. Lewis Nixon, New York; Duveen, New York

41 A shepherdess waiting for her shepherd, called The Shepherdess
c. 1755. Milwaukee, Charles Allis Art Museum. Canvas, 119 × 162.5 cm

Provenance: Isabella, Queen of Spain; Collection C. Kribben, Madrid and Berlin; Bachstitz Gallery, The Hague; Elisabeth P. Wildenstein, 1968; ac-

*42 Pastoral Scene with a Cage
c. 1755. Paris, Private Collection. Canvas, 60 × 50 cm

Provenance: Baudouin sale, February 15, 1770, lot 23 (as Boucher; according to Ananoff, 1976); Private Collection, Paris
Bibl.: Ananoff, 1976, II, no. 604 (Boucher)

This might be an early sketch by Fragonard, comparable through its subject matter with the Pasadena painting (cat. no. 40).

43 The See Saw
c. 1755. Lugano, Thyssen-Bornemisza Collection. Canvas, 120 × 94.5 cm (Fragment. Originally: 210 cm)

Provenance: Saint-J.[ulian] sale, June 21, 1784, lot 75 [210 × 93 cm]; M[orelle and others] sale, May 3, 1786, lot 177 [113 × 90 cm]; Collection Count de Sinéty, Paris; Collection Baron Nathaniel de Rothschild, Vienna; Collection Baron Maurice de Rothschild, Pregny; acquired in 1956 by the present owner
Bibl.: Goncourt, 1882, p. 331; Portalis, 1889,

Engraving by J.-F. Beauvarlet of cat. no. 43

Bibl.: Wildenstein, 1960, no. 32; Mandel, 1972, no. 38; Sutton, 1980, no. 7

See pp. 28–33 and cat. no. 46

p. 273; Nolhac, 1906, p. 150; Réau, 1956, p. 158; Wildenstein, 1960, nos. 46, 48; Catalogue Thyssen-Bornemisza Collection, 1969, no. 98; Mandel, 1972, nos. 52, 54; Rosenbaum, 1982, no. 48

See pp. 34–35; Pl. 35 and cat. no. 44

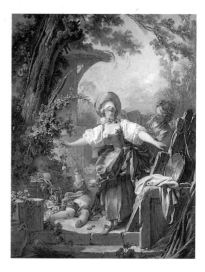

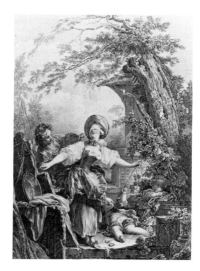

Engraving by J.- F. Beauvarlet of cat. no. 44

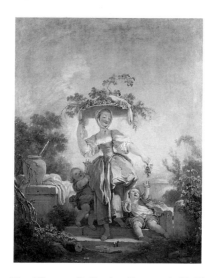

44 Blindman's Buff

c. 1755. Ohio, The Toledo Museum of Art. Canvas, 116.8 × 91.4 cm (Fragment. Originally: 210 cm high)

Provenance: Saint-J.[ulien] sale, June 21, 1784, lot 75 [210 × 93 cm]; M[orelle and others] sale, May 3, 1786, lot 177 [113 × 90 cm]; Collection Count de Sinéty, Paris; Collection Baron Nathaniel de Rothschild, Vienna; Collection Baron Maurice de Rothschild, Pregny; Rosenberg and Stieble, New York; acquired in 1954; gift of Edward Drummond Libbey

Bibl.: Goncourt, 1882, p. 331; Portalis, 1889, p. 273; Nolhac, 1906, p. 150; Réau, 1956, p. 158; Wildenstein, 1960, nos. 45, 47; Mandel, 1972, nos. 51, 53; Rosenberg, 1975–76, no. 36

See pp. 34–36; Pl. 34 and cat. no. 43

Engraved in 1760 by J.-F. Beauvarlet as Boucher (first state) then as Fragonard (second state), in a slightly more vertical format. Other than

assuming that there was an unlikely printing error in the sale catalogue [Saint-Julien], it would seem that between 1784 and 1786 the upper section of this painting and that of its pendant were cut down by about 90 cm. See also the copies of these two paintings which are of a highly vertical format and which give some indication of the original proportions. These are preserved by the d'Harcourt family and are now at the Château de Champs de Bataille (*Connaissance des Arts*, April 1960, p. 64).

45 Young Woman with a Wheelbarrow and Two Children, also called The Shepherdess

c. 1755. U.S.A., Private Collection. Canvas, 118 × 92.7 cm

Provenance: Collection Raynaud (according to Wildenstein); Wildenstein; Collection J. Stillman, Paris, then New York; Mrs. James Stillman, later Mrs. Fowler MacCormick, Chicago; Wildenstein, New York

46 The Woman Gathering Grapes (with Two Children), also called The Grape Harvester

c. 1755. U.S.A., Private Collection. Canvas, 118 × 94 cm

Provenance: See cat. no. 45
Bibl.: Wildenstein, 1960, no. 33; Mandel, 1972, no. 39; Sutton, 1980, no. 8

See pp. 28–33; Pl. 27

47 The Longed-for Moment, or The Happy Lovers

c. 1755–56 or c. 1763–65 (?). Paris, Private Collection. Canvas, 55 × 65 cm

Provenance: Walferdin sale, April 12–16, 1880, lot 60; A. Courtin sale, March 29, 1886, lot 4; Haro sale, May 30–31, 1892, lot 13; Collection Wasserman; Collection A. Veil-Picard, Paris; Collection A. Veil-Picard, Paris
Bibl.: Goncourt, 1882, p. 330; Portalis, 1889, p. 279; Nolhac, 1906, p. 118; Réau, 1956, p. 159;

Wildenstein, 1960, no. 287; Wilhelm, 1960, p. 105; Thuillier, 1967, pp. 106, 111, 113; Mandel, 1972, no. 305

See p. 98 and cat. no. 48

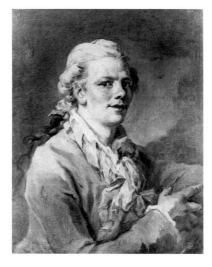

Fragonard was first accepted then rejected by G. Wildenstein; it remains tentative.

1956, p. 145; Wildenstein, 1960, no. 54; Wilhelm, 1960, pp. 47–48; Mandel, 1972, no. 62

See p. 30; Pl. 29, and cat. nos. 50, 52, and 53

52 Autumn
c. 1755–56. Paris, Hôtel Matignon. Canvas, 80 × 164 cm

Provenance: See cat. no. 50
Bibl.: Wildenstein, 1935, pp. 271–74; Réau, 1956, p. 145; Wildenstein, 1960, no. 55; Wilhelm, 1960, pp. 47–48; Mandel, 1972, no. 63

See p. 30; Pl. 30, and cat. nos. 50, 51, and 53

48 The Longed-for Moment, also called **The Happy Lovers**
c. 1755–56 or c. 1763–65 (?). Switzerland, Private Collection. Canvas, 49.5 × 60.5 cm

Provenance: Collection Hoentschel (?); Collection Pierpont Morgan; Collection Countess de la Béraudière
Bibl.: Wildenstein, 1921, no. 33; Réau, 1956, p. 159; Wildenstein, 1960, no. 288; Wilhelm, 1960, p. 105; Mandel, 1972, no. 306

See p. 98 and cat. no. 47

***49 Portrait of a Young Man** (Self-Portrait?), also called **Portrait of Hubert Robert**
c. 1755. Washington D.C., National Gallery of Art, Collection Samuel H. Kress. Canvas, 65.3 × 54.4 cm

Provenance: Doisteau sale, June 9–11, 1909, lot 37; Collection Dr. Tuffier; J. Seligmann; Collection Samuel H. Kress; donated to the gallery in 1961
Bibl.: Dayot-Vaillat, 1907, plate 76; Wildenstein, 1921, no. 20; Réau, 1956, p. 174; Mandel, 1972, no. 606 (rejected); Eisler, 1977, pp. 335–36 (attributed to Fragonard)

See p. 40; Pl. 44

The attribution of this magnificent portrait to

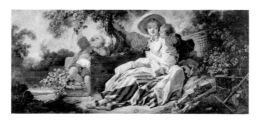

50 Spring
c. 1755–56. Paris, Hôtel Matignon. Canvas, 80 × 164 cm

Provenance: Forms part of the decoration, with two other *Seasons*, of the central salon on the first floor of the Hôtel Matignon, which belonged to the Duke de Valentinois, prince of Monaco, and then to the dukes of Galliera
Bibl.: Wildenstein, 1935, pp. 271–74; Réau, 1956, p. 145; Wildenstein, 1960, no. 53; Wilhelm, 1960, pp. 47–48; Mandel, 1972, no. 61

See p. 30; Pl. 28 and cat. nos. 51–53

One may well wonder whether this painting and cat. nos. 51–52 were actually planned for the salon they decorate at present (the formats seem to have been altered); moreover, the history of the provenance of *Winter* (cat. no. 53) is ambiguous.

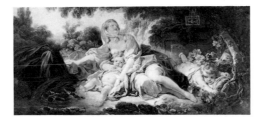

51 Summer
c. 1755–56. Paris, Hôtel Matignon. Canvas, 80 × 164 cm

Provenance: See cat. no. 50
Bibl.: Wildenstein, 1935, pp. 271–74; Réau,

53 Winter
c. 1755–56. Los Angeles County Museum of Art, William Randolph Hearst Collection. Canvas, 80 × 164 cm

Provenance: See cat. no. 50; after modification of the decoration of the salon (?); Ferrari de la Renotière sale, June 7, 1922, lot 8; Wildenstein, New York; Collection W. R. Hearst, California; acquired by the museum in 1947 with funds from Hearst Magazines Inc.
Bibl.: Wildenstein, 1935, pp. 271–74; Réau, 1956, p. 145; Wildenstein, 1960, no. 56; Wilhelm, 1960, pp. 47–48; Mandel, 1972, no. 64; Sutton, 1980, no. 10

See p. 30 and cat. nos. 50–52

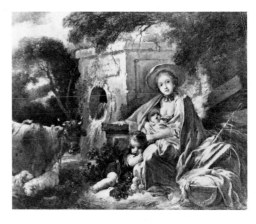

53a Countrywoman with Two Children

c. 1775. Private collection. Canvas, 33.5 × 44 cm

See cat. no. L 111

This painting has until recently been attributed to Boucher.

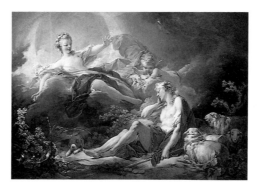

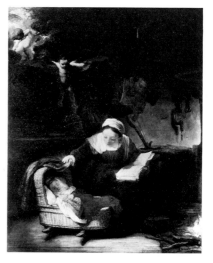

***54 Diana Resting**
c. 1753–55 (?). Private Collection. Canvas, 84 × 123 cm

Provenance: Collection N. Bardac, Paris, 1910; Collection Wildenstein, Paris, until 1930; Collection Colonel and Mrs. J. Balsan, New York, 1940; Collection Sir Winston Churchill, London, 1941–62; Collection Lady S. Spencer Churchill, New York, until 1967; Collection P. Roebling, Trenton, New Jersey; sale, Christie's, March 28, 1969, lot 53; Collection Earl C. Townsend, Sr., Indianapolis, 1974
Bibl.: Wildenstein, 1960, no. 26; Mandel, 1972, no. 27

The attribution to Fragonard is not absolutely certain.

56 Diana and Endymion (or **Night**?)
c. 1755–56. Washington D.C., National Gallery of Art. Canvas, 95 × 137 cm

Provenance: Collection W.R. Timken (Boucher); acquired by the gallery in 1959 (idem)
Bibl.: Wintermute, 1985–96, p. 137 (the young Fragonard?); Cuzin, 1986, I, pp. 65–66, no. 6 (Fragonard)

See p. 39; Pl. 43

Pendant to cat. no. 55

(idem); Collection Baron d'Aubilly (idem); Collection de Charette (idem); Wildenstein
Bibl.: Wildenstein, 1921, no. 10; Réau, 1932, p. 103; Réau, 1956, p. 187; Wildenstein, 1960, no. 7; Wilhelm, 1960, p. 5; Mandel, 1972, no. 7

See p. 14; Pl. 205 on p. 170

After Rembrandt's *Holy Family* now at the Hermitage, Leningrad.

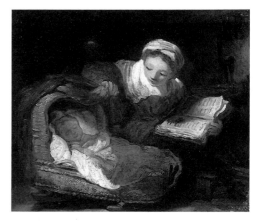

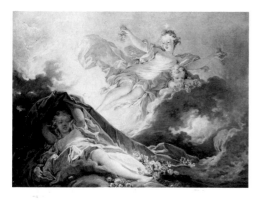

55 Venus Awakening, or **Dawn**
c. 1755–56. Private Collection. Canvas, 95.2 × 131.5 cm

Provenance: Collection Michel Ephrussi (according to Wildenstein); Charles Sedelmeyer sale, May 16–18, 1907, lot 201; Collection Eugène Sedelmeyer; François Coty sale, November 30–December 1, 1936, lot 20; anonymous sale, November 25, 1971, lot 22
Bibl.: Wildenstein, 1921, no. 4; Wildenstein, 1960, no. 25; Mandel, 1972, no. 26; Sutton, 1980, no. 5

See p. 39; Pl. 41, and cat. no. 56

57 The tippler at his window, called **The Jolly Fellow,** after A. Van Ostade
before 1756 (?). Private Collection. Canvas, 39 × 30 cm

Provenance: Anonymous [Sir d'Arques] sale, April 22, 1776, lot 96; Cailleux, Paris
Bibl.: Wildenstein, 1921, no. 273; Réau, 1932, p. 102; Réau, 1956, p. 187; Wildenstein, 1960, no. 5; Wilhelm, 1960, p. 80; Mandel, 1972, no. 5

See Chapter I and n. 5

58 The Holy Family, or **The Infant Jesus Asleep,** after Rembrandt
before 1756 (?). Private Collection. Canvas, 91 × 75 cm

Provenance: Boucher sale, February 18, 1771, lot 111; Collection Paillet, 1779 (according to Wildenstein); Collection Gildermeester, 1800 (idem); Collection R. Reinagle, 1831 (idem); Collection O'Neil (idem); Collection Berger

***59 The Virgin and Child,** after Rembrandt
before 1756 (?). San Francisco, De Young Memorial Museum. Canvas, 47 × 56 cm

Provenance: Le Dart sale, Caen, April 29–May 4, 1912, lot 111 (with measurements probably inverted); Wildenstein; L. [Michel Levy] sale, December 12, 1925, lot 95 (with inverted measurements); Collection H. Fleischaker, San Francisco (before 1934); donated to the museum in 1954
Bibl.: Réau, 1932, p. 101; Réau, 1956, p. 187; Wildenstein, 1960, no. 8; Wilhelm 1960, cited p. 6; Mandel, 1972, no. 8; Sutton, 1980, no. 1; Rosenberg, 1987, p. 58

See p. 14 and cat. no. 58

Interpretation of a detail from Rembrandt's *Holy Family,* the Hermitage, Leningrad. Possibly by the hand of the artist though this is not certain. Three very similar paintings, of unverifiable attribution and with confused provenances, are catalogued by Wildenstein under nos. 9, 10, and 11; D. Sutton (1980) and P. Rosenberg (1987) consider

the four paintings to be authentic. A fifth version (42 × 56 cm; Kleinberger sale, New York, November 18, 1932, lot 28), also of uncertain attribution, is likewise considered by P. Rosenberg to be authentic.

*60 The Sleeping Bacchante
c. 1756-57 (?). Paris, The Louvre. Canvas, 46 × 55 cm (including 6 cm added to the left)

Provenance: Collection La Caze; bequeathed to the museum in 1869
Bibl.: Goncourt, 1882, p. 325; Portalis, 1889, p. 271; Réau, 1956, p. 147; Wildenstein, 1960, no. 275; Wilhelm, 1960, p. 133; Mandel, 1972, no. 293; Rosenberg-Compin, 1974, I, p. 192 (not by Fragonard; Berthélemy?)

One cannot completely exclude the attribution to Fragonard, either at the end of his schooling in Paris or at the start of his Roman stay; the coarsely woven canvas calls to mind *The Lost Forfeit* in Leningrad (cat. no. 77) or *The Preparation for a Meal* in Moscow (cat. no. 78). The old varnishes that cover the Louvre painting do not facilitate a decisive judgment.

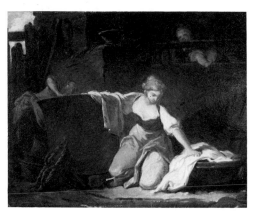

*61 Young Women Washing Clothes
c. 1757–58 (?). Private Collection. Canvas, 55 × 65.5 cm

Provenance: Collection Del Gallo Roccagiovine family, of French origin, settled in Rome since the Empire.

Even though the facial type of the young woman in the center is not found anywhere else in Fragonard's œuvre, his authorship for this painting, in which the rustic decor and the secondary figures, as well as the color scale, closely resemble paintings such as *The Turkey Cocks* (cat. no. 69) or *Laundresses at the Fountain* (cat. no. 62), should not be excluded. This could be one of the first paintings of realistic character painted by the artist in Rome. We only know the work from a photograph, and one could also consider the hypothesis that there was another young French artist working in a style similar to Fragonard's.

62 Laundresses at the Fountain, also called Fountain in Rome
c. 1758–60. U.S.A., Private Collection. Canvas, 48 × 62 cm

Provenance: Marquess d'Arcambal sale, February 22, 1776, lot 88 (together with its pendant); Gros sale, April 13, 1778, lot 58 (together with its pendant, "two sketches executed in Italy..."); anonymous [Lebrun?] sale, December 10, 1778, lot 129 (together with its pendant); Abbé de Gévigney sale, December 1–29, 1779, lot 1171 (together with its pendant); [Saint-Maurice] sale, February 6, 1786, lot 72 (together with its pendant); Castelmore sale, December 20, 1791, lot 31 (together with its pendant); Private Collection, France, before 1939; Wildenstein, New York
Bibl.: Nolhac, 1906, p. 138; Réau, 1956, p. 172; Exh., Grasse, 1957, no. 19; Wildenstein, 1960, no. 356; Wilhelm, 1960, p. 28; Mandel, 1972, no. 376

Pendant to cat. no. 63

63 Two Children Playing in a Room, or Hide-and-Seek
c. 1758–60. Private Collection. Canvas, 49 × 62 cm

Provenance: Marquess d'Arcambal sale, February 22, 1776, lot 88 (together with its pendant); Gros sale, April 13, 1778, lot 58 (together with its pendant, "two sketches executed in Italy"); anonymous [Lebrun?] sale, December 10, 1778, lot 129 (together with its pendant); Abbé de Gévigny sale, December 1–29, 1779, lot 1171 (together with its pendant); de [Saint-Maurice] sale, February 6, 1786, lot 72 (together with its pendant); Castelmore sale, December 20, 1791, lot 31 (together with its pendant); Barroilhet sale, April 2–3, 1860, lot 109; Wilson sale, March 14–16, 1881, lot 15; Mame sale, April 26–29, 1904, lot 17; Collection Mame, Chanceaux; anonymous sale, Galerie Charpentier, April 14, 1960, lot 28

62

Bibl.: Goncourt, 1882, no. 334; Portalis, 1889, p. 273; Réau, 1956, p. 164; Wildenstein, 1960, no. 357; Wilhelm, 1960, pp. 29–30; Mandel, 1972, no. 377

See Pl. 59 on p. 52

Pendant to cat. no. 62

64 Children's games, called **Morning,** or **War**
c. 1758–60. Paris, Private Collection. Canvas, 38 × 46 cm

Provenance: Natoire sale, December 14, 1778, lot 55 (together with its pendant, "subjects for a ceiling representing children's games"); perhaps anonymous sale, March 23, 1784, lot 52 (37.8 × 40.5 cm); Lenglier sale, April 24, 1786, lot 135 (according to Wildenstein); Marquess de M [ontesquiou] sale, December 9, 1788, lot 260; perhaps anonymous sale, January 28, 1858, lot 45; Collection H. Péreire, Paris; P. Cailleux; Collection Aubertin
Bibl.: Portalis, 1889, p. 281; Nolhac, 1906, p. 157; Wildenstein, 1960, no. 79; Wilhelm, 1960, p. 53; Mandel, 1972, no. 87

See pp. 49–50; Pl. 53

Pendant to cat. no. 65

65 Children's games, called **Evening,** or **Peace**
c. 1758–60. Paris, Private Collection. Canvas, 38 × 46 cm

Provenance: See cat. no. 64
Bibl.: Portalis, 1889, p. 281; Nolhac, 1906, p. 157; Wildenstein, 1960, no. 80; Wilhelm, 1960, p. 54; Mandel, 1972, no. 88

See pp. 59–50; Pl. 52

Pendant to cat. no. 64

66 The Storm, also called **The Cart Stuck in the Mud**
1759 (?). Paris, The Louvre. Canvas, 73 × 97 cm

Provenance: Collection La Caze; bequeathed to the museum in 1869
Bibl.: Goncourt, 1882, pp. 281, 339; Portalis, 1889, p. 273; Réau, 1956, p. 185; Wildenstein, 1960, no. 103; Thuillier, 1967, pp. 47, 69, 125; Mandel, 1972, no. 111; Cuzin, 1986, I, p. 62, p. 66, nn. 17–19

See p. 56; Pl. 65

67 The Train of Cattle
c. 1759. Private Collection. Canvas, 18 × 52 cm

Provenance: E. Arago sale, February 8–9, 1872, lot 25; Collection C. Groult; Wildenstein, New York

Bibl.: Portalis, 1889, p. 269; Nolhac, 1906, p. 140; Réau, 1956, p. 184; Wildenstein, 1960, no. 130; Mandel, 1972, no. 162; Sutton, 1980, no. 32

See p. 56

Pendant to cat. no. 68

68 The Watering Place
c. 1759. Private Collection. Canvas, 18 × 52 cm

Provenance: E. Arago sale, February 8–9, 1872, lot 25; Collection C. Groult; Wildenstein, New York
bibl.: Portalis, 1889, p. 269; Nolhac, 1906, p. 140; Réau, 1956, p. 183; Wildenstein, 1960, no. 131; Mandel, 1972, no. 163; Sutton, 1980, no. 33

See p. 56

Pendant to cat. no. 67

69 Country girl drawing water from a fountain, called **The Turkey Cocks at the Fountain** or **The Fountain**

c. 1759–60. Private Collection. Canvas, 48 × 60 cm

Provenance: Anonymous sale, April 15, 1868, lot 19 ("Farmyard," without measurements); Febvre sale, April 17–20, 1882, lot 9; Brame sale, March 20, 1883, lot 13; Beurnonville sale, June 3, 1884, lot 382; Beurnonville sale, January 30–31, 1885, lot 137; Collection G. Donaldson; Collection Charley
Bibl.: Portalis, 1889, p. 277; Nolhac, 1906, p. 129; Réau, 1956, p. 172; Wildenstein, 1960, no. 111; Wilhelm, 1960, p. 27; Mandel, 1972, no. 119

70 The Twins
c. 1759–60. Private Collection. Canvas, 37 × 47 cm

Provenance: Natoire sale, December 14, 1778, lot 54; Private Collection, France, 1965; sale, December 8, 1976(?); sale, Sotheby's, Monaco, February 6, 1981, lot 99
Bibl.: Goncourt, 1882, p. 333; Portalis, 1889, p. 275; Nolhac, 1906, p. 130; Réau, 1956, p. 168; Wildenstein, 1960, no. 461; Mandel, 1972, no. 485

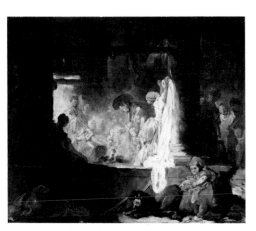

71 The Laundresses
c. 1759–60. Rouen, Musée des Beaux-Arts. Canvas, 54 × 69 cm

Provenance: Walferdin sale, April 12–16, 1880, lot 22 ("sketch"); acquired at the sale by the museum
Bibl.: Portalis, 1889, p. 273; Nolhac, 1906,

p. 138; Réau, 1956, p. 172; Wildenstein, 1960, no. 362; Wilhelm, 1960, p. 39; Thuillier, 1967, p. 49; Mandel, 1972, no. 385

See pp. 55–56; Pl. 58

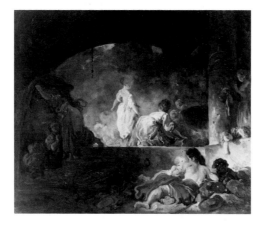

72 The Washerwomen
c. 1759–60. St. Louis Art Museum. Canvas, 61.5 × 73.1

Provenance: Private Collection, Moscow; Collection Cathabard, Lyons; A. Seligmann; Rey and Co. Gallery; purchased by the museum in 1937
Bibl.: Réau, 1956, p. 172; Wildenstein, 1960, no. 361; Wilhelm, 1960, p. 3; Thuillier, 1967, p. 49; Mandel, 1972, no. 383; Zafran, 1983, no. 51

See pp. 55–56; Pl. 57

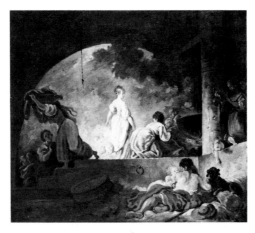

***72 a The Washerwoman**
c. 1759–60. Private Collection. Canvas, 42 × 48 cm

Provenance: A. Febvre sale, April 17–20 1882, lot 11; Beurnonville sale, May 21–22, 1883, lot 15; E. Kraemer sale, May 5–6, 1913, lot 37; anonymous sale, May 31, 1922, lot. 17; Charles Brunner, Paris; probably Fischer sale, Luzern, June 12–16, 1956, lot 1551
Bibl.: Portalis, 1889, p. 282; Nolhac, 1906, p. 139; Mandel, 1972, no. 384

The reserve concerning this painting expressed in the French edition of this book (cat. no. 72) should be modified in view of good photographic documentation. It does seem to be another example of the painting in St. Louis, which makes it all the more interesting as that means this style of painting was successful from the beginning of Fragonard's career.

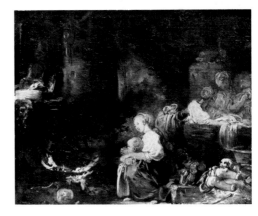

73 Women with Children, Washing Clothes
c. 1760. Denmark(?), Private Collection. Canvas; measurements unknown

Provenance: Perhaps anonymous sale, January 30, 1782, lot 78 ("A sketch with a most striking effect and spirited touch; it represents a ruin under which some women are busy washing clothes: one of them can be seen holding a child in front of a fire on which there is a copper pot." [29.7 × 39.1 cm]); Private Collection, France; Private Collection, Denmark, (1964)
Bibl.: Wildenstein, 1960, no. 360 (as lost); Mandel, 1972, no. 382 (as lost)

This very important painting, one of the most beautiful canvases dating from Fragonard's first Roman stay, was kindly brought to our attention by P. Rosenberg. The subject matter appears to have been exactly described in the 1782 sale catalogue, but as the measurements of the existing painting are not known it does not allow for a definitive identification.

74 The Italian Family, also called **The Happy Mother** or **Village Interior**
c. 1759–60. New York, The Metropolitan Museum of Art. Canvas, 48.9 × 59.4 cm

Provenance: Anonymous sale, May 12, 1884, lot 21; Collection Moreau-Chaslon (according to Portalis, 1889); Collection C.E. Haviland, Paris; Collection O. Linet, 1918; Collection Knoedler & Co.; Collection A. Loewenstein, Brussels, (1930–32); Collection Howard Black, New York, 1946; acquired by the museum in 1946 through the Harris Brisbane Dick Fund
Bibl.: Portalis, 1889, p. 279 *(Italian Rustic Interior)*; Sterling, 1955, p. 153; Réau, 1956, p. 168; Wildenstein, 1960, no. 365; Wilhelm, 1960, p. 37; Thuillier, 1967, p. 49; Mandel, 1972, no. 388

For another version see cat. no. 75. A third version (Private Collection), of seemingly weaker quality and smaller size (44 × 53 cm), passed through the Walferdin sale, April 3, 1880, lot 19 (Portalis, 1889, p. 279; Réau, 1956, p. 173; Wildenstein, 1960, no. 363; Mandel, 1972, no. 387; Sutton, 1980, no. 55).

Collection Frederick L. Spencer, New York; Collection Mrs. William Hayward, New York; Collection Mrs. James B. Donahue, New York; donated to the museum in 1956 by Jessie Woolworth Donahue
Bibl.: Goncourt, 1882, p. 333; Portalis, 1889, p. 276; Nolhac, 1906, p. 124; Réau, 1956, p. 157 (confused provenance); Wildenstein, 1960, no. 119; Wilhelm, 1960, p. 33; Thuillier, 1967, pp. 49, 50, 111; Mandel, 1972, no. 127; Sutton, 1980, no. 28

See p. 50; Pl. 56 and cat. no. 77

Sutton mentions another version (56 × 67.1 cm) previously in the Collection Max von Goldschmidt-Rothschild at Frankfurt-on-Main.

Provenance: Le Clerc sale, December 17, 1764, lot 298, together with its pendant; Collection of the Princes Youssoupov, Petrograd (Leningrad), under the title *The Happy Family* (cat. 1839, no. 365); Hermitage; in the present museum since 1925
Bibl.: Réau, 1956, p. 168; Wildenstein, 1960, no. 120; Wilhelm, 1960, p. 32; Thuillier, 1967, p. 49; Mandel, 1972, no. 129

See Pl. 55 on p. 48 and cat. no. 77

The subject and the scale of the figures do not allow one to determine whether or not this picture was painted as a pendant to *The Lost Forfeit*. The pairing of the two paintings may go back to a collector.

75 The Italian Family, also called **The Happy Mother** or **Village Interior**
c. 1759–60. Paris, Private Collection. Canvas, 62 × 74 cm

Provenance: Collection Duchess de Polignac; Collection Countess de Béhague; Collection Marquess de Ganay, Paris
Bibl.: Daulte, 1954, no. 14; Wildenstein, 1960, no. 364; Wilhelm, 1960, p. 36; Mandel, 1972, no. 386

For a similar version see cat. no. 74

77 The Lost Forfeit, or **The Captured Kiss** (sketch)
c. 1759–60. Leningrad, The Hermitage. Canvas, 47 × 60 cm

Provenance: Le Clerc sale, December 17, 1764, no. 298, together with its pendant; Collection of the Princes Youssoupov, Petrograd (Leningrad), together with its pendant (cat. 1839, no. 369)
Bibl.: Ernst, 1924, p. 122; Réau, 1956, p. 157 (confused provenance); Wildenstein, 1960, no. 118; Wilhelm, 1960, p. 31; Thuillier, 1967, p. 49; Mandel, 1972, no. 128

See p. 50; Pl. 54 and cat. nos. 76 and 78

76 The Lost Forfeit, or **The Captured Kiss** (finished version)
c. 1759–60. New York, The Metropolitan Museum of Art. Canvas, 48 × 62 cm

Provenance: Perhaps commissioned for Jacques-Laure de Breteuil; his sale January 16, 1786, lot 49 ("this pretty picture was painted in Italy..."); Chamgrand, Proby, Saint-Maurice sale, March 20, 1787, lot 224; Collection Dr. Aussant, Rennes; his sale December 28–29, 1863, lot 31; Collection Count Duchâtel (from 1866 to 1889); Reginald Vaile sale, London, Christie's, March 23, 1903, lot 29; Collection Eugène Fishof, New York; his sale, February 22, 1907, lot 102;

78 The Preparations for a Meal, or **The Poor Family**
c. 1759–69. Moscow, Pushkin Museum. Canvas, 47 × 61 cm

79 Child Leading a Cow
c. 1760. Paris, Private Collection. Canvas, 54 × 65 cm

Provenance: Leroy de Senneville sale, April 5, 1780, lot 58; Leroy de Senneville sale, April 26, 1784, lot 30; perhaps Collection de Clock, 1864 (*Chronique des Arts,* 1864, p. 211); perhaps Collection Marquess de Saint-Marc; his sale, February 22, 1859 (*The White Cow,* [58 × 71 cm]); H. Winterfield sale, London, December 9, 1936, lot 90; Cailleux, Paris
Bibl.: Portalis, 1889, p. 276; Nolhac, 1906, p. 133; Réau, 1956, p. 173; Wildenstein, 1960, no. 112; Mandel, 1972, no. 120

For the lost pendant see cat. no. L 77

80 A Shepherd and Shepherdess in a Stable
c. 1760. Private Collection. Canvas, 48 × 58.5 cm

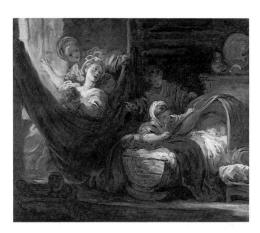

Provenance: Collection Eudoxe Marcille; by descent to his heirs
Bibl.: Portalis, 1889, p. 274 ("Conversation galante between a Shepherd and Shepherdess in a farm," without measurements); Cuzin, 1987, pp. 38–40, fig. p. 38

See Pl. 69 on p. 59

See p. 60; Pl. 72

The measurements given at the Natoire sale in 1778, and the sketch acquired on this occasion by G. de Saint-Aubin, (Wildenstein, 1960, fig. 69), confirm that the painting was cut down on the left and at the top and that its original composition was very close to the Besançon red chalk drawing (Ananoff, II, no. 891).

84 The Cradle
c. 1760 (?). Amiens, Musée de Picardie. Canvas, 46 × 55 cm

Provenance: Collection Lavalard; bequeathed to the museum in 1890
Bibl.: Portalis, 1889, p. 272 *(La Berceuse)*; Wildenstein, 1921, no. 67; Réau, 1956, p. 164; Wildenstein, 1960, no. 457; Wilhelm, 1960, p. 154; Thuillier, 1967, p. 68; Mandel, 1972, no. 481

See Pl. 62 on p. 53

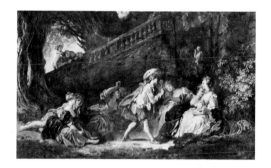

81 The Game of Battledore (fragment?)
c. 1759–60. Chambery, Musée des Beaux-Arts. Canvas, 67.5 × 114.7 cm

Provenance: Collection H. Garriod (1803–1883), formed in Italy; bequeathed to the museum in 1863
Bibl.: Cuzin, 1986-I, pp. 59–60, n. 7 to 10

See p. 64; Pl. 75

This could be the central fragment of quite a large decorative picture closely related to the painting in the Collection Bergeret (cat. L 118). The group of figures reappears in a red chalk drawing at the Stadelsches Kunstinstitut in Frankfurt-am-Main: *View in a park* (Ananoff, II, no. 820), which seems to date from 1760 or 1761.

82 View from the Villa d'Este at Tivoli, or The Great Staircase at the Villa d'Este
c. 1760. Private Collection. Canvas, 81.5 × 105 cm

Provenance: Natoire sale, December 14, 1778, lot 53 [97 × 135 cm]; Collection A. Ménageot; Marius Paulme sale, November 22, 1923, lot 86, (as Hubert Robert); Collection F. Gould, Cannes; his sale, Sotheby's, Monaco, June 28, 1984, lot 86
Bibl.: Portalis, 1889, p. 292; Wildenstein, 1960, no. 105; Thuillier, 1967, p. 47; Mandel, 1972, no. 113; Sutton, 1980, no. 26

83 The Waterfalls at Tivoli
c. 1760–62. Paris, The Louvre. Canvas, 72.5 × 60.5 cm

Provenance: Perhaps Collection Abbé de Saint-Non (Inventory 21-I/15-II, 1792); Collection La Caze; bequeathed to the museum in 1869
Bibl.: Daulte, 1954 no. 24; Wildenstein, 1959, p. 239; Wildenstein, 1960, no. 108; Wilhelm, 1960, p. 23; Mandel, 1972, no. 116; Sutton, 1980, no. 27

See p. 60; Pl. 74

A painting by Hubert Robert of the same subject, signed and dated 1776, passed through the Paulme (November 22, 1923, lot 72) and the F. Gould (Sotheby's, Monaco, June 28, 1984, lot 87) sales.

*85 Faith, Hope, and Charity (after Solimène)
1761 (?). Location unknown. Canvas. Measurements unknown

Provenance: unknown (document Witt Library, London)

This is a copy after Solimène *Theological Virtues*, a fresco at Saint Paolo Maggiore in Naples, of which Fragonard had also made a drawing (counterproof at the Bibliothèque de Besançon) which was engraved several times (Rosenberg, 1986, no. 17, p. 339). The attribution is not absolutely certain. It could be a rough sketch made by Fragonard during his stay in Naples in 1761; if this is the case, it would be the only extant painting executed by the artist during his Italian period.

86 Portrait of a young woman with a rose, called Portrait of Adeline Colombe
c. 1762 (?). U.S.A., Private Collection. Canvas, 49 × 39.4 cm

Provenance: Collection Count de Courtivron (according to Wildenstein); Wildenstein, New York

Bibl.: Daulte, 1954, no. 35; Wildenstein, 1960, no. 421; Mandel, 1972, no. 445

Bibl.: Réau, 1956, p. 185; Wildenstein, 1960, no. 106; Wilhelm, 1960, p. 40; Thuillier, 1967, pp. 47, 125; Wallace Collection Cat., 1968, p. 116; Mandel, 1972, no. 114

See pp. 71–74; Pl. 96

June 12, 1956, lot 166 (repr.); Wildenstein, New York
Bibl.: Nolhac, 1906, p. 135; Wildenstein, 1960, no. 148; Mandel, 1972, no. 167

87 The Wooden Bridge
c. 1762 (?). Private Collection. Canvas, 59 × 83 cm

Provenance: M. S. sale, February 16, 1861, lot 16; O. Mundler sale, November 27, 1871, lot 6; anonymous sale, May 20–21, 1873, lot 15; anonymous sale, February 3, 1881, lot 25 (Fragonard?, without dimensions); Beurnonville sale, May 9–16, 1881, lot 63; Collection Duke de Castries; Collection Viscountess E. d'Harcourt; Collection Viscount Emmanuel d'Harcourt; Collection M. and Mme. E. Ferkauf; Wildenstein, New York; sale London, Christie's, June 7, 1972, lot 97; Leger, London; sale Sotheby's, London, November 1, 1978, lot 38; Thaw & Co., New York
Bibl.: Portalis, 1889, p. 285; Wildenstein, 1921, no. 75; Daulte, 1954, no. 25, plate IV; Réau, 1956, p. 186; Wildenstein, 1960, no. 142; Wilhelm, 1960, p. 25; Mandel, 1972, no. 164

89 View of an Italian park, called **The Great Fountain at the Villa d'Este** or **The Fountain of Arethusa**
c. 1762–63 (?). Private Collection. Canvas, 58 × 72 cm

Provenance: Perhaps anonymous sale, May 23, 1780, lot 41 [59.4 × 72.9 cm]; Count d'E. sale, March 26, 1870, lot 27; Collection C. Groult, Paris; anonymous sale, December 5, 1947, lot 14; Silberman, New York
Bibl.: Wildenstein, 1960, no. 107; Wilhelm, 1960, p. 18; Mandel, 1972, no. 115

The description and the designation of "sketch" given in the 1780 sale make the identification with this painting questionable. J. Wilhelm (1960) refers to a second version of this painting, with variations and of "much inferior quality," which was on the market and on which he does not give an opinion.

91 Young girl leaning, holding a letter, called **The Letter**
c. 1763–65 (?). Private Collection. Canvas, 36.4 × 27.5 cm

Provenance: Gros sale, April 13, 1778, lot 55; La Rochefoucault-Liancourt sale, April 20–23, 1827, lot 56; Collection Duke de Narbonne-Pelet (according to Wildenstein); Wildenstein; Percival Farquhar sale, New York, May 12–13, 1942, lot 442
Bibl.: Goncourt, 1882, p. 333; Nolhac, 1906, p. 147; Wildenstein, 1960, no. 382; Mandel, 1972, no. 407; Sutton, 1980, no. 59

Saint-Aubin drew a rough sketch of the painting in his copy of the Gros sale catalogue.

88 The Gardens of the Villa d'Este, also called **The Little Park**
c. 1762–63. London, Wallace Collection. Canvas, 38 × 46 cm

Provenance: Anonymous sale, December 15, 1777, lot 214; perhaps Mercier sale, October 1, 1778, lot 17; Collection Marquess of Hertford; Collection Sir Richard Wallace; Lady Wallace Bequest, 1897

90 Shepherds in a Landscape, also called **The Herdsman** or **The Shepherds**
c. 1762–63. Private Collection. Canvas, 37 × 45 cm

Provenance: [Trouard] sale, February 22, 1779, lot 83; V. Doat sale, May 26, 1883, lot 6; Collection Groult; sale, Galerie Charpentier, June 9–10, 1953, lot 22 (repr.); sale, Galerie Charpentier,

92 Landscape with a herd drinking, called **View of an Italian Garden** or **The Watering Place**
c. 1763. Private collection. Canvas, mounted on panel, 33 × 42 cm

Provenance: Mme. [de Cossé] sale, November 11, 1778, lot 93 (canvas); anonymous sale, November 15, 1779, lot 36 (canvas); anonymous sale, December 11, 1780, lot 182 (canvas); per-

haps [Laborde] sale, June 13–14, 1784, lot 11; perhaps Le Sueur sale, November 22, 1791, lot 39; Moreau-Chaslon sale, May 8, 1886, lot 38; Collection Lehideux, Paris; anonymous sale, June 1, 1949, lot 40; anonymous sale, December 8, 1953, lot 33; anonymous sale, Sotheby's, London, December 12, 1973, lot 125
Bibl.: Portalis, 1889, p. 290; Nolhac, 1906, p. 140; Réau, 1956, p. 183; Wildenstein, 1960, no. 104; Mandel, 1972, no. 112

The *Italian Garden* in the Cossé sale, November 11, 1778, lot 93, catalogued separately by Wildenstein (see cat. L 104), definitely appears to be this painting ("*View of an Italian Garden*, in the foreground is a statue, at the foot of which a shepherd is seated. Near him is a herd of oxen under a shed. Farther off are various buildings." Canvas [32.4 × 43.2 cm]). The same description is repeated in the anonymous sale, December 11, 1780, lot 182. The anonymous sale of the November 15, 1779, lot 36, gives this other description: "A very picturesque landscape, where, in the foreground, is seen a stone statue and several figures near a herd of various large animals."

94

94 The White Bull
c. 1763–65. Paris, The Louvre. Canvas, 72.5 × 91 cm

Provenance: Collection S. Bardac, Paris; Wildenstein; Collection D. David-Weill (in 1921); Collection P. David-Weill; gift of E. and M. David-Weill to the museum in 1975
Bibl.: Wildenstein, 1921, no. 21; Henriot, 1926, pp. 145–47; Réau, 1956, p. 173; Wildenstein, 1960, no. 115; Wilhelm, 1960, p. 85; Mandel, 1972, no. 124; Compin, 1980–81, no. 50

P. Watel, Paris; Collection Wildenstein; Collection A. Veil-Picard; Collection A. Veil-Picard (son)
Bibl.: Portalis, 1889, p. 287; Nolhac, 1906, pp. 51, 154; Daulte, 1954, no. 31, plate VI; Réau, 1956, p. 151; Wildenstein, 1960, no. 213; Wilhelm, 1960, p. 73; Thuillier, 1967, pp. 49, 91–92; Mandel, 1972, no. 224; Sutton, 1980, no. 37

See pp. 82–83; Pl. 103 and for the pendant cat. no. 96

93 The Stable
c. 1763–64. Private Collection. Canvas, 48 × 60 cm

Provenance: Walferdin sale, April 12–16, 1880, lot 30; Collection Watel; Wildenstein; Collection A. Veil-Picard
Bibl.: Goncourt, 1882, p. 339; Portalis, 1889, p. 276; Nolhac, 1906, p. 140; Daulte, 1954, no. 15; Réau, 1956, p. 173; Wildenstein, 1960, no. 114; Wilhelm, 1960, p. 84; Mandel, 1972, no. 122

95 Rinaldo in the Gardens of Armida
c. 1763. Paris, Private Collection. Canvas, 72 × 91 cm

Provenance: L. Flameng sale, April 14, 1882, lot 27; Beurnonville sale, May 21–22, 1883, lot 13; Collection Mme. Watel, Paris; Collection

96 Rinaldo in the Enchanted Forest
c. 1763. Paris, Private Collection. Canvas, 72 × 91 cm

Provenance: Mercier sale, October 1, 1778, lot 16 (according to Wildenstein); Walferdin sale, April 12–16, 1880, lot 16; [Courtin] sale, March 29, 1886, lot 8; Muhlbacher sale, May 15–18, 1889, lot 19; Collection Bardac; Collection A. Veil-Picard; Collection A. Veil-Picard (son)

Bibl.: Portalis, 1889, p. 287; Nolhac, 1906, p. 154; Daulte, 1954, no. 30, plate V; Réau, 1956, p. 151; Wildenstein, 1960, no. 24; Wilhelm, 1960, p. 72; Thuillier, 1967, pp. 49, 91–92; Mandel, 1972, no. 225; Sutton, 1980, no. 38

See pp. 82–83; Pl. 104 and for the pendant cat. no. 95

97 The Master of the World

c. 1762–63. Paris, Private Collection. Canvas, 50 × 42 cm. Inscriptions, retraced, but originally present: *Fragonard après son retour d'Italie* (top left), and *Le Maître du Monde* (bottom right)

Provenance: Collection Marcille; Walferdin sale, April 12–16, 1880, lot 53; Collection Mniszech, then Collection Landau-Finaly (according to Mandel)
Bibl.: Mandel, 1972, no. 239

98 Mythological scene, called Cupid and Psyche

c. 1763. Private Collection. Canvas, 37 × 45 cm

Provenance: H. Walferdin sale, April 12–16, 1880, lot 38; Collection M. Déglise, 1889; C. Groult sale, March 21, 1952, lot 77; Knoedler, New York, 1955
Bibl.: Portalis, 1889, p. 286; Nolhac, 1906, p. 161; Wilhelm, 1960, [p. 82]

See Pl. 107 on p. 80

99 Niobe and Her Children

c. 1763–65 (?). Private Collection. Canvas, 44.4 × 36.2 cm

Provenance: Collection Mme. Charras; F. Doistau sale, June 9–11, 1909, lot 43; Collection U. Palm; his sale, Stockholm, April 11–12, 1935, lot 76; Collection E. Heÿne, Stockholm, 1960; sale, Christie's, London, July 7, 1972, lot 79
Bibl.: Dayot-Vaillat, 1907, no. 99; Réau, 1956, p. 148; Wilhelm, 1960, [p. 71]

100 All in a Blaze

c. 1763–64. Paris, The Louvre. Oval canvas, 37 × 45 cm

Provenance: Probably Gros sale, April 13, 1778, lot 57 (together with its pendant); F. de Villars sale, March 13, 1868, lot 29 (according to Wildenstein); Merton sale, March 24, 1874, lot 14 (idem); Becherel sale, November 26–28, 1883, lot 21; J. Doucet sale, June 6, 1912, lot 148; Collection Pardinel; Collection Coty (1921); Collection C. de Beistegui; donated to the museum in 1942, subject to usufruct; entered the museum in 1953
Bibl.: Goncourt, 1882, p. 277; Nolhac, 1906, p. 120; Wildenstein, 1921, no. 80; Réau, 1956, pp. 158–59; Wildenstein, 1960, no. 299; Wilhelm, 1960, p. 101; Thuillier, 1967, pp. 103, 111, 134; Mandel, 1972, no. 241

See Pl. 109 on p. 81 and cat. no. 208

Nolhac (1906, p. 120) has catalogued, wrongly it would seem, two paintings, one that of the Collection Beistegui, which passed through the Gros and Becherel sales, and the other that passed through the Villars and Merton sales.

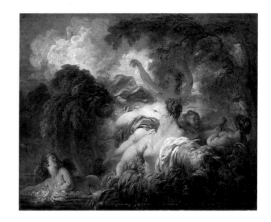

101 Women Bathing

c. 1763–64. Paris, The Louvre. Canvas, 64 × 80 cm

Provenance: Perhaps anonymous sale, March 11, 1776, lot 77 ("Some naked women are enjoying themselves in a place where they are bathing. Several trees and clumps of greenery give off an air of freshness." [64.8 × 81.1 cm]); perhaps [Varanchan] sale, December 29–30, 1777, lot 12; Abbé de Gévigney sale, December 1–29, 1779, lot 594 ("Eight young women are bathing, playing among the reeds; one of them, held by the others, gathers fruit from a tree whose branches virtually tumble over her."); Collection La Caze; bequeathed to the museum in 1869
Bibl.: Goncourt, 1882, p. 330; Portalis, 1889, p. 271; Nolhac, 1906, pp. 59, 118; Réau, 1956, p. 152; Wildenstein, 1960, no. 233; Wilhelm, 1960, p. 92; Thuillier, 1967, pp. 68, 89; Mandel, 1972, no. 245

See pp. 82–83; Pl. 108 and cat. no. 102

A replica or copy passed through the Walferdin, April 3, 1880, lot 13; Beurnonville, May 9–16, 1881, lot 60, and William Salomon, New York, April 4–7, 1923, lot 387, sales. On the other hand the "Women bathing, landscape with figures, panel, 17 × 24 cm" passed through the Walferdin sale, April 12–16, 1880, lot 79.

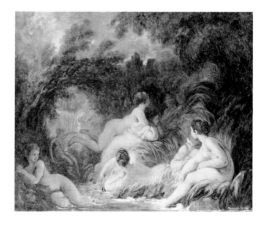

102 Women Bathing

c. 1763–64. U.S.A., Private collection. Canvas, 65 × 81 cm

Provenance: Perhaps anonymous sale, March 11, 1776, lot 77 (see cat. no. 101); Perhaps [Varanchan] sale, December 29–30, 1777, lot 12 (see cat. no. 101); perhaps Magnan de la Roquette sale, Aix, November 22, 1841, lot 158; anonymous sale, December 22, 1859, lot 2; Collection Countess Tyszkiewicz; Collection J. Bartholoni, Paris, (1921); Collection H. Walters, New York; Mrs. Walters sale, New York, May 1, 1941, lot 1.182; J. Gould sale, Sotheby's, New York, June 22, 1960, lot 17
Bibl.: Wildenstein, 1921, no. 30; Réau, 1956, p. 157; Wildenstein, 1960, no. 234; Wilhelm, 1960, p. 92; Mandel, 1972, no. 250; Sutton, 1980, no. 41

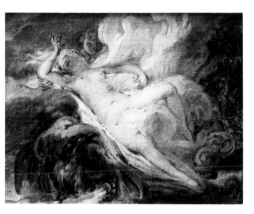

***103 Jupiter and Io**
c. 1763–65 (?). Angers, Musée des Beaux-Arts. Canvas, 24 × 30 cm

Provenance: Collection J. Robin; bequeathed to the museum in 1864
Bibl.: Wildenstein, 1960, no. 86; Mandel, 1972, no. 94

The attribution is not definite, despite the very Fragonardesque handling and treatment of light.

104 Young Woman Holding a Small Child
c. 1763–65. Paris, The Louvre. Oval canvas, 47 × 32.5 cm

Provenance: Collection La Caze; bequeathed to the museum in 1869
Bibl.: Portalis, 1889, p. 280; Wildenstein, 1960, no. 146; Mandel, 1972, no. 165

105 Mercury and Argus (after Carel Fabritius)
c. 1763–65 (?). Paris, The Louvre. Canvas, 59 × 73 cm

Provenance: Probably Walferdin sale, April 12–16, 1880, lot 47; sale, March 25, 1981, lot B ("French School of the 18th century"); acquired at that sale
Bibl.: Goncourt, 1882, p. 325; Portalis, 1889, p. 283; Cuzin-Rosenberg, 1983, pp. 49–50; Brown, 1986, pp. 797–99

The painting by Fabritius, for a long time unknown, passed through the Sotheby's, Monaco, sale, June 22, 1985, lot 147. It could be the painting sold in Paris, as Rembrandt, pendant to a *Medea and Jason*, on the June 19, 1764 (lot 20).

106 Annette and Lubin or **Annette at the Age of Twenty**
c. 1764–66. Rome, Galleria Nazionale d'Arte Antica. Canvas, 36 × 46 cm

Provenance: Collection Vassal de Saint-Hubert, to whom the engraving is dedicated; his sale, January 17–21, 1774, lot 107 (together with its pendant); M. L. C. de D.[Dubarry] sale, November 21, 1774, lot 104 (together with its pendant); Prince de Conti sale, April 8, 1777, lot 756 (together with its pendant); Boulogne sale, November 22, 1787, lot 71 (together with its

pendant, "subjects taken from Annette and Lubin"); Wildenstein, London; Collection Dimitri Sursock, duke of Cervinara, London, then Rome; bequeathed to the museum in 1960
Bibl.: Goncourt, 1882, p. 338; Portalis, 1889, p. 271; Nolhac, 1906, p. 142; Wildenstein, 1960, no. 129; Thuillier, 1967, p. 50; Mandel, 1972, no. 161; Sutton, 1980, no. 31

See p. 74; Pl. 97 and cat. no. L 1

Engraved by F. Godefroy together with its pendant, now lost, *Annette at the Age of Fifteen* (cat. no. L 1) in 1772. Subject taken from Marmontel.

107 The Shepherds
c. 1765 (?). Annecy, Musée de Beaux-Arts. Oval canvas, 40 × 30 cm

Provenance: Probably [Nogaret?] sale, March 23, 1778, lot 51; probably Vassal de Saint-Hubert sale, April 24, 1783, lot 66; probably Robert de Saint-Victor sale, November 26, 1822, lot 623; probably Baron Brunet-Denon sale, February 2, 1846, lot 333 (without measurements); Henri Rouart sale, December 9–11, 1912, lot 38; sale, Galerie Charpentier, December 10, 1935, lot 36; Collection Fabiani (according to Wildenstein); found in Germany after the Second World War (Musées Nationaux, MNR 870, deposited at Annecy in 1954 as "French School of the 18th century")
Bibl.: Portalis, 1889, p. 283; Réau, 1956, p. 186; Wildenstein, 1690, no. 153 bis.; Wilhelm, 1960, p. 55; Mandel, 1972, no. 171

See p. 74; Pl. 94 and see cat. nos. 108 and L 21

108 The Shepherds
c. 1765. Private Collection. Oval canvas, 40 × 30 cm

Provenance: Beurnonville sale, May 9–16, 1881, lot 75; Private Collection, Paris
Bibl.: Portalis, 1889, p. 272; Nolhac, 1906, p. 134; Wildenstein, 1960, no. 154 (A), fig. 85 bis; Mandel, 1972, no. 170

In 1881 the painting was set as a pendant to a *Herdsman Resting*, of the same measurements, which was considered by Wildenstein to be by Fragonard (catalogued under the same no. 154

as *The shepherds,* fig. 85 ter) but which seems more likely to be by Loutherbourg, to whom Portalis (1889, p. 272) was inclined to attribute the two paintings (see Chapter IV and n. 5). The provenance given to cat. no. 107 cannot completely be excluded, as relating, either totally or partially, to this painting, but the association of its pendant with Loutherbourg seems of long standing and could be authentic.

109 Landscape with Flock Fleeing from a Storm
c. 1763–65. Paris. Private Collection. Canvas, 52 × 73 cm

Provenance: Perhaps anonymous sale, November 15, 1779, lot 35 [64.8 × 72.9 cm]; perhaps Saint sale, May 4, 1846, lot 75 ("Landscape. In the foreground sandy rocks and various animals," without measurements); Mme. D. sale, November 13, 1860, lot 10 a; [Marquess d'Ivry] sale, March 31, 1914, lot 60; Collection L. Renault; Collection D. Aaron, Paris
Bibl.: Portalis, 1889, p. 284; Wildenstein, 1960, no. 125; Mandel, 1972, no. 157

See p. 75; Pl. 98

The description in the 1779 anonymous sale corresponds exactly to the existing painting, despite what Wildenstein has indicated; however the measurements, greater in height by 12 cm, would lead one to believe that the painting had been cut down at a later stage.

110 The Watering Place
c. 1763–65. Private Collection. Canvas, 51.5 × 63 cm

Provenance: Anonymous sale [Mme. de Saint-Sauveur?], February 12, 1776, lot 53 (according to Wildenstein); Randon de Boisset sale, March 24 , 1777, lot 230; anonymous sale, May 23, 1780, lot 40; [Duke de Choiseul] sale, December 10, 1787, lot 67; probably anonymous sale, July 8, 1793, lot 14; perhaps anonymous sale, December 28, 1846, lot 50 (on panel, without measurements); Laperlier sale, April 11–13, 1867, lot 33; Walferdin sale, April 3, 1880, lot 14; Collection Mme. C. Kestner (in 1889); Collection Lauverjat; Collection A. Veil-Picard; Collection Mme. J. Veil-Picard; sale, Sotheby's, Monaco, June 20–21, 1987, lot 389
Bibl.: Portalis, 1889, p. 289; Nolhac, 1906, p. 140; Réau, 1956, p. 186; Wildenstein, 1960, no. 126; Mandel, 1972, no. 158

See pp. 78–82; Pl. 100 and cat. no. 111

111 The Rock
c. 1763–65. Paris, Private Collection. Canvas, 53 × 62 cm. Signed, bottom left: *Fragonard*

Provenance: Walferdin sale, April 12–16, 1880, lot 54; [Courtin] sale, March 29, 1886, lot 7; anonymous sale, March 4, 1897, lot 16; anonymous sale, April 8, 1908, lot 9 (acquired by Lauverjat, according to Wildenstein); Collection A. Veil-Picard; Collection Mme. J. Veil-Picard
Bibl.: Portalis, 1889, p. 287; Nolhac, 1906, p. 140; Réau, 1956, p. 186; Wildenstein, 1960, no. 127; Thuillier, 1967, p. 70; Mandel, 1972, no. 159

pp. 78–82; Pl. 99 and cat. nos. 110 and 112

***112 The Rock**
c. 1763–65 (?). Private Collection. Panel, 54 × 61 cm

Provenance: Collection Marquess de Ganay (according to the 1964 sale catalogue); Wildenstein (idem); anonymous sale, June 9, 1964, lot 65

We only know this painting from the color photograph in the 1964 sale catalogue. The handling seems more sketchy and rougher than that of our cat. no. 111. It is difficult to give an opinion.

113 The Torrent
c. 1763–65. Private Collection. Canvas, 27 × 37 cm

Provenance: Huot-Fragonard sale, May 19–20, 1876, lot 5 (30 × 38 cm); Collection Casimir-Perrier; Collection E. Glaenzer, New York; Collection J. Seligmann, New York; F. Allen sale, Sotheby's, New York, January 28, 1953, lot 34; sale, Sotheby's, New York, April 11, 1981, lot 37
Bibl.: Portalis, 1889, p. 290; Nolhac, 1906, p. 136; Wilhelm, 1948, p. 302; Réau, 1956, p. 185; Wilhelm, 1960, p. 180 (cited)

See cat. no. 114

114 The Torrent
c. 1763–65. Private Collection. Canvas, 32 × 42 cm

Provenance: A. Kann sale, December 6–8, 1920,

lot 31; Seligmann (?); H. Leroux sale, March 23, 1968, lot 48; Cailleux, Paris
Bibl.: Wilhelm, 1960, p. 180

See cat.no. 113

A watercolor with gouache, of the same composition and similar measurements, originating from the Kraemer, Delagarde, and Colonna de Giovellina Collections, also figured in the H. Leroux sale, March 23, 1968, lot 9.

115 The Parents' Absence Turned to Account, or **The Farmer's Family**
Salon of 1765. Leningrad, The Hermitage. Canvas, 51 × 61 cm

Provenance: Submitted with the artist's candidature to the Académie in 1765; Salon of 1765, not in catalogue; Collection Bergeret de Grancourt in 1770; Lambert and du Porail sale, May 27, 1787, lot 222; Cochu sale, February 21, 1799, lot 17; Collection of Queen Hortense; Duchess de Saint-Leu; purchased by Alexander I in 1815 (according to Réau); entered the Hermitage in 1829 (according to I. Nemilova's catalogue, p. 287)
Bibl.: Goncourt, 1882, p. 331; Portalis, 1889, pp. 269, 279; Réau, 1956, p. 152; Wildenstein, 1960, no. 226; Wilhelm, 1960, p. 3; Seznec and Adhémar, 1960, pp. 43, 198–200; Thuillier, 1967, pp. 50, 111; Mandel, 1972, no. 237

See p. 89; Pl. 117

Engraved in 1770 by J.-F. Beauvarlet under the title *"The Farmer's Family; from the Collection of M. Bergeret."* Fragonard himself appears to have painted a miniature after his own painting (Aubert sale, March 2, 1786, lot 128; 6.7 × 10.8 cm).

*116 Young girl turning away, called **The Resistance**
c. 1765 or slightly earlier. Amiens, Musée de Picardie. Oval panel, 56 × 46 cm

Provenance: Marcille sale, January 12–13, 1857, lot 62; Collection Lavalard; bequeathed to the museum in 1890
Bibl.: Nolhac, 1906, p. 125; Wildenstein, 1921, no. 24; Wildenstein, 1960, no. 227; Mandel, 1972, no. 238

This could not be, as Wildenstein believes (1960), no. 331 in the Brunet-Denon sale, February 2, 1846, described as: *"The Resistance—subject with two figures"* without any indication of measurements or support, and which may relate to a composition such as *The Useless Resistance* in Stockholm (cat. no. 284). The quality of the work is disappointing and the attribution perhaps questionable. A very similar figure appears in the background of *The Farmer's Family* (cat.no. 115).

117 Coresus and Callirhoe, or **The High Priest Coresus Sacrifices Himself to Save Callirhoe**
Salon of 1765. Paris, The Louvre. Canvas, 309 × 400 cm

Provenance: Submitted with the artist's candidature to the Académie in 1765; Salon of 1765, no. 176; Collection of Louis XV; Collections of the Académie
Bibl.: Goncourt, 1882, p. 324; Portalis, 1889, p. 274; Réau, 1956, p. 148; Seznec and Adhémar, 1960, pp. 43, 188–98; Wildenstein, 1960, no. 225; Wilhelm, 1960, pp. 64–66; Thuillier, 1967, pp. 25, 49, 64; Mandel, 1972, no. 232

See pp. 85–89; Pls. 111–12

Engraved by J.-C. Danzel in 1773 (?)

For two lost sketches see cat.nos. L 71 and L 116; see also cat.nos. 118–19.

118 Coresus and Callirhoe, or **The Sacrifice of Callirhoe**
c. 1763–64. Angers, Musée des Beaux-Arts. Canvas, 129 × 186 cm

Provenance: Marquess de Lassay sale, May 17,

118

1775, "a large composition different from that engraved after the same master by J. Danzel," lot 102; Mercier sale, October 1, 1778, lot 15; Marquess de Livois sale (P. Sentout, catalogue of a collection, 1791, no. 243, p. 83); entered the museum in 1799
Bibl.: Goncourt, 1882, p. 324; Portalis, 1889, p. 274; Wildenstein, 1921, no. 23; Réau, 1956, p. 148; Wildenstein, 1960, no. 221; Wilhelm, 1960, p. 63; Thuillier, 1967, p. 49; Mandel, 1972, no. 233

See pp. 85–86; Pl. 110

119 Coresus and Callirhoe
1765 (?). Madrid, Real Academia de Bellas Artes de San Fernando. Canvas, 65 × 81 cm

Provenance: Collection Godoy, Madrid (inventory of 1808 [Quilliet] fol. 8 [copy of Fragonard]); collections of the Académie in 1816
Bibl.: Portalis, 1889, p. 274; Réau, 1956, p. 148; Wildenstein, 1960, no. 224; Mandel, 1972, no. 234; Williams, 1978–79, under no. 18

See p. 89 and cat. no. L 71 (?)

Probably another reduced copy of the Louvre painting.

120 An Ancient Sacrifice, called The Sacrifice to the Minotaur
c. 1765–66. Private Collection. Canvas, 71 × 90 cm

Provenance: Perhaps anonymous sale, July 8, 1777, lot 31 (see cat. no. 121); perhaps [Varanchan] sale, December 29–30, 1777, lot 15 (see

cat. no. 121); Collection Mme. J. Doucet, Neuilly, 1921
Bibl.: Portalis, 1889, p. 288 (as *Sacrifice of Iphigenia*); Nolhac, 1906, p. 153; Wildenstein, 1960, no. 218; Mandel, 1972, no. 229

See p. 89; Pl. 115

121 An Ancient Sacrifice, called The Sacrifice to the Minotaur
c. 1765–66. Private Collection. Canvas, 72 × 91 cm

Provenance: Perhaps anonymous sale, July 8, 1777, lot 31 ("A sacrifice, sketch painted on canvas by H. Fragonard" [71.5 × 89.3 cm]); perhaps [Varanchan] sale, December 29–30, 1777, lot 15 ("A sketch lightly executed: it represents the sacrifice of Iphigenia." [67.5 × 89.3 cm]); Walferdin sale, April 12–16, 1880, lot 17 (purchased by Brame according to Wilden-

stein); Collection Brame, 1889; J. Doucet sale, June 6, 1912, lot 146; Collection Mme. Watel-Dehaynin
Bibl.: Goncourt, 1882, p. 325; Portalis, 1889, p. 288; Nolhac, 1906, p. 153; Réau, 1956, p. 148; Wildenstein, 1960, no. 217; Wilhelm, 1960, p. 68; Mandel, 1972, no. 288

See p. 89; Pl. 116

Nolhac (1906, p. 153) draws attention to a "smaller sketch, in lightly colored grisaille" for this painting in the Collection J. Doucet in 1906; could it be the *Sacrifice of Iphigenia*, lot 49, Walferdin sale, April 12–16, 1880, (card?, 24 × 31 cm)?

122 Dawn
c. 1765 (?). Private Collection. Canvas, 52 × 61 cm

Provenance: Le Dart sale, Caen, April 29, May 4, 1912, lot 108; Wildenstein, New York; Collection Lorenzo Pellerano, Buenos Aires; Private Collection, Copenhagen
Bibl.: Wildenstein, 1960, no. 83; Mandel, 1972, no. 91

See p. 92

123 Family Scene, subject perhaps taken from Miss Sara, also called A Visit to the Foster Mother
c. 1765–66? Washington D.C., National Gallery of Art, Collection Samuel H. Kress. Canvas, 73 × 92 cm

119

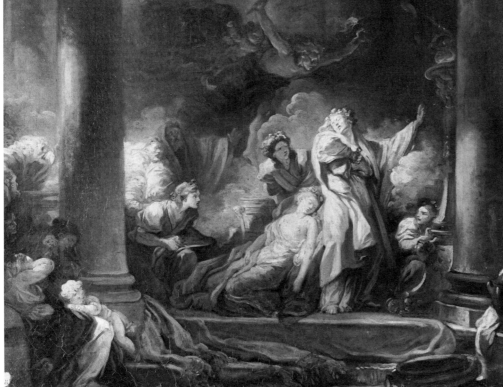

Provenance: Leroy de Senneville sale, April 5, 1780, lot 50 ("A painting consisting of eight figures, of which the subject is taken from the novel *Miss Sara* by M. de Saint-Lambert. This composition represents the moment when the two spouses come to visit their child. This piece adds to a broad and fluent touch, all the spirit and character appropriate to the subject." [72.9 × 89.3 cm]); Leroy de Senneville sale, April 26, 1784, lot 26; Mme. Goman sale, March 24, 1792, lot 100 (75 × 89 cm); perhaps Constantin sale, November 18, 1816, lot 365 (70 × 86 cm); J. Burat sale, April 28–29, 1885, lot 71; Collection M. Burat; Wildenstein; Collection Samuel H. Kress; bequeathed to the gallery in 1946;
Bibl.: Goncourt, 1882, p. 334; Portalis, 1889, p. 291; Nolhac, 1906, p. 127; Wildenstein, 1921, no. 69; Réau, 1956, p. 172; Wildenstein, 1960, no. 459; Wilhelm, 1960, pp. 196–97; Thuillier, 1967, p. 53; Mandel, 1972, no. 482; Eisler, 1977, pp. 333–35

See pp. 89–92; Pl. 118 and cat. nos. 124–25, and L 167

The "eight figures" mentioned in the Leroy de Senneville sales prevent a positive assimilation of the two works (the cat would have to be included!). The Goman sale painting had only "six figures" with the references "finished sketch, known under the title of *Good Mother.*" For the subject, see Chapter VIII, n. 24

124 Family Scene, subject perhaps taken from **Miss Sara,** also called **A Visit to the Foster Mother**
c. 1765–66 (?). Private Collection. Canvas, 64 × 79.5 cm

Provenance: Collection M. Bendixon, London; Wildenstein, New York; Collection Staub-Ter-linden, Switzerland; sale, Sotheby's, December 14, 1977, lot 105
Bibl.: Wildenstein, 1921, no. 70; Réau, 1956, p. 172; Wildenstein, 1960, no. 460; Mandel, 1972, no. 483

See cat. nos. 123, 125, and L 167

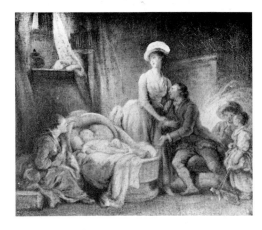

125 Family Scene, subject perhaps taken from **Miss Sarah,** also called **A Visit to the Foster Mother**
c. 1765–66. Switzerland, Private Collection. Canvas, 32 × 40 cm

Provenance: Perhaps Leroy de Senneville sale, April 5, 1780, lot 51 ("A painting with an admirable harmony of colors. It represents the same subject as the previous one, but with a completely different composition. There are four figures, of which the main one is a young and pretty woman, wearing a straw hat; her husband, seated beside her appears to be looking at a child in its cradle, on which the foster mother is leaning. This work, of striking and magical effect, is also imbued with a light and spirited touch." [31 × 39 cm]); perhaps Leroy de Senneville sale, April 26, 1784, lot 27; Marquess de [Montesquiou] sale, December 9, 1788, lot 259 ("The first idea for the painting of Sara visiting her children. Composition with six of the most ingenious and striking figures." [32.4 × 37.8 cm]); perhaps [Artaud] sale, November 15, 1791, lot 120 ("A finished sketch. Composition with six figures." [32.4 × 40.5 cm]); Beurnonville sale, May 9–16, 1881, lot 62; Beurnonville sale, May 21–22, 1883, lot 14; Collection Mme. L. Stern, Paris, 1911; Wildenstein, Paris; Collection Baron Edmond de Rothschild, Paris; Collection Baron Maurice de Rothschild; Collection Baron Edmond de Rothschild, Pregny
Bibl.: Portalis, 1889, p. 291; Nolhac, 1906, p. 127; Réau, 1956, p. 172; Wildenstein, 1960, no. 458; Wilhelm, 1960, p. 196; Mandel, 1972, no. 484

See cat. nos. 123–24, L 167

One may well wonder whether this is the painting that figured in the Leroy de Senneville sales, "with a completely different composition" from no. 123 and containing four figures. However, the essentials of the description and the measurements concord.

***126 Little Girl Standing and Reading**
c. 1765–66 (?). Location unknown. Measurements unknown

Provenance: Collection Demidoff (?); Collection Gimpel, London, 1946; Private Collection, England (?)
Bibl.: Illustrated London News, December 7, 1946

This work is exceptional in its style and not very attractive, however the attribution to Fragonard seems justified. The different proportions and the careful handling appear to hinder the identification of this painting with lot 110 in the Marshal de Ségur, M. de Clesle, sale of the April 9, 1793 (see cat. no. L 165). See, for a painting with similar motif but of much later date, our cat. no. 277; also the relationship with the little girl on the extreme right of the Washington D.C. canvas, our cat. no. 123 should be noted.

127 A Vestal Virgin
c. 1765–66. Private Collection. Oval canvas, 40 × 32.5 cm

Provenance: [Baché, Brilliant, Cossé, Quenet...]

sale, April 22, 1776, 98 ("A head of a vestal virgin. This painting is oval in shape," [40.5 × 32.4 cm].); Collection Baron Vitta; sale, Sotheby's, London, May 18, 1938 (lot unknown); Collection Mme. Bemberg, Paris; Cailleux, Paris
Bibl.: Dayot-Vaillat, 1907, no. 89; Wildenstein, 1960, no. 404 (as lost); Mandel, 1972, no. 431 (as lost)

It is tempting to identify this picture with the *Head of a Priestess* painted in Rome before April 1758 and considered by the Académie professors as "a little too insipid" (cat.no. L 16); but the painting appears to be of later date.

Provenance: Collection Descamps; acquired by the museum in 1818
Bibl.: Portalis, 1889, p. 284; Wildenstein, 1960, no. 174; Mandel, 1972, no. 187

129 Landscape with shepherd and flock of sheep, called Stormy Weather
c. 1766. Private Collection. Canvas, 50 × 61 cm

Provenance: Perhaps Collection Choiseul-Gouffier; Collection Köhler-Schlumberger, Mulhouse; sale, Palais Galliera, December 7, 1971, lot 13 (repr.) Drouot-Montaigne sale, November 22, 1987, lot 11
Bibl.: Goncourt, 1882, p. 338; Portalis, 1889, p. 289; Réau, 1956, p. 185; Wildenstein, 1960, no. 167; Wilhelm, 1960, p. 185; Mandel, 1972, no. 185

Engraved as *Stormy Weather* by J. Mathieu, with a dedication to the Count de Choiseul-Gouffier.

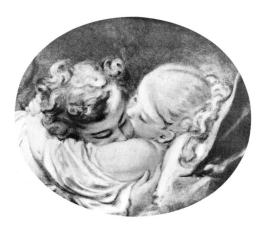

128 The Kiss
c. 1766–68 or c. 1763–65 (?). Paris, Private Collection. Oval canvas, 52 × 65 cm

130 Landscape with Thatched Cottage in a Mountainous Place
c. 1766. Rouen, Musée des Beaux-Arts. Oval canvas, 30 × 26 cm

Provenance: Laperlier sale, February 17–21, 1879, lot 12 *(The Kisses)*; Deglise sale, December 2, 1896, lot 17; Collection Charvet; Collection Wildenstein, New York and Paris; Collection Robert de Rothschild; Collection Alain de Rothschild
Bibl.: Portalis, 1889, p. 271; Nolhac, 1906, p. 118; Wildenstein, 1921, no. 34; Réau, 1956, p. 157; Wildenstein, 1960, no. 272; Wilhelm, 1960, p. 100; Thuillier, 1967, p. 111; Mandel, 1972, no. 290

See p. 98; Pl. 123

129

131 Landscape with a Lame Man
c. 1766. Paris, Private Collection. Panel, 24 × 32.5 cm

Provenance: [Montesquiou] sale, December 9, 1788, lot 258; [Artaud] sale, November 15, 1791, lot 119; Horsin-Déon sale, March 26, 1868, lot 12; A. Beurdeley sale, May 6–7, 1920, lot 153; Collection Weiss (according to Wildenstein); anonymous sale, May 6, 1925, lot 75; Collection Louis Paraf (according to Wildenstein), in 1930; Cailleux, Paris; Collection M. and Mme. Aubertin, Paris
Bibl.: Portalis, 1889, p. 289; Nolhac, 1906, p. 136; Wildenstein, 1960, no. 172; Wilhelm, 1960, p. 187; Mandel, 1972, no. 186

See Pl. 101 on p. 78

132 Landscape with field of corn and harnessed wagon, called The Harvesters Resting
c. 1766. Private Collection. Canvas, 55 × 64.8 cm

135 Landscape with Three Washerwomen, also called **The Washerwomen** or **The Laundresses**
c. 1766–68 (?). Richmond, Virginia Museum of Fine Arts. Canvas, 38.7 × 46.3 cm, signed to the right on the lintel of the door: *Fragonard*

Provenance: Anonymous sale, December 11, 1780, lot 181 (together with its pendant); Lambert and du Porail sale, March 27, 1787, lot 223 (together with its pendant, cottage noted by mistake as being on the left); [Saubert and Desmarest] sale, March 17, 1789, lot 93 (together with its pendant); Mlle. Lacaille sale, January 23, 1792, lot 69 (35.1 × 43.2 cm); Walferdin sale, April 12–16, 1880, lot 7; [Brame] sale, March 20, 1883, lot 12; [Courtin] sale, March 29, 1886, lot 6; anonymous sale, March 4, 1897, lot 17; Collection Baron Vitta, Paris; Collection Wildenstein; Newhouse Galleries, New York, 1980; acquired by the museum in 1980 through the Williams Fund
Bibl.: Goncourt, 1882, p. 334; Portalis, 1889, p. 282; Nolhac, 1906, p. 136; Réau, 1956, p. 185; Wildenstein, 1960, no. 160; Mandel, 1972, no. 178

See, for the pendant *(Landscape with a Man Gathering Wood)*, cat. no. L 85

Provenance: [Trouard] sale, February 22, 1779, lot 81; sale [Benou, according to documentation, Frick Reference Art Library; La Rochefoucauld-Liancourt according to Wildenstein], June 20, 1827, lot 20; Collection A. Lehmann; Collection Mrs. James Shewan, New York; Wildenstein, New York
Bibl.: Nolhac, 1906, p. 142; Wildenstein, 1960, no. 165; Mandel, 1972, no. 184

c. 1766–68. Lisbon, Fundação Calouste Gulbenkian. Canvas, 57 × 67 cm
Provenance: Collection Laperlier (does not figure in the 1879 sale); Walferdin sale, April 3, 1880, lot 16 (originating from the Collection Laperlier); Mme. Charras sale, April 2–3, 1917, lot 7
Bibl.: Portalis, 1889, p. 274; Nolhac, 1906, p. 137; Réau, 1956, p. 184; Wildenstein, 1960, no. 178; Mandel, 1972, no. 191

133 The Stream of Water

134 Autumn Landscape
c. 1766–68. Amiens, Musé de Picardie. Canvas, 21 × 32 cm

136 Landscape, called **The Two Washerwomen** or **The Pond** or **Fishing for Crayfish**
c. 1766–68. Fort Worth, Kimbell Art Museum. Canvas, 65 × 73 cm

Provenance: Leroy de Senneville sale, April 5, 1780, lot 49 (not sold); second Leroy de Senneville sale, April 26, 1784, lot 28; anonymous sale, May 2, 1870, lot 13; anonymous sale, April 27, 1872, lot 6; Walferdin sale, April 3, 1880, lot 15, (purchased by Brame according to Wildenstein); A. Febvre sale, April 17–20, 1882, lot 10; Collection M. Courtin, Paris; Private Collection, U.S.A. (1925); Newhouse Galleries, New York; purchased by the museum in 1968
Bibl.: Goncourt, 1882, p. 334; Portalis, 1889, p. 276 "Pool in a wood: children fishing for crayfish in a pool," pp. 282, 284 (one painting is catalogued twice); Nolhac, 1906, p. 138; Réau,

136

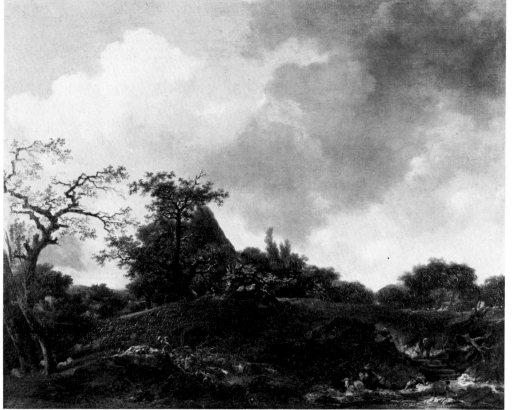

137

1956, p. 185; Wildenstein, 1960, no. 185; Mandel, 1972, no. 196; Slive, 1982, pp. 267–76

The painting is described in the 1780 Leroy de Senneville sale with the following commentary: "This piece, painted in one sitting, is an exact recreation of the effect of M. Lempereur's painting by Ruisdael, and which, through its light and spirited touch, becomes original." Ruisdael's painting, having been in the Collection Lempereur, passed through the Gros sale, April 14, 1778, lot 25, which also included many of Fragonard's paintings as well as drawings after the Dutch Masters (Slive, pp. 271–73).

137 Landscape with washerwomen, called **Landscape with a Large Stretch of Greensward**
c. 1768. Grasse, Musée Fragonard. Canvas, 73 × 91 cm

Provenance: Count de Vaudreuil sale, November 26, 1787, lot 110 (originating from the Belisard sale); Collection Marquess de Langeac; purchased in 1822 by Louis XVIII for the Palais de Saint-Cloud; entered the Louvre in 1837; sent to the Musée de Compiègne in 1887; deposited at the Musée Fragonard in 1959
Bibl.: Portalis, 1889, p. 284; Daulte, 1954, no. 3; Réau, 1956, p. 185; Wildenstein, 1960, no. 183; Wilhelm, 1960, p. 189; Thuillier, 1967, pp. 70–71; Mandel, 1972, no. 194

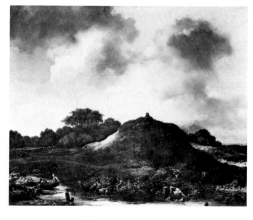

138 The Mound
c. 1766–68. Private Collection. Canvas, 37 × 45 cm

Provenance: Walferdin sale, April 12–16, 1880, lot 26; Collection N. Borthon, Dijon, 1890 (see cat. no. 35); Collection d'Hotelans; Collection Wildenstein, New York; Collection Clive Cookson, England
Bibl.: Portalis, 1889, p. 289; Nolhac, 1906, p. 136; Réau, 1956, p. 186; Wildenstein, 1960, no. 175; Mandel, 1972, no. 182

Almost certainly the painting from the Leroy de Senneville sale, April 5, 1780, lot 52, which we have catalogued as *The Pond* (cat. no. L 78), and thus the pendant to cat. no. 139.

***138a Landscape with a couple on top of a mound,** called **Annette and Lubin in a Landscape**
c. 1766–68 (?). Canvas, 36 × 44.5 cm

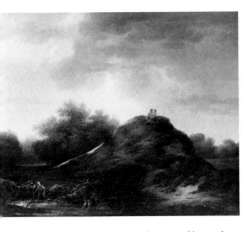

Provenance: Sotheby's sale, Monaco, November 4, 1983, lot 647 (according to the catalogue it was acquired in 1900 by F. Jeantet, director of *La Revue hebdomadaire*, and then in the collection of his heirs)

This painting, which seems to be authentic, judging from the illustration, may be a variant of *The Mound* (cat. no. 138), which is very close to it in composition and lighting, and furthermore of almost the same measurement.

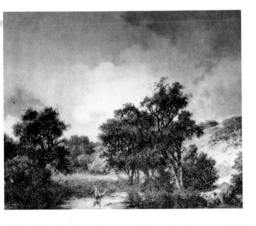

139 Wooded landscape with a herdsman and two oxen, called **The Thick Forest** or **The Pond**
c. 1766–68. Private Collection. Canvas, 37 × 47 cm

Provenance: Leroy de Senneville sale, April 5, 1780, lot 52 (together with its pendant); Walferdin sale, April 12–16, 1880, lot 6; Collection Viscountess de Courval (in 1889 according to Portalis); Collection Princess de Poix; Collection Duchess de Mouchy
Bibl.: Portalis, 1889, p. 282; Nolhac, 1906, p. 137; Wilhelm, 1948, p. 297; Réau, 1956, p. 185; Wildenstein, 1960, no. 163; Wilhelm, 1960, p. 184; Mandel, 1972, no. 181

See what is very probably the pendant, cat. no. 138 and L 78

140 The Ford
c. 1766–68. Chartres, Musée des Beaux-Arts. Paper mounted on panel, 28 × 38 cm

Provenance: Collection J. Courtois; donated to the museum in 1889

Bibl.: Daulte, 1954, without no. (preceding no. 7); Wildenstein, 1960, no. 164; Wilhelm, 1960, p. 188; Mandel, 1972, no. 183

141 Landscape with a horseman, called **The Glade,** or **The Shepherds**
c. 1766–68 (or 1775?). Detroit Institute of Arts. Canvas, 38 × 45 cm

Provenance: Huot-Fragonard sale, May 19–20, 1876, lot 55; Beurnonville sale, January 30–31, 1885, lot 138; Collection Cailleux (before 1928); Collection D. David-Weill, Neuilly-sur-Seine; Collection Wildenstein, New York; Collection Mr. and Mrs. E. B. Whitcomb; donated to the museum in 1948
Bibl.: Nolhac, 1906, p. 134; Henriot, 1926, pp. 115–17; Réau, 1956, p. 186; Wildenstein, 1960, no. 176; Wilhelm, 1960, p. 181; Mandel, 1972, no. 189; Zafran, 1983, no. 66

See p. 196; Pl. 240. The date is questionable.

***142 Landscape with Animals**

c. 1768 (?). Quimper, Musée des Beaux-Arts. Oval canvas, 45 × 63 cm
Provenance: Collection Count de Silguy; bequeathed to the museum in 1864
Bibl.: Wildenstein, 1960, no. 177; Mandel, 1972, no. 190

143 The Cowherds, or **The Meeting under the Willows**
c. 1768–70. Paris, Private Collection. Panel, 32 × 23 cm

Provenance: Anonymous sale, April 3, 1946 (lot unknown); Collection Tricau (according to Wildenstein); Collection Mme. E. Ader, Paris
Bibl.: Exh., Grasse, 1957, no. 21; Wildenstein, 1960, no. 187; Mandel, 1972, no. 198

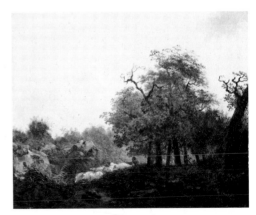

143 a Landscape with Shepherd and Flock
c. 1768–70. Private Collection. Canvas, 37.7 × 46.5 cm
Provenance: Les Marismas sale, December 19–20, 1845, lot 65
Bibl.: Rosenberg, 1987–88, fig. 4, p. 185

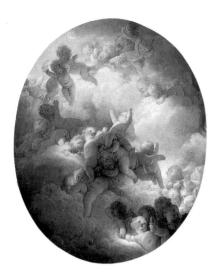

144 Group of children in the sky, called **The Swarm of Cherubs**
1767 or slightly earlier. Paris, The Louvre. Oval canvas, 65 × 56 cm

Provenance: Probably Salon of 1767, lot 137 (as belonging to Bergeret); anonymous sale, March 11, 1776, lot 76; B[enoit] sale, April 10, 1786, lot 42; Beurnonville sale, May 9–16, 1881, lot 58 (with measurements inverted); Collection Péreire, Paris; Collection André Péreire (son-in-law); Péreire Gift to the museum in 1949 subject to usufruct; entered the museum in 1974
Bibl.: Goncourt, 1882, p. 263; Portalis, 1889, p. 276 *(Swarm of Cherubs)*; Nolhac, 1906, pp. 54, 158; Wildenstein, 1924, no. 29 (with measurements inverted); Daulte, 1954, no. 19; Réau, 1956, p. 154; Wildenstein, 1960, no. 78; Seznec and Adhémar, 1963, pp. 37, 279–80; Thuillier, 1967, pp. 51–52; Mandel, 1972, no. 86

See pp. 92–94; Pl. 120

Wildenstein (1960) likens this painting to lot 94 in the anonymous sale of April 22, 1776, of different measurements, subject, and, it would seem, date (see cat. no. L 44).

145 Head of an Old Man in Profile
Salon of 1767 (?). Muncie (Indiana), Ball State University, Art Gallery. Round canvas, diam.: 21 cm

Provenance: Perhaps the "Head of an old man, painting of circular shape taken from the collection of M. Bergeret" in Salon of 1767, no. 138; perhaps Collection Bergeret; perhaps sold by Fragonard in 1790 to his cousin Maubert in Grasse; Collection de Blic, Grasse; Collection Malvilan, Grasse; Collection Wildenstein, New York; on permanent loan from the Collection E. Arthur Ball, Ball Brothers Foundation, 1951
Bibl.: Nolhac, 1906, p. 54; Wildenstein, 1960, no. 207; Seznec and Adhémar, 1963, pp. 37, 280; Thuillier, 1967, p. 50; Mandel, 1972, no. 218

See p. 94; Pl. 121

146 Head of an Old Man in Profile
1767 (?). Paris, Private Collection. Round canvas, diam.: 37 cm

Provenance: Perhaps "Head of an old man, painting of circular shape taken from the Collection of M. Bergeret" in the Salon of 1767, no. 138; perhaps Collection Bergeret

See p. 94; Pl. 122

It is difficult to decide which, this painting or that of cat. no. 145, figured in the Salon of 1767, no. 138. A sentence of Diderot's is intriguing ("this old man sees far") and may imply that the painting in the Salon was a third canvas now lost.

147 The Happy Hazards of the Swing, also called **The Swing**
1767. London, Wallace Collection. Canvas, 83 × 65 cm

Provenance: Commissioned in 1767 by the Baron de Saint-Julian; Collection Ménage de Pressigny; seized from his house in November 1794; Collection Marquess des Razins de Saint-Marc (according to Wildenstein); Duke de Morny sale, May 31, 1865, lot 98; Collection Lord Hertford; Collection Sir Richard Wallace; Lady Wallace Bequest, 1897
Bibl.: Goncourt, 1882, p. 328; Portalis, 1889, p. 276; Nolhac, 1906, p. 121; Réau, 1956, pp. 157–58; Wildenstein, 1960, no. 237; Wilhelm, 1960, pp. 87–88; Thuillier, 1967, pp. 27–28, 137, 138; Mandel, 1972, no. 251

See. p. 97; Pl. 125

Engraved by N. de Launay, probably in 1782,

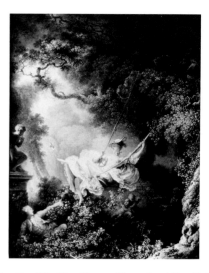

under the title *The Happy Hazards of the Swing* (with feathers in the hat). Portalis (1889, pp. 58–59, no. 1 and p. 276) mentions a "very good copy" of *The Swing* belonging to the Baron Edmond de Rothschild and thought that Launay's engraving was made after this painting.

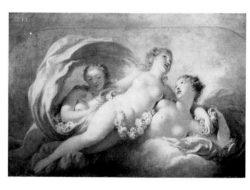

148 The Three Graces
before 1770 (c. 1766–68?). Grasse, Musée Fragonard. Canvas, 89 × 134 cm. Originally curved at the top; enlarged by 9 cm at the top

Provenance: sold by F.-H. Drouais to Countess du Barry in 1770; seized in 1794 at Louveciennes; claimed in vain by Countess du Barry's heirs in 1830; sent, with the Louvre *Cupid Setting the Universe Ablaze* (cat. no. 149) to the Cercle d'Artillerie of the Garde Impériale at Versailles; deposited at the Musée Fragonard in Grasse in 1958
Bibl.: Goncourt, 1882, p. 284; Portalis, 1889, p. 275; Wilhelm, 1956, pp. 219–20; Réau, 1956, p. 145; Wildenstein, 1960, no. 297; Wilhelm, 1960, p. 44; Mandel, 1972, no. 311

See p. 135; Pl. 165

This painting and cat. no. 149–51 are mentioned in a memorandum of Drouais' of the June 24, 1770: "On Sunday June 24, delivered to the Countess, four overdoors, for the old pavilion of Louveciennes, one representing the Graces, another Cupid setting the Universe ablaze, another Venus and Cupid and another Night. These four overdoors, painted by Fragonard, painter to the king. They were purchased by the Countess from Sir Drouais, to whom they belonged... for 1,200 livres. On the Countess's orders, three of the above mentioned overdoors

were relined, they were enlarged, repainted and allowing for enlargements, the money spent... 420 livres."

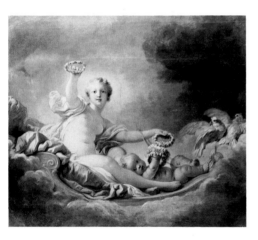

149 Cupid Setting the Universe Ablaze
before 1770 (c. 1768?). Toulon, Musée d'Art et d'Histoire. Canvas, 116 × 145 cm. Originally rounded corners and curved at the bottom; enlarged, top and bottom, by about 35 cm

Provenance: sold by F.-H. Drouais to Countess du Barry in June 1770; seized in 1794 at Louveciennes; claimed in vain by Countess du Barry's heirs in 1830; sent, with the *Three Graces* (cat.no. 148) to the Louvre to the Cercle d'Artillerie of the Garde Impériale at Versailles; deposited at the museum in April 1895
Bibl.: Goncourt, 1882, p. 284; Portalis, 1889, p. 275; Réau, 1956, p. 145; Wilhelm, 1956, pp. 219–20; Wildenstein, 1960, no. 298; Mandel, 1972, no. 312; Dupuy-Rosenberg, 1985, no. 12

See p. 135; Pl. 168 and cat.no. 148

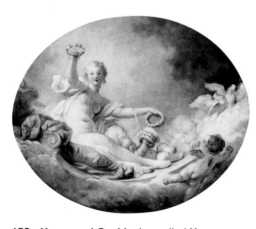

150 Venus and Cupid, also called **Day** or **Venus Offering Crowns**
before 1770 (c. 1768?). Dublin, National Gallery of Ireland. Canvas, 114 × 133 cm. Originally rounded corners; much enlarged across the top

Provenance: sold by F.-H. Drouais to Countess du Barry in June 1770; seized in 1794 at Louveciennes; given by Napoleon I to Baroness Denot; Collection Léon Helft (according to J. Wilhelm) (?); Collection Wildenstein, New York; Collection E. Bührle, Zurich; Collection Wildenstein, New York; acquired by the gallery in 1978
Bibl.: Goncourt, 1882, p. 284; Portalis, 1889, p. 275; Daulte, 1954, no. 20; Réau, 1956, p. 145; Wilhelm, 1956, pp. 215–17; Wildenstein, 1960,

no. 299; Wilhelm, 1960, p. 42; Mandel, 1972, no. 313; Sutton, 1980, no. 47

See p. 135; Pl. 167 and cat.no. 148

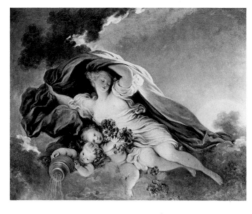

151 Night Spreads Her Veils, also called **Twilight**
1770 (?). Private Collection. Canvas, 115 × 146 cm

Provenance: Sold by F.-H. Drouais to Countess du Barry in 1770; Seized in 1794 at Louveciennes; given by Napoleon I to Baroness Denot; Collection Baron de Rothschild, Pregny; Collection Baron Edmond de Rothschild, Pregny
Bibl.: Goncourt, 1882, p. 284; Portalis, 1889, p. 275; Réau, 1956, p. 145; Wilhelm, 1956, pp. 215–18; Wildenstein, 1960, no. 300; Wilhelm, 1960, p. 46; Mandel, 1972, no. 315

See pp. 135–36; and cat.no. 148; Pl. 169

152 Venus and Cupid, also called **Venus Offering Crowns** or **Day**
before 1770 (c. 1768?). Private Collection. Oval canvas, 32 × 40 cm

Provenance: G. Mühlbacher sale, May 13–15, 1907, lot 21; Mme. Michel Ephrussi sale, May 19, lot 13; Collection Wildenstein, Igny; Collection Wildenstein, New York
Bibl.: Réau, 1956, p. 147; Wilhelm, 1956, p. 222; Wildenstein, 1960, no. 295; Mandel, 1972, no. 314

See Pl. 166 on p. 136 and cat.no. 150

153 Venus distributing crowns, called **Day**
c. 1770–72. Private Collection. Canvas, 72.5 × 127 cm (probably cut down)

Provenance: Private Collection, Belgium; Cailleux, Paris
Bibl.: Cailleux, 1960, p. VI, n. 36

See cat.no. 150

154 The Three Graces
c. 1770–72. Paris, Private Collection. Canvas, 62.5 × 138 cm

Provenance: Private Collection, Paris, 1956
Bibl.: Wilhelm, 1956, pp. 221–22; Wildenstein, 1960, under no. 297 (expresses reservations: "the features of some of the women do not display the characteristic features of Fragonard's style.")

See p. 137

The picture appears to be later than the one at Grasse (cat.no. 148) from which it may be distinguished through its significant variations.

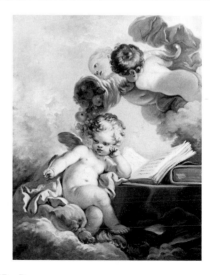

155 Day
c. 1768. U.S.A., Private Collection. Canvas, 100 × 80 cm

Provenance: Perhaps Bergeret sale, April 24,

1786, lot 106 (purchased by the Abbé de Saint-Non); Collection Rothschild, London; Collection Charles Davis (according to Wildenstein); Collection Besteigui (idem); Collection Count Paul de Courtivron, Paris (1921)
Bibl.: Portalis, 1882, pp. 260, 289; Wildenstein, 1921, no. 7; Wildenstein, 1960, no. 74; Wildenstein, 1961, p. 74; Mandel, 1972, no. 83; Sutton, 1980, no. 16

Owing to the lack of any indication of subject matter, support, or measurements, it cannot be proved that this is one of the four "allegorical subjects represented by children" which were acquired by the Abbé de Saint-Non under lot 106 of the Bergeret sale, April 24, 1786.

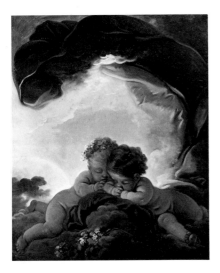

156 Night
c. 1768. U.S.A., Private Collection. Canvas, 100 × 80 cm

Provenance: See cat. no. 155
Bibl.: Portalis, 1882, pp. 260, 289; Wildenstein, 1921, no. 8; Wildenstein, 1960, no. 75; Mandel, 1972, no. 85; Sutton, 1980, no. 17

See cat. no. 155

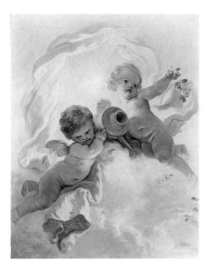

157 Dawn
c. 1768. U.S.A., Private Collection. Canvas, 100 × 80 cm

Provenance: Perhaps Bergeret sale, April 24, 1786, lot 106 (purchased by the Abbé de Saint-Non); Wildenstein, New York
Bibl.: Portalis, 1882, pp. 260, 289; Wildenstein, 1960, no. 76; Mandel, 1972, no. 84; Sutton, 1980, no. 18

See cat. no. 155

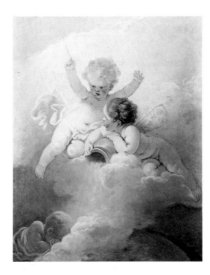

158 Dusk
c. 1768. U.S.A., Private Collection. Canvas, 100 × 80 cm

Provenance: Perhaps Bergeret sale, April 24, 1786, lot 106 (purchased by the Abbé de Saint-Non); Wildenstein, New York
Bibl.: Portalis, 1889, pp. 260, 289; Wildenstein, 1960, no. 77; Mandel, 1972, no. 85; Sutton, 1980, no. 19

See cat. no. 155

159 Cupid Sleeping
c. 1768. Private Collection. Canvas, 87 × 74 cm

Provenance: Perhaps anonymous sale, November 15, 1779, lot 600 ("A naked child, representing Cupid sleeping, his head crowned with roses, and holding his weapons in his hands; of the same size as the preceding one." [97 × 75 cm]); Dubois sale, December 18, 1788,

lot 80 ("A sketch handled with intelligence, representing Cupid sleeping" [89.3 × 70.2 cm]); French & Co., Inc., New York, 1955; Cailleux, Paris; Collection Marquesses of Dufferin and of Ava, London, 1962
Bibl.: Wildenstein, 1960, no. 62 (as lost); Exh. Cat. "International Art Treasures Exhibition," London, Victoria and Albert Museum, 1962, no. 15; Mandel, 1972, no. 70 (as lost)

160 The Toilet of Venus
c. 1766–68 (?). Private Collection. Canvas, 71 × 48 cm

Provenance: C. Marcille sale, January 12–13, 1857, lot 52; Barroilhet sale, April 2–3, 1860, lot 111; Barroilhet sale, March 15–16, 1872, lot 9; Z. Astruc sale, April 11–12, 1878, lot 24; Collection Nathan Wildenstein; Collection Peytel, Paris, 1921; anonymous sale, December 17, 1981, lot 45
Bibl.: Portalis, 1889, p. 290; Nolhac, 1906, p. 161; Wildenstein, 1921, no. 3; Réau, 1956, p. 147; Wildenstein, 1960, no. 314; Wilhelm, 1960, p. 93; Mandel, 1972, no. 335; Sutton, 1980, no. 49

See cat. no. 161

161 The Toilet of Venus

c. 1766–68 (?). Private Collection. Canvas, 58 × 39 cm

Provenance: Léon Michel-Lévy sale, June 17–18, 1925, lot 140; Collection Countess de Gontaut-Biron (according to Wildenstein)
Bibl.: Dayot-Vaillat, 1907, p. 105; Réau, 1956, p. 147; Wildenstein, 1960, under no. 314; Wilhelm, 1960, p. 93; Mandel, 1972, no. 335 A

See cat. no. 160

162 In the Corn
c. 1770 (?). Paris, Private Collection. Canvas, 40 × 33 cm

Provenance: According to Grappe, 1913, I. p. 32, perhaps in the house of the poet Marsollier des Vivetières (doubtful tradition); Collection Baron Robert de Rothschild; Collection Baron Elie de Rothschild
Bibl.: Réau, 1956, p. 160; Wildenstein, 1960, no. 40; Mandel, 1972, no. 41

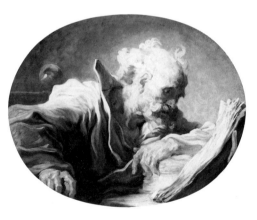

163 Old Man Reading, also called **St. Jerome,** or **Philosopher Reading**
c. 1766–68. Hamburg, Kunsthalle. Oval canvas, 59 × 72 cm

Provenance: Perhaps Collection Hall: "St. Jerome reading, full of enthusiasm"; ("State of my paintings with the price they cost me," May 10, 1778); anonymous sale, May 23, 1903; Léon Michel-Lévy, June 17–18, 1925, lot 138; Collection Wildenstein, New York; collection David-Weill, Neuilly-sur-Seine; Collection P. David-Weill, New York; sale, Sotheby's, June 10, 1959, lot 86, Hallsborough, New York; purchased by the museum in 1960
Bibl.: Villot, 1867, p. 75; Henriot, 1926, pp. 126–

30; Réau, 1956, p. 182; Wildenstein, 1960, no. 202; Wilhelm, 1960, p. 79; D. Roskamp, 1961, pp. 73–78; Mandel, 1972, no. 213

See p. 131; Pl. 159

Wildenstein refuses to accept this painting as lot 28 of the anonymous sale of November 15, 1779, for which he makes a separate entry (W. 196). In effect the measurements are quite different (49 × 65 cm) for the latter. Wilhelm on the other hand does not totally exclude the two paintings, a tradition which goes back to Henriot, in his catalogue of the Collection David-Weill, 1926, vol. I, p. 129. See cat. no. L 74.

164 Head of an Old Man
c. 1768 (?). U.S.A., Private Collection. Paper mounted on canvas, 41 × 33 cm; signed, bottom right: *Frago*

Provenance: Perhaps anonymous [De Ghendt?] sale, November 15, 1779, lot 34 ("with white hair, vigorously painted and executed in the style of Rembrandt," without measurements); anonymous sale, January 30–31, 1843, lot 106 ("Head of an old man with a beard. Rapid sketch with good color"); Collection Barroilhet; Warneck sale, May 27–28, 1926, lot 100; Collection Wildenstein, New York; Collection Georges A. Reutschler, Cincinnati
Bibl.: Wildenstein, 1960, no. 192; Wilhelm, 1960, p. 76; Mandel, 1972, no. 203

See p. 134

It is tempting to relate this painting to the "head of an old man seen from the front" in the [Baudouin] sale, February 15, 1770, lot 37, of similar measurements (39 × 32 cm); but the latter painting may also be lot 89 of the anonymous sale of the December 3, 1782, whose description differs. See cat. nos. L 28 and L 93.

165 Head of an Old Man, also called **St. Peter**
c. 1769. Amiens, Musée de Picardie. Oval canvas, 54 × 45 cm

Provenance: Anonymous sale, April 19, 1782, lot 82 (according to Wildenstein); Collection Lavalard; bequeathed to the museum in 1890

Bibl.: Wildenstein, 1921, no. 26; Réau, 1956, pp. 182–83, Wildenstein, 1960, no. 204; Mandel, 1972, no. 215

See p. 134

166 Bust of an Old Man Wearing a Cap
c. 1769. Paris, Musée Jacquemart-André. Canvas, 53 × 42 cm (originally oval)

Provenance: Collection F. de Villars; Collection E. André; Mme. André Bequest, 1912
Bibl.: Portalis, 1889, p. 290; Réau, 1956, p. 183; Wildenstein, 1960, no. 205; Wilhelm, 1960, p. 57; Thuillier, 1967, p. 50; Mandel, 1972, no. 216

See p. 134; Pl. 161

167 Bust of an Old Man, sometimes called **St. Peter**
c. 1769. Nice, Musée des Beaux-Arts (Jules Chéret). Oval canvas, 61 × 49 cm

Provenance: Perhaps [Bellanger] sale, March 17,

1788, lot 30 (together with its pendant "a copy by Grimou"); Sabatté sale, Champigny, November 18, 1945, where acquired by the Louvre; deposited at the museum in Nice in 1946
Bibl.: Daulte, 1954, no. 18; Réau, 1956, p. 183; Exh., Grasse, 1957, no. 14; Wildenstein, 1960, no. 206; Wilhelm, 1960, p. 77; Mandel, 1972, no. 217

See p. 134; Pl. 164

J. Wilhelm (1960) draws attention to an "identical" oval pastel in the collection of Mme. Meunié but he is reluctant to see it as an original. It is not absolutely certain that the Nice painting should be identified with lot 38 in the Sauvage sale, December 6, 1808: "A study of an old man's head, roughly touched in and by way of a first idea" of which the measurements (54 × 49 cm) do not correspond exactly; furthermore, it is not specified as being oval in shape.

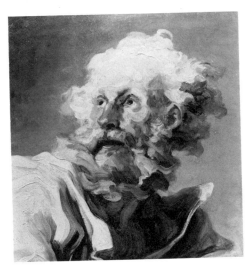

168 Head of a Bearded Man
c. 1768 (?). U.S.A., Private Collection. Canvas, 47 × 37 cm (according to Wildenstein).

Provenance: Marcille sale, January 12–13, 1857, lot 56; Bohler sale, April 11, 1888, lot 135; Collection C. Groult; Collection Wildenstein, New York; Collection A. Meyer, New York
Bibl.: Portalis, 1889, p. 291; Wildenstein, 1960,

no. 208; Wilhelm, 1960, p. 78; Mandel, 1972, no. 219

This could be a fragmented painting; see p. 132; Pl. 160

169 Man Writing, called **Inspiration,** sometimes called wrongly **The Abbé de Saint-Non**
c. 1767–68. Paris, The Louvre. Canvas, 80.5 × 64.5 cm

Provenance: Collection La Caze; bequeathed to the museum in 1869
Bibl.: Goncourt, 1882, pp. 281, 322, n. 1; Portalis, 1889, p. 279; Réau, 1956, pp. 181–82; Wildenstein, 1960, no. 241; Sterling, 1964, fig. 3; Mandel, 1972, no. 257; Compin-Rosenberg, 1974, no. 8

See pp. 108, 120; Pl. 137

170 Portrait of a young woman in Spanish costume, called **Study,** or **The Song**
c. 1769. Paris, The Louvre. Canvas, 81.5 × 65.5 cm

Provenance: Collection La Caze; bequeathed to the museum in 1869
Bibl.: Goncourt, 1882, pp. 281, 322, n. 1; Portalis,

1889, p. 276; Réau, 1956, p. 182; Wildenstein, 1960, no. 244; Wilhelm, 1960, p. 98; Thuillier, 1967, p. 83; Mandel, 1972, no. 260; Compin-Rosenberg, 1974, no. 9

See p. 119; Pl. 140

171 Portrait of Mademoiselle Guimard
c. 1768–69. Paris, The Louvre. Canvas, 81.5 × 65 cm

Provenance: Marcille sale, January 12–13, 1857, lot 64; Walferdin sale, April 12–16, 1880, lot 35; Collection Watel; Collection Mme. Watel-De-haynin; acquired by the museum in 1974 (in lieu of death duties)
Bibl.: Goncourt, 1882, p. 322; Portalis, 1889, p. 278; Nolhac, 1906, p. 113; Réau, 1956, p. 178; Wildenstein, 1960, no. 342; Wilhelm, 1960, p. 135; Mandel, 1972, no. 362; Compin-Rosenberg, 1974, no. 13; Rosenberg-Compin, 1974, I, pp. 188–91

See pp. 105–8, 119; Pl. 130

172 Presumed portrait of La Bretèche, called **Music**
1769. Paris, The Louvre. Canvas, 80 × 65; signed and dated, bottom right: *Frago 1769*

Provenance: Collection La Caze; bequeathed to the museum in 1869
Bibl.: Goncourt, 1882, pp. 281–82, 322; Portalis, 1889, p. 283; Réau, 1956, p. 173; Exh., Grasse, 1957, no. 16; Wildenstein, 1960, no. 242; Sterling, 1964, fig. 1; Thuillier, 1967, pp. 52, 79; Mandel, 1972, no. 258; Compin-Rosenberg, 1974, no. 7; Sutton, 1980, no. 43

See pp. 113, 118–19; Pl. 138

A label, dating it would appear to the eighteenth century, was once stuck to the back of the picture and carried the following inscription: "Portrait of Mr. La Bretèche, painted by Fragonard in one hour."

See p. 109–113, 119; Pl. 132

See p. 113; Pl. 133

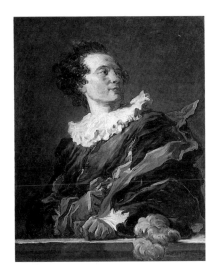

173 Presumed portrait of the Abbé de Saint-Non, sometimes called **Imaginary Figure**
1769 (?). Paris, The Louvre. Canvas, 80 × 65 cm

Provenance: Collection La Caze; bequeathed to the museum in 1869
Bibl.: Goncourt, 1882, pp. 281, 322, no. 1; Portalis, 1889, p. 281 ("Young man in a blue jacket"); Exh. Grasse, 1957, no. 15; Wildenstein, 1960, no. 243; Sterling, 1964, fig. 2; Mandel, 1972, no. 259

See pp.113, 119; Pl. 139

A label, dating it would appear to the eighteenth century, was once stuck to the back of the picture, carrying the following inscription: "Portrait of Mr. the Abbé de St Non, painted by Fragonard in 1769, in one hour."

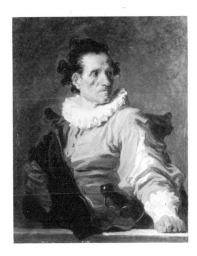

175 Portrait of a man in Spanish costume, called **The Warrior**
c. 1769–70. Williamstown, Mass., Sterling and Francine Clark Art Institute. Canvas, 81.5 × 64.5 cm

Provenance: Collection Sabatier d'Espeyran; Private Collection, Zürich (acquired in 1964)
Bibl.: Sterling, 1964, plates 1–3, fig. 6 and n. 1; Thuillier, 1967, p. 79; Mandel, 1972, no. 261

See p. 119; Pl. 142

174 Portrait of Diderot
c. 1769. Paris, The Louvre. Canvas, 81.5 × 65 cm

Provenance: Walferdin sale, April 2, 1880, lot 10; Beurnonville sale, May 9–16, 1881, lot 61; Daugias sale, May 16–17, 1892, lot 17; Collection L. Goldschmidt; Collection Count A. Pastré; Collection Countess C. de Vogué, 1934; acquired by the museum in 1972 (in lieu of death duties)
Bibl.: Goncourt, 1882, p. 322; Portalis, 1889, p. 275; Nolhac, 1906, p. 110; Réau, 1956, p. 173; Wildenstein, 1960, no. 250; Wilhelm, 1960, p. 97; Mandel, 1972, no. 268; Rosenberg-Compin, 1974, I, pp. 186, 188, nn. 10–16

176 Portrait of François-Henri, Duke d'Harcourt
c. 1770. Switzerland, Private Collection. Canvas, 80 × 65 cm

Provenance: Collection d'Harcourt family, Château d'Harcourt, then Château de Champs-de-Bataille; sale, Sotheby's, London, December 8, 1971, lot 21
Bibl.: Wildenstein, 1921, no. 90; Daulte, 1954, no. 22; Réau, 1956, p. 174; Wildenstein, 1960, no. 239 (with error in the plate no.); Wilhelm, 1960, p. 113; Thuillier, 1967, pp. 79, 86; Mandel, 1972, no. 255 (inverted with no. 256); Rosenberg-Compin, 1974, I, pp. 184–85

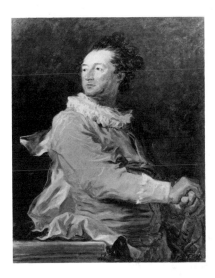

177 Portrait of Anne-François d'Harcourt, Duke de Beuvron
c. 1770. Paris, The Louvre. Canvas, 81 × 65 cm

Provenance: Collection d'Harcourt family; Château d'Harcourt, then Château de Champs-de-Bataille; Duke d'Harcourt Gift, subject to usufruct, 1970
Bibl.: Wildenstein, 1921, no. 89; Daulte, 1954, no. 23; Réau, 1956, p. 174; Wildenstein, 1960, no. 240 (with error in the plate no.); Wilhelm, 1960, p. 114; Thuillier, 1967, pp. 79, 86; Mandel, 1972, no. 256 (inverted with no. 255); Compin-Rosenberg, 1974, P. 11; Rosenberg-Compin, 1974, I, pp. 184–85, nn. 4–9

See p. 113; Pl. 134

178 Portrait of a man in Spanish costume, called **Portrait of a Young Artist** (the author Jacques-Antoine Naigeon?)
c. 1770. Paris, The Louvre. Canvas, 81.5 × 65 cm. Signed bottom center: *Frago*

Provenance: Collection Naigeon (Portalis); Col-

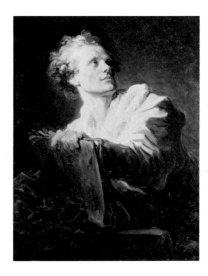

lection Carlos de Beistegui; presented to the museum in 1942 subject to usufruct; entered the museum in 1953
Bibl.: Portalis, 1889, p. 286; Wildenstein, 1960, no. 254; Wilhelm, 1960, p. 111; Mandel, 1972, no. 272

See p. 108; Pl. 131

Was traditionally thought to have been a portrait of the Dijon artist Jean Naigeon (1754–1832) which, seemingly, does not correspond with the probable date of the painting; instead, according to Mandel (1972), it may be the author and philosopher Jacques-André Naigeon (1738–1810), friend of d'Holbach and of Diderot.

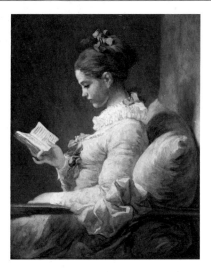

179 Portrait of a young woman in Spanish costume, called **The Reader**
1770–72. Washington D.C., National Gallery of Art. Canvas, 82 × 65 cm

Provenance: [Count Du Barry?] sale, March 11, 1776, lot 80 ("A young girl, seated near a window. She is leaning against a cushion, and holds a book which appears to occupy her." [81.1 × 64.8 cm]); anonymous sale, February 7, 1777, lot 15; Leroy de Senneville sale, April 5, 1780, lot 59 (78 × 60 cm; "a beautiful study from life, representing a young girl seated, seen in profile and bare-headed, she is holding an open book, which she is reading with great interest..."); Duquesnoy sale, March 10, 1803, lot 19 (77 ×

60 cm); perhaps anonymous sale, April 26, 1844, lot 14 (without measurements); perhaps Marquess de C[ypierre] sale, March 10, 1845, lot 55 (idem); Collection Count de Kergolay; Cronier sale, December 4–5, 1905, lot 8; Collection Dr. Tuffier, Paris; Collection Wildenstein; A.W. Erickson sale, Sotheby's, November 15, 1961, lot 16; gift of Mrs. Mellon Bruce in 1961
Bibl.: Portalis, 1889, p. 282; Nolhac, 1906, p. 147; Réau, 1956, p. 171; Wildenstein, 1960, no. 391; Wilhelm, 1960, p. 89; Mandel, 1972, no. 416; Sutton, 1980, no. 61

See pp. 117, 120; Pl. 143

180 Portrait of a man in Spanish costume, called **The Comedian**
c. 1770–72. Private Collection. Canvas, 80 × 65 cm

Provenance: Perhaps [Godefroy] sale, April 2, 1794, lot 24 (but only vague description: "two pictures, portraits of a man and a woman," without any indication of support or measurements) (according to Wildenstein); perhaps anonymous sale, April 24, 1819, lot 50 (neither the support nor the measurements are given); E. Vallet sale, January 25, 1884, lot 15; Collection Alphonse de Rothschild; Collection Edouard de Rothschild
Bibl.: Portalis, 1889, p. 285; Nolhac, 1906, p. 111; Réau, 1956, p. 182; Wildenstein, 1960, no. 245; Wilhelm, 1960, p. 110; Sterling, 1964, fig. 5; Thuillier, 1967, p. 79; Mandel, 1972, no. 262

See p. 120; Pl. 136

181 Portrait of a young woman in a Spanish costume, called **The Singer**
c. 1770–72. Private Collection. Canvas, 81 × 65 cm. Signed, bottom right: *Fragonard*

Provenance: [Roettiers] sale, January 13, 1778, lot 20 ("A young woman, seen in half-length and elegantly dressed; she holds a sheet of music, and seems to be smiling." [78.4 × 64.8 cm]); Dulac sale, November 30, 1778, lot 218; perhaps [Godefroy] sale, April 2, 1794, lot 24 (see cat.no. 180); anonymous sale, April 24, 1819, lot 50 (according to Wildenstein); E. Vallet sale, January 25, 1884, lot 14; Collection Alphonse de Rothschild; Collection Edouard de Rothschild

Bibl.: Portalis, 1889, p. 285; Nolhac, 1906, p. 112; Wildenstein, 1960, no. 246; Wilhelm, 1960, p. 109; Sterling, 1964, fig. 11; Mandel, 1972, no. 263

See p. 108; Pl. 135

Two pastel copies by Count de Bréhan, of this painting and that of cat.no. 180, are catalogued by Portalis (1889, p. 286; sale, Christie's, London, June 29, 1934, lot 1). They are dated 1773, a date that may place their execution shortly after that of the paintings.

182 Portrait of a Woman in Spanish Costume Holding a Dog
c. 1770–72. New York, The Metropolitan Museum of Art. Canvas, 81.3 × 65.4 cm

Provenance: Perhaps anonymous sale, June 25, 1779, lot 265 ("A woman playing with a little dog," without measurements); Collection Mme. Jägerschmidt, Paris, in 1897; Collection de Cambise (?); Collection Marquess des Isnards (according to Wildenstein); Collection Burat; Mme. L. Burat sale, June 17, 1937, lot 3; acquired by the museum in 1937, Fletcher Fund
Bibl.: Wildenstein, 1921, no. 31; Wildenstein, 1960, no. 256; Wilhelm, 1960, p. 112; Sterling, 1964 (unpaginated); Mandel, 1972, no. 273

See p. 117; Pl. 144

The painting that passed through the 1779 sale

could also be of the same type as that in the Alte Pinakothek (cat. no. 282). The identification of the sitter in this painting with the artist's sister has been abandoned.

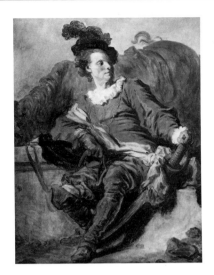

183 A gallant in Spanish costume, called **The Abbé de Saint-Non in Spanish Costume**
c. 1769. Barcelona, Museo de Arte Moderno. Canvas, 94 × 74 cm

Provenance: [Varanchan] sale, December 29–30, 1777, lot 16 ("A gentleman dressed as a Spaniard; he is seated near a fountain and holds the bridle of his horse, which is drinking," [100 × 74.2 cm]); anonymous sale, November 15, 1779, lot 599 ("A soldier very picturesquely dressed, seated on a rock letting his horse, which can be seen behind him, drink." Canvas [97.4 × 74.8 cm]); Collection Cailleux, Paris; Collection Don F. Cambo; bequeathed to the museum in 1947
Bibl.: Portalis, 1889, p. 273; Nolhac, 1906, p. 112; Daulte, 1954, no. 21; Réau, 1956, p. 174; Wildenstein, 1960, no. 251; Wilhelm, 1960, p. 117; Thuillier, 1967, p. 81; Mandel, 1972, no. 269

See p. 125; Pl. 150

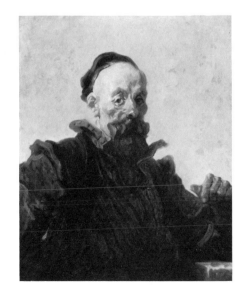

184 Portrait of a man, called **Don Quixote**

c. 1770. Art Institute of Chicago. Canvas, 80.5 × 64.7 cm

Provenance: Perhaps Maupérin sale, December, 780, lot 38 ("A Portrait of a man dressed in Spanish costume" [81.1 × 64.8 cm]); anonymous sale, April 20, 1885, lot 14; Collection C. Groult; Collection Wildenstein, New York; Collection Mr. and Mrs. Leigh B. Block, Chicago; donated to the museum in 1977
Bibl.: Portalis, 1889, p. 277; Wildenstein, 1960, no. 247; Wilhelm, 1960, p. 134; Sterling, 1964, fig. 17; Mandel, 1972, no. 264

See p. 123–25; Pl. 149

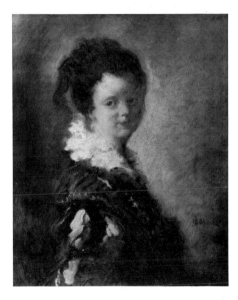

184a Portrait of a Young Women in Spanish Costume
c. 1770 (?). London, Dulwich Picture Gallery. Canvas, 62.9 × 52.7 cm. Inscribed (lower right): *Grimou*

Provenance: Perhaps Collection N. J. Desenfans, London; Collection Sir Francis Bourgeois: bequeathed to the gallery in 1811
Bibl.: Rosenberg-Compin, 1974, I, pp. 191–92, nn. 24–25

See p. 123; Pl. 148

The signature *frag*, painted over by the artist, is now legible again; it is located slightly above the inscription *Grimou.*

185 Pan and Syrinx
c. 1768. Private Collection. Canvas, 49 × 59 cm (oval view)

Provenance: Perhaps Marquess de Felino sale, March 27, 1775, lot 69 ("Pan and Syrinx, sketch painting, of oval shape, with spirited touch" [45.6 × 56.7 cm]); perhaps Le Sueur sale, November 22, 1791, lot 37 ("sketch fervently handled representing the god Pan chasing Syrinx" [40 × 54 cm]); Prousteau de Montlouis sale, May 5–6, 1851, lot 65; collection Count de la Béraudière; A. Sichel sale, March 1–5, 1886, lot 189; L. Michel-Lévy sale, June 17, 1925, lot 137; X. sale, November 27–28, 1934, lot 4;

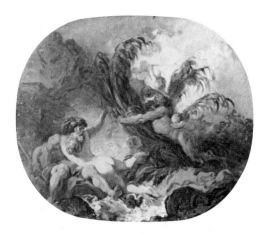

anonymous sale, March 23, 1982, lot 24
Bibl.: Portalis, 1889, p. 283; Réau, 1956, p. 148

186 A young couple and an old man asleep beside a fireplace, called **The Beggar's Dream** and sometimes **Do You Remember?**
c. 1768. Paris, Private Collection. Canvas, 70.2 × 92 cm

Provenance: [Trouard] sale, February 22, 1779, lot 80; anonymous sale, June 9, 1903, lot 1; J. Doucet sale, 2nd part, June 6, 1912, lot 147; Collection E. Guinle, Rio de Janeiro; Collection Weisweiller, Paris; anonymous sale, May 25, 1876, lot 35; sale, Sotheby's, Monaco, November 11, 1984, lot 8
Bibl.: Goncourt, 1882, p. 333; Nolhac, 1906, p. 133; Wildenstein, 1921, no. 44; Réau, 1956, p. 151; Wildenstein, 1960, no. 358; Wilhelm, 1960, p. 153; Mandel, 1972, no. 378

A wash drawing (Ananoff, I. no. 75) also called *The Beggar's Dream* and previously related to this painting appears to be a completely different subject. The painting seems to represent a young man in Spanish costume, courting a young woman who signals him to be quiet out of fear of waking the old man (her father?) who is asleep on the left.

187 Young girls throwing roses, called **The Inquisitive Children**
c. 1768 (?). Paris, The Louvre. Panel, 16.5 × 12.5 cm

Provenance: anonymous sale, July 8, 1793,

lot 18 (see cat. no. L 82); Collection Sauvageot; presented to the museum in 1856
Bibl.: Wildenstein, 1921, no. 37; Réau, 1956, pp. 161–62; Wildenstein, 1960, no. 279; Mandel, 1972, no. 297

perhaps anonymous sale, February 9, 1848, lot 65 (according to Wildenstein); anonymous sale, November 26, 1849, lot 58; Collection E. Cognacq
Bibl.: Goncourt, 1882, p. 328; Portalis, 1889, p. 286; Nolhac, 1906, p. 123; Daulte, 1954, no. 12; Réau, 1956, p. 161 (confused with cat. no. 190); Wildenstein, 1960, no. 283; Wilhelm, 1960, p. 99; Mandel, 1972, no. 301; Burollet, 1980, no. 27

Engraved as a pendant to the *Glass of Water* (see cat. no. L 3) by N. Ponce under the title *The Milk Jug.* The engraving depicts a landscape in the background, different animals in the clouds and sabots to the left; these modifications appear to be the invention of the engraver.

Provenance: Perhaps Walferdin sale, April 12–16, 1880, lot 55 ("the return of the herds," Canvas [56 × 72 cm]); Collection Marquess d'Harcourt (1921); Collection Marquess d'Harcourt (1925); Collection T. T. Ellis, Worcester; Mary G. Ellis bequest to the museum in 1940
Bibl.: Portalis, 1889, p. 272 ("Oxen harnessed to a cart," without measurements); Wildenstein, 1921, no. 17; Réau, 1956, p. 184; Wildenstein, 1960, no. 152; Wilhelm, 1960, p. 186; Thuillier, 1967, p. 67; Mandel, 1972, no. 168; Sutton, 1980, no. 35

The title *Annette and Lubin,* occasionally used, should be rejected.

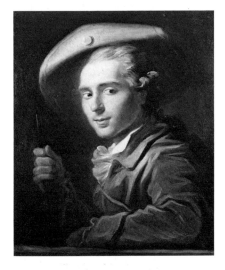

188 Portrait of a young man holding a gun, called **Portrait of Honoré-Léopold-Germain Maubert**
c. 1768–70. Private Collection. Canvas, 65 × 56 cm

Provenance: Collection Maubert, Grasse; Collection Malvilan, Grasse; Collection de Blic, Grasse; Collection Wildenstein; Collection Mrs. Mayer Sassoon, London, 1960; sale, Christie's, London, April 2, 1976, lot 89
Bibl.: Portalis, 1889, p. 283; Wildenstein, 1960, no. 537; Mandel, 1972, no. 560

See p. 127; Pl. 152

***190 Perrette and the Milk Jug**
c. 1768–70. Private Collection. Oval parchment, 54 × 64 cm

Provenance: Doisteau sale, June 9, 1909, lot 41; Doisteau sale, March 5–6, 1937, lot 30

This painting is only known from the photograph in the sale catalogue. If it is authentic, the supposed provenance of the Cognacq-Jay painting (see cat. no. 189) can be ascribed to it as well as to the latter.

192 The Little Swing, also called **The Pleasures of the Park**
c. 1768–70. Paris, Private Collection. Canvas, 50 × 68.5 cm

Provenance: Perhaps anonymous sale, April 15–17, 1844, lot 24; Collection Duke de Polignac; Collection Duchess de Polignac, 1901; Collection R. Kann, 1903; Collection Wildenstein; Collection Countess de Béhague; Collection Marquess de Ganay
Bibl.: Portalis, 1889, p. 276; Nolhac, 1906, p. 121; Wildenstein, 1960, no. 438; Wilhelm, 1960, p. 194; Mandel, 1972, no. 463

See Pl. 126 on p. 100

189 Perrette and the Milk Jug, or **The Milk Jug**
c. 1768–70. Paris, Musée Cognacq-Jay. Oval canvas, 52 × 65 cm

Provenance: Prault sale, November 27, 1780, lot 26; N. Ponce sale, December 13, 1831, lot 1;

191 The Return of the Herd, sometimes called **Annette or Lubin**
c. 1768–70. Worcester, City Museum and Art Gallery. Canvas, 65 × 80 cm. signed, bottom right: *Fragonard*

193 Fête in a park, called **The Fête at Rambouillet**
c. 1768–70. Lisbon, Fundação Calouste Gulbenkian. Canvas, 72 × 91 cm

Provenance: [Laborde] sale, June 13–14, 1784,

lot 10 ("The view of a picturesque garden, to the right of which are steps leading to an ornamental lake where the artist has placed a gondola full of people who seem to have gathered for a party on the water. Bowers form various well-shaded paths where many groups of men and women can be seen; large trees terminate the background of this painting, which is admirable as much for its magical effect and harmony of colors as for its spirited touch and the prevailing charm of its composition."); Duclos-Dufresnoy sale, August 18, 1795, lot 29 ("The Island of Love to which young girls and boys are headed in a gondola crossing a river whose waters rise bubbling through the ridges"); Villeminot sale, May 25, 1807, lot 22; anonymous sale, April 30, 1810, lot 30; Collection Wildenstein, Paris; Collection Marquess de Sayve; Collection C. Gulbenkian, 1928
Bibl.: Nolhac, 1906, p. 152; Wildenstein, 1960, no. 439; Wilhelm, 1960, pp. 192–93; Thuillier, 1967, pp. 103, 104, 125, 129, 138; Mandel, 1972, no. 464

See pp. 100–1; Pl. 127

194 Love Triumphant
c. 1769–70 (?). Paris, Musée Carnavalet. Canvas, 137 × 72 cm

Provenance: Collection Gilles Demarteau, decoration for his Salon, Rue de la Pelleterie;

Collection Gilles-Antoine Demarteau, 1777; Collection Dubosc; his sale, March 21, 1890, lot 4; Collection C. Groult; Collection J. Groult; his sale, November 28, 1972, (lot unknown); acquired by the museum by agreement before the sale
Bibl.: Nolhac, 1906, p. 158; Wildenstein, 1960, no. 63; Réau, 1956, p. 146; Mandel, 1972, no. 71; Wilhelm, 1975, pp. 6–20

See pp. 137–38; Pl. 170

Part of the decoration for the de Demarteau Salon. For Fragonard's possible participation in the other sections of the decoration see Chapter VI, n. 3.

Engraving by G. Vidal of cat. no. 195

195 The Two Sisters
1770 (?, or c. 1772 [?]). New York, The Metropolitan Museum of Art. Canvas, 71.3 × 55.9 cm (fragment)

Provenance: Marquess de Véri sale, December 12, 1785, lot 35 (100 × 81 cm); Collection Marquess de Saint-Marc; Collection A. Zarine, Paris; Wildenstein, New York; Collection E. J. Berwind, New York; Collection Miss Julia A. Berwind, New York; donated to the museum in 1953

Bibl.: Goncourt, 1882, p. 331; Portalis, 1889, p. 275; Nolhac, 1906, p. 131; Réau, 1956, p. 167; Wildenstein, 1960, no. 476; Mandel, 1972, no. 501; Sutton, 1980, no. 77

See p. 131; Pl. 155

The Metropolitan Museum of Art also has the pastel copy of this painting by the Abbé de Saint-Non, signed and dated (probably 1770); which, together with Vidal's engraving, allows us to determine what the painting was originally like (Wurth Harris, 1979). The rather strong luminarist effect would lead us to propose a slightly later date. The identification of the two models with Rosalie, the artist's daughter, and with Marguerite Gerard, his sister-in-law, must be discarded.

196 The Two Sisters
c. 1770 (?). Lisbon, Museu Nacional de Arte Antiga. Panel, 31.7 × 24 cm

Provenance: acquired by the museum in 1915 with funds from the Valmor Bequest
Bibl.: Réau, 1956, p. 183; Watson, 1961, pp. 38–39

See cat. no. 195

197 The Maternal Kisses, or **The Jealousies of Infancy**

c. 1770 (?). Switzerland, Private Collection. Canvas, 43 × 36 cm

Provenance: Perhaps [Varanchan] sale, December 29, 1777, lot 19 (40.5 × 32.4 cm); Beurnonville sale, May 9–16, 1881, lot 57; Laurent-Richard sale, May 28–29, 1886, lot 17; Collection Baron Adolphe de Rothschild; Collection Baron Maurice de Rothschild, Paris; Collection Baron Edmond de Rothschild, Pregny

Bibl.: Portalis, 1889, pp. 279–80; Nolhac, 1906, p. 126; Wildenstein, 1921, no. 60; Réau, 1956, p. 164; Wildenstein, 1960, no. 477; Wilhelm, 1960, p. 94; Mandel, 1972, no. 502

See cat. no. 198

198 The Jealousies of Infancy, or The Maternal Kisses

c. 1770 (?). U.S.A., Private collection. Canvas, 26 × 20 cm

Provenance: Walferdin sale, April 12–16, 1880, lot 76; Collection Stettiner, 1889; Collection S. Bardac; Wildenstein; Ambatielos sale, May 21–22, 1928, lot 23; [Devilder] sale, December 9, 1952, lot 18; Wildenstein, New York

Bibl.: Portalis, 1889, p. 280; Nolhac, 1906, p. 126; Réau, 1956, p. 164; Wildenstein, 1960, no. 478; Wilhelm, 1960, p. 94; Mandel, 1972, no. 503

See cat. no. 197

The quality is not as high as that in the other version (cat. no. 197).

199 The Young Girl with the Little Dogs

c. 1770 (?). Private Collection. Oval canvas, 60 × 50 cm

Provenance: Prault sale, November 27, 1780, lot 27 (together with its pendant); Laperlier sale, February 17–18, 1879, lot 10; Beurnonville sale, May 9–16, 1881, lot 64; Collection Sichel; Collection E. Cognacq; G. Cognacq sale, May 14, 1952, lot 14; Collection G. Renand, Paris, 1960

Bibl.: Goncourt, 1882, p. 334; Portalis, 1889, p. 285; Nolhac, 1906, p. 130; Wildenstein, 1921,

no. 58; Daulte, 1954, no. 32; Réau, 1956, p. 168; Wildenstein, 1960, no. 481; Wilhelm, 1960, p. 143; Mandel, 1972, no. 510

See, for the pendant, cat. no. 200

200 The Young Girl with the Cat

c. 1770 (?). Private Collection. Canvas, 42 × 33 cm (originally oval, 57 × 49 cm)

Provenance: Prault sale, November 27, 1780, lot 27 (together with its pendant); Collection Léon Michel-Lévy (according to Wildenstein); Collection Sidney Brown, Baden, Switzerland

Bibl.: Goncourt, 1882, p. 333; Nolhac, 1906, p. 130; Wildenstein, 1921, no. 272; Réau, 1956, p. 168; Wildenstein, 1960, no. 482; Wilhelm, 1960, p. 90; Mandel, 1972, no. 511

See, for the pendant, cat. no. 199

*201 Young man kissing a young girl, called The Kiss on the Neck or The First Kiss

c. 1770 (?). New York, Private Collection. Oval canvas, 32 × 26 cm

Provenance: Perhaps Collection Jallier; perhaps anonymous sale, November 26, 1834, lot 41; J. Reiset sale, April 29–30, 1870, lot 6; Wilson

sale, April 27–28, 1874, lot 33; Collection S. von Derwies; Wildenstein, New York; Collection J. M. Schiff, New York

Bibl.: Goncourt, 1882, p. 328; Portalis, 1889, p. 286 (38 × 31 cm); Nolhac, 1906, p. 118; Réau, 1956, p. 157; Wildenstein, 1960, no. 271, and under nos. 260–66; Mandel, 1972, no. 289

Composition engraved by G. Marchand with the inscription *Fragonard pin*, a dedication to the Duke de la Vallière and the reference "Taken from the collection of Mr. Jallier, Architect." The catalogued painting, even though it is in the reverse direction to the engraving, seems, in the photograph, to be of disappointing quality; perhaps it has been damaged or overpainted; perhaps it is an old copy. See cat. no. L 2. P. Rosenberg (Exh. Cat. *Fragonard*, New York and Paris, 1987–88) indicates that Mercure de France of January 1773 announced the printing of engravings by Marchand of this *Kiss* and its pendant (cat. no. L 2), which were made from pastels (and not oils) that belong to Jallier. This confirms that the painting is a copy. The Musée de Morlaix has a sketched version of poor quality, which could not be by Fragonard.

202 Getting Up, or Two Women on a Bed Playing with Two Dogs

c. 1770. Private Collection. Canvas, 74 × 59 cm

Provenance: Perhaps A. Hall, miniaturist, 1778, cited in the catalogue of his collection which was compiled by Hall himself (without measurements), anonymous [De Ghendt?] sale, November 15, 1779, lot 31 (without measurements); perhaps Dubois sale, March 31–April 5, 1784, lot 132 (81 × 54 cm); perhaps anonymous sale [2nd Dubois sale], December 20, 1785, lot 102; Collection Count de Reilhac, 1889 (81 × 54 cm); Kraemer sale, May 5–6, 1913, lot 20; Grencer sale, Galerie Charpentier, March 27, 1933, lot 23; Collection Marcel Midy; anonymous sale, Palais d'Orsay, March 28, 1979, lot 164
Bibl.: Villot, 1867, p. 74; Goncourt, 1882, p. 330; Portalis, 1889, p. 282 (?); Nolhac, 1906, p. 121; Réau, 1956, p. 159; Wildenstein, 1960, nos. 291, 292; Wilhelm, 1960, p. 144; Mandel, 1972, no. 309

The measurements given in the Dubois sales catalogues (1784–85) are intriguing, there may have been another version, similar to this, of the same subject.

(according to Wildenstein); Collection J. Balsan, New York, in 1960; Meyer sale, Sotheby's, New York, October 22, 1980, lot 9
Bibl.: Wildenstein, 1960, no. 268; Mandel, 1972, no. 286

For Wildenstein (1960), this is a fragment of a finished painting *The Coquette and the Young Fellow*, of similar composition to cat. no. 203. The attribution to Fragonard does not seem certain; it could be the work of an imitator.

Bibl.: Wildenstein, 1960, no. 51 bis; Mandel, 1972, no. 58

See cat. nos. 205 and 207

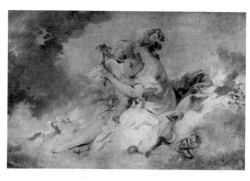

207 Venus Binding Cupid's Wings
c. 1770 (or c. 1775?). Private Collection. Canvas, 20 × 30 cm

Provenance: [Trouard] sale, February 22, 1779, lot 84; perhaps Duvaux sale, July 7, 1852, lot 26; Collection G. Joliet, Dijon (according to Wildenstein); Wildenstein; E. Gimpel; Collection J. W. Simpson, New York, in 1913; Collection Major Hugh Rose, London; Major Hugh Rose sale, Sotheby's, December 6, 1967, lot 15
Bibl.: Goncourt, 1882, p. 324; Nolhac, 1906, p. 161; Wildenstein, 1960, no. 52; Mandel, 1972, no. 59

See cat. no. 206

203 The Coquette and the Young Fellow
c. 1770. México, Museo de San Carlos. Oval canvas, 40 × 32 cm

Provenance: Walferdin sale, April 12–16, 1880, lot 9 ("charming grisaille lightly colored"); Collection C. Groult, Paris; Collection Wildenstein, New York; Collection A. Hammer; donated to the museum in 1977
Bibl.: Portalis, 1889, p. 274; Nolhac, 1906, p. 125; Réau, 1956, p. 161; Wildenstein, 1960, no. 267; Mandel, 1972, no. 285

See cat. no. 204

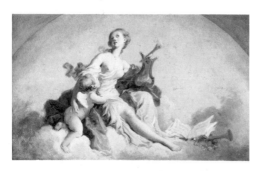

205 The muse of lyric poetry with Cupid on the clouds, called Music
c. 1770 (or c. 1775?). Pasadena, The Norton Simon Foundation. Canvas, 78 × 132 cm

Provenance: Collection Mme. M. Ephrussi (according to Wildenstein); Private Collection, France (idem); Collection André Weil, Paris, 1969 (idem); acquired in 1969
Bibl.: Wildenstein, 1960, no. 51 ter; Mandel, 1972, no. 60; Sutton, 1980, no. 9

It is not definite that this painting was once a pendant for cat. no. 206.

*204 Bust of a young girl wearing a bonnet, called The Coquette
c. 1770 (?). Private Collection. Canvas, 35 × 30 cm (fragment?)

Provenance: Perhaps anonymous [B.] sale, December 15, 1849, lot 60; Collection Wynn Ellis

206 Venus Binding Cupid's Wings
c. 1770 (or c. 1775?). Japan, Private Collection. Canvas, 78 × 132 cm

Provenance: Collection Mme. M. Ephrussi (according to Wildenstein); Private Collection, France; Collection André Weil, Paris, 1969 (idem); Los Angeles, Norton Simon Foundation, 1969; sale, Sotheby's, London, April 16, 1980, lot 97; sale, Sotheby's, London, November 17, 1982, lot 74

208 The Stolen Shift
c. 1770 (?). Paris, The Louvre. Oval canvas, 35 × 42.5 cm (originally: 32 × 40.5 cm)

Provenance: Probably Gros sale, April 13, 1778,

lot 57 (together with a pendant); Collection La Caze; bequeathed to the museum in 1869
Bibl.: Goncourt, 1882, p. 327; Portalis, 1889, p. 273; Nolhac, 1906, p. 120; Réau, 1956, p. 158–59; Wildenstein, 1960, no. 230; Wilhelm, 1960, p. 102; Thuillier, 1967, pp. 103, 111, 134; Mandel, 1972, no. 242

Composition engraved by E. Guersant under the title *The Stolen Shift,* in an oval (vertical) with, at the bottom, a step and an overturned torch.
This painting and that of cat. no. 100 appear to be the pendants in the 1778 Gros sale which Saint-Aubin had drawn in his sale catalogue (Bibliothèque Doucet, Paris). However there may have been other versions of these paintings. The difference in measurements, and especially what appears to be a difference in style (*All in a Blaze* seeming to be earlier), suggests caution. A version of *The Stolen Shift* passed through the Saint-Victor sale, January 23–24, 1882, no. 26, and then was part of the Collection E. Recipon (Portalis, 1889, p. 273).

209 Portrait of François de Bourbon, Count d'Enghien

c. 1770–73. U.S.A. Private Collection. Oval canvas in grisaille, 42 × 36 cm

Provenance: Wildenstein, New York
Bibl.: Goncourt, 1882, p. 321; Portalis, 1889, p. 286; Wildenstein, 1960, no. 249; Mandel, 1972, no. 266

Engraved by Miger with the reference "Drawn after the original, by Fragonard, Painter to the King" to illustrate *L'Histoire de la Maison de Bourbon* by Desormeaux (vol. III, 1782, between pp. 112 and 113). Other engravings, with the same presentation, were also made after works by Fragonard, which may have been grisaille paintings similar to this one, and not drawings as the letter accompanying the engravings leads one to believe: portraits of *Jeanne d'Albret,* of *Antoine de Bourbon,* of *Charles III, Duke de Bourbon,* of *Charles de Bourbon, de Vendôme,* and of *Louis de Bourbon, Prince de Condé.* The other portraits in the collection were engraved after Le Monnier and Vincent. The five volumes of *L'Histoire de la Maison de Bourbon* by Desormeaux were published between 1772 and 1788. The six portraits after Fragonard are in two volumes: one, *Charles III, Duke de Bourbon,* in vol. II (1776), and the others in vol. III (1782). The

engravings of *François de Bourbon,* of *Louis de Bourbon,* and *Charles III, Duke de Bourbon* were all in the Salon of 1779. Five engravings, by Miger, are not dated, but the one by C. Gaucher, after *Charles de Bourbon,* bears the date 1774. A date somewhere between 1770 and 1773 can therefore be proposed for the five projects among which this is included. Contrary to other portraits in the collection, which appear to be copies from older portraits, those by Fragonard, often with the head twisted to one side, seem definitely to be original creations. A series of small portraits (Chantilly, Musée Condé) has been considered for a long time as being partly the work of Fragonard; they are in fact copies by J. M. Ribou, probably after the engravings (E. J. and G. Seligman, 1958, pp. 23–38).

210 Portrait of a Lady as a Vestal Virgin, called **The Présidente Aubry**
c. 1770–72. U.S.A. Private Collection. Oval canvas, 80 × 63 cm

Provenance: Collection Wildenstein, New York;

Engravings by Gaucher and Miger (see cat. no. 209).

Collection Colonel and Mrs. J. Balsan, New York
Bibl.: Wildenstein, 1960, no. 405; Mandel, 1972, no. 429; Sutton, 1980, no. 63

See p. 127; Pl. 158

Wildenstein (1960) does not give the reason for identifying the sitter with the *Présidente Aubry.*

211 Bust of a Smiling Woman
c. 1770–72 (?). Private Collection. Oval canvas, 40 × 31 cm

Provenance: Beurnonville sale, May 9–16, 1881, lot 74; Collection F. Bemberg; later to his wife; Private Collection
Bibl.: Portalis, 1889, pp. 289–90; Nolhac, 1906, p. 127; Algoud, 1941, (unpaginated), plate 42

See Pl. 157 on p. 128

212 Portrait of a young woman, wrongly called **Mademoiselle Guimard**
c. 1770–72 (?). Private Collection. Oval canvas, 63 × 53 cm (originally round, transformed into an oval between 1914 and 1930)

Provenance: Collection F. Waller, London; Collection Baroness Nathaniel de Rothschild (ac-

cording to Portalis if it is the portrait of a young woman, height 50 cm); Collection Baron Arthur de Rothschild; Collection F. Wallis, England; Wildenstein, New York; Collection Mrs. J.W. Simpson, New York; Collection R. Hearst; Collection Fritz Thyssen, Mühlheim; Collection Countess Zichy-Thyssen
Bibl.: Portalis, 1889, p. 286; Wildenstein, 1960, no. 344; Mandel, 1972, no. 364; Sutton, 1980, no. 53; Exh. Cat. *Sammlung Fritz Thyssen,* Munich, Bayerisches Nationalmuseum, 1986, no. 17

Pendant to cat. no. 213

213 Portrait of a Young Woman, wrongly called **Mademoiselle Duthé**
c. 1770–72 (?). Private Collection. Oval canvas, 63 × 53 cm (originally round, transformed into an oval between 1914 and 1930)

Provenance: Collection Baroness Nathaniel de Rothschild; Collection Baron Arthur de Rothschild; Collection F. Wallis, England; Wildenstein,

New York; Collection Mrs. J.W. Simpson, New York; Collection Thyssen-Bornemisza, Rohoncz, Hungary (from 1930); Collection Thyssen-Bornemisza, Lugano, Switzerland
Bibl.: Portalis, 1889, p. 286; Réau, 1956, p. 177; Wildenstein, 1960, no. 345; Wilhelm, 1960, p. 151; Cat. Collection Thyssen-Bornemisza, 1969, no. 99; Mandel, 1972, no. 365

Pendant to cat. no. 212

The traditional identification of the sitter with Mademoiselle Duthé appears to be invalidated by a comparison with a portrait of the dancer by Perin-Salbreux (1775) in the Musée des Beaux-Arts, Tours.

214 Young couple conversing, called **The Casement Window**
c. 1770 (?). Private Collection. Canvas, 18 × 14 cm

Provenance: Walferdin sale, April 12–16, 1880, lot 1; Collection Count de Pourtalès; Collection A. Veil-Picard
Bibl.: Goncourt, 1882, p. 334; Portalis, 1889, p. 274; Wildenstein, 1960, no. 259; Wilhelm, 1960, p. 96; Mandel, 1972, no. 277

215 Portrait of a Man, wrongly called **Portrait of Chardin**

c. 1770–72 (?). Private Collection. Canvas, 64 × 52 cm

Provenance: Collection Malvilan, Grasse; Collection R. Kann, 1907; Wildenstein; Collection D. David-Weill, Neuilly-sur-Seine
Bibl.: Portalis, 1889, p. 273; Wildenstein, 1921, no. 74; Henriot, 1926, I, pp. 133–34; Réau, 1956, p. 173; Wildenstein, 1960, no. 525; Mandel, 1972, no. 548

216 A man leaning over a child, called **Joash and Joad**
c. 1770–72. London, Private Collection. Panel, 22 × 17 cm

Provenance: Walferdin sale, April 12–16, 1880, lot 21; Moreau-Chaslon sale, May 8, 1886, lot 43; A. Kahn sale, December 6–8, 1920, lot 29; Collection Hahnloser, Winterthur, Switzerland
Bibl.: Goncourt, 1882, p. 323; Portalis, 1889, p. 281; Nolhac, 1906, p. 164; Réau, 1956, p. 141; Wildenstein, 1960, no. 220; Wilhelm, 1960, p. 75; Mandel, 1972, no. 231

217 Young girl with a marmot, called **Fanchon the Hurdy-Gurdy Player**

c. 1770. Private Collection. Oval canvas, 40 × 32 cm

Provenance: R. Gimpel, Paris; Pardo, Paris; Private Collection

See cat. nos. 287 and 289, which seem to us to be later.

The attribution to Fragonard of *Curios Little Boy,* which is often taken as the pendant to this painting (Versailles sale, June 11–13, 1968, lot 107; Galliéra Paris, May 13, 1969, lot 9), should be rejected.

218 Bust of a Young Girl, also called **Adeline Colombe**
c. 1770–72. Private Collection. Oval canvas, 60 × 50 cm

Provenance: Collection Count de Lavau (according to Wildenstein); N. Wildenstein; J. Doucet sale, June 6, 1912, lot 149; Collection de Gunzburg (according to Wildenstein); Collection Mme. L.G. Thompson, Paris, in 1921; Collection Count de Beaurepaire; Wildenstein, New York; Collection J.D. Rockfeller
Bibl.: Wildenstein, 1921, no. 54; Réau, 1956, p. 177; Wildenstein, 1960, no. 415; Wilhelm, 1960, p. 116; Mandel, 1972, no. 439

See p. 130; Pl. 154

This painting is not, as Wildenstein indicates (1960), in the Frick Collection in New York.

219 Bust of a Young Girl, also called **The Dark Girl**
c. 1770–72. Cambridge, Mass., Fogg Art Museum. Canvas, 47 × 39.4 cm

Provenance: Marquess de Montmorency-Laval sale, April 5, 1782, lot 117 (according to Wildenstein); Lebrun sale, May 26, 1814, lot 46; Mme. Devisme sale, March 17, 1888, lot 39; J. Doucet sale, June 5–8, 1912, lot 150; H.G. Beeche sale, London, June 2, 1937, lot 65; anonymous [de la Verteville?] sale, May 9, 1945, lot 14; Collection E. Ader; Collection C.E. Dunlap, New York; Mrs. Dunlap Bequest to the museum in 1975
Bibl.: Portalis, 1889, p. 290; Nolhac, 1906, p. 112; Wildenstein, 1921, no. 57; Wildenstein, 1960, no. 484; Wilhelm, 1960, p. 146; Mandel, 1972, no. 513

See p. 127; Pl. 153

220 Bust of a young girl among the roses, called **Adeline Colombe**
c. 1772. Private Collection. Oval canvas, 80 × 64.8 cm

Provenance: Collection Adeline Colombe, Ecouen (according to Wildenstein, together with its pendant); Collection Lelong; Collection L. Guitry; Collection William Randolph Hearst, New York
Bibl.: Wildenstein, 1960, no. 414; Mandel, 1972, no. 438; Sutton, 1980, no. 64

221 Bust of a young girl among the roses with a cage and a bird, called **Marie-Catherine Colombe**
c. 1772. Private Collection. Oval canvas, 80 × 64 cm

Provenance: In the house of Adeline Colombe, Ecouen (according to Wildenstein); Collection Lelong (together with its pendant); Collection L. Guitry (together with its pendant), New York; Collection Mrs. William R. Hearst, New York; sale, Sotheby's, New York, January 22–23, 1976, lot 23

Bibl.: Wildenstein, 1960, no. 413; Mandel, 1972, no. 437

lot 388; Duveen; Collection William Randolph Hearst (according to Wildenstein); Collection Miss Marion Davies; donated to the Los Angeles County Museum of Art; sale, Los Angeles, June 21, 1982, lot 37
Bibl.: Réau, 1956, p. 177; Cailleux, 1960, p. V.; Wildenstein, 1960, no. 416; Wilhelm, 1960, p. 162; Mandel, 1972, no. 442

Oval canvas, 55 × 45 cm

Provenance: "Private collection near Grasse in 1889" (according to Wildenstein); Collection Barlow Webb, England (idem); Wildenstein, New York
Bibl.: Wildenstein, 1960, no. 419; Mandel, 1972, no. 441; Sutton, 1980, no. 66

See Pl. 297 on p. 237

222 Venus Refusing Cupid a Kiss, or **Venus and Cupid,** sometimes called **Mademoiselle Colombe**
c. 1772. Private Collection. Oval canvas, 37 × 34 cm

Provenance: Collection Maubert, Grasse; Collection Malvilan, Grasse; Collection de Blic, Grasse; Wildenstein, New York; Collection E. Rosenfeld, New York; Collection Barbara Hutton, New York; Wildenstein, New York
Bibl.: Portalis, 1889, p. 290; Cailleux, 1960, p. V.; Wildenstein, 1960, no. 429; Mandel, 1972, no. 454; Sutton, 1980, no. 69

223 Venus Holding the Apple, or **Victorious Venus,** called **Marie-Catherine Colombe**
c. 1770 (?). Private Collection. Oval canvas, 57 × 48 cm

Provenance: Anonymous sale, January 18, 1877, lot 12 (according to Wildenstein); Collection Doisteau, Paris (idem); Gimpel and Wildenstein; W. Salomon sale, New York, April 4–7, 1923,

224 Venus Holding the Apple, or **Victorious Venus,** called **Portrait of Marie-Catherine Colombe**
c. 1770 (?). Private Collection. Oval canvas, 55 × 45 cm

Provenance: "Private Collection near Grasse in 1889" (according to Wildenstein); Collection Barlow Webb, England (idem); sale, Galerie Charpentier, December 17, 1938, lot 1; sale, Christie's, New York, June 18, 1982, lot 85
Bibl.: Réau, 1956, p. 177; Wildenstein, 1960, no. 418; Mandel, 1972, no. 443

225 Cupid Holding an Arrow, also called **Marie-Catherine Colombe as Cupid**
c. 1770 (or c. 1775). U.S.A. Private Collection.

226 Cupid holding a quiver and an arrow, called **Portrait of Marie-Catherine Colombe**
c. 1770 (or c. 1775?). Private Collection. Oval canvas, 55 × 44 cm

Provenance: Collection C. Groult; Wildenstein, New York
Bibl.: Wildenstein, 1960, no. 417; Mandel, 1972, no. 440; Sutton, 1980, no. 65

227 Young Woman Crowned with Roses Holding a Mirror, sometimes called **Mademoiselle Guimard**
c. 1772. Private Collection. Oval canvas, 74 × 61 cm

Provenance: Collection Mlle. Guimard (according to Wildenstein); Collection Sir Hugh Lane, Dublin; Collection Robert O'Neil; Wildenstein, New York; Collection Mrs. I.D. Levy, New York; Mrs. J. Heine sale, November 24–25, 1944, lot 253
Bibl.: Réau, 1956, p. 178; Wildenstein, 1960, no. 412; Mandel, 1972, no. 446

Provenance: G. Cognacq sale, May 14, 1952, lot 15; Collection R. Fribourg, New York; donated to the museum in 1953
Bibl.: Réau, 1956, p. 177 *(Adeline Colombe)*; Wildenstein, 1960, no. 408; Mandel, 1972, no. 433

Wildenstein, 1960, no. 341; Wilhelm, 1960, p. 130; Mandel, 1972, no. 361

One wonders whether a *Young Woman Playing the Guitar* (29 × 19 cm), no. 91 in the 1921 Fragonard exhibition (owned by Count Moïse de Camondo, Paris), which could be a smaller version of this painting.

230 Bust of Minerva
c. 1772. Detroit Institute of Arts. Oval canvas, 70 × 56 cm

Provenance: Collection Wildenstein, New York; Collection Mr. and Mrs. Whitcomb; donated to the museum in 1953
Bibl.: Réau, 1956, p. 148; Wildenstein, 1960, no. 407; Mandel, 1972, no. 432

232 Cupid Sacrificing His Wings for the Delight of the First Kiss
c. 1770 (?). New York, Private Collection. Panel, 33 × 24 cm. Inscribed on the base of the altar: *Au bonheur du premier baiser*

228 Young Woman with a Lyre, or **A muse?,** sometimes called **Mademoiselle Colombe**
c. 1772. Paris, Private Collection. Oval canvas, 69 × 56 cm

Provenance: Collection Watel-Dehaynin (according to Wildenstein); Galliera sale, March 15, 1973, lot p; Galliera sale, March 26, 1974, lot 12; Private Collection, Paris
Bibl.: Wildenstein, 1960, no. 422; Mandel, 1972, no. 447

229 Bust of a Young Girl in Profile Crowned with Roses
c. 1772. New York, The Metropolitan Museum of Art. Oval canvas, 69 × 55 cm

231 Portrait of a Young Woman Playing the Guitar, wrongly called **Mademoiselle Guimard**
c. 1770–72. Private Collection. Canvas, 61 × 49 cm

Provenance: Collection Count de la Béraudière (according to Portalis); Collection Baron Edmond de Rothschild
Bibl.: Portalis, 1889, p. 278; Réau, 1956, p. 178;

Provenance: According to Wildenstein, in the National Depositary at Nesle (regrouping works seized from private individuals), in April–June, 1794: "*The Delight of the First Kiss*, pretty sketch on panel, 29 × 23 cm" with the annotation *Denon* in the margin; Rollin sale, April 1–2, 1853, lot 58; Walferdin sale, April 12–16, 1880, lot 15; [Mme. Paillard] sale, April 9, 1892, lot 15; Collection S. Bardac; Wildenstein, New York; Collection R.S. Bertron, New York, 1919; Collection Mrs. Baker (according to Wildenstein); sale Sotheby Parke Bernet, New York, October 29, 1977, lot 251; Private Collection, New York

Bibl.: Goncourt, 1882, p. 328; Portalis, 1889, p. 272; Nolhac, 1906, p. 118; Réau, 1956, p. 157; Wildenstein, 1960, no. 315; Wilhelm, 1960, p. 60; Mandel, 1972, no. 330

233 Sketch for a ceiling with three children, one representing Folly
c. 1770. Private Collection. Canvas, 29.5 × 42 cm

Provenance: Dulac sale, November 30, 1778, lot 7 ("Three Children, one representing Folly, sketch for a ceiling freely handled and of a beautiful color tone," [32.4 × 40.5 cm]); P. Cailleux, Paris; Private Collection; sale, Sotheby's, Monaco; October 26, 1981, lot 529
Bibl.: Nolhac, 1906, p. 158; Exh. Galerie Cailleux, 1934, no. 40; Réau, 1956, p. 146; Wildenstein, 1960, no. 316 (lost); Mandel, 1972, no. 336 (idem)

See p. 141; Pl. 174

234 The Triumph of Venus, or **The Toilet of Venus**
c. 1770–72. Besançon, Musée des Beaux-Arts et d'Archéologie. Panel, diam.: 75 cm

Provenance: Collection Pâris, Besançon (cat. of the Collection Pâris, 1806, no. 90, p. 58, as *Toilet of Venus*); bequeathed to the library of Besançon in 1819; transferred to the museum in 1843

Bibl.: Goncourt, 1882, p. 325; Portalis, 1889, p. 290; Wildenstein, 1921, no. 47; Réau, 1956, p. 147; Wildenstein, 1960, no. 84; Wilhelm, 1960, p. 83; Thuillier, 1967, p. 52; Mandel, 1972, no. 92

See p. 140; Pl. 173

235 Cupids and doves, called **Day**
c. 1770–72. Private Collection. Canvas, 80 × 148 cm

Provenance: Cailleux, 1953; Private Collection, Rome
Bibl.: "Notable works of Art now on the Market," *The Burlington Magazine,* December 1953, plate XX; Wildenstein, 1960, no. 72; Wilhelm, 1960, p. 51; Mandel, 1972, no. 80

See cat. no. 236

236 Sleeping cupids, called **Night**
c. 1770–72. Private Collection. Canvas, 80 × 148 cm

Provenance: See cat. no. 235
Bibl.: Wildenstein, 1960, no. 73; Wilhelm, 1960, p. 52; Mandel, 1972, no. 81

See cat. no. 235

237 Two cupids, called **Spring**
c. 1772. Private Collection. Oval canvas, 76 × 87 cm

Provenance: Daupias sale, May 16–17, 1892, lot 12 (rectangular, 68 × 116 cm); Collection Mrs. Burns, London; Marquise d'Harcourt sale, Christie's, London, May 6, 1927, lot 42; Collection F. Sabin; Wildenstein, New York
Bibl.: Nolhac, 1906, p. 157; Wildenstein, 1960, no. 67; Mandel, 1972, no. 74; Sutton, 1980, no. 15

See cat. no. 238, and also p. 140; Pl. 175

According to Wildenstein (1960), the painting was made into an oval by F.T. Sabin in 1927.

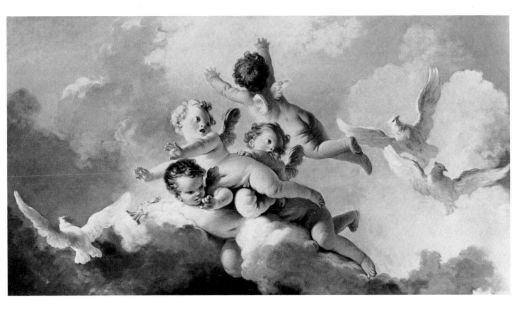

238 Two cupids, called **Spring**
c. 1772. Private Collection. Canvas, 16 × 22 cm

Provenance: Wildenstein, New York; Collection Fahnestock, New York (according to Wildenstein); Collection Mrs. Byron Foy (idem); Thelma Chrysler Foy sale, Sotheby Parke Bernet, New York, May 22–23, 1959, lot 632 (as originating from the Collection Mme. Julliand, Paris, and from the Collection Mme. W.W. Boumistrow)
Bibl.: Wildenstein, 1960, no. 66; Mandel, 1972, no. 75

Sketch for cat. no. 237

239–42 The Pursuit of Love
1771–72. New York, Frick Collection

Provenance: Commissioned by Countess du Barry for her pavilion at Louveciennes; rejected by the patron, and repossessed by the artist; transported by him to Grasse in January, 1790, and installed in the salon of his cousin Maubert; sold in 1898 by the heirs; Collection Pierpont-Morgan; Collection H.C. Frick, 1915 (through the intermediary of Duveen)
Bibl.: Goncourt, 1882, pp. 284 n. 1, 313–14; Portalis, 1885, pp. 490ff.; Portalis, 1889, pp. 95–104, 285; Réau, 1956, p. 152; Biebel, 1960, pp. 207ff.; Wildenstein, 1960, nos. 304–7; Wilhelm, 1960, pp. 119–24; Thuillier, 1967, pp. 52, 98, 115; Cat. Frick Collection, 1968, II, pp. 94–120; Sauerländer, 1968, pp. 127ff.; Munhall, 1971, pp. 400ff.; Mandel, 1972, nos. 319, 321, 324, 325; Posner, 1972, pp. 526ff.; Roland-Michel, 1980, pp. 25–34

See pp. 143–55

317.5 × 243.8 cm. Signed, bottom right, on the base of the vase: *fragonard*

Provenance: See above
Bibl.: Goncourt, 1882, pp. 284, 313; Portalis, 1889, p. 285; Réau, 1956, p. 152; Wildenstein, 1960, no. 304; Wilhelm, 1960, pp. 119–25; Thuillier, 1967, pp. 52, 98, 115; Cat. Frick Collection, 1968, II, p. 96; Mandel, 1972, no. 319

See pp. 152–55; Pls. 182–83

317.1 × 216.8 cm. Signed, toward the left, on the pedestal in the centre: *fragonard*

Provenance: See above
Bibl.: Goncourt, 1882, pp. 284, 313; Portalis, 1889, p. 285; Réau, 1956, p. 152; Wildenstein, 1960, no. 306; Wilhelm, 1960, p. 128; Thuillier, 1967, pp. 52, 98, 115; Cat. Frick Collection, 1968, II, pp. 96–98; Mandel, 1972, no. 324

See pp. 152–55; Pls. 186–87

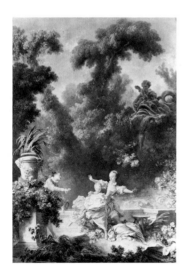

239 The Pursuit
1771–72. New York, Frick Collection. Canvas, 317.8 × 215.5 cm. Signed in the right foreground, on the pedestal: *fragonard*

Provenance: See above
Bibl.: Goncourt, 1882, pp. 284, 313; Portalis, 1889, p. 285; Réau, 1956, p. 152; Wildenstein, 1960, no. 305; Wilhelm, 1960, p. 127; Thuillier, 1967, pp. 52, 98, 115; Cat. Frick collection, 1968, II, p. 96; Mandel, 1972, no. 321

See pp. 152–55; Pls. 180–81

240 The Rendezvous, or **Storming the Citadel**
1771–72. New York, Frick Collection. Canvas,

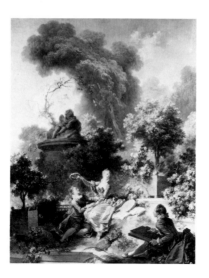

241 The Lover Crowned
1771–72. New York, Frick Collection. Canvas, 317.8 × 243.2 cm. Signed, bottom left center, on the step: *fragonard*

Provenance: See above
Bibl.: Goncourt, 1882, pp. 284–318; Portalis, 1889, p. 285; Réau, 1956, p. 152; Wildenstein, 1960, no. 307; Wilhelm, 1960, p. 129; Thuillier, 1967, pp. 52, 98, 115, *136*; Cat. Frick Collection, 1968, II, p. 98; Mandel, 1972, no. 325

See pp. 152–55; Pls. 184–85

242 The Love Letters, sometimes called **The Souvenirs,** or wrongly **The Declaration of Love**
1771–72. New York, Frick Collection. Canvas,

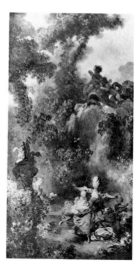

243 The Pursuit
c. 1771 (?). Private Collection. Canvas, 67 × 38 cm

Provenance: Carrier sale, March 9–10, 1846, lot 100 (*The Indiscrete* together with its pendant); Walferdin sale, April 12–16, 1880, lot 33 (*The Surprise* together with its pendant); Collection Watel; Collection Watel-Dehaynin
Bibl.: Goncourt, 1882, p. 334; Portalis, 1889, p. 279 (together with its pendant, under the one title *The Indiscrete* and p. 286 *The Pursuit*); Nolhac, 1906, p. 122; Daulte, 1954, under no. 29; Wildenstein, 1960, no. 301; Mandel, 1972, no. 322

See Pl. 178 on p. 143

Another version of *The Pursuit* consisting only of the lower section (28 × 36 cm) in the Collection

Groult and then in the Collection of Miss H.C. Frick (Wildenstein, 1960, no. 303), is of disappointing quality and may be a copy.

Pendant to cat. no. 246; see also the sketch, cat. no. 247.

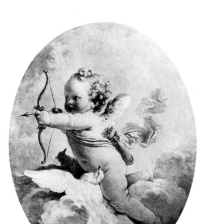

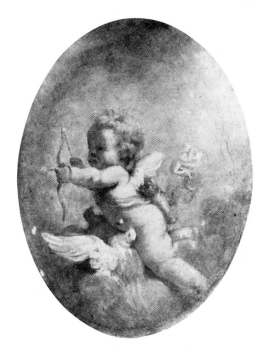

244 Storming the Citadel
c. 1771. Private Collection. Canvas, 67 × 38 cm

Provenance: Carrier sale, March 9–10, 1846, lot 100 (together with its pendant); Walferdin sale, April 12–16, 1880, lot 32 *The Daring Lover*, pendant; Collection Watel; Collection Watel-Dehaynin
Bibl.: Goncourt, 1882, p. 334; Portalis, 1889, pp. 276 and 279 (together with its pendant under the one title *The Indiscrete*); Nolhac, 1906, p. 121; Wildenstein, 1960, no. 302; Mandel, 1972, no. 320

See Pl. 179 on p. 143

246 Cupid with a Bow, or **Day**
c. 1770–72 (?). Private Collection. Oval canvas, 98 × 76 cm

Provenance: Kraemer sale, April 28–29, 1913, lot 22; Collection Gimpel, Paris; Collection Watel-Dehaynin (?)
Bibl.: Dayot-Vaillat, 1907, no. 129; Réau, 1956, p. 146

Pendant to cat. no. 245; see the sketch, cat. no. 248.

248 Cupid with a Bow, or **Day**
c. 1770–72 (?). Private Collection. Canvas mounted on panel, 22 × 17 cm

Provenance: Collection M. Fenaille (according to the 1959 sale catalogue); anonymous sale, June 23, 1959, lot 16 (attributed to Fragonard)

Sketch for cat. no. 246

249 Two cupids sleeping on flowers, called **Summer** (trompe-l'œil in grisaille)
c. 1772. Paris, Private Collection. Canvas, 79 × 120 cm

Provenance: Probably Marquess de la Roche-bousseau sale, May 5–8, 1873, lot 120 (84 × 116 cm); Cailleux, Paris
Bibl.: Portalis, 1889, p. 270; Nolhac, 1906, p. 158; Exh., Grasse, 1957, no. 18

See p. 141; Pl. 177 and cat. nos. 250–51, from the same series

245 Sleeping Cupid, or **Night**
c. 1770–72 (?). Private Collection. Oval canvas, 98 × 75 cm

Provenance: Kraemer sale, April 28–29, 1913, lot 21; Collection Gimpel, Paris; Collection Watel-Dehaynin (?)
Bibl.: Dayot-Vaillat, 1907, no. 128

247 Sleeping Cupid, or **Night**
c. 1770–72 (?). Private Collection. Canvas mounted on panel, 22 × 17 cm

Provenance: Collection M. Fenaille (according to the 1959 sale catalogue); anonymous sale, June 23, 1959, lot 15 (attributed to Fragonard)

Sketch for cat. no. 245

250 Two cupids with doves, called **Spring** (trompe-l'œil in grisaille)
c. 1772. Paris, Private Collection. Canvas, 79 × 120 cm

Provenance: Collection Wilson; sale, April 27–28,

1874, lot 34; Collection Lasquin; Cailleux, Paris
Bibl.: Exh., Grasse, 1957, under no. 18

See p. 141; Pl. 176 and cat. nos. 249 and 251, from the same series

251 Two cupids and a zephyr with clusters of grapes, called **Autumn** (trompe-l'œil in grisaille)
c. 1772. Paris, Private Collection. Canvas, 79 × 120 cm

Provenance: Collection Wilson; sale, April 27–28, 1874, lot 35; Collection Lasquin; Cailleux, Paris
Bibl.: Exh., Grasse, 1957, under no. 18

See p. 141 and cat. nos. 249–50, from the same series

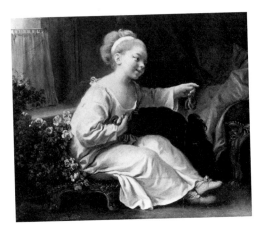

252 The Girl with the Ring Biscuits
c. 1772. Paris, Private Collection. Canvas, 37 × 45 cm

Provenance: Collection A. Veil-Picard; Collection A. Veil-Picard (son)

Bibl.: Wildenstein, 1960, no. 393; Mandel, 1972, no. 422; Sutton, 1980, no. 62
See p. 131; Pl. 156

253 The Dream of Love, or **The Warrior's Dream**
c. 1772 (?). Paris, The Louvre. Canvas, 61.5 × 50.5 cm

Provenance: C. Marcille sale, January 12–13, 1857, lot 55; J. Burat sale, April 28–29, 1885, lot 70; Collection Marquess de Talleyrand; Collection Wildenstein; Collection B. de Schlichtung; bequeathed to the museum in 1914
Bibl.: Goncourt, 1882, p. 327; Portalis, 1889, p. 289; Nolhac, 1906, p. 117; Réau, 1956, p. 163; Wildenstein, 1960, no. 211; Wilhelm, 1960, p. 198; Thuillier, 1967, p. 132; Mandel, 1972, no. 221

Engraved by N. F. Regnault (engraving advertised in 1791), as a pendant to the *Fountain of Love* (see cat. no. 373); with variations (the veil no longer covers the upper part of the woman's face).
For a sketched version, and a hypothetical appearance at a sale in 1803, see cat. no. L 119.

254 Love the Jester
c. 1772 (?). Washington, D.C., National Gallery of Art. Oval canvas, 55.9 × 46.4 cm

Provenance: Perhaps Leroy de Senneville sale, April 5, 1780, lot 56 (56 × 46 cm); perhaps Marquess de Véri sale, December 12, 1785, lot 39 (together with its pendant, 55 × 45 cm); perhaps Folliot sale, April 15–16, 1793, lot 50 (52.6 × 40 cm); Collection des Isnards (according to Wildenstein); Collection Wildenstein, New York; Collection Mrs. J. W. Simpson, New York; donated to the museum in 1947 in memory of Kate Seney Simpson
Bibl.: Goncourt, 1882, p. 326; Portalis, 1889, p. 270; Nolhac, 1906, p. 156; Réau, 1956, p. 146; Wildenstein, 1960, no. 319; Wilhelm, 1960, p. 141; Mandel, 1972, no. 344

The composition of this painting and that of cat. no. 255 appear to have been engraved after two gouaches (location unknown), which were

once in Paris, in the Collection Mme. Brasseur (Ananoff, 1976, II, nos. 1000 and 1001): *Love the Jester* by Janinet in 1777, *Love the Sentinel* by Miger in 1779.
Fragonard appears to have returned to these two compositions on several occasions: the Villeminot sale catalogue (May 25, 1807; see cat. L 204–5) notes that because of their success, Fragonard repeated the compositions twelve times. Numerous copies could also have been made after the engravings. See cat. nos. 255–60; and also cat. nos. L 52, L 137–38

255 Love the Sentinel
c. 1772 (?). Washington, D.C., National Gallery of Art. Oval canvas, 55.9 × 46.7 cm

Provenance: See cat. no. 254
Bibl.: Goncourt, 1882, p. 326; Portalis, 1889, p. 270; Nolhac, 1906, p. 156; Wildenstein, 1960, no. 320; Wilhelm, 1960, pp. 139–40; Mandel, 1972, no. 338

256 Love the Jester
c. 1772 (?). Washington, D.C., National Gallery of Art. Oval canvas, 56.2 × 47.3 cm

Provenance: Perhaps [second] Dennoor sale, April 5–7, 1797, lot 73 (54 × 43 cm); Collection Baron Alphonse de Rothschild, Boulogne, 1890; Collection Baron Arthur de Rothschild, London;

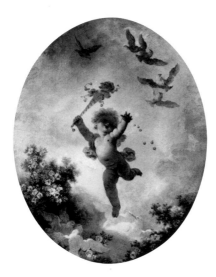

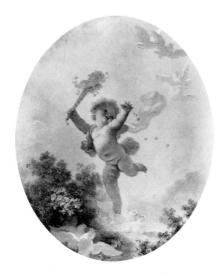

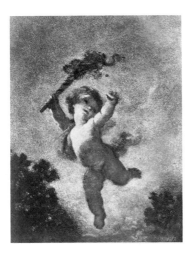

Collection A.W. Mellon, Pittsburgh; Collection Mrs. Mellon Bruce, New York; donated to the museum in 1970
Bibl.: Wildenstein, 1960, no. 321; Mandel, 1972, no. 345

The early provenance of this painting and its pendant (cat. no. 257) could be, either entirely or partially, the same as that for the other versions of the same subject.

Montpellier, 1779, lot 60); perhaps anonymous sale, March 16, 1783, lot 17; perhaps anonymous sale, March 13, 1815, lot 23; perhaps Deville sale, March 19, 1816, lot 11; perhaps anonymous sale, April 2, 1816, lot 25; perhaps anonymous sale, June 30, 1845, lot 17; perhaps Hesme sale, March 3, 1856, lot 51; perhaps Count d'Houdetot sale, December 18, 1859, lot 47; perhaps anonymous sale, January 22, 1874, lot 15; Collection C. Groult, Paris; Collection Wildenstein, New York
Bibl.: Portalis, 1889, p. 270; Nolhac, 1906, p. 156; Wildenstein, 1960, no. 318; Mandel, 1972, no. 343; Sutton, 1980, no. 50

260 Love the Jester
c. 1772 (?). Private Collection. Canvas, 40 × 30 cm

Provenance: Collection E. Marcille (in 1889); Collection Mme. Jahan (née Marcille); Collection Mme. Chevrier (in 1921)
Bibl.: Portalis, 1889, p. 270; Wildenstein, 1921, no. 53; Réau, 1956, p. 146

257 Love the Sentinel
c. 1772 (?). Washington, D.C., National Gallery of Art. Oval canvas, 56.2 × 47.3 cm

Provenance: See cat. no. 256
Bibl.: Wildenstein, 1960, no. 322; Mandel, 1972, no. 339

See cat. no. 256

258 Love the Jester
c. 1772 (?). U.S.A. Private Collection. Oval canvas, 56 × 45.7 cm

Provenance: Perhaps anonymous sale, December 15, 1777, lot 160 (52.6 × 43.2 cm); perhaps Collection Viscount de Saint-Priest, Montpellier (*A Young Cupid Holding a Bauble*, exhibited at the Société des Beaux-Arts de

*259 Love the Sentinel
c. 1772 (?). Location unknown. Oval canvas, 53 × 43.5 cm

Provenance: Collection W.T. Dannat, Paris; C. Sedelmeyer sale, May 16–18, 1907, lot 202; M. Dubernet sale, June 15–16, 1946

The attribution of this painting is open to discussion, like the other versions of *Love the Sentinel*: the painting on metal (54 × 45 cm) in the Musée Cognacq-Jay, or the one on canvas (55 × 44 cm), present location unknown, formerly in the Collection B. Zaharoff, Paris (Wildenstein, 1921, no. 52).

260a Love the Jester
c. 1772 (?). Private Collection. Oval canvas, 55 × 45 cm

Provenance: Galerie Stuker sale, Bern, November 16–December 6, 1978 and December 9–14, 1978, lot 2075 (according to the catalogue, Collection S. Anthony, 1861; Major General Frederick Edward Sotheby, Ecton Hall, Northampton; Lieutenant-Colonel H.G. Sotheby; D.M. Koetser Gallery); for the history of the less recent provenance, see cat. no. 258.

This painting seems to be of fine quality and worthy of being attributed to Fragonard.

261 The Good Mother
c. 1770–72 (?). Switzerland, Private Collection. Oval canvas, 47.6 × 37.5 cm (?)

Provenance: Probably Collection Ménage de Pressigny, 1779; seized during the Revolution on

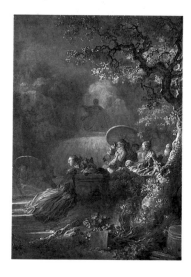

November 16, 1794; perhaps Aubert sale, April 17, 1806, lot 12 (without measurements); perhaps anonymous sale, November 12, 1810, lot 17 (idem); perhaps anonymous sale, August 1, 1812, lot 3 (idem); perhaps anonymous sale, January 18, 1813, lot 52 (idem); perhaps M. sale, December 14, 1875, lot 34 (idem); Collection Baron d'Aubigny; Collection de Charette; Collection A. Veil-Picard, Paris; Collection Mme. J. Veil-Picard, Paris
Bibl.: Goncourt, 1882, p. 331 (the engraved painting); Daulte, 1954, no. 10 (with error in the provenance); Réau, 1956, p. 171; Wildenstein, 1960, no. 452 (lost); Wilhelm, 1960, pp. 217–18; Mandel, 1972, no. 476 (a copy)

See cat. no. 262

Engraved by N. de Launay, under the title *The Good Mother* and with the reference "taken from the collection of Mr. Ménage de Pressigny"; the engraving was exhibited at the Salon of 1779.
A watercolor with gouache, now in the St. Petersburg Museum (Florida), is closer to this version than it is to the one in Boston (cat. no. 262) (see exh. cat. *Fragonard and His Friends*, St. Petersburg, Florida, 1982–83, no. 10).
The Goncourts (p. 306) note that Fragonard "dedicates *The Good Mother* to the Country." Did the proofs for the engraving carry this dedication during the time of the Revolution?

262 The Good Mother
c. 1770–72. Boston, Museum of Fine Arts. Oval canvas, 63 × 52 cm

Provenance: Probably La Fontaine sale, February 22, 1798, lot 146 ("An oval shaped painting, engraved and known under the title of *The Good Mother*..." [64' × 54 cm]); perhaps Aubert sale, April 17, 1806, lot 12 (without measurements but oval in shape) according to Wildenstein; perhaps anonymous sale, November 12, 1810, lot 17 (without measurements); perhaps anonymous sale, August 1, 1812, lot 3 (without measurements but oval in shape); perhaps anonymous sale, January 18, 1813, lot 52 (without measurements); perhaps Rolland sale, March 22, 1830, lot 385 (without measurements); perhaps d'Houdan sale, May 6–8, 1858, lot 127; perhaps M. sale, December 14, 1875, lot 34 (without measurements); Collection F. Spitzer, 1883; Collection Mme. Pellegrin; Wildenstein, New York;

Collection R. S. Bertron, New York; Collection R. Treat Paine II, Boston; donated to the museum in 1944
Bibl.: Goncourt, 1882, p. 306; Portalis, 1889, p. 281 *(The Young Mother)*; Réau, 1956, p. 171; Wildenstein, 1960, no. 451; Mandel, 1972, no. 475

See cat. no. 261

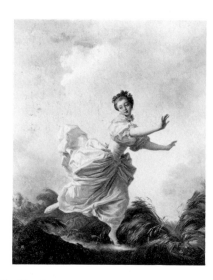

263 The Prearranged Flight
c. 1772–73 (?). Cambridge, Mass., Fogg Art Museum. Canvas, 59 × 49.5 cm

Provenance: Perhaps Collection Turpin de Crissé (the 1783 engraving is dedicated to the Marquise Turpin de Crissé); L'Homme sale, March 24–25, 1834, lot 89; Prousteau de Montlouis sale, May 5–6, 1851, lot 63; C. Marcille sale, March 6–7, 1876, lot 27; Collection Albert de Rothschild, Vienna; Collection L. de Rothschild, Vienna; Collection V. Karolyi; Collection S. de Berchtold; Collection Wildenstein, New York; Collection C. E. Dunlap, New York; bequeathed to the museum by Mrs. Dunlap in 1975
Bibl.: Goncourt, 1882, p. 331; Portalis, 1889, pp. 278–80; Nolhac, 1906, p. 122; Réau, 1956, p. 162; Wildenstein, 1960, no. 308; Mandel, 1972, no. 328; Sutton, 1980, no. 48

Engraved by Macret and Couché in 1783

Portalis (1889, p. 278) mentions an oval shaped "copy" of the painting (48 × 38 cm) in the Countess d'Harcourt's collection. Nolhac (1906, p. 122) distinguishes a *Prearranged Flight* (59 × 50 cm) that was in the L'Homme and Marcille collections from another (55 × 46 cm) which was in the Prousteau de Montlouis and Demidoff collections.

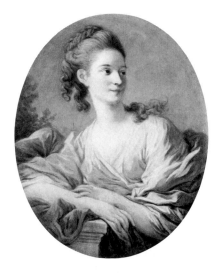

264 Blindman's Buff
c. 1773 (?). San Diego, Timken Art Gallery, Putnam Foundation. Canvas, 60 × 43 cm (fragment?)

Provenance: Walferdin sale, April 3, 1880, lot 12; Collection C. Groult; Wildenstein, New York; acquired in 1954 by the Putnam Foundation, La Jolla, California, for the Timken Art Gallery
Bibl.: Goncourt, 1882, p. 335; Nolhac, 1906, p. 150; Réau, 1956, p. 158; Wildenstein, 1960, no. 466; Wilhelm, 1960, p. 179; Mandel, 1972, no. 379

265 Portrait of a young woman, called Portrait of Gabrielle de Caraman, Marquise de la Fare
c. 1772–73 (?). New York, The Metropolitan Museum of Art. Oval canvas, 81 × 63 cm

Provenance: Collection La Fare (according to

Wildenstein); Wildenstein, New York; Collection Mrs. James B. Haggin; bequeathed to the museum in 1965
Bibl.: Wildenstein, 1960, no. 409; Mandel, 1972, no. 434

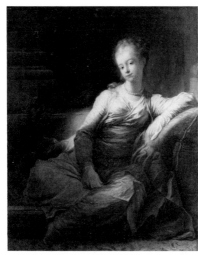

266 Portrait of a Young Woman as a Sultana, or Sultana Resting on an Ottoman
c. 1772. Private Collection. Canvas, 97 × 81 cm

Provenance: Randon de Boisset sale, February 27, 1777, lot 227; Vassal de Saint-Hubert sale, April 24, 1783, lot 64; sale, Sotheby's, London, December 10, 1986, lot 75
Bibl.: Goncourt, 1882, p. 332; Portalis, 1889, p. 289; Nolhac, 1906, p. 145; Réau, 1956, p. 163 (erroneously stated "owned by Mr. G. Wildenstein"); Wildenstein, 1960, no. 338 (as lost); Mandel, 1972, no. 354 (as lost)

Considered lost for a long time, this painting reappeared at the end of 1986; see Pl. 255 on p. 208.
See cat. nos. 267, 268, and 325; the last painting seems, by its technique, to be later

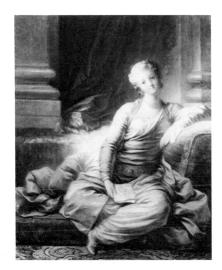

267 Sultana Seated on a Sofa
c. 1772 (?). U.S.A., Private Collection. Canvas, 47.5 × 32.5 cm

Provenance: Perhaps [Lespinasse, d'Arlet, de Langeac] sale, July 11, 1803, lot 252 ("A young and pretty sultana, shown seated on a sofa and wearing clothes of a voluptuous nature; she seems to be thinking with great interest about the contents of a letter that she is holding in her right hand. It is part of the nature of this attractive colorist to treat such a subject with as much grace as charm; the effects of light are maintained with the greatest brilliancy and contrast admirably with the overall half-tone color applied with great harmony in the lower half of the figure. This charming production justifies the talents of its author"; without any indication of support or measurements); Collection Baroness von Cramm (Barbara Hutton), New York; sale, Sotheby's, June 24, 1964, lot 40
Bibl.: Nolhac, 1906, p. 145; Wildenstein, 1960, no. 336; Mandel, 1972, no. 352; Sutton, 1980, no. 52

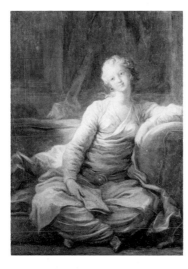

268 Sultana Seated on a Sofa, also called The Little Sultana
c. 1772 (?). Private Collection. Canvas, 16 × 11 cm

Provenance: Wildenstein, New York
Bibl.: Wildenstein, 1960, no. 335; Mandel, 1972, no. 351; Sutton, 1980, no. 51

Wildenstein puts forward the hypothesis that this could be a pendant to *Sultana Seated on Cushions*, of the same measurements, but now lost, (cat. no. L 82).

269 The Visitation
c. 1773. Private Collection. Canvas, 24.3 × 32.4 cm

Provenance: Prince de Conti sale, April 8, 1777, lot 755 ("First finished sketch, executed with precision, of the painting which was in Mr. Randon de Boisset's collection under no. 226"); [Calonne] sale, April 21, 1788, lot 173 (support not specified); Beurnonville sale, May 9–16, 1881, lot 71; Pardo, Paris
Bibl.: Goncourt, 1882, p. 323; Portalis, 1889, p. 291; Nolhac, 1906, p. 164; Réau, 1956, p. 142; Wildenstein, 1960, no. 14; Wilhelm, 1960, p. 14; Thuillier, 1967, p. 50; Mandel, 1972, no. 15

See cat. nos. 270, 271, and L 36; Pl. 214 on p. 176

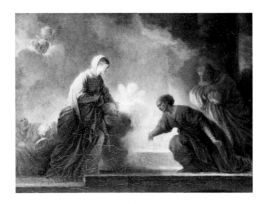

Portalis (1889) refers to a "copy on canvas" of the *Visitation to the Virgin* owned by Mr. Trumet de Fontarce, as distinct from the painting in the Beurnonville sale, May 9–16, 1881, lot 71.
The dating of the three existing versions of the *Visitation* poses a difficult problem. The analogy with the presentation and treatment of light in the *Adoration of the Shepherds* (cat. no. 300), datable to about 1775, is striking. However, a lost version (L 36) had already passed through the Duke de Grammont sale as early as January, 1775, and there is every reason to believe that it was very close to our cat. no. 269. The lost *Visitation* and the existing versions were almost certainly prior to the 1773–74 Italian trip.

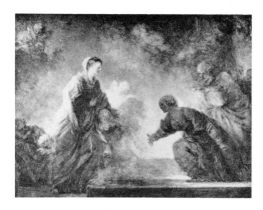

270 The Visitation
c. 1773. New York, Private Collection. Panel, 25 × 32 cm

Provenance: Walferdin sale, April 12–16, 1880, lot 34 (purchased by Pilloy); Doisteau sale, June 9–11, 1909, lot 38 (as orginating from the Collection of Alexandre Dumas—however it does not figure in the latter's sale, May 12–13, 1892); Brasseur sale, June 1, 1928, lot 16; Collection Paul and Marcel Jonas; Wildenstein; Collection Mrs. Irving Laughlin
Bibl.: Portalis, 1889, p. 291; Nolhac, 1906, p. 165; Wildenstein, 1960, no. 15; Wilhelm, 1960, p. 14; Thuillier, 1967, p. 50; Mandel, 1972, no. 17

See cat. nos. 269, 271, and L 36

It is difficult to ascertain whether the painting in the Carrier sale (March 9–10, 1846, lot 91; dimensions not stated) is this painting or another version. Wildenstein (1960, under no. 15) and Mandel (1972, under no. 17) mention a copy on panel (25 × 32 cm); reproduced in Wilhelm, 1955, fig. 2, p. 365, as once in the Collection Kraemer.

271 The Visitation
c. 1773. Private Collection. Canvas, 25 × 32 cm

Provenance: Probably Laneuville sale, June 5, 1826, lot 147; perhaps Laperlier sale, February 17–21, 1879, lot 15 (support not specified); perhaps Beurnonville sale, May 9–16, 1881, lot 72; Collection Grimelius in 1889; anonymous sale, December 6–7, 1965, lot 156; anonymous sale, December 12, 1966, lot 56
Bibl.: Portalis, 1889, p. 291; Nolhac, 1906, p. 165; Wildenstein, 1960, cited under no. 14; Mandel, 1972, no. 16

See cat. nos. 269, 270, and L 36

272 Roman Interior, also called **The Charlatan's Kitchen**
1774 (?). U.S.A. Private Collection. Canvas, 25 × 32 cm

Provenance: [E Arago] sale, February, 8–9, 1872, lot 24; Beurnonville sale, December 20, 1872, lot 73; Beurnonville sale, May 9–16, 1881, lot 66; Moreau-Chaslon sale, January 28–29, 1884, lot 20; Collection N. Nabokov (according to Wildenstein); Wildenstein, New York
Bibl.: Portalis, 1889, p. 274; Nolhac, 1906, p. 133; Réau, 1956, p. 172; Wildenstein, 1960, no. 359; Mandel, 1972, no. 381

See p. 164; Pl. 199

273 The Education of the Virgin
1775 (?). San Francisco, The Fine Arts Museums of San Francisco, Huntington Memorial Collection, California Palace of the Legion of Honor. Canvas, 84 × 115 cm (fragment)

Provenance: Most probably a fragment of lot 48 in the folliot sale, April 15–16, 1793 (165 × 133 cm); Walferdin sale, April 12–16, 1880, lot 65; Collection Siéhen; anonymous sale, April 16–21, 1883, lot 632; Collection Clément Bayard; Wildenstein, New York; acquired by the museum in 1929, thanks to the gift of Archer M. Huntington
Bibl.: Goncourt, 1882, p. 323; Portalis, 1889, p. 276; Nolhac, 1906, p. 156; Réau, 1956, p. 141; Wildenstein, 1960, no. 19; Wilhelm, 1960, p. 7; Mandel, 1972, no. 18; Sutton, 1980, no. 2; Rosenberg, 1987, p. 474

See pp. 169–75; Pl. 208

The provenance of the three existing versions of the *Education of the Virgin* (see also cat. nos. 274 and 275) is difficult to establish with any precision. It is impossible to say, due to a lack of precise descriptions, to which version each of the following relates: [Aubert sale, April 17–18, 1806, lot 13; anonymous sale, March 17, 1852, lot 37; anonymous sale, January 27, 1873, lot 6; Count... and the studio of... sale, December 13–15, 1853, lot 28.

274 The Education of the Virgin
c. 1775 (?). Private Collection. Canvas, 90 × 72 cm

Provenance: Walferdin sale, April 12–16, 1880, lot 66; Beurnonville sale, May 9–16, 1881, lot 73 (purchased by Grimelius according to Wildenstein); Collection Baron de Turkheim; Collection Countess de Pourtalès; Collection Marquise de Loys-Chandieu, Paris; Collection Bérard

Bibl.: Goncourt, 1882, p. 323; Wildenstein, 1921, no. 27; Réau, 1956, p. 141; Wildenstein, 1960, no. 17; Wilhelm, 1960, p. 8; Mandel, 1972, no. 19
See pp. 175–77; also cat. no. 273 for the history of the provenance

275 The Education of the Virgin
c. 1775 (?). Los Angeles, The Armand Hammer Foundation. Panel, 30.3 × 24.4 cm

Provenance: Lebrun sale, September 19, 1806, lot 150; Collection Mme T. (Wildenstein, 1921, under lot 27); Collection C. Groult (according to Wildenstein); G. Wildenstein; Collection Henry R. Luce, New York
Bibl.: Nolhac, 1906, p. 164; Wildenstein, 1960, no. 18; Wilhelm, 1960, p. 8; Mandel, 1972, no. 20; Rosenberg, 1987, no. 232

See p. 177; Pl. 209; also cat. no. 273 for the provenance

276 Young Child Standing on the Windowsill
c. 1775 (?). U.S.A. Private Collection. Canvas, 15 × 12 cm

Provenance: Perhaps G. sale, December 24, 1832, lot 81 (*Child at a Casement Window*, without measurements); perhaps anonymous

sale, May 6, 1839, lot 49 ("A young maid holds a child who is stretching out his arms to his mother," without measurements); Wildenstein, New York
Bibl.: Wildenstein, 1960, no. 463; Mandel, 1972, no. 487; Sutton, 1980, no. 74

See Pl. 233 on p. 191

277 Little girl reading the alphabet, called **The Reading Lesson**
c. 1775 (?). U.S.A. Private Collection. Canvas, 16.5 × 12.3 cm

Provenance: Wildenstein, New York
Bibl.: Wildenstein, 1960, no. 465; Mandel, 1972, no. 489; Sutton, 1980, no. 75

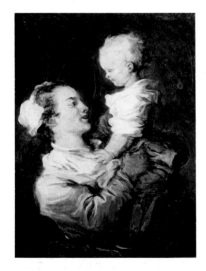

278 Mother and child, called **Portrait of the Wife and Son of the Artist**
c. 1775 (?). U.S.A. Private Collection. Canvas, 16 × 12 cm

Provenance: Collection David-Weill, Neuilly-sur-Seine; Wildenstein; Collection Charles Dunlap, New York; Mrs. C. E. Dunlap sale, Sotheby's, New York, December 4, 1975, lot 376
Bibl.: Henriot, 1926, I, pp. 137–39; Wildenstein,

1960, no. 462; Wilhelm, 1960, p. 81; Mandel, 1972, no. 486; Sutton, no. 73

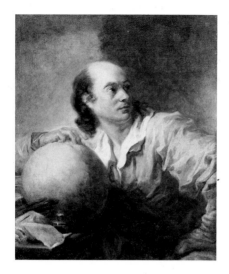

279 Portrait of a man in Spanish costume, called **The Astronomer Lalande**
c. 1775. Paris, Musée du Petit Palais. Canvas, 70 × 58 cm

Provenance: Collection E. Larcade; Collection Weisweiller; acquired by the museum in 1978
Bibl.: Wildenstein, 1921, no. 32; Réau, 1956, p. 174; Wildenstein, 1960, no. 253; Mandel, 1972, no. 271

See pp. 185–86; Pl. 221

A tradition, recorded by Wildenstein, that identifies the sitter as Charles Naudin (a miniaturist and pastelist who died in 1786) cannot be verified.

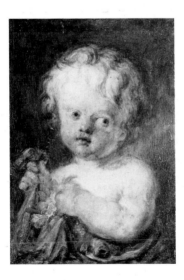

280 Fair-haired Child with Flowers
c. 1775. Paris, The Louvre. Panel, 19 × 14 cm

Provenance: F. Villot sale, January 25, 1864, lot 14; Collection Schlichting; donated to the museum in 1915
Bibl.: Wildenstein, 1960, no. 68; Mandel, 1972, no. 76

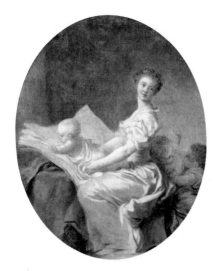

281 A Mother Making Her Child Play on a Big Book
c. 1775 (?). Boston, Museum of Fine Arts. Oval canvas, 46.4 × 37.5 cm

Provenance: La Rochefoucauld-Liancourt sale, June 20, 1827, lot 19 (together with its pendant, see cat. no. L 207); Collection Corbin (according to Wildenstein); Collection Forsyth Wickes, Newport; donated to the museum in 1965
Bibl.: Nolhac, 1906, p. 129; Wildenstein, 1960, no. 466; Mandel, 1972, no. 490

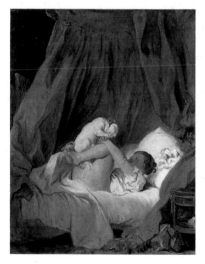

282 Young Girl Playing with a Dog on Her Bed, often called **The Ring Biscuit**
c. 1775. Munich, Bayerische Staatsgemälde-sammlungen, Alte Pinakothek. Canvas, 89 × 70 cm

Provenance: Lebas de Courmont sale, May 26, 1795, lot 40; Demidoff, Sr. sale, April 8–13, 1839, lot 88; anonymous sale, December 10–12, 1847, lot 38 (where it is noted as coming from Théophile Fragonard); anonymous sale, March 14, 1868, lot 8; Walferdin sale, April 12–16, 1880, lot 61; Collection Poidatz; Collection A. Veil-Picard; Collection J. Veil-Picard; acquired by the museum in 1977
Bibl.: Goncourt, 1882, p. 329; Portalis, 1889, p. 278; Réau, 1956, p. 159; Wildenstein, 1960, no. 280; Wilhelm, 1960, p. 145; Mandel, 1972, no. 298

313

See p. 184; Pl. 220

The dating of this work is problematic; the style is close to *Getting up* (cat. no. 202), but the small table on the right can hardly be dated before 1775 (see other comparable furniture by Topino, who became a master in 1773, reproduced by J. Nicolay, *L'Art et la Manière des Maîtres Ebénistes Français au XVIIIᵉ siècle*, Paris, 1976; for example, fig. L on p. 461).

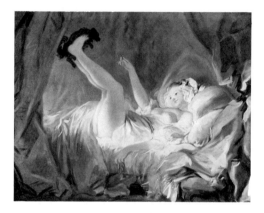

283 Young girl on her bed playing with a little black dog, called **The Ring Biscuits**
c. 1775. Paris, Private Collection. Canvas, 61 × 77.5 cm

Provenance: Perhaps de Villars sale, March 13, 1868, lot 31 (67 × 78 cm); perhaps Barroilhet sale, March 16, 1872, lot 10 (61 × 80 cm) (A *Ring Biscuit* without measurements also figured in the Barroilhet sale, March 10, 1856, lot 23); Cailleux, Paris
Bibl.: Exh. cat. *Masters of the Loaded Brush,* New York, Knoedler Gallery, 1967, no. 70

Another, very similar painting, but with the little dog in white (canvas, 64 × 80 cm), and of appreciably weaker quality, passed through the E. Kraemer sale, May 5–6, 1913, lot 36, the Collection Bondonneau and then the sale of June 4, 1970, lot 164 (Algoud, 1941, plate 62; Mandel, 1972, under no. 299, copy). Another version (canvas, 72 × 92), apparently also a copy, passed through the sale at Versailles (February 23, 1969, lot 25).

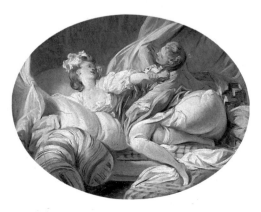

284 The Useless Resistance, sometimes called **The Surprise**
c. 1775. Stockholm, Nationalmuseum. Oval canvas, 45 × 60 cm

Provenance: Perhaps La Rochefoucault-Liancourt sale, June 20, 1827, lot 55; perhaps Brunet-Denon sale, February 2, 1846, lot 331 ("*The Resistance,* subject with two figures," without measurements); anonymous sale, December 22, 1852, lot 36; Laperlier sale, February 17–21, 1879, lot 11; Demidoff sale, Florence, San Donato, March 15–May 13, 1880, lot 1448; Collection Marquess d'Saint-Aubanel (1921); Collection P. Gallimard; Collection Wildenstein; Collection A. Loewenstein, Brussels (according to Wildenstein); Collection Van der Straten, Ponthoz (idem); Wildenstein; acquired by the museum in 1930
Bibl.: Goncourt, 1882, p. 334; Portalis, 1889, p. 287; Nolhac, 1906, p. 125; Réau, 1956, p. 159; Wildenstein, 1960, no. 276; Wilhelm, 1960, p. 104; Thuillier, 1967, pp. 108–9; Mandel, 1972, no. 294

See p. 184; Pl. 218

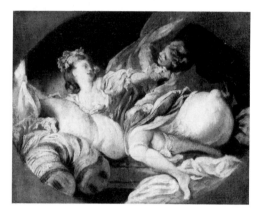

***285 The Useless Resistance**
c. 1775. Private Collection. Canvas, 37 × 42.5 cm

Provenance: E. Speelman, London
Bibl.: Sutton, 1980, no. 46

This appears to be another original version of the Stockholm painting (cat. no. 284).

286 The little boy with the curio, called **Portrait of Alexandre-Evariste Fragonard**

c. 1775. Portland, Art Museum. Canvas, 40 × 30 cm

Provenance: According to Wildenstein, Collection Ménage de Pressigny; seized in 1793; restored to his family; Collection Count de Malterre; Collection Gérault; Wildenstein, New York; Collection J.R. Bowles, Portland; Collection Mrs. B.C. Bowles; acquired by the museum in 1954 with the help of Mrs. M. Bowles Hollis
Bibl.: Wildenstein, 1921, no. 73; Réau, 1956, p. 181; Wildenstein, 1960, no. 506; Wilhelm, 1960, p. 204; Mandel, 1972, no. 46

The quality of this painting, like that of its pendant (cat. no. 287), is disappointing; however, the authorship does not appear to be in doubt.

287 The little girl with the marmot, called **Portrait of Rosalie Fragonard**
c. 1775. Portland Art Museum. Canvas, 40 × 30 cm

Provenance: See cat. no. 286
Bibl.: Wildenstein, 1921, no. 72; Réau, 1956, p. 181 (distinguishes between the painting in Portland and the Malterre painting); Wildenstein, 1960, no. 507; Wilhelm, 1960, p. 205; Mandel, 1972, no. 48

288 The little boy with the curio, called **Portrait of Alexandre-Evariste Fragonard**

c. 1775. Location unknown. Copper, 31 × 24 cm

Provenance: Marquess de Véri sale, December 12, 1785, lot 41 (together with its pendant); anonymous sale, April 28, 1790, lot 44 (together with its pendant); Collection Youssoupov, Petrograd (Leningrad) (catalogue, 1839, lot 239); Private Collection
Bibl.: Goncourt, 1882, p. 334; Portalis, 1889, p. 285; Nolhac, 1906, p. 131; Ernst, 1924, p. 126; Wildenstein, 1960, no. 509; Mandel, 1972, no. 47

289 The little girl with the marmot, called **Portrait of Rosalie Fragonard**
c. 1775. Moscow, Pushkin Museum. Copper, 32 × 24 cm

Provenance: Marquess de Véri sale, December 12, 1785, lot 41 (together with its pendant); anonymous sale, April 28, 1790, lot 44 (together with its pendant); Collection Youssoupov, Petrograd (Leningrad) (catalogue, 1839, lot 243)
Bibl.: Goncourt, 1882, p. 334; Portalis, 1889, p. 285; Nolhac, 1906, p. 131; Ernst, 1924, p. 128; Réau, 1956, p. 181; Wildenstein, 1960, no. 508; Mandel, 1972, no. 49

290 Young woman writing a letter, called **The Letter**

c. 1775 (?). Cincinnati Art Museum. Canvas, 38.1 × 29.5 cm

Provenance: Collection E. S. Bayer, New York; then to his wife; Collection Miss M. Hanna, Cincinnati; donated to the museum in 1946
Bibl.: Réau, 1956, p. 183

291 Allegory, called **The Sculptor's Vision**
c. 1775–78. Private Collection. Canvas, 72 × 60 cm

Provenance: Anonymous [Hals?] sale, November 23, 1868, lot 19; Beurnonville sale, May 9–16, 1881, lot 59; Collection G. Péreire; Collection Uzielli; Collection D. David-Weill, Neuilly-sur-Seine; Collection D. David-Weill, New York
Bibl.: Portalis, 1889, p. 291; Nolhac, 1906, p. 154; Wildenstein, 1921, no. 25; Réau, 1956, p. 151; Wildenstein, 1960, no. 189; Wilhelm, 1960, p. 86; Mandel, 1972, no. 200

For Portalis this is an allegory celebrating the return to health of Madame de Pompadour; he comments thus on the painting (p. 291): "the sculptor seated near the muse, chisel in hand, sees in a dream the composition of the marble group for which he has been searching to celebrate the return to health of Madame de Pompadour." Yet the painting seems to postdate the death of the marquise in 1764.
This could be an allegory of Love as the little cherubs are breaking the wings of Cupid, who is represented in the sculpted group.

292 Landscape, called **The Herd**
1775. Location unknown. Canvas, 31 × 40 cm. Signed: *Fragonard fecit, 1775* (according to Wildenstein)

Provenance: Collection Panhard (according to Wildenstein)
Bibl.: Wildenstein, 1921, no. 86; Wildenstein, 1960, no. 179; Wilhelm, 1960, p. 182; Mandel, 1972, no. 192

See p. 196; pendant to cat. no. 293

293 Landscape, called **The Two Windmills**
1775 (?). Private Collection. Canvas, 32 × 40 cm

Provenance: Robert de Saint-Victor sale, No-

292

vember 26, 1822, lot 621; Collection Panhard (according to Wildenstein)
Bibl.: Portalis, 1889, p. 284; Wildenstein, 1921, no. 85; Wildenstein, 1960, no. 180; Wilhelm, 1960, p. 183; Mandel, 1972, no. 152

See p. 197; pendant to cat. no. 292

Bibl.: Sterling, 1955, pp. 155–56, Réau, 1956, p. 184; Wildenstein, 1960, no. 350; Wilhelm, 1960, p. 20; Mandel, 1972, no. 369

Pendant to cat. no. 296

Provenance: Cailleux, Paris (?); Private Collection, Paris

294 The Three Trees
c. 1775. Private Collection. Panel, 33 × 24 cm

Provenance: Walferdin sale, April 12–16, 1880, lot 13; Collection Count de Pommereu; Cailleux, Paris
Bibl.: Portalis, 1889, p. 290; Daulte, 1954, no. 5; Réau, 1956, p. 184; Wildenstein, 1960, no. 188; Wilhelm, 1960, p. 190; Mandel, 1972, no. 199

295 The Shady Avenue, also called **The Grove**
c. 1775–76. New York, The Metropolitan Museum of Art. Canvas, 29.2 × 24.1 cm

Provenance: Collection Count A. Stroganov, St. Petersburg (in 1800); Collection G. Stroganov, Rome, 1912; Collection Wolkonski; probably Collection Scherbatov; Wildenstein, New York; Collection H. S. Bache, New York; donated to the museum in 1949

296 View of an Italian Villa, also called **The Cascade**
c. 1775–76. New York, The Metropolitan Museum of Art. Canvas, 29.2 × 24.1 cm

Provenance: See cat. no. 295
Bibl.: Sterling, 1955, p. 157; Wildenstein, 1960, no. 349; Wilhelm, 1960, p. 21; Mandel, 1972, no. 370

Pendant to cat. no. 295

297 Landscape with a shepherd and his herd, called **The Way Out of the Wood**
c. 1755–76. Paris, Private Collection. Panel, 30.5 × 24 cm. Inscription on the back: *no. 1326 Fragonnard père–Issue du bois*

298 Wooded Landscape with a Shepherd and Shepherdess near a Fountain
1778–80. Private Collection. Canvas (?), 54.5 × 61 cm

Provenance: Collection Count J. McCormack; sale, Christie's, London, November 29, 1974, lot 91

Though somewhat worn the painting seems to be authentic.

299 Countrywoman milking a cow in a landscape, called **The Milkmaid Surprised**
c. 1780 (?). Private Collection. Canvas, 58 × 71 cm

Provenance: Marquess de Saint-Marc sale, February 23, 1859, lot 5; anonymous sale, April 2, 1981, lot 26

The dating of this painting remains very problematic; the effect is close to that of the *Return of*

the Herd in Worcester (cat.no. 191). It already prefigures certain works by Demarne.

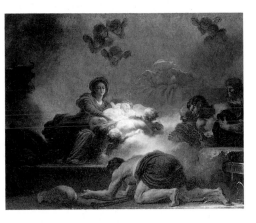

300 The Adoration of the Shepherds
c. 1775. New York, Private Collection. Canvas, 73 × 93 cm

Provenance: Probably commissioned by the Marquess de Véri; his sale, December 12, 1785, lot 36; Collection L., Versailles (according to Wildenstein); Collection Meurtault (idem); Collection Henri Leroux (idem); Wildenstein
Bibl.: Goncourt, 1882, p. 323; Portalis, 1889, pp. 62–63, 123–24, 269; Nolhac, 1906, p. 165; Réau, 1956, p. 142; Wildenstein, 1960, no. 90; Wilhelm, 1960, p. 16; Thuillier, 1967, p. 45; Mandel, 1972, no. 98; Rosenberg-Compin, 1974, pp. 263, 274, 276, 278; Sutton, 1980, no. 24; Bailey, 1985, p. 75

See pp. 178–79; Pl. 215

At the Véri sale, in 1785, the painting reached the price of 9,500 livres, the highest figure ever obtained for a work by Fragonard in his lifetime. A good copy of this canvas belonged to the Collection Bruant and the Collection Paulme (exhibited as original at the 1921 Fragonard exhibition, no. 13) and then to F. Gould (Sotheby's sale, Monte Carlo, June 28, 1984, lot 73).

301 Young girl holding a dog and a cat which are playing together, called Portrait of Adeline Colombe
c. 1775–78. Private Collection. Round canvas, diam. 70 cm

Provenance: According to Wildenstein, originates from the Château de Saint Brice, a property owned by Marie-Catherine Colombe, then Ravenez, de Guy, Colonel de Mondonville; Collection Mme. de Mondonville; Wildenstein; Collection Baron Edouard de Rothschild
Bibl.: Réau, 1956, p. 177; Cailleux, 1960, pp. III, IV; Wildenstein, 1960, no. 410; Wilhelm, 1960, p. 161; Mandel, 1972, no. 435

See p. 188; Pl. 228; pendant to cat.no. 302

302 Young girl with two doves, called Portrait of Marie-Catherine Colombe
c. 1775–78. Private Collection. Round canvas, diam. 70 cm

Provenance: See cat.no. 301
Bibl.: Réau, 1956, p. 177; Cailleux, 1960, pp. III, IV; Wildenstein, 1960, no. 411; Wilhelm, 1960, p. 160; Mandel, 1972, no. 436

See p. 188; Pl. 227; pendant to cat.no. 301

Mandel (1972), following Réau, draws attention to a "copy" from the Davies Collection, deposited since 1972 in the County Museum of Art, Los Angeles, which seems to be our cat.no. 223.

303 Young Couple at the Window
c. 1775–78. Besançon, Musée des Beaux-Arts. Panel, 17 × 13 cm

Provenance: Collection P.-A. Pâris; bequeathed to the library at Besançon in 1819; transferred to the museum in 1843
Bibl.: Goncourt, 1882, p. 335; Portalis, 1889, p. 280; Wildenstein, 1921, no. 45; Réau, 1956, p. 167; Wildenstein, 1960, no. 257; Wilhelm, 1960, p. 61; Thuillier, 1967, p. 72; Mandel, 1972, no. 275

See Pl. 226, p. 186; pendant to cat.no. 304

304 Young Mother and Her Child
c. 1775–78. Besançon, Musée des Beaux-Arts. Panel, 17 × 11 cm

Provenance: Collection P.-A. Pâris, bequeathed to the library at Besançon in 1819; transferred to the museum in 1843
Bibl.: Goncourt, 1882, p. 335; Portalis, 1889, p. 280; Wildenstein, 1921, no. 46; Réau, 1956, p. 167; Wildenstein, 1960, no. 258; Wilhelm, 1960, p. 62; Thuillier, 1967, p. 72; Mandel, 1972, no. 276

See Pl. 226 on p. 186; pendant to cat.no. 303

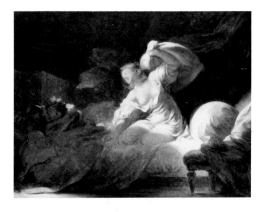

305 The Useless Resistance
c. 1775–78. San Francisco, M.H. de Young Memorial Museum. Panel, 24.3 × 32.4 cm

Provenance: Anonymous sale, July 8, 1793, lot 16; G. Mühlbacher sale, May 13–15, 1907, lot 20; Collection David-Weill, Paris; Wildenstein; Collection Rose F. and E. John Magnin, New York; donated to the museum in 1963, subject to usufruct; entered the museum in 1975
Bibl.: Goncourt, 1882, p. 327; Réau, 1956, p. 159; Wildenstein, 1960, no. 278; Wilhelm, 1960, p. 103; Mandel, 1972, no. 296

Two engravings of very similar composition, by Vidal and Regnault, may have been made after another painting (see cat. no. L 12). A copy by the Abbé de Saint-Non with very similar measurements, and which is mentioned in the inventory after his death in 1792 (Wildenstein, 1959, p. 239, no. 16), is now in the Wadsworth Atheneum in Hartford.

306 The Reader, called **The Letter,** or **The Souvenirs**
c. 1775 (?). Private Collection. Canvas, 38 × 30 cm

Provenance: Probably anonymous [Baché, Brilliant, de Cossé, Quenet, according to Wildenstein] sale, April 22, 1776, lot 91 ("A young and beautiful Italian woman seen in half-length leaning against a desk, and holding her cheek in her hand, she holds an opened letter and seems to read it with emotion. There reigns in this attractive piece a transparency of color which is charming; it is endearing through the interesting character that it portrays." (32.4 × 22.9 cm); anonymous [De Ghendt?] sale, November 16, 1779, lot 30 (32 × 24 cm); Count de Merle sale, March 1, 1784, lot 31 (31 × 22 cm); Volpato and Morghen sale, November 6, 1822, lot 20 (together with a pendant) (40 × 32 cm); Marquess de la Rochebousseau sale, May 5–8, 1873, lot 122 (as having belonged during the empire to Madame Récamier); Count de la Béraudière sale, May 18–30, 1885, lot 25; G. Mühlbacher sale, May 15–18, 1899, lot 16; Collection Marquess de Chaponay, 1921; Collection D. David-Weill, Neuilly-sur-Seine; Collection Fritz Mannheimer, Amsterdam; Collection Mr. and Mrs. C.W. Engelhard, New York
Bibl.: Goncourt, 1882, p. 335; Portalis, 1889, p. 282; Nolhac, 1906, p. 147; Wildenstein, 1921, no. 55; Réau, 1956, p. 171; Wildenstein, 1960, no. 386; Wilhelm, 1960, p. 165; Thuillier, 1967, pp. 37, 107; Mandel, 1972, no. 410; Sutton, 1980, no. 60

Certain discrepancies in the measurements do not allow this painting to be identified with any certainty with those that passed through the early sales; see also our cat. no. 307 of similar dimensions. This seems to have been a very successful composition, of which Fragonard may have made other copies, which are now lost.

307 The Reader, called **The Letter** or **The Souvenirs**
c. 1775 (?). Private Collection. Canvas, 35 × 28.5 cm

Provenance: Galerie Brunner, Paris, 1913; Collection Hahnloser, Winterthur; sale, Sotheby's, London, June 30, 1965, lot 27; see also cat. no. 306

306

Bibl.: Daulte, 1954, no. 27; Réau, 1956, p. 171; Wilhelm, 1960, p. 164

See cat. no. 306

308 Bust of an Old Man Wearing a Hat and Holding a Purse

c. 1775 (?). Private Collection. Canvas, 33 × 24 cm

Provenance: Perhaps Thélusson sale, December 1, 1777, lot 42, *A Bust of an Old Man* (31 × 22.9 cm); Collection P. A. Hall? (inventory, May 10, 1778: "a miser holding a sack of money, by Mr. Telusen [sic]"; see Villot, 1867, p. 74; anonymous [De Ghendt] sale, November 15, 1779, lot 20; Tonnelier sale, November 28, 1783, lot 29 (together with its pendant); Alphonse Kann sale, December 6–8, 1920, lot 30; Collection Dr. Tuffier; Collection P. David-Weill, New York

Bibl.: Goncourt, 1882, p. 333; Nolhac, 1906, p. 148; Wildenstein, 1960, no. 385; Wilhelm, 1960, p. 74; Mandel, 1972, no. 409

309 Bust of a Little Girl with an Open Book, sometimes called **Study**

c. 1775–78. London, Wallace Collection. Canvas, 46 × 38 cm. Signed on the right, on the page of the book: *frago*

Provenance: Anonymous [Calonne, Angelot] sale, May 11, 1789, lot 111; Montesquiou-Ferenzac sale, January 29–31, 1872, lot 6; Collection Lord Hertford; Collection Sir Richard Wallace; Lady Wallace Bequest, 1897

Bibl.: Portalis, 1889, p. 276; Nolhac, 1906, p. 146; Wildenstein, 1960, no. 377; Wilhelm, 1960, p. 148; Mandel, 1972, no. 401

For a lost pendant, see cat. no. L 146

310 A Lady Carving Her Name, also called **The Souvenir**

c. 1775–78. London, Wallace Collection. Panel, 27 × 20 cm. Signed on the edge of the bench: *fragonard*

Provenance: Anonymous sale, April 11, 1822, lot 11; perhaps anonymous sale, January 12, 1834, lot 40 (without measurements); Duke de Morny sale, May 31, 1865, lot 99; Collection Lord Hertford; Collection Sir Richard Wallace; Lady Wallace Bequest, 1897

Bibl.: Goncourt, 1882, pp. 325; 331; Portalis, 1889, p. 273; Nolhac, 1906, p. 151; Réau, 1956, p. 163; Wildenstein, 1960, no. 390; Wilhelm, 1960, p. 136; Thuillier, 1967, p. 134; Wallace Collection Cat., 1968, p. 116; Mandel, 1972, no. 414

This painting, or another very similar one (cat. no. L 5), was engraved by N. de Launay under the title *A Lady Carving Her Name.*

311 Happy Fertility, also called **The Happy Family**

c. 1776–77. Washington, D.C., National Gallery of Art, Mrs. W. R. Timken Bequest. Oval canvas, 53.9 × 65.1 cm

Provenance: Probably anonymous [Mlle Dubarry, M. Lalive de Bellegarde, M. Ruffaut] sale, Fe-

bruary 17, 1777, lot 55 ("A painting handled with much verve and of excellent effect, it represents the interior of a room in which there is a woman and several children; a man, who appears to surprise them, is seen at the casement window." [51.3 × 62.1 cm]); Collection La Rochefoucault-Liancourt; Collection Poilleux; Collection Guinle, Rio de Janeiro; Collection Ambatielos, London; Collection W. R. Timken; bequeathed to the gallery in 1959

Bibl.: Portalis, 1889, p. 280; Nolhac, 1906, p. 130; Wildenstein, 1960, no. 368; Mandel, 1972, no. 390; Sutton, 1980, no. 56

See p. 188; Pl. 230

The *Rustic Family*, lot 22 in the Mesnard de Clesle sale, January 5, 1804, taken into account by Wildenstein is actually a drawing.

See also cat. nos. 312–13 and L 9, L 145a

312 Happy Fertility, also called **The Happy Family**

c. 1776–77. Private Collection. Oval canvas, 54 × 64.8 cm

Provenance: Perhaps anonymous [Mlle. Dubarry, M. Lalive de Bellegarde, M. Raffaut] sale, February 17, 1777, lot 55; perhaps Collection Pâris; perhaps Collection de Charpentier, c. 1880; Private Collection, Switzerland

Bibl.: Mandel, 1972, no. 392; Sutton, 1980, no. 56

See Pl. 231 on p. 190

This appears to be the version engraved by

Antoine Louis Romanet in a rectangular format in 1791.

313 Maternal Love
c. 1776–77. U.S.A., Private Collection. Paper mounted on canvas, 19 × 22 cm

Provenance: Perhaps anonymous sale, April 28, 1790, lot 46, paper on canvas ("Maternal love also a sketch, executed in Italy," without measurements); Collection Marinescu, New York
Bibl.: Goncourt, 1889, p. 334; Wildenstein, 1960, no. 366 (as lost); Mandel, 1972, no. 389

See Pl. 232 on p. 190

Mandel's identification of this picture with lot 46 in the 1790 sale continues to be quite problematic.

315 Rest on the Flight into Egypt
c. 1776–78. Troyes, Musée des Beaux-Arts. Canvas, 188 × 124 cm

Provenance: Church of Saint Nizier de Troyes; entered the museum in 1939
Bibl.: Réau, 1956, p. 142; Wildenstein, 1960, no. 21; Wilhelm, 1960, p. 13; Mandel, 1972, no. 22; Sutton, 1980, no. 3

See p. 178; Pl. 210 and cat. nos. 316–17

317 Rest on the Flight into Egypt
c. 1778. New Haven, Yale University Art Gallery, on loan from the Barker Welfare Foundation. Oval canvas, 55 × 45 cm

Provenance: Anonymous [Mme. Auger?] sale, May 17–22, 1886, lot 19; Collection C. Pillet, in 1889; Collection Chevalier (according to Wildenstein); Collection Mme. Feuillet (idem); Wildenstein, New York; Collection Mr. and Mrs. C. V. Hickox, New York
Bibl.: Portalis, 1889, p. 287; Nolhac, 1906, p. 166; Réau, 1956 p. 142 (history of provenance confused); Wildenstein, 1960, no. 22; Wilhelm, 1960, cited p. 13; Mandel, 1972, no. 23; Zafran, 1983, no. 11

See p. 178; Pl. 211 and cat. nos. 315–16

314 Italian Family, called **Happy Family**
c. 1778. Private Collection. Canvas, 29 × 37 cm. Signed, center right: *Fragonard*

Provenance: Count Perregaux (junior) sale, December 8–9, 1841, lot 50; perhaps Polivanov sale, November 29, 1842, lot 33 (neither support nor measurements stated); Collection G. Bouctot, Paris; anonymous sale, Versailles, May 24, 1970, lot 27 (as attributed to Fragonard); see also cat. no. L 12
Bibl.: Portalis, 1889, p. 279; Nolhac, 1906, p. 127; Wildenstein, 1921, no. 81; Réau, 1956, p. 167 (confused with the composition of cat. nos. 319–21); Wildenstein, 1960, no. 371; Mandel, 1972, no. 393

316 Rest on the Flight into Egypt
c. 1778. Baltimore, Museum of Art. Oval canvas, 67 × 57 cm

Provenance: Collection La Rochefoucauld-Liancourt (sale, 1827?) (according to Wildenstein); Collection Poilleux (according to Wildenstein); Collection Langlois (idem); Mrs. Thaw sale, May 15, 1922, lot 22 (63 × 52 cm); Wildenstein; Collection Mary Frick Jacobs; Collection Mrs. Henry Barton Jacobs, Baltimore; donated to the museum in 1942–43
Bibl.: Réau, 1956, p. 142; Wildenstein, 1960, no. 23; Wilhelm, 1960, p. 13; Mandel, 1972, no. 24; Sutton, 1980, no. 4

See p. 178 and cat. nos. 315 and 317

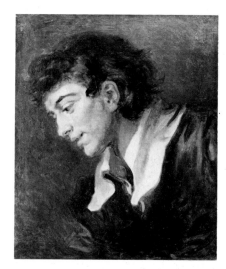

318 Bust of a Young Man
c. 1775–78 (?). Le Havre, Musée des Beaux-Arts André-Malraux. Canvas, 46 × 38 cm

Provenance: Perhaps Mme. [de Cossé] sale, November 11, 1778, lot 95 ("Joseph Vien and Honoré Fragonard: a head of an old man and a head of a young man, paintings forming pendants" [43.2 × 35.1 cm]); Walferdin sale, April 12–16, 1880, lot 51; Beurnonville sale, May 9–16, 1881, lot 70; Collection Mme. Charras; acquired by the museum in 1881

Bibl.: Portalis, 1889, p. 290; Nolhac, 1906, p. 115; Réau, 1956, p. 182; Wildenstein, 1960, no. 483; Thuillier, 1967, p. 107; Mandel, 1972, no. 512

See p. 188; Pl. 222

A closely related head can be found again in our cat. no. 319.

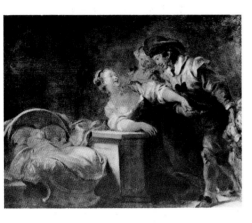

319 Young couple contemplating a sleeping child, called **The Return Home,** or **The Reconciliation** or **The Happy Family**
c. 1776–78. Paris, Private Collection. Canvas, 69 × 87 cm

Provenance: Perhaps Constantin sale, November 18, 1816, lot 365 ("A young married couple comes to contemplate their sleeping child in its cradle. Painting executed with a light touch and attractive coloring." [70 × 86 cm]); H. Didier sale, June 15, 1868, lot 59; Mme. Denain sale, April 6–7, 1893, lot 12; Collection A. Veil-Picard; Collection A. Veil-Picard (son)
Bibl.: Portalis, 1889, p. 287; Nolhac, 1906, pp. 83, 127; Réau, 1956, p. 167; Wildenstein, 1960, no. 453; Thuillier, 1967, p. 54; Mandel, 1972, no. 478

See pp. 193–96 and cat. nos. 320–21

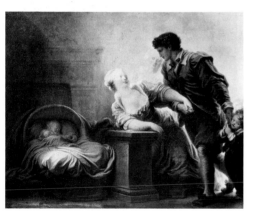

320 Young couple contemplating a sleeping child, called **The Return Home, The Reconciliation,** or **The Happy Family**
c. 1776–78 (?). Switzerland, Private Collection. Canvas, 72 × 92 cm

Provenance: Guillaumot sale, January 15, 1808, lot 9; [Du Taillis?] sale, November 27, 1815,

lot 43; perhaps Constantin sale, November 18, 1816, lot 365; Count de la Salle sale, March 29, 1856, lot 78; Marquess de Blaisel sale, May 25, 1868, lot 15; B. Narishkine sale, April 5, 1883, lot 15; Secrétan sale, July 1, 1889, lot 117; Duke de [Gramont?] sale, May 22, 1925, lot 8; Duke de Gramont sale, June 15, 1934, lot 33; Wildenstein; Collection Baron Maurice de Rothschild, Pregny; Collection Baron Edmond de Rothschild, Pregny
Bibl.: Goncourt, 1882, p. 334; Portalis, 1889, p. 287; Nolhac, 1906, pp. 83, 126; Réau, 1956, p. 167; Wildenstein, 1960, no. 454; Wilhelm, 1960, p. 195; Thuillier, 1967, pp. 54, 107; Mandel, 1972, no. 477

See pp. 195–96; Pl. 239 and cat. nos. 319 and 321

See Chapter VIII, n. 24 for the subject matter.

321 Young couple contemplating a sleeping child, called **The Return Home,** or **The Reconciliation,** or **The Happy Family**
c. 1776–78. U.S.A., Private Collection. Canvas, 45 × 54 cm

Provenance: Count Andréossi sale, April 13–16, 1864, lot 2; Collection E. Pereire; Collection H. Pereire; Tooth, London, 1938; Wildenstein, London, 1960; Private Collection
Bibl.: Portalis, 1889, p. 279; Wildenstein, 1921, no. 94 (56 × 67 cm); Réau, 1956, p. 167; Wildenstein, 1960, no. 455; Mandel, 1972, no. 479

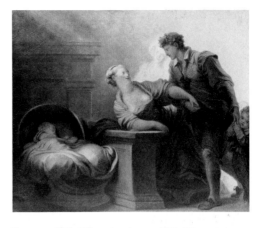

See pp. 193–96 and cat. nos. 319–20

322 Blindman's Buff
c. 1776 (?). Paris, The Louvre. Canvas, 38 × 47 cm

Provenance: Gros sale, April 13, 1778, lot 56 ("A landscape in a fresh and pastoral style, painted near Meudon. In the foreground of the painting and on a terrace, can be seen several groups of young girls and boys, some of whom are preparing to play blindman's buff, and the others, near a table, are occupied with other different games." [35.1 × 44.5 cm]); Ferlet sale,

322

April 18, 1792, lot 27 (35.1 × 43.2 cm); de Launay sale, May 7, 1792, lot 6 (37.8 × 45 cm); Collection A. Poliakov; acquired by the museum in 1926
Bibl.: Portalis, 1889, p. 287 ("Recreation after a collation in a garden"); Nolhac, 1906, p. 150; Wildenstein, 1960, no. 445; Wilhelm, 1960, p. 41; Mandel, 1972, no. 470

Wildenstein believes that this is a painting that passed through the [Baudouin] sale, February 15, 1770, lot 39: "A recreation, the collation having been taken in a garden: this attractive painting, with fresh coloring, is painted on canvas [36.4 × 44.5 cm]." See cat. no. L 30.

Despite the measurements and subject matter being very similar, this does not appear to be the Louvre painting, which we believe to be of a later date.

323 Portrait of a Woman
c. 1778. Private Collection. Canvas, 39 × 30 cm

Provenance: G. Rothan sale, May 29–31, 1890, lot 147; Wildenstein; Mme. de Polès sale, June

22–24, 1927, lot 15; Collection O. Bemberg; Collection F. Bemberg; Private Collection
Bibl.: Portalis, 1889, p. 290; Nolhac, 1906, p. 114; Réau, 1956, p. 183; Exh., Grasse, 1957, no. 12; Wildenstein, 1960, no. 485; Mandel, 1972, no. 514

324 The Little Coquette
c. 1778. Paris, Private Collection. Panel, 32 × 24 cm

Provenance: Walferdin sale, April 12–16, 1880, lot 27; Collection Count de Pourtalès; Collection A. Veil-Picard; Collection A. Veil-Picard (son)
Bibl.: Goncourt, 1882, p. 334; Portalis, 1889, p. 285; Nolhac, 1906, p. 114; Daulte, 1954, no. 37; Réau, 1956, p. 161; Wildenstein, 1960, no. 346; Wilhelm, 1960, p. 166; Mandel, 1972, no. 366

325 Sultana on an Ottoman
c. 1776–78 (?). Muncie, Indiana, Ball State University Art Gallery. Paper mounted on panel, 33 × 22 cm

Provenance: [Morelle] sale, May 3, 1786, lot 178 ("The sketch of the Sultana, known through the large finished painting which was in the collection of M. de Boisset. This lovely piece is of the

323

most brilliant color and the lightest touch." [32 × 21 cm]); Wildenstein, New York; on permanent loan from the Collection E. Arthur Ball, Ball Brothers Foundation, 1951
Bibl.: Goncourt, 1882, p. 333; Nolhac, 1906, p. 145; Wildenstein, 1960, no. 337; Mandel, 1972, no. 353

See Pl. 254 on p. 208

The light and flickering treatment of this picture prompts a dating later than that of the other versions (cat. nos. 266–68).

326　Blindman's Buff
c. 1776–78. Switzerland, Private Collection. Canvas, 55.3 × 62.1 cm

Provenance: Trouard sale, February 22, 1779, lot 79 ("Two young women seated at the foot of a statue of Venus: one holds a crown of roses that appears to be intended for a young shepherd who is coming toward them as the blindman..." [55.3 × 62.1]); Collection La Rochefoucault-Liancourt; Collection Poilleux, 1827 (according to Wildenstein); Collection Langlois (according to Wildenstein); Wildenstein; Collection Baron Edmond de Rothschild, Paris; Collection Baron Maurice de Rothschild, Pregny; Collection Baron Edmond de Rothschild, Pregny
Bibl.: Goncourt, 1882, p. 333; Portalis, 1889, p. 275; Nolhac, 1906, p. 150; Réau, 1956, p. 158; Wildenstein, 1960, no. 313; Mandel, 1972, no. 334

327　The Donkey's Stable

c. 1778. Paris, Private Collection. Canvas, 57 × 72 cm

Provenance: Collection Malvilan, Grasse; Collection C. Wertheimer, London; Wildenstein; Collection A. Veil-Picard; Collection A. Veil-Picard (son)
Bibl.: Portalis, 1889, p. 276; Daulte, 1954, no. 16; Réau, 1956, p. 172; Wildenstein, 1960, no. 369; Wilhelm, 1960, p. 152; Mandel, 1972, no. 394

A version, with smaller measurements (canvas, 37 × 45 cm), that passed through the Walferdin sale, April 12–16, 1880, lot 24; Beurnonville sale, April 9–16, 1881, lot 69, the Collections Mme. Charras; G. and F. Blumenthal; G. F. Gould, and then in several Sotheby's sales: June 22, 1960, lot 16; July 3, 1963, lot 9; and June 24, 1970, lot 71, in a mediocre state of conservation, appears to be of quite inferior quality.

328　Portrait of a Woman in White
c. 1778–80. Private Collection. Oval canvas, 43 × 34 cm

Provenance: Carrier sale, April 6, 1868, lot 19; Collection Ristelhueber (according to Wildenstein); Collection David-Weill (idem)
Bibl.: Nolhac, 1906, p. 112; Wildenstein, 1960, no. 374; Mandel, 1972, no. 398

Is not, as Wildenstein indicates (1960), in the Philipps Collection in Washington, D.C.

329　Portrait of a Young Girl, wrongly called **Mademoiselle Guimard**
c. 1778. Paris, Private Collection. Canvas, 45 × 37 cm

Provenance: Collection Mme. André; Collection of the artist Hébert; Collection A. Veil-Picard; Collection A. Veil-Picard (son)
Bibl.: Daulte, 1954, no. 36; Réau, 1956, p. 178; Wildenstein, 1960, no. 343; Wilhelm, 1960, p. 167; Mandel, 1972, no. 363

See p. 188; Pl. 223

Wildenstein (1960) draws attention to another version (55 × 40 cm), with variations, which was in the collection of Sir Hugh Lane.

330　Bust of a little girl wearing a bonnet, called **Portrait of a Young Girl**
c. 1778. Private Collection. Oval canvas cut into a square format, 32 × 29 cm

Provenance: Perhaps Prault sale, November 27, 1780, lot 25 ("A bust of a young girl, wearing a round bonnet, her head half-inclined over her right shoulder, and her neck covered by a fichu." [37.8 × 29.7 cm]); anonymous sale, March 12, 1782, lot 145 (32.4 × 27 cm); Collection Mme. J. Porgès; anonymous sale, November 29, 1976, lot B; anonymous sale, Sotheby's, Monaco, February 8, 1981, lot 97
Bibl.: Goncourt, 1882, p. 333; Nolhac, 1906, p. 113?; Wildenstein, 1921, no. 97; Réau, 1956, p. 183?; Wildenstein, 1960, no. 270; Mandel, 1972, no. 287

The oval seems to have been slightly reduced in height between 1780 and 1782. The light gray-white and pink coloring seems to reveal the influence of the pastel technique. The painting lacks subtlety and charm, yet the attribution seems reliable.

The painting in the Prault sale could also be our cat. no. 331, to which the term "round bonnet" applies less well.

331 Bust of a young girl with a large hat, called **The Dreamer**
c. 1778 (?). Switzerland, Private Collection. Canvas, 32 × 24 cm

Provenance: Perhaps Prault sale, November 27, 1780, lot 25 ("A bust of a young girl, wearing a round bonnet, her head half-inclined over her right shoulder, and her neck covered by a fichu." [37.8 × 29.7 cm]); according to Wildenstein, painted for Roslin d'Ivry, for his Château d' Hénonville; Baron d'Ivry sale, June 7–9, 1884, lot 20; Collection Baroness Willie de Rothschild, Frankfort (according to Portalis); Collection Maurice de Rothschild, Pregny; Collection Edmond de Rothschild, Pregny
Bibl.: Portalis, 1889, p. 287; Nolhac, 1906, p. 114; Réau, 1956, p. 183; Wildenstein, 1960, no. 340; Mandel, 1972, no. 356

332 The Little Mischief, or **The Little Girl with the Chinese Magot**
c. 1778. Paris, Private Collection. Canvas, 88 × 74 cm

Provenance: Laperlier sale, April 11, 1867, lot 31;

Collection Baron Edouard de Rothschild; Collection Baroness Edouard de Rothschild
Bibl.: Goncourt, 1882, p. 331; Portalis, 1889, p. 276; Nolhac, 1906, p. 131; Réau, 1956, p. 162; Wildenstein, 1960, no. 480; Wilhelm, 1960, p. 118; Mandel, 1972, no. 509

See p. 188

333 The New Model
c. 1778. Paris, Musée Jacquemart-André. Oval canvas, 52 × 62 cm

Provenance: Probably Folliot sale, April 15–16, 1793, lot 42 ("a painter in his studio busy posing the model; sketch on canvas" [51.3 × 62.1 cm]); Barroilhet sale, March 10, 1856, lot 27 (without measurements); perhaps anonymous sale, March 18, 1857, lot 16 ("a model," without measurements); Walferdin sale, April 12–16, 1880, lot 30; Collection Jacquemart-André; Mme. André Bequest, 1912
Bibl.: Goncourt, 1882, p. 334; Portalis, 1889, p. 275; Nolhac, 1906, p. 145; Réau, 1956, p. 160; Wildenstein, 1960, no. 293; Wilhelm, 1960, p. 132; Thuillier, 1967, p. 107; Mandel, 1972, no. 403

See p. 185; Pl. 219

334 Young Girl Stretched out on Her Bed
c. 1778. Paris, Private Collection. Canvas, 30 × 38 cm

Provenance: Parisez sale, January 25, 1868, lot 34 (neither support nor measurements stated); Collection Berthier, Paris; Wildenstein; Collection P. Decourcelle, Paris

Bibl.: Wildenstein, 1921, no. 28; Wildenstein, 1960, no. 228; Mandel, 1972, no. 240

See p. 185

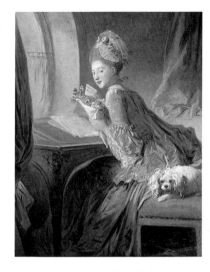

335 The Billet-Doux, or **The Love Letter**
c. 1778. New York, The Metropolitan Museum of Art. Canvas 83 × 67 cm

Provenance: Collection Baron Feuillet de Conches; Collection Mme. Jägerschmidt, Paris, 1897; E. Cronier sale, December 4–5, 1905, lot 7; Collection Gimpel and Wildenstein, Paris, 1907; Collection J. Bardac; Wildenstein; Collection Julius Bache, New York; bequeathed to the museum in 1949
Bibl.: Portalis, 1889, p. 272; Nolhac, 1906, p. 146; Sterling, 1955, pp. 157–58; Réau, 1956, p. 160; Wildenstein, 1960, no. 388; Wilhelm, 1960, p. 131; Mandel, 1972, no. 413

See p. 188; Pl. 229

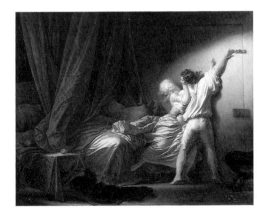

336 The Bolt
c. 1778. Paris, The Louvre. Canvas, 73 × 92 cm

Provenance: Marquess de Véri sale, December 12, 1785, lot 37 (acquired by the expert Le Brun "it represents an interior of a room with a young man and a young woman; the former is bolting the door and the other is trying to stop him. The scene takes place near a bed, the disorder of which tells the rest of the story..."); Grimod de la Reynière sale, November (?), 1792, actually April 3, 1793, lot 28 (reacquired by Le Brun);

Collection "Mr. d'Arjuson," who offered it to the Louvre in 1817 (?); Collection Marquess A. de Bailleul, Château de Ronville, Alizay (Eure); his daughter, Mrs. de la Potterie, deceased in 1921; offered to the Louvre in 1922 by the expert G. Sorteis; A. Vincent sale, May 26, 1933, lot 21; anonymous sale, March 21, 1969, lot 166; acquired by the museum in 1974
Bibl.: Goncourt, 1882, p. 329; Portalis, 1889, p. 290; Nolhac, 1906, p. 124; Réau, 1956, p. 161; Wildenstein, 1960, no. 495 (Véri and Grimod de la Reynière painting); Thuillier, 1967, pp. 54, 107; Mandel, 1972, no. 56 (Véri and Grimod de la Teynière painting); Rosenberg-Compin, 1974, II, pp. 270–76; Compin-Rosenberg, 1974, no. 22; Thuillier, 1974 (unpaginated); Rosenberg, 1974–75, no. 59

See pp. 179–84; Pl. 316 and cat. no. 337

Engraved by M. Blot under the title *The Bolt* in 1784.

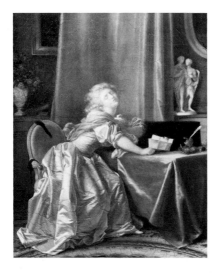

Provenance: Perhaps anonymous sale, March 30, 1785, lot 106; pendant to another painting (see no. L 110) ("a woman who learns of the death of her lover..." [37.8 × 27 cm])
Bibl.: Réau, 1956, p. 160

There is an engraving of this composition with significant variations in the troubadour spirit, inscribed: *Geneviève de Brabant,* and *Painted by Mlle Gérard, Engraved by Augustin Legrand.*

339 View of a park: Game of Blindman's Buff and **The Swing**
c. 1778-80. Washington, D.C., National Gallery

of Art, Collection Samuel H. Kress. Canvas in 2 sections: a) *Game of Blindman's Buff,* 216.2 × 197.8 cm; b) *The Swing,* 215.9 × 185.5 cm

Provenance: Marquess de C[ypierre] sale, March 10, 1845, lots 52–53; Collection Montesquiou-Ferzensac; Collection C. Groult, Paris; Wildenstein, New York; Collection Samuel H. Kress, 1954; donated to the museum in 1961
Bibl.: Goncourt, 1882, p. 334; Portalis, 1889, pp. 272, 273; Nolhac, 1906, p. 150; Réau, 1956, p. 158 (only "the section with the swing"); Wildenstein, 1960, nos. 447–48; Wilhelm, 1960, p. 176; Mandel, 1972, nos. 471–72; Eisler, 1977, pp. 328–31

See pp. 202–3 and Pls. 250–51; associated with cat. nos. 340–42 (?)

Wildenstein integrates this painting (W. nos. 447–48) with two paintings from the Abbé de Saint-Non Collection that were in the inventory drawn up after his death in 1792, nos. 1–2 (Wildenstein, 1959, p. 238); but the absence of measurements in the inventory, the reference "executed in Italy" and the subject *Game of Hot Cockles* for one of the two paintings would seem to prevent this integration. The two Washington, D.C. paintings actually appear to be, as Nolhac had already noted (1906), one painting that has been cut in two.

337 The Bolt
c. 1778. Private Collection. Panel, 26.3 × 39.5 (measurements include a band of 1.7 cm added to the bottom of the painting)

Provenance: Collection Duke de Coigny, seized in 1794 ("Sketch of the Bolt, on panel, by Fragonard"); Jourdan sale, April 4, 1803, lot 13 ("the sketch of an attractive subject already known among the curious"); B. G. Sage sale, February 8, 1827, lot 43; A. Rémusat sale, April 1–3, 1833, lot 171 ("The Bolt, sketch executed with much spirit"; without any indication of support or measurements); actually sold on April 22–23, 1833, lot 11; B[ertrand] sale, March 17, 1854, lot 7; Bertrand sale, November 16–17, 1855, lot 387; Collection A. Fauchier-Magnan, Paris; Collection Wildenstein, New York; Collection Baroness von Cramm (Barbara Hutton), New York; sale, Sotheby's, London, June 24, 1964, lot 41; Private Collection; sale, Sotheby's, Monaco, February 14, 1983, lot 645; Collection A. Ojeh
Bibl.: Portalis, 1882, p. 291; Nolhac, 1906, p. 124; Réau, 1956, p. 161; Wildenstein, 1960, no. 494; Mandel, 1972, no. 507; Rosenberg-Compin, 1974-II, p. 270, n. 41; p. 276

See p. 179; Pl. 217 and cat. no. 336

338 Woman in an Interior Learning Some Bad News, or **The Bad News**
c. 1780 (?). Private Collection. Canvas, measurements unknown

340 View of a park with children playing horse and rider, called **A Game of Horse and Rider**
c. 1778-80. Washington, D.C., National Gallery of Art, Collection Samuel H. Kress. Canvas, 115 × 87.5 cm (cut down in the upper section?)

Provenance: Collection W. Hope; Collection Jenny Colon; E. Pereire sale, March 6–9, 1872, lot 61; Collection Count Pillet-Will, Paris; Wildenstein, New York; Collection Samuel H. Kress; donated to the museum in 1946
Bibl.: Portalis, 1889, p. 273; Nolhac, 1906, p. 159; Réau, 1956, p. 158; Wildenstein, 1960, no. 443; Wilhelm, 1960, pp. 168–69; Mandel, 1972, no. 468; Eisler, 1977, pp. 331–32

Pendant to cat.no.341; also associated with cat.nos. 339, 342 (?)

See p. 203; Pl. 252

See pp. 198–201 and Pls. 243–44; associated with cat.nos. 339–41 (?)

For the preparatory studies see cat.nos. 343–44

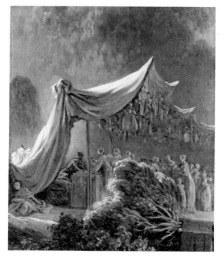

Wildenstein, New York; Collection E. Bührle, Zurich; Collection Mme C. Bührle, Zurich; Private Collection, U.S.A.; b) *The Toy Seller:* Walferdin sale, April 12–16, 1880, lot 12; Collection C. Groult; Wildenstein, New York; Collection E. Bührle, Zurich; Collection Mme C. Bührle, Zurich; Private Collection. U.S.A.
Bibl.: Goncourt, 1882, p. 334; Portalis, 1889, pp. 282–83; Nolhac, 1906, p. 149; Daulte, 1954, nos. 39–40; Réau, 1956, p. 184; Wildenstein, 1960, nos. 433–34; Wilhelm, 1960, p. 175; Mandel, 1972, nos. 459–60

See p. 202; Pls. 246–47

These two paintings appear to be fragments of one canvas cut down (due to its being in bad condition?) before the Walferdin sale, and which would have measured approximately 70 × 90 cm. Two or three centimeters are missing in the center to complete the joining of the two fragments.

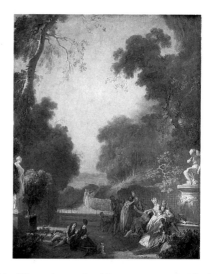

341 View of a park with young people playing a game of hot cockles, called **A Game of Hot Cockles**
c. 1778–80. Washington, D.C., National Gallery of Art, Collection Samuel H. Kress. Canvas, 115.5 × 91.5 cm (cut down in the upper section?)

Provenance: See cat.no. 340
Bibl.: Portalis, 1889, p. 273; Nolhac, 1906, p. 159; Réau, 1956, p. 158; Wildenstein, 1960, no. 444; Wilhelm, 1960, p. 170; Mandel, 1972, no. 469; Eisler, 1977, pp. 331–32

Pendant to cat.no.340; also associated with cat.nos. 339, 342 (?)

See p. 203; Pl. 253

343 The Marionettes
c. 1778–:80. Paris, Private Collection. Canvas, 67 × 86 cm

Provenance: Perhaps de Noé sale, April 7–8, 1858, lot 6 (according to Wildenstein); perhaps Collection Walferdin (does not figure in the sale catalogue); Collection L. Goldschmidt; Collection Count Pastré; Collection A. Veil-Picard; Private Collection
Bibl.: Portalis, 1889, p. 283; Wildenstein, 1921, no. 50; Daulte, 1954, no. 38; Réau, 1956, p. 184; Wildenstein, 1960, no. 435; Wilhelm, 1960, p. 173; Mandel, 1972, no. 461

See p. 202; Pl. 245

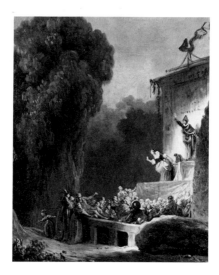

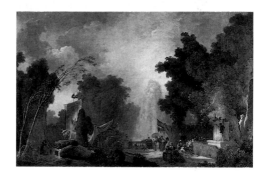

342 View of a park with popular amusements, called **The Fête at Saint-Cloud**
c. 1778–80. Paris, Banque de France. Canvas, 216 × 335 cm

Provenance: Early provenance unknown; appears to have been in the Banque de France since the beginning of the nineteenth century
Bibl.: Portalis, 1889, p. 277; Wildenstein, 1921, no. 51; Réau, 1956, p. 184; Wildenstein, 1960, no. 436; Wilhelm, 1960, pp. 171–72; Thuillier, 1967, pp. 119, 138; Mandel, 1972, no. 458

344 The Charlatans and The Toy Seller
c. 1778–80. U.S.A., Private Collection. Canvas. Fragmented painting (?). 2 canvases: a) *The Charlatans,* 49 × 38.7 cm; b) *The Toy Seller,* 40.6 × 34 cm

Provenance: a) *The Charlatans:* Walferdin sale, April 12–16, 1880, lot 11; [Brame?] sale, March, 20, 1883, lot 11; [A. Courtin] sale, March 29, 1886, lot 5; Collection P. Watel; Collection Mme. Watel, widow (1889); Collection C. Marcille (according to Wildenstein); Collection C. Groult;

345 The Happy Household
c. 1778–80. U.S.A., Private Collection. Round canvas, diam. 32.5 cm

Provenance: Guillaumot sale, January 15, 1808, lot 10 ("a parrot in a cage can be seen near them); Didot sale, April 6, 1825, lot 135 ("a young husband, seated and thrown back against a

sofa, enjoys the caresses of his child who reaches forward to kiss him and whom he is holding in his arms. His wife, no less happy, is standing behind him and is tenderly leaning on his shoulders. A parrot, with wings outstretched and beak open, wants to participate in the joy of the happy household: he is part of the family. It is with a small number of such excellant paintings that, near the end of the last century, Fragonard made an illustrious name for himself, which his son deservedly maintains."); Dubois sale, May 9, 1859? (according to Wildenstein); Count d' Houdetot sale, December 12–14, 1859, lot 42; W. Salomon sale, New York, March 31, 1923, lot 384; Collection E.A. Shewan, New York; Collection M. van Beuren, New York; Wildenstein, New York
Bibl.: Portalis, 1889, pp. 279, 288 (*Family Scene*); Nolhac, 1906, p. 127; Daulte, 1954, no. 43; Réau, 1956, p. 168; Wildenstein, 1960, no. 502; Wilhelm, 1960, p. 178; Mandel, 1972, no. 524; Sutton, 1980, no. 84

See cat. no. 346

346 The Happy Household
c. 1778–80. Private Collection. Round canvas, diam. 34 cm

Provenance: Probably Collection A. Vestier, the artist, in 1783; exhibited at the Salon de la Correspondance ("The interior of a household where a father embracing his child in the presence of the mother can be seen. Sketch by M. Fragonard. A.M. Vestier, painter"); Collection M.A. Didot; Collection Sir Thomas Lawrence, artist, who received it as a gift from Didot in 1825 (on the stretcher is the inscription: "To the illustrious Sir Thomas Lawrence, originator of the only interesting way of painting portraits, a way which consists of choosing the beautiful or good aspect, never too ungraceful, even with people who have not been blest by nature. Marc-Antoine Didot, grateful artlover, Paris, November 15, 1825, quai Malaquais, lot 17"); P. Cailleux, Paris; Penard y Fernandez sale, Palais Galliera, December 7, 1960, lot 35
Bibl.: Goncourt, 1882, p. 318; Réau, 1956, p. 168; Wildenstein, 1960, no. 501; Wilhelm, 1960, p. 177; Mandel, 1972, no. 523

See cat. no. 345

347 Scene from the Iliad(?)
c. 1780 (?). Quimper, Musée des Beaux-Arts. Canvas, 45 × 37 cm

Provenance: Probably M.L. (painter) sale, April 8, 1843, lot 9 ("combat between Mars and Minerva. Subject taken from the Iliad. Four figures. Sketch of charming color"); Collection Count de Silguy; bequeathed to the museum in 1864
Bibl.: Wilhelm, 1960, [pp. 69–70]; Cuzin, 1986-I, p. 63, p. 66, n. 20

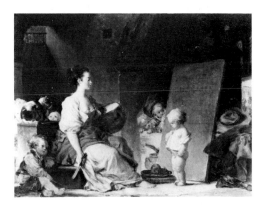

348 The Schoolmistress, or **Say "Please"**
c. 1780. London, Wallace Collection. Canvas, 28 × 37 cm. Signed on the blackboard to the right: *Fragonard*

Provenance: Probably Duclos-Dufresnoy sale, August 18, 1795, lot 28 a ("this composition is known through the engraving by N. Delaunay [de Launay] under the title *Say "Please"* [27 × 36.4 cm]); Count Perregaux sale, December 8–9, 1841, lot 49; Collection Marquess of Hertford; Collection Sir Richard Wallace; Lady Wallace Bequest, 1897
Bibl.: Goncourt, 1882, p. 334 or 332?; Portalis, 1889, p. 282; Nolhac, 1906, p. 129; Réau, 1956, p. 167; Wildenstein, 1960, no. 468; Wilhelm, 1960, pp. 155–56; Thuillier, 1967, p. 138; Mandel, 1972, no. 492

See cat. nos. 349–50 and L 11; Pl. 238 on p. 195

Another version (canvas, 28 × 37 cm) that passed through the Mühlbacher sale, May 13–15, 1907, lot 25, and then was in the Collection Sir Basil Zaharoff, exhibited in 1921 (no. 59), could be only a good, early copy.

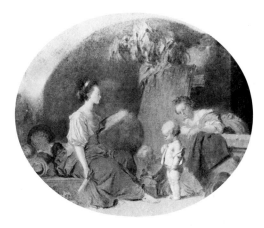

***349 Say "Please"**
c. 1780 (?). Private Collection. Oval canvas, 36 × 43 cm (if it is the Pillet-Will picture)

Provenance: Perhaps Collection Pillet-Will; Collection R. Owen, Paris, 1927; Collection Seligman, 1941
Bibl.: Portalis, 1889, p. 275; Algoud, 1941, fig. 68

See cat. nos. 348, 350, and L 11

The painting seems quite worn, but it has good possibilities of being original. It may even be the painting engraved by Nicolas de Launay, despite the variations in the background.

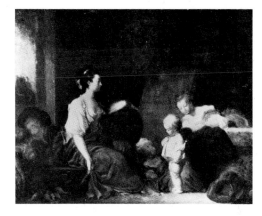

***350 Say "Please"**
c. 1780 (?). Private Collection. Paper mounted on canvas, 28 × 36 cm

Provenance: Perhaps [Saubert and Desmarest] sale, March 17, 1789, lot 94; perhaps Duclos-Dufresnoy sale, August 18, 1795, (lot unknown); perhaps Vavin sale, April 11, 1864; Du Boys sale, March 28, 1941, lot 25; Collection M. Midy; anonymous sale, March 28, 1979, lot 163

See cat. nos. 348–49 and L 11

The attribution of this painting to Fragonard seems feasible. It is very similar to that engraved by de Launay, despite certain differences (rectangular shape, no toys on the ground).

351 The Little Preacher
c. 1780. Paris, Private Collection. Canvas, 54 × 65 cm

Provenance: Aubert sale, March 2, 1786, lot 74;

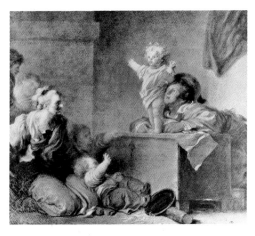

de Launay sale, May 7, 1792, lot 5 (together with its pendant); Collection Count G. Stroganov, Rome; N. Wildenstein; Collection A. Veil-Picard, Paris; Collection A. Veil-Picard (son), Paris
Bibl.: Goncourt, 1882, p. 332; Portalis, 1889, p. 285; Nolhac, 1906, p. 129; Daulte, 1954, no. 11; Réau, 1956, p. 171; Wildenstein, 1960, no. 471; Wilhelm, 1960, pp. 157–58; Thuillier, 1967, p. 68; Mandel, 1972, no. 495

See p. 193

Engraved as an oval by N. de Launay in 1791 under the title *The Little Preacher*, as a pendant to *Education Does All* (cat. no. 352).

352 Education Does All
c. 1780. São Paulo, Museu de Arte. Canvas, 54 × 65 cm

Provenance: Aubert sale, March 2, 1786, lot 73; de Launay sale, May 7, 1792, lot 5; Collection Count Stroganov, Rome; E. Roussel sale, March 25–28, 1912, lot 7; Collection W. Burris, London; Collection Wildenstein, New York; Collection Baron Thyssen-Bornemisza, Rohoncz; Collection Baron Thyssen-Bornemisza, Lugano; Collection Assis de Châteaubriand
Bibl.: Goncourt, 1882, p. 332; Portalis, 1889, p. 276; Nolhac, 1906, p. 128 (repr.); Réau, 1956, p. 171; Wildenstein, 1960, no. 472; Wilhelm, 1960, p. 159; Mandel, 1972, no. 496; Sutton, 1980, no. 76

See p. 193; Pl. 236

Engraved as an oval by N. de Launay under the title *Education Does All* as a pendant to *The Little*

Preacher (cat. no. 351). The print was advertised in 1791.

353 Portrait of Constance de Lowendal, Countess Turpin de Crissé
c. 1780. São Paulo, Museu de Arte. Oval canvas, 64 × 54 cm

Provenance: Collection Turpin de Crissé, Château d'Egligny, Seine et Marne (according to Wildenstein); Collection Mme. Le Couttey de la Forest, Paris (idem); Wildenstein, New York; Collection E. J. Berwind; Collection C. E. Dunlap, New York; Wildenstein, New York; Collection Assis de Châteaubriand
Bibl.: Réau, 1956, p. 181; Wildenstein, 1960, no. 503; Mandel, 1972, no. 531; Sutton, 1980, no. 85

354 The Elements Pay Homage to Nature, or **Nature's Awakening**
c. 1780. Lost (?). Canvas, 60 × 50 cm. Dated on the pedestal: MDCLXXX

Provenance: According to Wildenstein, Collection Chaslon; seized in February, 1794 ("offering or homage given to youth"); in the National Depository at Nesle ("the four elements coming to

pay homage to beauty"); perhaps Jourdan sale, April 4, 1803, lot 12 ("The four elements pay homage to Nature"); perhaps Beurnonville sale, May 9–16, 1881, lot 56; Collection Count Daupias, Lisbon; his sale May 16–17; 1892, lot 13; Collection S. Bardac; Wildenstein; Collection Dr. Tuffier; Collection Baron Penin de la Raudière, Château de Badifols d'Ans, perhaps destroyed during the Second World War
Bibl.: Portalis, 1889, p. 287; Nolhac, 1906, p. 160; Wildenstein, 1960, no. 490; Wilhelm, 1960, p. 200; Thuillier, 1967, p. 54; Mandel, 1972, no. 519

See p. 207

355 Sappho Inspired by Cupid, also called **A Muse Inspired by Cupid,** or **Poetry**
c. 1780. Switzerland, Private collection. Oval canvas, 63 × 53.3 cm

Provenance: Perhaps [Mlle. Lacaille] sale, January 23, 1792, lot 68; perhaps Basan sale, April 10–11, 1786, lot 68; perhaps anonymous sale, January 27, 1845, lot 15; perhaps anonymous sale, January 20, 1873, lot 12; perhaps anonymous sale, November 15, 1886, lot 18; Collection Beeche, 1921; Collection Baron Thyssen-Bornemisza, Lugano; Collection Countess M. Batthyany, Castagnola
Bibl.: Wildenstein, 1921, no. 63; Réau, 1956, p. 146 (confused with *The Favorable Inspiration,* cat. no. L 6); Wildenstein, 1960, no. 426; Mandel, 1960, no. 451

See cat. nos. 356–58; Pl. 267 on p. 216

The painting in the [Mlle. Lacaille], January 23, 1792, lot 68; the [Basan], April 10–11, 1796, lot 68 and the anonymous, January 27, 1845, lot 15 sales could correspond as much to this painting as to the other two versions (cat. nos. 356–57).

356 Sappho Inspired by Cupid, also called **A Muse Inspired by Cupid** (The muse Erato?), or **Poetry**
c. 1780. Private Collection. Oval canvas, 63 × 53 cm

Provenance: Perhaps [Mlle. Goman] sale, January

23, 1792, lot 68; perhaps anonymous sale, January 27, 1845, lot 75 (neither support nor measurements stated); A. Fould sale, May 14–15, 1875, lot 13; Montbrison sale, May 8, 1891, lot 32; Collection Baron Adolphe de Rothschild; Collection Baron Maurice de Rothschild, Paris; Collection A. Loewenstein, Brussels; Collection R. van der Straten, Brussels; Wildenstein
Bibl.: Nolhac, 1906, p. 160; Wildenstein, 1921, no. 62; Daulte, 1954, no. 41; Wildenstein, 1960, no. 425; Mandel, 1972, no. 448; Sutton, 1980, no. 68

See cat. nos. 355 and 357–58

***357 Sappho Inspired by Cupid, also called A Muse Inspired by Cupid, or The Favorable Inspiration**
c. 1780. U.S.A., Private Collection. Oval canvas, 64.5 × 53.5 cm

Provenance: Perhaps [Mlle. Goman] sale, January 23, 1792, lot 68; perhaps Basan sale, April 10–11, 1796, lot 68; perhaps anonymous sale, January 27, 1845, lot 15; perhaps, according to Wildenstein, anonymous sale, January 20, 1873, lot 12; perhaps, according to Wildenstein, anonymous sale, November 15, 1886, lot 18 (without measurements); probably Collection R. Filleul, Château de Chennevières, near Montargis

Bibl.: Portalis, 1889, p. 279 *(The Favorable Inspiration)*; Wildenstein, 1960, no. 427; Mandel, 1972, no. 452

See cat. nos. 355–56 and 358

To judge from the photograph, this version seems much weaker than the previous ones, and the attribution may even be doubtful.

358 Sappho, or The Muse and Cupid
c. 1780–85. Private Collection. Canvas, 30.8 × 22.2 cm (oval view)

Provenance. C. David de Thiais sale, Chartres, December 10, 1860, lot 12; Collection Eudoxe Marcille (purchased on "10 October 1860" according to a label on the back); by descent to his heirs
Bibl.: Goncourt, 1882, p. 271, n. 1, "This Muse embraced by Cupid... of which M. Marcille owns a charming grisaille where the silver lights running over the Muse's body are like a moonlight kiss"; Portalis, 1889, p. 279 *(The Favorable Inspiration)*; Wildenstein, 1921, no. 64; Réau, 1956, p. 146; Mandel, 1972, under no. 448; Cuzin, 1987, pp. 48–50, fig. p. 49

See cat. nos. 355–57, Pl. 268 on p. 216

359 Portrait of a young girl wearing a green ribbon, called Marie-Catherine Colombe

c. 1780. New York, Private Collection. Oval canvas, 45 × 38 cm

Provenance: Walferdin sale, April 12–16, 1880, lot 3; Collection C. Groult (according to Portalis, 1889); Collection Brizac (according to Wildenstein); Collection H. Douvillé (idem); J. Seligmann; Collection Mrs. Dickermann, New York; D. Aaron, New York
Bibl.: Portalis, 1889, p. 281; Réau, 1956, p. 177; Wildenstein, 1960, no. 420; Wilhelm, 1960, p. 163; Mandel, 1972, no. 444

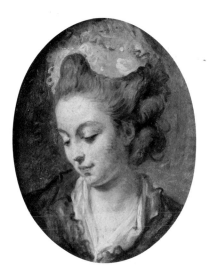

***360 Head of a Young Woman with Eyes Down Cast**
c. 1780 (?). Private Collection. Oval panel, 25 × 19 cm

Provenance. Carrier sale, April 6, 1868, lot 18; Wildenstein, New York; Collection Ambatielos; Collection Mrs. Johnston L. Redmond, New York; Collection Mrs. William H. Osborn, New York
Bibl.: Portalis, 1889, p. 290; Nolhac, 1906, p. 114; Wildenstein, 1960, no. 379; Mandel, 1972, no. 404

The attribution of the painting is problematic. Wildenstein (1960) mentions a pastel copy in his collection by the Abbé de Saint-Non.

361 Plutarch composing The Parallel Lives, called The Dream of Plutarch
c. 1780. Rouen, Musée des Beaux-Arts. Panel, 22 × 31 cm

Provenance: Collection Descamps; acquired by the museum in 1818

Bibl.: Portalis, 1889, p. 289; Daulte, 1954, no. 1; Réau, 1956, p. 151; Wildenstein, 1960, no. 85; Mandel, 1972, no. 93; Sutton, 1980, no. 20

See Pl. 311 on p. 247

The Rouen museum's 1818 catalogue (no. 194) explains the painting's subject matter as follows: "Plutarch composing *The Parallel Lives*.

"The subject of this little painting gives some idea of the Artist's character. It represents a dark grotto in which can be seen the venerable Plutarch seated in an armchair with a large open book on his desk: one can read in it *Vie des Hommes Illustres (The Parallel Lives)*... the Artist has represented Plutarch surrounded by a luminous vapor; a flame rises from his bared head; it is assumed that he is occupied by a romantic idea that is taking place before his eyes.

"The vault of the grotto opens up and scales descend from no one knows where, and on which, at each extremity, is a ball. On the higher one can be read: *Grandeur (Greatness)*; it is crowned with thorns; the crown of immortality awaits it in the heavens. On the lower one is written: *Médiocrité (Mediocrity)*; it is crowned with roses and surmounted by the hat of liberty.

"The artist finishes his dream by comparing, on the earth, men to reptiles which place their venom in a vessel on the fire; he claims that when this mixture reaches a certain degree of heat it evaporates and troubles the globe. This little painting has been treated, for effect, in the style of Rembrandt. One finds an intelligence heated to enthusiasm, a rich and molten touch, and that magical chiaroscuro which characterizes the brush of this artist, original in his genre."

362 The Pasha

c. 1780–85. Private Collection. Canvas, 73 × 92 cm

Provenance: Probably Vigier sale, May 14, 1818, lot 19 ("King Salomon, languidly lying on a divan, and having just taken a sorbet, has some young girls brought before him by the master of ceremonies." Without measurements); perhaps anonymous sale, March 18–20, 1850, lot 44 ("Odalisque presented to the Sultan," without measurements); perhaps [Nicole] sale, January 26, 1869, lot 30; Laurent-Richard sale, May 23–25, 1878, lot 95; Collection Mme. Waldeck-Rousseau; Collection Mme. Charcot; Collection J. Charcot; Collection Princess de Poix; collection Duchess de Mouchy; sale, Christie's, London, December 11, 1984, lot 138

Bibl.: Portalis, 1889, p. 283; Nolhac, 1906, p. 145; Réau, 1956, p. 162; Wildenstein, 1960, no. 339; Wilhelm, 1960, p. 215; Thuillier, 1967, p. 87; Mandel, 1972, no. 355

363 The Vow of Love

c. 1780–82. Location unknown (Great Britain?). Oval canvas, 64 × 55 cm

Provenance: Perhaps anonymous sale, March 4–5, 1842, lot 72 (without measurements); Saint sale, May 4–7, 11–14, 1846, lot 62 (purchased by Lord Hertford, according to the annotator of the catalogue in the Bibliothèque J. Doucet); Duke de Narbonne sale, March 24–26, 1851, lot 26; Horsin-Déon sale, March 26–27, 1868, lot 11; Narishkine sale, April 5, 1883, lot 14; Collection Baron Ferdinand de Rothschild,

London; Collection Baron Gustave de Rotschild, Paris, 1889; Collection Baron Albert von Goldschmidt-Rothschild, Frankfurt-am-Main; Collection Baroness Willie de Rothschild, Frankfurt-am-Main; Collection James A. de Rothschild, London, deceased in 1957

Bibl.: Goncourt, 1882, p. 270; Portalis, 1889, p. 288; Nolhac, 1906, p. 166; Réau, 1956, p. 164 ("to Mr. Edward R. Bacon"); Wildenstein, 1960, no. 496; Thuillier, 1967, p. 134; Mandel, 1972, no. 525

See p. 209 and cat. no. 364

Engraved by Mathieu and by N. de Launay as a pendant to the *Good Mother* (advertised in 1786).
An oval pastel "copy," "signed and dated 1784," passed through the La Rochebousseau sale, May 5–8, 1873.

362

364 The Vow of Love

c. 1780 (?). Grasse, Musée Fragonard (on deposit from the Louvre). Canvas, 62 × 51 cm

Provenance: Bequest of Anne Pauline Lepailleur, grandchild of Henri Gérard, Fragonard's brother-in-law, entered the Louvre in 1912; deposited in the Musée des Beaux-Arts in Algers in 1927 (Rosenberg-Compin, 1974, I, p. 192, "copy");

deposited in the Musée Fragonard, Grasse at an undetermined date
Bibl.: Cuzin, 1986, I, p. 66 n. 22

See p. 209; Pl. 257 and cat. no. 363

365 The hurdy-gurdy player, called **Rosalie as Fanchon the Hurdy-Gurdy Player**
c. 1780. Private Collection. Canvas, 43 × 30 cm

Provenance: Perhaps M. sale, January 10, 1818, lot 16 ("finished sketch and very attractive"); Simonet sale, May 7–8, 1863, lot 34; Rothan sale, May 29–31, 1890, lot 148; Collection Rutter; A. Lehmann sale, June 8, 1925, lot 20; Collection Mrs. Edward Esmond
Bibl.: Portalis, 1889, p. 277; Nolhac, 1906, pp. 148–49; Wildenstein, 1921, no. 68; Réau, 1956, p. 181; Wildenstein, 1960, no. 505; Wilhelm, 1960, pp. 137–38; Mandel, 1972, no. 45

366 Young Girl with a Marmot
c. 1780. Cambridge, Mass., Fogg Art Museum. Panel, 28 × 22 cm (original measurements: 28 × 14 cm)

Provenance: Collection Levis-Mirepoix (according to Wildenstein); seized during the Revolution in 1794; Duclos-Dufresnoy sale, August 18, 1795, lot 30 (Canvas, 29.7 × 14.1 cm); Wildenstein; Collection J. W. Simpson, New York; Collection Grenville L. Winthrop; donated to the museum in 1943

Bibl.: Portalis, 1889, p. 280; Nolhac, 1906, p. 131; Réau, 1956, p. 181; Wildenstein, 1960, no. 43; Mandel, 1972, no. 44

A copy attributed to Marguerite Gérard (lot 25, anonymous sale, Versailles, May 27, 1973) gives the original proportions of the composition.
In the Duclos-Dufresnoy sale catalogue it is noted as being a pendant to a *Blindman Accompanied by His Dog* by Chardin, lot 2 in the same sale.

367 The fair-haired child, called **Portrait of Alexandre-Evariste Fragonard**
c. 1780–82. Paris, Private Collection. Canvas, 32 × 24 cm

Provenance: Walferdin sale, April 12–16, 1880. lot 18; Collection Viscountess de Courval (according to Wildenstein); Collection Princess de Poix (idem); Collection Duke de Mouchy (idem); Private Collection
Bibl.: Goncourt, 1882, p. 334; Portalis, 1889, p. 276; Nolhac, 1906, p. 115; Réau, 1956, p. 181; Wildenstein, 1960, no. 516; Mandel, 1972, no. 539

One could ask whether this painting was not a fragment of a work related to *The Child with Punch* (cat. no. L 8).

***368 Portrait of a Child**
c. 1780–85. Private Collection. Paper mounted on panel, 13 × 12 cm

Provenance: Collection C. Marcille (according to Wildenstein); perhaps Walferdin sale, April 12–16, 1880, lot 95 or lot 96 (10 × 8 cm); Collection C. Groult (according to Wildenstein); Wildenstein, New York; Mrs. C. E. Dunlap sale, Sotheby Parke Bernet, New York, December 4, 1975, lot 362
Bibl.: Wildenstein, 1960, no. 511; Mandel, 1972, no. 534

The attribution to Fragonard is not definite.

369 Portrait of a young fair-haired little boy, called **Fanfan**
c. 1780–85. Private Collection. Canvas, 19 × 13.5 cm

Provenance: Cailleux, Paris
Bibl.: Réau, 1956, p. 181

See p. 228; Pl. 288

370 Portrait of Child with a Collar (Alexandre-Evariste Fragonard?)
c. 1783–85 (?). San Marino, The Henry E. Huntington Library and Art Gallery. Oval canvas, 21.5 × 19 cm

Provenance: Collection Dr. H. Wendland, Lugano; Private Collection, Switzerland; Collection Mrs.

L. Peyton Green, Los Angeles, 1956; Collection H.E. Huntington; bequeathed to the museum in 1979
Bibl.: "La Chronique des arts, principales acquisitions des musées en 1979," In *Gazette des Beaux-Arts,* no. 189 (March, 1980): 37

See p. 228; Pl. 286

***371 Portrait of a Fair-haired Child**
c. 1785. Private Collection. Canvas, 39 × 31 cm

Provenance: Perhaps Hiestaut sale, December 26–27, 1837, lot 46 ("Portrait of one of Fragonard's children: he is of fair complexion and wearing a ruff," without measurements; the identification remains hypothetical); anonymous sale, June 14, 1920, lot 16 (attributed to Danloux); Collection S.E. Soulas
Bibl.: Wildenstein, 1960, no. 514; Mandel, 1972, no. 537

The attribution to Fragonard does not appear to be definite.

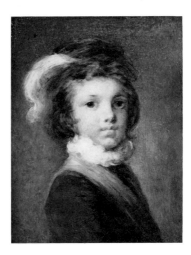

372 Child with a Plumed Hat
c. 1785. U.S.A., Private Collection. Canvas, 22 × 16 cm

Provenance: Perhaps [Dufresne, Lahaudé, Henry] sale, December 4, 1821, lot 50; Wildenstein, New York

Bibl.: Wildenstein, 1960, no. 513; Mandel, 1972, no. 536

See p. 228

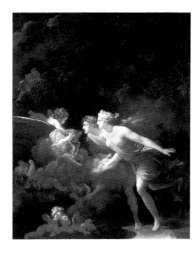

373 The Fountain of Love
c. 1785. London, Wallace Collection. Canvas, 64 × 56 cm. Signed, bottom right: *Fragonard*

Provenance: Duclos-Dufresnoy sale, August 18–21, 1795, lot 28 (62.1 × 50.6 cm); Villeminot sale, May 25, 1807, lot 21 (64 × 56 cm); Collection N. Demidoff, San Donato, Florence; second sale of the Collection San Donato, February 26, 1870, lot 106; Collection Sir Richard Wallace; Lady Wallace Bequest, 1897
Bibl.: Goncourt, 1882, p. 326; Portalis, 1889, p. 227; Nolhac, 1906, pp. 59, 116; Réau, 1956, p. 163; Wildenstein, 1960, no. 488; Wilhelm, 1969, p. 201; Thuillier, 1967, pp. 54, 99, 103, 136; Mandel, 1972, no. 516

See pp. 212–214; Pl. 264 and cat. nos. 374–75

Engraved by N.-F. Regnault in 1785.
Portalis (1889, p. 277), catalogues a "copy" (of this painting or that of cat. no. 374), pendant to a version of *The Dream of Love*, in the collection of Lady Holland at Stanmore Castle (J.R. Holland sale, Christie's, London, April 11, 1913, lot 50; then in New York, Collection J. Willys; see Mandel, 1972, no. 518A).

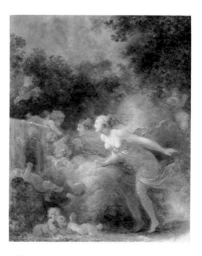

374 The Fountain of Love

c. 1785. U.S.A., Private Collection. Canvas, 47 × 37.5 cm

Provenance: Berend sale, December 2, 1889, lot 4; Collection M. Bernstein; Collection H. Bernstein; Collection Bartoloni; Wildenstein, New York; Collection I. Laughlin, Washington, D.C.; sale, Sotheby's, London, June 10, 1959, lot 22; Collection Mrs. H. Chanler, Geneseo, NY
Bibl.: Goncourt, 1882, p. 326; Portalis, 1889, pp. 71, 223; Nolhac, 1906, p. 116; Wildenstein, 1960, no. 487; Mandel, 1972, no. 518; Sutton, 1980, no. 81

See p. 214; Pl. 263 and cat. no. 373

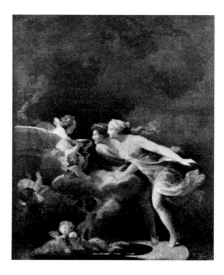

***375 The Fountain of Love**
c. 1785. Location unknown. Canvas, 53 × 46 cm

Provenance: Saint sale, May 4, 1846, lot 63 (without measurements; purchased by Walferdin according to the catalogue in the Bibliothèque J. Doucet); Walferdin sale, April 12–16, 1880, lot 56; Collection Mme. Paillard the widow, 1907 and 1926; Count de Lariboisière sale, March 27, 1936, lot 17; Collection M. Feral
Bibl.: Goncourt, 1882, p. 326; Portalis, 1889, p. 277; Nolhac, 1906, p. 116; Réau, 1956, p. 163; Wildenstein, 1960, no. 489; Wilhelm, 1960, p. 201; Mandel, 1972, no. 517

See cat. nos. 373–74

To judge from the photograph, the painting displays a harshness which casts doubts on the attribution to Fragonard. For Portalis (1889, p. 277) the painting in the Saint sale is not the same as that in the Walferdin sale.

376 Fragonard and (or?) Marguerite Gérard. **The Contract**
c. 1785–88 (?). Location unknown. Canvas, 45 × 55 cm

Provenance: Count Perregaux sale, December 8–9, 1841, without lot; Collection J. Duclos; Collection Marquise d'Hautpoul, 1856; d'Hautpoul sale, June 29, 1905, lot 42; Collection Countess d'Hautpoul; anonymous sale, June 5, 1908, lot 2
Bibl.: Portalis, 1889, p. 274; Réau, 1956, p. 161; Wildenstein, 1960, under no. 522; Wilhelm, 1960, p. 209

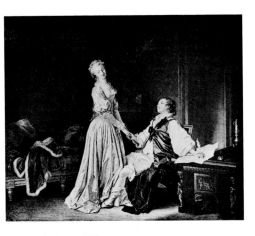

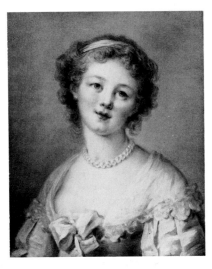

See p. 222; Pl. 278

A few slight variations distinguish this painting from that engraved by M. Blot (cat. no. L 13). One can, with caution, suggest Marguerite Gérard's participation in this version.

p. 116; Réau, 1956, p. 163; Wildenstein, 1960, no. 493; Wilhelm, 1960, p. 202; Thuillier, 1967, p. 55; Mandel, 1972, no. 522

See p. 212; Pl. 261 and cat. no. 377

size"); T. Emmerson sale, London, 1854; Collection Viscount Chaplin; J. Gylby Uppleby sale, Leeds, 1861; Wildenstein, New York; Collection R. Hearst; Collection Miss M. Davies; [C. Lederer – H. Lehrfeld] sale, Sotheby Parke Bernet, New York, November 28, 1962 (lot unknown)
Bibl.: Nolhac, 1906, p. 113; Wildenstein, 1960, no. 521; Mandel, 1972, no. 544

See cat. no. 379

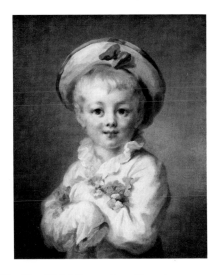

377 The Votive Offering to Love, or **The Invocation to Love**
C. 1785. New York, Private Collection. Canvas, 52 × 63 cm

Provenance: La Rochefoucauld-Liancourt sale, June 20, 1827, lot 23; Collection Duke de Polignac; Collection Wertheimer, London; Collection L. Neumann, London; Collection Mrs. Ferris-Thompson; Collection J. Bartholoni, Paris, 1921; Wildenstein, New York, 1923; Collection Mortimer L. Schiff; by descent to his widow, New York; Collection John M. Schiff, New York
Bibl.: Nolhac, 1906, p. 116; Wildenstein, 1921, no. 65; Réau, 1956, p. 164; Wildenstein, 1960, no. 491; Wilhelm, 1960, p. 203; Thuillier, 1967, pp. 135–37; Mandel, 1972, no. 520

See pp. 209–12; Pl. 258 and cat. no. 378.

379 The Child Dressed as Pierrot
c. 1785–88. London, Wallace Collection. Canvas, 61 × 51 cm

Provenance: Collection Marquess Eveillard de Livois (catalogue 1790, lot 245 together with its pendant, "the bust of a young boy seen life size dressed as Pierrot"); perhaps Mantion and Wagner sale, February 8, 1841, lot 65 ("Child as Pierrot," without measurements); C. Cope sale, Christie's, London, June 8, 1872, lot 34 (as Boucher, "Portrait of a boy as Pierrot"); Collection Sir Richard Wallace; Lady Wallace Bequest, 1897
Bibl.: Portalis, 1889, p. 285 ("Pierrot"); Nolhac, 1906, p. 114; Réau, 1956, p. 181; Wildenstein, 1960, no. 520; Wilhelm, 1960, p. 147; Mandel, 1972, no. 543

See p. 228; Pl. 289 and cat. no. 380

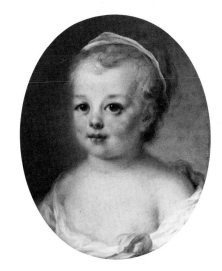

***381 Bust of a Child**
c. 1785–88. Hartford, (Conn.) Wadsworth Atheneum. Canvas, 39 × 31 cm

Provenance: Collection Ella Gallup Sumner and Mary Catlin Sumner; donated to the museum in 1957

The painting lacks vigor and charm; the attribution to Fragonard, however, can be maintained.

378 The Votive Offering to Love, or **The Invocation to Love**
c. 1785. Paris, The Louvre. Panel, 24 × 32.5 cm

Provenance: Walferdin sale, April 12–16, 1880, lot 28; Tabourier sale, June 20–22, 1898, lot 92; Dr. M. Audéoud Bequest, 1908
Bibl.: Portalis, 1889, p. 292; Nolhac, 1906,

380 The Girl with a Pearl Necklace
c. 1785–88. Private Collection. Canvas, 59 × 49 cm

Provenance: Collection Marquess Eveillard de Livois (catalogue, 1790, lot 245, together with its pendant, "the bust of a young and pretty girl, life

***382 Portrait of a Young Boy with a Plumed Hat**
c. 1785–88. Paris, Musée Cognacq-Jay. Oval canvas, 45 × 37 cm

Provenance: Carrier sale, March 9–10, 1846,

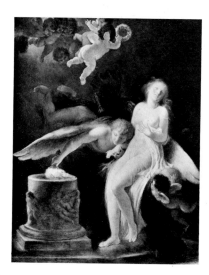

Almost certainly the version engraved by H. Gérard in 1793.

lot 92; N. Wildenstein; Mühlbacher sale, May 13–15, 1907, lot 22; Collection E. Cognacq
Bibl.: Portalis, 1889, p. 286; Nolhac, 1906, p. 115; Réau, 1956, p. 182; Wildenstein, 1960, no. 518; Mandel, 1972, no. 541; Burollet, 1980, no. 29

lot 4; Collection Count Cahen d'Anvers; Wildenstein, New York; Collection N. Ambatielos; Collection Grace Rainey Rogers; donated to the museum in 1942
Bibl.: Portalis, 1889, p. 281; Nolhac, 1906, p. 114; Wildenstein, 1960, no. 515; Mandel, 1972, no. 538; N. Coe Wixom, 1982, no. 30

See p. 228; Pl. 287

386 The Sacrifice of the Rose
c. 1788–90. Paris, Private Collection. Panel, 54 × 43 cm

Provenance: Probably Godefroy sale, December 14, 1813, lot 46 (51.3 × 41 cm); Vivant-Denon sale, May 1, 1826, lot 153 (idem); Brunet-Denon sale, February 2, 1846, lot 329; A. A. sale, March 31, 1882, lot 18; Count de Daupias sale, May 16–17, 1892, lot 14; perhaps S. sale, June 14, 1900, lot 5; Collection Deutsch de la Meurthe (according to Wildenstein); Wildenstein; Collection David-Weill (according to Wildenstein); Collection J. Bartholoni, 1921; P. Dutasta sale, June 3–4, 1926, lot 64; Collection Lesieur (according to Wildenstein); R. R. sale, June 5–6, 1946, lot 14
Bibl.: Goncourt, 1882, p. 327; Portalis, 1889, p. 288; Nolhac, 1906, p. 117; Wildenstein, 1921, no. 66; Réau, 1956, p. 164; Wildenstein, 1960, no. 497; Wilhelm, 1960, p. 199; Thuillier, 1967, pp. 54, and 136; Mandel, 1972, no. 526

This does indeed appear to be the painting in the Godefroy sale, explicitly noted as being on panel, but in which the young girl is described as "completely naked," whereas here she is covered by diaphanous drapery. The handling appears to be heavier and the light effect less subtle than that in our cat. no. 385, all of which would lead one to believe that Marguerite Gérard may have had a hand in the execution of this painting.

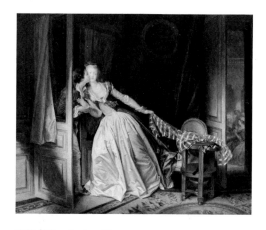

383 The Stolen Kiss
c. 1786–88. Leningrad, The Hermitage. Canvas, 45.1 × 54.8 cm

Provenance: Collection Stanislas-Auguste Poniatowski, king of Poland (1732–98); Łazieński Summer Palace, Warsaw in 1851
Bibl.: Portalis, 1889, p. 271; Nolhac, 1906, p. 124; Réau, 1956, p. 157; Wildenstein, 1960, no. 523; Wilhelm, 1960, p. 214; Thuillier, 1967, pp. 54, 72; Mandel, 1972, no. 546; Rosenberg-Compin, 1974, I, pp. 274–75; Rosenberg, 1984–85, no. 60

See pp. 224–25; Pl. 277

Engraved by N.-F. Regnault in 1788 as a pendant to *The Bolt*.

384 Portrait of a Young Boy, perhaps **Alexandre-Evariste Fragonard**
c. 1786–88 (?). The Cleveland Museum of Art. Panel, 21.2 × 17.2 cm

Provenance: Walferdin sale, April 12–16, 1880,

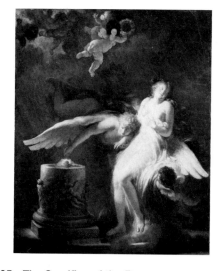

385 The Sacrifice of the Rose
c. 1788–90. California, Private Collection. Canvas, 65 × 54 cm

Provenance: Probably Collection Marguerite Gérard (perhaps previously owned by her brother, the engraver Henri Gérard); probably the painting mentioned in Marguerite Gérard's inventory in 1824 (Wells-Robertson, 1977, pp. 183, 186, n. 26); remained in the family until the middle of the nineteenth century (?); Collection E. Mir (in 1921); Private Collection, France; sale, Christie's, London, April 10, 1981, lot 64; Artemis group, London
Bibl.: Wildenstein, 1921, no. 293; Réau, 1956, p. 164 (history of provenance confused, see cat. no. 387); Wilhelm, 1960, p. 199 (cited); Artemis cat., London, 1982, no. 13

See p. 214; Pl. 265 and cat. nos. 386–87

***387 The Sacrifice of the Rose**
c. 1788–90. Buenos Aires, Museo Nacional de Arte Decorativo. Canvas, 65 × 54 cm
Provenance: Marquess de Forbin-Jeanson sale, June 12, 1840, lot 18; Collection C. Santamarina; Collection M. Quintana; S. Rodriguez de Quintana sale, Buenos Aires, November 22, 1930, lot 26; Collection Matias Errazuriz, 1930, purchased in 1937 by the government of Argentina to form the Museo Nacional de Arte Decorativo
Bibl.: Réau, 1956, p. 164 (history of the provenance confused, see cat. no. 385); Wildenstein, 1960, under no. 497; Wilhelm, 1960, p. 199 (cited)

Contrary to the other two versions (cat. nos. 385–86) the young woman is represented completely

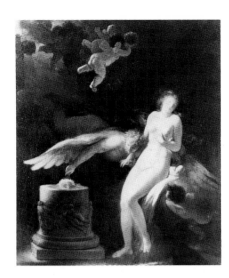

naked here. The quality seems weaker than in cat. no. 385, but it is difficult to make a definite judgment from a photograph.

388 The Sacrifice of the Rose

c. 1788–90. U.S.A., Private Collection. Canvas, 61 × 50 cm

Provenance: Walferdin sale, April 12–16, 1880, lot 57; Collection Count de Ganay, Paris, 1889; Collection Greffulhe, Paris; Collection Duke de Gramont; Collection Count C. de Gramont; sale, Christie's, London, June 25, 1971, lot 20; Wildenstein, New York

Bibl.: Portalis, 1889, p. 288; Nolhac, 1906, p. 117; Réau, 1956, p. 164; Wildenstein, 1960, no. 498; Wilhelm, 1960, p. 199 (cited); Mandel, 1972, no. 529; Sutton, 1980, no. 83

*389 The Sacrifice of the Rose, or The Offering to Love

c. 1788–90. U.S.A., Private Collection. Canvas, 33 × 24.8 cm

Provenance: Perhaps anonymous sale, February 11–12, 1842, lot 1 (neither support nor measurements stated); perhaps Destouches sale, March 4–5, 1847, lot 36; perhaps anonymous sale, February 27, 1852, lot 36; perhaps C. Marcille

sale, January 12–13, 1857, lot 54 (*Offering to Love*, without any indication of support or measurements); Walferdin sale, April 12–16, 1880, lot 58; Collection Mme. Paillard the widow, 1889; anonymous sale, April 9, 1892, lot 16; Collection C. Groult (according to Wildenstein); Wildenstein, New York

Bibl.: Goncourt, 1882, p. 327; Portalis, 1889, p. 288; Nolhac, 1906, p. 117; Wildenstein, 1960, no. 499; Mandel, 1972, no. 528

The authorship of this painting cannot be established with any certainty; see the beautiful watercolored drawing of the same composition which entered the Minneapolis Institute of Arts in 1983 (Pl. 266).

390 The Young Girl Forsaken, also called The Reverie, or Expectation, or The Age of Disillusionment

1790. New York, Frick Collection. Canvas, 317 × 197 cm

Provenance: Painted at Grasse in 1790 to complete the decoration of the Salon of Fragonard's cousin Maubert (see cat. nos. 239–42); for the rest of the provenance, see cat. nos. 239–42

Bibl.: Réau, 1956, p. 152; Wildenstein, 1960, no. 526; Wilhelm, 1960, p. 208; Cat. Frick Collection, 1968, p. 98; Mandel, 1972, no. 549

See p. 233; Pl. 292 and cat. nos. 239–42 and 391–99

391 Love the Sentinel

1790. New York, Frick Collection. Canvas, 150 × 120 cm

Provenance: See cat. no. 390
Bibl.: Wildenstein, 1960, no. 527; Cat. Frick Collection, 1968, p. 100; Mandel, 1972, no. 550

See cat. nos. 392–95

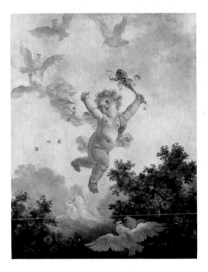

392 Love the Jester

1790. New York, Frick Collection. Canvas, 150.8 × 127.9 cm

Provenance: See cat. no. 390
Bibl.: Wildenstein, 1960, no. 528; Wilhelm, 1960, p. 207; Cat. Frick Collection, 1968, p. 100; Mandel, 1972, no. 551

See cat. nos. 391, 393–95

393 Love reaching for a dove, called Fickle Love

1790. New York, Frick Collection. Canvas, 151.4 × 121.2 cm

Provenance: See cat. no. 390
Bibl.: Wildenstein, 1960, no. 529; Wilhelm, 1960,

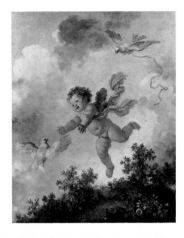

p. 206; Cat. Frick Collection, 1968, p. 100; Mandel, 1972, no. 552

See cat. nos. 391–92, 394–95

394 Love killing a dove, called **Cruel Love,** or **Love the Avenger**
1790. New York, Frick Collection. Canvas, 150 × 127 cm

Provenance: See cat. no. 390
Bibl.: Wildenstein, 1960, no. 531; Cat. Frick Collection, 1968, p. 100; Mandel, 1972, no. 544

See cat. nos. 391–93, 395

395 Love Triumphant

1790. New York, Frick Collection. Canvas, 318 × 142 cm

Provenance: See cat. no. 390
Bibl.: Wildenstein, 1960, no. 530; Cat. Frick Collection, 1968, p. 100; Mandel, 1972, no. 553

See cat. nos. 391–94

396–99 The Hollyhocks
1790. New York, Frick Collection. 2 canvases, 318 × 140 cm; 2 canvases, 318 × 63 cm

Provenance: See cat. no. 390
Bibl.: Wildenstein, 1960, nos. 532–35; Cat. Frick Collection, 1968, p. 102; Mandel, 1972, nos. 555–58

See p. 233; Pls. 294–95

400 Mother and her daughter in a park, called **Mother, the Lovely Nest!** (grisaille)
c. 1790. Paris, Private Collection. Canvas, 56 × 45.8 cm

Provenance: Collection Faucher-Maignan, Paris (in 1926, as Marguerite Gérard); Cailleux, Paris; Collection Vicountess Ward of Witley; sale, Christie's, London, December 11, 1981, lot 16; Agnew, London; sale, Christie's, South Kensington, London, July 17, 1986, lot 192

See p. 241; Pl. 300

***402 Portrait of a young girl holding a dove,** called **Portrait of Rosalie Fragonard**
c. 1790–92 (?). U.S.A., Private Collection. Oval canvas, 58.4 × 50.8 cm

Provenance: Collection Mme. d'Orbigny Bernon (according to Wildenstein); Collection Mlle. de la Gonterie (idem); Private Collection, Nantes (idem); Collection Countess La Morelie (idem); Wildenstein
Bibl.: Wildenstein, 1960, no. 510; Mandel, 1972, no. 533; Sutton, 1980, no. 86

The painting cannot be attributed to Fragonard with any great certainty; however, we know very little about the artist's final years, and one is at a loss to propose the name of another artist.

404 Portrait of a Child
c. 1790–95. Glasgow, Art Gallery and Museum. Panel, 1.84 × 1.56 cm

Provenance: Collection Archibald McLellan, Glasgow; bequeathed to the museum in 1854
Bibl.: Cat. *"French Paintings and Drawings,"* Art Gallery and Museum, Glasgow, 1985, p. 61 ("Style of J. H. Fragonard")

Pierre Rosenberg has graciously drawn our attention to this painting. Traditionally it is attributed to Jean-Baptiste Greuze; however, the first catalogue of the Collection McLellan (1855) significantly attributes it to "Fragonard after Greuze." The vibrant and delicate technique on a light ground seems to echo miniature painting on ivory.

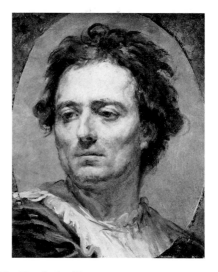

***401 Bust of a man,** called **Self-Portrait**
c. 1780–90 (?). U.S.A., Private Collection. Oval canvas, 63.5 × 52.7 cm

Provenance: Perhaps Z. Astruc sale, April 11–12, 1878, lot 23; anonymous sale, May 3, 1897, lot 39; Collection C. Groult, Paris
Bibl.: Wildenstein, 1960, no. 376; Mandel, 1972, no. 400; Sutton, 1980, no. 58

It is not certain that this beautiful portrait is by Fragonard, but the hypothesis that it is a late work by the artist can be put forward. The identification of the sitter as Fragonard is less than certain.

403 Bust of a Little Boy
c. 1790 (?). Private Collection. Oval canvas. 39.4 × 29.2 cm

Provenance: Perhaps Carrier sale, March 9–10, 1846, lot 93 (according to Daulte, 1954; but reported as "three-quarter view." This might be lot 94, "Life-size head of a child."); Collection Clifford Duits, London; Private Collection, Brussels
Bibl.: Daulte, 1954, no. 33

See Pl. 302 on p. 240

405 Head of a Man
c. 1790–95 (?). Private Collection. Canvas, 41 × 33 cm. Inscribed on the back: "Par Fragonard, souvenir de Pauline Bouchardy, donné à notre ami Monsieur Thiénon V. Joseph Bouchardy" (By Fragonard, in memory of Pauline Bouchardy, given to our friend Mr. Thiénon V. Joseph Bouchardy), according to the Groult sale catalogue, 1920.

Provenance: Collection J. Bouchardy; Collection Thénin; anonymous sale (?), 1884; lot 2 (ac-

cording to Wildenstein); [Groult] sale, June 21–22, 1920, lot 70 (attributed to Fragonard); Collection Calmann Lévy; Collection G. Calmann
Bibl.: Portalis, 1889, p. 290; Wildenstein, 1921, no. 39; Wildenstein, 1960, no. 238; Thuillier, 1967, pp. 79, 86; Mandel, 1972, no. 254

See Pl. 301 on p. 240

***406 A couple of lovers with a woman holding two children,** called **The Good Example**
c. 1790–1800 (?). Location unknown. Canvas, 32 × 24 cm

Provenance: Decourcelle sale, May 29–30, 1911, 55 ("English School of the 18th century")

The mediocre reproduction in the Decourcelle sale catalogue does not permit a definitive judgment.

407 Fragonard and a collaborator (Marguerite Gérard?) **Portrait of a Family**
c. 1795–98. Grasse, Musée Fragonard. Canvas, 91 × 71 cm

Provenance: Collection P. G. May (in 1926); P. Cailleux, Paris?; found in Germany after the Second World War; assigned to the Louvre by

the Office des Biens Privés; deposited in 1952 at the Musée Fragonard (as Marguerite Gérard)
Bibl.: Cuzin, 1986-I, pp. 63–64, 66, nn. 23–24

Engraved with variations under the title *Return from the Hunt* by H. Gérard as his sister Marguerite's creation. However the painting would seem, in part at least, to be the work of Fragonard, who probably collaborated on this with Marguerite Gérard (see p. 241).

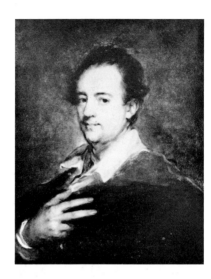

***408 Head of a Man**
c. 1800. Location unknown. Canvas, 80 × 63.5 cm

Provenance: Private Collection, Switzerland, in 1942; sale, Lucerne, Galerie Fischer, June 16–17, 1967, lot 226

See p. 241; Pl. 303

WORKS DONE IN COLLABORATION BY FRAGONARD AND MARGUERITE GÉRARD

(see also cat. nos. 376, 407)

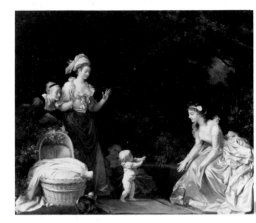

409 Fragonard and Marguerite Gérard
The First Step of Infancy
c. 1785. Cambridge, Mass., Fogg Art Museum. Canvas, 44 × 55 cm

Provenance: Perhaps O. sale, December 16–17, 1839, lot 89 together with its pendant (Fragonard: "Two very attractive paintings, one representing the first steps of infancy, the other a pastoral promenade," without measurements); de Rigny sale, June 2, 1857, lot 40; Pillot sale, December 6–8, 1858, lot 43; Collection Lord Rosebery, Mentmore, England; Wildenstein, New York; Collection Charles E. Dunlap, St. Louis, 1952; donated to the museum in 1961
Bibl.: Nolhac, 1906, p. 130; Wildenstein, 1960, no. 540; Wilhelm, 1960, p. 219; Mandel, 1972, no. 561; Rosenberg-Compin, 1974, II, p. 276 n. 59; Wells-Robertson, 1974, no. 71

See pp. 217–18; Pl. 270

Engraved by Vidal and Regnault in 1786 ("Painted by M. Fragonard and Mlle. Gérard"). As with cat. no. 410, the contribution of Fragonard to this painting appears to have been decisive. It should be noted that the sketches for the two paintings were sold under the single name of Fragonard (see cat. nos. L 201–2).

410 Fragonard and Marguerite Gérard
The Beloved Child, or **The Walk**
c. 1785. Cambridge, Mass., Fogg Art Museum. Canvas, 44 × 55 cm

Provenance: Perhaps O. sale, December 16–17, 1839, lot 89 (together with its pendant); de Rigny sale, June 2, 1857, Pillot sale, December 6–8, 1858, lot 46 together with its pendant. ("Figures by Mlle. Gérard, landscape by Fragonard"); Collection Lord Rosebery, Mentmore, England (?); Wildenstein, New York; Collection Charles E. Dunlap, New York, 1952; donated to the museum in 1961
Bibl.: Wildenstein, 1960, no. 541; Mandel, 1972, no. 563; Rosenberg-Compin, 1974, II, p. 276 n. 59

See pp. 218–21; Pl. 271

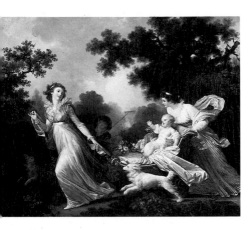

Engraved by Vidal in 1792 ("Painted by H. Fragonard and Mlle. Gérard"). See cat. no. 409.
Another larger version (canvas, 58 × 72 cm) from the Marquess de Saint-Marc sale (February 23, 1859, lot 6) passed through the Count de S. sale (December 5, 1928, lot 11: *The Chariot*, attributed to Marguerite Gérard).
From the photograph in this sale catalogue the painting appears to be of quite good quality, though nevertheless inferior to the Cambridge painting, and it may well be the work of Marguerite Gérard alone.

411 Fragonard and Marguerite Gérard
Young woman playing the guitar near a cradle, called Sleep My Child
c. 1788. Karlsruhe, Staatliche Kunsthalle. Canvas, 55 × 45 cm. Signed, bottom right: *Mte. Gérard*

Provenance: Villers sale, December 2, 1795, lot 6 ("Fragonard and Citizen Gérard. A young woman standing, plucking a guitar near a sleeping child; an Apartment in the background completes the composition. This subject, which is very movingly painted, is known from the engraving made after it and entitled: *Sleep my Child.*" [canvas, 54 × 43 cm]); Collection J. Maitland, Woodford Hall, Essex; sale, Christie's, London, July 30, 1831, lot 62; Collection Lord Chesterfield; Collection Earl of Carnarvon, 1960; Collection Lord Samuel; Speelman, London; acquired in 1979
Bibl.: Wildenstein, 1960, no. 545; Wilhelm, 1960, p. 212; Mandel, 1972, no. 568

See p. 221; Pl. 272

Engraved by H. Gérard (in 1789 according to the annotation in pencil on the proof in the Bibliothèque Nationale, Paris) under the title *Sleep My Child*, and with the note "M^te Gerard pinxit."
The head and the bust of the young woman manifestly recalls Fragonard's style; the collaboration is attested to by the text in the 1795 sale catalogue.

412 Fragonard and Marguerite Gérard
The Sleeping Child
c. 1788. Private Collection. Canvas, 45.5 × 37 cm inclusive, signed, bottom left: *Fragonard*

Provenance: Clos sale, November 18–14, 1812 lot. 9; Collection Magniac; sale, Christie's, 1892; Collection Lord Astor; Collection Lady Nicholls; E. Speelman, London (in 1962)
Bibl.: "Notable Works of Art now on the Market," *The Burlington Magazine,* December, 1962

See p. 221; Pl. 274

The catalogue for the Clos sale indicates that this painting "is engraved unter the title *Don't Wake the Sleeping Child*"; however, we are not familiar with this engraving.

413 *Fragonard and Marguerite Gérard*
Young woman reading a letter brought to her by a pageboy, called The Present
c. 1786–87 (?). Leningrad, The Hermitage. Canvas, 55 × 45 cm

Provenance: Perhaps Collection P.-J. Bergeret; Villers sale, December 2, 1795, lot 7, (together with a pendant. See cat. no. L 208, under the names of Fragonard and Citizen Gérard); Collection Cheremetiev, St. Petersburg; Museum of Social and Domestic Life, Leningrad; entered the Hermitage in 1931
Bibl.: Wildenstein, 1960, no. 543 (as lost); Wilhelm, 1960, p. 213 (as lost); Berezina, 1983, no. 193 (as Marguerite Gérard)

See p. 221; Pl. 273 and cat. no. L 208

Engraved by G. Vidal (in 1788 according to the

annotation in pencil on the proof in the Biliothèque Nationale, Paris) under the title *The Present* and as being after Marguerite Gérard: one of the states of this engraving carries the dedication, "à Messire Pierre de Bergeret, Chevalier Seigneur de la Comté de Négrepelisse, Receveur générale des Finances de sa Majesté de la Généralité de Montaubaun" (to Mr. Pierre de Bergeret, Count of Négrepelisse, General Treasurer to His Majesty in the County of Montauban). This dedication does not necessarily mean that the painting belonged to Bergeret the Younger, but it is interesting in that it gives new proof of the friendship between the Fragonards and the Bergeret family.

414 Fragonard and Marguerite Gérard
The Reading
c. 1785–86 (?). Cambridge, Fitzwilliam Museum. Canvas, 64.8 × 53.8 cm

Provenance: [Chamgrand, St. Maurice] sale, March 20, 1787, lot 229 (together with a pendant, see L 210, as "Mlle. Gérard, pupil of M. Fragonard's"); Collection C. Brinsley, Marlay; Brinsley Bequest to the museum, 1912

See p. 222 and cat. no. L 210

The young girl on the left certainly seems to betray the traits of Fragonard's style and touch.

415 Fragonard and Marguerite Gérard
Young couple reading letters, called **I Reread Them with Pleasure**
c. 1788. Private Collection. Canvas, 30 × 39 cm

Provenance: Galerie E. Jonas, New York–Paris, 1928; Collection Fritz Thyssen, Mühlheim; Collection Countess Zichy-Thyssen
Bibl.: Exh. cat. *Sammlung Fritz Thyssen*, Munich, Bayerisches Nationalmuseum, 1986, no. 18

See p. 222; Pl. 276

Fragonard's intervention is clearly evident in the face of the young man.

OTHER WORKS BY MARGUERITE GÉRARD IN WHICH FRAGONARD MAY HAVE PARTICIPATED EITHER IN THE CONCEPTION OR THE EXECUTION

***416** Marguerite Gérard (and Fragonard?)
Young woman holding a cat, called **The Triumph of Minette**
c. 1785. Moscow, Pushkin Museum. Canvas, 60 × 49 cm

Provenance: Collet sale, May 14, 1787, lot 311 a; Dubois sale, December 15, 1788, lot 95; Collection Prince Youssoupov (cat. 1839, lot 181)
Bibl.: Ernst, 1924, p. 184; Wilhelm, 1960, p. 210

Engraved by G. Vidal in 1786 under the title *The Triumph of Minette* and with the note "Mlle. Gérard pupil of M. Fragonard pinx."

***417** Marguerite Gérard (and Fragonard?)
The Cherished Bird
c. 1785–90. Private Collection. Canvas, 53 × 42 cm

Provenance: Collection E. Jonas, Paris, 1928 (advertised in *Le Gaulois artistique*, November 17, 1928)
Bibl.: Réau, 1956, pp. 164–67

***418** Marguerite Gérard (and Fragonard?)
Young women and children playing in a park, called **The Caresses of Innocence**
c. 1790–95. Private Collection. Canvas, 45.5 × 54.5 cm. Signed, bottom right: *Mlle Gérard*

Provenance: Collection Baron Donino, Paris; Cailleux, Paris; Collection Mrs. L. Peyton Green, Los Angeles (in 1956), (catalogue of her collection by W. R. Valentier, 1956, no. 35)

Engraved by H. Gérard (in 1799 according to the annotation in pencil on the proof in the Bibliothèque Nationale, Paris) under the title *The Caresses of Innocence* and with the note: "M. Gérard pinx.".
The collaboration with Fragonard seems quite feasible, particularly in the landscape.

***419** Marguerite Gérard (and Fragonard?)
The Childhood of Paul and Virginia
c. 1790–95. U.S.A., Private Collection. Canvas, 44.5 × 55.2 cm

Provenance: Wildenstein, New York (exh. cat. *Art in Early 19th-Century France*, April, 1982, no. 38)

***420** Marguerite Gérard (and Fragonard?)
The First Caresses of the Day
c. 1790–95. Private Collection. Canvas, 60 × 46 cm

Provenance: Sale, Rouen, November 30, 1980, lot 8

Lost Paintings

L 1 Annette at the Age of Fifteen
c. 1764–66. Lost. Canvas

Provenance: See cat. no. 106 (until 1787); the measurements 36.4 × 46 cm are given in the catalogue of the Boulogne sale in 1787
Bibl.: Goncourt, 1882 ed., p. 338; Portalis, 1889, p. 271; Nolhac, 1906, p. 142; Wildenstein, 1960, no. 128; Thuillier, 1967, p. 50; Mandel, 1972, no. 160

See p. 000 and cat. no. 106

Engraved by F. Godefroy together with its pendant (cat. no. 106) in 1772. According to the Boulogne sale catalogue (1787), the two paintings were also engraved by G. Marchand. The subject has been taken from Annette and Lubin in *Contes Moraux* by Jean-François Marmontel (1762).
The painting seems to have been lost since the Boulogne sale (1787). The Witt Library in London has a photograph of a painting given to Casanova, of the same composition and in the same direction as the engraving formerly on the London art market (Walker Gallery).

L 2 Young couple kissing, called The Kiss on the Mouth

c. 1770 (?). Perhaps oval canvas

Provenance: Collection Jallier
Bibl.: Goncourt, 1882 ed., p. 328; Portalis, 1889, p. 271; Wildenstein, 1960, under nos. 260–66; Mandel, 1972, no. 307

Engraved as a pendant to *The Kiss on the Neck* by G. Marchand with the note *Fragonard pin* and a dedication to "Monsieur le comte de la Tour d'Auvergne" (Count Tour d'Auvergne). The lost painting was probably a pendant to our cat. no. 201, if the latter is authentic. The version that passed through the sale in 1981 (Sotheby's, Monaco, October 26, lot 525) appears to only be a copy. The original may have been a pastel (see cat. no. 201).

L 3 The Glass of Water
c. 1770 (?) Canvas

Provenance: [Nogaret] sale, February 23, 1778, lot 50 ("Two women, one of whom is lying naked on a bed, in a charming manner, and a third one is playing tricks on them and throwing water, of oval shape…" [37.8 × 45.9 cm]);
Baron de Saint-Julian sale, February 14, 1785, lot 109 ("A young girl lying on a bed, while another tries to lift the covers, a third one is hiding behind a curtain to throw water on her. This painting, which is only a sketch, is of oval shape." [43.2 × 37.8 cm]); Collection M.G. Mühlbacher (in 1889, according to Portalis)
Bibl.: Goncourt, 1882 ed., p. 329; Portalis, 1889, p. 290 (square canvas but enclosing the subject in an oval shape); Nolhac, 1906, p. 120; Wildenstein, 1960, no. 285; Mandel, 1972, no. 303

Engraved by N. Ponce. The engraving appeared in 1787. See also no. L 56.

L 4 Young girl on her bed playing with a dog, called The Ring Biscuit
c. 1775 (?), Canvas

Provenance: Does not figure, as Wildenstein indicates, in the Varanchan sale, December 29–30, 1777, lot 32; anonymous [Bezenval] sale,

August 10, 1795, lot 77; anonymous sale, October 10, 1834, lot 58 (according to Wildenstein)
Bibl.: Goncourt, 1882 ed., p. 329; Wildenstein, 1960, no. 281; Mandel, 1972, no. 299

Engraved in 1783 by Bertony with the dedication to Baron de Bezenval.

L 5 A Lady Carving Her Name, or Angelica and Medor, or The Fair Julia
c. 1775–78. Panel

Provenance: [Calonne] sale, April 21, 1788, lot 174 ("Angelica writing the name of Medor on a tree. This painting has a striking effect and is full of charm" [31 × 22.9 cm]);
Mme. Goman sale, March 24, 1792, lot 99 ("A painting representing a young woman seated near a tree, busy writing the name of her lover; near her is a litte Spanish dog. This pretty composition is known under the title *The Fair Julia*." [32 × 24.3 cm])
Bibl.: Goncourt, 1882 ed., p. 320; Portalis, 1889, p. 273; Nolhac, 1906, p. 151; Wildenstein, 1960, no. 389; Mandel, 1972, no. 415

This painting appears to be very similar to that in the Wallace Collection (cat. no. 310). One cannot totally exclude the possibility that it is the same

341

painting but with the frame included in the measurements.
Engraved by N. de Launay (Salon of 1787).

L 6 The Favorable Inspiration
c. 1770–77. Oval canvas

Provenance: anonymous sale, December 15, 1777, lot 109 ("A painting of oval shape, it represents a young woman seen half-length, leaning against a table at which she is writing: Cupid appears, gives her a kiss, and presents her with an arrow for her to hold instead of the pen; this piece, a sketch finished in the first sitting, has been vigorously rendered and is full of charming expression and an astonishing dexterity." [43.2 × 35.1 cm])
Bibl.: Portalis, 1889, p. 281; Nolhac, 1906, p. 160 ("Sappho or Study guided by Cupid"); Wildenstein, 1960, no. 423; Mandel, 1972, no. 449

Engraved by Louis-Michel Halbou under the title *The Favorable Inspiration.* The composition, close to that of *Sappho and Cupid* (cat. nos. 355–58 and L 10), could be slightly earlier.

L 7 The Swaddled Cat, or The Child and the Cat
c. 1775–78. Canvas

Provenance: Silvestre sale, April 17, 1778, lot 55 (92 × 67 cm); anonymous [de Ghendt?] sale, November 15, 1779, lot 37 ("A young Child with a cat that he has swaddled. Behind him is a large column; two dogs and another child who watch him; this painting, executed in the style of Rubens and of a charming composition, is on canvas." [89.3 × 72.9 cm]); anonymous sale, November 25, 1782, lot 54 ("A Child seated at the base of a Column, dressed in white, wearing a plumed red bonnet, playing with a swaddled cat which he holds in his arms; on the left can be seen another child attentively watching him, with his hand resting on a greyhound and the other on a column; to the right is another dog." [89.3 × 70.2 cm])
Bibl.: Goncourt, 1882 ed., p. 317; Wildenstein, 1960, no. 474; Mandel, 1972, no. 499

Engraved by Marguerite Gérard (and Fragonard?) in 1778 (Wildenstein, 1956, no. XXVI).

L 8 Child with Punch, called Mr. Fanfan
c. 1775–78 (or c. 1780–82?). Canvas

Provenance: Leroy de Senneville sale, April 5, 1780, lot 54 ("A young Child, represented standing in a chemise, holding a Punch; he seems to be running away from two little dogs who follow him trying to bite the doll he is holding under his arm. This piece, as charming as possible, is full of grace in the gestures and the character of the head of the child; added to the free and intelligent handling, is a light and transparent color tone." [89.3 × 70.2 cm]); Reber sale, Basel, 1810, lot 953 (according to Wildenstein)
Bibl.: Nolhac, 1906, p. 130; Wildenstein, 1960, no. 475; Mandel, 1972, no. 500

Engraved by Marguerite Gérard (and Fragonard?) (Wildenstein, 1956, nos. XXIX–XXX). See cat. no. 367. The identification of the child with the artist's son (b. 1780) has to be excluded, even though one state of the engraving bears the inscription "Mosieur [sic] Fanfan jouant avec Monsieur Polichinelle et Compagnie" (Mr. Fanfan playing with Mr. Polichinelle and Company); the fact that it was put up for auction in April of this year makes the hypothesis untenable.

L 9 The Big Happy Family, also called The Mother of the Family
c. 1776–77. Oval canvas, 29 × 32 cm (according to Wildenstein)

Provenance: Collection Servat, 1777
Bibl.: Goncourt, 1882 ed., p. 331; Portalis, 1889, p. 279; Wildenstein, 1960, no. 367; Mandel, 1972, no. 391

Engraved by N. de Launay with a dedication to Cochin and the remark "taken from M. Servat's Collection." This engraving serves as a pendant to that of *Say Please* (cat. no. L 11), also by de Launay. The plate we are reproducing is a first state (Collection Rothschild, Louvre). See also cat. nos. 311–13 and L 145 a.

L 10 Sappho and Cupid
c. 1780. Oval canvas

Provenance: Marques de Véri sale, December 12, 1785, lot 38 ("A painting of oval shape, representing Sappho, to whom Cupid offers one of his arrows to write of what inspires her. She is seen full face, her throat bare and her head crowned with laurels. This graceful piece is bright with color and of an ingenious composition." [62.1 × 51.3 cm]); [Saubert and Desmarest] sale, March 17, 1789, lot 95 (same description and measurements as in the preceding sale); A. de Saint-Aubin sale, April 4, 1808, lot 4 ("Sappho inspired by Cupid, ready to write some verse with an arrow from the God of Cythera." [58.7 × 47.2 cm])
Bibl.: Goncourt, 1882 ed., pp. 326, 328; Portalis, 1889, p. 288; Nolhac, 1906, p. 161; Wildenstein, 1960, no. 424; Mandel, 1972, no. 450

Engraved by Angélique Papavoine (engraving advertised in 1788). See also cat. nos. 355–58.

L 11 Say "Please"
c. 1780

Provenance: Perhaps [Saubert and Desmarest] sale, March 17, 1789, lot 94 ("Two paintings by this Master, one of which is engraved under the title *Say 'please'*..." [27 × 37.8 cm]
Bibl.: Portalis, 1889, p. 275; Wildenstein, 1960, no. 469; Mandel, 1972, no. 493

Engraved in 1783 by N. de Launay with a dedication to the Marquise d'Ambert. See also cat. nos. 348–50.

L 12 The Useless Resistance
c. 1775–78

Provenance: unknown

Engraved by Vidal and by Regnault.
The many variations that exist of this composition and the painting in San Francisco (cat. no. 305) lead one to wonder whether the engravings were not based on a painting that is now lost. We might mention Cupid replacing the young assailant, the figure behind the young woman, the stool with sphinx-shaped feet. However, since the painting does not figure in any of the old sales, its existence must remain uncertain: perhaps the alterations were made by the engraver.

L 13 The Contract, also called The Promise of Marriage
c. 1785

Bibl.: Goncourt, 1882 ed., p. 331; Wildenstein, 1960, no. 522; Wilhelm, 1960, p. 209 (cited); Thuillier, 1967, p. 54; Mandel, 1972, no. 545; Rosenberg-Compin, 1974, II, pp. 273–74

Engraved by Maurice Blot under the title *The Contract* and with the inscription *Fragonard pinxit,* publicized in 1786, it only appeared in 1792. Blot's engraving depicts, at the back of the room, two engravings after Fragonard, *The Bolt* (cat. no. 336) and the *Wardrobe*, engraved by Fragonard himself in 1778. See cat. no. 376.

L 14 News of the Return
c. 1785 (?).

Provenance: [Chamgrand, Saint-Maurice] sale, March 20, 1787, lot 223 ("An interior of an apartment with a pretty woman dressed in clothes of silk, in a most charming costume: she is shown seated by a table, on which is placed a portrait that seems to interest her and in her right hand she holds a letter which she appears to be reading; on a footstool, to her left, can be seen a spaniel, symbolizing Fidelity," [48.6 × 37.8 cm] by Fragonard); probably Mesnard de Clesle sale, January 2, 1804, lot 12 (by M. Gérard)
Bibl.: Goncourt, 1882 ed., p. 331; Nolhac, 1906, p. 147; Wildenstein, 1960, no. 392 (as *The Letter*); Mandel, 1972, no. 417

Engraved by Louis-Charles Ruotte, with the inscription *Fragonard pinxit,* and under the title *News of the Return* (perhaps the engraving exhibited at the Salon of 1793, no. 429).

L 15 Study of a Man
1758 (?).

Provenance: Sent from Rome to the Académie Royale in Paris in May 1758
Bibl.: *Correspondance des directeurs*, vol. XI, pp. 210, 216; Wildenstein, 1960, no. 98; Mandel, 1972, no. 106

See p. 41

L 16 Head of a Priestess
1758 (?).

Provenance: Sent from Rome to the Académie Royale in Paris in May 1758
Bibl.: *Correspondance des directeurs*, Vol. XI, pp. 210, 216; Wildenstein, 1960, no. 97; Thuillier, 1967, p. 47; Mandel, 1972, no. 105

See p. 42

The *Head of a Vestal Virgin* (cat. no. 127) seems to be notably later and cannot be identified with this painting.

L 17 Study of a Man
1759

Provenance: Sent from Rome to the Académie Royale in Paris in August, 1759
Bibl.: *Correspondance des directeurs*, Vol. XI, pp. 294–95, 313; Wildenstein, 1960, no. 99; Mandel, 1972, no. 107

This could not be the study, of small dimensions, which passed through the Vouge sale (see cat. no. L 101): the studies sent from Rome by the students were of a much larger size.

L 18 St. Paul Regaining His Sight, after Pietro da Cortona
1759

Provenance: Sent from Rome to the Académie Royale in Paris in October 1759
Bibl.: *Correspondance des directeurs*, Vol. XI, p. 239; Wildenstein, 1960, no. 100; Thuillier, 1967, pp. 47, 66; Mandel, 1972, no. 108

See pp. 45 and 48

L 19 Girl with a Broom, after Rembrandt
Canvas

Provenance: Deshays sale, March 26, 1765, lot 138 (together with its pendant, see cat. no. L 20; [92 × 72 cm]); Boucher sale, February 18, 1771, lot 112 ("A Savoyarde who is holding her broomstick between her arms." [91.6 × 64.9 cm])
Bibl.: Portalis, 1889, p. 274; Wildenstein, 1960, no. 2; Mandel, 1972, no. 2

Pendant to cat. no. L 20. A copy of the painting

by Rembrandt is now in the National Gallery of Art, Washington, D.C.

L 20 Danaë, after Rembrandt
Canvas

Provenance: Deshays sale, March 26, 1765, lot 138 (together with its pendant, see cat. no. L 19 [92 × 72 cm])
Bibl.: Portalis, 1889, p. 274; Wildenstein, 1960, no. 3; Mandel, 1972, no. 3

May be a partial copy of the painting in the Hermitage, Leningrad, the format of which is horizontal? Pendant to cat. no. L 19.

L 21 Landscape, or **Herdsman Standing on a Knoll**, also called **The Shepherds**
1765, or slightly earlier

Provenance: Exhibited at the Salon of 1765 ("Landscape, Collection Bergeret de Grancourt." [59.4 × 48.6 cm])
Bibl.: Goncourt, 1882 ed., pp. 317–18; Portalis, 1889, p. 284; Wildenstein 1960, no. 153; Seznec and Adhémar, 1960, pp. 43, 198, 200; Mandel, 1972, no. 169

Probably of identical composition—but of slightly larger measurements—to the two existing paintings entitled *The Shepherds* (cat. nos. 107–8), the description given by Diderot (Salon of 1765) would also appear to correspond with them. However, he writes of "terraces" which is surprising. But the measurements given in the Salon catalogue may include the frame: in that case no. 107 or no. 108 might be identified with the painting in the Salon.

L 22 Night
1766–67

Provenance: Commissioned in 1761 (or 1767) by Marigny for the Château de Bellevue (overdoor intended for the gaming room); "Night represented by Diana, in a chariot drawn by hinds, preceded by Night who spreads out her star-spangled veil and is followed by Dreams"; apparently never executed
Bibl.: Engerand, 1901, p. 195; Furcy-Raynaud, 1904–5, p. 51; Wildenstein, 1960, no. 235; Mandel, 1972, no. 252

L 23 Day
1766–67

Provenance: See cat. L 22; "Day represented by Apollo in his chariot, preceded by Aurora who is scattering Flowers and is followed by the Hours"; apparently never executed
Bibl.: Engerand, 1901, p. 195; Furcy-Raynaud, 1904–5, p. 53; Wildenstein, 1960, no. 236; Mandel, 1972, no. 253

L 23 a Decoration for a ceiling of the Chancellerie d'Orléans (subject unknown)
c. 1767–69

See p. 141

L 24–25 Two overdoors (probably **Africa** and **America**)
1770

Provenance: Commissioned in 1770 from Fragonard by the Director of the Painters to the King for royal buildings and intended for the dining room of the state apartements at Versailles, where they were to serve as pendants to *Europe* and *Asia* by J.-B. Huet; apparently never executed
Bibl.: Engerand, 1901, pp. 195, 235; Wildenstein, 1960, no. 294; Thuillier, 1967, p. 27; Mandel, 1972, nos. 317–18

L 26 Seated Philosopher
Canvas

Provenance: [Baudouin] sale, February 15, 1770, lot 35 ("A Philosopher seated, his right elbow resting on a stone pedestal, his head leaning on his hand: this very attractive painting with a light and fluent touch has been painted on canvas…" [99.7 × 66.7 cm])
Bibl.: Portalis, 1889, p. 285; Wildenstein, 1960, no. 195; Mandel, 1972, no. 206

Wildenstein identifies this painting with lot 40 in the anonymous sale of the November 22–23, 1837.

L 27 An old man, half-length
Canvas

Provenance: [Baudouin] sale, February 15, 1770, lot 36 ("A beautiful old man, his closed fists resting on the table, half-length figure…" [72.9 × 56.6 cm])
Bibl.: Portalis, 1889, p. 291; Wildenstein, 1960, no. 200; Mandel, 1972, no. 211

L 28 Head of an old man, full face
Canvas

Provenance: [Baudouin] sale, February 15, 1770, lot 37 ("A head of an old man, seen full face." [39.1 × 32.4 cm])
Bibl.: Portalis, 1889, p. 290; Nolhac, 1906, p. 112; Wildenstein, 1960, no. 197; Mandel, 1972, no. 208

Identified by Wildenstein with cat. no. 164.

L 29 A head seen in three-quarter view

Provenance: [Baudouin] sale, February 15, 1770, lot 38 ("Another head seen from a three-quarter view, it is under glass," support not specified [36.4 × 29.7 cm])
Bibl.: Wildenstein, 1960, no. 203; Mandel, 1972, no. 214

The description in the 1770 sale catalogue is very imprecise. Even though the picture is included among the paintings, the fact that it is under glass would lead one to believe that it may have been a pastel.

L 30 The recreation after the picnic in the park
Canvas

Provenance: [Baudouin] sale, February 15, 1770, lot 39 ("A recreation after a picnic, in a Garden…" [36.4 × 44.5 cm])
Bibl.: Wildenstein, 1960, under no. 445

Probably cannot be identified, as Wildenstein does (W, no. 445), with the *Blindman's Buff* in the Louvre (cat. no. 322).

L 31 A man and a woman sleeping in a hut
Canvas

Provenance: [Baudouin] sale, February 15, 1770, lot 40 ("A man and a woman who are sleeping." [69 × 88 cm]); [Varanchan] sale, November 29–30, 1777, lot 17 ("A countryman's hut, built against the ruins of an Italian monument: in this spot, hit by a shaft of light, a man and a woman can be seen asleep beside a large dog; this sketch was done at one sitting." [70.2 × 92 cm])
Bibl.: Portalis, 1889, pp. 274, 279; Nolhac, 1906, p. 144; Wildenstein, 1960, no. 121; Mandel, 1972, no. 131

L 32 Pastoral scene
Canvas

Provenance: [Blondel d'Azincourt] sale, April 18, 1770, lot 37 ("A pastoral scene composed of three figures, in a garden…" [63.4 × 74.2 cm])
Bibl.: Wildenstein, 1960, no. 44; Mandel, 1972, no. 50

L 33 The Lyric Dance
Canvas

Provenance: Favre sale, January 11, 1773, lot 90 ("The Lyric Dance, represented by a lady dressed in white, accompanied by several Cupids in a pleasing landscape." [54 × 48.6 cm])
Bibl.: Portalis, 1889, pp. 274–75; Nolhac, 1906, p. 159; Wildenstein, 1960, no. 309; Mandel, 1972, no. 329

L 34 The Virgin and Child (in an ornamental cartouche with flowers by Daniel Seghers [1590–1661])
Panel

Provenance: Vassal de Saint-Hubert] sale, January 17–21, 1774, lot 18 ("Daniel Seghers and Fragonard: an ornamental cartouche with beautiful flowers of different species, by Seghers; in the middle M. Fragonard has very skillfully placed the Virgin, seated, holding the Infant Jesus." [Panel, 55.3 × 47.2 cm]); Conti sale, April 8, 1777, lot 759; Dulac sale, November 30, 1778, lot 167; anonymous sale, January 22, 1877, lot 22 (according to Wildenstein)
Bibl.: Goncourt, 1882, p. 325; Portalis, 1889, p. 291; Nolhac, 1906, p. 166; Wildenstein, 1960, no. 20; Mandel, 1972, no. 21

L 35 Woman playing the hurdy-gurdy, called **Fanchon the Hurdy-Gurdy Player**
Copper

Provenance: [Vassal de Saint-Hubert] sale, January 17–21, 1774, lot 106 ("A painting on copper of the same size as the preceding one and which was executed as a pendant [Siméon Chardin, *A Patient at the Hospital for the Blind*, 28.3 × 18 cm], it represents a hurdy-gurdy player leaning against a post, two little dogs play near a pillar in the Background..."); anonymous sale, May 30, 1799, lot 36 ("a young girl wearing a kerchief and playing the hurdy-gurdy")
Bibl.: Portalis, 1889, p. 281; Wildenstein, 1960, no. 42; Mandel, 1972, no. 43

For another, larger version see cat. no. 365.

L 36 The Visitation
Canvas mounted on panel (?)

Provenance: [Duke de Grammont] sale, January 16, 1775, lot 81 (Canvas, 40.5 × 55.3 cm); Randon de Boisset sale, February 27, 1777, lot 226; [Lambert and du Porail] sale, March 27, 1787, lot 221; [Vaudreuil] sale, November 26, 1787, lot 109; perhaps Calonne sale, London, March 23, 1795, lot 24 (without measurements)
Bibl.: Goncourt, 1882, p. 323; Portalis, 1889, p. 291; Nolhac, 1906, p. 165; Wildenstein, 1960, no. 16; Wilhelm, 1960, p. 14; Thuillier, 1967, pp. 50, 107; Mandel, 1972, no. 14

Seems to have been mounted on panel since the Lambert and du Porail sale.
A picture of the same subject in the Carrier sale (March 9–10, 1846, lot 91) may be identified with this painting or with one of the three other versions (cat. nos. 269–71).

L 37 A man and a woman leading animals
Canvas

Provenance: [Duke de Grammont] sale, January 16, 1775, lot 82 (54 × 40 cm), together with its pendant, (cat. no. L 38)
Bibl.: Portalis, 1889, p. 279; Wildenstein, 1960, no. 157; Mandel, 1972, no. 175

L 38 A man playing a flageolet beside a woman
Canvas

Provenance: [Duke de Grammont] sale, January 16, 1775, lot 82, together with its pendant, cat. no. L 37): ("A man playing a flageolet beside a woman; a shepherd watches them; there are some sheep and a cow." [54 × 40 cm])
Bibl.: Portalis, 1889, p. 279; Wildenstein, 1960, no. 156; Mandel, 1972, no. 174

L 39 Ruth and Boaz
Copper

Provenance: Probably [Duke de Grammont] sale, January 16, 1775, lot 83 ("A subject from the Old Testament... in the style of Adam Elsheimer. It is painted on panel."); anonymous sale, December 15, 1777, lot 56 ("A painting full of finesse and expressiveness. It represents Boaz and Ruth: in the Background is a house illuminated by a shaft of light; several other figures, some clumps of trees, and fine distant prospects com-

plete this exquisite and interesting composition." [9.4 × 18.9 cm]); [Vieux-Villier] sale, December 20, 1781, lot 100 ("Boaz who marries Ruth. In the foreground can be seen the two main figures, and on different planes of the picture are several other very small figures: the background of the Painting is decorated with landscape and mountains. [18.9 × 10.8 cm] This painting was made as a pendant to an Adam Elsheimer and has been painted with the greatest of care."); perhaps Barroilhet sale, March 10, 1856, lot 24 (the support and measurements are not given)
Bibl.: Nolhac, 1906, p. 164; Wildenstein, 1960, no. 212; Mandel, 1972, no. 223

L 40–41 Head of a Fair-haired Woman
Head of a Dark-haired Woman
Canvas

Provenance: Marquess' de Lassay sale, May 17, 1775, lot 103 ("Two heads of women forming pendants; one is fair the the other dark." [43.2 × 36.4 cm])
Bibl.: Wildenstein, 1960, nos. 347–48; Mandel, 1972, nos. 367–68

L 42 Love the Sentinel
Oval canvas

Provenance: Marquess [d'Arcambal] sale, February 22, 1776, lot 87 ("not very finished..." [54 × 43 cm]); anonymous [Baché, Brilliant, de Cossé, Quenet] sale, April 22, 1776, lot 93, (54 × 40.5 cm); Randon de Boisset sale, March 14, 1777, lot 228 (53.4 × 43.2 cm); Prince de Conti sale, April 8, 1777, lot 754 (54 × 43.2 cm); Mlle. Laguerre sale, April 10, 1782, lot 1
Bibl.: Portalis, 1889, p. 270; Nolhac, 1906, p. 156; Wildenstein, 1960, no. 317; Mandel, 1972, no. 337

The rapid succession of sales in the years 1776–77 leads us to believe that we are cataloguing several versions of this painting.

L 43 Vestal virgin seen in half-length
Oval canvas

Provenance: Anonymous [du Barry?] sale, March 11, 1776, lot 78 ("A young Vestal virgin seen in half-length. She is surrounded by roses and holds a garland in her hands; behind her is an altar on which a holy fire is burning. This painting is of oval shape..." [70.2 × 56.7 cm])
Bibl.: Wildenstein, 1960, no. 406; Mandel, 1972, no. 430

L 44 Four Cupids on Clouds
Canvas

Provenance: Anonymous [du Barry?] sale, March 11, 1776, lot 78a ("A sketch of several Cupids grouped together on clouds. Two can be seen who appear to be embracing each other." [Canvas, 62.1 × 48.6 cm]); anonymous [Baché,

Brilliant, de Cossé, Quenet] sale, April 22, 1776, lot 94 (the same measurements and description: "This painting, done in Italy and of great merit, is worked like a Poussin."); Vassal de Saint-Hubert sale, April 24, 1783, lot 65 (56.5 × 45.5 cm); Collection de Rémy, artist, who exhibited it at the Salon de la Correspondance, January, 1786, lot 25; Messrs. du C[arteaux] and S[avalet] sale, May 2, 1791, lot 160
Bibl.: Goncourt, 1882, p. 318; Nolhac, 1906, p. 158; Wildenstein, 1960, no. 61

L 45 Children Holding Flowers (sketch for a ceiling)

Provenance: [Jombert] sale, April 15, 1776, lot 42 ("A ceiling painted by H. Fragonard: it consists of architectural ornaments with children holding garlands of flowers." [64.9 × 81.1 cm])
Bibl.: Wildenstein, 1960, no. 71; Mandel, 1972, no. 79

L 46–47 Landscape with a herdsman waking a shepherdess
Landscape with a young village woman lying down, looking at a shepherd
No indication of support or measurements

Provenance: Anonymous [Baché, Brilliant, de Cossé, Quenet] sale, April 22, 1776, lot 89, together with its pendant. ("Two very pastoral landscapes: each one representing hillsides covered with rich pastures. Several groups of trees can be seen at various distances, and flocks of sheep scattered on different sides. On the right of the first painting, a young herdsman comes to awaken gently the sleeping shepherdess. In the second one, a young village woman, lying at the foot of a tree, watches her shepherd; he is a few feet away from her, standing beside a rock against which he is leaning. A nature that is charming, a soft brush, a candid touch, and happy effects of light give to these two pieces an extremely striking effect.")
Bibl.: Nolhac, 1906, p. 135; Wildenstein, 1960, nos. 158–59; Mandel, 1972, nos. 176–77

L 48–49 The Remembrance of Happiness (two paintings)
Canvas

Provenance: Anonymous [Baché, Brilliant, de Cossé, Quenet] sale, April 22, 1776, lot 90 ("Two paintings of which the subject is as follows: A young lover, having lost his beloved, has had a statue of her placed deep in a solitary grove. In the first picture, he is seen prostrated, helplessly embracing the knees of the statue and vowing never to leave it. In the second picture, he is shown still in the same place, though now aged and seeing an apparition. On a luminous cloud can be seen the object of his constancy: she tells him of the moment when he will be reunited with her. These two pieces, full of sentiment, are rich in color and of a brilliant touch." [35.1 × 27 cm])
Bibl.: Nolhac, 1906, p. 151; Wildenstein, 1960, nos. 310, 311; Mandel, 1972, nos. 331–32

L 50 The waterfalls of Tivoli with the artist at his easel
Canvas

Provenance: Anonymous [Baché, Brilliant, de Cossé,Quenet] sale, April 22, 1776, lot 92 ("the Waterfall of Tivoli, painted from life with much truth. The painter has placed himself in this tasteful painting. He is at his easel, surrounded by several children; others are amusing themselves nearby by trying to get hold of a donkey on which a young boy is seated." [59.4 × 72.9 cm])
Bibl.: Nolhac, 1906, p. 143; Wildenstein, 1960, no. 109; Mandel, 1972, no. 117

L 51 Head of a woman leaning on a pillow
Canvas

Provenance: Anonymous [Baché, Brilliant, de Cossé, Quenet] sale, April 22, 1776, lot 95 ("A head of a woman. She is seen in a three-quarter view, leaning on a pillow, and her shoulders are covered with a black fichu." [43.2 × 35.1 cm])
Bibl.: Nolhac, 1906, p. 113; Wildenstein, 1960, no. 394; Mandel, 1972, no. 423

L 52 Love the Sentinel
Canvas

Provenance: Anonymous [Baché, Brilliant, de Cossé, Quenet] sale, April 22, 1776, lot 97 (32.4 × 21.6 cm)
Bibl.: Wildenstein, 1960, no. 325; Mandel, 1972, no. 342

See cat. nos. 255, 257, 259

L 53 Head of a young girl
Canvas

Provenance: Anonymous [Baché, Brilliant, de Cossé, Quenet] sale, April 22, 1776, lot 99 ("A finished study of the head of a young girl: her hair is carelessly arranged; her half-lowered eyes have an ingenuous look." [45.9 × 37.8 cm]); probably [de Pille] sale, May 2, 1785, lot 72 ("A head of a young girl, with a pleasant expression; it is of a beautiful color tone and of the most striking effect." [45.9 × 37.8 cm])
Bibl.: Portalis, 1889, p. 290; Wildenstein, 1960, no. 269; Mandel, 1972, no. 288

The description in the 1776 sale catalogue suggests a painting very similar to our cat. no. 330.

L 54 Young Italian woman, half-naked, lying down
Canvas

Provenance: Anonymous [Verrier?] sale, November 18, 1776, lot 106 ("a young Italian woman, half-naked, lying voluptuously on a couch where she has fallen asleep. In this beautiful piece, softly handled, there prevails a mysterious, natural tone, full of vigour and freshness." [canvas, 48.6 × 59.4 cm]); B. sale, April 10, 1786, lot 43
Bibl.: Goncourt, 1882, p. 330; Portalis, 1889, p. 281; Nolhac, 1906, p. 120; Wildenstein, 1960, no. 274; Mandel, 1972, no. 292

This painting is known thanks to a sketch by Gabriel de Saint-Aubin in the margin of the Verrier (?) sale catalogue (Paris, Bibliothèque Nationale).

L 55 St. Peter Repentant
Canvas

Provenance: [Verrier] sale, November 18, 1776, lot 107 ("A sketch boldly handled, representing St. Peter prostrated, expressing his repentance." [165 × 116 cm])
Bibl.: Wildenstein, 1960, no. 92; Mandel, 1972, no. 100

Known from the sketch by Gabriel de Saint-Aubin (see cat. no. L 54).

L 56 The Glass of Water or Three Young Girls, One on a Bed
Canvas

Provenance: Randon de Boisset sale, February 27, 1777, lot 229 ("A painting on canvas [68.7 × 88 cm]; it represents three young girls, one of whom is on a bed."); Baron de Saint-Julien sale, February 14, 1785, lot 110 ("the same subject as the above, but not as finished." [72.9 × 92 cm])
Bibl.: Goncourt, 1882, p. 330; Portalis, 1889, p. 290; Nolhac, 1906, p. 120; Wildenstein, 1960, no. 284; Mandel, 1972, no. 302

See cat. no. L 3.

L 57 Landscape with a seated woman and a shepherd

Provenance: Ménil sale, April 4–5, 1777, lot 35 ("A Sketch representing a seated Woman who seems to be singing, [and] a shepherd behind a tree; he appears to be listening to her," support not specified, [40.5 × 30 cm])
Bibl.: Wildenstein, 1960, no. 155; Mandel, 1972, no. 173

L 58 The Waterfalls of Tivoli
Canvas

Provenance: Anonymous sale, December 15, 1777, lot 324 ("A view of the waterfalls of Thivoly (sic); this picture, painted with great freedom, conveys exactly the effect of this beautiful place; in the foreground a woman can be seen and, farther off, a man and a donkey." [72.9 × 97.4 cm]); possibly anonymous sale,

January 25, 1779, lot 72 ("The storm of Tivoli, with figures; sketch with great effect." [72.9 × 97.4 cm]); perhaps Castelmore sale, December 20, 1791, lot 30 ("A view of a landscape and waterfall painted at the waterfalls at Tivoli. Sketch skillfully handled." [72.9 × 89.3 cm]); probably Rothan sale, May 29–31, 1890, lot 149 ("The Waterfall. In the middle of the landscape, three willows and several poplars stand out strongly against the sheet of water that is falling from an enormous rock covered with vegetation. To the right, in a sunny field, a man and a woman are busy bunching vegetables with which they are filling the donkey's packs. Long trails of clouds race across the sky. Canvas. 74 × 98 cm"); Collection A. Veil-Picard (according to Wildenstein)
Bibl.: Portalis, 1889, p. 273; Nolhac, 1906, pp. 138, 143; Wildenstein, 1960, under no. 110; Wilhelm, 1960, p. 24; Mandel, 1972, under no. 118

We do not know this painting.
The *Small Cascades of Tivoli* (41 × 51 cm), which passed through the Beurnonville sale (1881, lot 68), the anonymous sale (April 13–15, 1905, lot 291), and the anonymous sale (April 6, 1954, lot 76) as by Fragonard, appears more likely to be by Hubert Robert.

L 59 Jailer opening the door of a prison
Canvas

Provenance: [Varanchan] sale, December 29–30, 1777, lot 13 ("A Tailer opening the door of a prison, study full of great truth." [97.4 × 81.1 cm]); Dulac sale, November 30, 1778, lot 6; [Abbé de Gevigney] sale, December 1–29, 1779, lot 595 ("Very beautiful, finished, sketch"); Mlle. B. sale, April 4, 1791, lot 32 ("the sinister figure of a tailer who holds the bolt of a door…")
Bibl.: Goncourt, 1882, p. 333; Portalis, 1889, p. 278; Nolhac, 1906, p. 153; Wildenstein, 1960, no. 94; Mandel, 1972, no. 103

L 60 A Lion
Canvas

Provenance: [Varanchan] sale, December 29–30, 1777, lot 14 ("A striking study in a bold style; it represents a lion" [119 × 83.8 cm]); probably Collection P.-A. Hall, miniaturist ("a lion, in the chimney corner," Hall inventory, May 10, 1778, see Villot, 1867, p. 74); Collection Baron de Staël, after 1793 (according to Wildenstein); perhaps Vivant-Denon sale, May 1, 1826, lot 154 ("A sketch with a warm and golden tone, and painted with great ease, representing a lion in repose." [101 × 79.7 cm])
Bibl.: Portalis, 1889, pp. 277, 282; Nolhac, 1906, p. 152; Wildenstein, 1960, nos. 116–17; Mandel, 1972, nos. 125–26

The painting must have been cut down, especially in height, for it to be identified with the one in the Collection Vivant-Denon. That is the hypothesis of Wildenstein who, however, catalogues two different numbers. Furthermore the vertical orientation of the picture relates badly to the idea of a piece made to be set into a chimney corner and the identification with Hall's painting is not definite.

L 61 The Weeping Woman, also called **The Handkerchief,** or **Sorrow**
Oval canvas

Provenance: [Varanchan] sale, December 29–30, 1777, lot 18 ("A Painting of oval shape, representing a young woman, seen in half-length, and symbolizing sadness; she is leaning on her elbow, and holds a handkerchief up to her face..." [59.4 × 48.6 cm]); [Abbé de Gevigney] sale, December 1–29, 1779, lot 1172 ("A young Woman leaning on a marble Table, holding her handkerchief against her face and looking upset;...")
Bibl.: Portalis, 1889, p. 275; Nolhac, 1906, p. 148; Wildenstein, 1960, no. 398; Mandel, no. 421

This painting can be related to that of the *Belated Repentance* (oval canvas, 59 × 48 cm), which passed through the Decourcelle sale, May 29–30, 1911, lot 16, under the name of Fragonard but which does not appear to be by him.

L 62 Hercules and Omphale, after Boucher
Canvas

Provenance: [Varanchan] sale, December 29–30, 1777, lot 32 (according to the annotated manuscript of the sale catalogue in the Bibliothèque Nationale, Paris); Sireul sale, December 3, 1781, lot 37 (92 × 73 cm); anonymous sale, June 1, 1787, lot 11 (92 × 70 cm); probably anonymous sale, February 29, 1792, lot 1
Bibl.: Portalis, 1889, p. 278; Nolhac, 1906, p. 10; Wildenstein, 1960, no. 1; Thuillier, 1967, p. 62; Mandel, 1972, no. 1

A copy, with the same measurements as the original *Hercules and Omphale* by Boucher (now in the Pushkin Museum, Moscow), and perhaps dating from the time of Fragonard's apprenticeship with Boucher.

L 63 Little girl holding a letter

Provenance: Collection P.-A. Hall (Hall's inventory, May 10, 1778; see Villot, 1867, p. 74)
Bibl.: Wildenstein, 1960, no. 383; Mandel, 1972, no. 408

L 64 Portrait of Pierre-Adolphe Hall

Provenance: Collection P.-A. Hall, (Hall's inventory, May 10, 1778: "A head of me, from the time when he used to do sketch portraits for a louis"; see Villot, 1867, p. 74)
Bibl.: Wildenstein, 1960, no. 252; Mandel, 1972, no. 270

L 65 Head of an old man

Provenance: Collection P.-A. Hall, (Hall's inventory, May 10, 1778; see Villot, 1867, p. 74)
Bibl.: Wildenstein, 1960, no. 193; Mandel, 1972, no. 204

The lack of precise details prevents a direct comparison with any one particular painting more than another.

L 66 Landscape with animals in the style of Castiglione

Provenance: Collection P.-A. Hall (Hall's inventory, May 10, 1778; see Villot, 1867, p. 74)
Bibl.: Wildenstein, 1960, no. 139; Mandel, 1972, no. 138

The lack of measurements prevents all comparisons with any other specific painting.

L 67 St. Peter

Provenance: Dulac sale, November 30, 1778, lot 219; ("A St. Peter, a masterly study and finely colored." [45.9 × 37.8 cm])
Bibl.: Nolhac, 1906, p. 166; Wildenstein, 1960, no. 93; Mandel, 1972, no. 101

L 68 Jupiter and Callisto
Canvas

Provenance: Dulac sale, November 30, 1778, lot 282 ("Jupiter and Calisto, sketch freely handled," [32.4 × 40.5 cm]); [Pasquier] sale, March 1, 1781, lot 90 (same measurements)
Bibl.: Wildenstein, 1960, no. 49 (identified with cat. no. 26)

L 69 Roman Charity
Canvas

Provenance: Anonymous sale, January 25, 1779, lot 73 ("Roman Charity. Sketch." [37.8 × 45.9 cm]); probably Ménageot sale, December 17–21, 1816, lot 14 ("The Subject of Roman Charity. Sketch," without measurements or indication of support)
Bibl.: Wildenstein, 1960, no. 219; Mandel, 1972, no. 230

See no. L 87

L 70 The Deliverance of St. Peter
Canvas

Provenance: [Trouard] sale, February 22, 1779, lot 82 ("St. Peter released from prison by an Angel: a highly effective sketch." [59.4 × 70.2 cm])
Bibl.: Goncourt, 1882, p. 323; Nolhac, 1906, p. 166; Wildenstein, 1960, no. 95; Mandel, 1972, no. 102

Among the paintings seized from the architect Belisard's house in 1795 were "two paintings, one representing St. Peter released from prison, the other the preparations for a baptism, by Peter Neefs, figures by Fragonard, in their golden frames" (37 × 48 cm). The comments are obscure and Wildenstein uses them to support his attribution to Fragonard of the figures in Neefs' *Interior of a Church* in the Louvre (W. no. 96); however, the figures in this painting are definitly from the seventeenth century. *The Deliverance of St. Peter* could be by Fragonard, but the measurements given do not facilitate its identification with the painting in the Trouard sale.

L 71 Coresus and Callirhoe
1765, or slightly earlier. Canvas

L 66 Landscape with animals in the style of Castiglione

Provenance: [Trouard] sale, February 22, 1779, lot 78 ("Finished sketch of the painting of Callirhoe that belongs to the King, the Print of which, engraved by Danzel, is known." [62.1 × 78.4 cm]); Exhibited at the Salon de la Correspondance, 1783, no. 155 (according to Wildenstein); [d'Espagnac and Tricot] sale, May 22, 1793, lot 122 ("The Sketch of the attractive painting, ... composition with seventeen figures..." [59.4 × 78.4 cm])
Bibl.: Goncourt, 1882, p. 324; Portalis, 1889, p. 274; Wildenstein, 1889, p. 223; Mandel, 1972, no. 236

See cat. no. 117. Could it be our cat. no. 199, which seems to consist of seventeen figures, measured without the frame?

L 72 Landscape with an old wooden bridge
Canvas

Provenance: [Trouard] sale, February 22, 1779, lot 85 ("A lightly sketched landscape with silvery tones: on the right, various animals can be seen crossing an old wooden bridge; farther off, on higher ground, is a cross, and, on the left, Washerwomen and other figures." [40 × 83 cm])
Bibl.: Wildenstein, 1960, no. 143; Mandel, 1972, no. 144

The subject appears to be similar to that of cat. no. 87

L 73 Head of a man in the style of Van Dyck
Canvas

Provenance: Anonymous sale, November 15, 1779, lot 33 ("A head of a man entirely in the style of Van Dyck, with a wide, turned-down shirt collar, the drapery is brown, lined with crimson," support not specified. [40.5 × 32.4 cm]); anonymous sale, March 26, 1788, lot 48 ("A head of a young man, freely executed, in the style of Van Dyck. Canvas." [40.5 × 32.4 cm])
Bibl.: Wildenstein, 1960, no. 255; Mandel, 1972, no. 267

L 74 Seated Philosopher
Canvas

Provenance: Anonymous sale, November 15, 1779, lot 28 ("A philosopher with a bald head and white beard; he is seated and his eyes are fixed on a large book; the style is bold and loose; the skillfull and masterly hand of its author is recognizable in this piece. Oval shape." [49 × 65 cm])
Bibl.: Wildenstein, 1960, no. 196; Mandel, 1972, no. 207

To be compared with the Hamburg painting (cat. no. 163), which is larger.

L 75 Head of an old man seen full face

Provenance: Anonymous [De Ghendt?] sale, November 15, 1779, lot 32 ("A head of an old man seen fullface, with white hair and beard, skillfully handled." [48.6 × 40.5 cm])
Bibl.: Wildenstein, 1960, no. 190; Mandel, 1972, no. 201

L 76 Head of an old man in the manner of Rembrandt
Canvas, 24 × 16 (according to Wildenstein)

Provenance: [Abbé de Gevigney] sale, December 1–29, 1779, lot 596 ("A head of an old man, painted in the manner of Rembrandt." Canvas, without measurements); Choiseul-Stainville sale, May 21–24, 1784, lot 8; Perhaps Desperet sale, June 7, 1865, lot 400
Bibl.: Wildenstein, 1960, no. 191; Mandel, 1972, no. 202

L 77 Interior of a Cowshed
Canvas

Provenance: Leroy de Senneville sale, April 5, 1780, lot 58 (see cat. no. 79, together with its pendant. "Two Picture Studies, ... the other an interior of a cowshed, where a cow and a young girl talking to a boy, who is on the top of a ladder, can be seen..." [54 × 64.8 cm]); Leroy de Senneville sale, April 26, 1784, lot 30, together with its pendant ("the other an interior of a cowshed where a young girl can be seen talking to a boy, and farther off a cow." [54 × 64.8 cm])
Bibl.: Portalis, 1889, p. 276; Nolhac, 1906, p. 133; Wildenstein, 1960, no. 112 bis; Mandel, 1972, no. 121

See cat. no. 79; the subject also appears to be close to that of cat. no. 80

L 78 The Pond
Canvas

Provenance: Leroy de Senneville, April 5, 1780, lot 52, together with its pendant ("Landscape representing 'a piece of high ground, covered with beautiful grass, on the extremity of which a woman is seated talking to a man who is also seated: to the left, on a distant plane, can be discerned, the entrance to a wood that continues toward the right where a gravelly path crosses it. In the foreground is a pond where some men are busy among the reeds pulling along a boat in which there is a woman" [37 × 47 cm])
Bibl.: Nolhac, 1906, p. 137; Wildenstein, 1960, no. 162; Mandel, 1972, no. 180

Can almost certainly be identified with our cat no. 138 (The Mound).

L 79–80 Landscape with a seated woman. Landscape with a young man and a wheelbarrow
Canvas

Provenance: Leroy de Senneville sale, April 5, 1780, lot 53: probably withdrawn from the sale ("Two landscapes, of the best tone, striking in effect and of a style as spirited as the best works by Ruisdael. In one of them one notices a woman seated in the shade of a large tree and farther off, a Peasant woman and three cows; in the other is seen a young man beside a wheelbarrow, and two young women who are looking at him." [31 × 40 cm]); Leroy de Senneville sale, April 26, 1784, lot 29
Bibl.: Nolhac, 1906, p. 135; Wildenstein, 1960, nos. 169–70; Mandel, 1972, nos. 147–48

See also cat. nos. L 139–40, of similar measurements

L 81 Woman with a Fan
Canvas

Provenance: Leroy de Senneville sale, April 5, 1780, lot 55 ("A Study, not very finished but of good effect, representing the Bust of a young Woman, whose head is covered by a black headdress, which she is holding aside in order to look at something." [31 × 24.3 cm])
Bibl.: Nolhac, 1906, p. 113; Wildenstein, 1960, no. 402; Mandel, 1972, no. 427

L 82 A Sultan Seated on a Sofa
Canvas

Provenance: Leroy de Senneville sale, April 5, 1780, lot 218 ("A charming study which, through the magic of its color, has the most striking of effects: it represents a sultan seated on a sofa." [15.5 × 11.4 cm]); anonymous sale, July 8, 1793, lot 18 ("Two little studies handled with intelligence; one presents the figure of a Sultan seated on cushions, the other some young girls who are throwing roses through a window." [16.2 × 10.8 cm]
Bibl.: Nolhac, 1906, p. 145; Wildenstein, 1960, no. 334; Mandel, 1972, no. 350

Made into a pendant for the *Inquisitive Children* (cat. no. 187) in 1793.

L 83 The Donkey's Dinner
Oval

Provenance: Prault sale, November 27, 1780, lot 23 ("A child trying to get on to a donkey while a little boy and a little girl are feeding it with grass. 'It is oval.'" Support not specified. [65 × 51 cm])
Bibl.: Goncourt, 1882, p. 333; Nolhac, 1906, p. 131; Wildenstein, 1960, no. 370; Mandel, 1972, no. 395

Mandel assumes that this could be the pendant to the Washington, D.C. *Happy Family* of similar format, which is also oval; given this assumption, it must be supposed that the measurements were inversed in the sale catalogue.

L 84 The Child with Cherries
c. 1768 (?)

Provenance: Prault sale, November 27, 1780, lot 24 ("the bust of a child carrying cherries in his hat." [37.8 × 29.7 cm]); Leroy de Senneville sale, April 26, 1784, lot 31 ("A young Child, seen in half-length, holding cherries in his hands: sketch nicely handled." [32.4 × 24.3])
Bibl.: Goncourt, 1882, p. 333; Portalis, 1889, p. 280; Nolhac, 1906, p. 115; Henriot, 1926, pp. 119–21

The treatment of *The Child with Cherries* (canvas, 43 × 32 cm), which passed through the Collections Mme. Charras (1889), E. Glaenzer, and Davil-Weill and the C.E. Dunlap sale, Sotheby's, New York, December 4, 1975, lot 356, appears to be too weak for the painting to be attributed without any reservations to Fragonard. It could be an old copy. The picture is considered as an original by Portalis (1889, p. 280), Wildenstein (1921, no. 71; 1960, no. 519), Henriot (1926. I, pp. 119–21), Wilhelm (1960, p. 142), Mandel (1972, no. 542), and Sutton (1980, no. 87). The

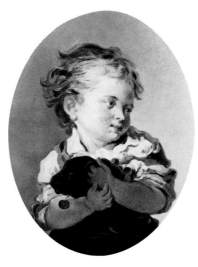

different measurements given for the painting in the Prault sale and that in the Leroy de Senneville sale should be noted: the fact that there may have been two original versions of the same subject cannot be excluded. Finally the pastel which passed through the anonymous sale in 1786 (May 18, lot 60) should also be noted: "a child seen in half-length carrying cherries in his cap," (40 × 32 cm); it could be another version of the same composition.

L 85 Landscape with a man gathering wood
c. 1763–65. Canvas

Provenance: Anonymous sale, December 11, 1780, lot 181 (together with its pendant); Lambert and du Porail sale, March 27, 1787, lot 223 (together with its pendant); [Saubert and Desmarest] sale, March 17, 1789, lot 93 together with its pendant ("two landscapes forming pendants... the other one presents a view of a forest clearing, in the foreground is a man gathering wood which he is about to put into a wheelbarrow beside him; farther off to the left, on a stretch of grass, a woman and a child are lying down; in the distance a cart drawn by several horses can be seen on a lane." [36.4 × 44.5 cm]); Lacaille sale, January 23, 1792, lot 69 (together with its pendant; 35.1 × 43.2 cm); anonymous sale, January 27–28, 1833, lot 71 (according to Wildenstein); anonymous sale, March 25–26, 1833, lot 62; V. Doat sale, May 26, 1883, lot 7 (The Approach of the Storm)
Bibl.: Nolhac, 1906, p. 139; Wildenstein, 1960, no. 161; Mandel, 1972, no. 179

See, for the pendant, the *Landscape with Three Washerwomen*, cat. no. 135

L 86 Bust of a woman holding Cupid
Oval canvas

Provenance: Collection Dupille, catalogue of the collection, 1780, no. 288 ("The bust of a pleasing woman, holding Cupid. This painting is of a fresh and pleasing color." [35.1 × 31 cm])
Bibl.: Wildenstein, 1960, no. 428; Mandel, 1972, no. 453

L 87　Human Charity, after P. van Mol

Provenance: Anonymous sale, April 9, 1781, lot 113 (without any indication of support; 38 × 43 cm)
Bibl.: Wildenstein, 1960, no. 6; Mandel, 1972, no. 6

See, for a *Roman Charity* of similar measurements (pendant to this painting), cat. no. L 69.

In the same sale (April 9, 1781, lot 112) there was another *Human Charity* after van Mol, of similar format (30 × 37 cm), by Le Camu.

L 88　A half-length view of an old man beside a table with a book

Provenance: Perhaps anonymous sale, October 25, 1781, lot 37 ("An overdoor, representing an old man in front of a table," without measurements); de [Pille] sale, May 17–18, 1786, lot 18 (unverified reference taken from Nolhac and Wildenstein, who both give "Old man, in half-length, near a table on which there is a book" [66 × 93 cm])
Bibl.: Nolhac, 1906, p. 148; Wildenstein, 1960, no. 201; Mandel, 1972, no. 212

The reference "overdoor" in the October 1781 sale would seem to suit this wide painting rather than that of cat. no. L 27.

L 89　Young woman reading a letter
Canvas

Provenance: M. sale, November 5, 1781, lot 47 ("A woman seated before her dressing table, busy reading a letter that she holds in her right hand. This subject of striking effect, painted by Fragonard, is illuminated by a light falling on to the table." [32.4 × 24.3 cm]). The description "light" is somewhat ambiguous as it could also mean that a lamp is placed on the table.

90　The Rest on the Flight into Egypt
Canvas

Provenance: Le Prince sale, November 28, 1781, lot 125 ("A rest on the flight into Egypt, of recumbent oval shape: large composition and of striking effect." Canvas. [89 × 92 cm])

See cat. no. 29

L 91　Rocks with waterfall
Canvas

Provenance: Sireul sale, December 3, 1781, lot 36 ("A view of rocks with waterfall. Rough sketch freely painted." [73 × 57 cm])
Bibl.: Portalis, 1889, p. 288; Wildenstein, 1960, no. 134; Mandel, 1972, no. 133

L 92　A Child (sketch for a ceiling)

Provenance: [Paillet] sale, January 30, 1782, lot 79 ("A sketch in oval shape; the subject a child, as a ceiling," without any indication of support or measurements)

Bibl.: Wildenstein, 1960, no. 69; Mandel, 1972, no. 77

L 93　An old man, half-length, dressed in black
Canvas

Provenance: Anonymous sale, December 3, 1782, lot 89 ("An old man seen in half-length, nearly full face, and dressed in black. This study is painted in oils in the manner of Rembrandt. [39.1 × 30 cm])
Bibl.: Nolhac, 1906, p. 112; Wildenstein, 1960, under no. 197

Identified by Wildenstein (no. 197) with our cat. no. L 28

L 94　Landscape with trees and waterfalls

Provenance: Exhibited at the Salon de la Correspondance, 1782, no. 6 ("Landscape embellished with trees and waterfalls," without measurements)
Bibl.: Wildenstein, 1960, under no. 134; Mandel, 1972, no. 133

L 95　Young girl at the casement window
Panel

Provenance: [Dujarry] sale, July 4–5, 1783, lot 36, together with its pendant, (see cat. no. L 96) ("In one of them is seen a young girl at the casement window talking with a young man; the fear of being caught is expressed in her face in a way that engages one's sympathy." [16.2 × 10.8 cm])
Bibl.: Wildenstein, 1960, no. 381; Mandel, 1972, no. 405

This painting may have been close in its subject matter to *The Casement Window* (cat. no. 214) and of a format and technique similar to the two Besançon paintings (cat. nos. 303-4).

L 96　Young girl reading a letter
Panel

Provenance: [Dujarry] sale, July 4–5, 1783, lot 36, together with its pendant, see cat. L 95 ("The other represents a young girl, who seems greatly distressed by the letter she is reading." [16.2 × 10.8 cm])
Bibl.: Wildenstein, 1960, no. 380; Mandel, 1972, no. 406

L 97　The Reader
Canvas

Provenance: Tonnelier sale, November 28, 1783, lot 29, together with its pendant (see cat. 308), ("Two half-length figures...; the other of a bare-headed young girl, her right arm supported on a table, holding a book in her hand." [31.7 × 24.3 cm])
Bibl.: Goncourt, 1882, p. 333; Nolhac, 1906, p. 148; Wildenstein, 1960, no. 384; Mandel, 1972, no. 411

L 98　Landscape with figures and animals

Provenance: Exhibited at the Salon de la Correspondance, 1783, no. 156 ("Landscape with figures of men and animals, owned by the Count de Choiseul-Gouffier")
Bibl.: Wildenstein, 1960, under no. 156; Mandel, 1972, under no. 174

L 99　Italian landscape with figures
Canvas

Provenance: de Vouge sale, March 15, 1784, lot 150 ("An Italian landscape, several people, seated, talking" [57 × 65 cm])
Bibl.: Wildenstein, 1960, no. 123; Mandel, 1972, no. 132

L 100　Study
Canvas

Provenance: de Vouge sale, May 15, 1784, lot 209 ("Academy figure, study from life" [62 × 49 cm])
Bibl.: Wildenstein, 1960, under no. 99

L 101　Landscape with a river, animated with figures and animals
Canvas

Provenance: Dubois sale, March 31, 1784, lot 131 ("Landscape, on the left of which a river and distant prospects can be seen; in the foreground is a young woman carrying a bundle on her head, and acoompanied by a small boy: they pass by a shepherd on a donkey under some trees. The thickness of the trees' foliage casts a half-tone over them, as well as over the two bullocks and a heifer, which produces a striking and novel effect..." [38 × 45 cm])
Bibl.: Nolhac, 1906, p. 137; Wildenstein, 1960, no. 149; Mandel, 1972, no. 141

L 102　Landscape with harvesters
Oval canvas

Provenance: Choiseul-Stainville sale, May 21–24, 1784, lot 7
Bibl.: Wildenstein, 1960, no. 166; Mandel, 1972, no. 188

L 103　The Lunch
Oval canvas

Provenance: [Laborde] sale, June 13–14, 1784, lot 12 ("A Painting of oval shape, consisting of five figures. This interesting piece is engraved under the title of lunch." [35.1 × 43.2 cm])

L 104　Italian Landscape
Canvas

Provenance: [Laborde] sale, June 13–14, 1784, lot 11 ("A beautiful study of a landscape executed in Italy." [32.4 × 40.5 cm])

Bibl.: Wildenstein, 1960, no. 122; Mandel, 1972, no. 130

Can also be identified with our cat. no. 92

L 105 Young girl mourning her bird
Canvas

Provenance: Anonymous sale, November 4, 1784, lot 138 ("A girl mourning her bird," without measurements)
Bibl.: Wildenstein, 1960, no. 396; Mandel, 1972, no. 425

L 106 The Resistance
Canvas

Provenance: [Baron de Saint-Julien] sale, February 14, 1785, lot 108 ("The interior of an apartment, decorated with two white curtains, where a young lady can be seen escaping from the hands of a young man who is determined to catch her again; a beautiful angora cat and a little poodle serve as accessories to this charming picture." Support not specified, [43.2 × 37.8 cm])
Bibl.: Goncourt, 1882, p. 330; Nolhac, 1906, p. 124; Wildenstein, 1960, no. 277; Mandel, 1972, no. 295

L 107 Landscape with laundresses
Canvas

Provenance: [de Boynes] sale, March 15, 1785, lot 92 ("A rich landscape, displaying in the foreground a large piece of high ground with picturesque slopes on which flocks of sheep are grazing; it is lit up by shafts of light that produce very varied effects; a pond where some country women are washing their clothes can also be seen; higher up there are others busy spreading them [clothes] out to dry; it ends with some huts and the entrance to a wood where some shafts of light loose themselves [sic] against the clear sky, which casts the greatest light and the greatest harmony over this painting," [71 × 90 cm])
Bibl.: Portalis, 1889, pp. 273–74; Nolhac, 1906, p. 139; Wildenstein, 1960, no. 132; Mandel, 1972, no. 155

Wildenstein believes that this landscape is the same as the landscape "lit by a beautiful sun and of striking effect" noted as belonging to Lenoir-Dubreuil by Thierry (*Guide des Amateurs et des Étrangers à Paris*, 1787, Vol. I, p. 461), which cannot be verified.

L 108 Landscape enlivened by a river and a bridge (in collaboration with Lantara)
Canvas

Provenance: [de Boynes] sale, March 15, 1785, lot 102 ("Lantara and Fragonard: A Charming Landscape by this master, representing, in the foreground, a river and a bridge that connects with Buildings on either side of the river; on the side is seen a rock, sheep, a woman and a child, by M. Fragonard. The Background ends with mountains and a sky in the style of Claude Le Lorrain" [23 × 30 cm])

Bibl.: Wildenstein, 1960, no. 141; Mandel, 1972, no. 140

L 109 Young woman putting on her garter
Canvas

Provenance: Anonymous sale, March 30, 1785, lot 106, together with its pendant (see cat. no. L 110; "Two Paintings by Fragonard, one representing a woman who is putting on her garter..." [37.8 × 27 cm])
Bibl.: Wildenstein, 1960, no. 399; Mandel, 1972, no. 419

L 110 Woman learning of the death of her lover
Canvas

Provenance: Anonymous sale, March 30, 1785, lot 106, together with its pendant, (see cat. no. L 109, "the other woman who learns of the death of her lover." [37.8 × 27 cm])
Bibl.: Wildenstein, 1960, no. 400; Mandel, 1972, no. 420

Perhaps identifiable with cat. no. 338

L 111 Countrywoman with Two Children
Canvas

Provenance: Godefroy sale, November 19, 1785 (planned for April 25, 1785), lot 65 ("A countrywoman seated near a fountain, suckling a child, while another one is on her knees; near her is a cow; the background ends with a landscape" [35 × 43 cm])
Bibl.: Wildenstein, 1960, no. 147; Mandel, 1972, no. 166

We can identify this painting with one still attributed to Boucher (Ananoff, 1976, II, p. 222, *The Peasant Family*; the date "1762" and signature are fake; formerly Collection Rothschild; Versailles sale, November 12, 1978, lot 30; Sotheby's sale, Monaco, June 26, 1983, lot 487). See cat. no. 53 a.

L 112 Young girl leaning on a table
Canvas

Provenance: Marquess of Véri sale, December 12, 1785, lot 40 ("A young girl seen in front of a Table on which her hands are resting; her head is bare and embellished with a single ribbon, her face seen in a three-quarter view and her shoulders covered with a fichu." [45.9 × 37.8 cm])
Bibl.: Portalis, 1889, p. 280; Nolhac, 1906, p. 148; Wildenstein, 1960, no. 395; Mandel, 1972, no. 424

L 113 Landscape with a River
Copper

Provenance: Marquess de Véri sale, December 12, 1785, lot 42 ("A pretty Landscape: it shows the entrance to a wood, in front of which are passing a number of similar, pretty figures,

several of whom are preparing to go on the water in boats. This little painting is fine and attractive; in it one finds the same spirit and color tone as in the other works by this Artist, and he proves that perfection is natural to him in all the genres." [25.6 × 33.7 cm])
Bibl.: Goncourt, 1882, p. 339; Portalis, 1889, p. 287; Nolhac, 1906, p. 137; Wildenstein, 1960, no. 441; Mandel, 1972, no. 466

L 114–15 Landscapes

Provenance: Purchased for 1,200 louis by a certain Vincent, artist, in 1785 (he does not appear to be François-André Vincent, dead without issue) and offered by his son to the Louvre in 1845
Bibl.: Wildenstein, 1960, nos. 354–55; Mandel, 1972, nos. 374–75

L 116 Coresus and Callirhoe
1765 or slightly earlier. Canvas

Provenance: Bergeret sale, April 24–29, 1786, lot 104 ("A first conception for the Sacrifice of Callirhoe; a rich and intelligent composition that led to the Author's admission to the Académie." [64.8 × 92 cm])
Bibl.: Goncourt, 1882, p. 324; Portalis, 1889, p. 274; Wildenstein, 1960, under no. 222; Mandel, 1972, no. 235; Sutton, 1980, no. 39

The expression "first conception" might lead one to believe that the composition displayed variations in comparison with the Louvre painting (cat. no. 117).
Wildenstein (1960, no. 222) identifies the Bergeret painting with one from a private collection in Bordeaux, for which the attribution to Fragonard should be taken cautiously.

L 117–18 Landscape enlivened by young people swinging
Landscape enlivened by shepherds playing battledore
Canvas

Provenance: Bergeret sale, April 24, 1786, lot 107, together with a pendant ("Two Landscapes enriched by Ruins and enlivened with figures; the middle of the first one is filled with young boys and young girls, who are swinging on a branch of a Tree; one of them is playing the tambourine. In the foreground of the second one, one notices an assembly of Shepherds and Shepherdesses playing battledore. These two pictures, freely painted, are full of harmony and of a brilliant color." [79.3 × 97.4 cm])
Bibl.: Portalis, 1889, p. 272; Nolhac, 1906, p. 141; Wildenstein, 1960, nos. 450, 449; Mandel, 1972, nos. 474, 473; Cuzin, 1986-I, p. 60

The second painting can be related, for its subject matter and perhaps for its composition, to the Chambéry *The Game of Battledore* (cat. no. 81).

L 119 The Dream of Love
c. 1770. Panel

Provenance: [de Clesne?] sale, December 4, 1786, lot 81 ("A charming sketch by this master whose subject appears, to us, to represent a sleeping warrior crowned by Love and dreaming of a woman who appears to him in a vision, and who is carried on clouds and accompanied by several Cupids…" Panel [31 × 23 cm]); perhaps sale November 18, 1803, lot 13 (*The Dream of Love*, without measurements)
Bibl.: Wildenstein, 1960, no. 210; Mandel, 1972, no. 222

See cat. no. 253

L 120–23 Four mythological subjects
309 × 260 cm (two paintings); 309 × 243 cm (two paintings)

Provenance: Painted for Mademoiselle Guimard's salon, Rue d'Antin; Collection Perregaux, 1786; Collection C. Lafitte, 1806; anonymous sale, December 21, 1846, lot 16
Bibl.: Goncourt, 1882, p. 283; Nolhac, 1906, p. 159; Wildenstein, 1960, nos. 330–34; Mandel, 1972, nos. 357–60

See p. 139

L 124 Young girl holding marionettes
Canvas

Provenance: Anonymous sale, January 22, 1787, lot 152a [41 × 38 cm] (reference not verified)
Bibl.: Nolhac, 1906, p. 131; Wildenstein, 1960, no. 473; Mandel, 1972, no. 498

L 125 Young Woman Entreated by Cupid
Round canvas

Provenance: [Chamgrand, Proby, Saint-Maurice] sale, March 20, 1787, lot 225 ("A young Woman seen in half-length and caressed by Cupid, painted at one sitting, and of circular shape." [diam. 41 cm]); perhaps anonymous sale, April 28, 1790, lot 45 ("A young woman caressed by Cupid, pretty sketch of oval Shape," without measurements)
Bibl.: Nolhac, 1906, p. 118; Wildenstein, 1960, no. 430; Mandel, 1972, no. 455

Perhaps to be related to cat. no. 222, of nearly circular format and of only slightly smaller measurements.

L 126 Young Woman Dozing
Oval

Provenance: Anonymous sale, December 6, 1787, lot 54 ("A woman dozing and appearing to be stricken with grief…" support not specified [59.4 × 45.9 cm])
Bibl.: Wildenstein, 1960, no. 397; Mandel, 1972, no. 426

L 127 Landscape with a woman and some children
Canvas

Provenance: [Vieux-Viller] sale, February 18, 1788, lot 134, together with its pendant, (cat. L 128: "A landscape and a bridge, on which a woman with three children, one of them in her arms, is walking." [62 × 46 cm])
Bibl.: Nolhac, 1906, p. 135; Wildenstein, 1960, no. 144; Mandel, 1972, no. 145

L 128 Landscape with a woman holding a child
Canvas

Provenance: [Vieux-Viller] sale, February 18, 1788, lot 134, together with its pendant (cat. L 127: "A landscape depicting as figures, a woman holding a child wrapped in a woolen blanket." [62 × 46 cm])
Bibl.: Nolhac, 1906, p. 135; Wildenstein, 1960, no. 145; Mandel, 1972, no. 146

L 129 Night
Canvas

Provenance: [Vieux-Viller] sale, February 18, 1788, lot 133 ("Night who is preceding the rising of the moon, spreads her veils over the horizon." [24 × 32 cm])
Bibl.: Nolhac, 1906, p. 160; Wildenstein, 1960, no. 296; Mandel, 1972, no. 316

To be related to *Night* (cat. no. 151) as Wildenstein believes? See also cat. no. L 177.

L 130 Cupid preparing his darts
Round

Provenance: [Vieux-Viller] sale, February 18, 1788, lot 136, together with its pendant, ("Two paintings of circular shape; in one of them Cupid prepares his darts…," support not specified. [diam. 24 cm])
Bibl.: Nolhac, 1906, p. 162; Wildenstein, 1960, no. 431; Mandel, 1972, no. 456

This painting and its pendant (cat. no. L 131) can be related to *Cupid Holding an Arrow* and *Victorious Venus* (cat. nos. 224–25). Could it be that we are dealing with two circular sketches?

L 131 Venus receiving the apple
Round

Provenance: [Vieux-Viller] sale, February 18, 1788, 136, together with its pendant, ("the other represents Venus receiving the apple," support not specified [diam. 24 cm])
Bibl.: Nolhac, 1906, p. 162; Wildenstein, 1960, no. 432; Mandel, 1972, no. 457

See cat. no. L 130

L 132 The Windmill
Canvas, 31 × 40 cm

Provenance: [Vieux-Viller] sale, February 18, 1788, lot 135 ("The view of a farm and a windmill near a river, where a boat with three figures can be seen; the background displays a mass of landscapes that are outlined against a very cloudy sky. This striking painting is in the style of Ruisdael." [31 × 40 cm]); Lebas de Courmont sale, May 26, 1795, lot 39 (according to Wildenstein); perhaps Huot-Fragonard sale, May 19–20, 1876, lot 6 ("*The Windmill.* It is near two thatched cottages built on the edge of a river; cloudy sky. Landscape inspired by the works of J. Ruisdael. 30 × 38 cm"); perhaps Beurnonville sale, June 3, 1884, lot 383
Bibl.: Portalis, 1889, p. 283; Nolhac, 1906, p. 143; Wildenstein, 1960, no. 181; Mandel, 1972, no. 151

L 133 Landscape with figures and animals
Canvas

Provenance: Anonymous sale, March 26, 1788, lot 47 ("A very picturesque landscape, by the same artist [Fragonard], and enlivened by a train of figures and Animals, in the style of Benedette." [73 × 65 cm])
Bibl.: Wildenstein, 1960, no. 140; Mandel, 1972, no. 139

L 134 The Three Washerwomen
Canvas

Provenance: Anonymous sale, March 17, 1788, lot 93; 27 × 33 cm (according to Wildenstein)
Bibl.: Wildenstein, 1960, no. 186; Mandel, 1972, no. 197

L 135 Head of an old man
Canvas

Provenance: Anonymous sale, March 26, 1788, lot 49 ("A head of an old man with a beard, vigorously executed. Oval canvas." [32.5 × 40 cm])

L 136 The Triumph of Cupid
Oval canvas mounted on panel

Provenance: Anonymous sale, March 26, 1788, lot 46 ("The Triumph of Cupid, composition with twelve figures, by M. Fragonard: this Painting displays the spirit and grace typical of this Artist." [43 × 25 cm])
Bibl.: Nolhac, 1906, p. 157; Wildenstein, 1960, no. 312; Mandel, 1972, no. 333

**L 137–38 Love the Jester
Love the Sentinel**
Canvases (?)

Provenance: de la Douchetière sale, April 14, 1788, lot 19 (38 × 40 cm)
Bibl.: Wildenstein, 1960, nos. 323–24; Mandel, 1972, nos. 346, 340

L 139–40 Two Landscapes in the Style of Ruisdael
Canvases

Provenance: Delasonne sale, March 5, 1789,

lot 17 ("Two charming paintings representing different views of landscapes, handled and colored in imitation of the beautiful works by Ruisdael." [Canvas. 29.7 × 37.8 cm])

Can be related to cat. nos. L 79–80, of similar measurements.

L 141–45 Five landscapes with figures
Canvases

Provenance: Marchal de Saincy sale, April 29, 1789, lot 41 ("Five large Paintings by this Artist, composed and executed to decorate a Salon; they represent various Landscape subjects of varied and pleasing sites, and are embellished with interesting figures." Canvas; without measurements)

Can be compared with cat. nos. 339–42; see p. 203 for a possible identification.

L 145a The Return of the Laborer
c. 1780 (?). Canvas

Provenance: [Saubert and Desmarest] sale, March 17, 1789, lot 94, together with a pendant (see cat. no. L 11): ("Two beautiful paintings, one of which is engraved under the title *Say 'please'*; the other the return of the laborer; there is nothing more vigorous or pleasing than these two charming compositions." [27 × 37.8 cm])
Bibl.: Wildenstein, 1960, no. 470; Mandel, 1972, no. 494

Should be identified with cat. no. 314 (?), or perhaps with another version of *The Happy Fertility* (cat. nos. 311–13 and L 9). At the Ferlet sale, April 18, 1792, appearing under lot 25 were "Two of the most interesting paintings by their composition; they have been engraved, one under the title *Say 'Please,'* the other under that of *Village Family*..." (29.7 × 35.1 cm), which could be identified with the paintings in the 1789 sale, despite the slightly different measurements.

L 146 Young girl at the casement window
Canvas

Provenance: Anonymous sale, May 11, 1789, lot 111, together with its pendant (see cat. no. 309; "Two young girls seen in half-length, one of whom is seen in a three-quarter view, her two hands resting on the ledge of the casement, bareheaded..." [45.9 × 35.1 cm]); Montesquiou-Fezensac, January 29, 1872, lot 7
Bibl.: Portalis, 1889, p. 281; Nolhac, 1906, p. 146; Wildenstein, 1960, no. 378; Mandel, 1972, no. 402

L 147–48 Young girl playing with a cupid
Young girl swinging on the curtains of her bed
Canvases

Provenance: Boyer de Fons-Colombe sale, Aix-en-Provence, January 18, 1790, lot 103, together with its pendant ("Two Paintings. One representing a young girl on her bed playing with a Cupid, the other shows a young girl swinging on the curtains of her bed." [65 × 79 cm])

L 149 River with boats
Panel

Provenance: Marin sale, March 22, 1790, lot 344 ("The view of a forest on the edge of which runs a river, where several boats full of people enjoying themselves can be seen; many other figures enliven this charming painting, which is one of the finest works by this master." [24.3 × 27 cm])
Bibl.: Portalis, 1889, p. 292; Nolhac, 1906, p. 137; Wildenstein, 1960, no. 440; Mandel, 1972, no. 465

For Mandel this is probably a study for *The Fête at Rambouillet* (cat. no. 193).

L 150 Landscape
Canvas

Provenance: Charlier sale, April 7, 1790, lot 107 ("A sketch on canvas, Landscape, animals and figures"; without measurements)

L 151 Landscape with a pond and ducks
Canvas

Provenance: Anonymous sale, May 31, 1790, lot 51 ("A landscape in the manner of Ruysdael; it is enlivened in the foreground by figures beside a pond and several ducks." [70 × 63 cm])
Bibl.: Wildenstein, 1960, no. 133; Mandel, 1972, no. 154

If the measurements have not been inverted in the sale catalogue, this would be the exceptional case of a painting in the Dutch style treated in a vertical format.

L 152 Love the Sentinel
Copper

Provenance: Artaud sale, November 15, 1791, lot 121 ("A painting of oval shape, representing a Cupid in front of a rosebush." [59.4 × 43.2 cm])

This reference to a painting on copper can be related to the painting in the Musée Cognacq-Jay (see cat. no. 259), the measurements of which are slightly different.

L 153 Composition with six figures (subject undetermined)
Canvas

Provenance: Artaud sale, November 15, 1791, lot 120 ("A finished sketch, composition with six figures." [Canvas. 32.4 × 40.5 cm])

By way of a hypothesis, this could be cat. no. 125.

L 154 Landscape with country folk dancing
Canvas

Provenance: Le Sueur sale, November 22, 1791, lot 35 ("The view of a Landscape and of a steep mountain, covered with dwellings and bushes. The foreground of this interesting painting is enlivened with a number of small figures of country folk, some of whom are dancing beside an inn." [Canvas. 70.2 × 54 cm])

One wonders whether the measurements may have been inverted in the 1791 sale catalogue.

L 155 Allegory of Painting
Canvas

Provenance: Le Sueur sale, November 22, 1791, lot 36 ("A sketch composed with much genius, and lightly colored, presenting an allegorical subject of painting." [Canvas. 70.2 × 54 cm])

L 156 Woman on a Bed
Canvas

Provenance: Le Sueur sale, November 22, 1791, lot 38 ("A charming sketch in oval shape, presenting the subject of a woman on a richly draped bed." [43.2 × 59.4 cm])

L 157 Landscape with animals
Canvas

Provenance: Le Sueur sale, November 22, 1791, lot 39 ("A small Landscape Painting with a train of animals in the foreground, and finished in the manner of Rembroudt [sic]." [Canvas. 32.4 × 40.5 cm])

That this could be *Landscape with a Herd Drinking* (cat. no. 92) cannot be excluded.

L 158–59 The Swing
A Game of Hot Cockles
Canvases

Provenance: Collection Abbé de Saint-Non ("Italian Landscape with figures, subject matter a swing" and "A Landscape painted in Italy with figures, subject matter a game of Hot Cockles," without any indication of measurements, according to the inventory made after the Abbé's death in 1791.)
Bibl.: Wildenstein, 1959, p. 238; Wildenstein, 1960, under nos. 447–48; Mandel, 1972, under nos. 471–72

L 160 A young man and a girl in a relaxed pose
Canvas

Provenance: Collection Marquess Eveillard de Livois ("A pleasant sketch and of a pleasing color tone. A young man and a girl in a relaxed pose can be seen" [49 × 59 cm], no. 244 in the catalogue of the collection drawn up for the purpose of a sale in 1791; finally not sold.)
Bibl.: Wildenstein, 1960, no. 286; Mandel, 1972, no. 304

L 161 Italian landscape
Canvas

Provenance: Pope sale, January 30, 1792, lot 31 ("A picturesque landscape in the Italian garden style, where various groups of men and women may be seen enjoying themselves on several planes, lit up by shafts of sunlight; very pretty painting as striking for its effects as for the charm of the place that it represents." [32.4 × 39.1 cm])
Bibl.: Portalis, 1889, p. 284; Wildenstein, 1960, no. 442; Mandel, 1972, no. 467

L 162 Landscape with buildings and figures
Canvas

Provenance: According to Wildenstein, [Mme. Goman] sale, February 6, 1792, lot 32, "Ruysdael and Fragonard." (View of a flat open countryside, with, on the right, buildings and monuments surrounded by trees; in the foreground two figures. A luminous and silvery picture" [35 × 38 cm], quoted thus by Wildenstein.)
Bibl.: Wildenstein, 1960, no. 173; Mandel, 1972, no. 150

We have not been able to find the catalogue of this sale; Mme. Goman's sale took place on the March 24, 1792 (see cat. nos. 123 and L 5).

L 163 Landscape
Canvas

Provenance: According to Wildenstein, [Mme. Goman] sale, February 6, 1792, lot 31 "Ruysdael, Fragonard." (On the left, a piece of high ground, a fallen tree with a man and a woman and a dog nearby at its foot; some bushes in the foreground; in the middle some thatched cottages on the edge of some land watered by a river, where a boat with four people in it can be seen" [54 × 68 cm], quoted thus by Wildenstein.)
Bibl.: Wildenstein, 1960, no. 138; Mandel, 1972, no. 137

We have not been able to find the catalogue of this sale; Mme. Goman's sale took place on the March 24, 1792 (cat. nos. 123 and L 5).

L 164 Landscape with a couple of shepherds and a herd
Canvas

Provenance: Ferlet sale, April 18, 1792, lot 26 ("A charming picture of a landscape seen from a point of view in a flat countryside, broken by rivers and distances; the foreground is embellished with a stretch of grass, where a young village man and his shepherdess can be seen watching their herd. This very graceful piece, is finished and handled in the style of J. Ruysdael." [32.4 × 40.5 cm])

Can be compared with *The Herd* (cat. no. 292), not that the identification is conclusive.

L 165 Young child learning his letters
Canvas

Provenance: [Marchal de Ségur, Mr. de Clesle, Mr. Baudouin, etc.] sale, April 9, 1793, lot 110 ("A charming study for a larger subject, of a young child learning his letters. The grace and intelligence in the attitude of the figures is always true to life in everything that comes from the hands of this Artist." [37.8 × 35.1 cm])
Bibl.: Goncourt, 1882, p. 334; Portalis, 1889, p. 280; Nolhac, 1906, p. 131; Wildenstein, 1960, no. 464; Mandel, 1972, no. 488

See cat. no. 126 and, for the subject, cat. no. 277.

L 166 Landscape in the style of Ruisdael
Canvas

Provenance: Anonymous sale, June 3, 1793, lot 70 ("View of a landscape treated in the style of Ruysdael." [70 × 56 cm])
Bibl.: Wildenstein, 1960, under no. 134; Mandel, 1972, under no. 133

L 167 Subject taken from Miss Sara
Canvas

Provenance: Anonymous sale, July 8, 1793, lot 15 ("A charming Picture representing a subject taken from the Novel of *Miss Sara.*" [24.3 × 32.4 cm])
Bibl.: Wildenstein, 1960, no. 456; Mandel, 1972, no. 480

See, for paintings of perhaps the same theme, cat. nos. 123–25.

L 168–74 The Kisses

Provenance: Anonymous sale, July 8, 1793, lot 20 ("Seven small pictures of different shapes, contained within the same frame, depicting different compositions, subject matter Kisses"); perhaps Gaultron sale, January 25–26, 1858, lot 53 ("the Kisses, three small ovals of the same size")
Bibl.: Wildenstein, 1960, nos. 260–66; Mandel, 1972, nos. 278–84

May be compared with cat. nos. 201 and L 2?

L 175 Young woman on her bed playing with a dog, called The Ring Biscuit
c. 1775 (?). Canvas

Provenance: Anonymous sale, July 8, 1793, lot 21 ("A young girl in her bed and accompanied by her dog" [35.1 × 40.5 cm]); Collection E. Marcille; Marcille sale, 1857, lot 65 (according to Nolhac and Wildenstein); Walferdin sale, April 12–16, 1880, lot 62; Collection Cedron (in 1889)
Bibl.: Goncourt, 1882, p. 329; Portalis, 1889, p. 278; Nolhac, 1906, p. 119; Wildenstein, 1960, no. 282; Mandel, 1972, no. 300

L 176 Bust of a philosopher
Canvas

Provenance: Anonymous sale, July 8, 1793, lot 19 ("A bust of a philosopher, study handled very artistically" [54 × 81.1 cm])
Bibl.: Wildenstein, 1960, no. 194; Mandel, 1972, no. 205

L 177 Night

Provenance: Anonymous sale, July 8, 1793, lot 17 ("Another allegorical subject of Night who spreads her veils," without measurements)

To be compared, for its subject matter, with the Louveciennes overdoor (cat. no. 151); see also cat. no. L 129.

L 178–79 Women and children in a landscape
(two paintings)
Oval canvases

Provenance: Anonymous sale, July 8, 1793, lot 13 ("Two paintings with the most admirable harmony of color, representing women and children in a landscape" [H. 46 cm, width not specified])
Bibl.: Wildenstein, 1960, nos. 150–51; Mandel, 1972, nos. 142–43

L 181 The Happy Spouses

Provenance: Seized during the Reign of Terror, in the small Hôtel d'Angivillier in 1793 ("*The Happy Spouses* by Fragonard") according to Wildenstein
Bibl.: Wildenstein, 1960, no. 500

May be compared with cat. nos. 345–46?

L 180 Landscape with a herdsman leading his herd
Canvas

Provenance: Anonymous sale, December 27, 1793, lot 12 ("A Landscape of picturesque composition, enlivened with figures distributed on different Planes, and the foreground of which is taken up with a Herdsman who is leading his herd" [64 × 86 cm]); Wildenstein records: 55 × 81 cm
Bibl.: Wildenstein, 1960, no. 168; Mandel, 1972, no. 153

L 182 View of Quiévrain after Philips Wouwerman (1619–1668)
Canvas

Provenance: Seized during the Reign of Terror from the house of the émigré Guinet in 1793 (according to Wildenstein); 56 × 79 cm
Bibl.: Wildenstein, 1960, no. 4; Mandel, 1972, no. 4

L 183 Landscape

Provenance: Seized during the Reign of Terror

from the house of Clermont d'Amboise on 28 Nivôse an II [January 17, 1794]: ("A landscape by Fragonard")
Bibl.: Wildenstein, 1960, no. 137; Mandel, 1972, no. 136

L 184 View of Saint-Cloud
Panel

Provenance: Seized during the Reign of Terror from the house of Clermont d'Amboise in June 1794, ("A picture of a landscape painted on panel by Fragonard"); Described as *View of Saint-Cloud* in the inventory of the National Depositary at Nesle (April–May 1794)
Bibl.: Wildenstein, 1960, no. 437; Mandel, 1972, no. 462

L 185–86 War
Peace
Oil sketches in grisaille on paper. Without any indication of measurements; "of square shape in Folio size"

Provenance: C. de Ligne sale, Vienna, November 4, 1794, lots 2–3 ("The Senate, assembled in front of the temple, offers sacrifices and consults the oracles to decide for peace or war. The first senator goes forward and announces to the gathered people that the gods have ordered war, while pointing to Mars and Bellona in the sky… the pendant to the preceding piece is executed in the same manner; it represents peace. A landscape embellished with a serene sky; in the distance, the temple of Janus is closed. In the foreground a priest offers a sacrifice; some young girls dance in front of the altar, which is surrounded by women and girls in the arms of young warriors. These two drawings were sent by Fragonard to Mr. d'Aoust, a banker in Brussels, who purchased them for 300 livres.")
Bibl.: Goncourt, 1882 ed., p. 307; Nolhac, 1906, p. 161; Wildenstein, 1960, nos. 215–16; Mandel, 1972, nos. 226–27

Should these be compared with the two oils on paper in the Graphische Sammlung Albertina in Vienna, which are attributed to Fragonard but are actually by Nicolas-Guy Brenet?

L 187–88 Cupids

Provenance: Seized during the Reign of Terror from the house of the Marquess d'Autichamp in 1794, no. 540 (according to Wildenstein)
Bibl.: Wildenstein, 1960, no. 328–29; Mandel, 1972, no. 348–49

L 189-90 Bust of a man meditating
A man drawing
Panel

Provenance: Seized during the Reign of Terror from a Private Collection in Arras in 1794 (according to Wildenstein); 17 × 14 cm (?)
Bibl.: Wildenstein, 1960, nos. 198–99; Mandel, 1972, nos. 209–10

Paintings perhaps in the same spirit as the two

little Besançon panels, of similar measurements (cat. nos. 303–4).

L 191-92 Love the Jester
Love the Sentinel

Provenance: Collection Ménage de Pressigny; seized in 1794 and restored to his widow in 1795 (?)
Bibl.: Wildenstein, 1960, under nos. 317–18

Identified by Wildenstein with his nos. 317–18.

L 192a The Genius of Liberty
1794

See p. 000 and Chapter X, n. 20.

L 193 Landscape

Provenance: Collection J. Dubarry, Toulouse (see C. Lucas, *Inventaire de tableaux… dans la maison de Jean Dubarry*, March 13, 1795, no. 113, according to Wildenstein)
Bibl.: Roschach, 1888, p. 193; Wildenstein, 1900, no. 351; Mandel, 1972, no. 371

L 194–95 Two landscapes (forming pendants)

Provenance: Collection J. Dubarry, Toulouse (see C. Lucas, *Inventaire des tableaux (…) dans la maison de Jean Dubarry*, March 13, 1795, no. 20, according to Wildenstein)
Bibl.: Roschach, 1888, p. 193; Wildenstein, 1960, nos. 352–53; Mandel, 1972, nos. 372–73

L 196 A woman lying down

Provenance: Collection J. Dubarry, Toulouse (see C. Lucas, *Inventaire des tableaux (…) dans la maison de Jean Dubarry*, March 13, 1795, no. 20, according to Wildenstein)
Bibl.: Roschach, 1888, p. 193; Wildenstein, 1960, no. 290; Mandel, 1960, no. 308

L 197 Landscape with a flock of sheep and laundresses
Canvas

Provenance: [Bouquet] sale, 2 Ventôse an V (February 20, 1797), lot 101 ("A landscape where, on the right, can be seen the corner and the gate of a park, where some tall cypresses stand; in the foreground is a flock of sheep; farther off, the shepherd followed by his dogs; and in another part [are] some laundresses by a tub; the left-hand side ends in distant prospects. This pretty picture has as much vigor and is as striking as a good work by Ruysdael" [36.4 × 44.5 cm]); probably La Fontaine sale, 4 Ventôse an VI (February 22, 1798), lot 145 ("A charming landscape painting, composed in the Italian garden style; the foreground is enlivened by a flock of sheep and, farther off, some young laundresses busy washing clothes. This piece,

very striking through the intelligent use of chiaroscuro, is handled in a truly admirable style.")
Bibl.: Nolhac, 1906, p. 143; Wildenstein, 1960, no. 124; Mandel, 1972, no. 156

L 198–99 Landscapes
Panel

Provenance: Seized during the Revolution from the house of Charles-Paul Bourgeois Vialard de Saint-Maurice, on 26 Prairial an V (French Revolutionary calendar), deposited on June 24, 1797, at the National Depository at Nesle and then sent to the Muséum central: "Two Landscapes in the manner of Ruysdael, in which the figures are by Fragonard" (51 × 68 cm, according to Wildenstein)
Bibl.: Furcy-Raynaud, 1912, pp. 84, 324; Wildenstein, 1960, no. 135–36; Mandel, 1972, no. 134

L 200 The Old Oak
Panel, without measurements ("small picture")

Provenance: [Fould, Morice and Savalète] sale, April 4–8, 1799, lot 124 ("A view of a countryside with the remains of an old oak in the foreground near two trees; in front and on a transverse plane are a man and a woman preceded by a dog, further off a shaft of sunlight strikes some treetops"; quoted thus by Wildenstein)
Bibl.: Nolhac, 1906, p. 142; Wildenstein, 1960, no. 171; Mandel, 1972, no. 149

L 201–2 The First Step of Infancy.
The Beloved Child
Canvases

Provenance: Van Leyden sale, Amsterdam, October 10, 1804, lot 131, "Fragonard," ("Two charming Sketches, of which the subjects have, for the most part, been engraved under the title the *First Step of Infancy*; pieces filled with grace, and handled with spirit" [24.3 × 35.1 cm])
Bibl.: Wildenstein, 1960, nos. 538–39; Mandel, 1972, nos. 562, 564; Wells-Robertson, 1974, under no. 71

See cat. nos. 409–10

There is no reason to doubt the attribution to Fragonard of these two paintings, which appear to be the sketches for the two paintings in the Fogg Art Museum, Cambridge, Mass. This attribution was printed in the sale catalogue during the artist's lifetime and at a period when his "rating" was at its lowest.

L 203 Head of an old man
Canvas

Provenance: Sauvage sale, December 6, 1806, lot 38 ("Study of a head of an old man, roughly touched in and by way of a first sketch" [54 × 49 cm])
Bibl.: Wildenstein, 1960, under no. 206

Identified by Wildenstein with the painting in the Musée des Beaux-Arts, Nice (cat. no. 167).

L 204–5 Love the Jester
Love the Sentinel
Canvases

Provenance: Villeminot sale, May 25, 1807, lot 23 (together with its pendant), (60 × 50 cm)
Bibl.: Goncourt, 1882, p. 326; Nolhac, 1906, p. 156; Wildenstein, 1960, nos. 326–27; Mandel, 1972, nos. 341, 347

L 206 The Elopement by Night

Provenance: Collection A.A. Calvet de Lapalun (1736–1820), Avignon
Bibl.: J.S. Hallam, 1986, p. 177

L 207 The Schoolmistress, or Say "Please"
Canvas

Provenance: La Rochefoucauld-Liancourt sale, June 20, 1827, lot 19, together with a pendant (cat. no. 281)
Bibl.: Nolhac, 1906, p. 128; Wildenstein, 1960, no. 467; Mandel, 1972, no. 491

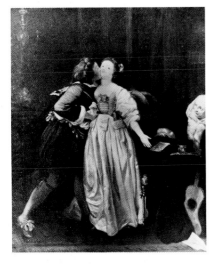

L 208 Fragonard and Marguerite Gérard
A young man embracing a lady who is showing him a letter, called I Was Thinking of You
Canvas

Provenance: Villers sale, December 2, 1795,

lot 7, ("Fragonard and the citizen Gérard: Two paintings; they depict interiors of Apartments: in one a Gentleman embracing a Lady, who is showing him a letter where she has already written a few lines; an old woman, witness to this scene, is seated nearby..." [54 × 43 cm]); see cat. no. 413

Engraved by Vidal. The version (a copy?) that passed through the sale at Versailles on May 28, 1962, lot 30 (55 × 46 cm; "signed to the left and dated 1795") is reproduced here.

L 209 Fragonard and Marguerite Gérard
The Trapdoor
Canvas

Provenance: Villers sale, December 2, 1795, lot 5 ("Fragonard and the citizen Gérard. An interior of a Study; an invisible Lover is presenting a bouquet and a letter to two girls through a trapdoor in the ceiling; the barks of a spaniel are on the point of revealing the trick to a Duenna who can be seen at the door of the Room. This ingenious composition combines a precious execution with much expression and a fine and spirited touch." [54 × 43 cm])
Bibl.: Wildenstein, 1960, no. 544; Mandel, 1972, no. 567

Mandel (1972) links the painting with the composition of the *Petards* engraved by Auvray, which would appear to be erroneous.

L 210 Marguerite Gérard (and Fragonard?)
Young woman playing the lute accompanied by an officer
Canvas

Provenance: Anonymous sale [second Dubois sale?], December 20, 1785, lot 116 (Mlle. Gérard: the interior of an apartment where a young woman, dressed in white satin and seen from the back, is standing playing a lute; in front of her is a table covered with a Turkish carpet, where a book of Music can be seen: there is also an officer, seated, holding his hat, and looking at this young woman; the rest of the picture is filled with a bed, a door, and a footstool, on which there is a cape. This piece, executed under the eyes of Mr. Fragonard, her master, is of a most pleasant composition, of spirited drawing, of a seductive

color and harmony. Canvas. [64.8 × 54 cm]); [Chamgrand and Saint-Maurice] sale, March 20, 1787, lot 229, together with its pendant (see cat. no. 414) [63.4 × 52.6 cm]

The early date and the reference "under the eyes of Mr. Fragonard, her master," alone would not allow for Fragonard's participation in this painting; however, a wash drawing, *The Music Lesson* (unknown private collection; Ananoff, I, no. 72; II, fig. 337; see our plate 275 on p. 221), which does seem to be by the master, corresponds so closely to the described picture that one has to ask whether, at least in the conception, this painting is not the work of Fragonard. The fact that, in 1787, the painting was made into a pendant for *The Reading* in the Fitzwilliam Museum, Cambridge (cat. no. 414), which we believe to be partially by Fragonard, should be underlined.

L 211 Marguerite Gérard (and Fragonard?)
The Deserved Regrets

Provenance: Collection A.A. Calvet de Lapalun (1736–1820), Avignon, under the name of Fragonard
Bibl.: J.S. Hallam, 1986, p. 177

Perhaps the painting engraved by N. de Launey under the name of M. Gérard.
This painting can be related to the canvas (32.5 × 40.5 cm) that passed, under Marguerite Gérard's name and the title *The Deserved Regrets*, through the sale of June 9, 1964, lot 29; another version (or the same painting cut down?) passed through the Palais Galliera sale, March 2, 1977, lot 49.

L 212 Marguerita Gérard (and Fragonard?)
Young girl studying an engraving, called The Interesting Student
c. 1785

Provenance: unknown
Bibl.: Wilhelm, 1960, p. 211; Wells-Robertson, 1979, p. 183

Engraved by G. Vidal in 1786 under the title *The Interesting Student* and as by "Mlle. Gérard, pupil of M. Fragonard pinx."
The young girl is looking at an engraving after *The Fountain of Love* by Fragonard; the latter's participation in this painting, however, remains hypothetical.

Concordance

between Georges Wildenstein's *The Paintings of Fragonard*, New York and Oxford, 1960 (W), and the present catalogue.

W	1	–	L 62	W	44	–	L 32	W	89	–	2	W 133 – L 151
W	2	–	L 19	W	45, 47	–	44	W	90	–	300	W 134 – L 91
W	3	–	L 20	W	46, 48	–	43	W	91	–	22	W 135 – L 198
W	4	–	L 182	W	49	–	26	W	92	–	L 55	W 136 – L 199
W	5	–	57	W	50	–	24	W	93	–	L 67	W 137 – L 183
W	6	–	87	W	51	–	25	W	94	–	L 59	W 138 – L 163
W	7	–	58	W	51 bis	–	206	W	95	–	L 70	W 139 – L 66
W	8	–	59	W	51ter	–	205	W	97	–	L 16	W 140 – L 134
W	12	–	29	W	52	–	207	W	98	–	L 15	W 141 – 108
W	13	–	30	W	53	–	50	W	99	–	L 17	W 142 – 87
W	14	–	269	W	54	–	51	W	100	–	L 18	W 143 – L 72
W	15	–	270	W	55	–	52	W	103	–	66	W 144 – L 127
W	16	–	L 36	W	56	–	53	W	104	–	92	W 145 – L 128
W	17	–	274	W	57	–	3	W	105	–	82	W 146 – 104
W	18	–	275	W	58	–	4	W	106	–	88	W 147 – 53 a, L 111
W	19	–	273	W	59	–	5	W	107	–	89	W 148 – 90
W	20	–	L 34	W	60	–	6	W	108	–	83	W 149 – L 101
W	21	–	315	W	61	–	L 44	W	109	–	L 50	W 150 – L 178
W	22	–	317	W	62	–	159	W	110	–	L 58	W 151 – L 179
W	23	–	316	W	63	–	194	W	111	–	69	W 152 – 191
W	24	–	23	W	66	–	238	W	112	–	79	W 153 – L 21
W	25	–	55	W	67	–	237	W	112 bis	–	L 77	W 153 bis – 107
W	26	–	54	W	68	–	280	W	114	–	93	W 154 A – 108
W	27	–	35	W	69	–	L 92	W	115	–	94	W 155 – L 57
W	28	–	32	W	71	–	L 45	W	116, 117	–	L 60	W 156 – L 38
W	29	–	33	W	72	–	235	W	118	–	77	W 157 – L 37
W	30	–	34	W	73	–	236	W	119	–	76	W 158 – L 46
W	31	–	40	W	74	–	155	W	120	–	78	W 159 – L 47
W	32	–	45	W	75	–	156	W	121	–	L 31	W 160 – 135
W	33	–	46	W	76	–	157	W	122	–	· L 104	W 161 – L 85
W	34	–	20	W	77	–	158	W	123	–	L 99	W 162 – 138, L 78
W	35	–	21	W	78	–	144	W	124	–	L 197	W 163 – 139
W	36	–	11	W	79	–	64	W	125	–	109	W 164 – 140
W	37	–	12	W	80	–	65	W	126	–	110	W 165 – 132
W	38	–	13	W	83	–	122	W	127	–	111	W 166 – L 102
W	39	–	14	W	84	–	234	W	128	–	L 1	W 167 – 129
W	40	–	162	W	85	–	361	W	129	–	106	W 168 – L 180
W	41	–	37	W	86	–	103	W	130	–	67	W 169 – L 79
W	42	–	L35	W	87	–	27	W	131	–	68	W 170 – L 80
W	43	–	366	W	88	–	1	W	132	–	L 107	W 171 – L 200

W 172	–	131	W 236	–	L 23	W 301	–	243	W 365	–	74
W 173	–	L 162	W 237	–	147	W 302	–	244	W 366	–	313
W 174	–	130	W 238	–	405	W 304	–	240	W 367	–	L 9
W 175	–	138, L 78	W 239	–	176	W 305	–	239	W 368	–	311
W 176	–	141	W 240	–	177	W 306	–	242	W 369	–	327
W 177	–	142	W 241	–	169	W 307	–	241	W 370	–	L 83
W 178	–	133	W 242	–	172	W 308	–	263	W 371	–	314
W 179	–	292	W 243	–	173	W 309	–	L 33	W 374	–	328
W 180	–	293	W 244	–	170	W 310	–	L 48	W 376	–	401
W 181	–	L 132	W 245	–	180	W 311	–	L 49	W 377	–	309
W 182	–	134	W 246	–	181	W 312	–	L 136	W 378	–	L 146
W 183	–	137	W 247	–	184	W 313	–	326	W 379	–	360
W 185	–	136	W 248	–	39	W 314	–	160	W 380	–	L 96
W 186	–	L 133	W 249	–	209	W 315	–	232	W 381	–	L 95
W 187	–	143	W 250	–	174	W 316	–	233	W 382	–	91
W 188	–	294	W 251	–	183	W 317	–	L 42	W 383	–	L 63
W 189	–	291	W 252	–	L 64	W 318	–	258	W 384	–	L 97
W 190	–	L 75	W 253	–	279	W 319	–	254	W 385	–	308
W 191	–	L 76	W 254	–	178	W 320	–	255	W 386	–	306
W 192	–	164	W 255	–	L 73	W 321	–	256	W 388	–	335
W 193	–	L 65	W 256	–	182	W 322	–	257	W 389	–	L 5
W 194	–	L 176	W 257	–	303	W 323	–	L 137	W 390	–	310
W 195	–	L 26	W 258	–	304	W 324	–	L 138	W 391	–	179
W 196	–	L 74	W 259	–	214	W 325	–	L 52	W 392	–	L 14
W 197	–	L 28	W 260	–	L 168	W 326	–	L 204	W 393	–	252
W 198	–	L 189	W 261	–	L 169	W 327	–	L 205	W 394	–	L 51
W 199	–	L 190	W 262	–	L 170	W 328	–	L 187	W 395	–	L 112
W 200	–	L 27	W 263	–	L 171	W 329	–	L 188	W 396	–	L 105
W 201	–	L 88	W 264	–	L 172	W 330	–	L 120	W 397	–	L 126
W 202	–	163	W 265	–	L 173	W 331	–	L 121	W 398	–	L 61
W 203	–	L 29	W 266	–	L 174	W 332	–	L 122	W 399	–	L 109
W 204	–	165	W 267	–	203	W 333	–	L 123	W 400	–	L 110
W 205	–	166	W 268	–	204	W 334	–	L 82	W 402	–	L 81
W 206	–	167	W 269	–	L 53	W 335	–	268	W 403	–	36
W 207	–	145	W 270	–	330	W 336	–	267	W 404	–	127
W 208	–	168	W 271	–	201	W 337	–	325	W 405	–	210
W 210	–	L 119	W 272	–	128	W 338	–	266	W 406	–	L 43
W 211	–	253	W 274	–	L 54	W 339	–	362	W 407	–	230
W 212	–	L 39	W 275	–	60	W 340	–	331	W 408	–	229
W 213	–	95	W 276	–	284	W 341	–	231	W 409	–	265
W 214	–	96	W 277	–	L 106	W 342	–	171	W 410	–	301
W 215	–	L 185	W 278	–	305	W 343	–	329	W 411	–	302
W 216	–	L 186	W 279	–	187	W 344	–	212	W 412	–	227
W 217	–	121	W 280	–	282	W 345	–	213	W 413	–	221
W 218	–	120	W 281	–	L 4	W 346	–	324	W 414	–	220
W 219	–	L 69	W 282	–	L 175	W 347	–	L 40	W 415	–	218
W 220	–	216	W 283	–	189	W 348	–	L 41	W 416	–	223
W 221	–	118	W 284	–	L 56	W 349	–	296	W 417	–	226
W 222	–	L 116	W 285	–	L 3	W 350	–	295	W 418	–	224
W 223	–	L 71	W 286	–	L 160	W 351	–	L 193	W 419	–	225
W 224	–	119	W 287	–	47	W 352	–	L 194	W 420	–	359
W 225	–	117	W 288	–	48	W 353	–	L 195	W 421	–	86
W 226	–	115	W 290	–	L 196	W 354	–	L 114	W 422	–	228
W 227	–	116	W 291, 292	–	202	W 355	–	L 115	W 423	–	L 6
W 228	–	334	W 293	–	333	W 356	–	62	W 424	–	L 10
W 229	–	100	W 294	–	L 24–25	W 357	–	63	W 425	–	356
W 230	–	208	W 295	–	152	W 358	–	186	W 426	–	355
W 231	–	L 147	W 296	–	L 129	W 359	–	272	W 427	–	357
W 232	–	L 148	W 297	–	148	W 360	–	73	W 428	–	L 86
W 233	–	101	W 298	–	149	W 361	–	72	W 429	–	222
W 234	–	102	W 299	–	150	W 362	–	71	W 430	–	L 125
W 235	–	L 22	W 300	–	151	W 364	–	75	W 431	–	L 130

W 432	–	131	W 460	–	124	W 488	–	373	W 518	–	382
W 433, 434	–	344	W 461	–	70	W 489	–	375	W 519	–	L 84
W 435	–	343	W 462	–	278	W 490	–	354	W 520	–	379
W 436	–	342	W 463	–	276	W 491	–	377	W 521	–	380
W 437	–	L 184	W 464	–	L 165	W 493	–	378	W 522	–	L 13
W 438	–	192	W 465	–	277	W 494	–	337	W 523	–	383
W 439	–	193	W 466	–	281	W 495	–	336	W 525	–	215
W 440	–	L 149	W 467	–	L 207	W 496	–	363	W 526	–	390
W 441	–	L 113	W 468	–	348	W 497	–	386	W 527	–	391
W 442	–	L 161	W 469	–	L 11	W 498	–	388	W 528	–	392
W 443	–	340	W 470	–	L 145 a	W 499	–	389	W 529	–	393
W 444	–	341	W 471	–	351	W 500	–	L 181	W 530	–	395
W 445	–	322	W 472	–	352	W 501	–	346	W 531	–	394
W 446	–	264	W 473	–	L 124	W 502	–	345	W 532	–	396
W 447, 448	–	339	W 474	–	L 7	W 503	–	353	W 533	–	397
W 449	–	L 118	W 475	–	L 8	W 505	–	365	W 534	–	398
W 450	–	L 117	W 476	–	195	W 506	–	286	W 535	–	399
W 451	–	262	W 477	–	197	W 507	–	287	W 537	–	188
W 452	–	261	W 478	–	198	W 508	–	289	W 538	–	L 201
W 453	–	319	W 480	–	332	W 509	–	288	W 539	–	L 202
W 454	–	320	W 481	–	199	W 510	–	402	W 540	–	409
W 455	–	321	W 482	–	200	W 511	–	368	W 541	–	410
W 456	–	L 167	W 483	–	318	W 513	–	372	W 542	–	L 208
W 457	–	84	W 484	–	219	W 514	–	371	W 543	–	413
W 458	–	125	W 485	–	323	W 515	–	384	W 544	–	L 209
W 459	–	123	W 487	–	374	W 516	–	367	W 545	–	411

Select Bibliography

The bibliography refers the reader to works cited in abbreviated form either in the notes to the text or in the catalogue. The following form has been used for the monographs to which we have constantly referred: Goncourt, 1865 [1882]; Portalis, 1889; Nolhac, 1906; Réau, 1956; Wildenstein, 1960; Thuillier, 1967; Mandel, 1972; and the unpublished, *unfortunately*, manuscript by J. Wilhelm, 1960. Other works on Fragonard, which have not been consulted for the present study, are F. Naquet, *Fragonard*, Paris, n.d. [1890]; V. Josz., *Fragonard, mœurs du XVIII^e siècle*, Paris, 1901 (second edition); G. Grappe, *La vie et l'œuvre de J.H. Fragonard*, Paris, 1929; L. Guimbaud, *Fragonard*, Paris, 1947; L. Guerry-Brion, *Fragonard*, Milan, 1952; F. Boucher, *Fragonard*, Paris, n.d.; J.J. Lévêque, *Fragonard*, Paris, 1983.

Adémar, Jean *See* Seznec, Jean

Algoud, Henri. *Fragonard*. Monaco, 1941.

Ananoff, Alexandre. "La réalité du voyage de Fragonard aux Pays-Bas." In *Bulletin de la Société de l'Histoire de l'Art Français. Année 1959*, Paris, 1960, pp. 15–22.

—— *L'œuvre dessiné de Jean-Honoré Fragonard (1732–1806)*. Paris, 4 vols., 1961–70.

—— *François Boucher*, in collaboration with Daniel Wildenstein, Lausanne and Paris, 2 vols., 1976.

Bailey, Colin B. "Le marquis de Véri collectionneur." In *Bulletin de la Société de l'Histoire de l'Art Français. Année 1983*, Paris, 1985, pp. 67–83.

Berezina, Valentina N. *The Hermitage. Catalogue of Western European Paintings. Early and Mid-Nineteenth Century.* Florence and New York, 1983.

Bergeret *See* Tornézy, Albert, 1895.

—— *See* Vilhelm, Jacques, 1948.

Biebel, Franklin M. "Fragonard and Mme du Barry." In *Gazette des Beaux-Arts*, October 1960, pp. 207–26.

Bjurström, Per. *Drawings in Swedish Public Collections 4, French Drawings Eighteenth Century.* Stockholm, 1982.

Brown, Christophe. "Mercury and Argus by Carel Fabritius: a newly discovered painting." In *The Burlington Magazine*, November 1986, pp. 797–99.

Burollet, Thérèse, *Ville de Paris–Musée Cognacq-Jay. Peintures et Dessins.* Paris, 1980.

Cailleux, Jean. "Fragonard as Painter of the Colombe Sisters." In *L'Art du Dix-huitième siècle*, supplement to *The Burlington Magazine*, September 1960, pp. I–IX.

Cantarel-Besson, Yveline. *La naissance du musée du Louvre.* Paris, 2 vols., 1981.

Carritt, David. In exh. cat. *18th Century French Paintings, Drawings and Sculpture.* London, Artemis, David Carritt Limited, June 6 to July 7, 1978.

Cayeux, Jean de. "Le Pavillon de Mme du Barry et son architecte C.N. Ledoux." In *La Revue de l'Art Ancien et Moderne*, May 1935, pp. 213–24; June 1935, pp. 35–48.

—— "Introduction au catalogue critique des Griffonis de Saint-Non et Catalogue des Griffonis de Saint-Non." In *Bulletin de la Société de l'Histoire de l'Art Français. Année 1963*, Paris, 1964, pp. 297–384.

Chaussard, P. "Notice historique et inédite sur M. Louis David." In *Le Pausanias Français, Etat des Arts du Dessin en France à l'ouverture du XIX^e siècle, Salon de 1806*, Paris, 1806, pp. 145–74.

Collé, Charles. *Journal et Mémoires*, Paris, 1767; Vol. III, ed. 1868, cited in the present work.

Compin, Isabelle. In exh. cat. *Cinq années d'enrichissement du Patrimoine national 1975–1980.* Paris, Grand Palais, November 15, 1980 to March 2, 1981.

Compin, Isabelle and Rosenberg, Pierre. In exh. cat. *Tableaux de Fragonard et meubles de Cressent au Musée du Louvre*. Paris, The Louvre, Pavillon Denon, April 12 to September 30, 1974 (*Le petit journal des grandes expositions*).

— *See also* Rosenberg, Pierre. 1974, I.

Cornillot, Marie-Louise, *Inventaire Général des Dessins des Musées de Province, Collection Pierre-Adrien Pâris*. Besançon and Paris, 1957.

Correspondance des directeurs de l'Académie de France à Rome avec les Surintendants des Bâtiments (1688–1804), edited by Anatole de Montaiglon and Jules Guiffrey, Paris, 18 vols, 1887–1912; Vol. XI (1754–63), Paris, 1901 cited in the present work.

Courajod, Louis. *L'Ecole Royale des Elèves Protégés*. Paris, 1874.

Cuzin, Jean-Pierre. "De Fragonard à Vincent." In *Bulletin de la Société de l'Histoire de l'Art Français. Année 1981*, Paris, 1983, pp. 103–24.

— (1986, I) "Fragonard dans les musées français: quelques tableaux reconsidérés ou discutés." In *La Revue du Louvre et des musées de France*, Paris, 1986, no. 1, pp. 58–66.

— (1986, II) In exh. cat. *La France et la Russie au siècle des Lumières*. Paris, Grand Palais, November 20, 1986 to February 9, 1987.

— "Fragonard, multiple et cohérent." In *Connaissance des Arts*, September 1987, pp. 35–50.

Cuzin, Jean-Pierre and Rosenberg, Pierre. In exh. cat. *Musée du Louvre. Novelles acquisitions du Département des Peintures (1980–1982)*. Paris, 1983.

Daulte, François. Exh. cat. *Fragonard*. Kunstmuseum Bern (Switzerland), June 13 to August 29, 1954.

Dayot, Armand and Vaillat, Léandre. *L'œuvre de J.B.S. Chardin et de J.H. Fragonard*. Paris, n.d. [1907].

Diderot, Denis. *Correspondance*. Selected and edited by G. Roth and J. Varloot, Paris, 16 vols., 1955–70.

Dupuy, Marie-Anne and Rosenberg, Pierre. In *La peinture en Provence dans les collections du musée de Toulon du XVIIᵉ au début du XXᵉ siècle*. Toulon, n.d. [1985].

Eisler, Colin. *Paintings from the Samuel H. Kress Collection. European Schools Excluding Italian*. Oxford, 1977.

Engerand, Fernand. *Inventaire des tableaux commandés et achetés par la Direction des Bâtiments du Roi (1709–1792)*. Paris, 1901.

Ernst, Serge. *The Youssoupov Gallery*. Leningrad, 1924.

Frick Collection. An Illustrated Catalogue, The. Vol. II: *Paintings: French, Italian and Spanish*. Texts on Fragonard by Edgar Munhall. New York, 1968.

Furcy-Raynaud, Marc. "Correspondance de M. de Marigny avec Coypel, Lépicié et Cochin." In *Nouvelles Archives de l'Art français*. Paris, 1904.

— "Objets saisis chez les émigrés et condamnés." In *Nouvelles Archives de l'Art français*, Paris, 1912.

Gaehtgens, Thomas and Lugand, Jacques. *Joseph-Marie Vien*. Paris, forthcoming.

Goncourt, Edmond and Jules de. "Fragonard." In *Gazette des Beaux-Arts*, 1865, 1, pp. 32–41 and pp. 132–62; reprinted in *L'Art du XVIIIᵉ siècle*, Paris, 1873; third edition, Paris, 1882, pp. 241–342 cited in the present work.

(Grasse) Exh. cat. *Œuvres de Fragonard, exposition organisée en commémoration du cent-cinquantième anniversaire de la mort du peintre*. Grasse, Musée Fragonard, July 15 to September 30, 1957.

Guimbaud, Louis, *Saint-Non et Fragonard d'après des documents inédits*. Paris, 1928.

Hallam, John S. "Boilly et Calvet de Lapalun, ou la sensibilité chez le peintre et l'amateur." In *Bulletin de la Société de l'Histoire de l'Art Français. Année 1984*, Paris, 1986, pp. 177–92.

Henriot, Gabriel. *Collection David Weill*. Vol. I, *Peintures* (2 vols.), Paris, 1926.

Kirby, Lynne. "Fragonard's The Pursuit of Love." In *The Rutgers Art Review*, January 1982, Vol. III, pp. 58–79.

Laclotte, Michel *See* Vergnet-Ruiz.

Le Carpentier, Charles, *Galerie des Peintres célèbres*. Paris, 1821.

Lenoir, Alexandre. "Fragonard." In *Biographie Universelle ancienne et moderne*, Paris, 1816, pp. 419–21.

Lugand, Jacques *See* Gaehtgens, Thomas.

Mandel, Gabriele. *L'opera completa di Fragonard*. Milan, 1972 (after Daniel Wildenstein).

Manning, Bertina S. Exh. cat. *Paintings from the collection of Walter P. Chrysler, Jr*. Portland Art Museum, Oregon, March 1956 to April 1957.

Mariette, Pierre-Jean. *Abécédario de P.-J. Mariette et autres notes inédités de cet amateur sur les arts et les artistes*. Selected and edited by Philippe de Chennevières and Anatole de Montaiglon, Paris, 6 vols., 1851–60; Vol II, 1853–54 ("Fragonard," p. 263) cited in the present work.

Mongan, Agnès, Ofer, Philip, and Seznec, Jean. *Fragonard: Drawings for Ariosto*. New York, 1945.

Munhall, Edgar. "Fragonard's Studies for the Progress of Love." In *Apollo*, May 1971, pp. 400–7.

— *See also Frick Collection*.

Nolhac, Pierre de. *J.-H. Fragonard 1732–1806.* Paris, 1906.

Portalis, Baron Roger. *Honoré Fragonard sa vie et son œuvre.* Paris, 1889.
— *Scènes de la vie champêtre, Panneaux décoratifs de Fragonard.* Paris, 1902.
— "Les peintures décoratives de Fragonard et les panneaux de Grasse." In *Gazette des Beaux-Arts*, December 1885 (II), pp. 481–93.

Posner, Donald. "The True Path of Fragonard's 'Progress of Love.'" In *The Burlington Magazine*, August 1972, pp. 526–34.

Ratouis de Limay, Paul. "Un chanteur de l'opéra graveur et collectionneur au début du XIXᵉ siècle." In *Bulletin de la Société de l'Histoire de l'Art Français. Année 1949,* Paris, 1950, pp. 70–78.

Réau, Louis. "Les influences flamandes et hollandaises dans l'œuvre de Fragonard." In *Revue Belge d'Archéologie et d'Histoire de l'Art*, April 1932, fasci. 2, pp. 97–104.
— *Fragonard sa vie et son œuvre.* Brussels, 1956.

Renouvier, Jules. *Histoire de l'Art pendant la Révolution.* Paris, 1863.

Roland Michel, Marianne. "Fragonard – Illustrator of the 'Contes' of La Fontaine." In *L'Art du Dix-huitième siècle,* supplement to *The Burlington Magazine*, October 1970, pp. I–VI.
— "Fragonard illustrateur de l'amour." In *Aimer en France,* acts of the international congress at Clermont-Ferrand (1979) edited with an introduction by P. Viallaneix and J. Ehrard, Clermont-Ferrand, 1980, I, pp. 26–34.
— *Le Dessin français au XVIIIᵉ siècle.* Fribourg, 1987.

Roschach, Kimerly. In exh. cat. *Eighteenth-Century French Book Illustration, Drawings by Fragonard and Gravelot from the Rosenbach Museum & Library.* Philadelphia, H. Philip and A. S. W. Rosenbach Foundation Museum, May 15 to July 28, 1985; Houston, Museum of Fine Arts, September 27 to December 1, 1985.

Roschach, Ernest. "Catalogue des tableaux trouvés à Toulouse dans la maison de Jean Dubarry." In *Mémoires de l'Académie des Science de Toulouse,* Toulouse, 1888, pp. 193–96.

Rosenbaum, Allen. Exh. cat. *Collection Thyssen-Bornemisza – Maîtres Anciens.* Paris, Musée du Petit Palais, January 7 to March 28, 1982.

Rosenberg, Pierre. "Le XVIIIᵉ siècle français à la Royal Academy." In *Revue de l'Art*, 3, 1969, pp. 98–100.
— In exh. cat. *De David à Delacroix.* Paris, Grand Palais, November 16, 1974 to February 3, 1975.
— Exh. cat. *The Age of Louis XV. French Painting 1715–1174.* Ohio, Toledo Museum of Art, October 26 to December 7, 1975; The Art Institute of Chicago, January 10 to February 22, 1976; Ottawa, National Gallery of Canada, March 21 to May 2, 1976.
— "[Reviews] Per Bjurström, Drawings in Swedish Public Collections 4, French Drawings Eighteenth Century." In *Master Drawings*, 1984, I, pp. 64–70.
-- Erh. cat. *Fragonard,* Paris, Grand Palais, September 24, 1987 to January 4, 1988; New York, The Metropolitan Museum of Art, February 2 to May 8, 1988.
— *Catalogue des tableaux français du musée de San Francisco.* Forthcoming.
— *Saint-Non. Fragonard. Panopticon italiano. Un Diario di viaggio ritrovato 1759–1761,* in collaboration with Barbara Brejon de Lavergnée. Rome, 1986.

Rosenberg, Pierre and Schnapper, Antoine. Exh. cat. *Jean Restout (1692–1768).* Rouen, Musée des Beaux-Arts, June 17 to September 15, 1970.

Rosenberg, Pierre and Compin, Isabelle. "Quatre nouveaux Fragonard au Louvre, I." In *La Revue du Louvre et des musées de France,* 1974, no. 3, pp. 183–92.
— "Quatre nouveaux Fragonard au Louvre, II." In *La Revue du Louvre et des musées de France,* 1974, nos. 4–5, pp. 263–78.

Rosenberg, Pierre, 1974 *See also* Compin, Isabelle, 1974.
— 1983 *See also* Cuzin, Jean-Pierre, 1983.
— 1985 *See also* Dupuy, Marie-Anne, 1985.

Roskamp, Dietrich. "Der Philosoph von Jean-Honoré Fragonard." In *Jahrbuch der Hamburger Kunstsammlungen,* Vol. 6, 1961, pp. 73–78.

Sahut, Marie-Catherine. Exh. cat. *Carle Van Loo Premier Peintre du roi (Nice 1705–Paris 1765).* Nice, Musée des Beaux-Art (Jules Chéret), January 21 to March 13, 1977; Clermont-Ferrand, Musée Bargoin, April 1 to May 30, 1977; Nancy, Musée des Beaux-Arts, June 18 to August 15, 1977.
— In exh. cat. *Diderot et l'Art de Boucher à David.* Paris, Hôtel de la Monnaie, October 5, 1984 to January 6, 1985.

Sandoz, Marc. "Hugues Taraval (Paris 1729–Paris 1985)." In *Bulletin de la Société de l'Histoire de l'Art Français. Année 1972,* Paris, 1973, pp. 195–255.

Sauerländer, Willibald. "Über die ursprüngliche Reihenfolge von Fragonards 'Amours des bergers.'" In *Münchner Jahrbuch der Bildenden Kunst,* Vol. XIX, 1968, pp. 127–56.

Schnapper, Antoine. *David* (trans. by Helga Harrison). Fribourg and New York, 1980.
— *See* Rosenberg, Pierre, 1970.

Seligman, Ethlyne J. and Germain. "The myth of the Fragonard portraits at Chantilly or the re-discovery of

Jean-Marie Ribou." In *The Art Quarterly*, spring 1958, pp. 23–38.

Seznec, Jean et Adhémar, Jean. *Diderot, Salons*. Vol. II, 1765, Oxford, 1960; Vol. III, 1767, Oxford, 1963.

Slive, Seymour. "A Fragonard Landscape after Jacob van Ruisdael's 'Wooded Landscape with a pound.'" In *The Shape of the Past, Studies in Honor of Franklin D. Murphy*, Los Angeles, 1982, pp. 267–76.

Sterling, Charles. *The Metropolitan Museum of Art, A Catalogue of French Paintings, XV–XVIII Centuries*. Cambridge, Mass., 1955.

— *Sterling and Francine Clark Art Institute, Portrait of a man (The Warrior), Jean-Honoré Fragonard*. Williamstown, Mass., 1964.

Sutton, Denys. Exh. cat. *Fragonard*. Tokyo, National Museum of Western Art, March 18 to May 11, 1980; Kyoto, Municipal Museum, May 24 to June 29, 1980.

Thuillier, Jacques. *Fragonard*. Geneva, 1967.

— In exh. cat. *Tableaux de Fragonard et meubles de Cressent au Musée du Louvre*. Paris, The Louvre, Pavillon Denon, April 12 to September 30, 1974 (*Le petit journal des grandes expositions*).

Thyssen-Bornemisza Collection. *Catalogue of the Thyssen-Bornemisza Collection*. Lugano Castagnola, 1969 (under the direction of Rudolf J. Heinemann; commentary on French paintings by Charles Sterling).

Tornézy, Albert. "Bergeret et Fragonard, journal inédit d'un voyage en Italie, 1773–1774, précédé d'une étude par M. A. Tornézy." In *Bulletin et mémoires de la Société des Antiquaires de l'Ouest, T. XVII, année 1894*, Poitiers, 1895, pp. 1–431.

Vergnet-Ruiz, Jean and Laclotte, Michel. *Petits et grands Musées de France. La peinture française des primitifs à nos jours*. Paris, 1962.

Vilain, Jacques. In exh. cat. *French Painting: The Revolutionary Decades 1760–1830*. Sydney, Art Gallery of New South Wales, October 17 to November 23, 1980; Melbourne, National Gallery of Victoria, December 17, 1980 to February 15, 1981.

Villot, Frédéric. *Hall. Sa vie, ses œuvres*. Paris, 1867.

— *Notice des tableaux exposés dans les galeries du Musée Impérial du Louvre*, part three, *Ecole française*. Paris, third edition, 1869.

Volle, Nathalie. *Jean-Simon Berthélemy*. Paris, 1979.

Watson, F. J. B. "Fragonard: the Definitive Book." In *The Connoisseur*, March 1961, pp. 38–39.

Wells-Robertson, Sally. "Marguerite Gérard et les Fragonard." In *Bulletin de la Société de l'Histoire de l'Art Français. Année 1977*, Paris, 1979, pp. 179–89.

Wildenstein, Daniel and Georges. *Documents complémentaires au catalogue de l'œuvre de David*. Paris, 1973.

Wildenstein, Georges. Exh. cat. *Exposition d'œuvres de J. H. Fragonard*. Paris, Musée des Arts Décoratifs, Pavillon de Marsona, Palais du Louvre. June 7 to July 10, 1921.

— "Deux tableaux de Fragonard au Musée d'Angers." In *Beaux-Arts*, May 1, 1923, pp. 120–22.

— "Quatre Fragonard inédits, les dessus de porte de l'hôtel de Matignon." In *Gazette des Beaux-Arts*, June 1935, pp. 271–74.

— *Fragonard aquafortiste*. Paris, 1956.

— "L'Abbé de Saint-Non artiste et mécène." In *Gazette des Beaux-Arts*, November 1959, pp. 225–44.

— *The Paintings of Fragonard*, New York and Oxford, 1960.

— "Un amateur de Boucher et de Fragonard, Jacques-Onésyme Bergeret (1715–1785)." In *Gazette des Beaux-Arts*, July–August 1961, pp. 39–84.

Wilhelm, Jacques. *Bergeret de Grancourt, voyage d'Italie 1773–1774, avec les dessins de Fragonard*. Paris, 1948.

— "Fragonard as a painter of realistic landscapes." In *The Art Quarterly*, autumn 1948, pp. 297–304.

— "In search of some missing Fragonard paintings." In *The Art Quarterly*, winter 1955, pp. 364–76.

— "Deux dessus de portes de Fragonard provenant du Château de Louveciennes." In *La Revue des Arts*, 1956, no. 4, pp. 215–22.

— "Fragonard." Mimeographed, 1960.

— "Le salon du graveur Gilles Demarteau peint par François Boucher et son atelier avec le concours de Fragonard et de J. B. Huet." In *Bulletin du Musée Carnavalet*, 1975, no. 1, pp. 6–20.

Williams, Eunice. Exh. cat. *Drawings by Fragonard in North American Collections*. Washington, D.C., National Gallery of Art, November 18, 1978 to January 21, 1979; Cambridge, Mass., Fogg Art Museum, February 16, to April 1, 1979; New York, Frick Collection, April 20 to June 3, 1979.

— "A pair of portrait miniatures by Jean-Honoré Fragonard." In *Art at Auction. The Year at Sotheby's 1981–1982*, London, 1982, pp. 210–12.

Wintermute, Alan P. "Inventory of Paintings by the Ten 'First Painters to the King' in Public Collections in the United States." In exh. cat. *The First Painters to the King* by Colin B. Bailey. New York, Stair Sainty Matthiesen, October 16 to November 22, 1985; New Orleans Museum of Art, December 10, 1985 to January 19, 1986; Columbus Museum of Arts and Sciences, February 8 to March 26, 1986.

Wixon, Nancy Coe. *The Cleveland Museum of Art. Catalogue of Paintings. Part three. European Paintings of the 16th, 17th, 18th Centuries.* Cleveland, 1982.

Wurth Harris, Mary Ann "The Abbé de Saint-Non and his pastel copy of a painting by Fragonard." In *Apollo*, July 1979, pp. 57–61.

Zafran, Eric M. "Fragonard." In *Chrysler Museum at Norfolk, Bulletin*, Vol. 5, no. 6, June 1976, unpaginated.

— Exh. cat. *The Rococo Age. French Masterpieces of the Eighteenth Century.* Atlanta, High Museum of Art, 1983.

Index

Works by Other Artists

The numbers in italic refer to the page on
which the plate appears.

Names

The numbers in italic refer to the page on which the name appears in a caption.

Photo Credits

The author and the publishers wish to thank all those who have supplied photographs for this book. The author provided the photographs which are not listed below. The numbers refer to the plates.

The photo research for this book was done by Ingrid de Kalbermatten

Amiens, Musée de Picardie 62 and cat. 84 (photos Lauros-Giraudon, Paris); 2; cat. 116, 134, 165
Amsterdam, Rijksmuseum 151, 200
Angers, Musée des Beaux-Arts 37, 39, 110, 146; cat. 24, 25, 103, 118
Annecy, Musée 94; cat. 107 (photo Réunion des Musées Nationaux, Paris)
Baltimore, The Baltimore Museum of Art cat. 316
Besançon, Bibliothèque Municipale 77–84
– Musée des Beaux-Arts et d'Archéologie 66, 70, 71, 73, 105, 124, 171, 172, 173, 192, 194, 225, 226, 291; cat. 234, 303, 304 (photos AGNO 3, Besançon)
Boston, Museum of Fine Arts cat. 262, 281
Budapest, Museum of Fine Arts 64, 241
Buenos Aires, Museo Nacional de Arte Decorativo cat. 387
Cambridge, Fitzwilliam Museum 414
Cambridge, Mass., Fogg Art Museum 106, 153, 235, 270, 271, 293; cat. 219, 263, 366, 409, 410
Chambéry, Musée des Beaux-Arts 75; cat. 81
Chicago, The Art Institute of Chicago 63, 149; cat. 184
Cholet, Musée cat. 19 (photo Réunion des Musées Nationaux, Paris)

Cincinnati, Cincinnati Art Museum cat. 290
Cleveland, The Cleveland Museum of Art 262, 287; cat. 384
Copenhagen, Statens Museum for Kunst 68 (photo Hans Petersen, Hornbaek)
Detroit, Detroit Institute of Arts 26, 240; cat. 11, 12, 13, 14, 141, 230
Dublin, National Gallery of Ireland 167; cat. 150
Fort Worth, Kimbell Art Museum cat. 136
Frankfurt-am-Main, Städelsches Kunstinstitut 203 (photo Ursula Edelmann); 76, 197
Grasse, Cathedral 19; cat. 22 (photos Yann Thibault, Le Rove)
– Musée Fragonard cat. 137 (photo Jacques Mayer, Grasse); 165, 257; cat. 148, 364, 407
Hamburg, Kunsthalle 159; cat. 163
Hartford, Wadsworth Atheneum cat. 381
Indianapolis, Indianapolis Museum of Art cat. 34
Karlsruhe, Staatliche Kunsthalle 91, 272; cat. 411
Le Havre, Musée des Beaux-Arts André-Malraux 222; cat. 318 (photos Gilbert Fernez, Le Havre)
Le Mans, Musée de Tessé 18 (photo Réunion des Musées Nationaux, Paris)
Leningrad, The Hermitage 54, 117, 145, 273, 277; cat. 77, 115, 383, 413
Lisbon, Museu Calouste Gulbenkian 127; cat. 133, 193
– Museu Nacional de Arte Antiga cat. 196
London, Thos. Agnew and Sons, Ltd. 281
– British Museum 85, 89, 90
– Christie's 256; cat. 298
– Courtauld Institute of Art 107, 269, 274, 278, 302, 303; cat. 8, 85, 126, 349
– Dulwich Picture Gallery 148
– Leggatt Brothers 188

Saint-Jean-Cap Ferrat, Musée Ile de France 61 (photo Studio Zoom, Beaullieu-sur-Mer)

Saint Louis, The Saint Louis Art Museum 57; cat. 72

San Diego, Timken Art Gallery cat. 264

San Francisco, The Fine Arts Museums of San Francisco 4, 196, 208; cat. 59, 273, 305

San Marino, California, The Henry E. Huntington Library and Art Gallery 286; cat. 370

São Paulo, Museu de Arte 236; cat. 352, 353

Stockholm, Nationalmuseum 20, 21, 50, 218; cat. 30, 284

Tel Aviv, Studio Mula 227, 228

Toledo, The Toledo Museum of Art 34; cat. 44

Toulon, Musée d'Art et d'Histoire 168; cat. 149 (photos Studio BAOBAB, Toulon)

Troyes, Musée des Beaux-Arts 210; cat. 315 (photos François Monsallier, Troyes)

Vienna, Graphische Sammlung Albertina 234

Washington, D.C., National Gallery of Art 43, 118, 143, 230, 250, 251, 252, 253; cat. 56, 123, 179, 238, 254, 255, 311, 339a, 339b, 340, 341

Williamstown, Sterling and Francine Clark Art Institute 142; cat. 175

Worcester, Worcester Art Museum cat. 191

Acknowledgments

The material for this book was assembled independently of the work done by Pierre Rosenberg for the exhibition *Fragonard*, held in the fall and winter of 1987–88 in Paris at the Grand Palais, and in New York at the Metropolitan Museum of Art; however, I would like to thank Pierre Rosenberg for generously allowing me to include in this catalogue three paintings of which I had been unaware (cat. nos. 15, 73, and 404).

I am extremely grateful to Cecile Scailliérez for her help, particularly researching and verifying the material on public sales of previous centuries. I also owe thanks to the following people for the encouragement, aid, and information they kindly provided: Annie Angremy, Joseph Baillio, Isabelle Compin, Dominique Cordellier, Natalie Coural, Marie-Anne Dupuy, Jacques Foucart, Pierrette Jean-Richard, Alastair Laing, Sylvain Laveissière, Monique Mosser, Claudie Ressort, Marianne Roland Michel, Udolpho Van de Sandt, David Scrase, Jacques Thuillier, Jacques Wilhelm, Eunice Williams.

Finally, my thanks are due to Ingrid de Kalbermatten, Alain Le Coultre, Franz Stadelmann at Office du Livre for their patience and cooperation, and to the Cailleux, Pardo, and Wildenstein galleries, which gave me precious help with photographic material. I would like to pay tribute here to the memory of Jean Hirschen, who died while this book was being completed.

Jean-Pierre Cuzin

This book was printed and bound in June 1988 by Benziger AG, Einsiedeln, Switzerland
Setting: Typobauer Filmsatz GmbH, Ostfildern, West Germany
Photolithography: Gravor S.A., Biel, Switzerland
Design and Production: Franz Stadelmann
Editorial: Martha Swiderski-Ritchie

Printed and bound in Switzerland